REYNOLDS

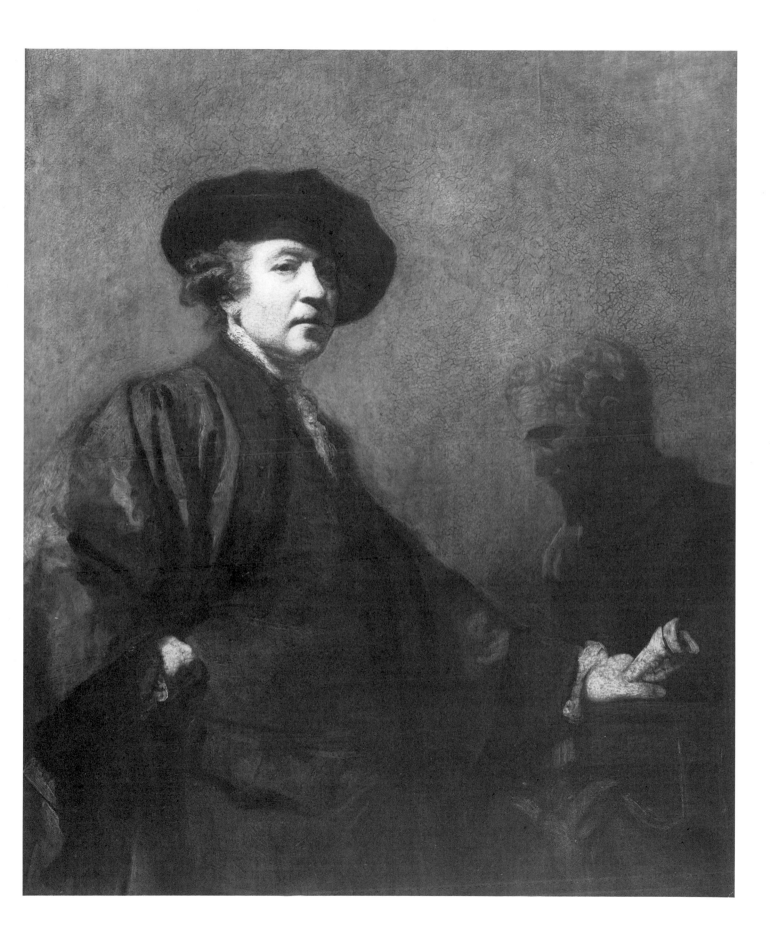

REYNOLDS

edited by
NICHOLAS PENNY

with contributions by
Diana Donald, David Mannings,
John Newman, Nicholas Penny,
Aileen Ribeiro, Robert Rosenblum
& M. Kirby Talley Jr.

Harry N. Abrams, Inc., Publishers, New York

Frontispiece
Sir Joshua Reynolds DCL (Cat. 116)

Library of Congress Cataloging-in-Publication Data

Reynolds, Joshua, Sir, 1723–1792.
 Reynolds.

 Catalog of an exhibition held by the Royal Academy
of Arts, London.
 Bibliography: p.
 Includes index.
 1. Reynolds, Joshua, Sir, 1723–1792—Exhibitions.
 2. Royal Academy of Arts (Great Britain)—Exhibitions.
I. Penny, Nicholas, 1949– . II. Donald, Diana.
III. Royal Academy of Arts (Great Britain) IV. Title.
ND497.R4A4 1986 759.2 85–28572
ISBN 0–8109–1565–0

Printed and bound in Great Britain

Contents

Sponsor's Preface

National Westminster Bank is delighted to be sponsoring the Sir Joshua Reynolds Exhibition. This major event presents the first opportunity for the public to see together so many of the works of one of the great masters of British Art. It is, of course, also a tribute to the Royal Academy's first President.

Our link with the Royal Academy has been a close one. My predecessor, Robin Leigh-Pemberton, was chairman of the Royal Academy Trust Appeal launched in 1982 to which we were pleased to contribute in order to help preserve the work of the Academy for the future.

I believe the increasing amount of sponsorship by industry is a welcome step in making the arts available to a wider audience. National Westminster has been a major supporter in recent years, giving assistance to a wide spectrum of activities ranging from events of national and international importance to local occasions.

Our help for the Arts is in fact part of a larger programme of community assistance undertaken by the Bank embracing social projects, charitable donations, secondments and sponsorship. As a major financial institution we feel the Bank has a role to play in contributing to the social fabric and cultural life of the country and so we are pleased to be associated with this celebration of a leading figure from our national heritage. I do hope you will enjoy the exhibition which the staff of the Royal Academy have worked so hard to organize.

LORD BOARDMAN
Chairman,
National Westminster Bank PLC

Foreword

This exhibition, organised by the Royal Academy of Arts in association with the Réunion des musées nationaux of France, celebrates the varied talents of the man who dominated the history of British painting in the latter part of the eighteenth century: the Academy's first President, Sir Joshua Reynolds.

Reynolds's skill as a painter is justly renowned. His works portray, in the most striking and ambitious manner, the noblemen, the beauties, the naval and military heroes of the day, as well as the intellectual circle in which he himself moved, and through his writings and the force of his example Reynolds was able to communicate a conception of the place of Art and of the Artist in society which was to have wide appeal during his life and after his death.

The influence of the French Academy in the establishment of academic ideals in eighteenth-century Europe is well known, and it is fitting that this exhibition should first have been seen in the galleries of the Grand Palais in Paris – where its success has done much to enhance the artist's European reputation – before moving to the Royal Academy itself, over which Reynolds presided with such distinction.

The exhibition would not have been possible without the closest co-operation between our institutions and the dynamism of its co-ordinators, Nicholas Penny, Keeper of Western Art at the Ashmolean Museum, Oxford, and Pierre Rosenberg, Conservateur en chef of the Department of Paintings at the Louvre. The catalogue is edited by Dr Penny and contains valuable contributions by him and by other distinguished scholars.

None of these efforts would, however, have borne fruit had we not been able to rely upon the remarkable generosity of numerous British collections and the positive assistance of museums in Europe and America. To all those who have lent works to the exhibition we express our profound gratitude.

The exhibition in London was made possible only by the financial support of the National Westminster Bank PLC, to whom our sincere thanks are also due.

Shortly before the exhibition opened in Paris, we were to learn with deep regret of the death of Sir Ellis Waterhouse, the doyen of Reynolds scholars, the importance of whose contributions to the study of the artist's work in general, and to the preparation of this exhibition in particular, cannot be overestimated.

HUBERT LANDAIS
Directeur des musées de France

ROGER DE GREY
President, Royal Academy of Arts

Index of Lenders

Numbers referred to are catalogue numbers

EIRE
Dublin, The National Gallery of Ireland 14, 89, 173

FRANCE
Paris, Musée du Louvre 146

WEST GERMANY
Berlin, Gemäldegalerie, Staatliche Museen Preussischer
 Kulturbesitz 49

GREAT BRITAIN
H. M. The Queen 149
Abercorn, The Trustees of the Abercorn Heirlooms Trust 3
Aberdeen, University of 87
Alexander, David 67, 137, 176
Birmingham, The Special Trustees for the former United
 Birmingham Hospitals 144
Bradford, Art Galleries and Museums 53
Bristol, City Museum and Art Gallery 41
Broughton-Adderley, Mrs E. 154b
Buccleuch and Queensbury K.T., The Duke of 104
Cadogan, The Earl 24
Cambridge, The Syndics of the Fitzwilliam Museum 38, 58, 70,
 94, 102, 135, 155
Cardale, The Rev. Arthur Mudge 17
Cardiff, National Museum of Wales 141
Cowdray, The Viscount 138, 142
Devonshire, The Duke of 30, 32, 139
Dixon, Rob 56, 91, 128
Edinburgh, National Gallery of Scotland 84, 122, 131
Edmunds, Andrew 186, 199
Egremont, The Lord 47
Eliot, Property of the Eliot Family 2, 23
Faringdon, The Collection Trust, Buscot 93
Fitzwilliam, Executors of the 10th Earl 21, 150
Firle Estate, The Trustees of 133
Goodwood House, by courtesy of the Trustees 64, 65
Harewood, The Earl of 61, 118, 170
Harvey-Bathurst, The Hon. Mrs 8
Hertford, The Marquess of 28
Howard, The Castle Howard Collection 100
Lennox-Boyd, The Hon. C. 154a
London, The British Library 195
London, The Trustees of the British Museum 20, 44, 55, 59, 60,
 68, 68a, 71, 72, 72a, 80, 83, 84, 88, 117, 123, 124, 127, 129, 134,
 140, 143, 148, 152, 174, 177, 178, 180, 181, 182, 183, 185, 187,

188, 191, 192, 193, 194, 196, 197, 198, 201, 203, 204, 205, 206,
 207, 208, 209
London, Society of Dilettanti 109, 110
London, Governors of Dulwich Picture Gallery 151
London, The Iveagh Bequest, Kenwood (G.L.C.) 16, 34
London, Marble Hill House (G.L.C.) 12
London, The Trustees of the National Gallery 26, 33
London, The National Maritime Museum 19
London, The National Portrait Gallery 13, 37, 66, 125, 136, 184
London, The Royal Academy of Arts 18, 112, 113, 114, 115, 116,
 160, 162, 163, 164, 167, 168, 172, 175, 179
London, The Trustees of The Tate Gallery 90, 99, 106
London, Witt Print Collection, Courtauld Institute of Art 62a
Manchester, The Whitworth Art Gallery, University of 189, 190
Marlborough, The Duke of 108
Merseyside County Council, Lady Lever Art Gallery 36, 132
Middleton, The Lord 45
Newcastle upon Tyne, Laing Art Gallery 51
Nottingham, Newstead Abbey 10
Oxford, The Visitors of the Ashmolean Museum 55a
Petworth, National Trust (Egremont Collection) 31
Plymouth, City Museum and Art Gallery 4, 5, 145
Radnor, The Earl of 40, 75, 126
Rosebery, The Earl of 43, 63
Rothschild Collection, Ascott 81
Sackville, The Lord 73, 82
Saltram, The National Trust 11, 111, 169
Saunders-Watson, Commander L. M. M. 1
Tavistock, The Marquess of 25, 79
Tetton, The Trustees of the Heirlooms Settlement 74

UNION OF SOVIET SOCIALIST REPUBLICS
Leningrad, The State Hermitage Museum 154

UNITED STATES OF AMERICA
Boston, Museum of Fine Arts 52
Buffalo, Albright-Knox Art Gallery 92, 157
Chicago, The Art Institute of 57
Cleveland, Museum of Art 39
Houston, Menil Foundation Collection 77
Los Angeles, County Museum of Art 95
Minneapolis, Institute of Arts 101
New Haven, Yale Center for British Art 70
New York, The Metropolitan Museum of Art 54, 130
Washington, National Gallery of Art 107

Also many owners who prefer to remain anonymous

Advisory Committee

Martin Butlin

Francis Haskell

John Hayes

Evelyn Joll

The late Sir Ellis Waterhouse

Christopher White

Acknowledgements

Thanks are owed to the following individuals, in addition to the lenders, who contributed in many different ways to the organization of the exhibition and the preparation of the catalogue:

David Alexander
Brian Allen
Maureen Attrell
Barbara Baker
John Barnes
John Brealey
David Blayney Brown
David Buttery
Eric Chamberlayne
Margaret Christian
Keith Christiansen
Michael Clarke
Juliet Collings-Wells
Malcolm Cormack
Jane Dacey
Peter Day
Eric Denker
G. P. Edwards
The Madam Fitzgerald
Anne French
Joan Friedman

Peter Funnell
Hazel Gage
The Knight of Glyn
Mrs Gray
John Hardy
Craig Hartley
Francis Haskell
Ella Hendriks
Christopher Hogwood
Christopher Holden
Hugh Honour
Deborah Howard
Eric Hunter
John Ingamells
Michael Jaffé
Kasha Jenkinson
Ronnie Katzenstein
Amanda Kavanagh
John Kerslake
P. I. King
Martin Royalton Kisch

Michael Kitson
Gillain Lewis
Iva Lisikewycz
Anne Lurie
Mrs MacInnes
Colin McClaren
Ian McClore
Frances McDonald
Jane Martineau
W. R. Maxwell
Sir Oliver Millar
David Moore-Gwyn
Evelyn Newby
Constance-Anne Parker
Viola Pemberton-Pigott
Martin Postle
Helen Raye
Duncan Robinson
Pat Rogers
Natalie Rothstein
Mrs M. Rowe

Matthew Rutenberg
Diana Scarisbrick
Douglas Schulz
David Scrase
Douglas Smith
Dorothy Stroud
Sir John Summerson
Gerald Taylor
David Udy
Helen Valentine
Marie Valsamidi
Mary-Jane Victor
Sir William Watkins Wynn
Lavinia Wellicome
Christopher White
Jon Whiteley
Michael Wynne
Antonia Yates
Kai Kin Yung

Photographic Acknowledgements

The exhibition organizers would like to thank the following for making photographs available. All other photographs were provided by the owners of the works of art reproduced.

University of Aberdeen figs 50, 52
Alinari fig. 59
The Ashmolean Museum, Oxford fig. 17
Birmingham City Museum and Art Gallery Cat. 100; fig. 44
The Bridgeman Art Library, London Cat. 97, 98
Christie's, photograph by A. C. Cooper Ltd Cat. 154
Courtauld Institute of Art Cat. 31, 40, 43, 75, 81, 93, 111; figs 11, 20, 21, 68, 72, 90, 91, 107
Prudence Cuming Associates Ltd Cat. 2, 7, 10, 15, 21, 23, 24, 27, 28, 40, 42, 45, 46, 47, 55, 61, 64, 65, 69, 72, 74, 75, 84, 86, 103, 108, 109, 110, 112, 116, 118, 119, 120, 121, 126, 138, 142, 147, 150, 154b, 156, 160, 168, 186; figs 3, 15, 16, 26, 43, 68
Mark Fiennes, London Cat. 30, 32
Grade One Photographic, London Cat. 85
Greater London Council, Iveagh Bequest, Kenwood House figs 14, 53

Studio Lourmel 77, Photo Routier fig. 39
Mancktelow Photography, Kent Cat. 73, 82
Paul Mellon Centre for Studies in British Art Cat. 8, 9, 17, 27, 50, 104, 147, 158, 159, 170; figs 1, 6, 7, 12, 14, 18, 22, 47, 55, 64, 66, 80
The Metropolitan Museum of Art, New York Cat. 22, 105
Studio Morgan Cat. 87
National Gallery of Ireland, Dublin Cat. 3
National Gallery of Scotland, Edinburgh fig. 10
National Monuments Record figs 60, 71, 76
A.E. Mc.R. Pearce, Somerset fig. 56
Edward Reeves, Lewes Cat. 133
Royal Academy of Arts Cat. 6; fig. 8
Warburg Institute fig. 60
White House Studios, Edinburgh Cat. 43, 63
Woburn Abbey, Beds Cat. 25, 79

Royal Academy of Arts

THE SECRETARY OF THE ROYAL ACADEMY
Piers Rodgers

EXHIBITIONS SECRETARY
Norman Rosenthal

DEPUTY EXHIBITIONS SECRETARY
Annette Bradshaw

EXHIBITION ASSISTANT
Elisabeth McCrae

EXHIBITION DESIGNER
Ivor Heal

GRAPHIC DESIGNER
Philip Miles

Editor's Note

The editor and compilers of the catalogue owe a special debt to the late Sir Ellis Waterhouse, the greatest of all scholars to have written on Reynolds, who not only granted access to his valuable photographic collection but also to his richly annotated and grangerized volumes of Graves and Cronin, and patiently replied to numerous postal enquiries.

The editor would like to record his gratitude for the hospitality and help he has invariably received in the library of the Royal Academy and in the Paul Mellon Centre, and the debt he owes to the congenial academic atmosphere and practical amenities of King's College, Cambridge and Balliol College, Oxford. David Mannings was enabled to travel to the U.S.A. because of a generous grant from the British Academy. Diana Donald would like to record the assistance provided by the Whitworth Art Gallery.

Chronology

REYNOLDS'S LIFE	CONTEMPORARY EVENTS IN BRITAIN (*especially artistic and literary*)	CONTEMPORARY EVENTS IN EUROPE (*especially artistic and literary*)
1723 Joshua Reynolds born in Plympton (16 July), the third son and seventh child of the Rev. Samuel Reynolds.		
1740 Reynolds begins his apprenticeship in London with Thomas Hudson.	**1742** Jean Baptiste Van Loo leaves England. Hudson becomes leading portrait painter in London.	**1743** Death of Rigaud.
1744–9 Active as a portrait painter in Devonport and London.	**1744** Death of Alexander Pope. **1745** Hogarth completes his *Marriage à la Mode*. **1745–6** Second Jacobite Rebellion. **1747** Garrick co-manager of the Drury Lane Theatre. **1748** Richardson's *Clarissa Harlowe* published.	**1746** Death of Largillière. **1747** Death of Solimena.
1749 Sails with Commodore Keppel to the Mediterranean (11 May). Stays on Minorca.	**1749** Fielding's *Tom Jones* and Johnson's *Vanity of Human Wishes* published.	**1749** Death of Subleyras.
1750 Arrives in Rome (April).	**1750** Canaletto leaves London and returns to Italy.	**1750** Pompeo Batoni established as the leading artist in Rome. Tiepolo commences his frescoes at Würzburg. **1751** The first part of the *Encyclopédie* published.
1752 Visits Naples (April) and then sets out from Rome for Florence (May), Bologna and Venice (July and August), Paris (September), London (October) and then returns briefly to his family in Devonshire.		**1752** Mengs returns from Dresden to Rome.
1753 Established in London, first in St Martin's Lane and then in Great Newport Street.	**1753** Hogarth's *Analysis of Beauty* published. Liotard painting in London (leaves 1756). Ramsay and he, together with Reynolds, attract fashionable custom from Hudson.	**1753** Giaquinto succeeds Amigoni as court painter in Madrid. Boucher paints his *Rising* and *Setting of the Sun* (Wallace Collection, London). **1754** Death of Piazzetta.
	1755 Johnson's *Dictionary* and Hume's *History of Natural Religion* published. William Chambers settles in London. **1755–7** Ramsay visits Italy.	**1755** Lisbon earthquake. Sensational success of Greuze at the Salon. **1756** Outbreak of the Seven Year War. Publication of Piranesi's *Le Antichità Romane*.

REYNOLDS'S LIFE	CONTEMPORARY EVENTS IN BRITAIN (especially artistic and literary)	CONTEMPORARY EVENTS IN EUROPE (especially artistic and literary)
	1757 Burke's *Philosophical Enquiry* published.	**1757** Publication of first volume of the *Antichità di Ercolano*.
	1758 Robert Adam and Richard Wilson return to London from Italy.	**1758** Death of Rosalba Carriera.
1759 Reynolds's first writing on art published in Dr Johnson's *Idler*.	**1759** The British Museum opens to the public.	**1759** Publication of Voltaire's *Candide*. Charles III crowned King of Spain.
1760 Moves to Leicester Fields and builds a new studio.	**1760** George III crowned. Sterne's *Tristram Shandy* begins to appear. The first public exhibition of paintings held in London.	**1761** Completion of ceiling painting of *Parnassus* in Villa Albani, Rome, by Mengs who then travels to Madrid to succeed Giaquinto as court painter.
		1762 Publication of Rousseau's *Emile* and *Contrat Social*. Tiepolo travels to Madrid. Catherine the Great assumes power in Russia.
	1763 West settles in London.	**1763** Peace of Paris.
1764 Founds 'The Club' with Dr Johnson. Briefly but severely ill.	**1764** Death of Hogarth.	**1764** Winckelmann's *History of Ancient Art* and Beccaria's *Dei Delitti e delle Pene* published. Tiepolo completes fresco of the Throne Room in Madrid.
	1765 Nathaniel Dance returns to London from Rome. Johnson's edition of Shakespeare published.	**1765** Death of Giaquinto. Fragonard's *Corésus et Callirhoe* (Louvre, Paris) acclaimed at the Salon.
	1766 Angelica Kauffmann settles in London. Goldsmith's *Vicar of Wakefield* published.	**1766** Publication of Lessing's *Laokoon*.
	1767 Cotes, now in fashion as a portraitist, begins to enjoy royal favour.	**1767** Expulsion of Jesuits from France and Spain.
1768 Revisits Paris (9 September–23 October). Is elected President of the Royal Academy (14 December).	**1768** Foundation of the Royal Academy.	
1769 Opening of the Royal Academy (2 January). Reynolds delivers his first Discourse.	**1769** West's *Departure of Regulus* commissioned by the King. First exhibition of the Royal Academy.	**1769** Greuze exhibits *Septime Sévère* (Louvre, Paris). Publication of Gluck's *Alceste*.
	1770 Death of Cotes. Publication of Goldsmith's *Deserted Village*.	**1770** Death of Boucher and of Tiepolo.
1771 Again in Paris (15 August–early September) in connection with the Crozat Sale.	**1771** Exhibition of West's *Death of Wolfe*. Barry returns to London from Rome.	
1772 Elected Alderman of the Borough of Plympton (September).		**1772** First partition of Poland.
1773 Awarded Doctorate of Civil Law at the University of Oxford (9 July). Elected Mayor of Plympton (September), sworn in as Mayor (4 October).	**1774** Gainsborough moves from Bath to London.	**1774** Louis XVI crowned King of France.
1775 Elected member of the Academy at Florence.	**1775** Commencement of the War against rebel American colonies.	**1775** Completion of Pigalle's portrait of Voltaire. Publication of Lavater's *Physiognomy*. First performance of *Barber of Seville* by Beaumarchais.
	1776 Romney fashionable as a portraitist. Adam Smith's *Wealth of Nations*, the first part of Gibbon's *Decline and Fall of the Roman Empire* and the first part of Burney's *History of Music* published.	**1776** The Comte d'Angiviller begins to commission the series of statues of 'Grands Hommes'.

REYNOLDS'S LIFE	CONTEMPORARY EVENTS IN BRITAIN (especially artistic and literary)	CONTEMPORARY EVENTS IN EUROPE (especially artistic and literary)
	1777–83 Barry decorates the Great Room of the Royal Society of Arts.	
	1778 Admiral Keppel acquitted at court martial. Fanny Burney's *Evelina* published.	**1778** Death of Piranesi.
1779 *Discourses* collected and published as a book (May).	**1779** Death of Garrick. Fuseli arrives in London.	**1779** Death of Mengs. Death of Chardin. First performance of Gluck's *Iphigenia*.
	1779–83 Siege of Gibraltar.	
	1780 New premises of the Royal Academy opened in Somerset House. Copley's *Death of Chatham* completed.	
1781 Tour with Philip Metcalf to Bruges, Ghent, Brussels, Antwerp, The Hague, Amsterdam, Düsseldorf, Cologne, Liège, Brussels, Ghent and Ostend (24 July–14 September).		
	1782 Gainsborough begins to enjoy royal favour. Whigs briefly in government.	**1782** Completion of Canova's *Theseus*.
1783 Recovering from violent inflammation of his eyes (19 January).	**1783** Peace of Versailles and recognition of American Independence.	**1783** Début of Mme Vigée Lebrun at the Salon.
1784 Sworn in as successor to Ramsay as Painter in Ordinary to the King (1 September).	**1784** Success of Fox in the Westminster Election. Death of Johnson.	**1784** Death of Diderot. Death of Batoni.
1785 Second tour abroad with Philip Metcalf visiting Brussels, Antwerp and Ghent (20 July–August).	**1785** Secret marriage of Prince of Wales to Mrs Fitzherbert.	**1785** David's *Oath of the Horatii* exhibited in Rome.
	1786 Boydell's Shakespeare Gallery planned.	**1786** Goya appointed the King's painter.
		1787 Mozart's *Don Giovanni* performed.
	1788 Death of Gainsborough. Commencement of trial of Warren Hastings.	
1789 Obscuring of one eye (13 July). Visits Sussex coast (August). Vision lost in afflicted eye (October).	**1789** Lawrence exhibits his portrait of Queen Charlotte.	**1789** Meeting of the Estates General at Versailles. Fall of the Bastille.
1790 Resigns as President of the Royal Academy (11 February). Withdraws resignation (15 May). Is described as 'almost' having stopped painting (16 October). Delivers final Discourse to the Royal Academy (10 December).	**1790** Burke's *Reflections on the French Revolution* published.	**1790** Publication of Kant's *Critique of Pure Reason*.
1791 Nearly totally blind (5 November).	**1791** Boswell's *Life of Johnson* and Paine's *Rights of Man* published.	
1792 Dies of a malignant tumour on the liver (23 February).		
		1793 Execution of Louis XVI and abolition of Christianity in France.

An Ambitious Man

The career and the achievement
of Sir Joshua Reynolds

Nicholas Penny

Portraiture and fiction

Sir Joshua Reynolds is remembered as a portraitist rather than as a painter of heroic or poetic subjects, and modern critics tend to agree with Samuel Johnson who 'grieved' that his friend should 'transfer to heroes and to goddesses, to empty splendor and to airy fiction, that art, which is now employed in diffusing friendship, and renewing tenderness, in quickening the affections of the absent, and continuing the presence of the dead'.[1] This, however, is a partial, even a sentimental, characterization of Reynolds's portraiture.

Some of Reynolds's paintings were designed to satisfy domestic needs, to commemorate and to console, but most of them were intended to support self-esteem and even to promote a public image. Destined to hang in grand reception rooms more often than in private ones, many of his portraits were shown first at public exhibitions in London, and reproductions of them—even of some intimate and informal ones—were also to be seen in the windows of print shops by the 'common porters' and 'kitchen-maids and stable-boys' who were excluded from such exhibitions, as also from the auction rooms.[2] Moreover, a good many of Reynolds's portraits were almost as heroic, divine, splendid—and as fictional—as the history paintings in the grand manner with which Johnson contrasted them.

Congratulated on the truth, in attitude and expression, of one of his portraits, Reynolds replied that he had simply painted what he saw—it was like 'copying a ham or any object of still life'.[3] He would surely not have said this if it was usually the case, and the portrait in question (of the old lawyer Joshua Sharpe, Cat. 138) is relatively rare in that it depicts the sitter as he would have been in the artist's studio. More imagination was usually required—the ladies and gentlemen who sat to him had to be shown standing up and often moving in parks or palaces, or on battlefields; and their poses and their clothes sometimes had to be invented. Above all, appropriate expressions had to be found.

When painting the Lord Chief Justice, who had recently lost his teeth, Reynolds observed wittily that he had 'made him exactly what he is now, as if I was upon my oath'.[4] But he would not have made this remark if he always felt that he was 'upon my oath'. It was said by one contemporary that in his male portraits Reynolds sometimes 'lost likeness' in his endeavour to 'give character where it did not exist';[5] but another conceded that his genius was to combine truth

with fiction, so that one was shocked to discover 'the exact features' of one's 'half-witted' acquaintances painted so that 'every muscle in their visage appears to be governed by an enlightened mind'.[6] His paintings of women, especially young ones, were considered as more explicitly flattering.[7] Idiosyncratic features were reduced to accord with a personal ideal of a contemporary fashion, as was usual in European portraiture. With women it was not enough to give them an enlightened mind.

Today it is conventional to praise portrait painters for their psychological penetration. But in most cases Reynolds had no prior knowledge of the character of his sitters. Indeed he may not always have known their names, for some were first entered in his pocket-book as 'a lady' or a 'stranger'.[8] When they were well known he did not reveal their weaknesses. He knew that many of his fashionable ladies were less gracious, his mothers less loving, his princes less dignified, his bishops less wise, and his commanders less valiant than he makes us believe.

Reynolds cast the privileged members of society into impressive roles, more varied and more convincing than any which they could have proposed for themselves. His capacity to do so may perhaps be explained by reference to his artistic ambition, stimulated by the precarious social position of his own family, to make painting a profession instead of a trade, a liberal art rather than a craft, and to earn the respect accorded to the tragic or epic poet. He did eventually attract commissions for history paintings and allegories, but for the most part he was obliged to paint portraits, for which there was a greater demand in England than in any other country in Europe, and his great achievement was the pragmatic one of making his portraits heroic and poetic. To demonstrate his genius he was obliged to discover genius in his sitters—or to endow them with it.

The pupil of Hudson and Richardson

Reynolds was born in 1723 in Plympton, a small town near the increasingly important naval port of Plymouth in Devon. His father, the Rev. Samuel Reynolds (Cat. 4), formerly a fellow of Balliol College, Oxford, was the master of the Free Grammar School at Plympton. He seems to have been 'a classic example of the good-natured and absent-minded schoolmaster, whose enquiring mind was easily distracted

towards new interests, but who was lacking in steady application to any one pursuit'.[9] He had a good library and learned friends and relations in high places—one brother was a fellow and bursar of Corpus Christi College, Oxford, and the other a canon of St Peter's, Exeter, and a fellow of King's College, Cambridge, and of Eton College (fig. 1)—but

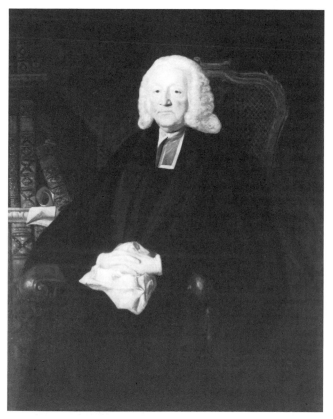

Fig. 1 Rev. John Reynolds, 1757 (Eton College)

Samuel did not send his own sons to university, and perhaps could not have afforded to do so.[10]

Samuel's first son, Humphrey, was a naval lieutenant. He was drowned in 1741. His second son, Robert, was established as an ironmonger in Exeter. Samuel planned to apprentice Joshua, his third son, to an apothecary.[11] This was a respectable trade, but a trade all the same, distinct from the 'learned' profession of medicine, and with none of the prospects of glory, honour, or power which the Church or the Navy offered, even if only distantly, to many of the companions of Joshua's youth and to others in his family.

Joshua himself had other ambitions, and friends of the family, struck by the boy's artistic efforts—very limited though these seem to have been—recommended that he should be apprenticed, not to an apothecary, but to Thomas Hudson, a portrait painter with a new London practice who had recently been working in his native Devonshire.[12] This was arranged in October 1740 when Joshua was nearly eighteen years old.

In the autumn of 1742, when Jean-Baptiste Van Loo returned to France, Hudson was considered, *faute de mieux*,

the best portrait painter in London[13] but it would be surprising if Reynolds had not by this date detected that his master's imaginative gifts, if more extensive than those required by an apothecary, were little more than would be expected of a fashionable tailor. Although apprenticed for four years, Reynolds left Hudson in the summer of 1743. The disagreement, if there was one, was not considered discreditable and cannot have been very serious since relations between the two men were cordial in subsequent years.[14]

By January 1744 Reynolds had been active for some months as a portrait painter in Plymouth Dock (now Devonport), but later in the year, certainly by early December, he was back in London, where he was also recorded as painting in May 1745. A period of retirement to the provinces after a London training was not unusual, and concern for his family may have provided an additional motive for Reynolds's movements. His father died at the end of 1745 and in the following year he was sharing a house with his unmarried sisters in Plymouth Dock. Although he may also have practised in London in the following years, his chief patrons seem to have been the naval officers in Plymouth and the leading families of the neighbourhood.[15]

Reynolds painted children and young ladies full-length, holding flowers (Cat. 1) or playing with lambs in a park setting; officers three-quarter-length in stock attitudes of genteel ease (Cat. 10, 11) and, most commonly perhaps, men and women head and shoulders within a feigned oval frame (Cat. 12). The compositions are as conventional as we would expect from a pupil of Hudson, but the colour, chiaroscuro and handling are sometimes remarkable. Reynolds is interested in the subtle repetition in the sky of the pink and grey of a dress, in the surprising shadow cast over the eyes by a raised hand, in swift brushwork for foliage and fur, in buttery highlights on metal buttons. He was also concerned to make women look more soulful (Cat. 5) and men look more gallant and formidable (Cat. 3) than had been conventional in British portraiture.

Recognition of Hudson's limitations can only have been encouraged by examining the remarkable collection of Old Master drawings which he had assembled. These Reynolds had been allowed to copy: in particular we know that he made imitations of those by Guercino.[16] He was also employed to bid for drawings on Hudson's behalf at auction, and on one occasion (in March 1742), when engaged in this way, he witnessed the homage which the world could pay to genius. The crowd, to the multiplied whispers of the name of Alexander Pope, parted to make a passage for the prematurely wizened poet, who shook the hands extended to him, among them that of the young apprentice.[17] No English painter had ever enjoyed such reverence as this.

Reynolds, who did not reminisce about Hudson, enjoyed recalling this contact with Pope. His earliest surviving notebook,[18] which he filled over the course of subsequent years, includes many quotations from Pope and also many from Pope's friend Jonathan Richardson, who was Hudson's father-in-law, and also a portrait painter, although he had retired from practice at the moment Reynolds began. Reynolds claimed that he owed his 'first fondness' for his

art to Richardson's polemics[19]—which provide (together with Dryden's preface to his prose translation of *Du Fresnoy*) the earliest and the most eloquent sustained argument in the English language for painters to be considered as on a par with poets. Readers of Richardson, and of the French and Italian theorists (above all de Piles and Bellori) who influenced him, knew that 'great taste' could only be acquired from a study of ancient sculpture and of Italian painting of the sixteenth and seventeenth centuries. With this in mind more and more gentlemen were travelling to Italy, and above all to Rome, from Britain. Painters had more imperative motives to make the journey, although they less commonly had the means to do so.

Reynolds in Italy

At the end of April 1749 Richard, first Baron Edgcumbe of Mount Edgcumbe near Plymouth, who had known Reynolds as a boy and had sat to him for his portrait, introduced the artist to Commodore Keppel (fig. 2), son of the Earl of Albemarle. Earlier in the year Keppel had been given

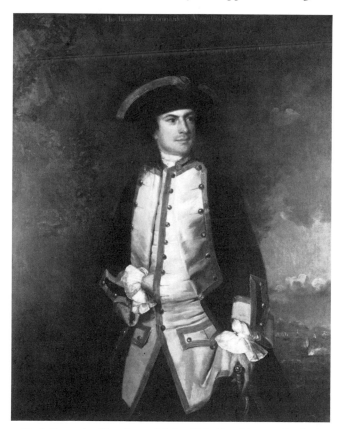

Fig. 2 Commodore Keppel, 1749 (National Maritime Museum, London)

the mission of obtaining, by threats and presents, an agreement with the Dey of Algiers to restrain his pirates. On his way to the Mediterranean he had been forced by gale damage to make a brief stop at Plymouth, and it was then that he was introduced to Reynolds, who made the quick decision to accept an offer to accompany him on his mission. After

stops at Lisbon, Gibraltar and Algiers Reynolds landed on Minorca where he passed the second half of the year painting portraits of the British garrison whilst Keppel continued negotiating.[20] On 27 January 1750 he sailed to Leghorn. He was settled in Rome in April, remaining there for two years, supported in part by money advanced to him by his two married sisters.[21] After a visit to Naples in April of 1752, he travelled north from Rome to Florence, Bologna, Venice and Paris. Arriving back in England in October, he revisited his family and friends in Devon before establishing himself early in the following year in a studio in St Martin's Lane, London.[22]

In the pocket sketchbooks which survive from this period we find laundry lists, addresses, and opinions transcribed from travel books mingled with his own brief critical judgements and notes on colour and technique. There are drawings of landscape, of ornament, but only one or two of architecture; most are from antique sculpture or from paintings (Cat. 158, 159), as old as Mantegna and as modern as Tiepolo, often of separate figures, but also diagrams of chiaroscuro made, as he later recommended, 'without any attention to the subject or to the drawing of the figures'.[23] There is little to suggest an analytical attitude to composition or to spatial organization. There are few careful studies of details,[24] but such studies would not have been appropriate in such a small sketchbook designed for making hasty notes standing up, and in a larger album there are some finished drawings in red chalk of heads in Raphael's Vatican frescoes (Cat. 160).[25]

In Rome Reynolds made sketch copies for himself, including some in the Vatican where he contracted the chill which was said to have precipitated his deafness.[26] He also made some finished copies, offering to send one back to Lord Edgcumbe.[27] This practice (of which he later expressed disapproval[28]) was recommended by the European academies of art. But Reynolds never received the fundamental training to which those academies attached still more importance. Significantly, he marked and translated in his copy of Fréart's treatise on painting (*L'Idée de la Perfection* of 1662) a passage on the essential value for the Old Masters of the study of geometry, perspective and anatomy.[29] He was aware of his own deficiency in these matters, but it was too late to rectify this.

There are a number of indifferent drawings of uncertain date of the posed model by Reynolds,[30] and he may have taken advantage of the life-class of the French Academy in Rome as other British artists did—he certainly knew French artists in Italy.[31] In Rome he must have studied the antique: in Florence he seems to have drawn from the plaster cast;[32] and there is also a reference to a drawing of the Laocoon made by him early in his apprenticeship.[33] But his ignorance of anatomy, evident in his earliest work (despite his father's anatomical prints and the possibility that he studied the subject in preparation for his career as an apothecary[34]), persisted in his maturity. So, too, did his ignorance of linear perspective (despite his early drawings of a bookcase and of his father's schoolhouse inspired by his study of the *Jesuits Perspective*[35]). The chair arms in some of the most considered of his mature pictures (for instance, in one of his group

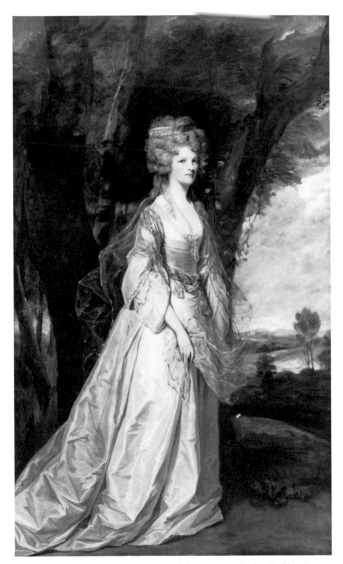

Fig. 3 Lady Sunderlin, 1788 (Staatliche Museen, Berlin-Dahlem)

portraits of the Society of Dilettanti, Cat. 110), and even the simplest mouldings on the bases of the columns, are often incompetently foreshortened—as is, for example, the projecting knee of his Child Baptist (Cat. 101) or the branch upon which Colonel Coussmaker leans (Cat. 130).

In 1750, the year of Reynolds's arrival in Rome, Pompeo Batoni emerged decisively as the leading artist in the city and established himself as a portraitist of British travellers.[36] If we compare Batoni's portraits, or those of the leading French artists, of the middle decades of the eighteenth century, with those by Reynolds at any date, we are immediately struck by Reynolds's reluctance to portray the interior of a room, and by the minimal, often perfunctory and obviously improvised outdoor settings he provides. We notice, too, how rarely Reynolds exhibits the sitter's hands in any complex open gesture. In his early portraits hands were often conveniently concealed in pockets or waistcoats,[37] and even in his last works we may catch him extending drapery over miscalculations in composition and blunders in drawing—

sometimes a hand or arm thus concealed has, with the increasing transparency of the paint, made an alarming reappearance, as is the case with the left arm in the fine portrait of Lady Sunderlin recently acquired by the Staatliche Museen, Berlin-Dahlem (fig. 3).

It was suggested to Reynolds by Lord Edgcumbe that he should study with Batoni, but Reynolds replied that he had nothing to learn from him. This was clearly false. But he may well have sensed that he had more to lose than to gain from such an association. It is evident that Reynolds felt that modern Italian painters had no real connection with the Old

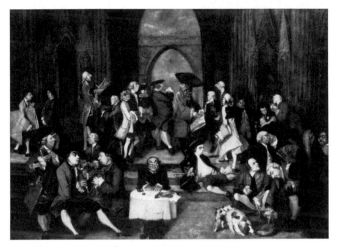

Fig. 4 Travesty of the School of Athens, 1751
(National Gallery of Ireland, Dublin)

Masters. His notes on colour and technique make it clear that he did not believe that the latter's secrets had survived them. In Venice, it is true, he consulted Zuccarelli as to whether or not Titian, Veronese and Tintoretto employed a gesso ground, but he seems to have done so in a sceptical spirit— 'He does not think that Titian did. I am firmly of the opinion they all did.'[38] This desire to return alone to the past was Reynolds's greatest strength as a painter, although from one point of view it was his greatest weakness for it entailed a dangerous disregard for the established and reliable ways of using oil-paint.

Caricatures in pen and ink of stiffly-posed figures with large heads in profile such as had long been produced in Roman studios had recently been made fashionable by Ghezzi, whose works were also available as prints (some of them published in England in the 1740s[39]). Thomas Patch, an English artist resident in Italy, may already have begun to specialize in painted caricatures.[40] Reynolds painted a number of such works in Rome, perhaps for recreation as much as for money. The most ambitious, but not the best preserved of them, is a travesty of Raphael's *School of Athens* with milordi—the same milordi who were sitting for portraits by Batoni—in place of philosophers, and a gothic instead of a Roman architectural setting (fig. 4). The word 'gothic' was still used, as Raphael had used it, vaguely as a synonym for northern barbarism—and Reynolds was no doubt ridiculing as disguised barbarians his fellow country-

Fig. 5 Joseph Wilton, 1752 (National Portrait Gallery, London)

men whose pretentions as connoisseurs, as we know from one of his own later (anonymous) publications,[41] irritated him. Any satire, however, must have been good-humoured since we know that such pictures were commissioned by the subjects themselves.

The mock-heroic implies recognition of the heroic, and we may discern in this exercise in the lowest style of portraiture Reynolds's interest in the highest style represented by Raphael's fresco itself. It also suggests that Reynolds was already acutely aware of how hard it was to reconcile an emphasis on idiosyncratic features and topical fashion with nobility of expression and grandeur of attitude. Back in England he avoided painting caricatures, although his pen doodles reveal that he did not lose the aptitude.[42] It is possible that Reynolds practised as a portrait painter continuously during his period abroad, but the few works that can certainly be dated belong to his journey home: a portrait of Joseph Wilton, the English sculptor, made in Florence (fig. 5)[43] and one of Catherine Moore (Cat. 16), future wife of the architect Sir William Chambers, made in Paris, where we also know that he painted Monsieur Gautier, 'Secretaire du Roi'.[44]

New directions in male portraiture

Once established in London, Reynolds continued to enjoy the support of Lord Edgcumbe who recommended the Duke of Devonshire and the Lord Chamberlain (the Duke of Graf-

ton) to sit to him.[45] He soon moved to larger premises in Great Newport Street, where his intelligent, talented and much maligned younger sister, Frances (known as Fanny), kept house for him (and painted her own miniatures). It was fashionable for people in society to call on portrait painters and examine their recent work which was separately displayed for this purpose. Reynolds arrested the visitors' attention with a portrait of Guiseppe Marchi, a Roman whom he had taken back to England as his assistant (Cat. 18).[46] Out of the dark background the deep reds and golds of a turban and a fur-lined jacket glow like embers, the highlights achieved with richly encrusted impasto. The costume, colour and handling are unmistakably indebted to Rembrandt, by whose paintings Reynolds had been attracted before he went to Italy, and indeed while he was in Italy (he copied a Rembrandt self-portrait in the Corsini collection in his first days in Rome[47]). This is not, however, quite what we would expect, and the reverse of what was then expected, from an artist just returned from the Grand Tour.

Also intended as a demonstration piece was a full-length portrait of Keppel (Cat. 19), dated on a print to 1752 but probably only begun in that year. It was certainly revised many times,[48] to make the setting and the action more dramatic and to remove it from the atmosphere of the studio in which it was created. Precedents for the striding pose may be found in the full-length portraits of both Hudson and Ramsay, but not the air of urgent command nor the unity of figure with setting, contrived not only by the colour but by the wind which has whipped up the storm and disturbs Keppel's clothes. 'A figure so animated, so well drawn, and all its accompaniments so perfectly in union with it, I believe never was produced before by an English pencil,' was the opinion of the poet William Mason.[49]

The painting was said to depict an incident in Keppel's career from the period shortly before Reynolds knew him,[50] and whether or not Reynolds intended this he certainly meant to hint at a specific historical circumstance. Commanders had commonly been posed waving batons in front of smoky skirmishes in the middle-distance, but Reynolds, when given a commission for a portrait of Captain Orme, aide-de-camp to General Braddock, saw an opportunity to paint a soldier actually engaged in the battle—to create, in fact, a military equivalent to the Keppel portrait. Here again the windswept hair, the thunderous sky, and the action (the Captain, holding his dispatches, turns towards us, one arm on the reins of his foaming, stamping mount) suggest some portentous episode not only in Orme's career, but in national history (Cat. 26).

Reynolds returned to Keppel's pose on several occasions[51] and strove to give other naval portraits a similar heroic character—although never with quite the same success. The portrait of Orme was perhaps still more fruitful as an idea and anticipated some of his finest late works. Both remained for some time in the studio: the Keppel because it was uncommissioned, the Orme because it was not paid for. The former was quickly famous and the latter portrait was said to have attracted 'much notice by its boldness and singularity'. Both led to other commissions for full lengths.[52]

The Duke of Grafton has already been mentioned, but Reynolds soon attracted other eminent peers, and perhaps partly through the interest of the Keppels was commissioned to paint one of the Royal Princes: the Duke of Cumberland in Garter robes (Cat. 30). His bulk is brilliantly converted into power, and his heavy features are animated with an air of alert command, but the action and suggestions of narrative found in the portraits of Keppel and Orme could not be transferred to the conventions of state portraiture because, as Reynolds himself later remarked, the purpose of 'robes of dignity' was to encumber the wearer, 'thence indicating or implying' that they could command others to act for them.[53]

Reynolds also painted full-lengths of noblemen in 'vandyke' and in Hussar costume, of which the finest example is the portrait of Peter Ludlow at Woburn Abbey (Cat. 25). What distinguishes these from the similar portraits by his rivals is their seriousness. There is no suggestion of fashionable foppery, or even of the charm and intrigue of the masquerade, as there is for instance in some paintings by Batoni. The costume, together with the solemn colour and lighting, reinforces and adds historical resonance to the aristocratic authority implied by the relaxed grandeur of the poses. To this air of being at ease with power Reynolds's female sitters could not of course properly aspire, but it is curious (as David Mannings has remarked) that he did often paint ladies hand on hip, which had hitherto been a male prerogative in portraiture.

Reynolds must have entertained ideas for his most ambitious portraits before he received commissions. In one faint memo in a notebook we find him considering the idea of giving the 'Faunus Meditans' (the name given in a book of prints owned by him to an antique statue of a cross-legged faun) a book and a 'studious look' from Van Dyck—'slippers &c perhaps'.[54] The attitude he gave to Keppel seems to have derived from a drawing which he had made of an antique statue (although it is surely not, as has so often been claimed, a 'quotation' from the *Apollo Belvedere*[55]), and this practice persisted. It is these ambitions, and this art historical awareness, that Reynolds owed to Rome, and ultimately to the writings of the Richardsons.

Female intimacy: ladies and actresses

The full-length portraits just discussed were made by Reynolds whilst he was engaged on hundreds of smaller works. His pocket-books, which survive for the second half of the decade (with the exception of 1756), show that at the height of the season he sometimes received five or six sitters a day, most of them coming for an hour. He worked every day—including Sunday, for he seems already to have ceased attending church, to the distress of his sister and his pious friends.[56] In one year he had over 150 different sitters. He was assiduous in seeking publicity. He himself published a mezzotint of one of his best portraits (Cat. 21), and probably encouraged the publication of others.[57] Despite the rivalry of Hudson, of Allan Ramsay and, for a while, of Benjamin Wilson and Jean-Etienne Liotard, he was able to raise his

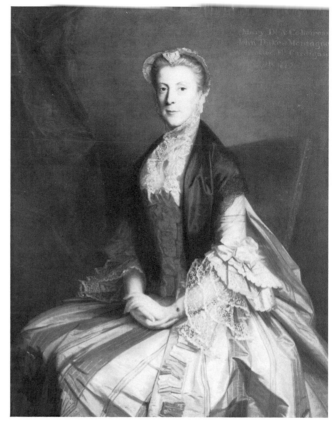

Fig. 6 Lady Cardigan, 1755 (Deene Park)

prices steadily—asking five guineas for a head and shoulders in 1752 and five times that sum eight years later—without any reduction in the demand for his work.[58]

In the majority of cases Reynolds only painted the faces from the sitter, employing a servant or a pupil as a model for the hands or clothes. A lay figure was also employed, as may be deduced from the poses (fig. 6)[59]—although it is worth pointing out that a contemporary complained that many sitters, especially ladies, influenced by dancing masters and boarding schools and by the practice of Hudson (fig. 7), only admired portraits which were 'neat, formal, upright' and showed the sitter 'at some stiff sort of employment'.[60]

Poses were repeated, often very closely, for convenience, and Reynolds made no secret of this—indeed, he may even have encouraged sitters to select attitudes from engravings of his works.[61] Despite the animation of his full-lengths, there is little action in his smaller portraits. The nobility in their robes hold their coronets, comically uncertain of what to do with them, and men of letters hold a quill or place their hand near one. However, in some of the best of his intimate female portraits, domestic circumstances, and indeed conversation with the beholder, are suggested in a manner which must derive from portraits by such French artists as Nattier, Aved or Tocqué—as, for example, when Keppel's mother, the Countess of Albemarle (Cat. 33), pauses at her knotting to attend to what we have to say. Listening is, in fact, commonly suggested in the portraits of ladies, by the inclination or tilting of the head, as in the

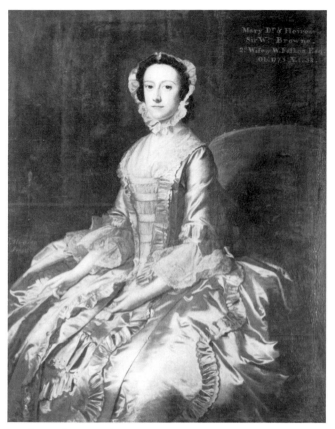

*Fig. 7 Thomas Hudson, Mary Browne, Mrs William Folkes, c. 1752
(Private Collection)*

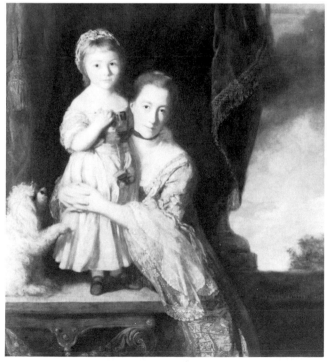

Fig. 8 The Countess Spencer with her Daughter (The Earl Spencer, Althorp)

portrait of Miss Mary Pelham (Cat. 27), or by the raising of the eyebrows, by a hovering smile, or by fingers pressed lightly against temple, cheek or chin. What Reynolds would have avoided, even had he been capable of it, was the 'flutter' of French portraiture, as evident in the painting of expression as in the painting of dresses.

Reynolds's portraits of ladies are often similar in composition to those which his chief rival, Ramsay, painted after his return from a second visit to Italy in the summer of 1757. Ramsay, whose paintings Reynolds admired, and even on one occasion copied,[62] had less range and less force. He was, however, more careful as a draughtsman, more interested in the description of expensive fabrics, more delicate in his handling, and more subtle in colour. Reynolds gives Kitty Fisher (in the Petworth portrait, Cat. 31) a pose which was also popular with Ramsay, who, however, could never have painted anyone wearing a green dress against a deep green background. Reynolds gave the Countess Spencer (fig. 8) a rose-pink dress such as Ramsay might certainly have painted, and the contrast with the pale blue worn by her blue-eyed daughter is something Ramsay might also have relished, but Ramsay would not have let the pink merge with the dark shadow of a deep red curtain behind, nor would he have given his paint such relief when depicting her lace. Reynolds's forceful, rich colour and his impasto give his figures a remarkable physical proximity, whereas Ramsay's figures recede from the picture plane, making us aware of the space between us and them, and of the air about them.

The Countess Spencer, Kitty Fisher, Mary Pelham and the Countess of Albemarle in Reynolds's portraits all, in their different ways, seem 'natural', unselfconscious, at their ease, addressing us directly. But this has not been achieved by observation alone. Lady Spencer and her child, for instance, did not pose together in this way. Indeed, it is clear that their sittings were at different times. Their attitudes were invented by the artist, and the choice, at least, of their expression was his also. The theme of the picture—that of a mother and daughter not only looking out lovingly at the brother and uncle for whom the painting was made, but also surely *returning* his look—is as imaginative as that of setting Keppel upon the stormy beach or Orme in the midst of battle.

Reynolds's female sitters, including—indeed, especially— notorious courtesans such as Kitty Fisher or Nelly O'Brien (fig. 9), appear to be women of superior 'breeding', women of sensibility and intelligence. Northcote, Reynolds's pupil and biographer, emphasized his master's capacity (which was perhaps learnt from Ramsay) to paint his female sitters as 'ladies', whether or not they were; and in case we supposed that the imagination was not involved in this task he pointed out correctly that Hogarth, the most talented English portrait painter in the period before Reynolds, was incapable of painting real refinement in a female face.[63]

Concern for decorum obviously limited the range of expressions and actions appropriate for his female sitters, but special opportunities were provided by portraits of actors and actresses. Paintings of stage performances which are found in French painting early in the century had been popular in England for several decades and were energetically promoted

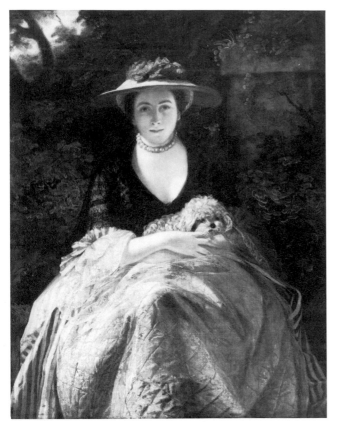

Fig. 9 Nelly O'Brien, 1760–2 (Trustees of the Wallace Collection, London)

as advertisement by the great actor and stage-manager, David Garrick, who moved in the same social circles as Reynolds and was frequently painted by him (see Cat. 42, 69). As we know from a fragmentary account of an argument between Reynolds and Dr Johnson on the power of the human eye, Reynolds gave much thought to what expressions might and might not be effective on the stage, and whereas English theatrical paintings, typically, showed several characters in a room, providing an equivalent to what was actually seen on a stage, he preferred to paint a single actor 'close-up'—presented, that is to say, in a way now familiar to us from films, but then only imperfectly available to the theatre-goer with a glass.[64] The most remarkable of these paintings by Reynolds is that of Mrs Abington as the ill-bred Miss Prue (Cat. 78). She behaves with a freedom generally permitted in portraiture only to men, leaning towards us over a chair back, her thumb in her mouth. This painting is one of only a very small number made by Reynolds after the mid-1760s which emulate the intimacy and directness of his best earlier portraits.

Studio, Court and country

In the summer of 1760 Reynolds bought and adapted at great expense a large house which provided him with space to display his own works, to accommodate his assistants, and to receive his sitters in style. It was on the west side of Leicester Fields (now Leicester Square), nearer the fashionable residential West End than Covent Garden and St Martin's Lane, which had been, and for a while remained, the areas where artists set up their studios. He gave a ball and put his servants in livery. He also set up a carriage splendidly painted and gilt in which he instructed his modest sister to ride. When she complained that it was 'too shewy' he replied, 'What? Would you have one like an apothecary's carriage?'[65] Such ostentation was important for any artist whose work obliged him to be constantly in the public eye: even the uncouth Samuel Johnson appeared in gold lace and a scarlet waistcoat whilst his Tragedy *Irene* was performed.[66]

Earlier in the same year Reynolds also had an unprecedented opportunity to advertise his genius in the exhibition which opened on 21 April for two weeks in the Great Room of the Society for the Encouragement of Arts, Manufacturers and Commerce. Such exhibitions became an annual event, and Reynolds, as a member of the Society, had probably done much to promote this first one.[67] 1760 was also the year of King George III's accession.

Reynolds was eager to attract the King's favour. He made sketches for a painting of the Royal Wedding;[68] he exhibited portraits of one of the royal bridesmaids (she was a Keppel—Cat. 44) and of the Queen's Mistress-of-the-Robes; he even contrived to paint Lord Bute, the King's former tutor, chief minister and the key to favour at Court (fig. 10). But Bute was attached to his fellow Scot, Ramsay, whom the King made his painter.[69] As it turned out, however, although George III was far more active as a patron than his philistine predecessors had been, he had no desire, and perhaps had not the means, to provide his court painter with the opportunities which an artist in this position might expect in Paris, Madrid, Vienna or Naples. Ramsay established a factory to paint official royal portraits but strove for no other royal commissions. By about 1766 he had withdrawn from practice. His position as Reynolds's chief rival was taken by Francis Cotes who between 1767 and his death in 1770 was the favourite painter of the Queen.[70]

The most powerful British nobles were more lavish patrons both of architecture and painting than the King, but they seldom encouraged British painters to produce anything more ambitious than portraits. The Church provided a little work for painters, but it seemed derisory to foreigners. As a Frenchman put it in 1753, 'In England, religion does not avail itself of the assistance of painting to inspire devotion; their churches at the most are adorned with an altarpiece, which nobody takes notice of.'[71] Hogarth and other artists supplied large religious paintings *gratis* for the Foundling Hospital in this period—an initiative which excited some patriotic applause but did not prompt great commissions for either ecclesiastical or public buildings. There had been a fashion for having huge histories and allegories painted on the walls and ceilings of private houses in the early decades of the eighteenth century, but few new interiors of the 1750s had large modern canvases or murals of any sort. An exception was the gallery of Northumberland House where there were full-sized copies by Mengs, Batoni and others of frescoes by Raphael, Guido Reni and the Caracci. Reynolds

contributed to the decoration not with a history painting but with full-length portraits of the Duke and Duchess.[72]

Northumberland House was one of a dozen or so London houses of palatial size, but, for the most part, the power of the nobility was more conspicuously expressed in their great country seats. These were often designed or adapted to

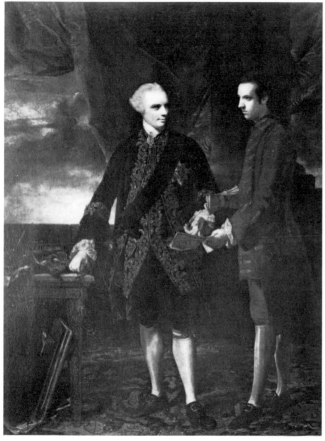

Fig. 10 Lord Bute with his secretary, Mr Jenkinson, 1763 (Private Collection)

accommodate a collection of Old Master paintings and always designed to exhibit full-length portraits. The demand for such portraits was already established in England in the late sixteenth century, and irresistibly glamorous models for them had been established in the seventeenth century by Van Dyck. The British are not surprised by the existence of portraits such as that of Lord Middleton in his coronation robes or the Earl of Bellomont as a Knight of the Bath (Cat. 45, 89)—to cite only two of Reynolds's most successful performances of this sort—but such magnificence would have been extraordinary in the portrait of a non-royal personage in France in the eighteenth century, and indeed was much rarer in any other country in Europe than it was in Britain.

Portraits of peers, whether designed to hang in town or country, tended to represent the sitters laden with robes which were only worn for court ceremonial, but there were rural portraits for the less exalted families (who were in London for less of the year and only owned or rented rela-

tively modest houses there). The small pictures of men, with their dogs, and sometimes their wives, shooting, walking or sitting in the country they owned, such as Thomas Gainsborough had painted in Suffolk during the early 1750s, belong to this category. Shortly before settling in Bath in 1759 Gainsborough transferred this type of portrait to life-sized canvas[73]—an idea perfected in his portrait of William Poyntz which he sent from Bath for exhibition in London in 1762.[74] Reynolds's first notable portrait of this sort, of Philip Gell (Cat. 50), a Derbyshire squire, seems to have been painted at the same date although it was completed later, in 1763,[75] and it is interesting that Pompeo Batoni in the same period briefly took to painting British visitors shooting and riding in the Campagna.[76]

Among later examples by Reynolds of this class of

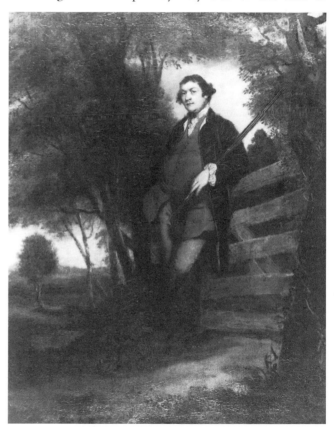

Fig. 11 John Parker, 1763–7 (The National Trust, Saltram)

portrait[77] there is an unusual small-sized painting of John Parker MP painted between 1763 and 1767 (fig. 11), which is of interest because Reynolds might in this case have actually seen his sitter in such an attitude. On one of his late summer excursions to Devon, he went hunting and shooting with Parker at his seat of Saltram, near Plymouth, and made bets as to who was the better shot.[78] Reynolds indeed was sufficiently at ease in the company of the great sometimes to underestimate their sense of propriety, as when he neglected to change from his travelling boots into buckled shoes prior to being received by a Duke (probably the Duke of Marlborough) who had invited him to stay.[79]

Like other English portraitists, Reynolds very rarely paint-ed men going for a walk, as distinct from going shooting, unless they had their wife or mother on their arm,[80] although wooded scenery appeared behind them commonly enough. But from his earliest work onwards he painted ladies walking in the country, usually advancing from the right, and often placed entirely on the right-hand side of the painting, com-monly, in his later work, with a dog bounding beside them, and moving swiftly themselves (compare Cat. 51 and 121). They may be carrying or plucking flowers, drawing on a glove, holding a parasol, pulling aside their skirts or resting a hand on a balustrade. Especially when stationary, and lean-ing by an urn, there is an attempt, again unusual in portraits of men, to suggest that their mood is conditioned by the setting, that they are responsive to the breeze or the birdsong or the sound of a stream. As the imitation of simple country life came into fashion with toy dairies and cottages, Reynolds also painted ladies feeding poultry (fig. 12), playing with a spinning wheel or dressed up as gypsies.

These rural portraits by Reynolds tend to suffer by com-parison with those by Gainsborough, who had a finer sens-itivity to landscape, and more sympathy with refined passivity in female, and certainly in male, sitters. Reynolds seems to have been aware of Gainsborough as early as 1762, as we have suggested, and he noted down Gainsborough's name and address in his pocket-book on 21 November 1768 for some unspecified reason (perhaps connected with the foundation of the Royal Academy), but Gainsborough did not move from Bath to London until 1774 and only became a serious rival when he attracted favour at Court. Neverthe-less, it is inevitable that they should be compared today.

The reliable and respectable Reynolds does not inspire the same sympathy as the more volatile and bohemian Gainsborough. Both were dedicated to their art, but Gainsborough's habits of work were as capricious as those of Reynolds were methodical. It is also true that Reynolds relied far more than Gainsborough did on assistants, although the extent and character of their contribution is highly con-jectural (and mostly based on the hyperbolic and contradic-tory evidence of Northcote[81]). The poor drawing of the hands, the frequent pentimenti visible in the drapery and the boldness of the landscape backgrounds in Reynolds's portraits are evidence that he often painted these parts him-self. Still-life, however, he probably painted very rarely. His assistants were his pupils and their work could easily be com-pleted or adjusted by him. Only during the late 1750s and in the 1760s does he seem to have depended upon the services of an independent drapery expert outside his studio, Peter Toms.[82] It seems that Toms's participation certainly extend-ed not only to landscape backgrounds but to foreground foliage in a portrait such as that of Master Thomas Lister (Cat. 53). Gainsborough would never have left such features to an assistant.

The chief difference between the attitudes to portraiture taken by Gainsborough and Reynolds, however, is that Gainsborough was less ambitious; his portraits are less varied and never strive for the grand effects Reynolds so valued. The poetry which he sought was not such as to make him

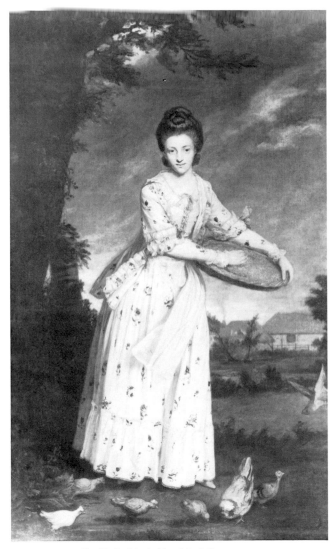

Fig. 12 Sophia Aufrère, Mrs Pelham, 1770–4
(The Earl of Yarborough, Brocklesby)

impatient with contemporary fashions, whether for cascades of lace or crowns of feathers, nor did he wish to turn English ladies into classical goddesses.

Classical drapery and classical roles

Like many previous English portrait painters with a large output Reynolds was dismayed by the hard work of record-ing endlessly varied and highly elaborate fashionable clothes. He was attracted, as Hudson had been, by a compromise between contemporary style and the clothes seen in old portraits, especially those by Van Dyck and Lely, whereby a 'sweet disorder' was licensed—and this compromise was itself reflected in fashionable masquerade costumes.[83] The great advantage of such a formula, however, was its con-venient repeatability. Reynolds was also doubtless concerned at the way that portraits began to look ridiculous as fashions changed—something which had long been lamented by

theorists of art—and he was attracted by a generalized treatment of clothes because it provided opportunities for greater freedom of handling and for adopting the severe purity of the antique. Full-length portraits such as his Duchess of Hamilton (Cat. 36, exhibited at the Society of Artists in 1760) or his Lady Frances Warren of 1759 (Fort Worth), both with drapery derived from antique sculpture, ermine robes and a park landscape, represent something quite new in English art. Much later, in one of his *Discourses* delivered at the Royal Academy, Reynolds wrote that the portrait painter who wishes to dignify a female subject 'will not paint her in the modern dress, the familiarity of which alone is sufficient to destroy all dignity. He takes care that his work shall correspond to those ideas and that imagination which he knows will regulate the judgement of others; and therefore dresses his figure something with the general air of the antique for the sake of dignity, and preserves something of the modern for the sake of likeness.'[84] We may doubt, however, whether such a poetic vision as that of the Duchess of Hamilton really originated in carefully calculated compromise between the consumer's conflicting requirements.

Reynolds retained from his early education some rudimentary Latin (rather less than he hoped we would suppose), but he ridiculed the writing of Latin verse in the universities and opposed the use of an 'ancient and permanent language' for modern epitaphs, in opposition to Dr Johnson.[85] All the same, he strove to write English prose like Johnson's—that is, a prose highly latinate in vocabulary and syntax. There is an obvious analogy between such 'classical' prose and his 'classical' portraits, but it is in some respects misleading. Reynolds believed that the ancients were closer to nature than modern artists, and that the drapery and the attitudes of their sculpture were simple as well as dignified. The grace and the elegiac mood in his classical portraits seem natural and sincere because of their simplicity, and there are no ostentatious trappings of wealth, and only discreet references to rank (generally an ermine robe). On the other hand Reynolds's classical prose is complex, artificial, obviously enriched and patrician.

The English language as used by Reynolds also achieves authority (or slips into pomposity) through its latinity. But when he painted authority explicitly—which, of course, was only in his male portraits—he avoided antique attire, although such had become common in English portrait busts, public statues and tomb effigies, where he approved of it,[86] and although he must have known of the several attempts to introduce the convention of Roman dress into English painted potraiture which had been made since the late seventeenth century.[87] The only portrait by Reynolds of a man in classical dress is of the Polynesian, Omai (Cat. 100), who had come to England with Captain Cook. For a 'child of nature' it must have seemed inevitable. Perhaps he tried to persuade sitters to adopt it but they were too attached to their robes of state, which were also above fashion but had the advantage of asserting rank unambiguously.

In English eighteenth-century portraits women were often given, in addition to dress which did not belong to them, actions, or at least attributes, which were equally alien. Pope noted in his *Epistle to a Lady* (published in 1735) that a lady might be depicted in 'ermined pride', or as a shepherdess, as the Magdalen or as St Cecilia. Among mythological guises, that of Diana was especially popular in France and Italy, and not uncommon in England, when Reynolds began to paint, and his portrait of Lady Anne Dawson of 1753–4 (fig. 13) is in this tradition. Still more popular in England, in fact commonplace, were portraits of ladies as shepherdesses (fig. 14), but Reynolds seems only once to have given a sitter a crook. There was a reaction in Reynolds's lifetime, vigorously expressed by Johnson, against the artifices of pastoral poetry. Reynolds employed other pastoral conventions, however. He was perhaps the first portraitist to depict a lady writing a lover's name upon a tree, a device common in arcadian literature, and perhaps the last artist to paint a lady dipping her hand in a fountain.[88] He was also always fond of lambs.

In addition, Reynolds's female sitters adorn terms of Hymen, sacrifice to Hygeia or the Graces (Cat. 44, 57), or tend tombs inscribed 'ET IN ARCADIA EGO'. English parks at this date were full of ornamental classical temples and statuary, and verse was full of ornamental classical images and diction, but the improbability of the poetical employment Reynolds gave his sitters did sometimes surprise contemporaries. Lady Sarah Bunbury, it was cattily observed, 'never did sacrifice to the graces', but enjoyed eating beefsteaks and playing cricket.[89]

Reynolds also elevated English ladies to the rank of goddess, muse, or heroine in a more expressive and animated manner than had been the case with Lady Anne Dawson. Kitty Fisher, for instance, was depicted in 1759 as Cleopatra in the act of dissolving a pearl (Cat. 34); but it was the larger and slightly later portrait of Miss Greville and her younger brother as Cupid and Psyche (Cat. 38) which seems to have attracted most notice,[90] and set the trend for works of this type.

Such portraits in the 1760s are often stiff or incongruous. Mrs Blake (fig. 15) seems to possess little aptitude for her part as Chaste Juno (and she did later leave her husband), whereas the Duchess of Manchester (Cat. 72) is comically eager to disarm her infant of Cupid's arrows. But the finest of all Reynolds's portraits of this sort, Mrs Hale as Euphrosyne (Cat. 61), was also painted in these years. In showing her dancing with an escort of revelling musicians Reynolds risked making her look ludicrously undignified, but succeeded in endowing her with a combination of vitality and grace which must exhilarate every visitor to Robert Adam's music room at Harewood House for which it was painted. It appears to initiate the circular rhythms of the stucco ceiling and of the Axminster carpet, complements the colour scheme and extends the classical allusion in the ornament. Adam, except when designing a picture gallery, liked to use looking-glasses (which by then cost no more than good full-length portraits) or paintings which were either pretty allegories or mythologies (often miniature), or innocuous ruinscapes (like those supplied by Biagio Rebecca and Zucchi for this room), all of which were subordinate to his architecture. Credit for the equal marriage between

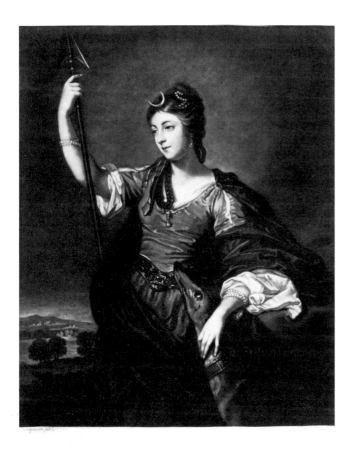

Fig. 13 James McArdell (after Reynolds, *Lady Anne Dawson, c.* 1754), mezzotint, *c.* 1755 (Fitzwilliam Museum, Cambridge)

his genius and that of Reynolds here should probably go to the patron, Edwin Lascelles, or to his heir who was Mrs Hale's brother-in-law, for Adam's original drawing for the room shows it as it is but with a mythological scene instead of the portrait above the chimney.[91]

In this period, eagerness for the portrait of an absent beloved sister or husband accompanied anxiety that it would make a suitable wall ornament. The Countess of Kildare, for example, longed for a 'lively representation' of her 'Angel' (the Earl) better than the 'nasty one of Liotard's' which made him 'look like a German'. She wanted him to be painted wearing his blue Master General's coat (more appropriate, if less beautiful, she considered, than his red Major General's coat); she also specified the type of French frame and pointed out that it was to fit above the chimney in her blue dressing room, but would not be attached to the chimney because she wanted to display her 'fine china on the white marble mantelpiece'.[92] All this information, together with the coat, her husband would have given to the artist—in this case, Ramsay.

Both Ramsay and Reynolds were at the same date, in the early 1760s, painting portraits for the breakfast room or gallery at Holland House which had been fitted up with blue paper and gilt borders by Caroline Fox (later Lady Holland; see Cat. 29) who wrote to Lady Kildare, her sister: 'You'll see your name marked for one of the half-lengths in the Gal-

lery, there are but two full-lengths in the room, so if the mark should be effaced you can't mistake, as the rest are either heads or half-lengths of a particular size ... The two full-lengths over the chimney are for Louisa, and the picture of Sal, Lady Sue and Charles [i.e. Cat. 48], done by Reynolds. Ramsay is doing mine [i.e. fig. 56], to go between the doors, over against the window.'[93] This room no longer survives but the saloon at Saltram designed by Adam in 1768 does. Reynolds's portrait of Teresa Parker of 1772 is still there, and was obviously painted to match the seventeenth-century portraits in the same room, the white, gold and pink of the plasterwork, and the blue damask hangings which Mrs Parker ordered from Genoa in 1770.[94]

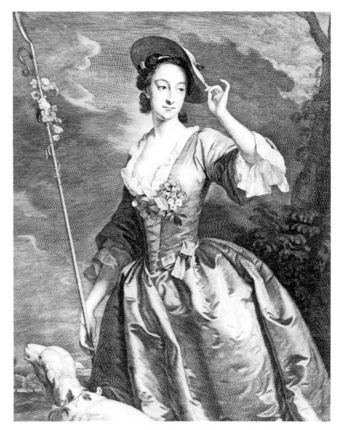

Fig. 14 James Lovelace (after Thomas Hudson, *Mary Carew*), engraving, 1744 (British Museum, London)

There must have been discussion not only concerning the colour of the walls, the character of the neighbouring paintings, and the height at which portraits were to be hung. What the sitter wore was not always selected by the artist, nor surely what the sitter did. Whose idea was it that Mrs Hale should be painted as Euphrosyne? It is tempting to suppose that Reynolds tried to impose this sort of portrait on patrons who were reluctant to commission mythological paintings, but the letters regarding *The Montgomery Sisters: 'Three Ladies Adorning a Term of Hymen'* (Cat. 90) reveal that it was the patron's idea to have the sisters painted 'representing some emblematical or historical subject' which Reynolds was to select in consultation with them.

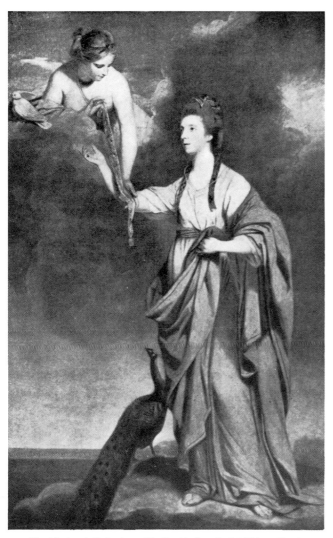

Fig. 15 Annabella Bunbury, Mrs Patrick (later Lady) Blake as 'Juno',
exhibited 1769 (present whereabouts unknown)

Paintings of this sort, however fanciful, remained portraits and, when exhibited, they were usually described as such—for example, as 'a young lady in the character of Hebe'. Even when listed simply as 'A nymph with a young Bacchus' or 'Thais', Horace Walpole, annotating his catalogues, recognized the sitters (or models) and it is surely obvious that these are all paintings of real mortals imperfectly transformed in the performance of elevated roles. Individual character is not lost and the charm of *Mrs Hale as Euphrosyne* depends on this—as does the bathos of the *Duchess of Manchester as Diana*.

The occasion for commissioning many of these fanciful female portraits was an engagement, that brief, envied, interval of ambiguous identity, free from filial obligations and unafflicted with domestic responsibilities, when thinking was most liable to be wishful and compliments were unusually hyperbolic. Lady Ann Dawson surely posed as Diana, the virgin huntress, shortly before her marriage with Thomas Dawson in July 1754—when she was still Lady Ann Fermor. Reynolds's only shepherdess, Miss Dashwood, was certainly

painted, holding a crook and pressing a posy of flowers to her bosom, shortly before her marriage with Lord Garlies (Cat. 54). Two of the three Montgomery sisters were also painted when they were engaged to be married. Mrs Hale when she first sat to Reynolds was Miss Chaloner. Mrs Pelham (painted feeding poultry, as a pretty hint of her maternal talents) sat as Miss Aufrère. The lady he depicted writing the name Lloyd on a tree was Mrs Lloyd by the time the painting was exhibited, but surely still Miss Leigh when she sat to Reynolds (Cat. 103).

Young men were not usually painted when they were engaged (not least because this event did not separate them so decisively from their own family). They were painted, however, at the conclusion of their education, when leaving Eton or the University or when in Rome by Batoni or Mengs. At this stage in their life they might also be painted in fancy dress—in vandyke costume, and even, in one extraordinary portrait, as archers (Cat. 74). They do not, however, appear as woodcutters or herdsmen to match the portraits of their wives or sisters with spinning-wheels and lambs, nor as Roman senators and Greek gods. James Barry, it is true, painted Edmund Burke as Ulysses and the Prince of Wales as St George; but these paintings were not commissioned and did not sell.[95]

One way in which male portraits could be made more poetic was by the addition of allegory. Aware of the distaste for allegory in poetry so forcefully expressed by Johnson, Reynolds defended its use in paintings and in particular the mingling of allegorical with 'real personages' in those of Rubens.[96] His earliest and most effective use of allegory, however, may have been suggested by Garrick. Reynolds in 1760–1 portrayed the great actor in comic perplexity as to whether he should be more attracted by Comedy or Tragedy (Cat. 42). Comedy, although adult, was inspired by the uninhibited infantile vivacity of one of his nieces[97]—a vivacity also found in his contemporary portrait of the Yorke children (Cat. 39)—but we may recall one of his fascinating manuscript notes: 'If I had never seen any of the works of Correggio, I should never perhaps have remarked in nature the expression which I find in one of his pieces; or if I had remarked it, I might have thought it difficult or perhaps impossible to be executed.'[98] These figures of Comedy and Tragedy are among Reynolds's earliest ideal inventions, although they are later than the 'Venus' for whom Reynolds made three appointments in December 1759.

The pocket-books of the artist are not only revealing on account of what he wrote in them, but on account of the printed material they included: the one he used in 1781 for instance—*Kearsley's Gentleman and Tradesman's Pocket Ledger*—printed banker's rates of interest, the House of Peers in alphabetical order, and a 'succinct account of the heathen gods and goddesses'.

The Royal Academy and new opportunities

In May 1752, the month in which Reynolds left Rome, an English Academy of Art had been founded there by a group of noblemen, but with little consequence. Reynolds may

have been involved in the plans for this. He was certainly involved three years later when the Society of Dilettanti, a dining club of gentlemen who had been on the Grand Tour, revived their earlier schemes of sponsoring an academy in London. The artists, however, wanted more independence than the Society proposed. They eventually succeeded in organizing an annual exhibition which, as has been mentioned, was established in 1760. Out of the success of this there emerged two rival groups, the Free Society of Artists, which continued to exhibit at the Royal Society of Arts, and the more successful Incorporated Society of Artists, which was granted a Royal Charter in 1765 and which organized annual exhibitions at Spring Gardens, to which Reynolds contributed. From the Incorporated Society, late in 1768, some of the most influential members seceded and formed a rival body which obtained support at Court through the diplomatic skill of Sir William Chambers, the King's architect, and was able to call itself the Royal Academy. Chambers was himself appointed Treasurer—a position directly responsible to the King and hence highly influential—but Reynolds, who had carefully kept aloof, and indeed literally distant (visiting France during September and October), was unanimously elected the first President on 14 December 1768. He was consequently knighted on 21 July 1769.[99] Further honours followed, including, in 1773, a doctorate from Oxford and the office of Mayor of his native Plympton.

The artists' chief motive for the establishment of their Academy was that it gave them professional status: titles to advertise their qualifications; the means to distinguish themselves from printmakers, wax modellers and animal painters; elected officers to represent their common interests; a royal patron to sanction the social importance of their annual exhibition; and the means to administer charity to impoverished artists and their families. Ostensibly the 'principal object', and certainly an important one, was 'the establishment of well-regulated schools of design'[100] with a cast collection, library, life-classes, prizes, and professorial lectures. In practice, however, the education, although more regular than that provided by any earlier institution in this country, was far less thorough than it was in European academies. It would be hard to claim that it had a formative influence on any major English artist. It also had relatively little importance for their careers because the prizes awarded were unconnected with a system of state patronage.

Reynolds's presidential *Discourses*, although delivered annually (until 1772 and thereafter biennially) to the students, were also attended by 'people of fashion and dilettanti'.[101] Published both as separate pamphlets and eventually collected as a book, and translated into Italian, German and French, they were clearly intended not only for artists, but for a wide public. In this respect the *Discourses* continued the work begun by Jonathan Richardson. Reynolds, like Richardson, repeatedly insisted on the 'true dignity' of painting 'which entitles it to the name of a liberal Art, and ranks it as a sister of poetry',[102] but in place of the idiosyncratic colloquialisms of Richardson he achieved a consistently elevated manner, and, at times, a sacerdotal gravity worthy of Johnson.

'Present time and future may be considered as rivals, and he who solicits the one must expect to be discountenanced by the other'.[103] Such an opinion delivered by an artist who had himself not resolutely rejected all the demands of fashion may have seemed poignant (perhaps hypocritical). However, Reynolds was not concerned to defend his own past practice. He firmly reminded his audience that portraiture, like still-life, landscape or the painting of either vulgar or gallant narrative (in the manner of Hogarth or Watteau) could never merit the highest praise,[104] whereas Richardson had allowed portrait painting to be almost equivalent to history painting.[105] In his first Discourse Reynolds commended the procedures of the Florentine, Roman and Bolognese painters and their followers who made finished preparatory drawings for every composition and then 'more correct studies' of every 'separate part'—hands, feet, draperies and heads—prior to painting.[106] But such was not his own method, nor, indeed, one which he encouraged in his own pupils. In his later Discourses he permitted himself to be more personal, referring to his own experiences and to his own collection,[107] and to his relationship with contemporaries such as Gainsborough,[108] but he still spoke from the President's chair, and not as a private individual.

It is easy to demonstrate that the leading ideas in the *Discourses* were not new. But on some subjects Reynolds provided a novel outlook: in particular, his severe account of the proper boundaries of the art of sculpture anticipated and helped to shape the neo-classicism of the end of the century, and his painter's view of architecture did much to encourage the 'picturesque' aesthetic.[109] Reynolds impresses us as having accepted nothing on trust: he is frequently critical of earlier academic authorities and questions, very much in the spirit of Johnson, many of the 'rules' they propounded.[110] He may at times have sounded like a voice from the past: such, indeed, was his intention. But it was a voice from the distant, not the recent, past, and it had an urgent and uncompromising message for the present.

In his third Discourse, delivered at the prize-giving on 14 December 1770, he warned that 'a mere copier of nature can never produce any thing great; can never raise and enlarge the conceptions, or warm the heart of the spectator'. The 'genuine painter', he continued to an audience of young painters who no doubt considered themselves genuine enough, would have higher aspirations: 'instead of endeavouring to amuse mankind with the minute neatness of his imitations, he must endeavour to improve them by the grandeur of his ideas; instead of seeking praise, by deceiving the superficial sense of the spectator, he must strive for fame, by capturing the imagination.'[111]

Reynolds could be far less positive and far more reflective, more of a philosopher and less of a pedagogue, as, for example, in the conclusion to his Discourse delivered a decade later on the opening of the Academy's new building, where he alludes to platonic conceptions of beauty and to art as an indirect agent of enlightenment:

'The Art which we profess has beauty for its object; this it is our business to discover and to express; but the beauty of which we are in quest is general and intellectual; it is

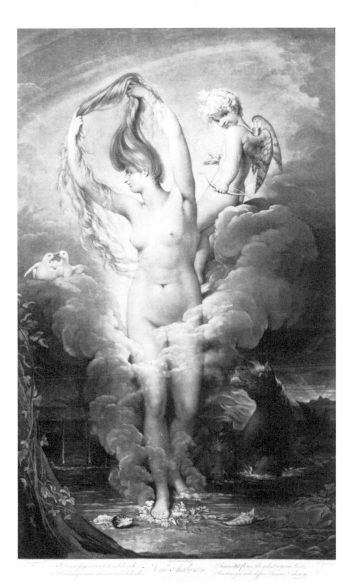

Fig. 16 Valentine Green (after James Barry, *Venus Anadyomene*, exhibited 1772), mezzotint, 1772 (Royal Academy of Arts)

The confession of the artist's inevitable deficiency, the repeated conditional 'may', and the qualification ('if it does not lead directly') fail to impede the optimistic moral progress of this long sentence. We are left, however, with a pious hope rather than a firm conviction.

Reynolds surely intended that his own work exhibited at the Academy should support the exalted notions he expounded in the *Discourses*. We observe him demonstrating how grand portraiture could be, and also extending his range, taking account not only of the portraits by his rivals, but of the success of scenes from Roman history by Nathaniel Dance and Benjamin West and the widespread admiration for the large epic subjects painted by James Barry. Barry was a protégé of Edmund Burke who returned from Italy in 1771 with lofty ambitions which Reynolds himself had helped to foster,[113] and whose *Venus* exhibited in 1772 achieved a sublimity (hovering on the brink of absurdity) never formerly seen in British art (fig. 16). At the Academy's exhibition in 1773 Reynolds showed his first true 'History Painting', an uncommissioned work, entitled *Count Hugolino and his Children in the Dungeon* (Cat. 82).

Also in 1773 Reynolds attempted to secure permission for himself and other Royal Academicians (West, Barry, Angelica Kauffmann, Dance and Cipriani), to decorate the interior of St Paul's Cathedral. He believed that the Protestant exclusion of pictures from churches had been the chief factor inhibiting the development of history painting in northern Europe. The scheme for St Paul's was vetoed by the Bishop of London,[114] but attitudes were more enlightened in Oxford. All Souls College had commissioned an altarpiece from Mengs which was installed in their chapel in 1772 (fig. 17); Brasenose College commissioned windows painted after designs by Mortimer which were complete by 1776. Then in 1777 Reynolds was commissioned to prepare designs for a large window in the gothic chapel of New College, Oxford, to be painted on glass by Thomas Jervais (or Jarvis), consisting of Seven Virtues below and a Nativity, conceived of as a *Notte* in imitation of Correggio, above (figs 18, 26).[115] In the 1770s Reynolds also exhibited a Child Baptist, the first of several devotional subjects by him designed for a domestic, or at least a non-ecclesiastical, destination, the most notable of which was his *St Cecilia* (Cat. 95) for the music room of the town house designed by Robert Adam for one of Reynolds's most munificent patrons, Sir Watkin Williams Wynn. At the close of the decade he painted a foreshortened figure of *Theory* (Cat. 112) for the centre of the ceiling of the library which Chambers designed for the new premises of the Royal Academy in Somerset House — in emulation, perhaps, of Titian's great ceiling painting for Sansovino's library in Venice.

Justice and *Fortitude* (Cat. 119, 120), the least spiritual of the Virtues, painted as cartoons for the New College window, are among Reynolds's most memorable creations, as memorable indeed as his personification of Comedy in the painting of Garrick. But generally his portraits of individuals acting as higher beings attract us more than the higher beings themselves. Although, as we have seen, Reynolds, in his *Discourses*, warned that the great artist could not be a

an idea that subsists only in the mind; the sight never beheld it, nor has the hand expressed it: it is an idea residing in the breast of the artist, which he is always labouring to impart, and which he dies at last without imparting; but which he is yet so far able to communicate, as to raise the thoughts, and extend the views of the spectator; and which, by a succession of art, may be so far diffused, that its effects may extend themselves imperceptibly into publick benefits, and be among the means of bestowing on whole nations refinement of taste: which, if it does not lead directly to purity of manners, obviates at least their greatest depravation, by disentangling the mind from appetite, and conducting the thoughts through successive stages of excellence, till that contemplation of universal rectitude and harmony which began by Taste, may, as it is exalted and refined, conclude in Virtue.'[112]

Fig. 17 Anton Raphael Mengs, *Noli me Tangere*, 1770–1
(All Souls College, Oxford, on loan to the Ashmolean Museum, Oxford)

Childhood and the family

Reynolds's first exhibited history painting (Cat. 82) originated as an expressive study of an old model, 'White the Paviour', and it was apparently the artist's friend, the poet Oliver Goldsmith, who recommended that the canvas should be turned into a narrative of Ugolino and his sons in prison—a subject from Dante which, significantly, Jonathan Richardson had recommended to artists.[119] The original study was probably similar to the *Captain of Banditti* (Private Collection), an evocation of Salvator Rosa shown at the Academy in 1772, which could also have been extended in this way. But the models that Reynolds most employed

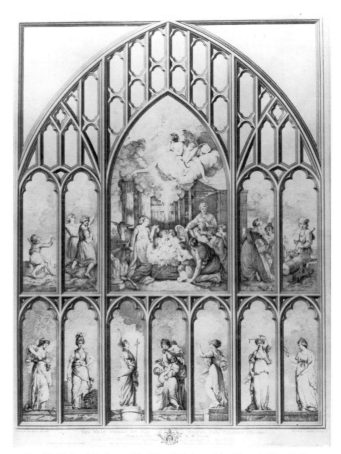

Fig. 18 Richard Earlom, *The West Window of the Chapel, New College, Oxford, painted on glass by Jervaise after Reynolds*, stipple, 1785
(British Museum, London)

'mere copier of nature', he also urged that the artist should never cease to refer to nature, and he deprecated Boucher's practice, which he had observed in Paris, of painting extempore from his imagination.[116] Even when painting the angels for the New College *Nativity* Reynolds had before him the reflections in a mirror 'hung angularly' of a group of 'young, female children, with their hair dishevelled'.[117] Nevertheless, he believed that to achieve the 'ideal'—the 'highest' style—'common nature' must be transcended by a systematic generalization from the model. Perhaps it was the influence of contemporary moral philosophy, or perhaps it was simply to discourage students from thinking of themselves as inspired, that, in his earliest published writings and in his *Discourses*, Reynolds made the process of idealization sound more like the calculation of averages than an act of the imagination.[118] But he may not have realized how much the success of his own most elevated creations owes to the vestiges of individuality which survive in them.

were not old beggars but urchins, and in the 1770s he began to make an increasing number of paintings from them which were generally known as 'fancy pictures'. He had time to do so because custom was attracted by his rivals (Cotes in the 1760s and then Romney and Gainsborough in the 1770s). Fashion was a factor here, but less important, surely, than Reynolds's very high prices (he now charged £150 for a whole-length). It seems likely that Reynolds deliberately adjusted his prices to give himself less business—and more time both for ambitious commissions, such as the New Col-

lege window or the great portrait of the Marlborough Family, and for the personal and experimental fancy pictures. There is certainly no other easy explanation for him raising his price yet again in 1779 from £150 to £200.[120]

In his fancy pictures Reynolds explored new techniques which were inappropriate for commissioned works, and a range of sentiment inappropriate for portraiture. Both techniques and sentiment were inspiredby his study of the Old Masters—the beggars of Murillo, the idylls attributed to Giorgione, the children of Rembrandt and the putti of Correggio. These paintings seem seldom to have been commissioned. They are sometimes recorded, and must always be suspected, as designed for collectors—that is, as Waterhouse put it, 'as companions, or at least as acceptable neighbours, in galleries in which nothing but old masters was normally admitted'. Fanny Burney noted when she visited Knole, the seat of the Duke of Dorset, in October 1779 that 'several pictures' by Reynolds were 'mixed with those of the best old painters' and it was 'not at first easy to distinguish the new from the old'.[121]

In some of Reynolds's pictures of children it is not only the manner of the Old Masters but also the activities of adults which are travestied—as in the *Infant Academy* (fig. 27), or the destroyed painting of the Bedford children acting the story of St George and the Dragon (fig. 45), or the portrait of Master Crewe as Henry VIII (Cat. 97)—and sometimes adult emotions are also disturbingly foreshadowed. Both girl and kitten in his *Felina* of 1788 (Private Collection) may seem 'innocently gay', but there is a hint, as a contemporary noted, of future delight in the torture of lovers and mice;[122] in the earlier *Muscipula* (fig. 19) purchased by the French Ambassador, the Comte d'Adhémar in 1785, the insinuation is clearer.[123] These paintings may perhaps suggest underlying anxieties in Reynolds. But if Reynolds was considered emotionally 'frigid', and 'bland' in the equanimity he maintained in society, there is no need to suppose that he was sexually repressed or never emotionally agitated. According to the scandalous (and by no means reliable) *Town and Country Magazine* in 1779 he had had love affairs with several of his sitters—'Lady G———r' and 'Lady L———r' are specified—and was then keeping 'Miss J———gs', formerly protected by 'Lord F———'.[124] It is worth noting that the pair of fancy pictures in which innocence and erotic precocity are most obviously entangled—the *Cupid* and *Mercury* as a Cockney linkboy and pickpocket respectively (Cat. 92, 93)—were bought by, and surely painted for, the Duke of Dorset and presumably allude in a sympathetic, if nudging, way to the Duke's disreputable and extravagant private life.[125] The bachelor artist, however, as we shall see, also celebrated family life.

Reynolds usually had living with him from 1770 onwards one or two of his nieces, Theophila (Offy) and Mary (Polly) Palmer and Elizabeth (Betsey) Johnson, and they often served as his models. By the end of the 1770s Mary had replaced her Aunt Fanny, who had grown into an increasingly difficult spinster, as the artist's housekeeper.[126] As Reynolds grew older he grew fonder of youthful company and with the children who sat to him for their portraits he was remarkably

Fig. 19 John Jones (after Reynolds, *Muscipula*, completed by 1785), stipple, 1786 (British Museum, London)

relaxed. Sir Charles Bunbury recalled how he would fix their attention with fairy stories; Sir George Beaumont how he delighted them with tricks; and Northcote the 'grand rackets there used to be at Sir Joshua's when the children were with him! He used to romp and play with them, and talk to them in their own way; and, whilst all this was going on, he actually snatched those exquisite touches of expression which make his portraits of children so captivating.'[127] (By contrast, Mrs Hoppner seems to have whipped the children who sat to her husband if they did not keep still![128])

These portraits are captivating not only because of their spirited and mischievous expressions, but also because of the seriousness which Reynolds respected in children. The range is most fully displayed in his great Marlborough family group (Cat. 108) painted in the late 1770s. Here the dogs (two of them are Blenheim spaniels) and the youngest members of the family, excited, teasing, but also frightened, contrast with the exalted but careful air of the mother and the oldest daughter, and also with the serious manner in which the Duke examines his son. The latter carries some of the Morocco cases which contained the great collection of antique gems which the Duke had amassed over the last two decades, and seems to consider the future when he will inherit not only treasures but great responsibilities. (Reynolds's

painting of an urchin holding a book in the same pose and similar expression at the same date, Cat. 105, perhaps originated as a rehearsal for this figure). The Duke holds a large cameo of the Emperor Augustus, to which our attention is directed by the younger brother and by the hand of the Duchess, and about which, or rather about whom, the Duke has perhaps been speaking. The suggestion of an edifying narrative on inheritance and duty was highly original, although there are some precedents in English portraiture.[129]

Many artists have made the powerful look splendid, and some have made them look worthy; but perhaps only Titian, Rubens or Van Dyck united these themes with domestic charm as effectively as Reynolds did here, and the way that the dignity of the painting is enhanced by the humour may remind us of Reynolds's defence of Shakespeare's mixture of comedy with tragedy[130]—something which he may have begun to think about when he painted Garrick's choice between the two types of drama. The columns, admirably continued in the outlines of the framing figures, remind us of Reynolds's ridicule of Hogarth's theory that sinuous lines are always to be preferred to straight,[131] for their twisting movements, as also the easy fluent movements of dogs and some of the children, are controlled by the rectangularity and symmetry of the composition. A few years later Reynolds, praising Titian's Pesaro altarpiece, reflected that Rubens would have replaced the 'formality and regularity' with more 'animation and bustle', but that the painting would thus have lost in 'solemn majesty' what it gained in 'splendour'.[132] This is a good example of how much more helpful Reynolds's writing can be for our understanding of his intentions as a painter than has been commonly alleged.

Some of Reynolds's earlier family groups had been very clumsily composed and even in the superb group portraits of the same period, showing members of the Society of Dilettanti (Cat. 109, 110) discussing the merits of ancient vases, ancient gems and vintage wine, there is an uncomfortable crowding and evidence of miscalculation (the expedient of the chair in the foreground of the second painting must be an afterthought, but it is not a happy one). The success of the Marlborough group was made possible by unusually careful preparatory studies, extensive revision, and special concentration (it seems partly to have been painted at Blenheim Palace, away from the distractions of his studio). It is surely his greatest achievement. He seems to have hoped to paint a similar group in 1786 when a newspaper report was published that 'Sir Joshua has just begun a conversation piece for the Prince of Wales's gallery at Carlton House, in which their Majesties and all the Royal children are to be introduced'.[133] Nothing came of it, and to endow with lively harmony the sullen discord of the Royal Family would have probably been a task beyond even Reynolds's powers.

Literary and political circles

Reynolds was appointed painter to the Society of Dilettanti in 1769, but he had been elected to the Society three years earlier, not as an artist but as a gentleman.[134] He belonged to numerous clubs and, despite his deafness, was much

addicted to the tavern and a frequent attender at the Playhouse. During the 1760s in the London season he was said to have seldom dined at home.[135] In the 1770s and 1780s he entertained more himself, at meals of remarkable informality, both in his town house and in the villa on Richmond Hill built for him by Sir William Chambers.[136] More literary men were to be found at his than at any other London table.[137] At his ease with bishops, 'wits', actresses, and 'bluestockings', Reynolds had relatively little close social contact with his fellow artists, except, perhaps, with Ramsay who had retired from practice and become a man of letters.

Reynolds had known Johnson since the mid-1750s when his sister was regularly hospitable to him (and attentive to his insatiable appetite for tea)[138] and the two men became especially close. Johnson encouraged Reynolds's literary interests, and, as Reynolds admitted, 'qualified' his mind to 'think justly'.[139] Reynolds's first published works were the three unsigned epistolary essays he produced for Johnson's publication *The Idler* in 1759 and he also contributed notes to Johnson's 1765 edition of Shakespeare. Johnson was widely but wrongly suspected of ghost-writing the *Discourses*.[140] It was to provide Johnson with an appropriate audience that Reynolds in 1764 proposed the foundation of The Club (later known as The Literary Club) which met, at first on a weekly basis, for supper at the Turk's Head Tavern, and included among its members Edmund Burke, Oliver Goldsmith, David Garrick, Richard Brinsley Sheridan, Charles Burney, James Boswell, Joseph Banks and Edward Gibbon.[141]

Clubs had often commissioned series of portraits—those by Kneller of the Kit Cat Club were famous; those by Knapton of the early members of the Society of Dilettanti would have been familiar to Reynolds—and Hudson had painted a group portrait of club members which provides a precedent for Reynolds's own Dilettanti groups.[142] The Literary Club did not commission portraits, but many of them dined frequently with Henry Thrale, a prosperous brewer and Tory Member of Parliament, and his brilliant wife. The Library (also a breakfast room) in their house at Streatham, south of London, was adorned by thirteen portraits of their favoured guests, all by Reynolds.[143]

In his portraits of his literary friends Reynolds often disregarded convention by emphasizing physical deficiencies. Baretti, for instance, the Italian author and a tutor to the Thrale family, was painted as short-sighted (Cat. 85). So, too, in one portrait was Johnson, rather to his annoyance. Reynolds also painted himself for the Thrales as a deaf man. And yet it is easy to overestimate the candour. Reynolds's companion profile portraits, painted for the Duke of Dorset, of Goldsmith and Johnson (Cat. 73, 79), perhaps his closest friends, the one gently pensive, the other agitated by profound thoughts, are informal (with open collars and without wigs) but avoid those grotesque and comic features in both men of which Reynolds, as we know from his writings, was an acute observer.[144]

Reynolds was a conciliating influence upon his friends such as only someone commanding their highest respect could have been. He made peace between Burke and Johnson and

between Garrick and Goldsmith. He was also attached to people of opposite persuasions: to the democrat Wilkes as well as to the Tory Johnson; and he even dined with Burke and his enemy Warren Hastings on consecutive days.[145]

When his old friend and patron Augustus Keppel, now Admiral Keppel, was honourably acquitted at his trial by court martial in 1779 (for alleged reluctance to engage with the French Fleet because of his sympathy with the cause of the American colonists) Reynolds joined in the general jubilation of the Admiral's Whig supporters. He supplied a series of portraits for his friend to present to his closest political allies, and hastened to arrange for a print (Cat. 60) to be published of an earlier portrait.[146] Here Reynolds employed his art to serve a political party, but it also served his interest, and he would not have hesitated to paint Keppel's opponents.

In the late 1770s political controversy put a considerable strain on Reynolds's circle. In 1778 Johnson found himself out of sympathy with much of The Club and complained to Boswell that Reynolds was too much under the influence of the Whigs, Fox and Burke.[147] The Whigs, however, probably considered that Reynolds was too much influenced by Johnson, who was indeed described as his 'oracle', and we know that Reynolds defended Johnson's Tory politics against Burke.[148] In the 1780s Reynolds does appear to have been closely attached to Whig society and was much patronized by both the Duchess of Devonshire and the Prince of Wales. However, his most munificent and imaginative patrons were the Duke of Dorset (who purchased the *Ugolino* as well as several fancy pictures and portraits and who seems to have sold Reynolds's paintings to French collectors[149]) and the Duke of Rutland (who purchased, in addition to portraits, the cartoon for the New College Nativity for the astounding sum of £1,200). Both Dukes held high office under the younger Pitt, Fox's opponent. Reynolds had no connection with Pitt himself (who anyway took notoriously little interest in art[150]) but he was on friendly terms with Pitt's brother-in-law, Edward Eliot, and with Pitt's protégé, Lord Rolle, who was relentlessly ridiculed by the Foxite Whigs. It is also worth pointing out that the Corporation of Plympton, of which Reynolds was Mayor, was consistently Tory.[151]

In 1784, on Ramsay's death, Reynolds, after what he considered to be an insulting delay, was appointed 'painter in ordinary to the King'. He was irritated to discover that his stipend was lower than that of the King's rat-catcher, and he still received no real patronage from 'a certain person'.[152] However, two years later the Empress Catherine of Russia, the greatest patron and the most avid Royal collector of the age, gave him a commission for a history painting of a size and subject of his own choice.[153] He painted an episode from Pindar: *The Infant Hercules Strangling the Serpents sent by Juno* (Cat. 140) in allusion to Russia's precocious emergence as a world power.

At last he was treated as Titian or Rubens had been. More than ever he must have felt himself as the heir of the Old Masters, and hence in communion with the past and with posterity. From this attitude it was perhaps natural to take a neutral view of the political controversies of his day. It was also good business to do so, and Reynolds's conception of artistic genius did not preclude the exercise of sound commercial acumen.

Engravers and printsellers

At the same date that Reynolds received his commission from the Empress of Russia he was also approached by the printsellers and publishers to paint history subjects. Boydell wanted scenes from Shakespeare to adorn his Shakespeare Gallery (conceived of in the winter of 1786 and opened 1789). The plan was that the public should visit the Gallery rather as they went to the theatre, and then purchase engravings of their favourite scenes for their own homes and also subscribe to an illustrated edition of Shakespeare's work. Another successful printseller, Macklin, commissioned a Holy Family from Reynolds.[154] Commerce looked as if it might succeed where the Church and the Court had failed.

There is evidence that at the end of his life Reynolds was composing an essay on the state of the arts in Bourbon France in which he seems to have taken the expected Whig line that the arts could suffer from the attentions of the Court. The surviving fragment concludes awkwardly: 'The splendor of a Court as of Individuals who compose that Court is to a Nation what lace is to an individual. . . .'[155] He did not protest when at the Royal Academy Banquet of 1789 the Prince of Wales, the guest of honour, proposed the absurd toast in honour of Boydell as someone who had done 'more for art than the grand Monarque of France'. The toast was suggested by Burke.[156] Even if Reynolds concurred with his friend's theories we may be certain that he preferred receiving the patronage of the Empress of Russia to that of Boydell or Macklin, who were the equivalent of today's Cinema or Television producers. His mixed feelings about Boydell are in fact suggested by several sources.[157]

We have noted that Reynolds, early in his career, had published a mezzotint engraving of one of his portraits. He almost certainly actively encouraged the subsequent regular publication of others. This was already an established practice with English portrait painters, but Reynolds was fortunate in that he began to have his works reproduced at the very moment that a group of Irish *émigrés* were giving new vitality to the art of mezzotint engraving.[158] In addition to achieving publicity for Reynolds himself the engravers provided a service which was much appreciated by Reynolds's sitters who could present prints of their portraits to their friends—and the artist's pocket-books and ledgers show that Reynolds often arranged this.

In the case of some of his portraits of celebrities—courtesans such as Kitty Fisher or best-selling authors such as Laurence Sterne—there is also the possibility that Reynolds's chief reason for making the paintings was in order that reproductions could be made of them. This is suggested in the case of *Sterne* (Cat. 37) by the fact that the painting was uncommissioned. We do not know what professional advantage, or exactly what share, if any, in the profits, was involved for Reynolds in such cases, but we suppose that the initiative was probably his.

During the 1770s the great profits involved in printmaking, especially now that there was a large export market for mezzotints, prompted the engravers to play a larger part in the marketing of their own works. An especially interesting enterprise of this period is represented by Valentine Green's mezzotints after Reynolds's full-length portraits of society beauties such as the Whig Duchess of Devonshire (Cat. 102) and the Tory Duchess of Rutland (fig. 43). Green solicited subscriptions in the late 1770s for a series of these which were to be known as the 'Beauties of the Present Age'. The series was 'on the plan' of the famous series of female portraits 'at Windsor by Sir Peter Lely and at Hampton Court by Sir Godfrey Kneller'.[159] There was, however, a great difference. Reynolds's original paintings were never kept together in a royal palace or even exhibited together. Looking at these prints we are struck by the effective compositional similarities and contrasts, but Reynolds is unlikely to have had the series in mind when he made the earliest portraits which were reproduced. We suspect that the initiative was in this case the engraver's.

Valentine Green quarrelled violently and publicly with Reynolds when he was not granted the right to make a print of Reynolds's portrait of the actress Mrs Siddons (Cat. 134, 151). Reynolds did not suffer because he had always been careful to maintain close links with more than one engraver at a time. Notes in his pocket-books suggest the care that Reynolds took in selecting engravers for his works, and although surviving proofs which purport to have been corrected by him are rare,[160] he surely took an active interest in the mezzotint process. He seems to have encouraged two of his assistants, Marchi and his pupil Doughty, to learn the craft.[161] His notes on Rubens discuss with approval the control which that artist had over the prints after his paintings and show how much thought Reynolds gave to the question of loss and compensation in black and white reproduction.[162] He knew that the mezzotints guaranteed his fame abroad and also with posterity, for he was aware of how many of his paintings had begun to deteriorate, on account of the fugitive pigments he had favoured in the 1750s and 1760s and because of his subsequent experiments with waxes and varnishes (discussed in this catalogue by Talley).

Reynolds's handling became more exciting in the last decades of his life, as his technique became more dangerous. He is said to have disgusted ladies who admired the 'well-furnished' and 'richly-burnished' portraits by the American painter John Singleton Copley.[163] Ironically, Reynolds had done much to encourage Copley but had tried to discourage the brilliance and high finish he gave to the subordinate parts of his paintings.[164] By comparison Reynolds's paintings were thought to resemble 'rotten eggs against barn doors'. Reynolds did in fact commend Rembrandt's exploitation of accidents in handling.[165] He used the palette knife vigorously in his painting of trees, rocks and earth; he deliberately allowed paint to run;[166] for highlights, especially on hair or bark, he dragged dry paint over the surface; there are also virtuoso passages of paint worked swiftly 'wet in wet' in the manner of Hals, especially for the greys in black garments. His touch was never neat like Copley's, nor was it

Fig. 20 Macbeth and the Witches, 1786–9 (The National Trust, Petworth)

ever feathery and it is unlikely that he was attracted by the dissolution of the solid world into brush-strokes, so often found in Gainsborough—although he did declare his admiration for that artist's 'lightness of touch'.[167]

Much of the boldness of Reynolds's handling survives in the mezzotints after his paintings, as it could not in any other reproductive medium. The strength his paintings retain in reproduction makes us realize how much more Reynolds depended upon light and shade as well as colour, when compared with Gainsborough or Romney or Copley. But no print could convey anything of the original magic of the *Macbeth and the Witches* which Reynolds painted for Boydell, a painting which, in as much as it can now be deciphered at all (fig. 20 and Cat. 152), impresses us as utterly ludicrous, but which Northcote seriously likened to the *St Lawrence* of Titian (Gesuiti, Venice), that is to the most haunting nocturne in the history of European art.[168]

The supernatural machinery in the *Infant Hercules* may also have depended upon effects of light and colour which have only imperfectly survived, but the choice of a fat baby not merely as the chief subject, as in a Nativity, but as chief actor, and the prominence given to a frightened dog in the front of the stage, must always have disqualified the painting from the status of Tragedy or Epic. And yet in the figure of Tiresias Reynolds created something truly heroic. Looking at the blind seer we may recall how he admired Raphael for deliberately avoiding graceful contrasts in his depiction of St Paul preaching in Athens (his weight placed equally on both legs), and how he commended another figure in the same cartoon (Royal Collection, on loan to the Victoria and Albert Museum, London) who 'seems to think from head to foot'.[169]

The last years

Reynolds had a stroke in November 1782, but he seems to have recovered fully by December. However, in the summer of 1789 one of his eyes clouded and by the autumn it was

blind. The other eye weakened and, a year later, he had ceased trying to paint.[170] He continued to write: his final Discourse was delivered to the Academy in December 1790. But he was depressed by his blindness and steadily weakened by his diseased liver.

Early in 1790 Reynolds resigned briefly from the Royal Academy after a violent quarrel over the appointment of the Professor of Perspective. But for the frustration of abandoning his art he might have done more to anticipate, disarm, divide or conciliate his opponents, and he would not perhaps have been tempted to adopt methods which at least looked irregular.[171] He was motivated by pride, but also by an honourable belief in the importance of proper instruction in the Academy Schools. From the start he entertained notions of extending the Academy's educational aims to provide a 'repository for great examples of art'—a National Gallery, in fact.[172] There was resistance to this and even to the loan exhibition he arranged of Poussin's Sacraments which he had obtained for the Duke of Rutland. The offer of his own collection to the Academy was rejected.[173] He did eventually exhibit a large portion of it in 1791, but it was for sale, with an entrance fee for the benefit of Ralph Kirkeley, his old servant.[174]

Reynolds's collection, which he assembled not only for pleasure but partly on speculation and partly for the study of technique, included some masterpieces—among them the Susanna of Rembrandt (now in Berlin) and the Moonlit Landscape by Rubens (fig. 21)—but these he valued less than a Correggio, a Leonardo and a Michelangelo none of which can be accepted as genuine. His collection was 'swarming' with false pictures, especially Italian ones, and it was cruelly observed that 'no unfledged peer or full-plumed loan-jobber was more liable to be deceived, even in those branches of the art which he professed most to admire'.[175] There were

superb Italian works among his thousands of drawings,[176] but the auctioneers selling his collection of paintings knew what they were doing when they put his Roman and Florentine paintings in small type, his Bolognese, Venetian, French and Flemish paintings in larger, and his Dutch in very large type.

From his collection of prints and plaster-casts, and also from the sketches he made on his travels, especially after antique sculpture and the works of the sixteenth-century Roman and seventeenth-century Bolognese schools, Reynolds took numerous ideas for his portraits. Sometimes his source was meant to be recognized, and is part of the meaning of the painting, as in a general way with his drapery after the antique, or more specifically in the case of Mrs Siddons as the Muse of Tragedy (Cat. 134, 151) where the pose is taken from Michelangelo; and there is sometimes, as has been mentioned, an element of travesty in the fancy pictures. Here we may legitimately write of allusion or 'quotation' as Horace Walpole described it.[177] But very often the 'quotations' seem only to have been spotted by art historians in this century. And Reynolds himself observed that 'It often happens that hints may be taken and employed in a situation totally different from that in which they were originally employed.'[170]

Reynolds's efforts to rival Titian, Veronese, Van Dyck, Rubens or Rembrandt, on the other hand, were of an obvious kind which could never be concealed, and which were applauded. 'We see the richness of colouring and the luxuriance of Rubens, without the excess of his manner, and without the tumult that so often fills his works. He imitates the brilliant hues, the truth and decisive manner of Rembrandt, but never admits anything mean or disgusting.'[179] In view of this it may seem surprising that Reynolds in his Discourses and elsewhere commended the 'great manner' of

Fig. 21 Peter Paul Rubens, *Moonlit Landscape, c.* 1635 (Courtauld Institute Galleries, London)

the Bolognese and Roman schools over the 'ornamental' Venetian and Flemish.[180] This may be explained away as deference to orthodox academic priorities made without reference to his own practice. But it is perhaps more revealing than that; for, despite his love of Venetian and Flemish colouring, Reynolds was anxious to be more than an 'ornamental' painter, and (to borrow his own distinctions) was determined not to 'dazzle' rather than 'affect', and not to heighten the 'elegant' at the expense of the 'sublime'. He certainly sometimes intended to delight the eye, as in his portraits of children or in the group portraits of the Dilettanti (inspired, he admitted, by Veronese[181]); but he also intended that colour should fill the mind of the beholder with the solemn and splendid character of his subject. The dark skies behind his military portraits, for instance, do much more than merely enhance the brilliance of the uniforms.

The boldness of handling in Reynolds's late work has already been mentioned. It is connected with his interest in volatile expression. The slash of shadow between the lips of Charles Burney suggests that his mouth is just opening (Cat. 125); the flickering dashes of paint around the eyes of Mrs Abington (in the part of Roxalana, lifting a curtain) suggest the quickness of their glance. Reynolds also became more attracted by physical movement. His mothers and children became more and more lively, and when the Countess Spencer's daughter—so quiet and still in their double portrait—was grown up and married (to the Duke of Devonshire) and was herself a mother, she was painted by Reynolds in a very different way (Cat. 139). Mother and child demonstrate their delight in each other's company with expansive gestures, and, we imagine, a good deal of noise. The Duchess was, we are not surprised to learn, applauded by doting poets for dispensing with the services of wet nurses—unrepressed by 'frigid fashion' she 'open'd all her breast'.[182]

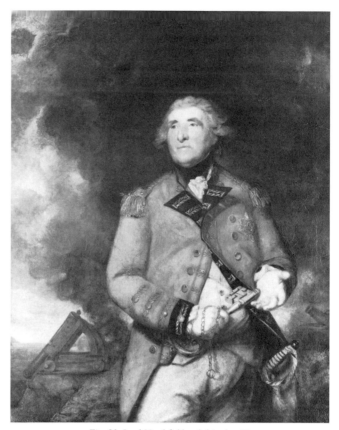

Fig. 23 *Lord Heathfield*, exhibited 1788
(Trustees of the National Gallery, London)

In Reynolds's whole-lengths of the 1780s there is also more action: the Prince of Wales with a drawn sword is about to ride gallantly into battle on a grey stallion (fig. 22); Colonel Tarleton, during campaigns in North Carolina, coolly adjusts his leggings whilst horses rear and cannons roar (Cat. 129); General Heathfield, weighing the Key of Gibraltar in his hand, ponders, during the siege of that fortress, upon the destiny of his country (fig. 23). The Prince, whose uniform is an invention,[183] never did ride into battle and the noble aspirations suggested by the painting could hardly have compensated for his notorious delinquencies. Admiration for the heroism of Tarleton, however, could perhaps have helped the public to forget the disastrous loss of the American Colonies. And to look at the portrait of Heathfield was not merely to witness but to participate in the defence of the British Empire. This portrait was commissioned by Boydell,[184] who keenly appreciated the increasing demand for patriotic imagery (but did not anticipate that his booming export business would be ruined by war), and it has the same relationship to the enormously popular contemporary battle pictures by West and Copley that Reynolds's earlier theatrical portraits have to the paintings of stage performances.

Boydell hung the portrait of Heathfield surrounded by four paintings of the Siege of Gibraltar by Paton in his Shakespeare Gallery where paying visitors could also see Reynolds's *Macbeth* and the *Death of Cardinal Beaufort*

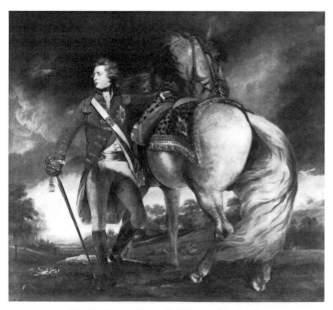

Fig. 22 *George, Prince of Wales*, exhibited 1784
(Lord Brocket, Brocket Hall)

(Cat. 148). Whereas the history paintings commissioned in the 1760s and 1770s for reception rooms designed by Adam had tended to be as slight and trite as the polite conversation that took place beneath them, the paintings commissioned by Boydell because they were designed for a gallery which resembled a theatre were free to amaze and enthral and even alarm. Reynolds's paintings for Adam's music rooms—his Euphrosyne and his St Cecilia—avoid the insipidity of Angelica Kauffman, but his paintings for Boydell do not avoid the sensationalism of Fuseli.

Reynolds's late female portraiture shares some of the qualities of the Shakespearean paintings of the Visionary and Terrible: and in them, as also in his late male portraits, the clouds and the smoke increase. 'Miss Emily' the 'lady of the town' protected by Lord Greville who was the model for *Thais* (Cat. 124) has all the vitality of *Mrs Hale as 'Euphrosyne'* (Cat. 61), but is setting fire to Persepolis rather than dancing in Arcady. *Mrs Beckford sacrificing to Hygeia* (Cat. 132) looks

Fig. 24 Mrs Billington as St Cecilia, 1786–9 (Gift of Lord Beaverbrook, Beaverbrook Art Gallery, New Brunswick)

as if she may really have been involved in sorcery, which we would not suspect of *Sarah Bunbury sacrificing to the Graces* (Cat. 57). The greatest of his last female portraits were of professional performers: the singer Mrs Billington (fig. 24 and Cat. 157) and the actress Mrs Siddons (Cat. 134, 151). The former almost succeeds in becoming St Cecilia, whose part she plays, and Reynolds does succeed both in emulating the shimmer, the flow and the exuberant health of a Rubens, and in adding that 'poetical conception of character' which he felt Rubens lacked.[185] In his portrait of Mrs Siddons, the greatest tragic actress of her day, commissioned by Sheridan who was the manager of the Drury Lane Theatre where she starred, Reynolds, stimulated by the atmosphere of the stage, by the sublime forms of the Sistine Chapel ceiling, and by the magical light of Rembrandt, created a work with all the qualities associated with the greatest religious art. The same is true of his portrait of Heathfield. But neither was inspired by the Church.

In such works we may feel that Reynolds closed the gap between the painting of portraits and of heroic and poetic subjects. Some contemporaries expressed this view. To a French visitor to London the '*portraits de Regnols*' were comparable with '*tableaux d'histoire*'.[186] Reynolds himself, however, saw clearly what he had not done. In his final Discourse he considered his relationship with Michelangelo as that of an admirer rather than an imitator. 'I have taken another course, one more suited to my abilities, and to the taste of the times in which I live. Yet however unequal I feel myself to that attempt, were I now to begin the world again, I would tread in the steps of that great master: to kiss the hem of his garment, to catch the slightest of his perfections, would be glory and distinction enough for an ambitious man.'[187] This is religious language. But it was not inspired by the Church. Reynolds in his last months dosed himself heavily with Laudanum. 'No clergyman attends him; no holy rites console his languishing hours,' his friend Boswell lamented.[188] He died on 23 February 1792 and was buried in St Paul's Cathedral with great pomp.

NOTES

1. *The Idler*, no. 45, 1759 (quoted in Northcote 1818, I, p. 239).
2. See Northcote 1818, I, pp. 99–101 for Johnson's justification of this exclusion and also p. 134 for maids and stable-boys. For common porters and print shops see anon., *More Lyric Odes* 1785, p. 21. For the question generally see Whitley 1928, I, pp. 177–8.
3. Leslie and Taylor 1865, II, p. 476 (erroneously printing barn for ham).
4. Reynolds 1929, p. 148.
5. Anon., *Observations* 1790, p. 15.
6. Pasquin 1786, pp. 32–3 (cf. Pasquin 1796, I, p. 10).
7. Pasquin 1796, II, p. 68.
8. There are several appointments in the artist's pocket-books for the late 1750s for 'a lady', and 'a stranger'—presumably because Reynolds's servant did not catch the name of the person proposing to sit. In some cases, however, anonymity seems to have been preserved throughout as can be seen from the ledgers (Cormack 1970, pp. 120, 132, 157)—presumably a clandestine love affair explains this.
9. Waterhouse 1973, p. 13.
10. For childhood and background generally see Cotton 1859 (*Some Account*), pp. 34–5; Pearce-Edgcumbe 1901; Hilles 1936, p. 4; Hudson 1958, pp. 5–8.
11. Cotton 1856, p. 44.
12. Ibid., pp. 43–8.

13. Vertue 1933–4, pp. 66, 85, 111, 121.
14. Cotton 1856, pp. 61–2. But that there was a quarrel is clearly stated by Malone in Reynolds 1798, I, p. ix.
15. For retirement to the provinces generally see Lippincott 1983, p. 38. For Reynolds's movements see Hudson 1958, pp. 20–2. Residence, acquaintance and property in London are strongly suggested by the artist's letters from Rome to Miss Weston (Reynolds, 1929) and practice there is referred to by Malone in Reynolds 1798, I, p. viii.
16. Northcote 1818, I, p. 18. One very probable copy and one other possible one are in the collection of Denis Mahon (Mahon 1967, pp. 77–9 and Kenwood 1979, nos 69, 70). Three are included in an extra-illustrated copy of the first volume of *Testimonies to the Genius and Memory of Sir Joshua Reynolds* which belongs to the Hon. Christopher Lennox-Boyd. It is significant that Guercino's drawings had been imitated in the prints by Arthur Pond and Charles Knapton published in the early 1740s. Bartolozzi also made his reputation with imitations of Guercino (Pasquin 1796, p. 104).
17. Northcote 1818, I, pp. 19–20; Hilles 1952, p. 24.
18. British Art Centre, Yale, Reynolds MS 33.
19. Reynolds told this to three of his friends on separate occasions — Malone (see Reynolds 1798, I, p. viii), Johnson (see Northcote 1818, I, note p. 14) and Boswell (see Hilles 1952, p. 23).
20. Hudson 1958, pp. 25–30.
21. For the exact date of departure to Leghorn see Hilles 1936, p. 9. For the sister's loans see Cotton ('Notes and Observations') 1859, p. 11.
22. Northcote 1818, I, pp. 26–9, 46–52. The itinerary may be reconstructed from the artist's sketchbooks.
23. Reynolds 1798, II, p. 246 (*Notes on Du Fresnoy*).
24. Two small Italian sketchbooks are in the British Museum (Binyon 12 & 13), two are in the Soane Museum (the smaller of them not certainly by Reynolds although connected with him), two are in a private collection (Cat. 159, 160), and another, of dubious status, is in the Ashmolean Museum (Brown 1982, no. 1514). The architectural drawings in the Lucas album are not by him.
25. These are in the Lucas album on loan to the Royal Academy. The existence of such drawings is specifically mentioned by Edwards (1808, p. 198).
26. For deafness see Malone in Reynolds 1798, I, p. lxxxviii, but also Pearce-Edgumbe 1901, p. 18.
27. Cotton 1859 ('Notes and Observations'), p. 1; Millar 1969, I, p. 107; and for Edgcumbe see Reynolds 1929, p. 8.
28. Reynolds 1798, I, p. xiii; Reynolds 1929, p. 17.
29. British Art Centre, Yale, n.d. 1130/f67, p. iii (with Reynolds's own translation on the flyleaf). For Reynolds's awareness of his deficiency see Malone in Reynolds 1798, I, p. xlix. See also Farington in Reynolds 1819, I, pp. cxli–cxlii.
30. Edwards (1808, p. 208) certainly exaggerates the rarity of these. Those in the Lucas album may well date from Italy. See also Herrmann 1968, p. 658. The attribution of the British Museum's academy studies to Reynolds is surely strengthened by the fact that they were owned by Richard Payne Knight who recorded that they were by him. Knight was (as the artist's pocket-books make clear) a close friend of Reynolds, and attribution to Reynolds would not then have increased the value of the drawings.
31. Reynolds specifically refers to his acquaintance with Vernet in a letter (Northcote 1818, II, p. 90). See also Leslie and Taylor 1865, I, p. 55 for Doyen.
32. One of the British Museum sketchbooks (Binyon 12, fol. 17) includes a drawing of the 'Farnese Flora' (a statue in Rome) made in Florence.
33. Cotton 1856, p. 51. This study was perhaps made at the St Martin's Lane Academy.
34. Malone in Reynolds 1798, I, p. vi; Northcote 1818, I, note p. 10; Whitley 1928, II, p. 283.
35. Malone in Reynolds 1798, I, p. vii; Northcote 1818, I, pp. 12–13; Cotton 1856, p. 17; Plymouth 1973, nos 53, 82. It has been assumed that the Jesuit referred to was Padre Pozzo whose elaborate and expensive thesis was indeed celebrated, but the standard perspective textbook was *La Perspective Pratique* by another Jesuit, Père Dubreuil, and Dr J. Edgcumbe has confirmed that this was Reynolds's source (in an article which he will publish shortly).
36. Waterhouse 1980; Kenwood 1983, pp. 7–13.
37. Northcote 1818, I, p. 23 — but see also Mannings (1975) on this point.
38. Cotton 1859 ('Notes and Observations'), p. 28.
39. Lippincott 1983, pp. 132–3.
40. Francis Watson's claim that Patch only practised as a caricaturist in Florence after his banishment from Rome is challenged by O'Connor (1983, p. 18) with strong but not conclusive evidence.
41. Reynolds 1798, I, p. 350 (*The Idler*, no. 76).
42. Northcote 1818, I, p. 46 (and Northcote in Hazlitt 1830, p. 301) suggests that Reynolds deliberately stopped painting caricatures. See the pen drawing in his pocket-book for 1757.
43. Waterhouse 1941, p. 38 (National Portrait Gallery).
44. There is an engraving by Fassard. Jane Roberts points out that the painting appears in Gautier's sale of 6 April 1759 (no. 153).
45. Mason in Cotton 1859 ('Notes and Observations'), p. 50.
46. Northcote 1818, I, p. 53. See Rouquet 1755, pp. 42–3 for such displays generally.
47. Cotton 1859 ('Notes and Observations'), p. 1.
48. This has been confirmed by recent X-ray photographs.
49. Mason in Cotton 1859 ('Notes and Observations'), p. 50.
50. Northcote 1818, I, p. 64.
51. Most obviously in his portraits of the Earl of Carlisle (Castle Howard) and Colonel St Ledger (Waddesdon Manor).
52. Northcote 1818, I, pp. 65–6; Mason in Cotton 1859 ('Notes and Observations'), p. 50.
53. Northcote 1818, II, p. 267.
54. British Art Centre, Yale, MS Reynolds 33, fol. 1 verso (faint) previous to the fol. numbered as 1 by Reynolds.
55. The 'slight' drawing of an 'Apollo-like' statue is mentioned by Leslie and Taylor (1865, I, p. 106) who do not say that it was of the Apollo Belvedere which they would certainly have recognized. It does not resemble the Apollo Belvedere at all closely and as Waterhouse observes (1965, p. 31) no one at the time noticed the resemblance. See also Balkan 1979, note p. 64. (For an alternative view see the entry in this Catalogue for the Keppel portrait.)
56. Radcliffe 1930, p. 87. See also Northcote 1818, I, p. 119; Whitley 1928, II, pp. 281, 283, 290; Roberts 1834, I, p. 376. Reynolds seems to have held deist beliefs — see Boswell 1928–34, XVII, p. 77.
57. That McArdell's print of Lady Charlotte Fitzwilliam was not only published by Reynolds but was done so entirely on his initiative is established by a MS letter belonging to the Countess Fitzwilliam (see Cat. 21).
58. Northcote 1818, I, pp. 52 (note), 78, 82–3, 97.
59. Ibid., I, p. 57 mentions Marchi posing and II, p. 27 mentions the use of the lay figures (see also Whitley 1928, II, pp. 291–2). For the hands see Northcote 1818, II, p. 267 and Gwynn 1898, pp. 49 and 112. The anonymous translator of De Piles in the preface to the English edition of 1743 refers on p. viii to the tradition of Van Dyck keeping servants for this purpose.
60. Peter Romney quoted in Gamelin 1894, pp. 35–6.
61. Northcote 1818, I, p. 83.
62. Hazlitt 1830, p. 217. For a copy by Reynolds of Ramsay see Cormack 1970, p. 118. Reynolds seems also to have made copies of Rosalba Carriera, Hoare, Mengs ('Minx'), and Holbein — ibid. pp. 118, 121, 129, 138, 147.
63. Fletcher 1901, p. 212; cf. Hazlitt 1830, pp. 299–300.
64. Smith 1845, pp. 129–30 for the argument between Reynolds and Johnson. This type of painting was successfully imitated in the series of portraits of actors and actresses painted by Gainsborough Dupont in the 1790s and now in the Garrick Club.
65. Northcote 1818, I, pp. 102–3; Fletcher 1901, p. 204; and for the location of artist's studios see Lippincott 1983, pp. 15, 32.
66. Boswell 1934–50, I, p. 200.
67. Hudson 1958, pp. 60–1.
68. Millar 1969, p. 100. There is a curious story, perhaps not wholly apocryphal, in Pasquin 1796, II, p. 69, of a plan that Reynolds had to paint a highly ambitious picture of the Coronation procession. He is said to have insisted on the price being fixed in advance which caused offence. Was this in fact the plan for the wedding painting and does it explain why it was never completed?
69. For a brilliant but partially conjectural, and not wholly charitable, account of the artist's motives see Waterhouse 1965, pp. 54–5. For Bute see Whitley 1928, I, pp. 252–4.

70. For Cotes see Johnson 1976.
71. Rouquet 1755, p. 22.
72. Kenwood 1982, pp. 17–18. Slightly later, the music room at West Wycombe Park was adorned with its copies after the same artists.
73. Tate Gallery 1980, no. 71.
74. This portrait is at Althorp. It might have been intended as a companion for that by Knapton of John Spencer (whose son married Poyntz's daughter), which is also a shooting picture of ambitious scale—Garlick 1976, pp. 31, 42, pls 16, 20.
75. Waterhouse 1973, p. 23.
76. Kenwood 1983, pp. 44–5, 51–2 (nos 16, 22).
77. That of Robert Child formerly at Osterley Park was destroyed by fire in about 1949. There are two earlier seated portraits by Reynolds of gentlemen with guns—Plymouth 1973, no. 5.
78. Pocket-book for 1770, week of 10–17 September, also fol. 3.
79. Northcote 1818, I, p. 294; Leslie and Taylor 1865, II, note p. 28.
80. The most notable example is the portrait of Lord Cawdor (Cawdor Castle, Nairn) exhibited at the Academy in 1778 (no. 249).
81. Northcote claims at one point that the pupil assistants painted the hands in the portraits but at another that they modelled them! (Northcote 1818, II, p. 27; Fletcher 1901, pp. 30–1; Gwynn 1898, pp. 49, 112.)
82. Edwards 1808, pp. 53–5; Northcote 1818, II, pp. 28–9; Whitley 1928, I, p. 279.
83. Ribeiro 1977; Nevinson 1964.
84. Reynolds 1975, p. 140 (Discourse VII, lines 735–46).
85. Boswell 1928–34, VI, p. 46; Boswell 1934–50, III, pp. 82–5.
86. Reynolds 1975, p. 187 (Discourse X, lines 370–90).
87. Examples are Carlo Maratta's full-length portraits at Althorp of the Earls of Roscommon and Sunderland. These were imitated by Stephen Slaughter's portrait of the 5th Earl of Sunderland at Althorp (Garlick 1976, pp. 56, 78, pls 10, 11). Clostermans also painted portraits of this sort. Several of Knapton's portraits of the Society of Dilettanti are in Roman dress, including one of the 2nd Duke of Dorset who was also painted full-length in such attire by Franz Richter (at Knole).
88. In his portrait of Mrs Walters of 1757 at Gorhambury. The motif was introduced into English portraiture by Van Dyck and was most common in the last years of the seventeenth century.
89. Piozzi 1861, II, note p. 173.
90. Northcote 1818, I, p. 66.
91. Soane Museum, Adam vol. XIV, no. 118.
92. Fitzgerald 1949–53, I, pp. 18, 133, 153, 158–9.
93. Ibid., I, pp. 223, 388.
94. Dodd 1981, pp. 17–18.
95. Pressly 1981, pp. 75–6, 111–12.
96. Reynolds 1975, pp. 128–9 (Discourse VII, lines 367–89); see also Hilles 1936, p. 191.
97. The story is told of both Mary Horneck and of Offy (Cotton 1856, p. 70). For Reynolds and children see also Hazlitt 1830, p. 267.
98. Quoted by Malone in Reynolds 1798, I, p. lii. Cf. Hilles 1936, p. 225.
99. Strange 1775; Edwards 1808, pp. vii–xxix; Northcote 1818, I, pp. 164–71; Cust 1914, pp. 51–9. The fullest account of the societies and academies comes in Whitley 1928, II, chapters 10, 11, 13, 14, 15.
100. *Annual Register*, December 1768.
101. Charles Burney cited in Hilles 1936, p. 182.
102. Reynolds 1975, p. 42 (Discourse III, lines 300–1).
103. Ibid. p. 73 (Discourse IV, lines 511–12).
104. Ibid. pp. 51–2 (Discourse III, lines 313–35).
105. Richardson 1719, pp. 44–6.
106. Reynolds 1975, p. 19 (Discourse I, lines 159–62).
107. Ibid. p. 161 (Discourse VIII, lines 507–17).
108. Ibid. p. 252 (Discourse XIV, lines 166–82).
109. Discourses X and XIII.
110. Reynolds 1975, pp. 156ff. (Discourse VIII, lines 307ff.).
111. Ibid. p. 42 (Discourse III, lines 23–32).
112. Ibid. p. 171 (Discourse IX, lines 71–86).
113. Reynolds 1929, pp. 16–19.
114. Ibid., pp. 37–8.
115. Ibid., pp. 58–61; Cotton 1859, p. 58; Leslie and Taylor 1865, II, pp. 200, 265–6.

116. Reynolds 1975, pp. 224–5 (Discourse XII, lines 529–43). See also the 'Notes to Du Fresnoy' in Reynolds 1797, II, p. 236.
117. Mason in Cotton 1859 ('Notes and Observations'), p. 58.
118. Reynolds 1797, I, pp. 357–62 (*Idler*, no. 82); cf. 'Notes to Du Fresnoy' in ibid., II, pp. 212–13, 267; and above all Reynolds 1975, pp. 43–9 (Discourse III, lines 63–265). For Adam Smith see Hilles 1936, note p. 20. As Northcote noted (Hazlitt 1830, p. 86) Mudge also expounded the theory that Beauty was the 'medium' form.
119. Richardson 1719, pp. 26–35.
120. Northcote was sure that Romney drew sitters away from Reynolds when he first became fashionable (Hazlitt 1830, p. 25). A newspaper report of 27 July 1789 (Whitley 1928, II, p. 122) refers to the artist's price-rise a decade earlier as connected with a resolution to devote himself less to portraits.
121. Burney 1842–6, I, p. 259; Waterhouse 1973, pp. 26–7.
122. See the verses by S. Collings made, or adapted, for the engraving of this picture.
123. The painting never went to France but was sold by the Ambassador to Charles James Fox. At least one fancy picture (of a praying boy) did go to France—see Malone in Reynolds 1798, I, p. xxxvi.
124. *Town and Country Magazine*, XI, 1779, pp. 400–4. This reference, which seems to have escaped Reynolds's biographers, was drawn to my attention by Diana Donald. For the 'frigid heart' see Piozzi 1861, II, p. 175 and for his 'bland' manner see Reynolds 1798, I, note p. liii.
125. I owe this point to an unpublished lecture on the fancy pictures by Sir Ellis Waterhouse.
126. Hudson 1958, pp. 152, 156. The best character of Fanny is given by Piozzi 1951, I, pp. 79–80.
127. Fletcher 1901, p. 78; Leslie and Taylor 1865, II, p. 134; Whitley 1928, I, p. 369.
128. Papendiek 1887, I, p. 296.
129. See Scarisbrick 1980, p. 753 and Zwierlein-Diehl 1980 for the cameo. Notable earlier family portraits with this sort of narrative dimension are Highmore's Lee family of 1736 (Wolverhampton City Art Gallery) and Hudson's Courtenay family of the mid-1750s (Powderham Castle, Devon).
130. Hilles 1936, pp. 101–5.
131. MS note on Hogarth quoted in Hudson 1958, p. 66—cf. Northcote 1818, II, p. 54.
132. Reynolds 1797, II, pp. 43–6, 232–3.
133. Whitley 1928, II, p. 63.
134. Leslie and Taylor 1865, I, pp. 186–9.
135. Fletcher 1901, p. 186.
136. Hudson 1958, pp. 108–11 (for the villa); Northcote 1818, I, pp. 295, 304.
137. Malone in Reynolds 1798, I, p. lxxxii; Northcote 1818, II, p. 95; Hazlitt 1830, pp. 41, 290–1; Boswell 1934–50, III, p. 65.
138. Northcote 1818, I, pp. 80–1.
139. Malone in Reynolds 1798, I, p. xxx.
140. Hilles 1936, pp. 134–40.
141. Malone in Reynolds 1798, I, p. lxxxiii; Boswell 1934–50, I, pp. 477–81.
142. Benn's Club of 1748–52—see Kenwood 1979, no. 52.
143. Northcote 1818, II, note p. 4 (erroneously describing the room as a dining-room). For the library's use as a breakfast-room see Piozzi 1861, I, p. 27. For the series generally see ibid., II, pp. 170–80; Piozzi 1951, I, pp. 49, 470–6; also Sherbo 1974, pp. 142, 157, 193.
144. Hilles 1952, p. 78.
145. Leslie and Taylor 1865, I, p. 127; II, pp. 491, 530. The dinners on consecutive nights are recorded in the pocket-book for 1789 on 12 and 13 March. Reynolds's letters (1929, p. 6) have been taken to prove that he knew Wilkes previous to his journey to Italy, but the name was not unusual.
146. Leslie and Taylor 1865, II, pp. 230–8; Reynolds 1929, pp. 68–70.
147. Boswell 1934–50, III, pp. 106, 261. Roberts (1834, I, p. 58) is interesting in this connection.
148. See Boswell 1928–34, XVII, p. 9 for the defence of Johnson against Burke. For 'oracle' see Gibbon 1901, p. 143. See Radcliffe 1930, for Reynolds's family's staunch Toryism—also Hazlitt 1830, p. 86.
149. Douglas 1928, I, p. 140.
150. Reynolds 1929, p. 133.

151. Ibid. p. 132, for Eliot; pocket-book for 1786, 14 May for Rolle—
cf. Leslie and Taylor 1865, II, p. 492; for Plympton see Cotton 1859
(*Some Account*), p. 96.
152. Reynolds 1929, pp. 112–13; Hilles 1952, p. 170; Hudson 1958,
pp. 176–9.
153. Reynolds 1929, p. 149.
154. Edwards 1808, p. 203; Northcote 1818, II, pp. 226–8; Hilles 1952,
pp. 180–4.
155. Hilles 1936, pp. 188–9.
156. Whitley 1928, II, p. 112.
157. Gwynn 1898, pp. 226–30; Friedman 1976, pp. 116–17.
158. Alexander 1973.
159. Whitman 1902, p. 15.
160. One touched proof is described by Antony Griffiths in British
Museum 1978, p. 32. Interestingly there is a touched proof of the
same mezzotint in the Fitzwilliam Museum. Timothy Clayton points
out an early reference to proofs touched by Reynolds in the sale of
the estate of Benjamin Green (Phillips, 5/6 July 1798). Reynolds's
interference with the engraved frontispiece to Boswell's *Life of
Johnson* is also documented—see Arts Council 1984, pp. 82–3.
161. Griffiths in British Museum 1978, p. 39.
162. Reynolds 1797, II, pp. 51–3.
163. Anon., *More Lyric Odes*, 1785, p. 6 (cf. 1786, p. 9).
164. Copley and Pelham 1914, pp. 42–4, 96.
165. Reynolds 1975, p. 223 (Discourse XII, lines 480–92).
166. The patterned scarf in the portrait of Frances, Lady Tyrconnel at
Belvoir Castle is an extreme example of this. See also Ingamells 1985,
p. 145 for glazes permitted to run in the landscape background of the
portrait of Mrs Carnac.
167. Reynolds 1975, pp. 257–9 (Discourse XIV, lines 362–402).
168. Northcote 1818, II, pp. 227–8.
169. Reynolds 1975, pp. 154–5, 221 (Discourses VIII, lines 315–21 and XII,
lines 415–24).

170. Northcote 1818, II, p. 131 for the stroke in 1782. See ibid. pp. 246–8
and Burney 1842–6, II, p. 186 for clouding in 1789. A rumour of an
earlier stroke (Piozzi 1951, note p. 382) is contradicted by the
evidence of the pocket-books. He was still painting a little early in
1790 (Whitley 1928, II, p. 125).
171. Hudson (1958, pp. 214–21) gives a very full and fair account. See also
Hilles 1936, pp. 249–76 for Reynolds's own version.
172. Reynolds 1975, p. 15 (Discourse I, lines 46–53).
173. Ibid., note p. 15; Northcote 1818, II, pp. 275, 278; Hilles 1936,
pp. 184–5.
174. Ibid. pp. 185–6.
175. Knight 1810, pp. 310–11.
176. See the section by Martin Royalton-Kisch on pp. 61–92 of the British
Museum 1978 exhibition catalogue.
177. Walpole 1782, note pp. viii–ix.
178. Reynolds 1975, p. 221 (Discourse XII, lines 431–2).
179. 'Shanhagan' 1779, pp. 28–9. For the influence of Rubens see White
1981, pp. 31–7 and for the influence of Rembrandt see White in New
Haven 1983, pp. 1–45.
180. Reynolds 1975, pp. 62–3 (Discourse IV, lines 190–215). Cf. Reynolds
1797, I, p. 352 (*The Idler*, no. 76) and II, p. 12 (*Journey to Flanders*).
181. Malone reporting Sir George Beaumont in Reynolds 1798, I, note
p. lxxiii. David Alexander has pointed out to me that Beaumont also
relates this in a letter to an unknown correspondent (perhaps Malone)
now in the Huntington Library—HM 36833.
182. See the end of Roscoe's translation of Tansillo's poem *The Wetnurse*
of 1798.
183. Annand 1970.
184. British Museum 1978, p. 55.
185. Reynolds 1797, II, p. 122 (*Journey to Flanders*).
186. Mercier 1982, p. 153.
187. Reynolds 1975, p. 282 (Discourse XV, lines 546–54).
188. Boswell 1976, pp. 356–8.

Reynolds in an
International Milieu

Robert Rosenblum

As the first President of the Royal Academy, as the painter who counted among his friends and his sitters many of the most illustrious thinkers, writers, and actors of eighteenth-century England, as the author of the *Discourses on Art*, a coherent body of theory and practical criticism so distinguished in thought and in prose style that it has earned a major place in the history of aesthetics, Sir Joshua Reynolds has secured a central position in that pantheon of British cultural deities who have reigned since the Enlightenment. But if Reynolds's name has always been hallowed, his art has been curiously unloved and even unstudied. To be sure, no great art museum would feel adequate without a major portrait by Reynolds; and no course in British art would neglect to mention his efforts to elevate the insular and empirical traditions of British painting to more universal and ethereal realms, whether by the actual practice of history painting or by the ennobling of portraiture through allegory or erudite art-historical quotations. Yet just as Reynolds himself remained aloof in the 1760s while other artists jockeyed for position, and then, like a *deus ex machina*, ended up in 1768 as the Academy's first President, so, too, has his art remained remote, isolated in an aura of Olympian authority and grandeur that seldom appears to mingle comfortably either with a museum-going public or with the established patterns of art history. Gainsborough, forever paired and contrasted with Reynolds, has long beguiled a larger public; and as for international art history, Reynolds has always been difficult to assimilate, falling into a limbo between the seductive virtuosity of his rococo contemporaries and the zealous austerity of the neo-classic reformers who would destroy this aristocratic style. And if an occasional portrait or history painting by Reynolds might summon up the word 'romantic', his general sense of decorum, of moderation, belies that epithet as well. Sharing attitudes of both the earlier and the later eighteenth centuries, Reynolds has seemed to belong nowhere. It is a symptomatic fact that in one of the most vivid and cosmopolitan recent surveys of eighteenth-century painting, Michael Levey's *Rococo to Revolution* (1966), Reynolds goes unillustrated and appears only as a commentator on other artists; and it is no less telling that in my own *Transformations in Late Eighteenth Century Art* (1967), Reynolds turns up only twice in obscure footnote references. Clearly, it is time to locate Reynolds more firmly in the history of eighteenth-century art.

To be sure, one generation of art historians did make a heroic effort to graft Reynolds on to the great tree of Western painting: that brilliant group of German scholars who found refuge in London in the 1930s and established the Warburg Institute. There, during the grimmest war years, they could integrate their old and their new lives by studying Reynolds and other British artists within a broad international context, an effort typified by Fritz Saxl's and Rudolf Wittkower's path-breaking exhibition, 'British Art and the Mediterranean', held at the Warburg Institute in 1941, and finally published, after the War, as a book (1948). Throughout these traumatic years of Western history, scholars who were prevented in reality from crossing the Channel could at least do so in imagination. Thus between 1938 and 1943 such distinguished historians of Continental art as Edgar Wind, Rudolf Wittkower, Ernst Gombrich and their British disciple, Charles Mitchell, published many articles in which Reynolds was resurrected as almost a surrogate art-historical voyager; and even Erwin Panofsky could use Reynolds as a climax to such iconographical genealogical tables as 'Hercules at the Crossroads'[1] or 'Et in Arcadia ego'.[2] It was well known, after all, that Reynolds was erudite and that he recommended witty allusions to other works of art, a point that had already been made in Hone's *The Conjurer* (Cat. 173), which, by depicting a magician surrounded by a collection of Old Master prints quoted in works by Reynolds, became so close to a libellous accusation of plagiarism that it had to be exhibited outside the Royal Academy's precincts. It now remained to refine this detective work and to track down the bounty of sources from which Reynolds borrowed. A remarkable abundance and variety of artists turned up in these side-by-side confrontations of Reynolds's paintings and their famous or obscure quotations: Michelangelo, Raphael, Titian, and Correggio, certainly; but also Salviati, Giulio Romano, Poussin, Annibale Carracci, Albani, Guercino, Trevisani, Rembrandt, Rubens, Van Dyck, etc. It was an encyclopaedic accumulation that seemed infinitely extendible, providing a delightful parlour game to be played with photographs in art libraries. For a short time, during the war years, Reynolds almost became an *alter ego* for those learned German art historians who, first transplanted from the Continent to insular England, could bridge the cultural gap by uncovering, in this venerable local master's works, a display of erudition comparable with their own.

In all of this, however, Reynolds's position as an artist still remained remote. In place of a unique deity, intelligible only in the context of British social and literary traditions, he became a uniquely knowledgeable art historian, almost the peer of those mid-twentieth-century scholars who unveiled his secrets. But there is still another Reynolds waiting to be more fully disclosed, and that is the Reynolds who, far from being engaged only in a private dialogue with the Old Masters of the sixteenth and seventeenth centuries, was a member of a cosmopolitan community of artists of his own generation, as well as an artist whose innovations could cast shadows across the early decades of international Romanticism.

In the 1980s it is particularly appropriate to revisit and to reconsider Reynolds from a more eighteenth-century viewpoint; for his generation, that of artists who came to maturity in the 1750s and 1760s, was faced with problems curiously parallel to those we know at first-hand today. We have suddenly discovered, it seems, that we may be living at the beginning of what has been called a Post-Modernist era, a time, that is, when the great tradition of Modernist art appears to have expired and can only be looked at with nostalgia, and a time when stylistic pluralism and rampant quotations from the 'Old Masters' of early twentieth-century art are proliferating. The situation, in fact, is comparable with that confronted by many ambitious artists of Reynolds's own generation who, at the brink of their professional careers, found that the grand inheritance of Renaissance and Baroque painting had faded into stale provincial variations or mannered formulas that for many seemed only pathetic echoes of earlier golden ages.

There were many ways to compensate for this sense of a void, of the loss of a vital artistic inheritance. One was to try to paint with an empirical insistence upon the truth of things seen, in a manner that suggested the absence, rather than the presence, of the artifice of inherited styles. But the other side of this coin was to imitate the variety of the multiple styles found in the encyclopaedic repository of art history, a practice that, it was hoped, might resurrect or, perhaps more realistically, might pay learned respect to the grand heritage of a lost era. In this experience, Reynolds's closest counterpart is probably found in his junior by five years, the German painter Anton Raphael Mengs (1728–79), whose very name, imposed upon him by his ambitious painter-father, Ismael, symbolized the hopeful reincarnation of the disparate spirits of Antonio Allegri (i.e. Correggio) and Raphael in the art of a son he had destined to be a painter. Mengs, in fact, was soon to demonstrate that, like a chameleon, he could adapt the look of the most mutually incompatible styles, not only recreating, on various occasions, his two namesakes, Correggio and Raphael, as well as many seventeenth-century painters from Guercino to Poussin, but also managing to mimic a wide range of styles in Graeco-Roman painting and sculpture even to the point of creating a forgery intended to trick Winckelmann into thinking that a lost Greek painting, *Jupiter and Ganymede*, had been rediscovered.[3]

In this free-wheeling diversity of venerable references, Mengs instantly finds a companion in Reynolds, whose nick-name might also have been 'Anthony Raphael Reynolds', given the frequency of his allusions to these two masters. Already in 1751, in his parody of the *School of Athens* (fig. 4), Reynolds displays not only that sense of an irretrievable gulf between a Renaissance past and a mid-eighteenth-century present, but translates this, as Manet would later do in his own restatement of Raphael, the *Déjeuner sur l'herbe*, into a lampoon that makes us laugh, rather than weep, at the discrepancy between a remote, ideal era and the true facts of the present. This witty accommodation of earlier works of art to modern situations can even entail the juxtaposition, in one canvas, of two different stylistic modes. In *Garrick between Tragedy and Comedy* (Cat. 42), exhibited at the Society of Artists in 1762, Reynolds shrewdly represents Comedy in the appropriate style of Correggio, whereas Tragedy evokes the ghosts of Bolognese Seicento masters. If Reynolds's touch is usually lighter than Mengs's in these adaptations, the principle of eclecticism remains the same. Indeed, it is telling that in the 1770s both artists, when faced with religious commissions, virtually repainted Correggio's famous *Adoration of the Shepherds* in Dresden, but added, almost as a measure of the distance between past and present, contemporary portraits. Mengs's painting (fig. 25), executed in Rome in 1771–2 for Charles III of Spain, includes the

Fig. 25 Anton Raphael Mengs, *The Adoration of the Shepherds*, 1771–2 (The Prado, Madrid)

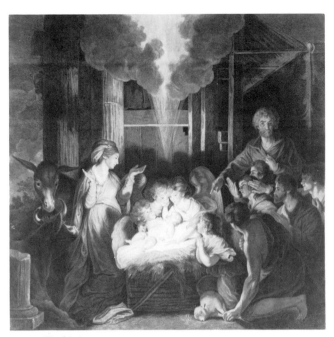

Fig. 26 G. S. and J. G. Facius (after Reynolds, *The Nativity*, exhibited 1779), reduced to a rectangle, stipple, 1785 (Rob Dixon)

artist's own self-portrait on the left, illuminated by the heavenly glow of Correggio's nocturnal light. As for the Reynolds, a commission for a stained-glass window in the antechapel of New College, Oxford, that was also transcribed into an oil-painting exhibited at the Royal Academy in 1779 (but later destroyed by fire at Belvoir Castle in 1816 and now known only through engravings [fig. 26] and a modello), this variation upon Correggio's so-called *La Notte* features, as the figure of Joseph, an instantly recognizable portrait of one of Reynolds's best-known models, George White, who often posed for dishevelled old men in states of solitude or despair, and Horace Walpole also identified, in his marginal comments to the exhibition catalogue, Mrs Sheridan in the role of the Madonna. In the actual window Reynolds himself appeared with the glass painter in the adjacent panel. Such intrusions of contemporary faces within the respectful restatement of a venerable Renaissance religious masterpiece underline the distance that both artists sensed between past and present.

In portraiture as well as history painting, both Reynolds and Mengs used the history of art as a dictionary of noble styles to be borrowed, like clothing from the attic, for dressing-up occasions that would give their sitters a variety of resonances. Holbein's swaggering portrait of Henry VIII, for example, provides an amusing foil to Reynolds's portrait of a child, *Master Crewe* (Cat. 97), who, in effect, puts on, as in a charade, the costume and pose of the sixteenth-century portrait, much as Manet, and still later, Picasso, would resurrect the living personages around them as famous works of art. The ancestral images of British seventeenth-century nobility, as defined for eternity by Van Dyck, are similar touchstones of history throughout Reynolds's career, whether in single equestrian figures, such as *Captain Robert*

Orme (Cat. 26), with its allusion to the portrait of Charles I (Louvre), or in later group portraits, such as the *Marlborough Family* (Cat. 108), which revives the huge dimensions and grandiose, theatrical sweep of Van Dyck's even larger group portrait of the *Pembroke Family* (fig. 46). But if these borrowed models from the history of British portraiture are relevant to the painting of later generations of nobility, Reynolds could also essay a different manner of portraiture, which insists instead upon a surprising candour and directness, as if a moment of intimate observation were seized without reference to the artifice of inherited styles. It was an approach that seemed particularly appropriate to his own circle of intellectual friends, those men of letters whom he often represented with such startling immediacy that, as in the case, say, of the portraits of Samuel Johnson, Giuseppe Baretti, or Oliver Goldsmith (Cat. 73, 79, 85) we feel the ring of unedited truth, of a kind that inaugurates traditions of plain prose statement in portraiture generally associated with the Realist aesthetic of the nineteenth century.

Again, Mengs's approach to the problems of portraiture often paralleled that of Reynolds. When depicting cosmopolitan men of learning, like the German classical scholar Johann Joachim Winckelmann (Metropolitan Museum of Art, New York) or the Spanish biographer and editor, José Nicolas de Azara (Museo de Bellas Artes, Saragossa), Mengs painted straightforward portraits of an almost style-less simplicity that obliges us to focus on nothing more than an intelligent face and a book; whereas in dealing with the various manifestations of European nobility, the sitters are seen through the shifting lenses of historical styles. His royal portraits from Dresden mimic, as the provincial Court itself did, the French mode, here adapting formulas from French aristocratic portraiture of the late seventeenth and early eighteenth centuries; but his later royal portraits for Spanish patrons adapt to a different local tradition, altering the style to mirror knowledge of Velazquez, who, like Van Dyck in England, provided a seventeenth-century paragon for later eighteenth-century portraiture of nobility. It is fascinating to see, too, how Mengs's self-portraits, a long-lived theme with many variations, are comparable to Reynolds's own series of self-portraits, at times presenting the official and dignified pose of a learned artist aware of his public position, and at other times revealing surprisingly intimate glimpses of his own changing moods and expressions, like brief entries in a personal diary. Here again, Reynolds's singularity—which, in effect, is a bewildering multiplicity of styles and a constant shifting between the empirical and the artificial—finds company. Gainsborough might well have said about Mengs, as he did of Reynolds, 'Damn him, how various he is!'

Reynolds's dialogue with the art of his contemporaries, a question of broad analogy in the case of Mengs, becomes, in the case of eighteenth-century French artists, a direct exchange of ideas and images.[4] The true story of Reynolds's knowledge and use of the work of French painters of the period *c.* 1750–90 is yet to be told; for the traditions of British hagiographical writings about Reynolds have either actively or passively ignored the enormous importance of France

upon the archetypal master of eighteenth-century British art and culture. 1792, the year of Reynolds's death, was a particularly inauspicious moment for the British to be sympathetic toward the French. Only a year before, in 1791, mobs in Birmingham had destroyed the home and laboratory equipment of the theologian and scientist, Joseph Priestley, because of his pro-Revolutionary sentiments; and this belligerent Francophobia was immediately reflected in comments by Reynolds's first biographer, Edmond Malone, whose account of his subject's life and works, first published in 1797, would refer to the 'pernicious French Revolution' and would contrast 'this *free* and *happy* country [England]' with 'the *ferocious* and *enslaved* Republick of France'.[5] And if France, in the 1790s, was politically repugnant to Malone, by the 1850s, when the painter and academician Charles Robert Leslie was preparing what was to become the standard biography of Reynolds (to be completed and published by Tom Taylor in 1865, six years after Leslie's death), France, especially the eighteenth-century France of Reynolds's own lifetime, had become a Victorian symbol of wanton decadence. As if to free the British painter of any accusation of being polluted by his French contemporaries, Leslie offers a round condemnation of the Paris art scene at the time of Reynolds's visit there from 13 August to 6 September 1771. According to this Victorian biographer, Paris was then an offence to art both of the past and present. As for the past, in the Louvre, 'Raphaels and Correggios, Guidos and Rubenses were stacked about the neglected rooms. Such care as there was was worse even than neglect.' As for the present, Leslie assures us that Reynolds would not 'have found much in modern French art to console him for the neglect of earlier and greater times. The mannerism of Vernet, the mingled *minauderie* and indecency of Boucher, the prurient sentimentalism of Greuze, the cold classicality of Pierre and his old friend Doyen, would leave him nothing to envy Paris. Whatever the weakness of nascent English art, it was already a more vigorous tree than that which had its roots in the apartments of the Louvre devoted to the Académie de Peinture.'[6] Clearly, something young, virile and British was being contrasted with something old, feeble and French; and no less clearly, the artifice and eroticism that presumably characterized art under Louis XV and Louis XVI were totally alien to what was assumed to be the inherent integrity and prudery of the national hero who had been the first President of the Royal Academy.

Yet the truth, we are beginning to realize, was quite different, though the art-historical traditions of ignoring or suppressing Reynolds's contacts with France are so strong that his visits to Paris and his friendship with French artists both at home and abroad are often deleted even from modern accounts of his art and life. Repellent as Malone or Leslie might have found Boucher, Reynolds, who always gravitated to the top of social and artistic hierarchies, made certain to establish contact with the French master who, after the death of Carle Van Loo in 1765, had become '*premier peintre du roi*' and Director of the Academy. Indeed, in autumn 1768, just months before the official opening of the Royal Academy in London, Reynolds visited Boucher's

studio in Paris in the company of Edmund Burke's brother, William, and was given as a souvenir a drawing of a young woman with two cherubs, which Reynolds himself was to inscribe 'Given me by Bouchèr. J. Reynolds' (Boston Museum of Fine Arts).[7] And during this trip he troubled as well to seek out other contacts in France, visiting Versailles with Louisa Henrietta Flint (an Englishwoman who lived in France and who, in 1769, would translate Reynolds's first Discourse into French) and dining with a Scotsman who was director of the Gobelins and who represented for Reynolds the kind of ideal international mix that he supported, contrary to the nascent Royal Academy some of whose members argued for the exclusion of foreigners.[8] And it is typical of Reynolds's aspirations *vis-à-vis* the French art establishment that when Carle Van Loo visited London in 1764, the year before his death, Reynolds also paid him a call.

These personal exchanges between Reynolds and the two successive pinnacles of the French Academy in the 1760s were not only professional and social, a token of his hopes to make the Royal Academy join a pan-European community of art, but aesthetic as well. For instance, Reynolds's *Venus Chiding Cupid* (Kenwood) could hardly have been painted without

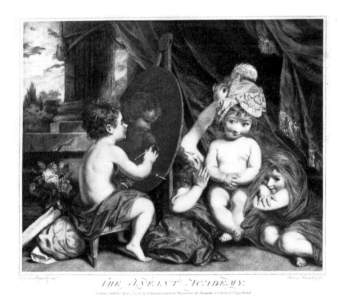

Fig. 27 Francis Haward (after Reynolds, *The Infant Academy*, exhibited 1782), stipple, 1783 (British Museum, London)

Boucher's precedent. The pink tonalities, the cloud-puff environment, the restless delight in sensual, circuitous rhythms are direct adaptations of the French rococo style, just as the subject itself extends Boucher's many narrative variations upon the theme of a mischievous and erotic contretemps between Venus and Cupid. Typically, too, Reynolds treats Boucher's art as a borrowed quotation from a foreign source, in so far as he 'Anglicizes' his subject-matter, depicting Cupid as foolishly puzzling not over erotic matters, but over the difficulties of doing sums with the old British monetary system of pounds, shillings, and pence. And Van Loo's art, too, could later be rephrased and Anglicized by

Reynolds, as in another of his rococo paintings, *The Infant Academy* (exhibited in 1782—fig. 27). The humorous transformation of serious adult activities—the study of architecture and chemistry, of music and dance, of painting and sculpture—into the domain of childhood play was familiar in the work of Boucher (as in the series of decorative panels for the Marquise de Pompadour now at the Frick Collection). But Van Loo's own *Allegory of Painting* of 1753 (fig. 28), again part of a commission for the Marquise de

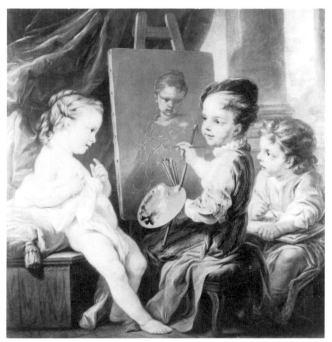

Fig. 28 Carle Van Loo, *Allegory of Painting*, 1753 (Mildred Anna Williams Collection, Fine Arts Museum of San Francisco)

Pompadour, provides an even closer precedent to Reynolds's paraphrase. Once more, Reynolds translates his French rococo sources into a topical London situation; for his cherubic painter, rather than transcribing a naked little girl into a canvas that might perhaps turn out to be a Venus, would metamorphose her, instead, into a fashionable portrait of a modern lady, more hat than mythology. The witty mixture of high seriousness (the classical architecture and statue fragment; the study of the nude) and the true-life facts of the learned artist confronted with the perpetual demand for high-style portraiture, is virtually a comment, couched in French rococo language, on the amusing disparity between the lofty intentions of the Royal Academy and the realities of British patronage and practice. And it was characteristic of Reynolds, too, that rather than finding this disparity a symptom of a tragic alienation between artist and public, as did, say, his fellow academician, James Barry, he could interpret the situation in a humorous, shoulder-shrugging vein that continued such earlier observations on the facts of modern British life *vis-à-vis* the grand tradition of the Old Masters as he had made in his parody of the *School of Athens*.

Reynolds's adaptation of a French rococo mode in which children mirrored adults (even to the whimsical point of

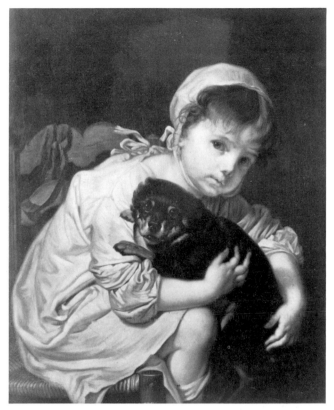

Fig. 29 Jean-Baptiste Greuze, *A Child Playing with a Dog*, exhibited 1769 (Private Collection)

representing Jupiter and Hannibal as cuddly infants) was complemented by his exploration of another emotional vein associated with children, namely their potential for a kind of innocent purity and sweetness that would set them apart from the decadent morality of adults. It is Reynolds's contemporary, Jean-Baptiste Greuze, of course, who is usually identified with this excursion into a domain of sentimentality that seems to set the stage for the nineteenth century's pre-Freudian interpretations of children as secular angels or creatures interchangeable with puppies, kittens, and rabbits. But Reynolds, across the Channel, participated quite as fully in the visual reinforcement of these new cultural myths, to an extent that makes one speculate about the degree to which the two artists exchanged knowledge of each other's work. The conjunction of an adorable infant or child with a no less adorable puppy is familiar enough in Reynolds's portraits, witness that of *The Princess Sophia of Gloucester* (exhibited at the Academy in 1774; Royal Collection) or of *Miss Jane Bowles* (fig. 42); and one wonders whether Reynolds had not been prompted to adapt this winsome formula by Greuze's *Un jeune enfant qui joue avec un chien*, shown at the Salon of 1769 (fig. 29). This kind of childhood innocence was also one that could take on religious overtones of purity of flesh and spirit, so that Reynolds's *Infant Samuel* (exhibited at the Academy in 1776; replica in the Tate Gallery) or his *Age of Innocence* (Cat. 145) are virtually counterparts of Greuze's familiar images of young girls at prayer, of which *La Prière du Matin* (fig. 30) is the best-known example.

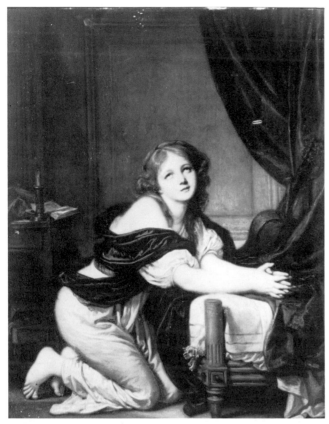

Fig. 30 Jean-Baptiste Greuze, *Morning Prayer, c.* 1775–80
(Musée Fabre, Montpelier)

As the child's sexuality surfaced, this all-too-temporary state of innocence and chastity could easily be lost in the decadent world of prurient adults. Greuze had countless ways of depicting this, as did Reynolds, whose *Cupid as Link Boy* (Cat. 92) begins as a pudgy rococo cherub and is then metamorphosed before our eyes into a bat-winged demon who holds a phallic torch instead of Cupid's bow and arrow. At times, the coincidences between Greuze's and Reynolds's works are so close that we feel that Reynolds, like most educated Europeans in the 1770s and 1780s, kept in constant touch with Greuze's prolific production of paintings and engravings. For instance, Reynolds's *Lesbia, or the Dead Sparrow* (1788; Burton Collection, London) is a reprise of a famous Greuze from the Salon of 1765, *Une jeune fille qui pleure son oiseau* (National Galleries of Scotland, Edinburgh), which also offers the erudite and titillating combination of a reference to Catullus's famous poem and a metaphor of a young girl who, in the guise of her pet bird's death, is mourning her prematurely lost virginity.

On many levels of the interpretation of children and family life, Greuze's new icons of childhood and maternity correspond with Reynolds's own new visions. The image of the joys of maternity and of breast-feeding, in part a product of Rousseau's recommendations to return to more primal roots of natural experience, is mirrored in both artists' work. One of Reynolds's best-known portraits, *Lady Cockburn and Her Three Eldest Sons* (National Gallery, London; see

Cat. 88), may reflect, as Edgar Wind once observed, such Christian icons of maternal love as the theme of Charity, in images transmitted from Michelangelo down to Van Dyck.[9] But it is also an idea that should be seen in the context of the visual manifestations of the later eighteenth century's new ideas about maternity, such as Greuze's own many themes and variations upon 'La Mère Bien-Aimée'. This can be found within a milieu no less aristocratic than that of Lady Cockburn, the home of the Comte de Laborde in Greuze's painting of 1769 (fig. 31), where the Comtesse is also seen overwhelmed, from head to waist, by her cherubic children, the modern variations of the putti and angels that accompanied Venus or the Virgin Mary.

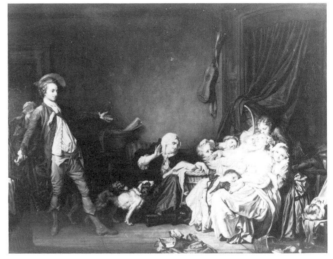

Fig. 31 Jean-Baptiste Greuze, *La Mère bien aimée,* 1769
(Comte de Laborde, Madrid)

To the list of Boucher, Van Loo, and Greuze, another of Reynolds's French contemporaries, Joseph-Marie Vien, should be added, especially as a Continental wind blowing in the direction of a modish classicizing inflection in the 1760s. In that decade in particular, Reynolds appears to have turned often to Vien's fashionable new images of attenuated young women who, dressed in vaguely classical draperies, go about their antique chores of adorning vases and statues or offering sacrifices on altars. Already in the ambitious portrait of *Lady Elizabeth Keppel,* shown at the Society of Artists in 1762 (Cat. 44), Reynolds has helped to elevate his subject (who is depicted in her already socially elevated role as a bridesmaid at the marriage of Queen Charlotte in 1761) by having her decorate with a garland of flowers a statue of Hymen incribed with verses from Catullus's *Hymenaeus,* an appropriate classical reference for this modern event. And in his even loftier portrait shown at the Society of Artists in 1765, *Lady Sarah Bunbury Sacrificing to the Graces* (Cat. 57), this kind of learned, antique conceit, which would render the predictable high moments in the life of a young socialite in a classical guise, was further elaborated. In the cases of both these transformations, at once ambitious and light-hearted, of fashionable portraiture into antique allegory,

Vien seems to have shown the way with his Salon paintings of 1761 and 1763, which featured such comparable motifs as, in 1761, *Jeune Grecque ornant un vase de bronze avec une guirlande de fleurs* and, in 1763, *Offrande présentée dans le temple de Vénus* (fig. 32) and *Une prêtresse brûle de l'encens sur un trépied*.[10] These paintings, all immediately engraved, established a feminine mode of mock classical ritual in which attenuated, statuesque women, single or accompanied, enact a not very taxing charade involving flowers or incense. Reynolds's grand portraits of Lady Elizabeth Keppel and Lady Sarah Bunbury are so close to this French mode (which would also include Van Loo's *Offrande à l'Amour* at the Salon of 1761 [Hartford, Wadsworth Atheneum]) that again, even in the inclusion of the French neo-classical tripod, the so-called 'Athénienne', we feel that Reynolds must have been constantly alert to the news from the Paris Salons. Indeed, many of the artist's most important sitters in the early 1760s—the Fox and Lennox families, George Selwyn and Lady Sarah Bunbury herself, for example—paid frequent visits to Paris and eagerly reported and imported its fashions, as is amply testified by their correspondence.

Vien's inventions seem to lie behind even the most ambitious of Reynolds's later efforts in this mock-serious

domain of classical antiquity cross-bred with high society, his portrait of *The Three Montgomery Sisters: 'Three Ladies Adorning a Term of Hymen'* (Cat. 90). In earlier discussions of this painting by Wittkower[11] and Gombrich,[12] it is Poussin who provided the iconographic and compositional support for this cheerful performance in which Lady Keppel's earlier hymeneal ritual is much complicated by the presence of three beautiful sisters who, as a verbal counterpart to Reynolds's pictorial allusions to antiquity, were referred to in their own time as 'The Irish Graces'. Marriage is again on their minds, for Elizabeth, the beauty in the centre, is to be married to Luke Gardiner, who, in fact, commissioned this grandiose and erudite, yet graceful and smiling image

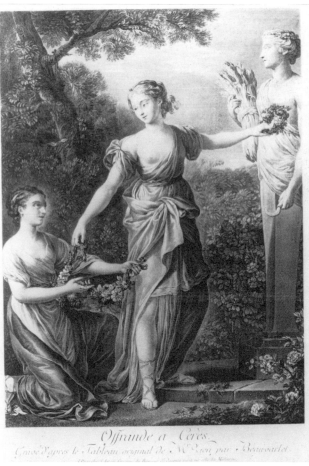

Fig. 33 Beauvarlet (after Joseph-Marie Vien, *Sacrifice to Ceres*), line engraving (Bibliothèque Nationale, Paris)

of sisterly harmony and modern betrothal customs. But this intricate rhythm of the balletic ascent of elegantly poised women and intertwining garlands recalls not so much Poussin, but rather an earlier painting by Vien, *Proserpine ornant la statue de Cérès sa mère avec des fleurs qu'elle et ses compagnons viennent de cueillir, Pluton en devient amoureux*, first exhibited at the Salon of 1757 (Grenoble, Musée des Beaux Arts), then made into a Gobelins tapestry, and then re-exhibited at the Salon of 1763 perhaps in a variant form without the stormy

Fig. 32 Beauvarlet (after Joseph-Marie Vien, *Sacrifice to Venus*), line engraving (Bibliothèque Nationale, Paris)

episode of Pluto's abduction (fig. 33). Although there may well be a common seventeenth-century source for both Vien's and Reynolds's paintings, the analogies between the two trios of classicizing ladies adorning statues suggest once more that, as usual, Reynolds was *au courant* with everything happening at the Paris Salons, which, after all, offered the obvious model for emulation by the Royal Academy.

Such an interchange with contemporary French painting is further supported in other kinds of allegorical portraiture explored by Reynolds. To be sure, the representation of contemporary men and women in the guise of mythological personages goes back to antiquiy, as any Roman ruler would know, and it also had a rich Renaissance afterlife, as in Bronzino's portrait of Andrea Doria as Neptune; but in eighteenth-century France this tradition was revitalized, especially in the rendering of women, often famous actresses, playing some classical role. Did Reynolds's ideas for this hybrid genre, which would virtually become identified with his name in histories of British painting, have Parisian roots? It is perhaps revealing that one of his first tentative efforts in this mode, the awkward portrait of *Lady Anne Dawson as Diana* (fig. 13), dates from just after his first visit to Paris in 1752, and his later and more successful ventures into this domain of role-playing (so consonant with Reynolds's own eclectic spirit as stage director of a multitude of dramas, both tragic and comic) mirror a wide range of French prototypes. In only two of countless mid-eighteenth-century French examples, Jean-Marc Nattier's portraits of *The Duchesse de*

Chaulnes as Hebe (Salon of 1745; fig. 34) and *The Duc de Chaulnes as Hercules* (Salon of 1747; Louvre, Paris), we already have previews of Reynolds's allegorical portraits, whether we think of David Garrick playing Hercules or the later portrait of Mrs Musters in the role of Hebe (fig. 35),

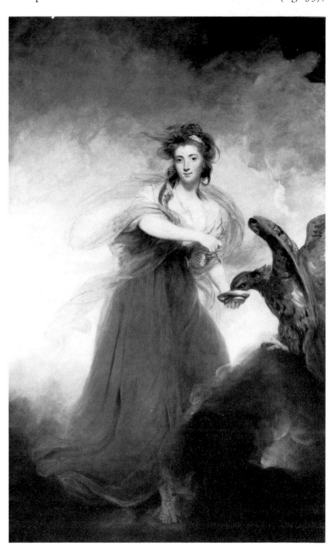

Fig. 35 Mrs Musters as Hebe, exhibited 1785
(The Iveagh Bequest, Kenwood House, GLC)

who, like Nattier's duchess, reigns above us with an Olympian hauteur. And when Reynolds painted famous London actresses and courtesans in allegorical guises, such as *Miss Kitty Fisher in the Character of Cleopatra* (Cat. 34), could Van Loo's example, as in his renderings of *Madame Clairon as Medea* (fig. 36) at the Salon of 1759, have prompted the perfect choice of the kind of sitter who would fit most comfortably into this theatrical masking of the demands of empirical portraiture with an external layer of classical universality? In the case of what is probably Reynolds's most famous allegorical portrait of an actress, *Mrs Siddons as the Tragic Muse* (Cat. 134), an eighteenth-century French prototype is again at hand. To be sure, Reynolds meant to allude

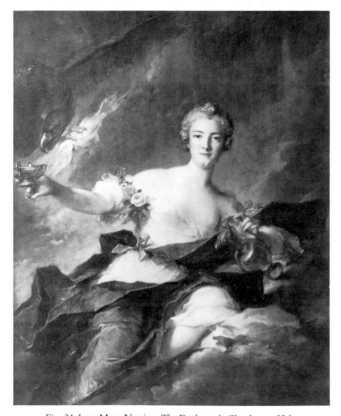

Fig. 34 Jean-Marc Nattier, *The Duchesse de Chaulnes as Hebe*,
exhibited 1745 (Musée du Louvre, Paris)

Fig. 36 Carle Van Loo, *Madame Clairon as Medea*,
exhibited 1759 (Potsdam)

in Mrs Siddons's posture to the figures of the prophets
Jeremiah and Isaiah as a homage to Michelangelo's imagery
of tragic grandeur; but the closest parallel to Mrs Siddons's
portrait is, in fact, a painting he must have seen at the Salon
of 1771 during his three-week, late-summer sojourn in Paris
that year, François-Hubert Drouais's portrait of *Madame Du
Barry as a Muse* (fig. 37). The haughty, enthroned posture
of Mme Du Barry playing this classical role is, like
Reynolds's vision of Mrs Siddons, a witty exercise in theat-
rical staging, and apparently was imprinted in Reyolds's pro-
digious visual memory for later use.

Nevertheless, *Mrs Siddons* borrows a Michelangelesque *ter-
ribilità* which, if totally alien to Drouais's rococo world, is
fully compatible with Reynolds's own growing exploration
in the 1780s of themes of high drama and terror. Of these,
the *Infant Hercules* (Cat. 140) is the most elaborate, and it,
too, fits into an international constellation that ranges here
from St Petersburg to Paris. A response to a commission of
1786 by one of the most prescient and enthusiastic patrons
of late eighteenth-century British painting, Catherine the
Great, the *Infant Hercules* characteristically translates a classi-
cal subject into topical Anglo-Russian terms.[13] The myth
of the young Hercules is meant to be read as a flattering alle-
gory of the prowess of the young Russian Empire within
a pan-European context. Moreover, the aged soothsayer
Tiresias on the left introduces, like the appearance of George
White in Reynolds's Correggesque *Nativity*, a posthumous
portrait of Dr Johnson himself, who, now bearded for this
classical Greek performance, strikes the same attitude of antic
gesticulation recorded in Reynolds's earlier portrait of John-
son of 1769 (Cat. 73), as if he were conjuring up here a proph-
ecy about the great future of this burgeoning Eastern empire.

As for Paris, Reynolds's choice of the legend of the infant
Hercules may reflect, in addition to his familiar taste for the
rendering of children in mock-heroic poses, a recent French
prototype. This subject, whose interest for the later
eighteenth-century was furthered by its appearance in a
resurrected Pompeian fresco at the House of the Vettii, had
already been essayed by Reynolds's contemporary, Jean-

Fig. 37 Françcois Hubert Drouais, *Madame Du Barry as a Muse*,
exhibited 1771 (Musée de Versailles)

Hugues Taraval. He first exhibited it as a painted sketch at
the Salon of 1767 (fig. 38) and then as a large and somewhat
altered painting, commissioned for Louis XVI, at the Salon
of 1785 (Louvre, Paris).[14] Given what appears to be
Reynolds's eagerness to learn about current events on the
other side of the Channel, it is likely that the French version
did not escape his notice. In any case, Taraval's successive
depictions of this subject provide the kind of stressful display
of theatrical gestures of horror and surprise which Reynolds
in turn would orchestrate into a more fearful symphony of
ominous smoke and shadow. But this venture into the
Romantic territory of the Sublime is countered by the puck-
ish and cuddly infant Hercules and the cowering and lovable
spaniel, who suddenly make light of the stormy drama and
thrust us into what resembles an aristocratic British nursery
where babies and puppies frolic together. This see-sawing
from darker, more disturbing territories to a more familiar,
emotionally balanced world of reason, wit, and grace was
typical of Reynolds's equivocal position between an earlier,
more smiling eighteenth-century generation and a later more
irrational breed (generally born *c.* 1740) that would
unbalance this precarious poise.[15]

Fig. 38 Jean Hughes Taraval, *The Infant Hercules*, exhibited 1767
(Musée Municipal, Châlons-sur-Marne)

It is telling that in Reynolds's own country the Anglo-Swiss artist, Henry Fuseli, a member of this later generation and an artist of vast consequence for the international history of Romanticism, often echoed Reynolds's choice of themes. Both artists depicted, for instance, the Death of Dido, the Death of Cardinal Beaufort, Macbeth and the Witches, Puck, Ugolino; but by contrast, Reynolds again appears to be the stage-director who never himself fully penetrates, as does Fuseli's generation, this hallucinatory region of demons and ghosts, of uncommon fear and suffering, where common sense has been left far behind with the thinkers of the Enlightenment. Still, Reynolds's own work must be included in any international study of the origins of Romanticism, for it touches upon a multitude of fresh questions posed in the late eighteenth century, whether the new interpretation of children or of people from places as exotic as Tahiti and China, the new multiplicity of styles that characterizes the work of many later artists from West and David to Turner and Ingres, or the new investigation of non-classical literary sources, such as Shakespeare and Dante. As for the latter, Reynolds's role as a pioneer of Romanticism would be assured if only for his astonishingly precocious depiction of the gruesome tale of incarceration, starvation, and cannibalism, *Count Hugolino* (Cat. 82), which, typically for his almost impersonal flexibility in switching from one emotion and style to another, he could exhibit at the Royal Academy in 1773 with an exercise in childish sweetness and charm, *The Strawberry Girl* (Wallace Collection, London). Known, like most of Reynolds's work, through prints that quickly reached the Continent, *Hugolino* was the very first example in the later eighteenth century of that harrowing subject from Dante that would later haunt French artists down to the time of Carpeaux and Rodin. Reynolds himself must have been aware of the importance of *Hugolino*, for he sent a print after it to Etienne-Maurice Falconet in Paris, in gratitude for the sculptor's gift to him of a plaster version of his allegory, *L'Hiver*, exhibited at the Salon of 1765; and

Falconet, in turn, was sufficiently impressed by the originality of *Hugolino* to discuss it in his own writings.[16] Soon after Reynolds's death, the young Davidian, Antoine-Jean Gros, copied a print after the *Hugolino* in the sketchbooks (fig. 39) preserved in the Louvre, *c*. 1793–6.[17] Another Davidian, Fortuné Dufau, amplified this inspiration in what was to be the first painting of this subject in a Paris Salon, that of 1800 (Valence, Musée des Beaux-Arts), a good twenty-seven years after its London début.[18]

Even in the domain of portraiture, Reynolds often offers strange glimmers of disturbing emotional undercurrents that, we feel, already create chinks in the armour of reason and detachment so typical of the artist and his generation. One particularly potent example is *Lady Charles Spencer in a Riding Habit* (Cat. 96), in which the decorum and aloofness of most of Reynolds's female portraits of the aristocracy are shattered in favour of a startling confrontation not only with Lady Spencer's own windswept and turbulent expression but with the almost equal intensity of her lone companion, the horse that stares out at us, too, almost as in a double portrait. In its sudden, close-up empathy with both human and equine passions at the same fever pitch, *Lady Spencer* takes a remark-

Fig. 39 Antoine-Jean Gros, *Sketch of Hugolino*. *c*. 1793–6
(Cabinet des Dessins, Musée du Louvre)

able position at the beginning of a long line of Romantic portraiture that leads across the Channel into territory familiar to us through Géricault. More particularly, though, one wonders whether one of the most precocious of French Romantic portraits, Prud'hon's haunting double portrait of the postmaster Georges Antony and his horse (fig. 40) was not directly inspired by Reynolds's earlier example of an equestrian portrait that explores together the psychology of man and beast.[19]

But Reynolds's shadow must have been cast far beyond

the Romantics, for on both sides of the Channel and the Atlantic, every nineteenth-century artist was certainly aware of his pre-eminent role as the leading British master of the eighteenth century and the one who wanted to elevate painting to the international level of the 'Grand Style'. We know, for instance, that the eminent German master, Hans von Marées, read the *Discourses* and was specifically influenced by them in his own efforts to incorporate learned references in his painting;[20] but on even more surprising levels, Reynolds may make later appearances on the Continent, as he was so often to do in the history of nineteenth-century British painting. One wonders, for example, whether Manet

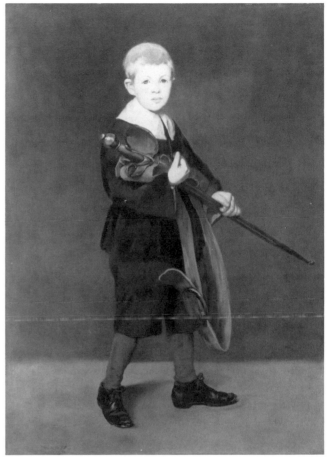

Fig. 41 Edouard Manet, *Boy with a Sword*, 1861
(Metropolitan Museum of Art, New York)

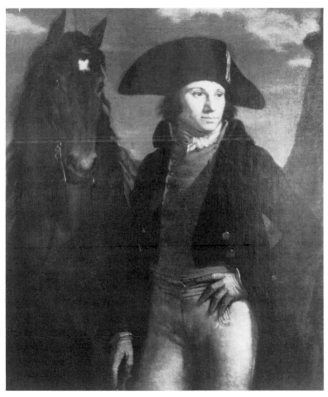

Fig. 40 Pierre-Paul Prud'hon, *Georges Antony*
(Musée des Beaux-Arts, Dijon)

himself was not attracted to Reynolds's idea of portraiture as a kind of mock costume-drama and of the use of the venerable art of the museums in a parodistic way. Indeed, it was a member of Manet's circle, Ernest Chesneau, who was not only the first to recognize Manet's Renaissance allusions in the *Déjeuner sur l'herbe* but who was preparing at the same time his history of recent English and French painting (*L'Art et les artistes modernes en France et en Angleterre*, Paris 1864) in which Reynolds received prominent and favourable treatment. Is Manet's *Boy with a Sword* (fig. 41) not a descendant of Reynolds's *Master Crewe as Henry VIII* (Cat. 97)? Is the spirit of *Olympia* not in part understandable in the tradition of Reynolds's own satirical shifting back and forth between the prosaic truths of the present and the distant poetry of masterpieces of painting from another, lost era? That we may

even ask such questions is a tribute to the fact that, as Gainsborough recognized, Reynolds was endlessly vexing in his prodigious variety and could be interpreted in countless ways. And it is also a reminder that it is high time to think of Reynolds himself not only as an aloof father-figure in the history of British painting, but as a master who still needs to be integrated into the international history of modern art.

NOTES

1. Panofsky 1930.
2. Panofsky 1936.
3. On this hoax see Pelzel 1972.
4. Much of the material offered here on Reynolds and contemporary French painting was originally presented as an unpublished lecture in Paris ('Reynolds et ses contemporains français', delivered at the Assemblée Générale of the Societé de l'Histoire de l'Art Français on 7 May 1983) and in New York ('Reynolds and the French Connection', delivered at the Annual Meeting of the College Art Association on 25 February 1982).
5. Malone in Reynolds 1798, I, pp. cii–civ.
6. Leslie and Taylor 1865, I, pp. 414–15.
7. On this drawing, which is often mistakenly considered a souvenir of Reynolds's visit to Paris in 1752 rather than in 1768, see Slatkin 1973.
8. On these contacts see Hilles 1936, pp. 36–7, 270–1.
9. Wind 1938.

10. For the most recent accounts of Vien's paintings of antique rituals and the prints made after them by Beauvarlet and Flipart see Hôtel de la Monnaie 1984, pp. 411–13, 489–90, 508–9.

11. See Saxl and Wittkower 1948, no. 64.

12. See Gombrich 1942.

13. For the most informative account of the *Infant Hercules* and of many other paintings by Reynolds see Tinker 1938, Chapter III.

14. For the most recent account of Taraval's versions of the *Infant Hercules* see Hôtel de la Monnaie 1984, pp. 356–8.

15. For a short account of the British contribution to the origins of Romantic painting, including that of Reynolds, see Rosenblum 1971.

16. For the most recent account of Falconet's relations with Reynolds see

Anne Betty Weinshenker, *Falconet: His Writings and His Friend Diderot*, Geneva 1966, p. 15. The print must have been sent between 1774 and 1781 (when it is discussed in Falconet's *Œuvres*, II, pp. 271–2). Falconet's own son, Pierre-Etienne, studied painting with Reynolds in 1766 and exhibited portraits, at the exhibition of 1773 which included *Hugolino*.

17. On these copies after Reynolds and other English artists see Joannides 1975.

18. On the Dufau see Rosenblum 1968.

19. The importance of *Lady Spencer* as a prototype for French and German Romantic portraits, including Prud'hon's *Georges Antony*, has been suggested by Becker 1971, p. 39.

20. See Ettlinger 1972.

'All Good Pictures Crack'

Sir Joshua Reynolds's practice and studio

M. Kirby Talley, Jr

Impermanence: fading, flaking and cracking

Sir Joshua Reynolds was the most eclectic of technicians, including Leonardo, to put brush to canvas. His persistence in following practices which he knew perfectly well would seriously shorten the life of his pictures can only be described as perverse. The fleeting quality of his colours was common knowledge among his contemporaries, who were often openly critical. J. T. Smith in his *Life of Nollekens* recounts an amusing anecdote regarding Charles, 6th Earl of Drogheda, who sat to Reynolds in 1761. Shortly afterwards, the Earl went abroad where he remained almost thirty years, apparently debauching himself since he 'became bilious, and returned to Ireland with a shattered constitution. He found that the portrait and the original had faded together, and corresponded, perhaps, as well as when first painted.'[1] While the Earl of Drogheda may have accepted his faded portrait in a philosophical vein, another of Reynolds's sitters, Sir Walter Blackett, assuredly did not. Blackett, who sat to Reynolds in 1766–9, lived to a great age and saw his portrait fade away. Indignant, he penned the following epigram:

> Painting of old was surely well designed
> To keep the features of the dead in mind,
> But this great rascal has reversed the plan,
> And made his pictures die before the man.[2]

Horace Walpole, after attending the Academy dinner at the time of the 1775 Exhibition, acknowledged that 'Sir Joshua Reynolds is a great painter; but unfortunately, his colours seldom stand longer than crayons'.[3] (A curious comparison if pastels are the 'crayons' he mentions since, if well kept, they do not fade at all.) In another letter Walpole suggested that Reynolds should be 'paid in annuities only for so long as his pictures last'.[4] Reynolds himself was capable of joking about the problem,[5] but it surely had a negative effect on his business. Mr and Mrs Bowles were determined to have their daughter Jane portrayed by Romney until Sir George Beaumont managed to change their minds 'But his pictures fade,' charged the parents. Beaumont countered, 'No matter, take the chance; even a faded picture from Reynolds will be the finest thing you can have.' The portrait, probably of 1775, is now in the Wallace Collection (fig. 42) and is in good condition, if faded—and cracked in parts.[6]

Fading was not the only technical problem with

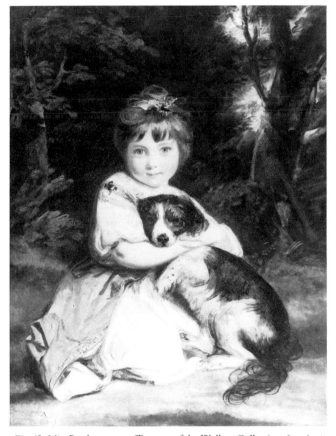

Fig. 42 Miss Bowles, c. 1775 (Trustees of the Wallace Collection, London)

Reynolds's pictures. He had a passion for using a wide variety of media. Indiscriminate use of concoctions made of varnish, Venice turpentine, wax, eggs, and other miscellaneous ingredients had dire consequences for the structural adhesion of various layers of paint to one another and, in combination, to the support. Northcote relates an unhappy accident which occurred when John Powell, one of Sir Joshua's assistants, was bringing a picture back to the studio after copying it at his home. On the street a young man gesticulating with his stick 'struck the picture, when a large part of the face and hand of the painting dropped from the canvas, to the utter astonishment and dismay of poor Powell, who was totally unable to repair the damage.'[7] Charles Robert Leslie

had no difficulty believing the truth of this story since he had seen many pictures by Reynolds demonstrate the same phenomenon after relining. The poor adhesion of paint to support was attributed by Leslie to the rapid drying of his impasto primarily composed of wax and Venice turpentine.[8] Despite the seriousness of this structural defect, Reynolds seemed to have been fairly phlegmatic when confronted with occurrences of paint falling off his canvases. In a letter dated 24 September 1784 to the Duke of Rutland regarding his painting of *The Nativity* (fig. 26, exhibited at the Royal Academy in 1779) Reynolds wrote, 'the falling off of the colour must be occasioned by the shaking in the carriage, but as it now is in a state of rest, it will remain as it is for ever; what it wants, I will next year go on purpose to mend it.'[9]

Leslie postulated that Reynolds's fascination with nostrums stemmed from his father's interest in pharmacy, and it is certainly significant that amateur chemical experiments were a common recreation in this period, shared even by Samuel Johnson. This, however, is hardly an adequate explanation. Reynolds himself remarked 'I had not an opportunity of being early initiated in the principles of *colouring*: no man indeed could teach me. If I have never been settled with respect to colouring, let it at the same time be remembered that my unsteadiness in this respect proceeded from an inordinate desire to possess every kind of excellence that I saw in the works of others.'[10] What proved fatal was the impatient emulation of the effects, rather than the careful imitation of the methods, of the Old Masters—as Haydon, who had access to the artist's notes, lamented.[11]

The man who taught Reynolds his craft (even if he did not 'initiate him in the principles of *colouring*') was Thomas Hudson (1701–79),[12] pupil and son-in-law of Jonathan Richardson the Elder, and one of the most successful portrait painters in London after the death of Sir Godfrey Kneller in 1723.[13] Although Hogarth's second St Martin's Lane Academy was in existence by 1735, it only supplied a supplementary education. From Hudson, Reynolds undoubtedly learned the standard studio practice of portrait painters, including the use of drapery painters, which was current in England from Van Dyck up to the time Reynolds was a pupil.[14] An excellent summation of eighteenth-century technical practices was given by Thomas Bardwell (1704–67) in his *Practice of Painting and Perspective Made Easy* published in 1756. The actual technique as described by Bardwell would have been in general the technique employed by Hudson: it is a sound practice geared for the type of repetitive work involved in churning out portraits.[15] Such training enabled Reynolds to set up as a young, competent portraitist, in Devonshire and in London, and among the pictures painted in the period 1743–9 will be found none of the problems noticeable in works created after his sojourn in Italy.

The secrets of the Old Masters

On his return to England Reynolds's usual method was first to prepare his composition in dead-colour, that is in a cool monochrome underpainting, and then to add glazes and scumbles—an ideal technique so long as the materials used are sound. His notes made in Italy make clear that this was suggested by the Old Masters he studied there. In a typical memorandum he noted that 'The Leda, in the Colonna Palace, by Corregio, is dead coloured white, and black or ultramarine in the shadows; and over that is scumbled, thinly and smooth a warmer tint, I believe caput mortuum. The lights are mellow, the shadows bluish, but mellow.'[16] And on Titian's *Venus and Adonis*, also in the Colonna Palace (and today in the National Gallery, London), of which he made a copy, he wrote that it was 'dead coloured white, with the muscles marked bold: the second painting, he scumbled a light colour over it: the lights a mellow flesh colour; the shadows in the light parts of a faint purple hue; at least they were so at first. That purple hue seems to be occasioned by blackish shadows under, and the colour scumbled over them.'[17] Only five colours were used for this copy and there was no yellow among them. A short notation reads, 'Dead colour and white and black only; at the second sitting, carnation. (To wit, the Barocci in the palace Albani, and Corregio in the Pamphili.)'[18]

During his stay in Rome, Reynolds avoided as much as possible the practice of making copies of pictures for the English milords to take home with them as souvenirs. Many young artists sought such employment in order to supplement their meagre incomes. Years after his visit, Reynolds was to advise Barry, who was then in Rome, to avoid this type of copying as a waste of time. According to Northcote, Reynolds only copied 'when he desired to possess himself of some peculiar excellence which another possessed before him'.[19] Apparently, he also made studies after pictures, especially by Raphael, in order 'to assist him in his future practice, even in portrait, in respect to simplicity, dignity, character, expression, and drawing'.[20] Quite often he only copied those parts of a picture he especially admired. Several entries made in his Roman sketchbook made it quite clear that Reynolds worked at a great tempo when copying. In April 1750 he was busy in the Corsini Palace where he copied pictures after Rubens, Titian and Rembrandt. Three days were spent on Titian's *Portrait of Philip II* and one day on Rembrandt's *Self-portrait*. On 30 May he began copying Guido Reni's *St Michael the Archangel Chaining the Dragon* which is in the Chiesa dei Capuccini. By 10 June he was finished, which is quick work indeed. This copy graced the ceiling of Reynolds's picture gallery, and after his death passed to his niece, Mary, Marchioness of Thomond, who in 1818 gave it to George IV.[21]

Contact with paintings by the Italian Old Masters did not cease when Reynolds returned to London. Indeed, as he began to prosper he was able to buy such paintings and submit them to still closer examination. Northcote recalled that his investigations were indefatigable—'I remember once, in particular, a fine picture of Parmegiano, that I bought by his order at a sale, which he rubbed and scoured down to the very pannel on which it had been painted, so that at last nothing remained of the picture.'[22] Malone also described this expensive form of research, and Reynolds himself told Sir Abraham Hume that he ruined a Watteau in his attempts

to discover the technique used. The Redgraves claimed to have known a restorer, formerly a pupil of West, 'who possessed portraits by both Titian and Rubens which he said had belonged to Sir Joshua, and parts of which, to obtain this wished-for secret, had been scraped or rubbed down to the panel, to lay bare the under-paintings or dead colourings'.[23]

While Reynolds did not conceal these doings to people outside his studio, he was secretive with his pupils and assistants. One day a young painter showed Reynolds a picture which had been painted with a concoction of wax and various varnishes. After he left Reynolds remarked, 'That boy will never do any good, if they do not take away from him all his gallipots of varnish and foolish mixtures.' Northcote said that Reynolds never allowed him to use anything other than pigments supplied by the colourman. Varnishes and experiments were not tolerated and everything used by Reynolds was kept out of sight and under lock and key.[24] This is a clear indication that Reynolds realized the danger of his experiments. It may also explain why he wrote many of his technical memoranda in Italian, although this could have been done for Marchi who, it seems, had access to his master's secrets.

The studio: assistants, drapery painters and pupils

In 1753, after Reynolds's return to England and when he had established himself in London, the first member of his studio was Giuseppe Marchi whom he had brought back with him from Rome. Northcote describes Marchi at this time as 'pupil': so presumably Sir Joshua first had to train him. Except for a brief interlude in Wales in 1768 and 1769, when Marchi unsuccessfully attempted to establish himself as an independent portraitist, he stayed with Reynolds during his entire career.

Among leading portrait painters in England only Hogarth seems not to have made use of drapery painters, and he, significantly, deliberately avoided becoming a portrait specialist. In Reynolds's early years a vast practice was enjoyed by Joseph van Aken (c. 1699–1749) who was employed by all successful portraitists. It was even alleged that canvases painted only with 'masks' were sent to him 'by the stage coaches from the most remote towns in England'.[25] Reynolds, of course, was trained by Hudson who was one of Van Aken's best clients, and so would have been fully familiar with this sort of delegation of labour.

During the period he was training Marchi, Reynolds probably employed George Roth who worked for Hudson after Van Aken's death.[26] By 1755 Reynolds used the services of Peter Toms. Edward Edwards even claimed that 'many of Sir Joshua's best whole-lengths are those, to which Toms painted the draperies'. He specifically cited the portrait of *Lady Elizabeth Keppel* at Woburn (the engraving is Cat. 44) as an example. If Edwards is to be believed, Toms, whose normal price for painting the drapery, hands, and other accessories for full-lengths was twenty guineas, was only given twelve by Sir Joshua for the Keppel portrait.[27] By 1760

Reynolds had his first pupil, Thomas Beach (1738–1806), and as the pressures of a successful business increased he took on other assistants. Farington in his *Memoirs of the Life of Sir Joshua Reynolds* said that Reynolds's 'school . . . resembled a manufactory, in which the young men who were sent to him for tuition were chiefly occupied in copying portraits, or assisting in draperies, and preparing backgrounds'.[28]

Northcote, who entered the studio in 1771 and stayed there until 1776, gives the best idea of what it was like to be a student-assistant. In a letter dated May 1771 he wrote to his brother Samuel that he worked until evening when he went out for a walk. A few months later he wrote that 'Sir Joshua gives the most instruction when it is drawn from him by questions'.[29] From this it is obvious that Reynolds's primary concern in having students was not to teach them but to keep the assembly line moving. He also apparently did not like his pupils, some of whom lived in, being disturbed by visitors. Later in life Northcote was to complain that most of his time was spent copying pictures or painting draperies. Whenever he could, he attempted to steal some time to paint heads after the life, but there was little opportunity for this. Reynolds paid Northcote a hundred guineas with board per annum, which he felt was not over-generous.[30]

If everything was not completely to Northcote's liking, he did learn the trade of portrait painting. On 8 April 1772 he wrote to his brother that he was at work on the drapery to a *Mr Calthorp*. 'This is the first I have ever painted from the layman and I am much afraid how I shall do it. I am to paint him in a blue coat with a glove on one hand and his hat in the other, with a yellow curtain behind. I should have painted it a red curtain but the damask is lost which the curtain used to be painted from. I shall make part of a building appear behind the curtains and a landscape in the background.'[31] In November 1772 he painted the drapery for a whole-length portrait of the *Duke of Cumberland* and for the portraits of *James Beattie* and of *Robinson, Archbishop of Armagh*, whilst for the portrait of *Miss Sarah Child*, shown at the Academy in 1773, he 'did the cage from the real cage, and some very large weeds at her feet'.[32] Other than doing the drapery and accessories, Northcote was also employed in turning out copies of subject pictures, among them *The Infant Jupiter* (Cat. 84) shown at the Academy in 1774, for which he well remembered preparing 'a ground-work on black and white'.[33] What is not clear is whether an assistant would have prepared the underpainting of an original work. Such was certainly the practice in the studio of many earlier artists, but the assistants there would have had the drawings and perhaps an oil-sketch by the master to guide them, whilst Reynolds, it seems, seldom made preparatory works of this sort. The chief work of the assistants Reynolds employed was to paint drapery and other accessories. Northcote on one occasion conceded that 'the whole together of the picture, was at last his own, as the imitation of particular stuffs is not the work of genius, but is to be acquired easily by practice, and this was what his pupils could do by care and time more than he himself chose to bestow; but his own slight and masterly work was still the best'.[34]

Despite frequent assertions to the contrary, there is good reason to suppose that Reynolds did paint or at least finish draperies in many of his portraits, but the still-life accessories may reasonably be supposed to have almost always been the work of assistants. Landscape is more of a problem. The boldness with which it is often painted suggests his own hand, but on the relatively rare occasions when topographical features were requested it is probable that he depended upon others to execute them as well as to supply models. In this respect it is interesting to find in the pocket-book for 1769 the memorandum 'Tomkins Landscape Pr./ in Margret Street/ Cavendish Square/ Ld. Delawarr's Lodge/ in the New Forest'.[35] This might mean that William Tomkins, a landscape painter and picture restorer, was to paint this feature in the background of Lady Delawarr's portrait.

With the exception of Northcote, none of Reynolds's scholars distinguished themselves as painters. Several of them died young or in unfortunate circumstances. Charles Gill (fl. 1769–c. 1828), who was with Reynolds between 1771 and 1774, placed an advertisement in the *Bath Chronicle* in 1787 in which he stated, 'It has been reported that he is mad (Gill himself); this villany is calculated to abuse him or his paintings'. William Doughty (1757–82) studied with Reynolds between 1775 and 1778. Probably the best of all Reynolds's students, his early death in Lisbon cut his promise short.[36] While Northcote frequently informs us as to Sir Joshua's generosity in lending pictures from his collection to young artists, and to his willingness to answer their questions and give advice, he also stresses that as far as his own pupil-assistants were concerned, 'he gave himself not the least trouble about them or their fate'.[37] It is clear that Northcote had very mixed feelings regarding his master. He admitted that he was himself treated kindly and with concern by Sir Joshua after he left the house in Leicester Fields.

Sizes of portraits and prices

In Reynolds's day there were five standard sizes of portraits available to the client:

1) Head, $24\frac{1}{2}$ in × $18\frac{1}{2}$ in in 1764, but changed to 24 in × 25 in in 1782;
2) Bust, called the 'Three-quarter' because it measured $\frac{3}{4}$ yd, including one or both hands, 30 in × 25 in;
3) Kit-cat, or head and shoulders with one or both hands, 36 in × 28 in;
4) Half-length, 50 in × 40 in;
5) Whole-length, 94 in × 58 in.

Colourmen provided canvases in these standard sizes beginning with the Three-quarter (no price given); Kit-cat at 2s. 6d.; Half-length at 5s.; Whole-length at £1. 2s. Another size, the Bishop's Half-length, 56 in × 45 in, used to portray the seated figure below the knees, cost 8s. Larger sizes were made on order. Before his trip to Italy Reynolds charged modest prices. When he returned to London his prices were the same as those charged by his competitors. Over the years they increased more or less as follows, leaving all rivals far behind after the mid-1760s.[38]

	Head	Bust or $\frac{3}{4}$	Kit-cat	Half-length	Whole-length
1742–8	3 guineas				
1753–5	12 ,,			24 guineas	48 guineas
1757	15 ,,			30 ,,	60 ,,
1758/9	20 ,,	20 guineas	30 guineas	50 ,,	100 ,,
1760	25 ,,			50 ,,	100 ,,
1764	30 ,,	35 ,,	50 ,,	70 ,,	150 ,,
1765–81	35 ,,	35 ,,	50 ,,	70 ,,	150 ,,
1782–91	50 ,,	50 ,,	100 ,,	100 ,,	200 ,,

There were, of course, many exceptions to the prices tabulated above. Prices would seem to have been negotiated not only for group portraits but for subordinate figures (such as black page boys) and sometimes for children—but not apparently for pets, although both dogs and horses do have separate appointments in his pocket-books. The fancy subjects and history paintings were usually painted, and even repeated, without commission, and this seems to have been the case with a few portraits as well. In one or two instances Reynolds gave portraits away to the sitter—the portrait of *Mrs Abington as Roxalana* is an example. He also sometimes accepted a favour in lieu of a fee—a kiss from Mary Hamilton was all he charged for repairing the portrait of her uncle, Sir William.[39]

The painting room and picture gallery: furnishings and studio props

In 1760 Reynolds bought a house in Leicester Fields where he was to live for the remainder of his life. To it he added 'a splendid gallery for the exhibition of his works, and a commodious and elegant room for his sitters'.[40] This octagonal painting room, which measured approximately 20 ft long by 16 ft wide, formed an extension to the main house. Next to it was a small store-room filled with rejected and unfinished portraits and with plaster casts after the antique lined up on shelves. In this room Northcote was allowed to work. From his description of the painting room there was only one, high, window, the sill being 9 ft 4 in from the floor. The room had a fireplace and a door which, when shut, harmonized with the wall. Reynolds's famous sitter's chair (Cat. 163) was raised 18 in from the floor on the so-called 'throne'. For easy movement the chair turned on castors. There was no chair for Reynolds since he never sat when painting. From a remark made in passing by Northcote, it is likely that Reynolds had a screen or screens covered in red and yellow material which were so arranged next to the sitter as to reflect coloured light on the shadowed side of the face.

While there would have been many easels in the studio, a favourite was a mahogany one (Cat. 164) given to him by his friend, the poet William Mason, probably c. 1783 in return for Reynolds having written his Notes for Mason's translation of *Du Fresnoy's Art of Painting*. Like Kneller, Reynolds had a mirror in his studio which could be arranged so that the sitter could observe him at work on the canvas (Cat. 165). Dr James Beattie (Cat. 87), who sat to Reynolds in 1773, noted in his diary: 'I was not in the least fatigued; for by placing a large mirror opposite to my face, Sir Joshua

Reynolds put it into my power to see every stroke of his pencil.'[41] The mirror also served to assist Reynolds in capturing special perspective effects—as in the manner in which Mason saw it employed to reflect the faces of the children from which he painted the angels in the *Nativity*.[42]

Lay figures were used for arranging the drapery in portraits; Reynolds, who seems seldom to have given his pupils instruction, did advise them to re-toss the material in order to get a more natural effect. Although he usually worked from models for his subject pictures, he did occasionally use the lay figure for the poses. Leslie quoted from a reminiscence of Stothard, who visited Reynolds when he was at work on *The Death of Dido* (Cat. 123), exhibited at the Academy in 1781: 'He had built up the composition with billets of wood, over which the rich drapery under the queen was thrown, and on it a lay figure in her attitude and dress.'[43] Pieces of coloured damask were on hand to serve as curtains for the backgrounds of portraits. Like Lely, who had an extensive collection of clothes and pieces of material to serve as garments for his sitters and lay figures, Reynolds seems to have had a similar assortment to hand.[44] Mary Isabella, Duchess of Rutland (fig. 43) told Sir Francis Grant RA that before Sir Joshua commenced with her sitting she had to try on 'eleven different dresses' before he painted her 'in that bedgown'.[45] Quite often, however, sitters or patrons must have specified the clothes in which they wished to be portrayed. We imagine that this was probably the case when

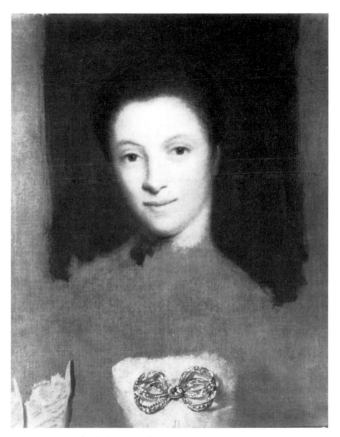

Fig. 44 Unfinished portrait of a woman, c. 1760 (Private Collection)

Lady Elizabeth Keppel was painted in the dress she wore as bridesmaid at the wedding of George III. If the memory of the Duchess of Rutland and the reporting of Grant are to be depended upon then her story is good evidence that Reynolds did sometimes paint draperies himself: otherwise he would not have needed her to model the clothes. In other instances, however, sitters' clothes were sent to the studio where they would have been used on the lay figure or indeed sent out to free-lance drapery painters such as Toms. Unfinished portraits by Reynolds are often of finished heads to which clothes have yet to be added (Cat. 46 and 77)—in one case an elaborate diamond brooch has also been finished. Such a precious item could not be sent by the sitter to the studio (fig. 44). However, a note in the pocket-book on 2 January 1759 reads 'Prince Edward's Cloaths send to Mr. Toms.' Opposite 9 November in the same year we read 'send for the Marquess of/Lindsy's Cloathes to/Mr. Davenport in/

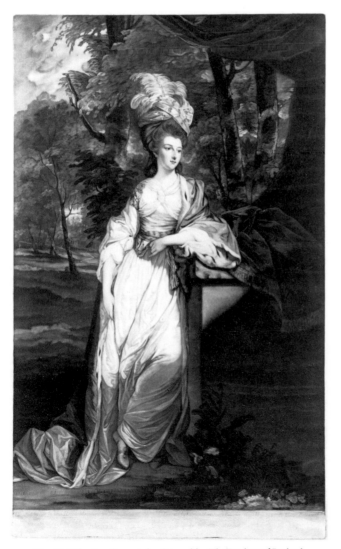

Fig. 43 Valentine Green (after Reynolds, *The Duchess of Rutland*, exhibited 1781), mezzotint, 1780 (Royal Academy of Arts)

Tavistock St.' Official robes were, obviously, often a special problem and in the accounts column opposite the week commencing 20 July 1767 we read 'The speaker's wig at Thede Peruke maker middle Temple Mr. Stevens keeper of the House of Commons to send a day or two before for the mace'.

Among the props which Reynolds himself supplied was a silver inkwell which still survives (Cat. 162), and a pet macaw. This bird had free run of the house, much to the consternation of the housemaid charged with cleaning up after it. She was none too kind to the bird, who bore her enough of a grudge to attack the portrait of her which Northcote had painted.[46]

Since the picture gallery was also added to his new residence by Sir Joshua, it was probably part of the building which housed the painting room. Rouquet noted that 'Every portrait painter in England has a room to shew his pictures, separate from that in which he works'. According to Rouquet, visiting these galleries was a popular pastime of leisured persons. They were shown around by a footman who 'knows by heart all the names, real or imaginary, of the persons, whose portraits, finished or unfinished, decorate the picture room'.[47] No doubt Reynolds had the obvious commercial advantages of such an arrangement in mind when he built his gallery; however, it housed, beyond his own works, pictures from his extensive collection of Old Masters. This gallery was open to the public and young students were also permitted to study there. Northcote became rather irritated with one of them by name of James 'Little' Roberts who spent hours there sketching after paintings, 'even while people are there to see them, as they are continually for the whole day'.[48]

Sittings and models

According to Northcote, Reynolds's average daily routine began at eight o'clock when he got up. By ten o'clock he had finished breakfast and usually spent the following hour making corrections to pictures in his studio or sketching out new ideas. Between eleven o'clock and four o'clock he received sitters.[49] This generalization is not entirely supported by the pocket-books for the 1770s and 1780s, and in the 1750s and 1760s the first sitting during the London season was frequently at nine o'clock in the morning, and not unusually at eight o'clock.

The chief evidence for generalizations about the duration and number of sittings given to each portrait has been the reply which Reynolds wrote on 9 September 1777 to Daniel Daulby who had made a preliminary approach concerning a portrait: 'It requires in general three sittings about an hour and half each time but if the sitter chooses it the face could be begun and finished in one day. It is divided into separate times for the convenience and ease of the person who sits, when the face is finished the rest is done without troubling the sitter.' In reading this, however, it should be remembered that Reynolds would have given an optimistic estimate to attract a customer. He also probably considered Daulby's portrait as an entirely routine task. The pocket-books suggest

that it was rare for three sittings to suffice, although this was generally considered the normal amount for other artists (as may be seen from Bardwell's *Practice of Painting*). There were often very many more: Colonel Coussmaker, for instance, seems to have come sixteen times to the Reynolds's studio for his full-length portrait (Cat. 130). Also, the flexibility implied by Reynolds's letter applies only to the last decades of his professional life: before 1770 he would have found it hard to be so obliging. It is clear that in the 1750s and 1760s the standard sitting commenced on one hour and concluded on or shortly before the next. There were exceptions, of course—Miss Johnson's sittings in 1761 were regularly for two successive hours and Lord Middleton in the same year seems to have preferred sittings of an hour and a half. These longer sittings must have become far easier for the artist after about 1770. We imagine also that Reynolds's friends sat on an informal basis when he was not busy—there is evidence that they did so without appointments during the 1770s and 1780s. There is no reference in the pocket-book to the long sittings which Beattie had for his portrait and recorded in his diary.[50]

With very few exceptions, sitters were expected to come to Reynolds's studio. Anne, Duchess of Cumberland, sister-in-law to King George III, made a great to-do about condescending to come to Leicester Fields. Northcote, who was evidently witness to this, noted that Sir Joshua 'made her no answer, nor did he trouble himself to inform her, that there was no other way by which she could have had her portrait painted by him: indeed, the great Duke of Cumberland [referring to her husband's uncle], and many others of the royal family, had not conceived it to be beneath their dignity to come to his house for the same purpose'.[51] Sometimes, however, Reynolds did work outside the studio. Early in his career, in 1746, he painted Miss Chudleigh (subsequently Duchess of Kingston) when she was staying at Saltram, and he may well have made other portraits on subsequent visits to Saltram. He certainly painted whilst staying at Blenheim Palace— an anecdote is recorded concerning the quantities of snuff he let fall on the Duke's carpets. It also seems that in 1781 whilst a guest at Streatham Park, the home of the Thrales, he began his portrait of Charles Burney (Cat. 125).[52]

In addition to using the lay figure to complete the draperies after the sittings were over, models might also be employed for this purpose. Northcote told his brother in 1771 that he was often used by Reynolds to model hands in portraits.[53] Models were doubtless primarily used for the fancy subject pictures and as a subsidiary figure in portraits, but they might also substitute for sitters who would not have had time or patience for a complicated composition. The notation 'Archers' in the pocket-book for 1769 presumably refers to models who posed on several occasions for the unusually active poses of the double portrait of Townshend and Acland (Cat. 74). The artist's black servant served as a model as well as a footman, according to Northcote, and appears in the military full-lengths of the mid-1760s,[54] and the daughter of another servant, Ralph Kirkley, was the model for Reynolds's first *Venus*, painted in 1759.[55] North-

cote also was employed as a model in the artist's first history paintings—the *Hugolino* exhibited in 1774 (Cat. 82),[56] and the artist's nieces, and eventually his great-niece, were often the models for his fancy pictures. On one notable occasion he asked a lady from high society to model for a history painting—Mrs Sheridan sat for the Virgin in his *Nativity*. It has also been assumed that the great courtesans Kitty Fisher and Nelly O'Brien, who come so frequently to the artist's studio, served as models for fancy pictures, although there is no reliable evidence for this.[57] For the most part Reynolds depended upon the paupers, beggars and urchins he invited into his studio from the London street. Two of them can be identified: George White, a bearded Irish paviour employed by Reynolds for the Count in *Ugolino* and numerous other works of the early 1770s and soon taken up by other London artists;[58] and a boy, mentioned by Mason as a favourite, who appears in at least four paintings of the late 1770s including the *Infant Samuel* shown at the Academy in 1776 and the *Schoolboy* (Cat. 105).[59]

Composing the portrait

The Abbé Le Blanc in his *Letters on the English and French Nations* (1747) remarked on the very obvious reliance upon standard poses among the English portraitists: 'I have been to see the most noted of them; at some distance one might easily mistake a dozen of their portraits for twelve copies of the same original. Some have the head turned to the left, others to the right: and this is the most sensible difference to be observed between them. Moreover, excepting the face, you find it all, the same neck, the same arms, the same flesh, the same attitude; and to say all, you observe no more life than design in those pretended portraits.'[60] Anyone familiar with those corridors lined with the lesser pictures in English country houses will have to agree to a large extent with Le Blanc's remarks. (In the seventeenth century Lely's studio already made use of ready-painted poses. These were pre-fabricated postures, without heads, and were even numbered, no doubt for the convenience of the assistants who would paint in a head on the appropriate canvas. In 1693 John Baptist Medina arranged by letter from London with various Scottish sitters exactly how they wanted to be portrayed so that he could have the drapery painted prior to his visit.[61])

Northcote relates an amusing anecdote about one of Reynolds's youthful productions when he was still working in the Hudson tradition. One of Hudson's favourite poses for gentlemen had the hat placed under one arm, the hand of the other arm stuck in the waistcoat. According to North-cote, one of Reynolds's sitters requested having his hat on his head. Reynolds complied, but when the portrait was unpacked at the sitter's home he discovered he had two hats, one on his head and the other under his arm.[62] Reynolds was in fact to censor the practice of depending upon pre-conceived formulae for portrait poses, although he certainly never entirely shed the habit himself. Indeed, in about 1758, according to Northcote (who was not at that time in the studio), Reynolds kept a portfolio 'containing every print

that had been taken from his portraits; so that those who came to sit had this collection to look over, and if they fixed on any particular attitude, in preference, he would repeat it precisely in point of drapery and position; as this much facilitated the business, and was sure to please the sitter's fancy'.[63] There are certainly repeated poses (see, for example Cat. 23 and 40) but the drapery is always varied, despite this allegation.

Reynolds's chief source of inspiration was certainly not his own work. He was distinguished among his contemporaries by his capacity to incorporate into his paintings ideas from the Old Masters, not only from portrait painters such as Van Dyck to whose work English portraitists had always looked back, but from Michelangelo and from Rembrandt. The nature of his debt—and of his erudition—is discussed in detail elsewhere in this catalogue by Nicholas Penny, Robert Rosenblum and John Newman. It is important to emphasize that his concern with the Old Masters was not such as to preclude the artist's perception of characteristic actions in his sitters. In fact, chance and the spontaneous gesture played a definite role in many of his compositions. He told Northcote that during a sitting in 1754 the client kept turning to look at one of the Old Masters on the wall of his painting room. 'I snatched the moment, and drew him, as then appeared to me, in profile, with as much of that expression of pleasing melancholy as my capacity enabled me to hit off.'[64] A similar anecdote was told by Mrs Siddons when she sat as *The Tragic Muse* (Cat. 134, 151). While

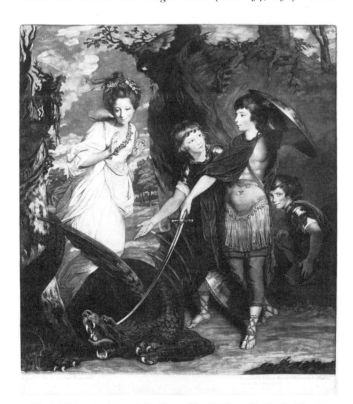

Fig. 45 Valentine Green (after Reynolds, *Children of the Bedford Family Acting St George and the Dragon*, exhibited 1777), mezzotint, 1778 (Fitzwilliam Museum, Cambridge)

Reynolds was busy preparing some colour she evidently looked up at a picture; Reynolds, seeing this, told her to hold the pose. However, the pose of this picture is also indebted to Michelangelo's *The Prophet Isaias* in the vault of the Sistine Chapel.[65] In this instance, a learned quotation combined with a chance gesture has resulted in the most successful of Reynolds's fancy pictures. When Lord William Russell sat for his portrait in *Francis, 5th Duke of Bedford, with His Brothers and Miss Vernon: 'St George and the Dragon'* (fig. 45), exhibited at the Academy in 1777, he was so frightened that he went and crouched in a corner of the studio. Reynolds told him to 'Stay as you are, my little fellow' and painted him so. The crouching Lord William steals the show from the rest of the composition which is stilted and bombastic.[66] (A similar story is told of the little girl in the Marlborough family portrait who shrinks in fear from the mask held before her[67]—although interestingly the episode in question is inspired by a motif on ancient gems.) In 1781, when Mrs Moore came to sit for him, Reynolds told her to 'Stop' at the entrance to his studio. Her hat, blocking the light from the window, cast a special half-shadow on her face and he made her stand in the doorway while he furiously worked to capture the effect.[68] The pensive pose in *Joshua Sharpe* (Cat. 138) was evidently the result of the elderly man simply sitting down in his normal way.[69]

Technique: materials used

Of equal importance for Reynolds to the Grand Manner, the lofty subject well-chosen and transformed to his own purposes, was the surface effect, that all too often inimitable quality of paint associated with certain masters, above all Rembrandt and Titian. To accomplish a duplication of those luscious textural effects such as loaded highlights slapped, dabbed, or patted on and frequently drawn out by the brush in exquisite and characteristic trails, or rich shadows like bottomless pools created by numerous glazes, Reynolds had all the necessary ingredients to hand, but, as earlier mentioned, he lacked patience. A fairly good idea can be formed of the materials he used by looking through Northcote's *Life*, and Sir Joshua's technical memoranda, most of which were included in his ledgers.

OILS
The only specific oil mentioned is nut oil. During a stay in Devonshire in 1762 Reynolds visited a local gentleman who made him a present of 'a large jar of very old nut oil, grown fat by length of time, as it had belonged to an ancestor of the family. This prize Reynolds most eagerly took home with him in the carriage, regarding it as deserving of his own personal attention.'[70] Undoubtedly linseed oil was the oil most frequently used to grind colours. This would have been boiled over lead to increase its drying properties, and as such used to mix with colours or to make the disastrous painting medium megilp.

DRIERS
The type of lead used as a drier, at least in one instance, was

Sal Saturni or sugar of lead, the basic lead acetate. Reynolds may also have used red lead as a drier since he believed the shadows in Venetian pictures were made of drying oil boiled over red lead.[71]

BALSAMS AND RESINS
Two balsams were used, copaiba and Venice turpentine, and two resins, mastic and copal.

PAINTING MEDIUMS BASED UPON BALSAMS AND RESINS
Early in his career Reynolds seemed to have used a fairly straightforward technique. In 1755 he merely mixed an unspecified 'varnish' with his palette for flesh painting.[72] However, as his desire to emulate the effects of the Old Masters increased so did his use of bizarre nostrums. He made frequent use of megilp. A notation dated 1767 for his portrait of *Miss Hester Cholmondeley* reads: 'verniciulo con yeos (?) lake e magilp'.[73] This means that he glazed the picture with a yellow lake made by Richard Yeo mixed with megilp. Megilp is made by dissolving mastic in turpentine and then combining that with linseed oil boiled over lead. The result is a buttery medium which works beautifully under the brush. In his own *Self-portrait*, also from 1767, one of the layers was added 'poi con mastivar' or 'then with mastic varnish'.[74] Venice turpentine was also used with wax as a medium.[75]

Another favourite medium, perhaps due to its rich colour or hardness, was copal varnish. 'My own picture marked behind. Finished con vernicio de Birming (copal Varnish from Birming[ham]) senza Olio'.[76] The 'senza Olio'—'without oil'—is not strictly correct since copal is made by dissolving the pulverized resin in hot drying oil. What Reynolds most likely meant was that he did not add any oil to the varnish medium. Beechey was certain that Sir Joshua's usual medium was made from wax and varnish 'generally Copal from Birmingham'.[77]

These mediums must have been very thick since Reynolds once complained to Northcote, '"You don't clean my brushes well." "How can I?" said Northcote; "they are so sticky & gummy."'[78] Evidently Reynolds preferred using varnishes to oils, because, as Northcote wrote to his brother on 23 August 1771, 'the oils give the colours a dirty yellowness in time, but this method of his has an inconvenience full as bad, which is that his pictures crack; sometimes before he has got them out of his hands'.[79]

AQUEOUS PAINTING MEDIUM
For his *Self-portrait* painted on 27 April 1772 Reynolds employed, 'First acqua e gomma Dragona Vermn. Lake, Black, without yellow.' Beechey noted, 'I rather think gum Tragacanth, for that is a gum which mixes well with water, & makes a mucillage. That & powered mastic dry hard.'[80] This medium was mixed with the colours which are listed.

FINAL COATINGS: VARNISHES AND OTHER MATERIALS
One of Sir Joshua's favourite final coatings was egg. A notation dated 27 April 1772 on his *Self-portrait* states: 'varnished with Egg after/Venice/Turpentine'. This means

that he varnished in two layers, the first being egg, which was probably made by beating the white to a froth, followed by a layer of Venice turpentine. Sir William Beechey commented that 'His egg-varnish *alone* would in short time tear any picture to pieces painted with such materials as he made use of'.[81] At times he evidently only polished the surface with wax as can be assumed from the final notation on his 1767 *Self-portrait*: 'poi cerata sensa colori'—'then waxed without colours'.[82]

In some instances pictures underwent multiple varnishings. 'Mrs Joddrell—Head oil, cerata, varnisht with ova poi varn. con Wolf, Panni, Cera senza olio, Verniciato con ovo poi con Wolf.' Haydon remarked, 'Good heavens! Let us recapitulate in English. The head painted in oil, then waxed, varnished, egged, varnished again with Wolff's, then waxed, sized, oiled, egged again, and then finally varnished with Wolff!!! That is, varnished three times with different varnishes, and egged twice, oiled twice, and waxed twice, and sized—perhaps in 24 hours. The surface Sir Joshua got was exquisite, his delight must have been intense, and though the reward was worth the risk, in such extraordinary infatuation he must be a beacon' (that is, a warning light).[83]

VOLATILE PLANT OILS

The only essential oil mentioned is spirits of turpentine. One day in 1775 when cleaning out a gallipot with turpentine, Reynolds caused some excitement when he threw the contents into the fireplace in the studio. A flame shot up the chimney; this was noticed and a fireman duly appeared with the first fire-engine. For this considerate service Reynolds was required to pay £5.00.[84] Turpentine was used for other purposes than cleaning gallipots and from a notation most likely on Mrs Joddrell's portrait it is clear that during the second sitting the paint was put on 'thick, occasionally thinned with Turpentine'.[85]

WAX AND ASPHALTUM

An early influence on Reynolds were the portraits of William Gandy (c. 1655–d. 1729), son of James Gandy who was taught by Van Dyck and for whom he later worked as assistant. Northcote goes so far as to say that Gandy was an 'early master' to Reynolds, but this can only be interpreted in the sense that his works inspired him to emulation. Reynolds could have both seen Gandy's pictures in Exeter and Plymouth and spoken to people who had known the painter. One of Gandy's observations Reynolds was fond of repeating was that 'a picture ought to have a richness in its texture, as if the colours had been composed of cream or cheese, and the reverse to a hard and husky or dry manner'.[86] This early influence, combined with Reynolds's love for the texture of Rembrandt's pictures, decided matters: he was to devote his technical efforts to the creation of a creamy or cheesy surface texture. To achieve such an effect Reynolds began using wax, either alone or in various combinations. His attention may have been drawn to wax by the Comte de Caylus's *Mémoire sur La Peinture à L'Encaustique et Sur La Peinture à La Cire* (1755). Painting with wax was a different technique from encaustic, 'parce-qu'elle n'en a le caractère, ni

par les ingrédiens qui entrent dans sa compositon, comme nous l'avons dit, ni par le feu, qui n'est nullement nécessaire à l'exécution des tableaux peints selon le procédé que nous allons décrire'.[87] Wax simply dissolved cold in spirits of turpentine could then be mixed with pigments.

Around 1766 Reynolds began noting down his experiments and Leslie dates Sir Joshua's increased interest in bizarre materials from this time. Mr Cribb, the framemaker, informed Leslie that Reynolds once told him that he experimented only with those paintings which did not matter to him. But this seems very dubious. The earliest reference to wax being used is for his 'Miss Kitty Fisher face cerata drapery painted con cera e poi V'—apparently in 1766.[88] Beechey thought that by 'cerata' Reynolds intended 'varnished'. Haydon correctly noted, 'Of course not; rubbed with wax first'.[89] In this instance, Reynolds rubbed the area of the face with wax. Whether this layer of wax was first put down as a couch and then painted on or whether it was put as a veil over a first painting is not clear. Since wax is opaque it is more likely that Reynolds applied it as a couch for his paints. One of Reynolds's sitters told Wilkie that, 'Sir Joshua dabbed on a quantity of stuff, laid the Picture on its back, shook it about till it settled like a batter pudding, and then painted away'.[90] The drapery was done with wax and then varnished. Wax was also frequently combined with a balsam or resin to make a painting medium. 'Ld. Villers, given to Dr. Barnard, painted with Ve[r]nice fatto di Cera & Venice turpentine—mesticato con gli Colori, macinati in olio'[91]—that is, the portrait was painted with a 'varnish' made by mixing wax pre-dissolved in spirits of turpentine with Venice turpentine. This medium was then added to pigments ground in oil.

It would seem from the technical memoranda that Sir Joshua attempted every possible variation on the theme. His notes on Mrs. Sheridan, which may be for *Mrs Sheridan in the character of Saint Cecilia* (Cat. 94), shown at the Academy in 1775, read: 'Mrs Sheridan.—The face in Olio, poi cerata; Panni in Olio, poi con cera senza olio, poi olio e cera.' The face was first painted in oil, then waxed; the drapery was done in oil, then with wax without oil, then oil and wax. Eastlake dismissed the possibility of Reynolds having used pigments ground only in dissolved wax. He may have been wrong about this since Caylus says of wax dissolved in spirits of turpentine: 'On fit broyer des couleurs avec cette cire liquefiée, on leur donna la consistance des couleurs broyées à l'huile, & l'on exécuta un tableau dont la manœuvre fut facile.' Commenting on the condition of this picture, Beechey remarked, 'the colours . . . leave the canvas in masses, except the head, which is perfect.' This would certainly seem to indicate that Reynolds did sometimes use pigments ground solely in dissolved wax. It should not be forgotten that pieces fell off his pictures during transportation.[92]

Haydon blamed Reynolds's fascination for Rembrandt on his use of 'something of the consistence of Butter, which is a most bewitching Vehicle certainly'. Despite his own awareness of the dangers of using wax, either alone or combined with Venice turpentine or copal varnish—it cracks, adheres poorly, presents great problems when a picture needs to be

lined—Haydon was always jealous of the effects Reynolds managed to achieve. He once lamented, 'My Pictures want that rich cheesy surface Sir Joshua never lost it.' But then he wisely added, 'Sir Joshua is for the finished Artist; he ruins the Youth'[93] (and, Haydon could have added, pictures). This did not seem to bother Reynolds. When confronted by Sir George Beaumont, who complained that the wax vehicle recommended by him cracked, Reynolds coolly replied, 'All good pictures crack.'[94]

If this were not enough, Reynolds could not resist the temptation of using asphaltum. This pigment is organic, being a mixture of hydrocarbons, and when prepared with a drying oil results in a rich, transparent brown capable of producing luscious glazes. Due to its transparency it could also be used for underdrawing and underpainting, the effect being quite similar to a sepia wash drawing. Asphaltum has a long history of usage in England, the earliest references in the technical literature occurring around 1600. Doerner believed that Rembrandt used asphaltum with success for glazing. For someone like Reynolds who wanted nothing more than to duplicate the *chiaroscuro* of the great Dutch painter, the temptation was too much. Asphaltum, of course, being a sort of tar, never dries, regardless of what is added to it for that purpose. If used in great amounts it can tear a picture to pieces. In the anonymous *Artist's Repository and Drawing Magazine*, first published between 1784 and 1786, the following caution is found: asphaltum 'is used in oil painting, but must not be much trusted to; it gives the appearance of age to pictures, &c.'[95] Philip Reinagle (1749–1833), an animal and landscape painter, told Haydon that 'He remembered Sir Joshua's using so much asphaltum that it used to drop on the floor'.[96]

Exactly when Reynolds began using asphaltum is not clear. From his memoranda it would appear he started experimenting with it in the early 1770s since he firmly states in his notation on *Joseph Hickey*, exhibited at the Royal Academy in 1772, 'Stabilito in maniera de servirsi di Jew's pitch', which Beechey correctly translated as, 'I am settled in my manner of using Asphaltum'.[97] It was used both for underpainting and for glazing. 'Aug. 15, 1774. White, Blue. Asphaltum. Verm—Senza nero Miss Foley. Sir R. Fletcher. Mr Hare.'[98] For these pictures he substituted asphaltum for black on his palette. In other pictures he used it both as a substitute for black and for glazing, as for example in his *A Beggar Boy and His Sister*, exhibited at the Royal Academy in 1775: 'Aug. 26 1774. White, asphal. verm. minio principalm. e giallo di Napoli, ni nero ni turchino. Regazzo con sorella, glaze con asphaltum e lacca.'[99] The consequences of his overabundant use of asphaltum are most poignantly apparent in his late *Self-portrait Wearing Spectacles* (Cat. 149).[100]

PIGMENTS
From the technical memoranda it is clear that Reynolds used very few colours for any one picture. He may have experimented with new or different pigments, but he used a very limited palette when painting. Compared with the palettes for flesh painting recommended by Thomas Bard-

well, or used by George Romney, Reynolds's were sparse.[101] In his Notes attached to Mason's translation of *De Arte Graphica* Reynolds wrote, 'I am convinced the fewer the colours the cleaner will be the effect of those colours. . . . Two colours mixed together will not preserve the brightness of either of them single, nor will three be as bright as two.'[102] In a letter to his brother in August 1771 Northcote reported that Sir Joshua had told him to use as few colours as possible: 'lake, yellow ochre, blue and black are sufficient . . . to paint anything.'[103]

With the exception of pigments prepared for him by friends and acquaintances, such as Richard Yeo, one of the original Royal Academicians, Reynolds would have dealt with established colourmen. Among those he did business with was a Mr Sandys whom Northcote mentions having visited. John Middleton's shop was in St Martin's Lane, near Leicester Fields, and a shop assistant once told a young artist she used to sell colours to Reynolds. In his pocket-books he mentions a Mr Poole who had his business in Holborn, also near to Leicester Fields. His business was taken over by the Browns who also supplied Sir Joshua.[104]

BLACK
The general terms 'black' and 'blue black' are given by Northcote as being on his palette in 1755.[105] Mason records that Reynolds once asked him whether he 'thought blue (ultramarine or Prussian I suppose) or blue-black (which is a species of charcoal) produced the best demi-tints for carnation'. Evidently Reynolds had not made up his mind since he told Mason he sometimes used blue, sometimes black.[106] Upon one occasion, not entirely from choice, Reynolds even used soot: he had placed a portrait of *George Colman* (exhibited at the Academy in 1770) face towards the fire to hasten its drying. Wind coming down the chimney blew soot over the picture and darkened its overall hue, according to Northcote. This may, however, have been the same picture mentioned by Sir George Beaumont. According to him, Reynolds merely said, 'A fine cool tint' and scumbled the soot into the flesh colour.[107]

BLUE
Ultramarine was listed by Northcote as being on his palette for flesh painting in 1755. Mason records that Reynolds bought it in large quantities, as well as the 'finest' smalt which, he told Mason, was almost as expensive as ultramarine. This may have been an exaggeration on Reynolds's part since, according to the prices given in *The Artist's Repository* of 1784–6, ultramarine cost between three to ten guineas per ounce. Smalt cost between 1/6d and 12s per ounce. Even ultramarine ashes, a lesser grade, cost between 18s and 40s per ounce.[108] A memorandum for 29 July 1768 gives another blue, 'turchino', which when mixed with vermilion and yellow lake could be used in place of black. 'Turchino' is frequently listed by Reynolds and in Italian simply means 'deep blue'. Mrs Merrifield said that it was a catch-all term used for native and artificial blues made from copper, which used to be imported into Italy by the Turks. Beechey and Haydon give, no doubt correctly,

Prussian blue for 'turchino' as used by Reynolds in his memoranda.[109] Under a notation on *Joseph Hickey* (exhibited at the Academy in 1772) appears 'Azuro' which means 'sky-blue'. This may refer to the manufactured basic copper carbonate known as 'blue verditer'. Reynolds sometimes used this pigment, but with little success since it usually turns green. He was aware of this defect, for in 1780 he told Lord Barrington, who had evidently complained about the colour of the sky changing colour in one of his pictures, that 'This was occasioned by a blunder of my colourman, who sent blue verditer (a colour which changes green within a month), instead of ultramarine, which lasts forever.'[110] Such a sky gone green can be seen in *Captain John Foote* (1765).

BROWN
The use of asphaltum has been discussed above. Another organic pigment similar to it, and also bituminous, is Cologne earth. Reynolds used this on his *Self-portrait* of 1773 (Cat. 86), sent to Plympton.[111] For the first painting of *Mrs Joddrell* he mixed 'Umbra e Biacca' together. 'Umbra' would have been either the raw or burnt earth.[112]

GREEN
Reynolds does not appear to have used any specific green pigments. In his *Practice of Painting* (1756) Bardwell lists one only: the green earth, 'terra verte'. The reason for the absence of a specific green on Reynolds's palette was due most probably to the instability of most greens. Those listed in *The Artist's Repository* were sap green, 'terra verte', and verdigris. However, under the instructions for painting only one green is given, 'terra verte', followed by a brief remark: 'greens are usually compositions'.[113]

RED
Two fugitive reds are listed by Northcote as being on Reynolds's palette for flesh painting in 1755. The use of these fleeting colours was responsible for the fading in so many of Reynolds's pictures, even during his lifetime. Sir William Forbes mentioned the fading in the portrait of *James, 14th Earl of Erroll*, 1762, which he attributed to the sea air since the picture hung in a castle by the sea. In his reply to Forbes dated 6 August 1779, Reynolds explained the real reason for the fading. 'The truth is for many years I was extremely fond of a very treacherous colour called Carmine, very beautifull to look at, but of no substance.'[114] According to Northcote, he tried in 1775 to persuade Sir Joshua to use vermilion instead of carmine and lake. 'I remember he looked on his hand and said "I can see no vermilion in flesh." I replied, "but did not Sir Godfrey Kneller always use vermilion in his flesh colour?" When Sir Joshua answered rather sharply, "What signifies what a man used who could not colour. But you may use it if you will!"'[115]

Exactly when Reynolds started using vermilion is not clear, but it was many years before his sharp exchange with Northcote. It is listed in his Italian notebook of 1752 as one of the pigments to be used when painting heads. Mason, who watched the painting of *Robert, 4th Earl of Holderness* in 1755, lamented the fact that Reynolds used lake instead of the red

earths for the first and second painting. From Mason's testimony, however, it is quite clear Reynolds began using vermilion in around 1759. He had two gallipots under water in which he kept prepared tints, one deeper, one lighter, made of vermilion and white which he used for painting the flesh in his *Venus*. Reynolds told him that he had abandoned lake for Chinese vermilion, which he later stopped using, preferring the best English vermilion.[116] For his portrait of the *Rt. Hon. Charles Townsend* (1764–7) he used 'Lacca. poi Verniciata con Virmilion'.[117] Evidently, since he could not resist the colour, Reynolds put on the lake, which is fugitive, as an underpainting. The vermilion was then used as a glaze. This, of course, would be difficult, but not impossible, since vermilion is fairly opaque. Red lead was used in his portrait of *Sir Robert Fletcher* (1774). 'Biacca, nero, ultramarine, verm. sed principalmente minio senza giallo.' The 'minio' or red lead was primarily used even though vermilion was on the palette. Since there was no yellow to soften the vermilion if needed, Sir Joshua probably preferred the yellower tone of red lead. Beechey remarked, 'Red lead won't stand. It becomes grey.'[118] Later in his career Reynolds seems to have made some use of earth colours. Among the colours to be used for his *Death of Dido*, exhibited at the Academy in 1781, he listed 'Indian Red, light Red'.[119]

WHITE
Northcote only gives the general term 'white' for the 1755 palette. Mason, however, specifically mentions flake white, or basic lead carbonate, as the white on this palette.[120] Throughout the memoranda only the general terms 'white' and 'biacca' appear.

YELLOW
Two yellows were included on the 1755 palette for flesh painting: orpiment and yellow ochre. Yellow ochre, which is a natural earth, is one of the most stable pigments. Orpiment, however, which is sulphide of arsenic, is dangerous both due to its poisonous nature and its incompatibility with other pigments, especially lead white. Leslie noted that the lights on most of the pictures painted around 1755 have darkened due to orpiment being mixed with lead white.[121] In his portrait of *Theophila (Offy) Palmer with a Muff* (1767), he used 'yeos yellow' which was most probably a yellow lake made by Richard Yeo. Another unspecified 'Lacca Giallo' or yellow lake was used with Prussian blue and vermilion to duplicate black.[122] A specific organic yellow much favoured by Reynolds was 'gamboge', which is a yellow gum resin coming from various types of *Garcinia* or evergreen trees growing in India and Asia. Gettens and Stout credit it with being a more permanent pigment in oil than in water, the latter, however, being the most frequently used medium. Its deep brownish colour no doubt appealed to Reynolds who was nonetheless aware of its drawbacks. He even made a series of tests in 1772, mixing gamboge with various mediums such as Venice turpentine, wax, turpentine and oil. These mixtures were painted out on a canvas and Eastlake, who saw it in the early part of the nineteenth century, said that all the mixtures had held except gamboge

in oil. Gamboge was generously used for *The Infant Samuel*, exhibited at the Academy in 1776. 'Samuel—red flesh glazed with Gamb. & Verm. Drap. Gamb. & Lake. Sky retouched with Orpimt.' Haydon noted, 'All *faders* except Verm.'[123] 'Giallo di Napoli' or Naples yellow, lead antimoniate, is frequently listed in the technical memoranda. There was some confusion as to its composition during the first half of the eighteenth century. Bardwell, who states in his book that a yellow tint for flesh painting could be made by mixing it with white, preferred using yellow ochre. This may have been because its composition was a mystery to him. A recipe, however, for Naples yellow is given in *The Artist's Repository*: '12 oz. of ceruse, or white lead, 1 oz. of alum, 1 oz. of sal ammoniac, [and] 3 oz. of diaphoretic antimony' were put in an unglazed earthen pan which was covered and heated moderately for seven or eight hours.[124]

PRIMING AND THE USE OF COLOURED GROUNDS

It would appear that Reynolds's common practice was to paint directly on unprepared raw canvas. In a letter to his brother Samuel dated 23 August 1771 Northcote confided that, 'Sir Joshua always paints on the bare cloth unprepared, after the manner of the Venetians, whom he much admires (don't show this part of the letter to anybody because Sir Joshua would not choose to have it known).'[125] He did so for his *Self-portrait* (1770), and for a version of the 1775 *Self-portrait* painted for the Uffizi, the original being painted on a mahogany panel.[126] The *Self-portrait* for Plympton was painted 'on a Common Colourman's Cloth, *first Varnished over with Copal Varnish*'. Evidently, Sir Joshua sometimes felt an isolating layer between canvas and paint to be necessary. Haydon, who saw this picture in the Town Hall at Plympton in 1809 with Wilkie, commented that it was 'in *perfect condition*'.[127] *Elizabeth, Lady Melbourne* (1770/1), was painted 'sopra una *Tela di fundo*'. Beechey was uncertain whether '*Tela di fundo*' referred to a ready-prepared or a raw cloth; Haydon noted that it meant raw, unprepared canvas.[128] Another picture painted on raw cloth was *The Nativity*, exhibited at the Academy in 1779, unfortunately destroyed in the great fire at Belvoir Castle in 1816. Sir George Beaumont saw it in 1815 and informed Beechey that it was in perfect condition.[129]

When Reynolds purchased his canvas from the colourman he would have specified primed or unprimed cloth. *The Artist's Repository* notes that 'Portrait painters chose a very thin priming. Perhaps cloths are yet better without priming. Priming is a colour laid on the cloth, &c. previous to those which are to form the picture, and should be in its tint rather light than dark.'[130] Robert Dossie in *The Handmaid To The Arts* (1758) warned against the ready-prepared canvases sold by the colourmen. According to Dossie the priming, which was nothing more than size and whiting, was apt to peel off. It was also too absorbent, drawing off the oil from the colours and causing them to sink in. His recommended method for preparing cloths calls for soaking them in hot drying oil, then laying on two or three coats of drying oil and red ochre. When this is dry, hot drying oil is to be brushed on until it no longer sinks in. A final coat of white

lead in oil is applied and this can be rendered grey or any other desired colour. Such a canvas is, of course, doomed to disintegration due to the saturation with oil.[131] While many of Reynolds's technical practices were faulty, his preference for unprimed cloth was not unsound; Beechey even went so far as to attribute the good condition of some pictures to such an unprimed ground. According to him, such pictures 'remain fixed, because his first colouring is partly absorbed; but painted on a ground prepared in oil, the wax & Varnish separate as soon as it becomes dry & hard, having nothing for these materials to adhere to'. Leslie claimed that Reynolds made extensive use of gypsum in his priming.[132]

Coloured grounds can expedite work since they provide easy half-tints. Raw canvas would, of course, furnish a tan ground and Mason mentioned in passing the 'light-coloured canvas' used for the 1755 portrait of the *Earl of Holderness*. In the technical memoranda there is little information on this aspect of Reynolds's practice other than a brief remark on an unidentified picture: 'May 17th 1769 on a grey ground'.[133] Northcote records one of Reynolds's precepts based upon his studies of the Old Masters in Italy: 'Make a finished sketch of every portrait you intend to paint, and by the help of that dispose your living model: then finish at the first time on a ground made of Indian Red and black.'[134] Such dark grounds, which were popular with the Italians, do not seem to have been common with Reynolds. A look at a few of the unfinished pictures will give some idea of the sort of coloured grounds Reynolds used. He frequently uses a buff-coloured ground as can be seen in *Mrs John Spencer and her Daughter* (Cat. 32) and *Mrs Richard Hoare and Child* (Cat. 52). Grey grounds were also employed, as, for example, in *Lord Rockingham and his Secretary, Edmund Burke* (Cat. 70) which can be seen under the light peach colour applied over the areas of Burke's wig and robe.

Actual painting technique: first, second, third (and more) sittings

What Reynolds learned from Hudson was a method of painting very similar to that set forth in detail by Thomas Bardwell in 1756. During his stay in Italy Reynolds had the opportunity of studying the Old Masters and he developed a method of painting which was to a large extent based upon his observations. In short, this manner was nothing more than laying-in the picture in a cool monochrome underpainting finished off by glazing and scumbling, and, in many instances, a layer or layers of tinted varnish. While in Florence in 1752, he noted down the following rule for painting heads: 'The ground colour, blue-black and white. Light: first sitting the features, marked firm with red: next sitting the red colours. Blue-black, vermilion, lake, carmine, white, drying oil.'[135] On a grey ground he first blocked in the features in red. Over that he worked up the face in red colours and would have glazed over this. Drying oil alone was the medium and five colours were used. Yellow is absent from the palette.

Northcote gives a description of the palette for flesh painting around 1755. It would have been laid as follows:

First sitting
1) Carmine + white: various tints
2) Orpiment + white: various tints
3) Blue-black + white: various tints
4) 'a mixture on the pallet as near the sitter's complexion as [possible]'

Second and subsequent sittings
1) Black
2) Blue-black
3) White
4) Lake
5) Carmine
6) Orpiment
7) Yellow ochre
8) Ultramarine

Medium: unspecified varnish

Since Reynolds used a relatively small, paddle-shaped palette, as can be seen in his early *Self-portrait shading the eyes* (Cat. 13), there would not have been an excessive number of tints laid out.

During the first sitting the face would have been blocked in in a fairly cool monochrome, and part of the pose may also have been sketched in. Mason, however, gives the best description of Reynolds's early practice. He was allowed to attend all the sittings for *Robert, 4th Earl of Holderness* (1755). The canvas had a 'light-coloured ground' and over the area for the head Reynolds laid a couch of white. This would produce an optically resilient effect. While this patch was still wet and using no other colours than flake white, lake, and black, he began without making any preparatory sketch, 'with much celerity to scumble these pigments together, till he had produced, in less than an hour, a likeness sufficiently intelligible, yet withal, as might be expected, cold and pallid to the last degree'. Naples yellow was added to the palette during the second sitting. Holderness's crimson velvet coat was first painted and then glazed with lake. Mason noted that while the coat held its colour, the face soon faded. Over the monochrome underpainting Reynolds applied his glazes and tinted varnish. A memorandum dated 7 July 1766, but probably for the portrait of *Master Pelham* (1759), reads: 'Mr. Pelham, painted with lake and white and black and blue, varnished with gum mastic dissolved in oil with sal Saturni and rock alum. Yellow lake and Naples and black mixed with the varnish.' 'Sal Saturni', or sugar of lead, was added to hasten drying; this eventually produces myriad white spots which later turn brown or black. Another memorandum, dated 3 April 1769, reads: 'per gli Colori. Cinabro Lacca/e Ultramarine e nero/senza Giallo &c prima in olio ultima con Vernicio Solo/e giallo.' For the first sitting the colours, without yellow, were mixed with oil. The underpainting was finished by applying a tinted varnish made by adding yellow to it. It goes without saying that many of these tinted varnish layers have been removed by restorers, mistaking them for darkened varnish.[136]

During the first sitting the heads were quite often completely finished. Dr Beattie recorded in his diary that the first sitting lasted five hours, 'in which time he finished my head, and sketched out the rest of my figure.' The general method would be for Reynolds to finish the heads first before going on to the drapery and background. Of *The Montgomery Sisters* (Cat. 90), exhibited at the Academy in 1774, Northcote said that Reynolds finished 'the three portrait heads, and sketch[ed] the outline of the composition' before going on a trip to Portsmouth.[137] This approach can be clearly seen in *Mrs John Spencer and her Daughter* (1759; Cat. 32), *Mrs Richard Hoare and Child* (1767/8; Cat. 52), *Kitty Fisher* (1766; Cat. 46) and *The Study of a Young Black* (Cat. 77). An exception to this obviously logical approach is the *Lord Rockingham and his Secretary, Edmund Burke* (c. 1766; Cat. 70), in which the background, setting, accessories, and part of the drapery have been brought to an advanced state of completion by the assistant while Burke's face is still in its monochrome state, and Rockingham's has been worked on in a second sitting. This picture serves as a warning for anyone who might wish to assume that there was a set manner for producing pictures in the Reynolds studio.

While Reynolds was a great experimenter with materials and techniques, his general method remained more or less that which he established by studying the works of the Italian masters, especially Coreggio and Titian. This established manner was summed up in the note on his *Self-portrait* given to Burke. 'June 22, 1770—Sono stabilito in maniera di dipingere. Primo e secundo, o con olio, o copivi gli Colori solo nero, Utram. et biacca. Secondo medesimo. Ultimo con giallo-okero, e lacca, e nero, e ultramarine senza biacca ritoccata con poco biacca e gli alteri Colori.' The first and second paintings were done only with black, ultramarine and white, mixed either with oil or copaiba. Yellow ochre, lake, black and ultramarine, without white, were used for the third painting and applied as glazes and scumbles. Retouching was done with white and the other colours. Beechey, who correctly assumed that the glazing medium would have been wax and Venice turpentine or some other such mixture, warned: 'Take off that, & his pictures return to Black & White'[138]—and, he could have added, black and blue in many instances. A bluish-grey pallor is a phenomenon frequently encountered when looking at many of Reynolds's portraits, but it is far less common in his late works.

Restoration

Many of Reynolds's pictures had to be restored during his own lifetime. His pupil William Doughty, who was with him from 1775 to 1778, repaired the picture of *Lord Holderness* painted in 1755. It had begun to crack and there was even danger of the forehead peeling off.[139] Reynolds himself even refurbished pictures, as he did for Mary Hamilton in 1785. The portrait of her uncle, *Sir William Hamilton*, begun 1762 and finished 1772, was retouched by Sir Joshua who offered to '*renovate* it with *lasting* Colors'.[140] In 1784, as we have seen, he wrote to the Duke of Rutland assuring him he would repair the flaking which had occurred to *The*

Nativity. After Reynolds's death, Marchi seems to have been greatly occupied with restoring his master's pictures. Joseph Farington records that in 1796 Marchi was busy working for the Duchess of Rutland, the Duke of Beaufort, Lord Walpole, Lord Orford and Mr Walpole, repairing their pictures by Reynolds. One of the pictures he cleaned and glazed was *Charles James Fox, Lady Sarah Bunbury and Lady Susan Fox Strangways* (Cat. 48) of the early 1760s, which 'had become almost white'.[141]

During his career, Reynolds often cleaned and restored pictures himself. In a letter to the Duke of Rutland dated 4 October 1786 he even boasted of 'all my experience in picture cleaning'.[142] Reynolds was duly critical of restorers: he told Lord Ossory in September 1786 that 'It is very rare to see a picture . . . of any great painter that has not been defaced in some part or rather [*sic*], and mended by picture cleaners, and have been reduced by that means to half their value.'[143] Others were equally censorious. The anonymous author of *An Essay in Two Parts on the Necessity and Form of a Royal Academy* (1755) bewailed the damage done to English collections by the cleaners. Pictures were reduced to 'dead Colourings' by them and the author is certain that more pictures were ruined in England during the past twenty years due to their interference than during the past hundred years elsewhere 'by all Accidents whatsoever'. On top of this, they charged extravagant prices for their damage.[144] A writer to *The Gentleman's Magazine* of 19 November 1764 attacked the damage done by cleaners to collections. In his opinion they had been reduced to a 'wretched condition . . . by their undergoing the various operations of a set of miscreants called *picture cleaners*; men, who, for the generality, know no more of painting than a Hotentot, and, consequently, know not when they are doing good or hurt to a picture'.[145]

Since Reynolds was critical of most cleaners he and his assistants did restoration work in the studio from time to time. In the account-book for 1783, among the charges made to Lord Erroll, appears an entry 'For mending a picture.' No specific charge is listed in the account-book. However, in a letter dated 29 July 1780 and addressed to Sir William Forbes, the charge for this work is given as £5.5s.[146] A charge of 15s was made to Lord Pembroke 'For lining a Picture of Baron Issenberg'. This is the *Self-portrait* by Baron Reis d'Eisenberg, probably given to Henry, 10th Earl of Pembroke, by the artist between 1754 and 1765.[147] Northcote recounts that Reynolds frequently 'restored' damaged Old Master paintings: from Northcote's testimony, Reynolds was quite free as far as repainting was concerned. He worked on the face of Velasquez's *Philip the Fourth when a Boy* so much that Northcote, who was unaware of this at the time, complimented Reynolds saying, 'and how exactly it is in your own manner, Sir Joshua'. The dark background to Velasquez's *Moor Blowing on a Pipe* was transformed into a sky by Reynolds, and Northcote approvingly remarked that, 'with this and some few other small alterations, it became one of the finest pictures I ever saw'.[148]

While critical of the practices of others, Reynolds seems not to have hesitated to alter pictures when it suited him. Lord Ossory had bought a copy of Titian's *Venus and Adonis*, made, in Reynolds's opinion, by Titian himself from the version then in the Palazzo Colonna. The picture was examined by Spiridione Roma (*c.* 1735–1787), a portraitist and picture restorer active in London after 1770, who declared it to have been badly damaged and greatly repainted. Nonetheless, Reynolds wanted the picture and proposed to trade Gainsborough's *Girl and Pigs* for it. He told Ossory that 'If it was mine I should try to get this off, or ruin the picture in the attempt.' Further on, he says the sky and trees 'must be repainted which I have the vanity to think nobody can do but myself'. Unfortunately for Reynolds, Lord Ossory declined his offer and requested him to send the picture to Benjamin Vandergucht (d. 1794), a dealer and cleaner. Somewhat hesitantly, Sir Joshua complied, but he did not fail to mention to Ossory the damage done by restoration to Van Dyck's large picture of *Philip 4th Earl of Pembroke and His Family* at Wilton, and Titian's *Vendramin Family*, then at Northumberland House and now in the National Gallery. Of Vandergucht he could only say that he might be as good as any of his colleagues, but that anything he might do would lessen the value of the picture.[149]

Although Reynolds had little time for professional cleaners, he did employ one, an Italian by the name of Biondi who lived in Oxford Road not far from Orchard Street. He was recommended to Reynolds in 1786 to clean Poussin's *Seven Sacraments* purchased by the Duke of Rutland and recently arrived in London. Biondi was supposedly in possession of 'an extraordinary secret for cleaning pictures'. At first Reynolds thought this so much nonsense, but the person who brought Biondi to his attention must have persisted since Sir Joshua informed the Duke that he had 'tried him by putting into his hands a couple of what I thought the most difficult pictures to clean of any in my house. The success was so complete that I thought I might securely trust him with the Sacriments, taking care to be allways present when he was at work. He possesses a liquid which he applies with a soft sponge only, and, without any violence of friction, takes off all the dirt and varnish without touching or in the least affecting the colours.' Reynolds allowed Biondi to clean the *Sacraments* and told the Duke that they were now just as 'they came from the easel'.[150] In January 1787 the Duke paid Reynolds '£8 lining, £7.7 Cleaning', which, considering the amount of work, was a very fair price.[151] Biondi was later recommended by Reynolds in 1787 to Lord Hardwicke as the best restorer he had ever encountered.

Dealing and 'faking'

Another activity which brought in far more income than restoration was picture dealing. From his correspondence there can be little doubt that Reynolds was a *marchand amateur*. He sold pictures to and/or advised the Dukes of Rutland and Portland, Lords Ossory, Warwick, Carlisle, Exeter, Pembroke, and Darnley. His practices as a dealer were not always above board, at least by present-day standards. Writing in November 1785 to his agent, the portrait painter Edmund Francis Cunningham who was at the time in Lille, Reynolds said he was prepared to have copies made of the

Rubenses he wanted from the Church of the Capuchins. To this end he was going to send over a former pupil and would 'give him proper directions how to give the copy an old appearance, so that few, even amongst the Connoisseurs shall distinguish the difference'. The families of the original donors were to be told that the originals were almost 'totally lost' and that the copies were 'the best means of preserving the remembrance of the gift of their family'.[152] This deal did not materialize. Such an arrangement was, however, successfully made with the Boccapaduli family who sold Poussin's *Seven Sacraments* to the Duke of Rutland in 1785. It cost Reynolds considerable effort to encourage this affair and he collaborated closely with James Byres (1734–1817), the Duke's agent in Rome. Since the Italian authorities would never have permitted these pictures to leave Rome, Byres devised the ruse of having copies made. Reynolds knew about this since he assured the Duke that he need not worry that Byres would send the copies instead of the originals. After the pictures had safely arrived in London and were restored, Reynolds wrote to the Duke in October 1786 and told him that one of the conditions the Boccapaduli family had set Byres was that 'he should bring the strangers as usual to see the copies . . . and, I suppose, swear they are originals'. Rather phlegmatically, Reynolds added that these copies would probably be sold in the future, others being put in their place![153] The most valuable single work which Reynolds helped to extract from Italy was Bernini's *Neptune* which he bought as an investment and might have sold more easily had he not criticized the sculptor in his *Discourses*.

Reynolds was not above using his knowledge of old techniques to perpetrate the occasional joke. When Jean-Baptiste van Loo once visited Reynolds he boasted that he could not be fooled by copies. The story goes that Reynolds then showed the Frenchman a copy he had made after Rembrandt. After studying the picture carefully, Van Loo declared it a genuine Rembrandt.[154] A more serious trick was played on the picture dealer Noël Desenfans (1745–1807) who irritated Reynolds by his constant praise of the Old Masters over the moderns. To embarrass him, Reynolds had Marchi, who evidently specialized in faking Claudes, copy Claude's *View Near the Castle of Gandolfo*. This was properly aged and substituted in the frame of the original. Reynolds then wrote on 14 April 1791 to William Cribb, his frame-maker who was in on the plot, and asked him to come and collect the picture for lining and varnishing. While at Cribb's, Desenfans was 'by chance' allowed to see the picture which he bought for £200 as the original. At this point Reynolds pounced, returned the cheque and expressed his astonishment that such an admirer of the Old Masters could be so put upon by a modern copy. To his credit, Desenfans later admitted in writing that he had often been fooled in the beginning of his career by fakes which had been given old-looking linings to enhance their appearance of genuine age. There was even an infamous fake factory in Westminster where pictures were first covered with dirt and varnish and then cooked in an oven. Reynolds did not live to read Desenfans's admission that he foolishly 'preferred to the best modern productions those of the Westminster oven'.[155]

Permanence: Reynolds's lasting merit

To a certain extent Reynolds had something of the faker in him as far as his obsession with the techniques of the Old Masters is concerned. His fevered attempts to duplicate the surface effects which only time can bestow resulted in the rapid deterioration of many of his works, and the great vulnerability of most of them. Looking at so many of his pictures which have faded, cracked excessively, and done so many unpleasant things which were not his intention when trying to emulate the works of his predecessors, one can only regret that he was so persistent. And yet this physical deterioration is very much of secondary importance in comparison to that sympathetic and perspicacious penetration into human character which is uniquely Reynolds's and as vivid as the day he recorded it with such unwieldy material as oil-paint. One has to agree wholeheartedly with Sir George Beaumont's advice to Miss Bowles's parents who had misgivings about Sir Joshua's pictures fading. 'No matter, take the chance; even a faded picture from Reynolds will be the finest thing you can have.'

NOTES

1. Smith 1828, II, p. 294.
2. Redgrave 1981, p. 55.
3. Leslie and Taylor 1865, II, p. 125.
4. Ibid. II, p. 511.
5. Northcote 1818, II, p. 70.
6. Leslie and Taylor 1865, II, p. 134; Ingamells 1985, pp. 147–8.
7. Northcote 1818, II, pp. 83–4.
8. Leslie and Taylor 1865, II, note 1 p. 215. The painting was destroyed in the fire at Belvoir Castle in 1816.
9. Reynolds 1929, p. 111.
10. Northcote 1818, II, p. 19.
11. Haydon 1845, p. 41; 1960–3, V, p. 585.
12. For Hudson see Kenwood 1979.
13. For Kneller see National Portrait Gallery 1971.
14. Northcote 1818, I, pp. 17–18.
15. For Bardwell see Talley and Groen 1975; Talley 1978. For studio practice in the seventeenth century see Talley 1981.
16. Northcote 1818, I, p. 36.
17. Ibid. p. 37.
18. Loc. cit.
19. Ibid. II, p. 24.
20. Ibid. I, p. 45. See also Graves and Cronin 1899–1901, IV, p. 1637 for list of copies after Raphael and others sold at Greenwood's, 15 April 1796.
21. Northcote 1818, II, p. 305; Leslie and Taylor 1865, I, pp. 40–1; Millar 1969, I, p. 107.
22. Northcote 1818, II, p. 22.
23. Ibid. II, p. 23; Leslie and Taylor 1865, II, p. 139 and note 1; Redgrave 1981, p. 57.
24. Northcote 1818, II, pp. 20–1.
25. Rouquet 1755, pp. 35, 38, 45. For examples see Talley 1981, pp. 348–9.
26. Whitley 1928, II, p. 306; Waterhouse 1981, p. 321.
27. Edwards 1808, p. 54.
28. Pye 1845, p. 153.
29. Whitley 1928, II, p. 283.
30. Gwynn 1898, pp. 57, 110, 111; Whitley 1928, II, p. 299.
31. Ibid. p. 290.
32. Northcote 1818, II, p. 25; Gwynn 1898, p. 93; Whitley 1928, II, p. 291.
33. Northcote 1818, I, p. 285.
34. Ibid. II, p. 27.
35. The memorandum is written in the accounts column opposite the middle of the week commencing 20 March 1769.

36. Whitley 1928, II, p. 285; Waterhouse 1981, p. 112; and for Doughty see Ingamells 1964.
37. Northcote 1818, II, p. 180; Gwynn 1898, p. 225.
38. *Artist's Repository* 1784–6, II, p. 63; Cormack 1970, p. 105; Reynolds 1929, p. 56; Leslie and Taylor 1865, I, note 2 p. 101, note 1 p. 224; II, note 11 pp. 343–4; Northcote 1818, I, pp. 78, 82–3, 97, 221; II, pp. 4, 86, 271–2; Waterhouse 1973, p. 40.
39. Reynolds 1929, p. 122 and note 2, pp. 190–1.
40. Northcote 1818, I, p. 102.
41. Ibid. I, p. 299. For Kneller see Talley 1981, p. 349.
42. Cotton 1859, p. 58.
43. Leslie and Taylor 1865, II, pp. 326–7.
44. For studio furnishings: Northcote 1818, I, pp. 102–3; II, pp. 25–7, 64; Leslie and Taylor 1865, I, note 3 p. 182; II, p. 356.
45. Ibid. I, p. 248; for Lely see Talley 1981, pp. 369–72.
46. Northcote 1818, I, p. 252; Leslie and Taylor 1865, II, note 1 p. 80, 82.
47. Rouquet 1755, pp. 42–3.
48. Whitley 1928, II, p. 289.
49. Northcote 1818, II, p. 325.
50. For Daulby see Reynolds 1929, p. 56. I am indebted to Nicholas Penny for this discussion of Reynolds's sittings.
51. Northcote 1818, II, p. 9.
52. Ibid. I, p. 24; Leslie and Taylor 1865, II, pp. 196, 214, 313; Waterhouse 1941, p. 47.
53. Whitley 1928, II, p. 284.
54. Northcote 1819, I, p. 204.
55. Mason quoted in Leslie and Taylor 1865, I, p. 174.
56. See Cat. 82.
57. Leslie and Taylor 1865, I, p. 213. The theory has been challenged by Nicholas Penny.
58. Martin Postle has traced the career of George White in an article to be published shortly.
59. Cotton 1859, p. 57.
60. Le Blanc 1747, I, pp. 115–16.
61. Talley 1981, pp. 345–9, 367, and *passim*.
62. Northcote 1818, I, p. 23.
63. Ibid. I, pp. 55–6, 83.
64. Ibid. I, p. 68.
65. Leslie and Taylor 1865, II, pp. 422–3.
66. Ibid. II, p. 184.
67. Ibid. II, p. 198.
68. Ibid. II, note 1 p. 315.
69. Ibid. II, p. 476.
70. Northcote 1818, I, p. 118.
71. Ibid. I, p. 38; Cormack 1970, p. 141.
72. Northcote 1818, I, p. 78.
73. Cormack 1970, p. 141.
74. Loc. cit.; Eastlake 1847, p. 540.
75. Cormack 1970, p. 141.
76. Haydon 1960–3, V, p. 580.
77. Ibid. p. 583.
78. Ibid. p. 585.
79. Whitley 1928, II, p. 282.
80. Haydon 1960–3, V, p. 578.
81. Cormack 1970, p. 143; Leslie and Taylor 1865, I, note 10 p. 466.
82. Cormack 1970, p. 141; Eastlake 1847, I, p. 540.
83. Haydon 1960–3, V, pp. 574, 579.
84. Northcote 1818, II, pp. 26–7.
85. Haydon 1960–3, V, p. 579.
86. Northcote 1818, I, p. 22. For Gandy see Talley 1981, pp. 306–58.
87. Caylus 1755, p. 69.
88. Cormack 1970, p. 141.
89. Haydon 1960–3, V, p. 575; Leslie and Taylor 1865, I, note 8 p. 266.
90. Haydon 1960–3, V, p. 585.
91. Ibid. p. 575.
92. Ibid. p. 579; Eastlake 1847, I, p. 543; Caylus 1755, p. 71.
93. Haydon 1960–3, IV, pp. 232–3; V, pp. 583, 586.
94. Leslie and Taylor 1865, I, pp. 112–13.
95. *Artist's Repository*, 1784–6, II, p. 20.
96. Haydon 1960–3, III, p. 140.
97. Ibid. V, pp. 577, 581.
98. Cormack 1970, p. 168.
99. Eastlake 1847, I, p. 542.
100. For asphaltum see Doerner 1949, p. 89; Van de Graaf 1958, pp. 59–60; Gettens and Stout 1966, pp. 94–5; Harley 1970, pp. 140–1; Talley 1981, pp. 25, 39, 75, 159.
101. Talley and Groen 1975, p. 65; Williams 1937.
102. Reynolds 1819, III, p. 142.
103. Whitley 1928, II, p. 282.
104. Ibid. I, pp. 332–5.
105. Northcote 1818, I, p. 78.
106. Cotton 1859, p. 52.
107. Northcote 1818, I, p. 158; Haydon 1960–3, V, p. 575.
108. Cotton 1859, pp. 53–4; *Artist's Repository* 1784–6, II, pp. 27, 73.
109. Cormack 1970, p. 141; Merrifield 1849, I, p. ccii; Haydon 1960–3, V, pp. 576, 577.
110. Reynolds 1929, p. 74; Cormack 1970, p. 143.
111. Cormack 1970, p. 169.
112. Haydon 1960–3, V, p. 579.
113. Talley and Groen 1975, p. 62; *Artist's Repository* 1784–6, II, pp. 66, 67, 73, 101.
114. Copy of letter among the Hilles MSS, Beinecke Rare Book and Manuscript Library, Yale University.
115. Northcote 1818, II, p. 18.
116. Cotton 1859, p. 51, 55–6; Leslie and Taylor 1865, I, note 1 p. 60.
117. Cormack 1970, p. 141.
118. Eastlake 1847, I, p. 542; Haydon 1960–3, V, p. 579.
119. Haydon 1960–3, V, p. 580.
120. Cotton 1859, p. 51.
121. Leslie and Taylor 1865, I, p. 142; Talley and Groen 1975, p. 61.
122. Cormack 1970, p. 141.
123. Haydon 1960–3, V, p. 580; Eastlake 1847, I, p. 444; Gettens and Stout 1966, pp. 114–15.
124. *Artist's Repository* 1784–6, II, p. 74; Harley 1970, pp. 90–1; Talley and Groen 1975, p. 61.
125. Whitley 1928, II, p. 282.
126. Eastlake 1847, I, pp. 542–3; Northcote 1818, II, p. 5.
127. Haydon 1960–3, V, p. 580 and note 6.
128. Ibid. p. 577.
129. Ibid. p. 580.
130. *Artist's Repository* 1784–6, II, p. 64.
131. Dossie 1758, I, pp. 201–3.
132. Haydon 1960–3, V, p. 585; Leslie and Taylor 1865, I, note 10 p. 466.
133. Cotton 1859, p. 50; Cormack 1970, p. 142.
134. Northcote 1818, I, p. 37.
135. Leslie and Taylor 1865, I, note 1 p. 60.
136. Northcote 1818, I, p. 78; Cotton 1859, pp. 50–1; Eastlake 1847, I, pp. 539, 541; Church 1890, pp. 93–4; Cormack 1970, p. 142.
137. Northcote 1818, I, pp. 291–2, 299.
138. Haydon 1960–3, V, pp. 576–7.
139. Cotton 1859, p. 51.
140. Letter in Hilles MSS in Beinecke Rare Book and Manuscript Library, Yale University.
141. Farington 1978–84, II, pp. 588, 591, 593.
142. Reynolds 1929, p. 163.
143. Ibid. p. 160.
144. *An Essay in Two Parts*, 1755, pp. 6, 17.
145. *Gentleman's Magazine* 1764, p. 534.
146. Letter in Hilles MSS, in the Beinecke Rare Book and Manuscript Library, Yale University; Leslie and Taylor 1865, II, p. 427.
147. Cormack 1970, p. 131; Pembroke 1968, p. 15, cat. no. 1.
148. Northcote 1818, II, pp. 189–90.
149. Reynolds 1929, pp. 153–4, 159.
150. Ibid. p. 163.
151. Cormack 1970, p. 163.
152. Reynolds 1929, pp. 142–3.
153. Ibid. pp. 125–7, 165.
154. Northcote 1818, II, p. 25.
155. Reynolds 1929, pp. 215–16; Pye 1845, pp. 242–3.

COLOUR PLATES

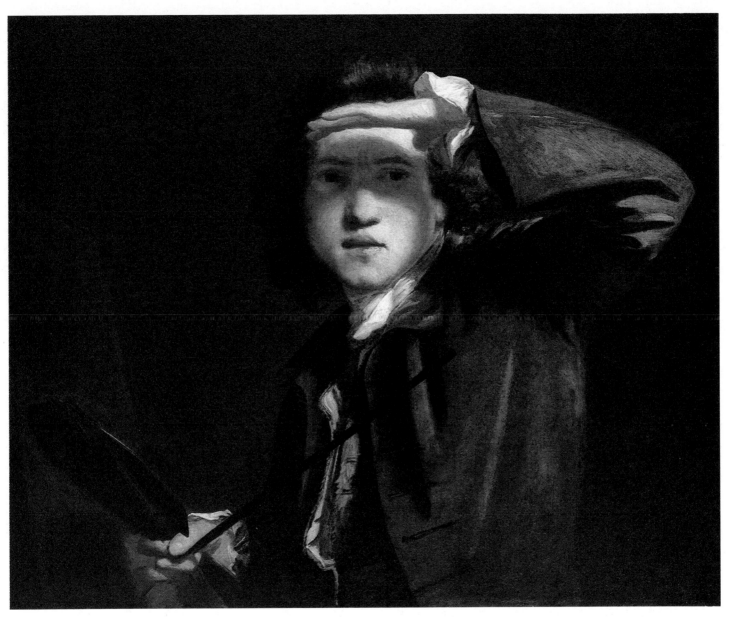

13 *Self-portrait Shading the Eyes*

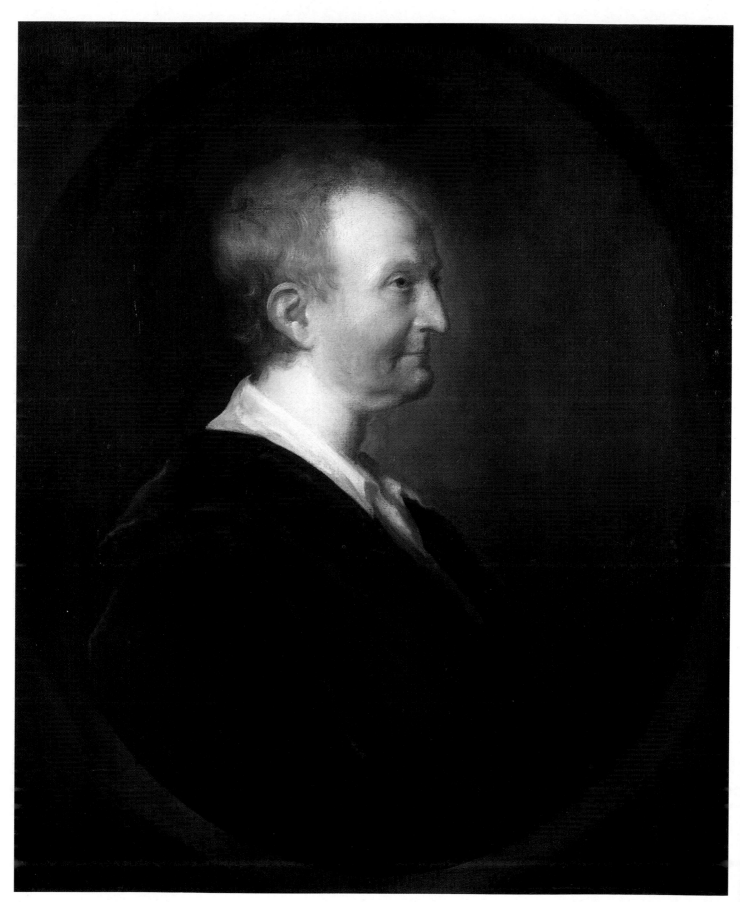

4 *The Reverend Samuel Reynolds*

7 *Boy Reading*

11 *First Lieutenant Paul Henry Ourry*

10 *Portrait, possibly of William, Fifth Lord Byron*

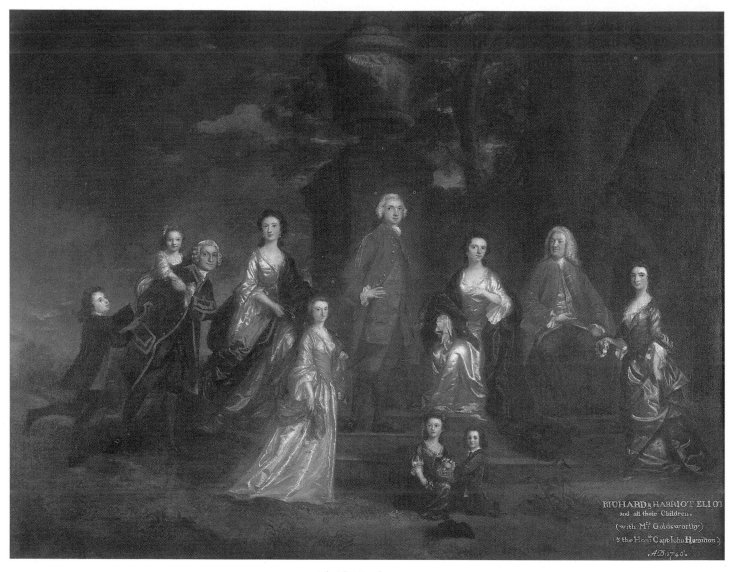

2 *The Eliot Family*

15 *Ralph Howard's Escapade*

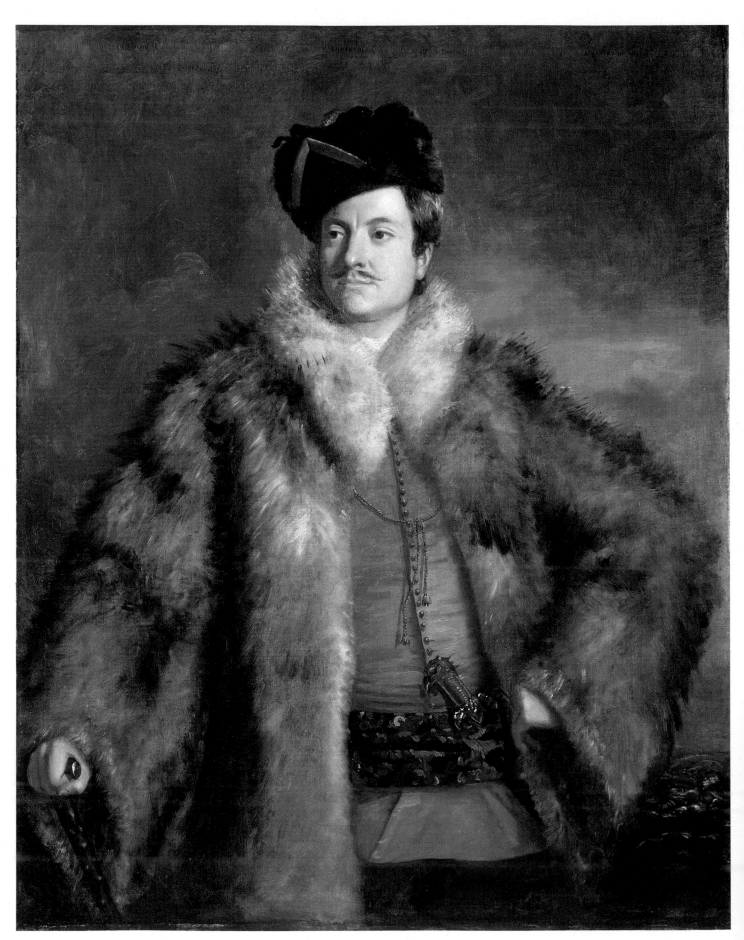

3 *Captain the Hon. John Hamilton*

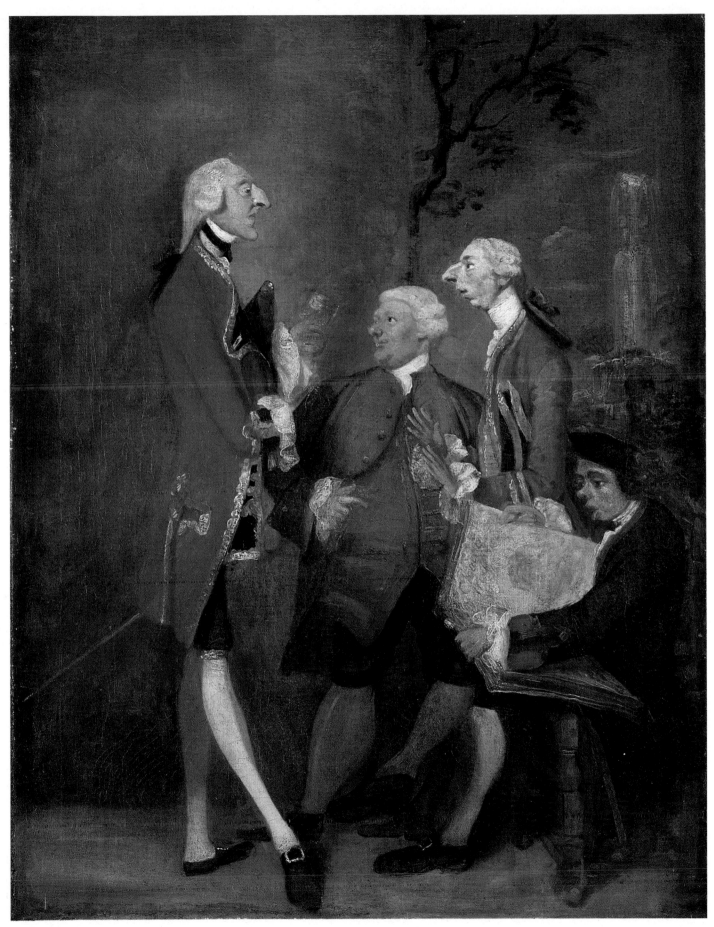

14 *Four Learned Milordi*

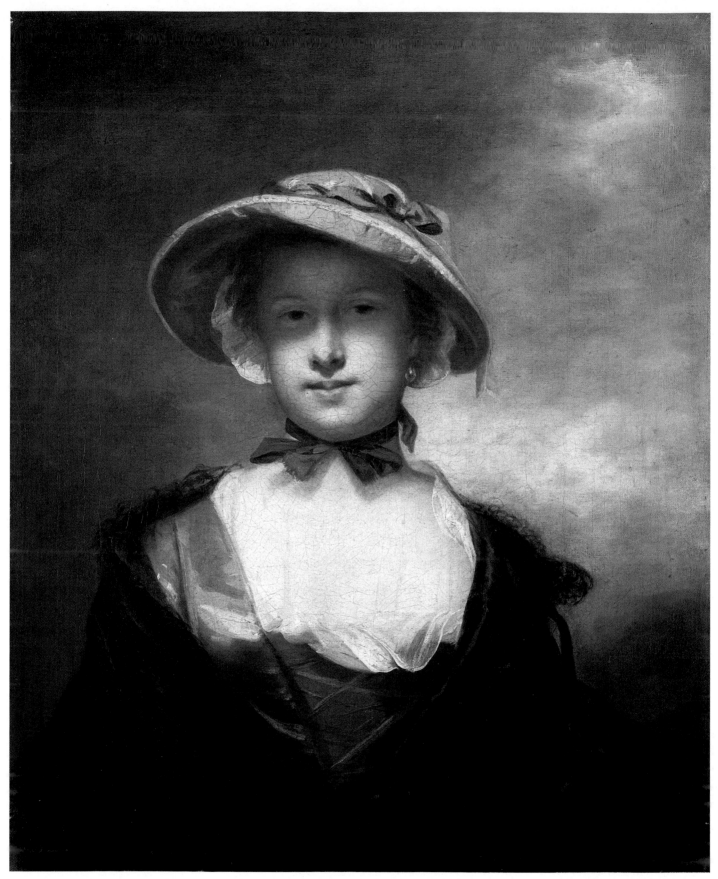

16 *Catherine Moore*

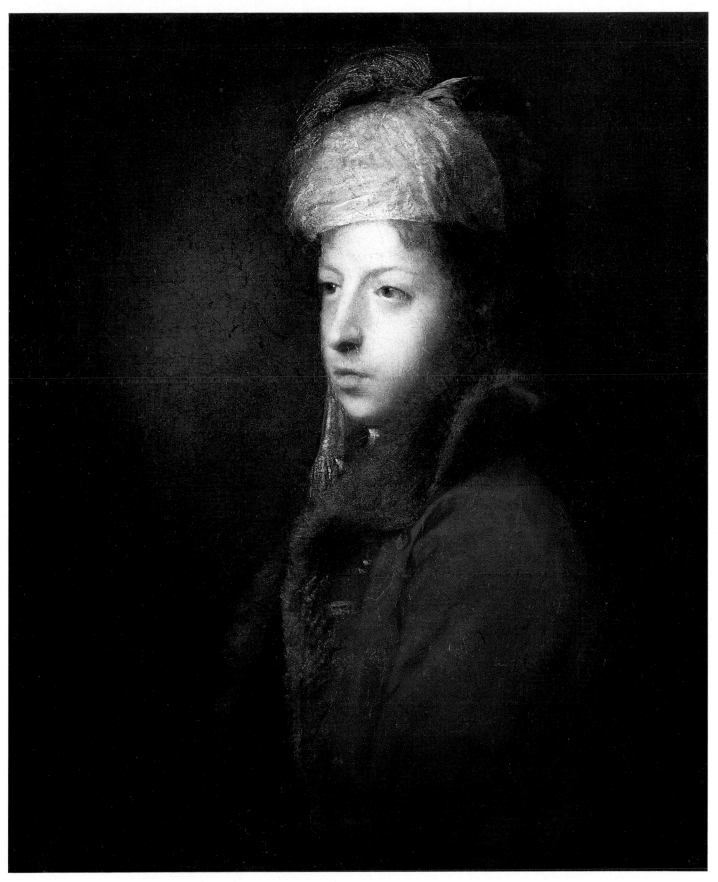

18 *Guiseppe Marchi*

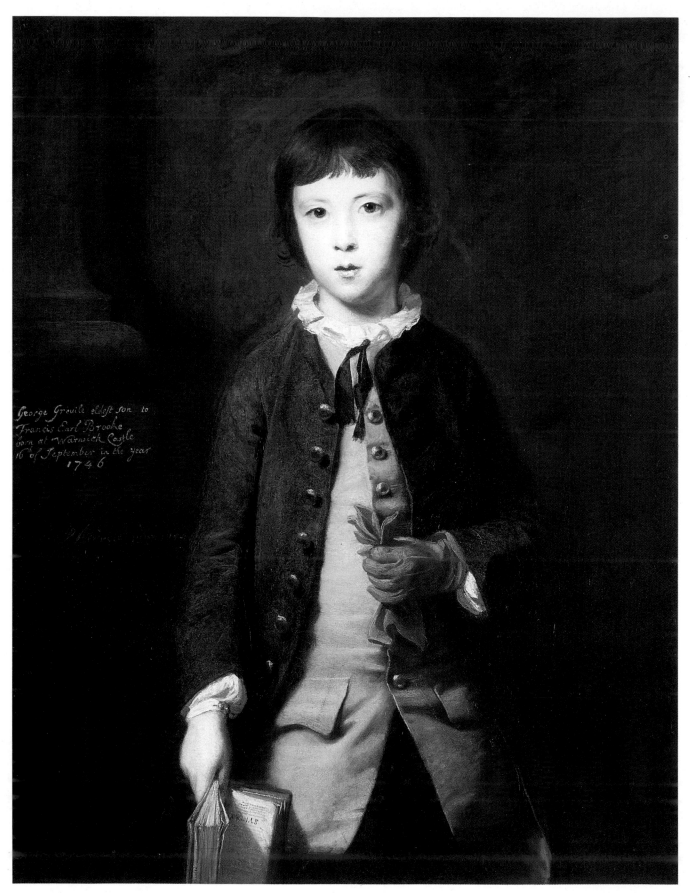

George Greuile eldest son to
Francis Earl Brooke
born at Warwick Castle
16 of September in the year
1746

22 *Lord George Greville*

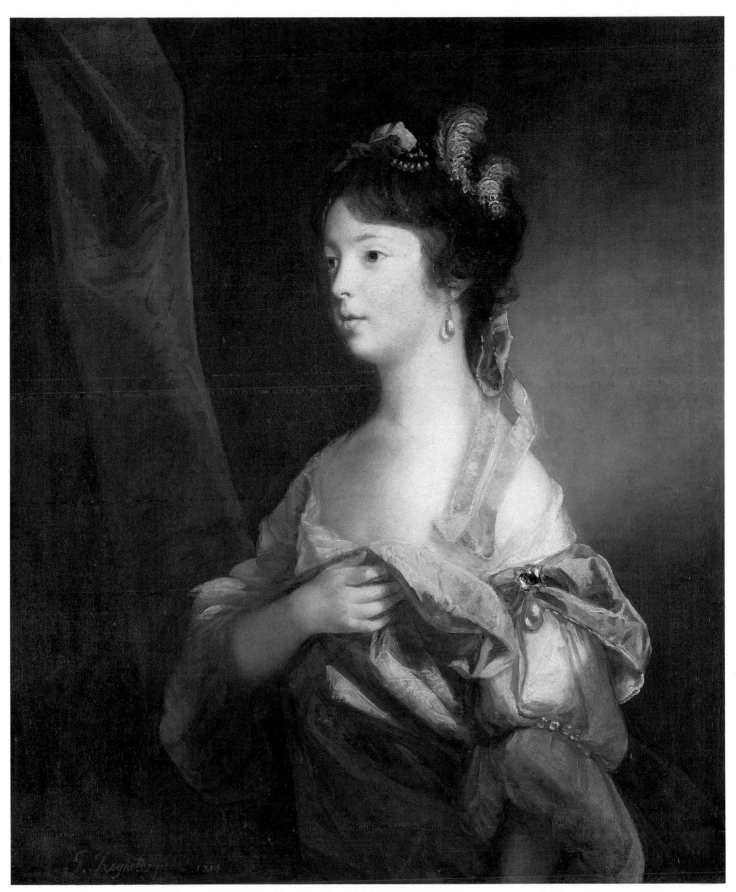

21 *Lady Charlotte Fitzwilliam*

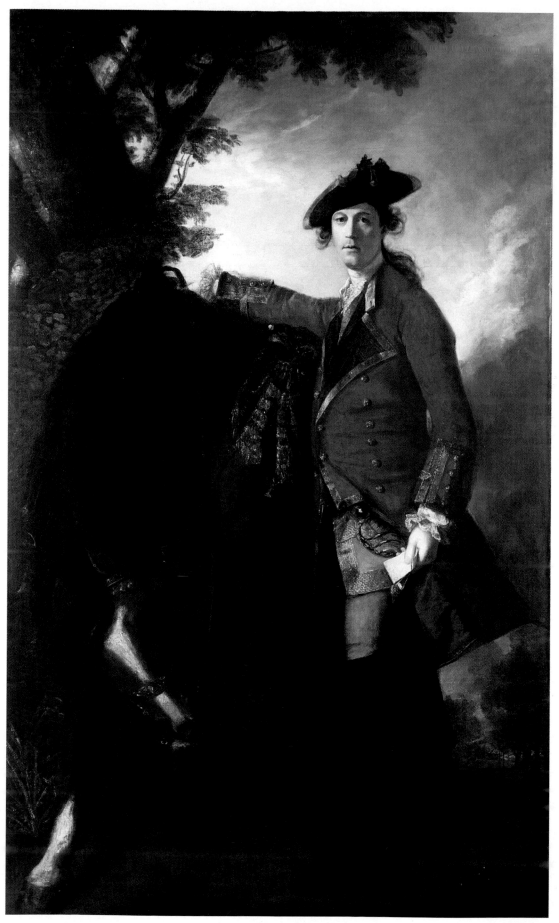

26 *Captain Robert Orme*

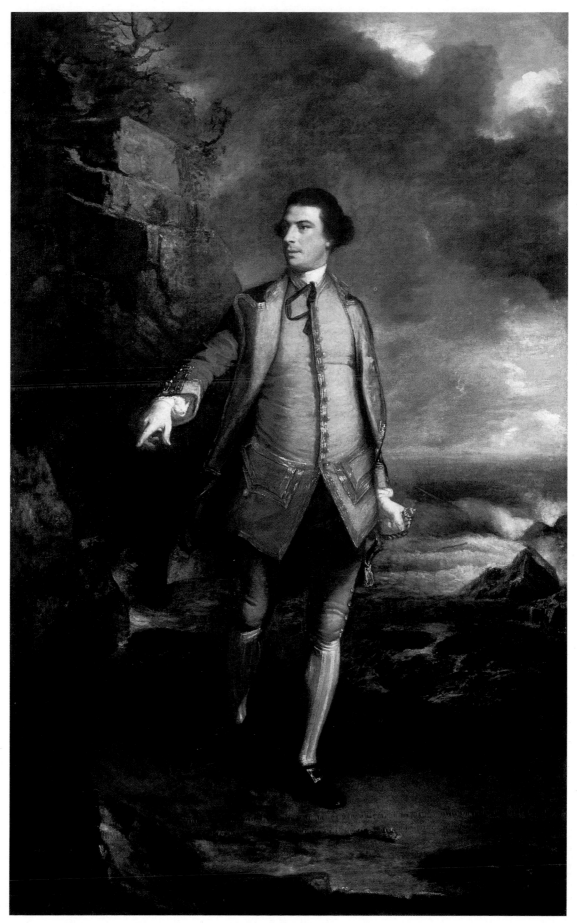

19 *Commodore Augustus Keppel*

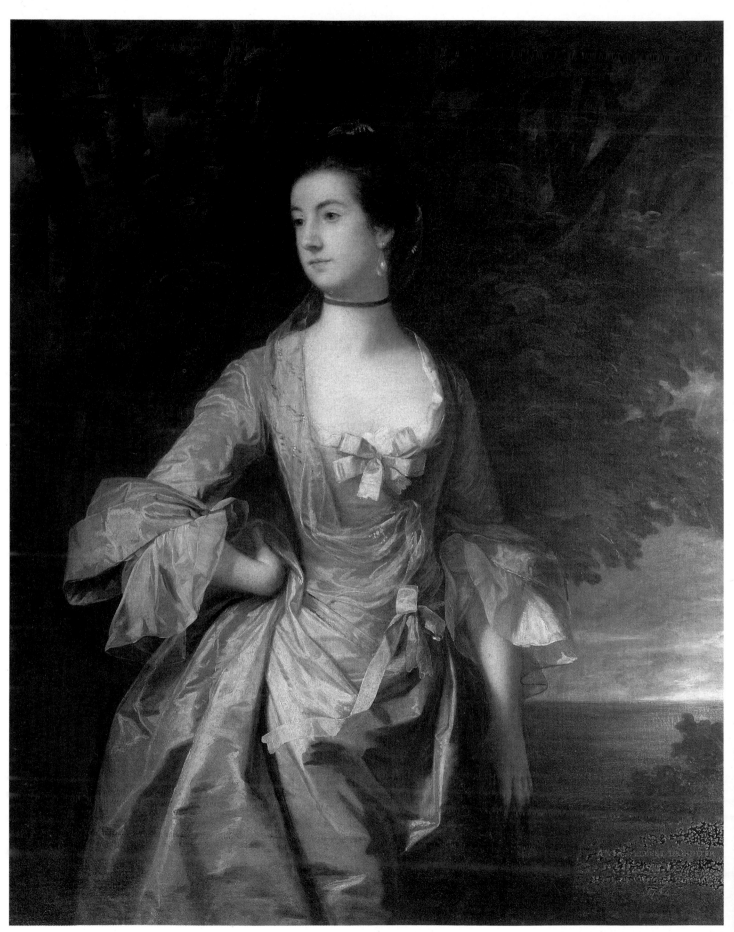

23 *Mrs Hugh Bonfoy*

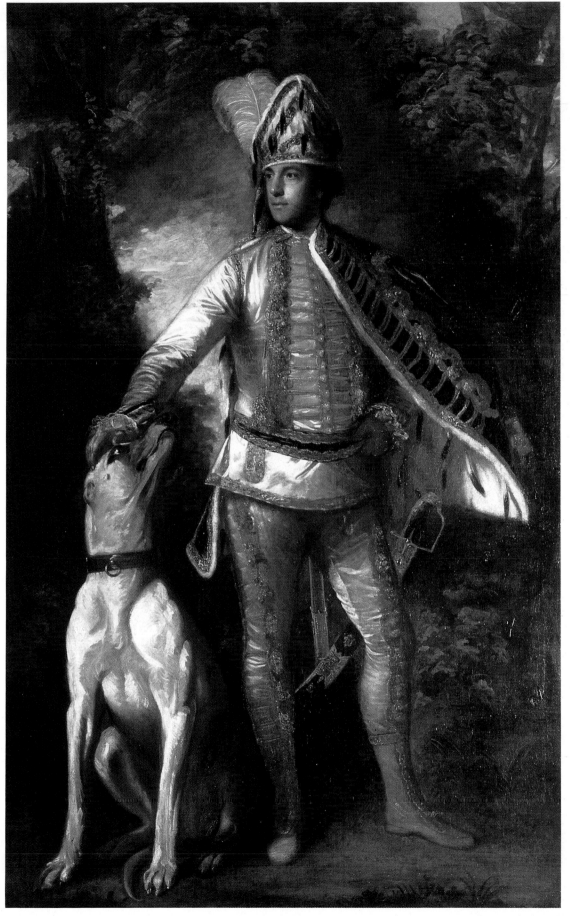

25 *Mr Peter Ludlow*

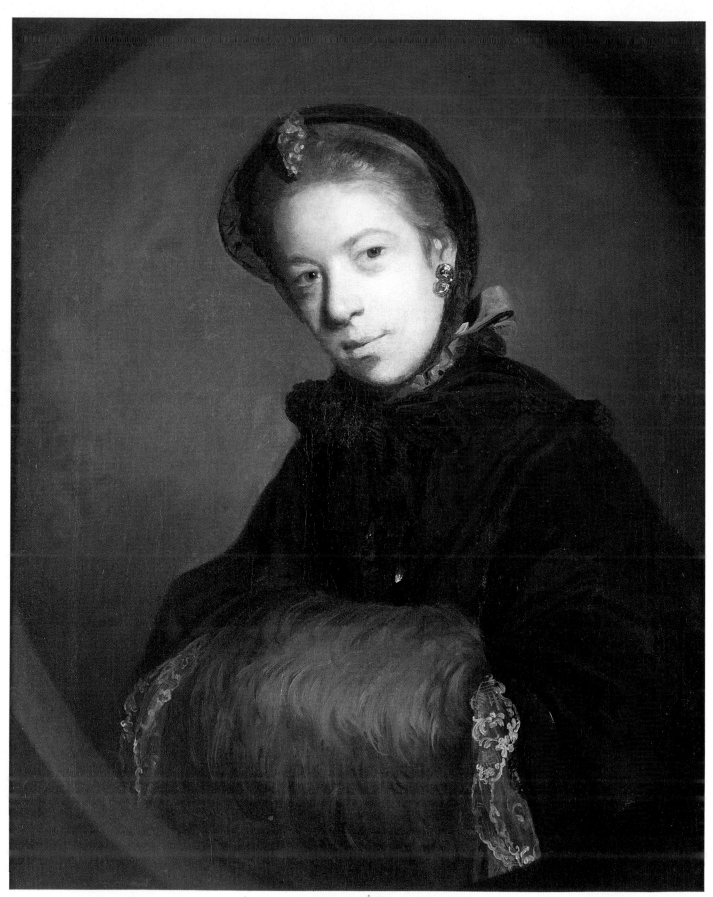

27 *Miss Mary Pelham*

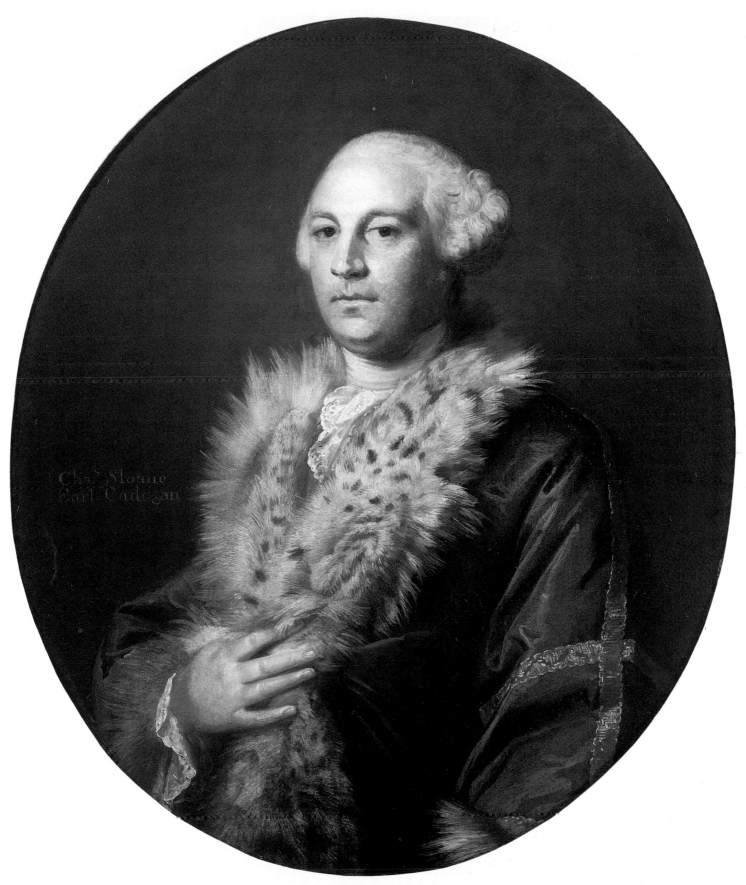

24 *The Hon. Charles Sloane Cadogan* MP

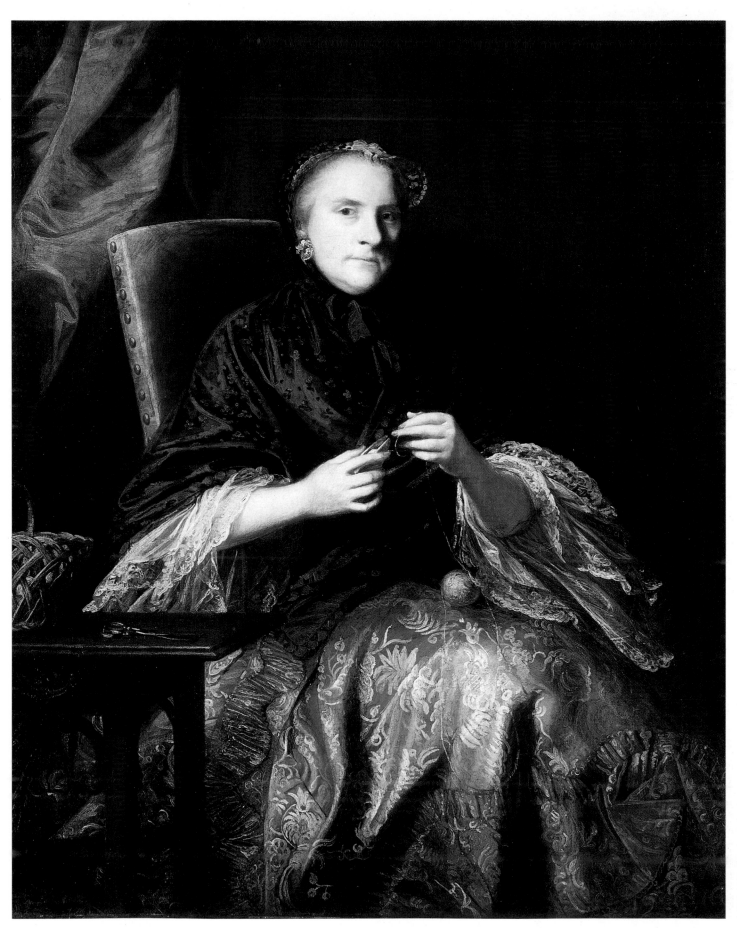

33 *Anne, Countess of Albemarle*

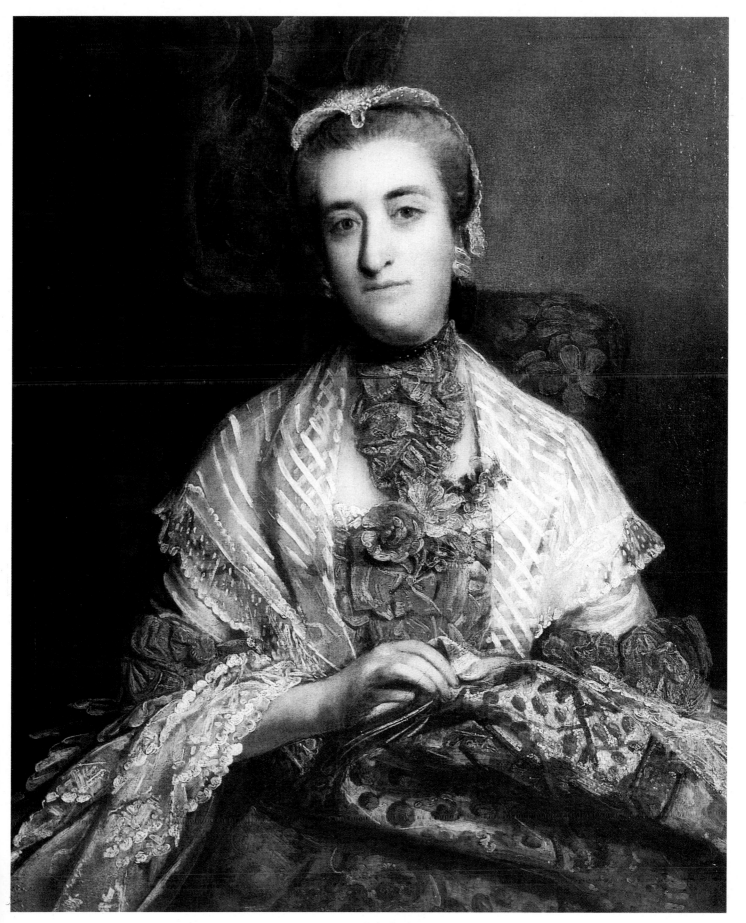

29 *Lady Caroline Fox*

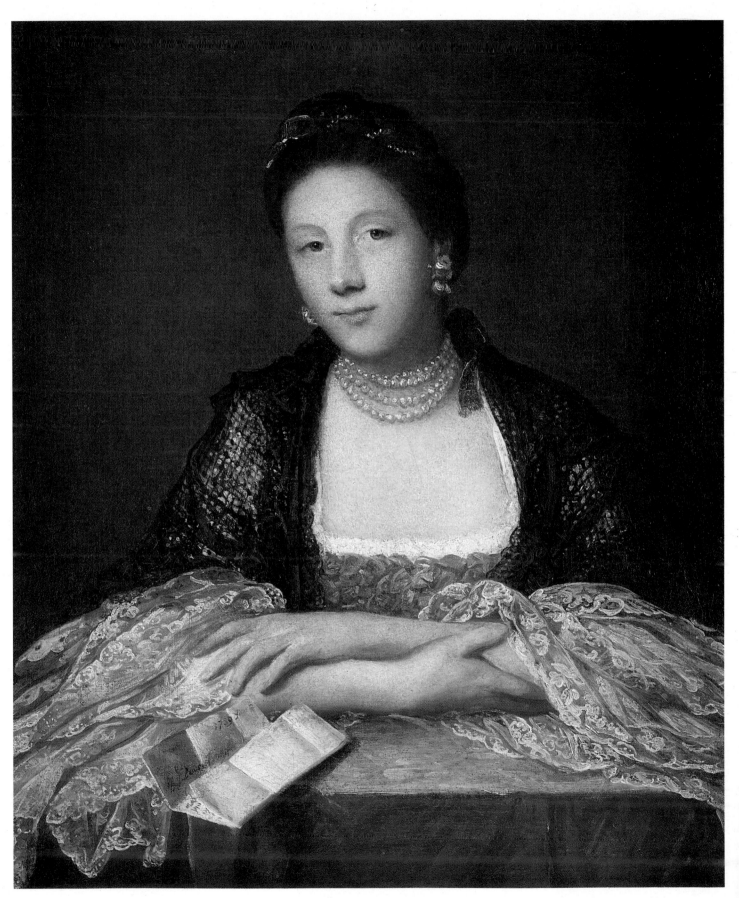

31 *Miss Kitty Fisher*

46 *Miss Kitty Fisher*

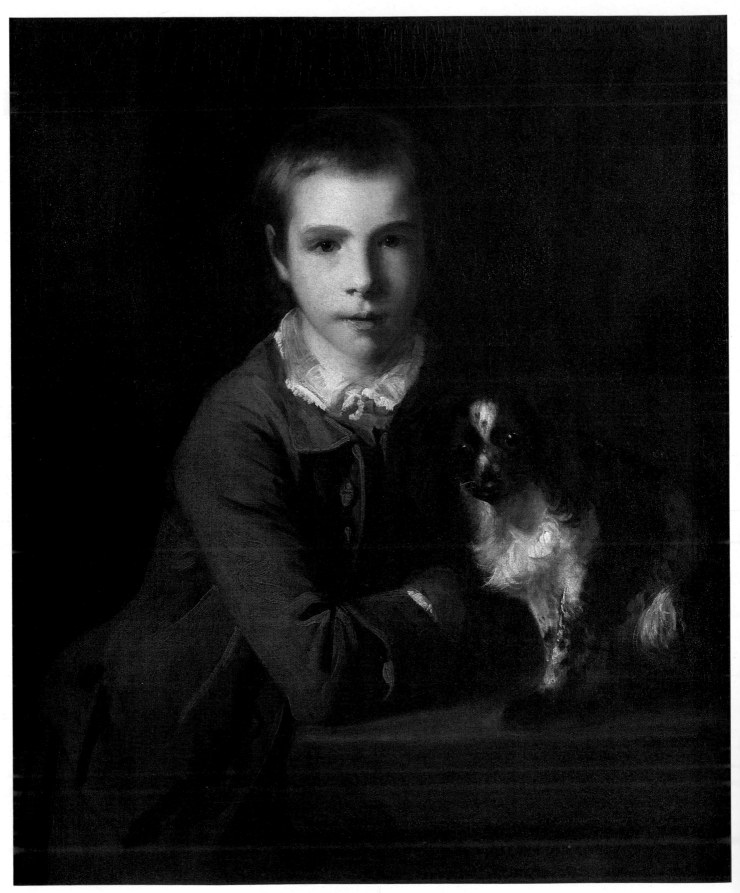

35 *Viscount Milsington*

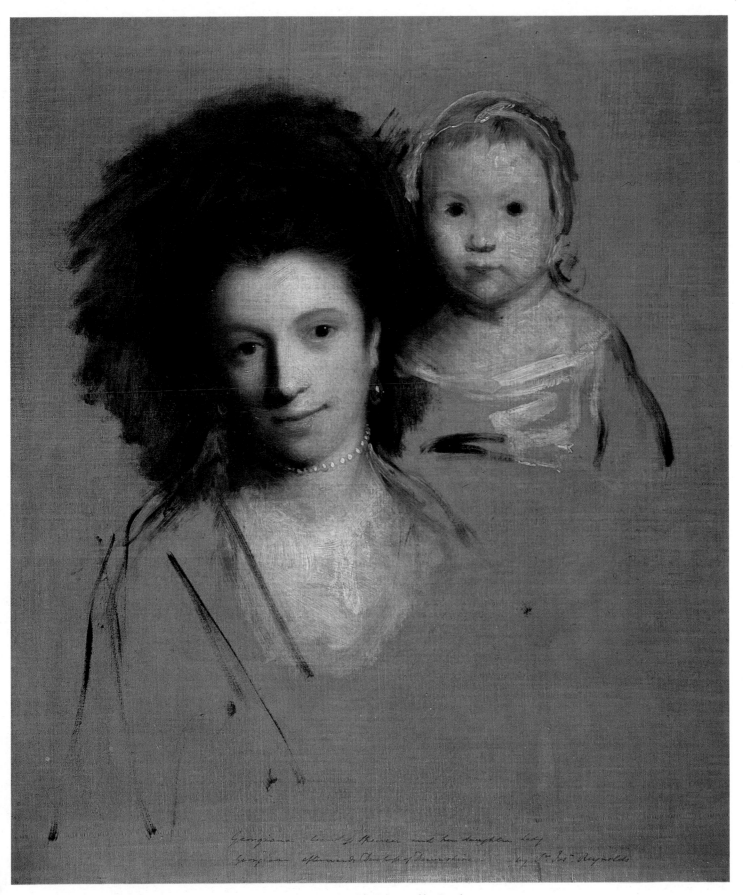

32 *Mrs John Spencer and her Daughter*

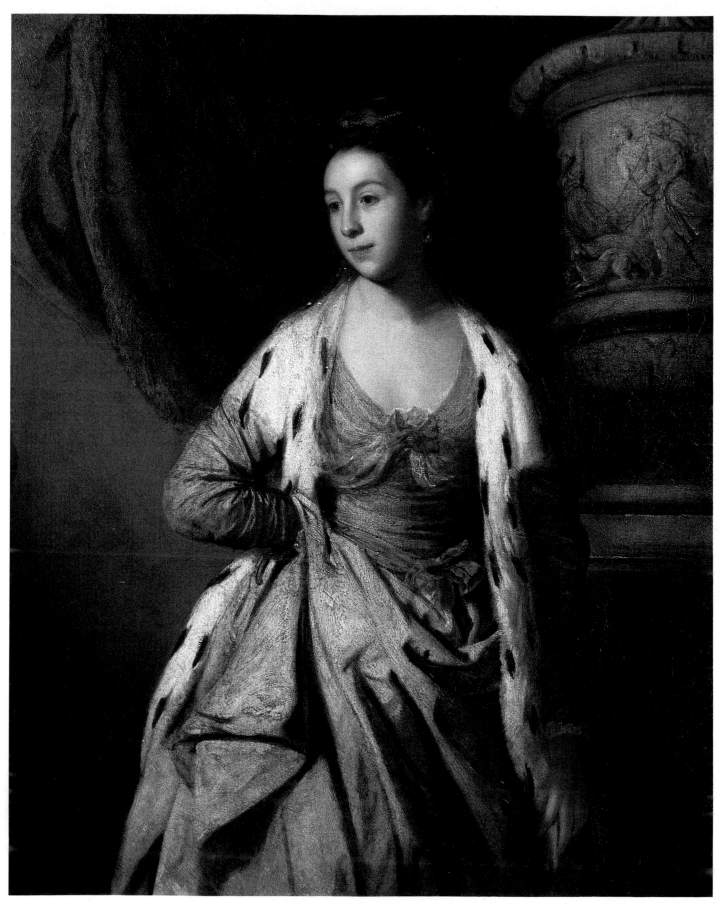

40 *Rebecca, Viscountess Folkestone*

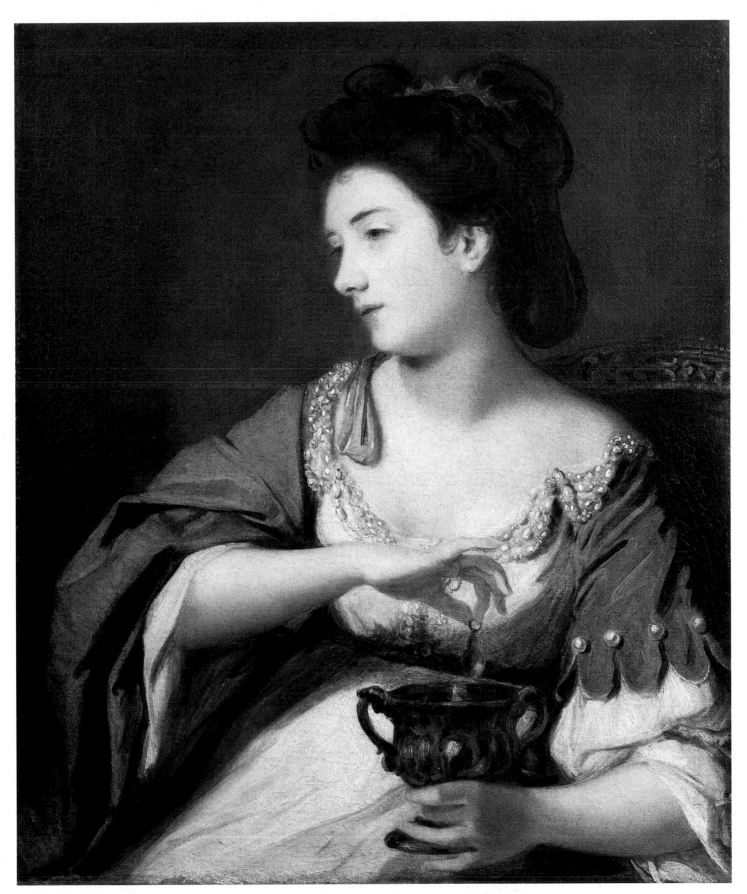

34 *Miss Kitty Fisher in the Character of Cleopatra*

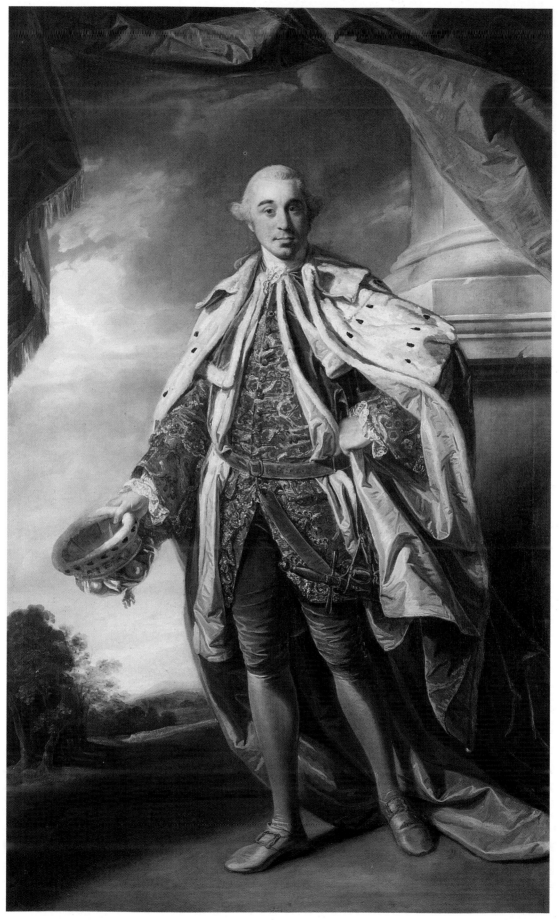

45 *Lord Middleton*

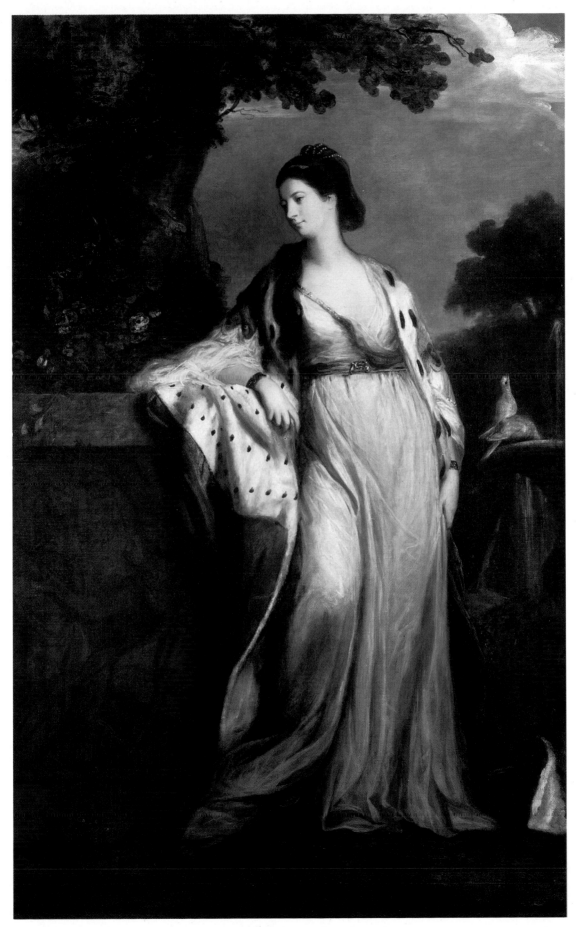

36 *Elizabeth Gunning, Duchess of Hamilton and Argyll*

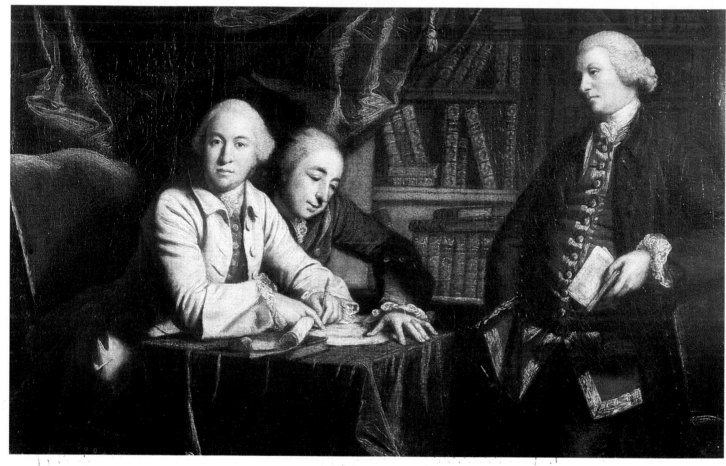

41 A 'Conversation'

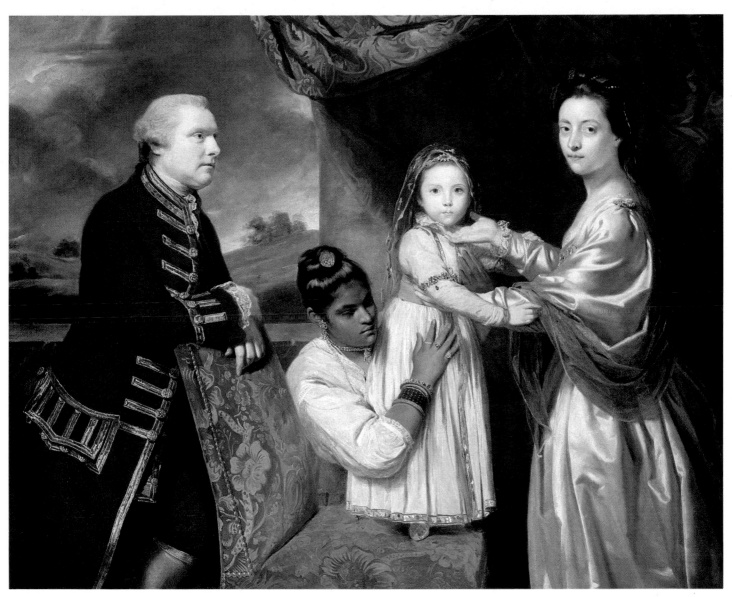

49 *George Clive with his Family and an Indian Maidservant*

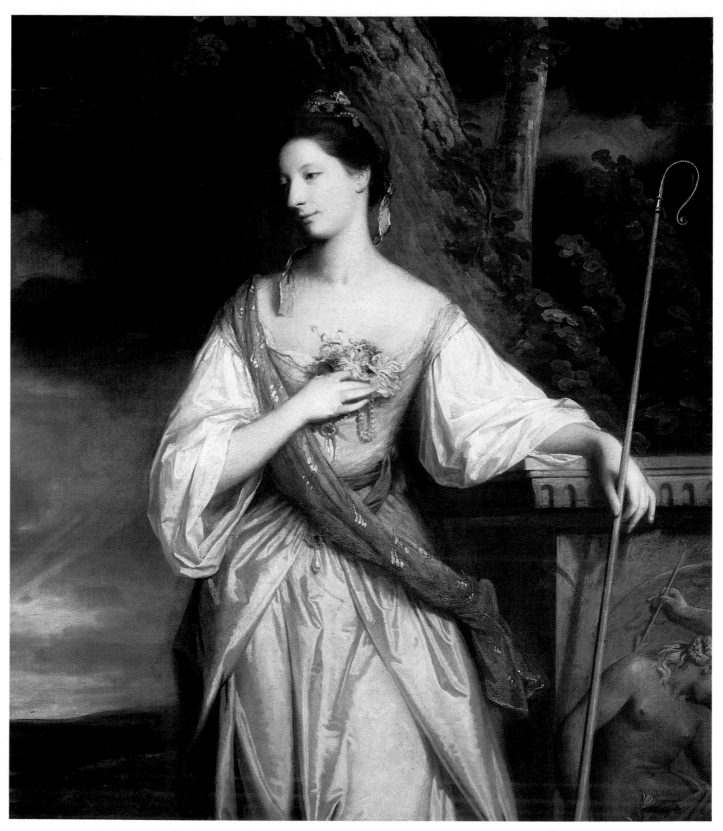

54 *Anne Dashwood*

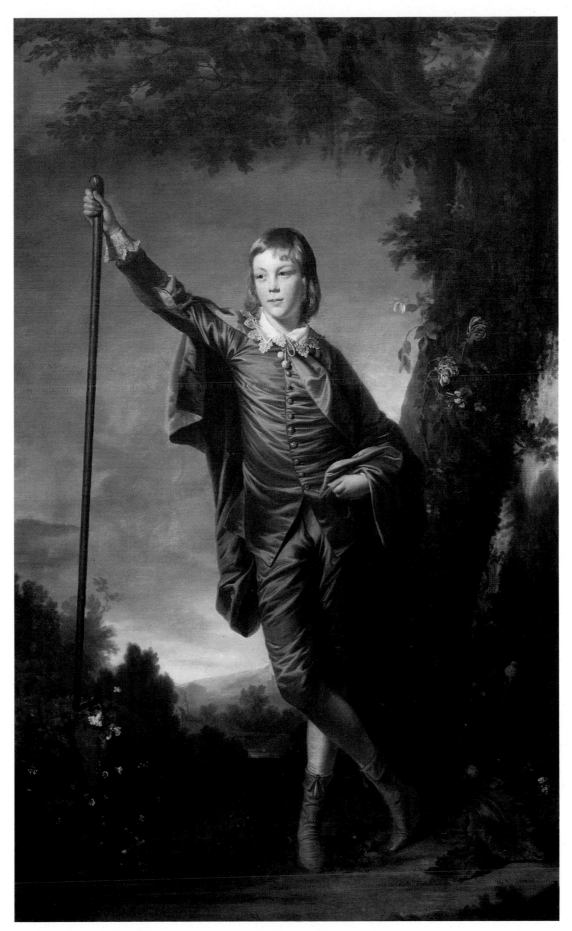

53 *Master Thomas Lister*

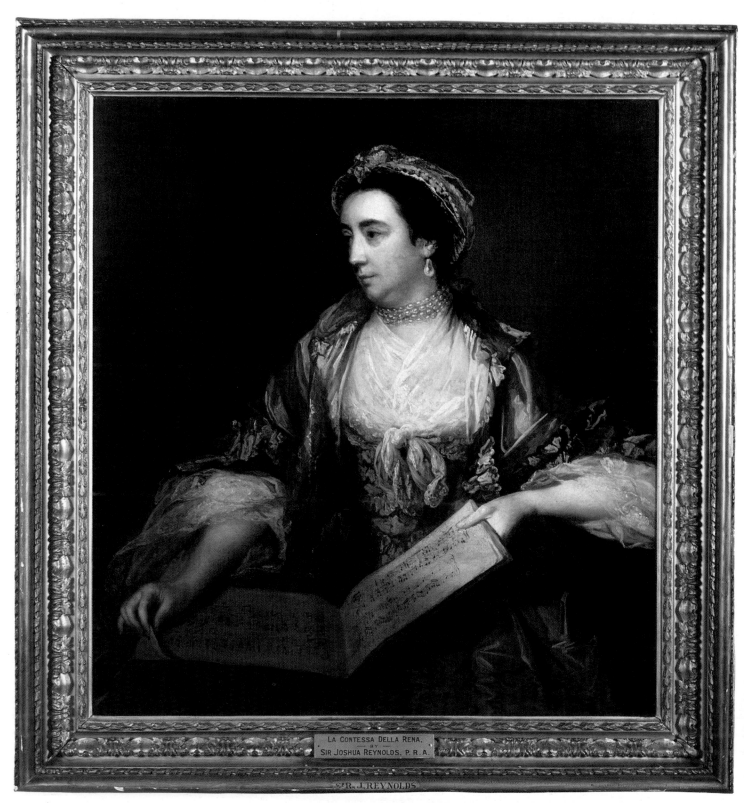

The labels on the frame read:

LA CONTESSA DELLA RENA,
BY
SIR JOSHUA REYNOLDS, P. R. A.

SIR J. REYNOLDS

43 *The 'Contessa' della Rena*

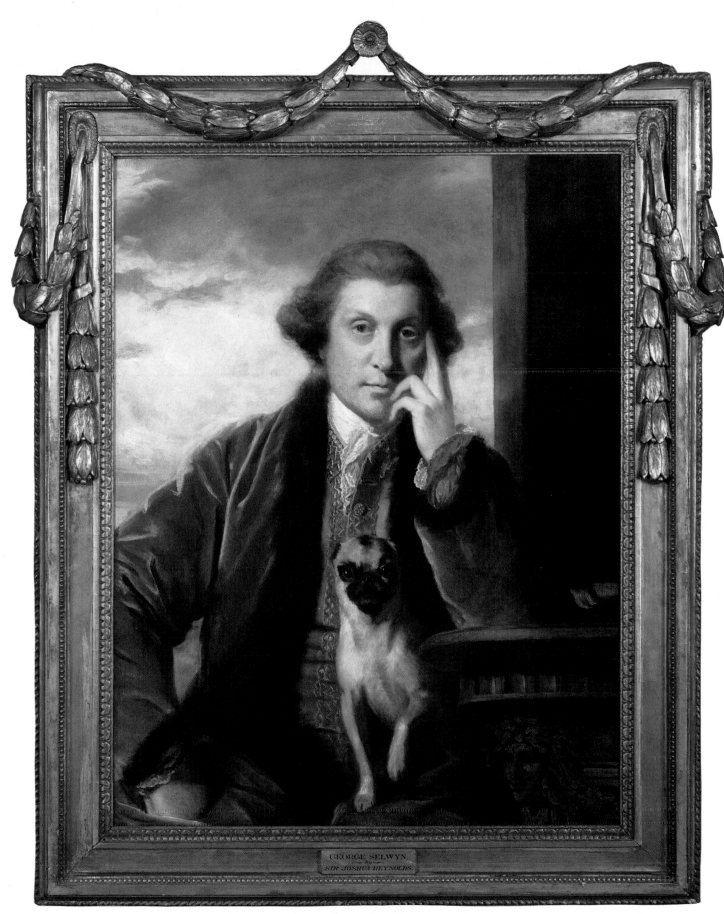

63 *George Selwyn*

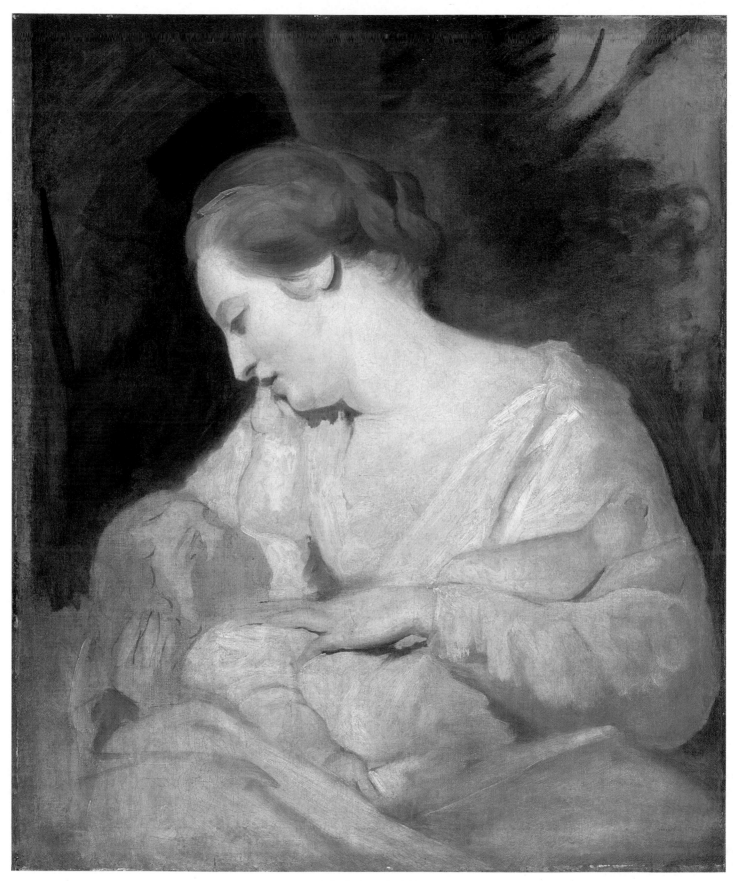

52 *Mrs Richard Hoare and Child*

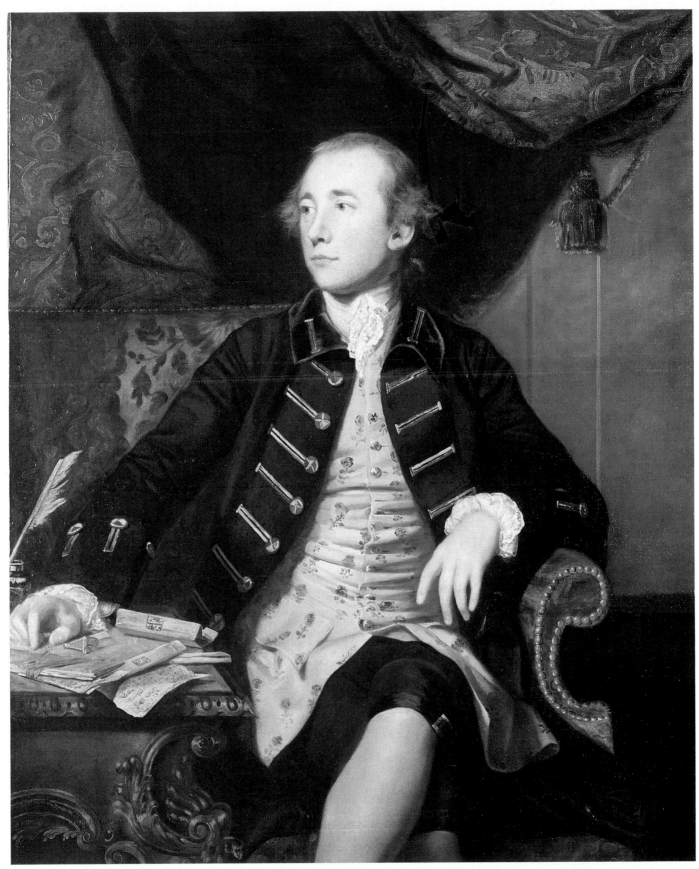

66 *Warren Hastings*

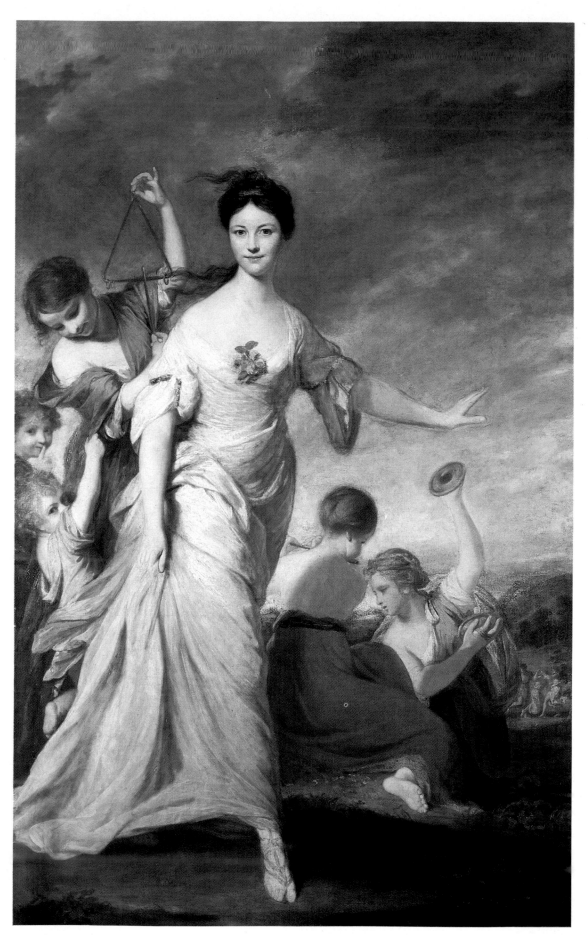

61 *Mrs Hale as 'Euphrosyne'*

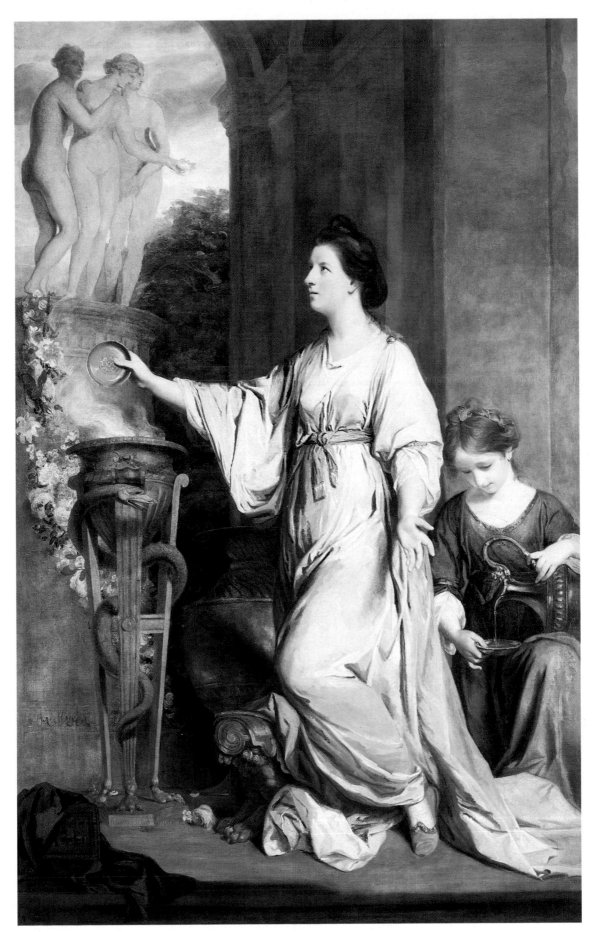

57 *Lady Sarah Bunbury Sacrificing to the Graces*

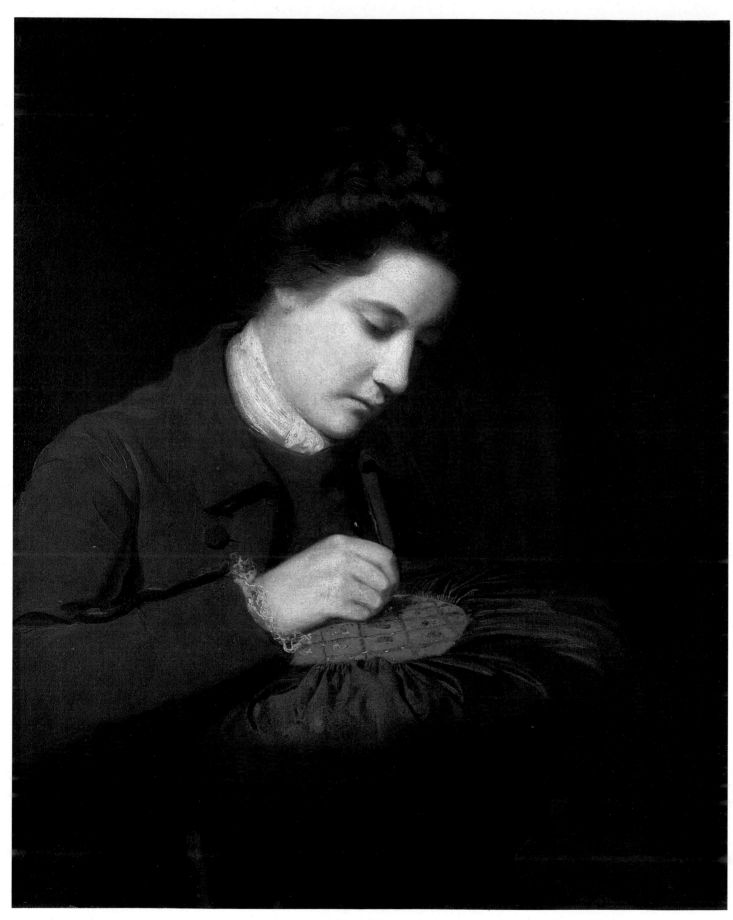

64 *Lady Charles Spencer*

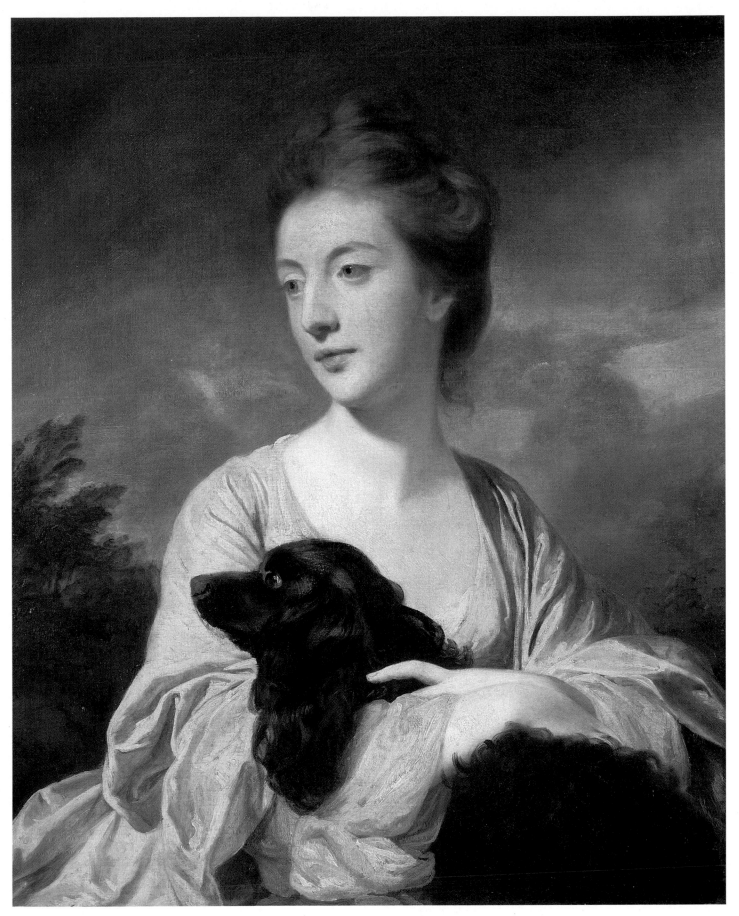

65 *Mary, Duchess of Richmond*

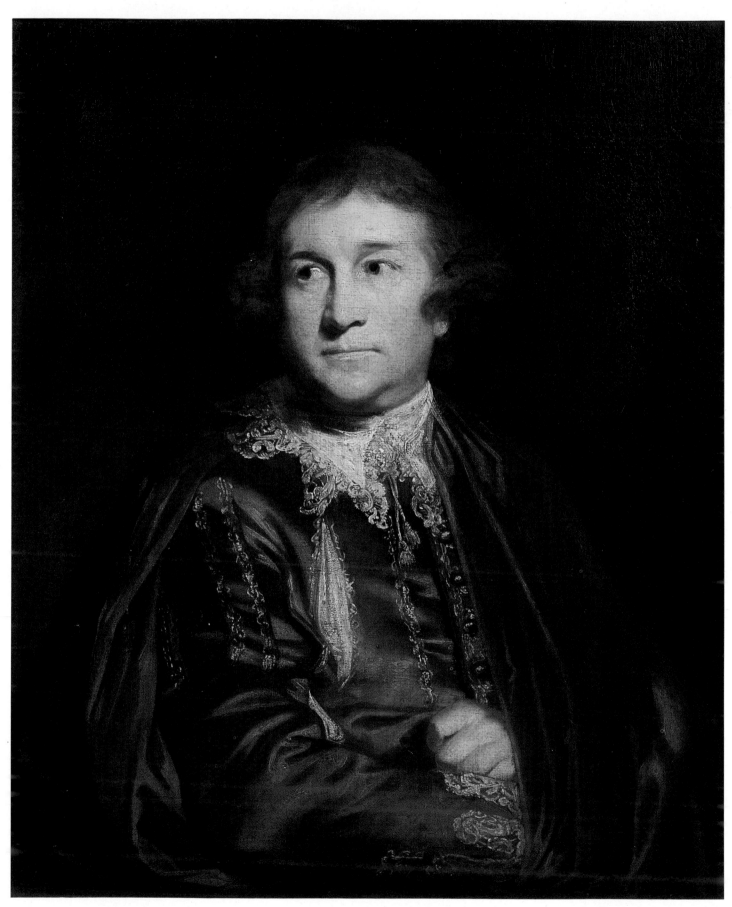

69 *David Garrick in the Character of Kiteley*

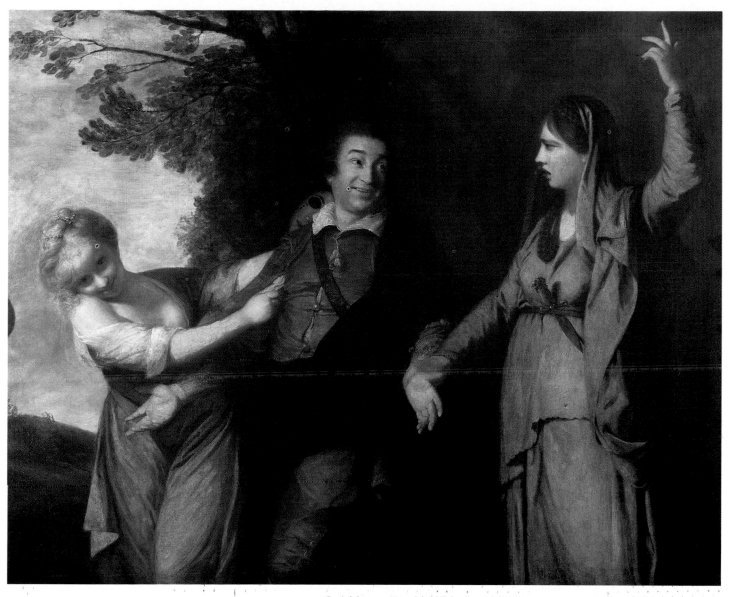

42 *Garrick between Tragedy and Comedy*

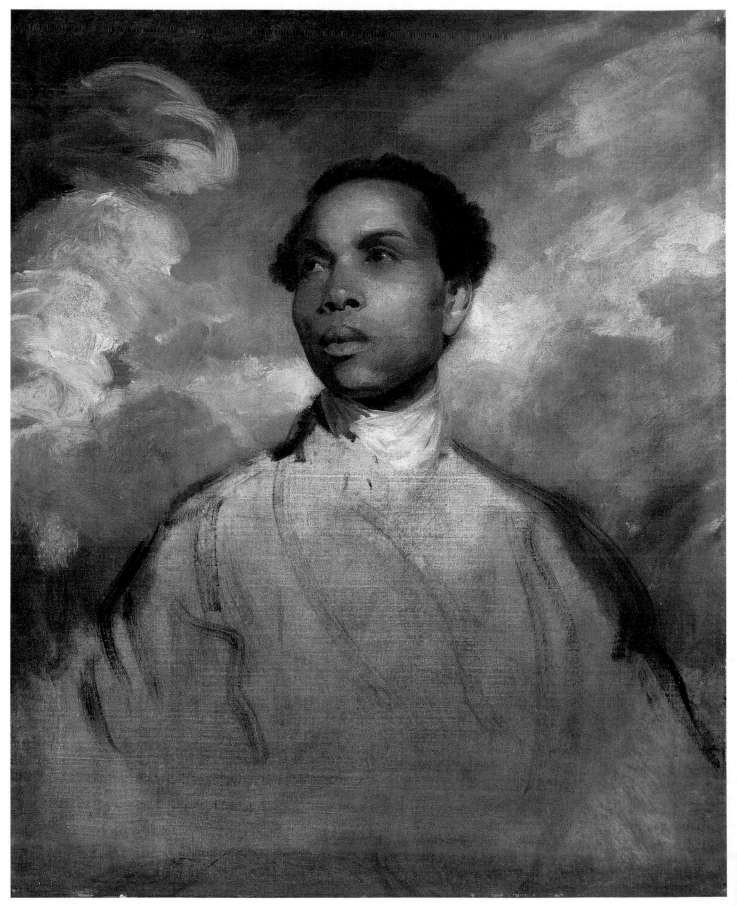

77 *A Young Black*

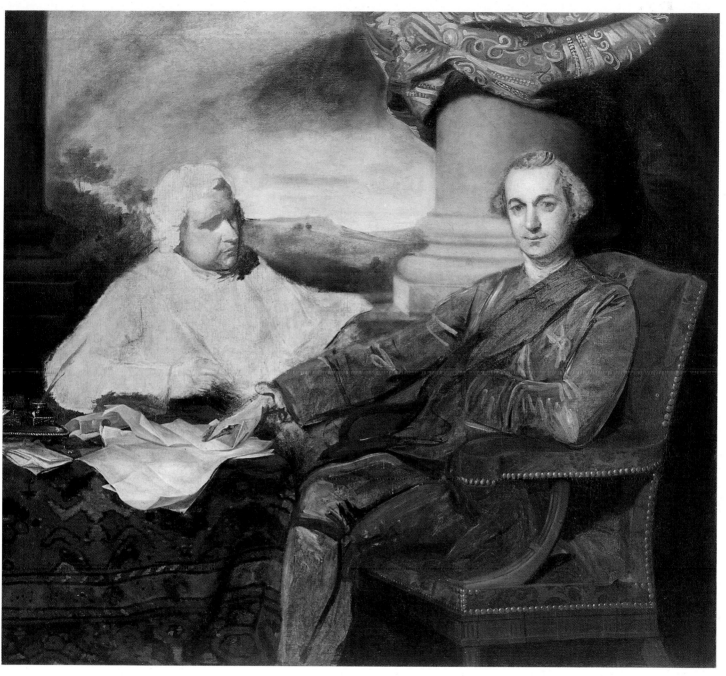

70 *Lord Rockingham and his Secretary, Edmund Burke*

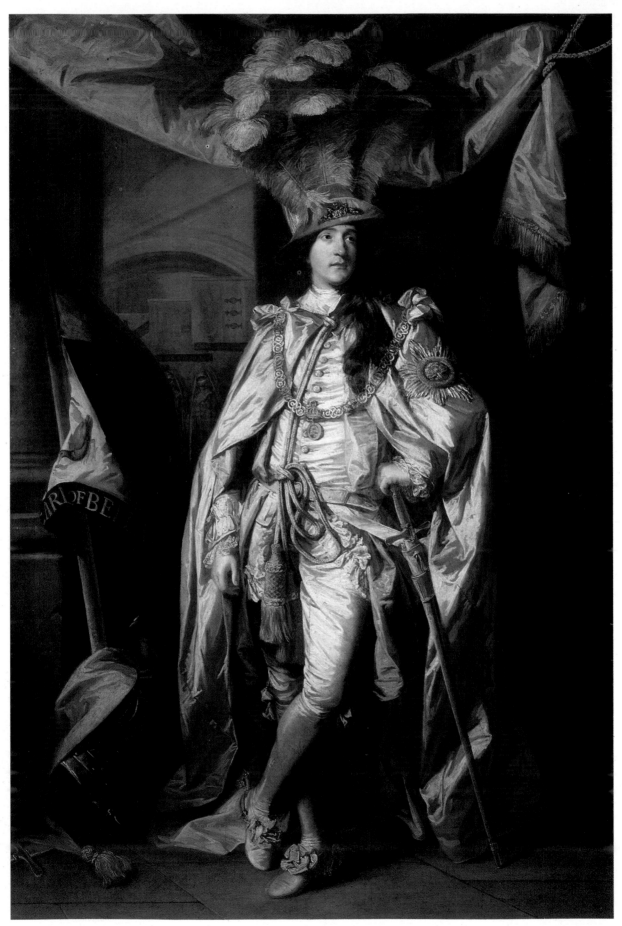

89 *Charles Coote, Earl of Bellomont* KB

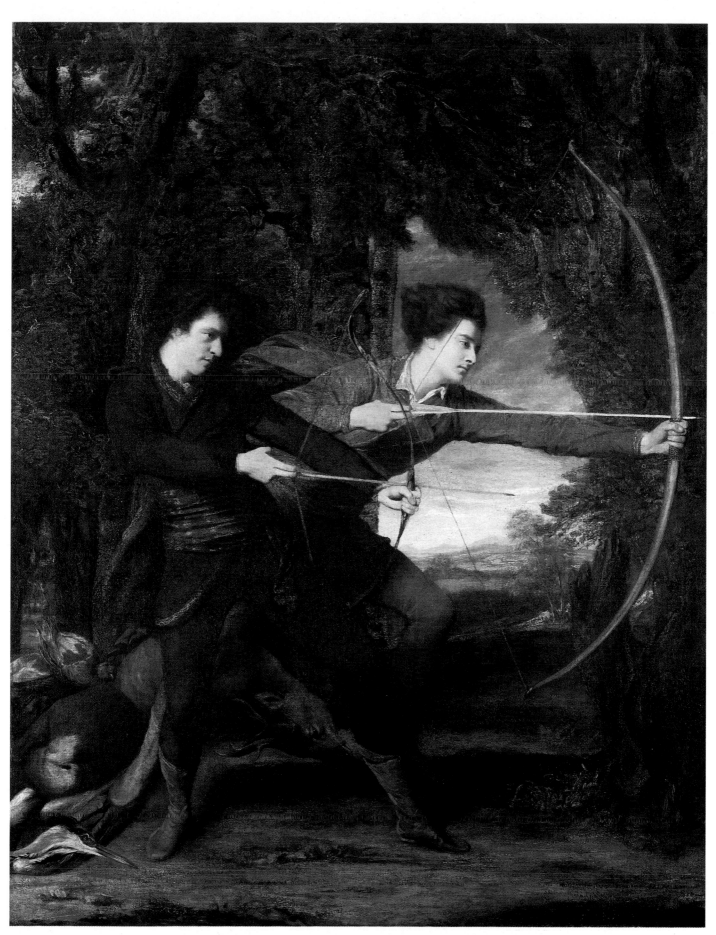

74 *Thomas Townshend and Colonel Acland (The Archers)*

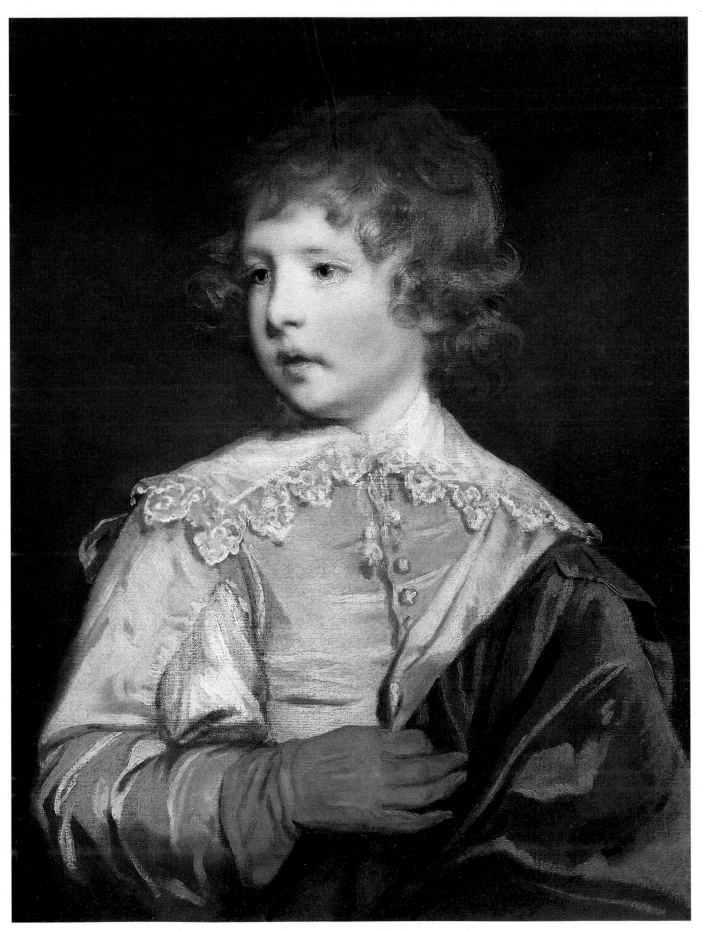

76 *Lord George Seymour Conway*

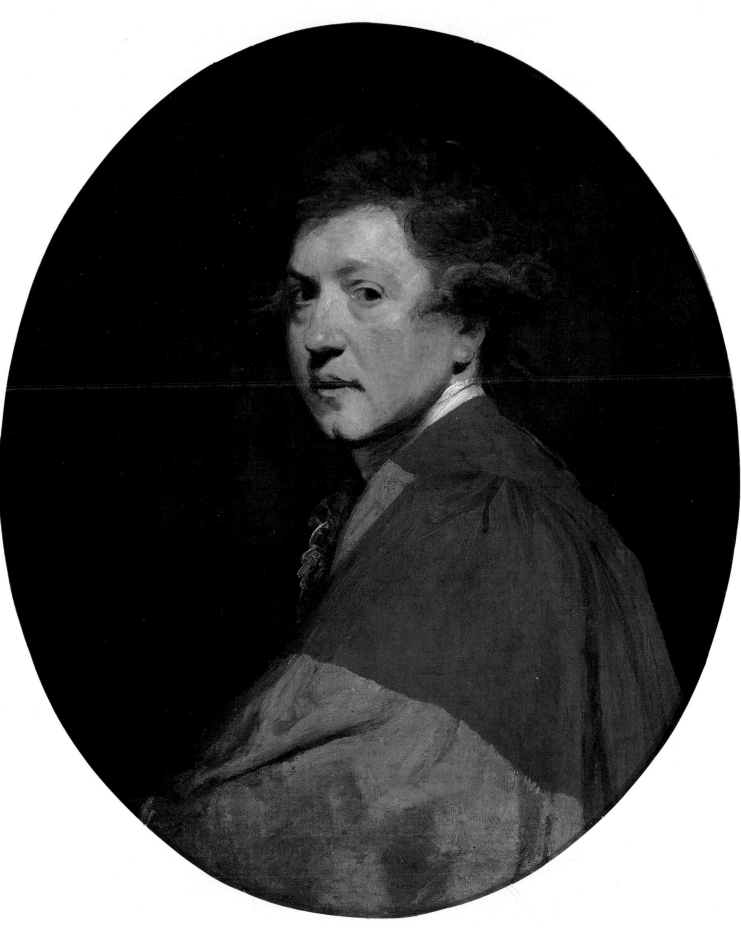

86 *Self-portrait in Doctoral Robes*

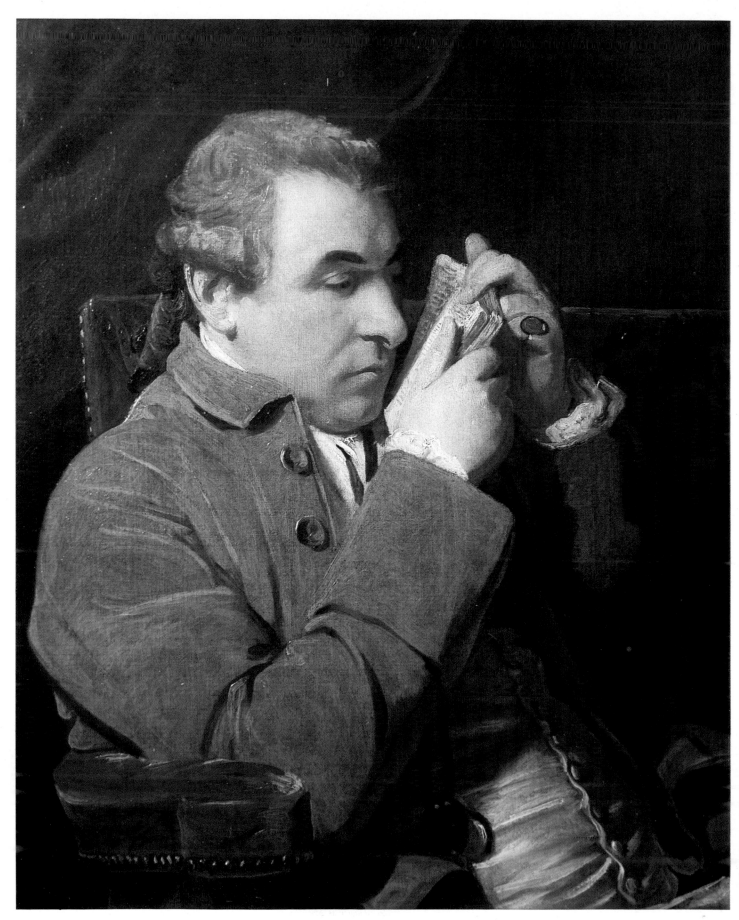

85 *Giuseppe Baretti*

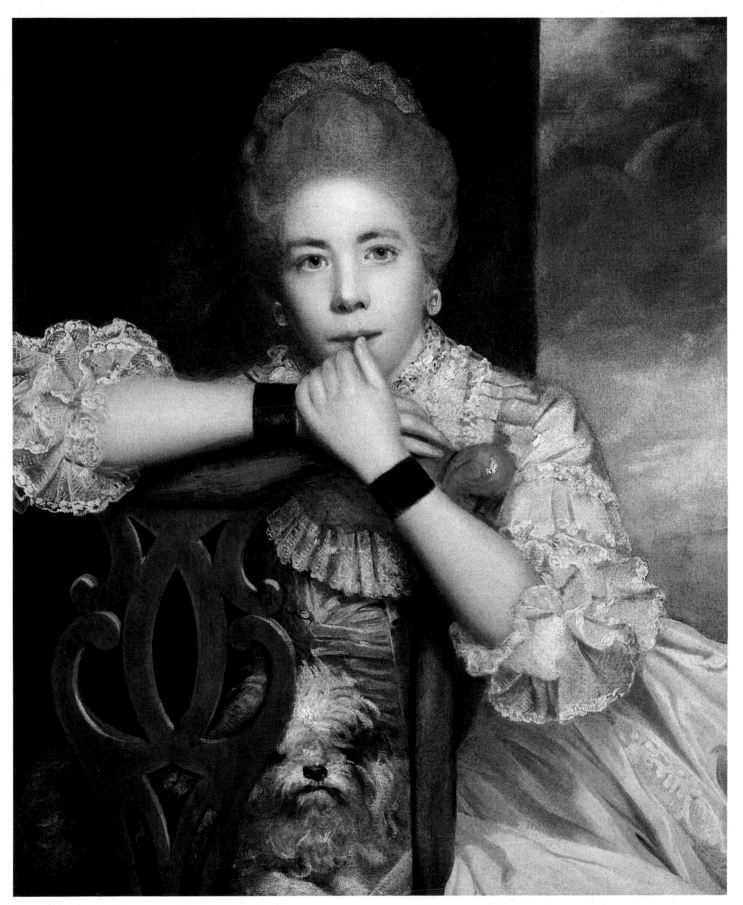

78 *Mrs Abington as 'Miss Prue'*

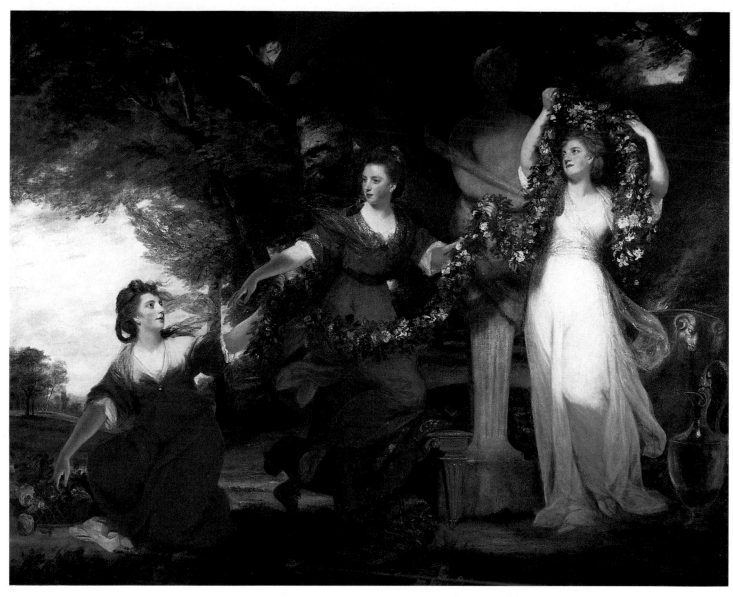

90 *The Montgomery Sisters: 'Three Ladies Adorning a Term of Hymen'*

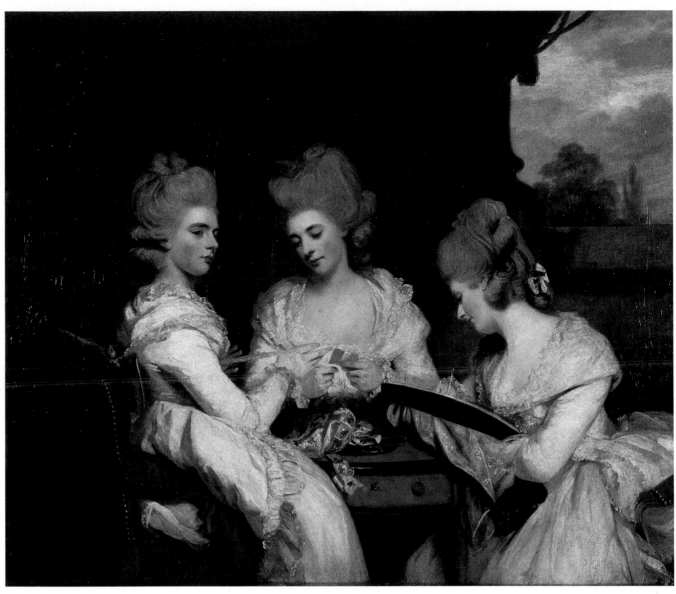

122 *The Ladies Waldegrave*

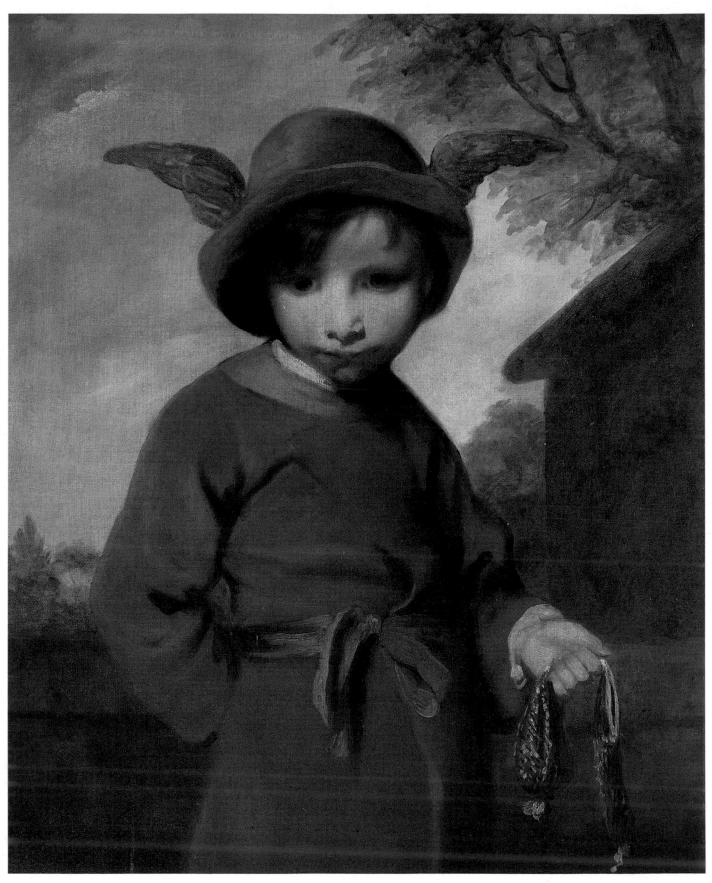

93 *Mercury as Cut Purse*

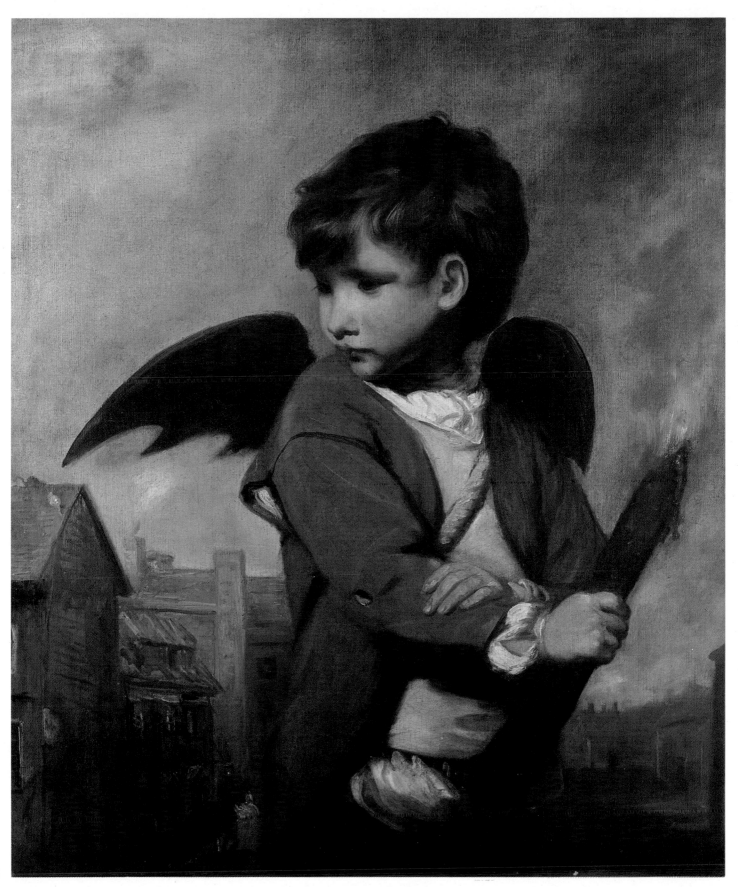

92 *Cupid as Link Boy*

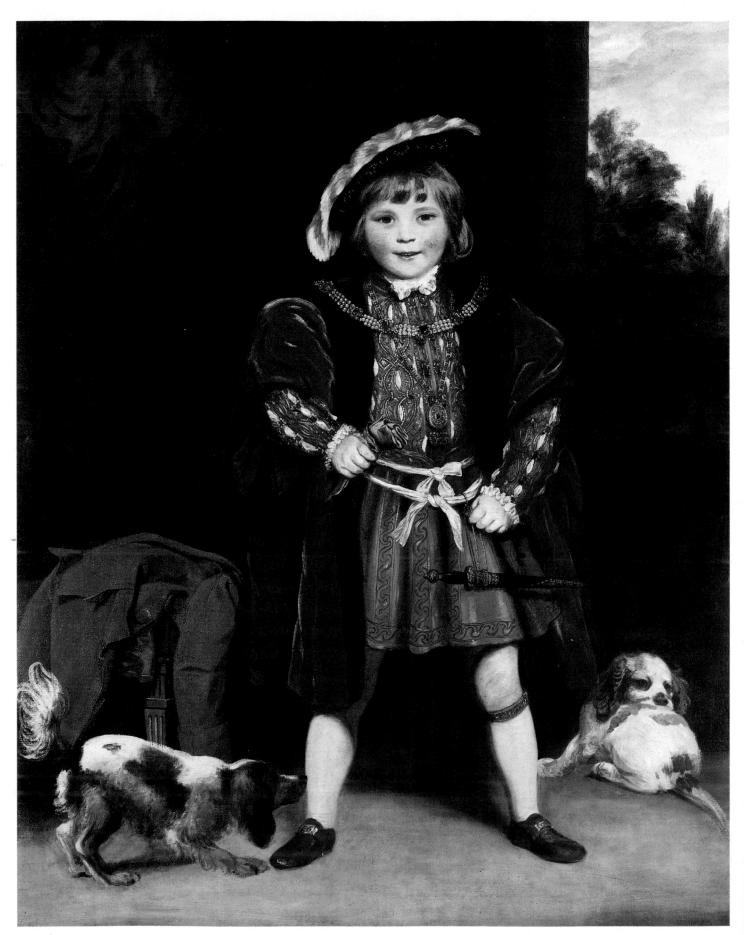

97 *Master Crewe as Henry VIII*

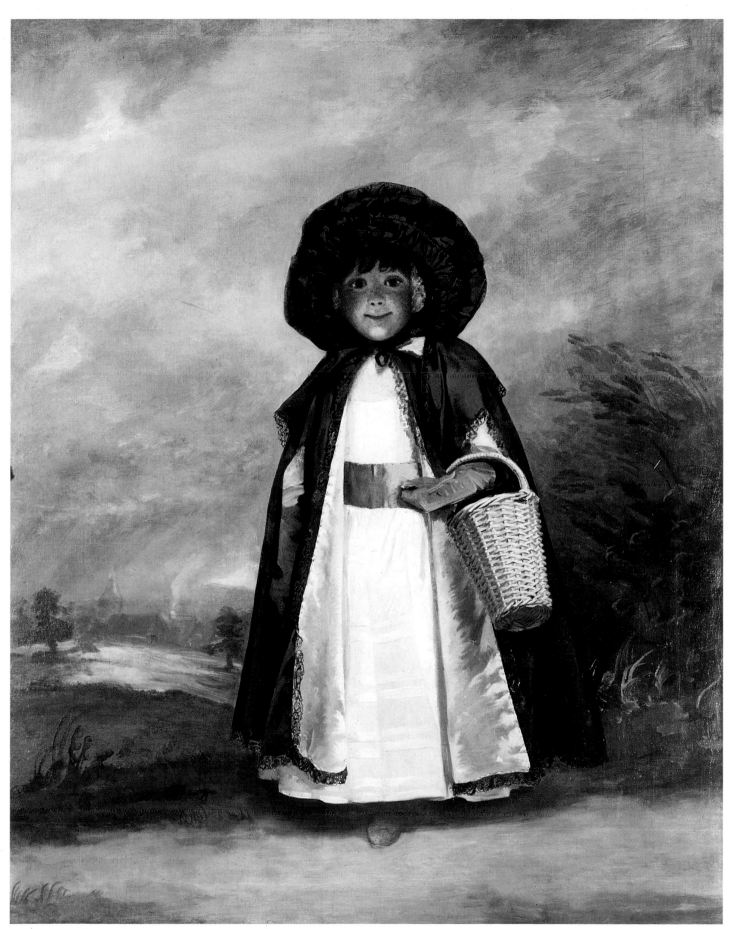

98 *Miss Crewe*

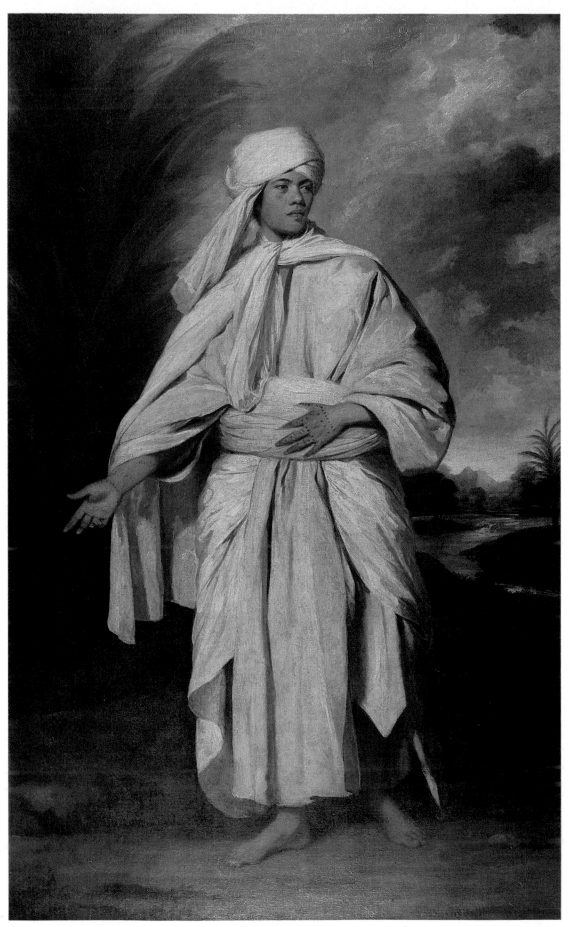

100 *Omai*

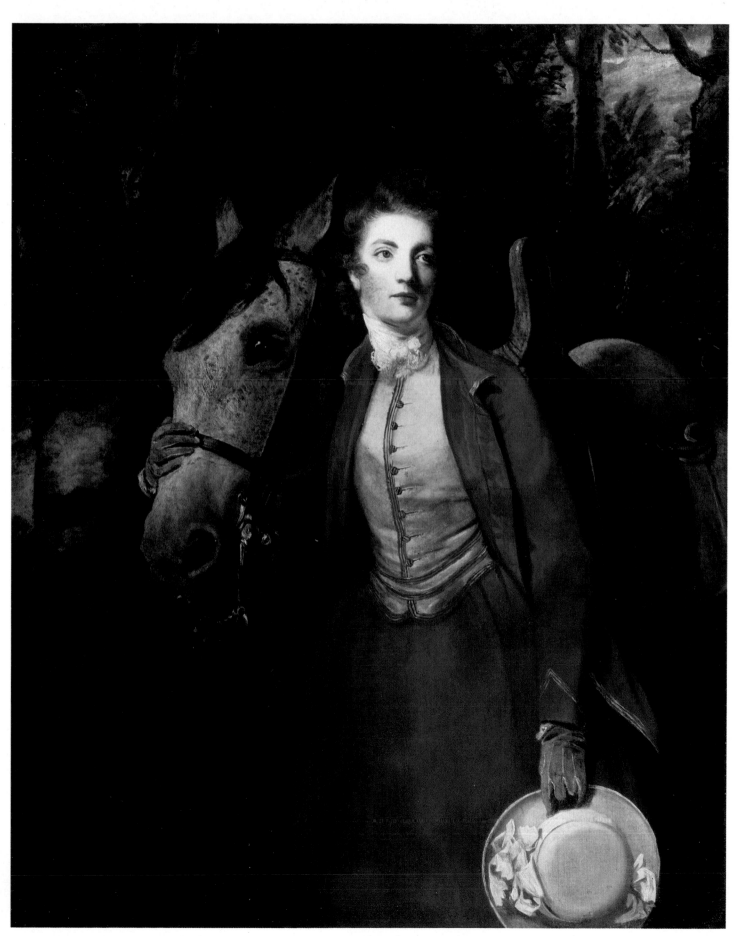

96 *Lady Charles Spencer in a Riding Habit*

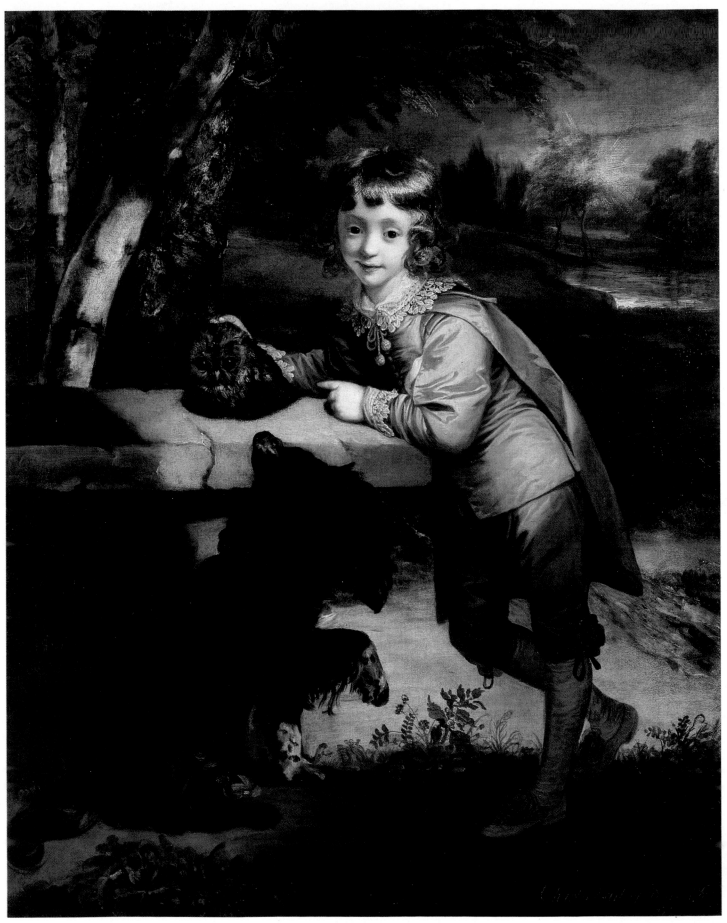

104 *Charles, Earl of Dalkeith*

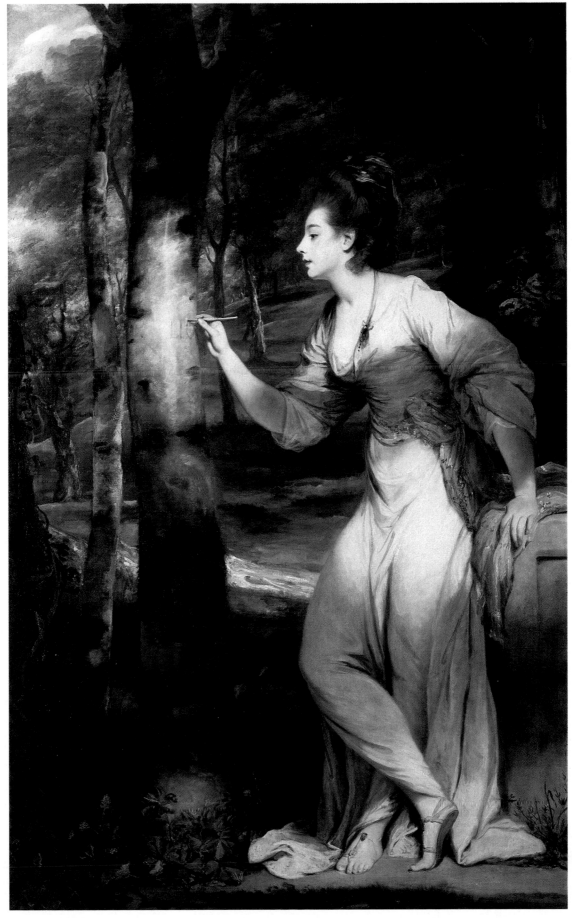

103 *Mrs Lloyd*

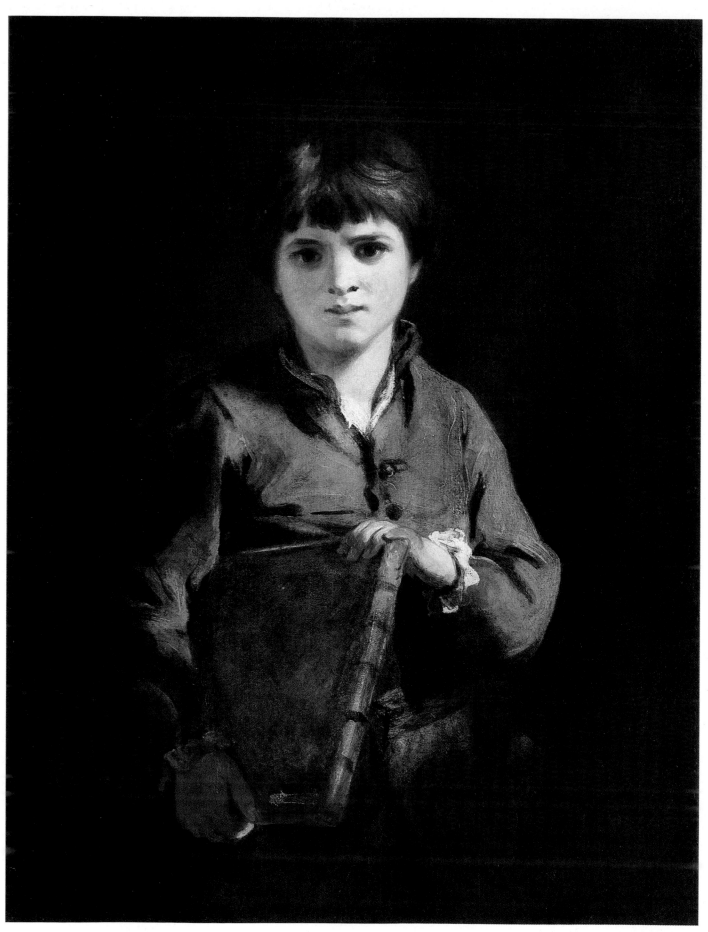

105 *The Schoolboy*

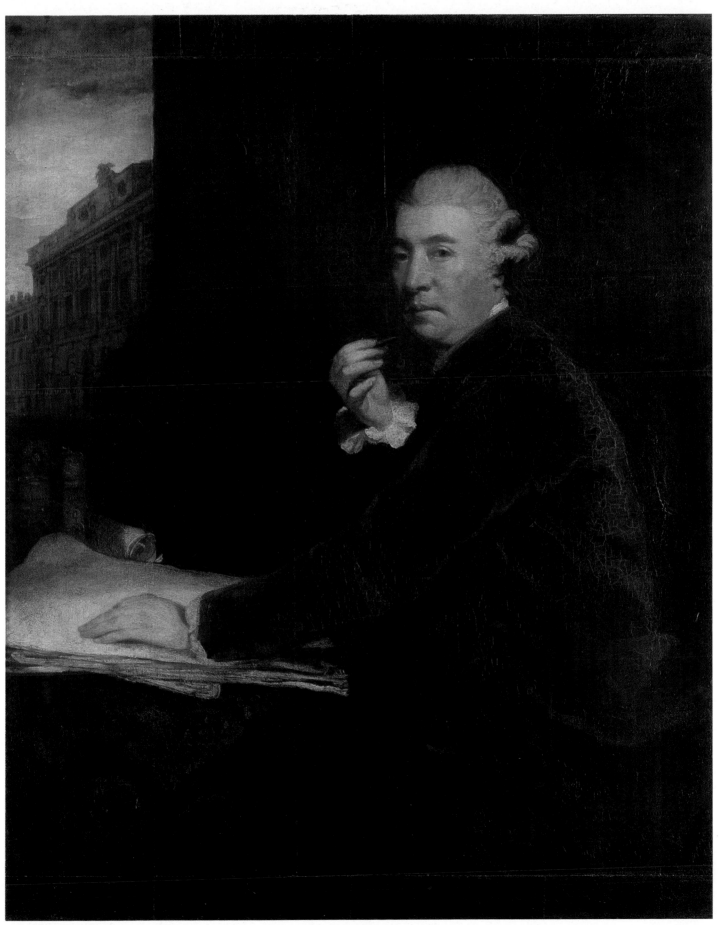

113 *Sir William Chambers* RA

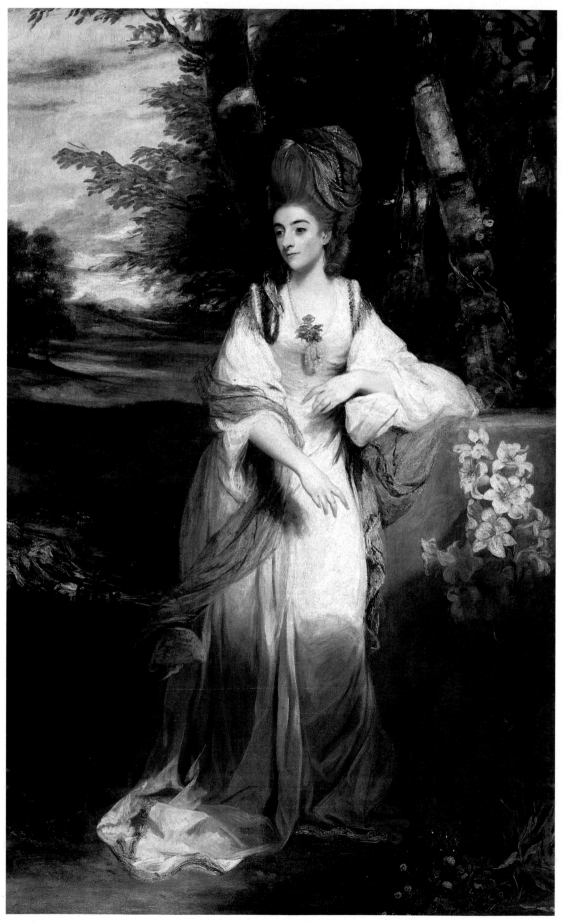

106 *Lady Bampfylde*

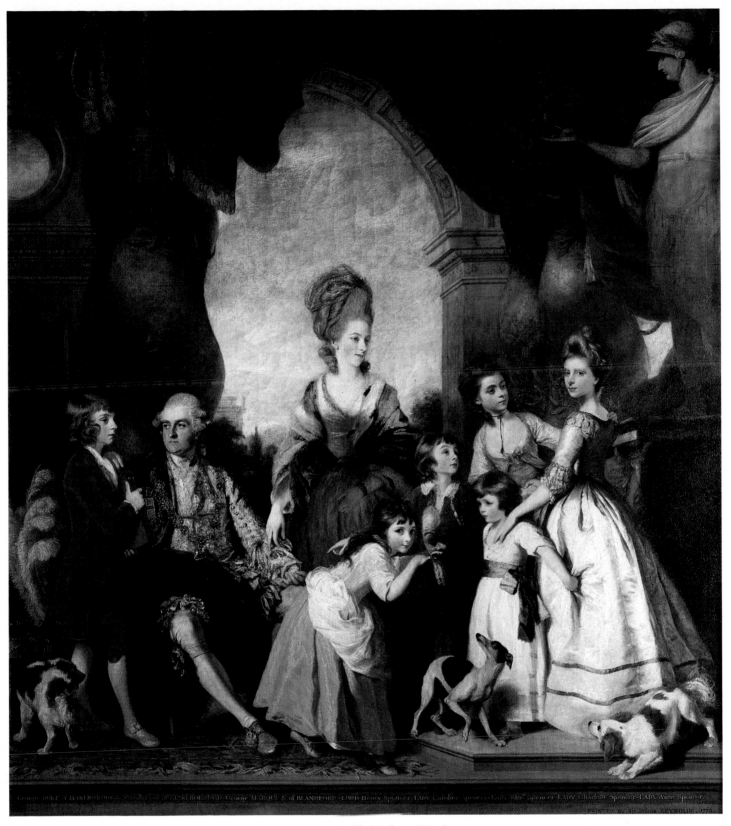

108 *The Marlborough Family*

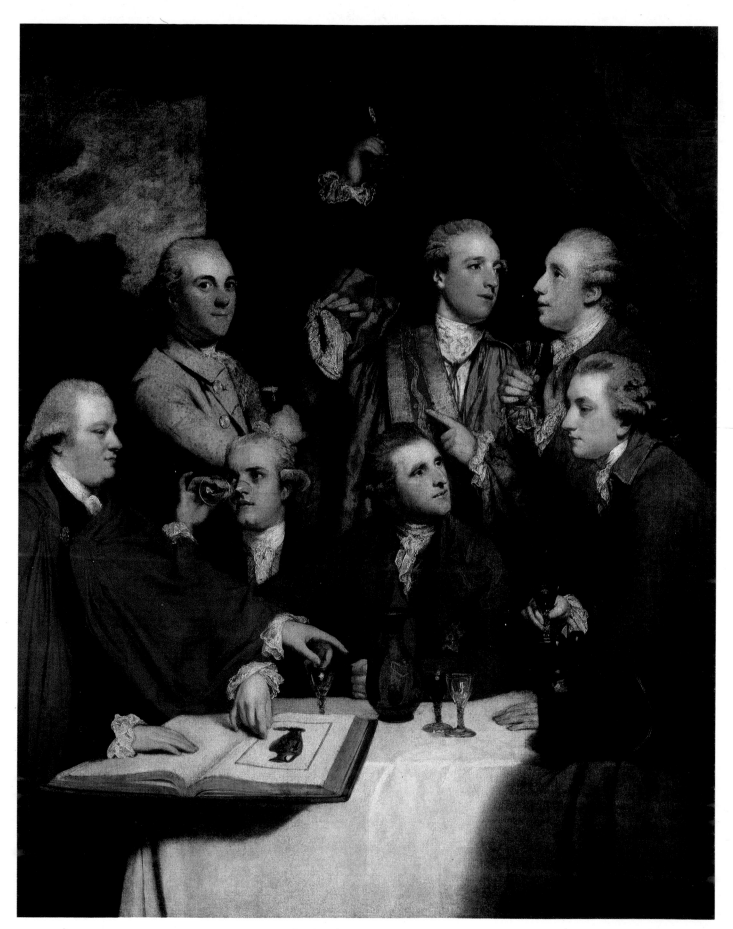

109 *Members of the Society of Dilettanti*

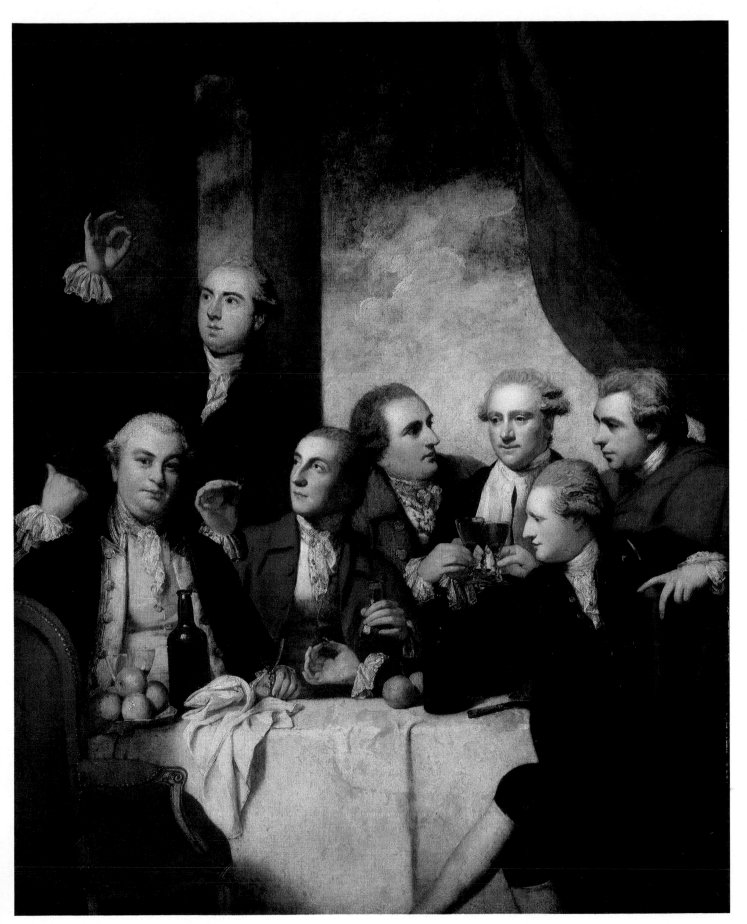

110 *Members of the Society of Dilettanti*

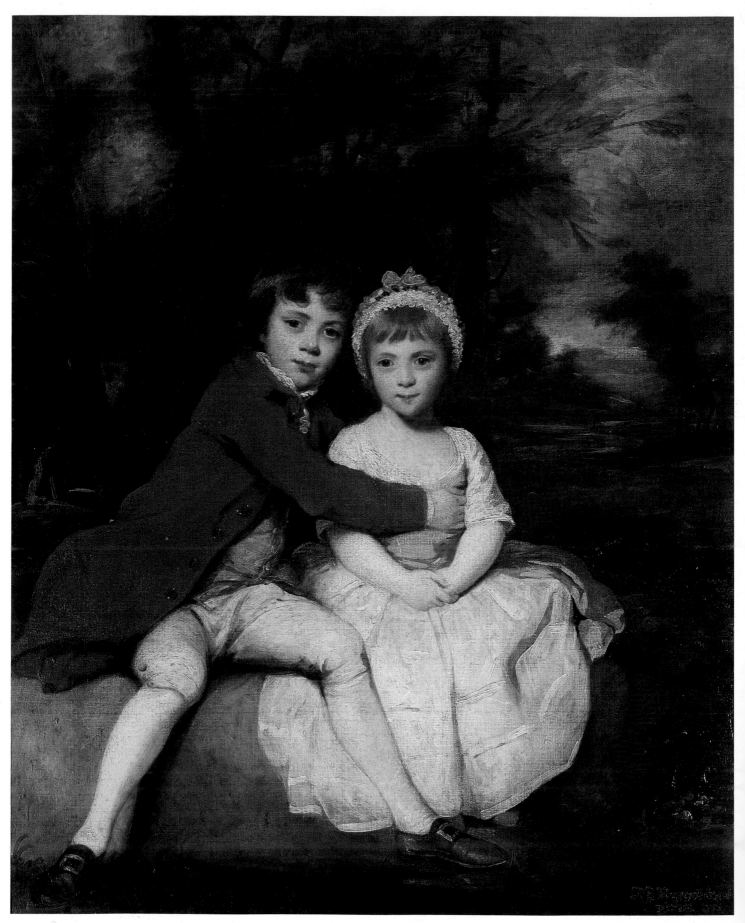

111 *Master Parker and his Sister, Theresa*

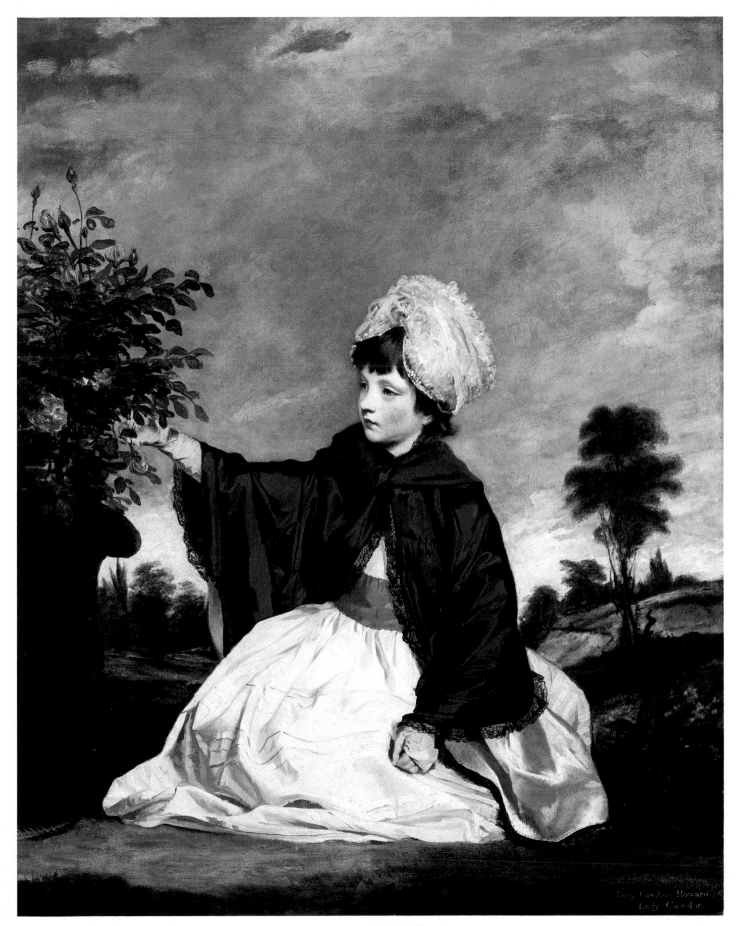

107 *Lady Caroline Howard*

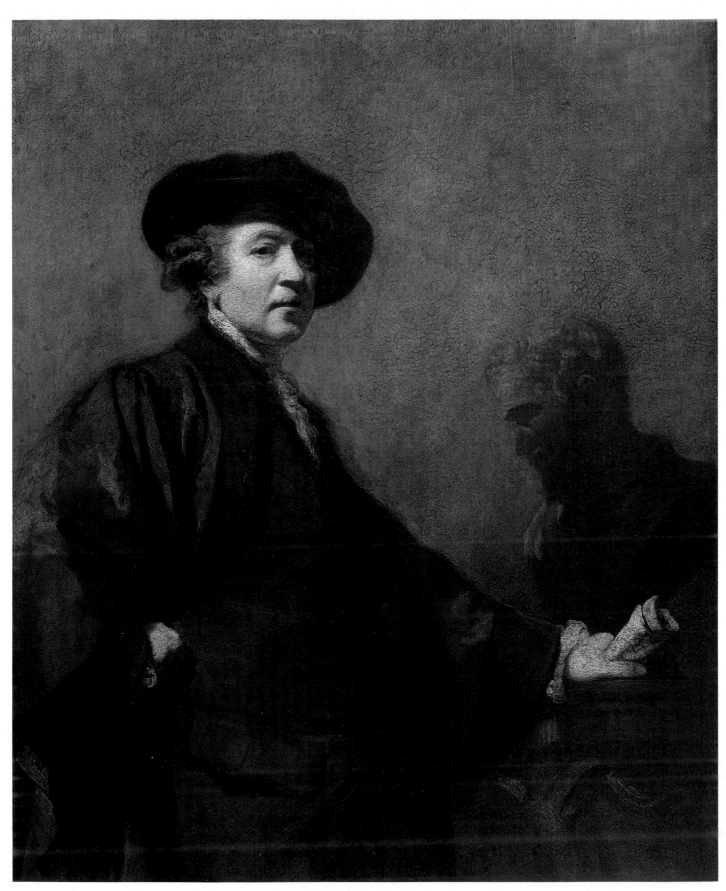

116 *Sir Joshua Reynolds* DCL

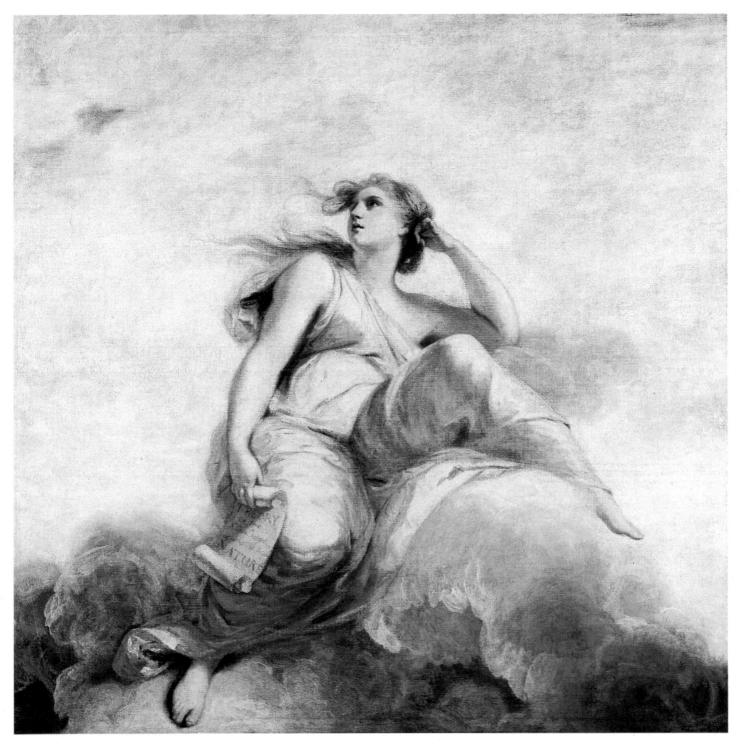

112 *Theory*

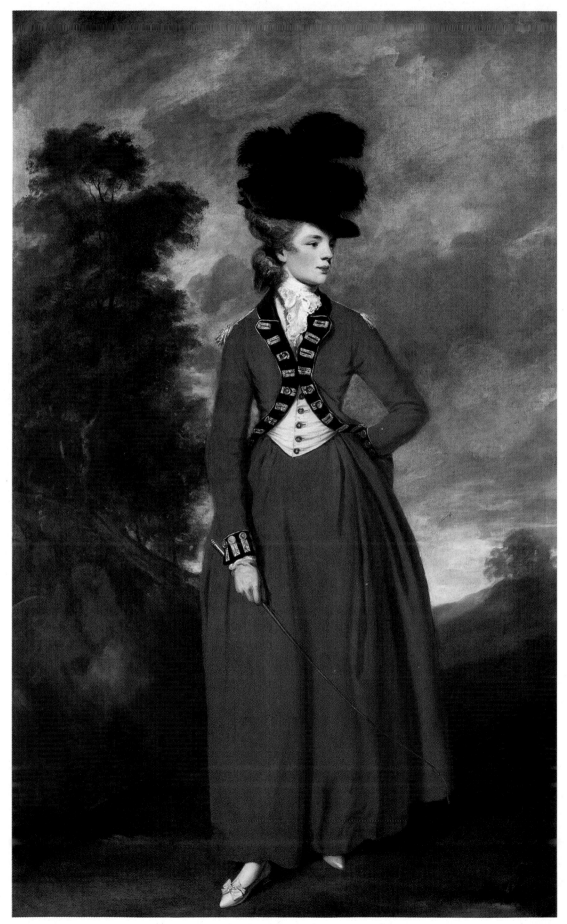

118 *Lady Worsley*

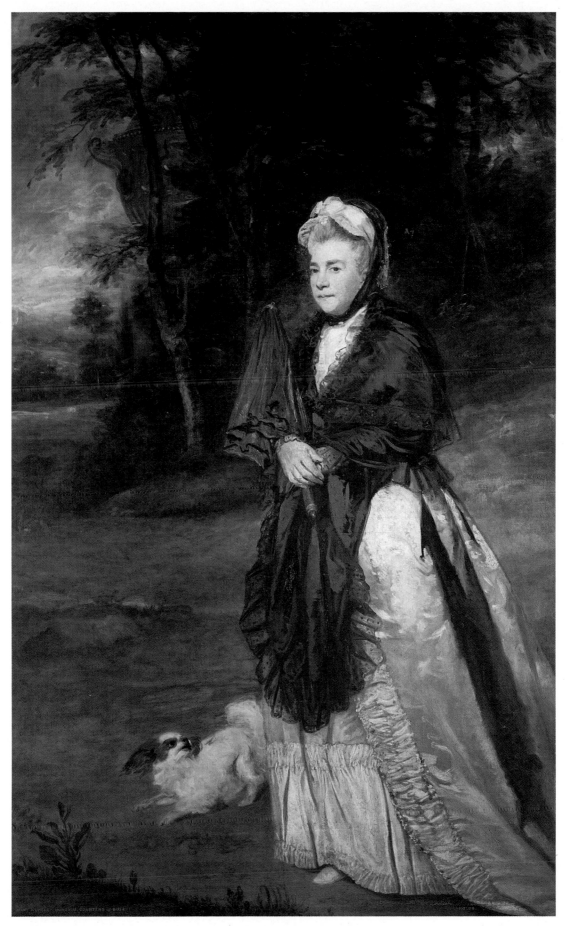

121 *Mary, Countess of Bute*

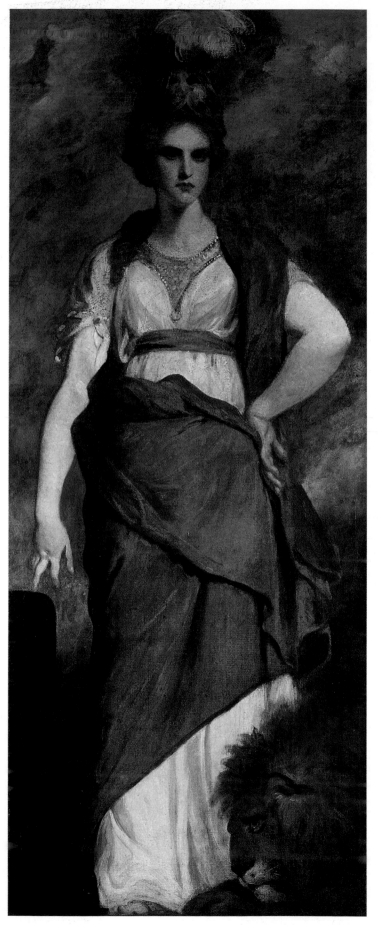

119 *Fortitude*

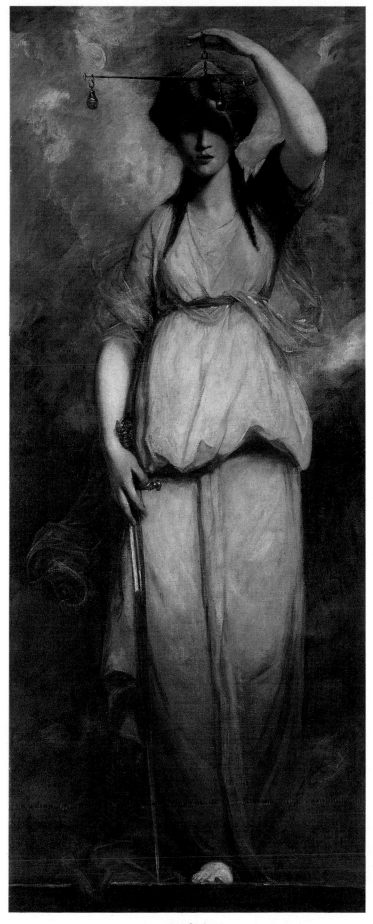

120 *Justice*

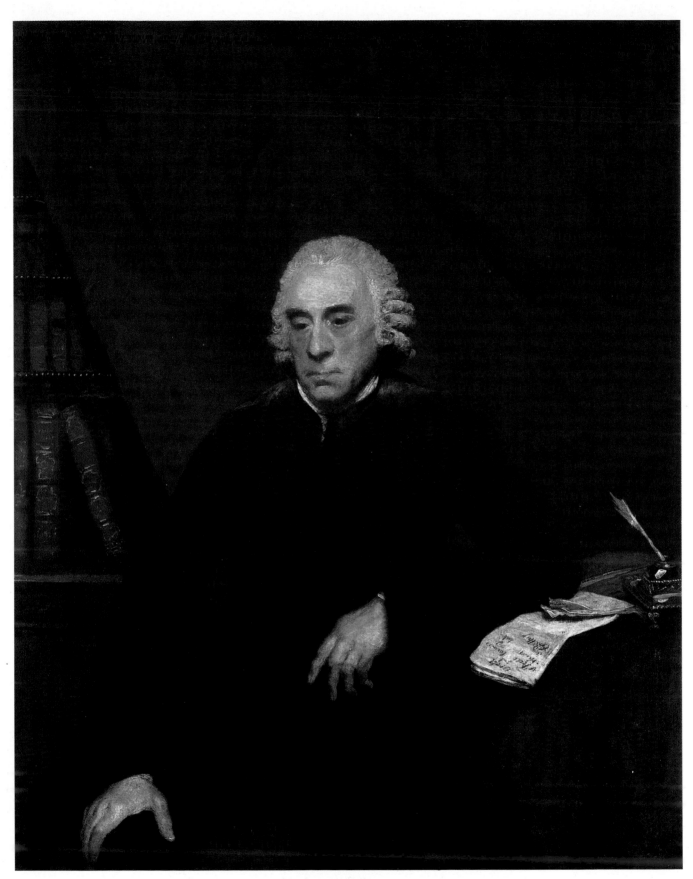

138 *Joshua Sharpe*

125 *Doctor Charles Burney*

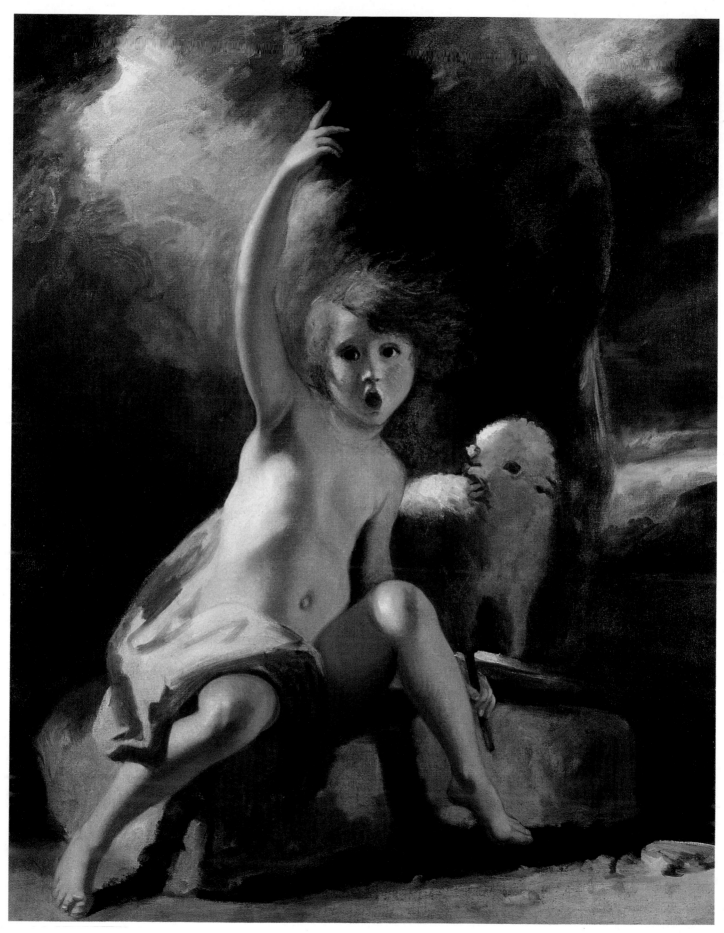

101 *The Child Baptist in the Wilderness*

140 *The Infant Hercules*

126 *Lady Catherine Pelham-Clinton*

133 *The Lamb Children*

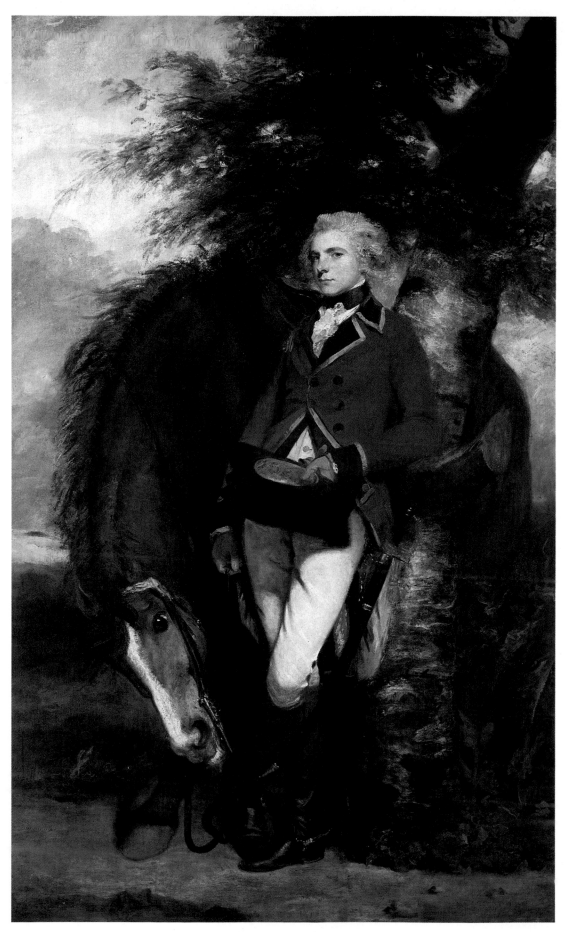

130 *Colonel George Coussmaker*

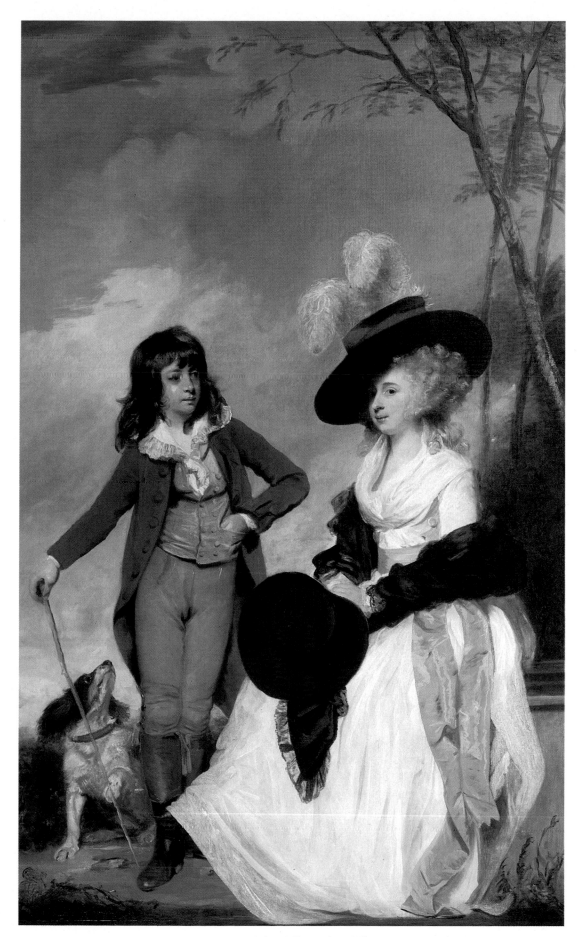

142 *Miss Gideon and her Brother, William*

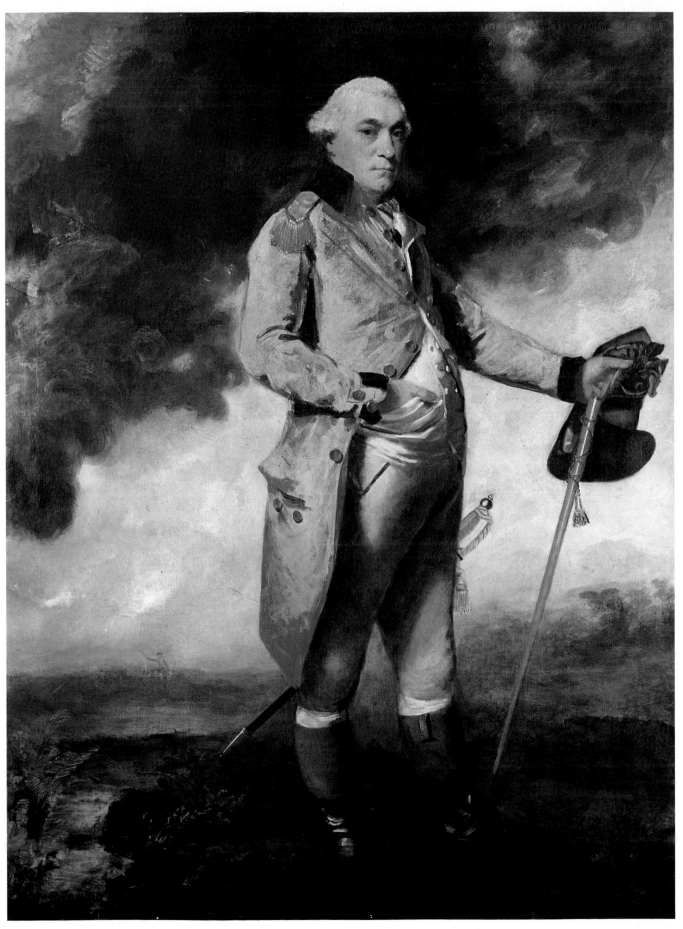

141 *Colonel Morgan*

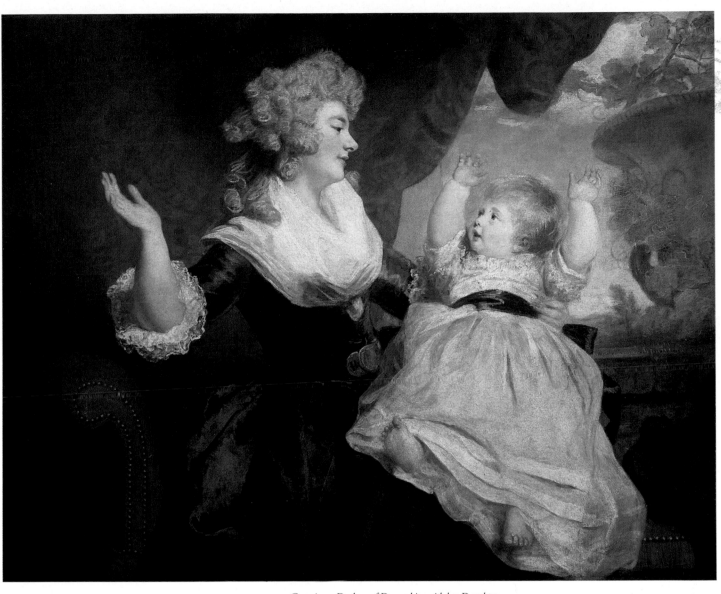

139　*Georgiana, Duchess of Devonshire with her Daughter*

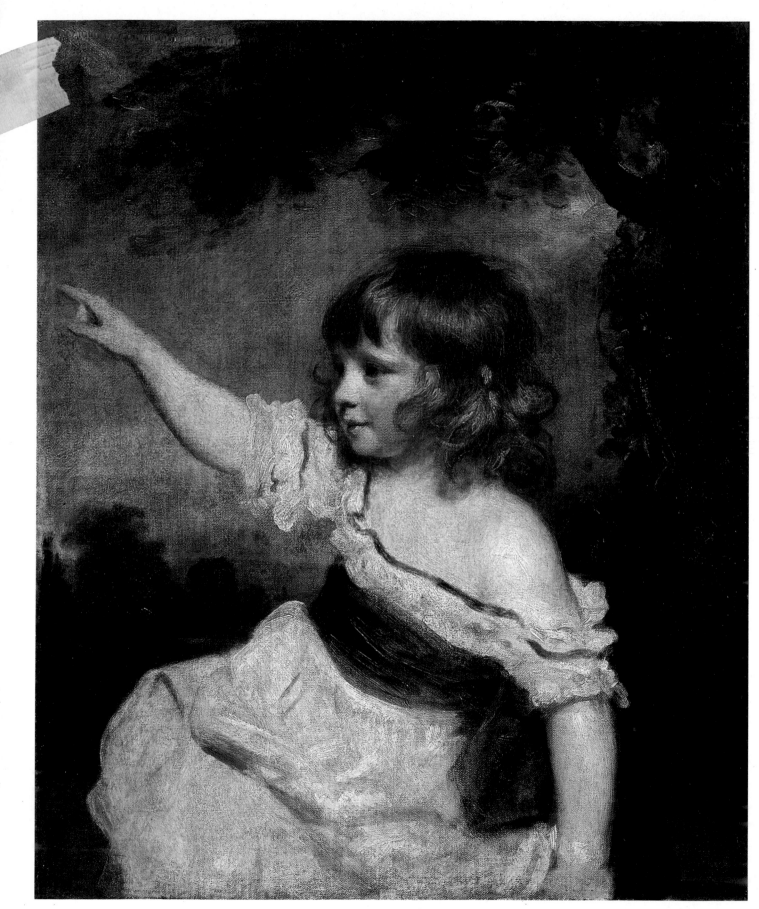

146 *Master Hare*

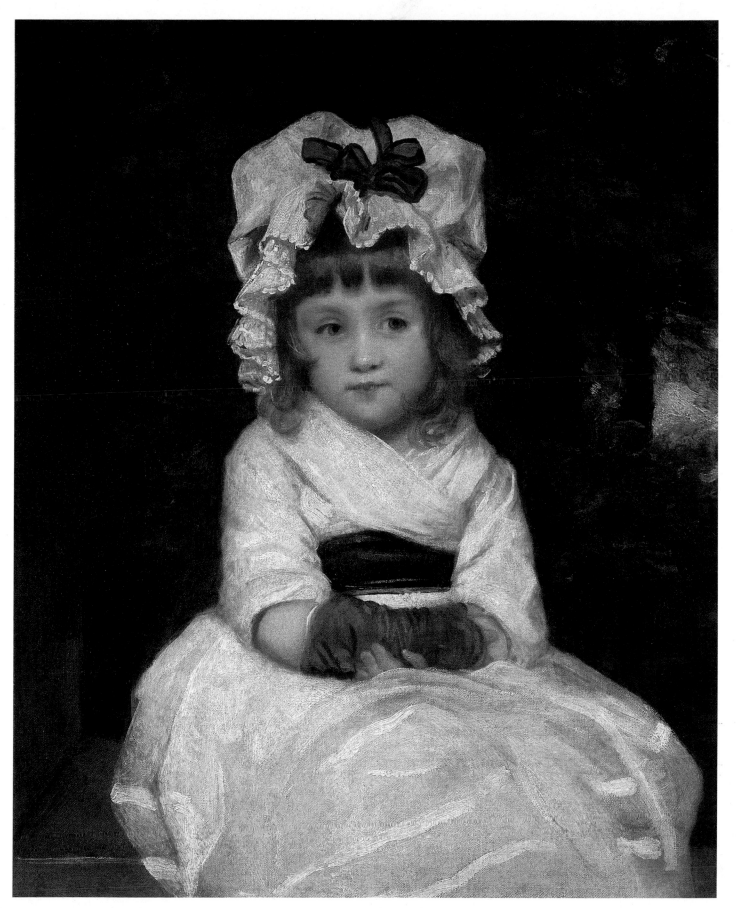

147 *Penelope Boothby*

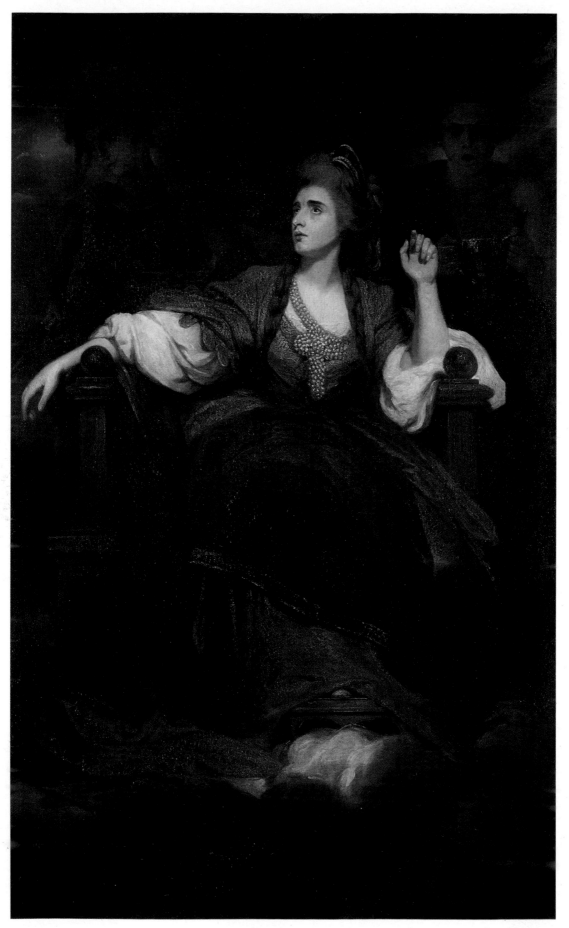

151 *Mrs Siddons as the Tragic Muse*

THE CATALOGUE

A Note on the Presentation of the Catalogue

Entries are by the editor, David Mannings, or (in the case of the satirical prints) Diana Donald and are initialled accordingly N.P., D.M., or D.D. Entries for the paintings incorporate notes on costume made by Aileen Ribeiro. Notes by John Newman on comparative material have been appended to some of the entries for prints.

To increase the value of the Catalogue as a future reference work we have included the entries for prints made after Reynolds's paintings (and which often supply important information about the paintings) in the main section of the Catalogue, which is ordered chronologically, at the point which would have been appropriate for the painting itself, regardless of the publication date of the print (when that is known). The chronological order is established by the dates on which Reynolds seems to have completed a painting and, in cases where this is the same for two paintings, by the date he seems to have commenced them. Such an order can only be approximate, and in two instances (Cat. 77, 99) it is highly conjectural.

For the titles of portraits we have employed the names by which the sitters were known when they were painted, although in a few cases this conflicts with familiar usage.

In the Literature section of each Catalogue entry on a painting we list only those books and articles which refer in a significant way to the painting itself (rather than merely to the sitter) and also references to any mention of the painting in the standard catalogues by Graves and Cronin (however erroneous) and by Waterhouse (however minimal). We also include references to the article in the Walpole Society's journal by Malcolm Cormack which prints the artist's two last ledgers (there must have been at least one earlier one) which belong to the Fitzwilliam Museum; but this has always been checked against the original manuscript and occasional omissions and alternative readings are noted. In the text of each entry we have tried to acknowledge parenthetically the assistance we have received from earlier authors, but it is more convenient to acknowledge here our debt to the *Dictionary of National Biography* and to the *Complete Peerage*.

Constant reference is made in the Catalogue to the artist's pocket-books—what we would now call diaries, but with an accounts page opposite the date page—which survive for most years of the artist's practice. These are in the library of the Royal Academy with the exception of that for 1755 (the earliest) which is in the Cottonian Collection at Plymouth (and has been published by Waterhouse). We have not used the term 'sitter books' because it obscures the fact that Reynolds included in these books numerous social engagements and some business appointments as well as sittings. In every case I have double-checked the references: they will very often be found to differ from earlier catalogues which have supplied them.

In the entries for each painting we have listed the prints up to and including those by S. W. Reynolds made in the 1820s. These early prints can tell us something about the dating and original condition of the paintings and are evidence of how popular, how familiar (and hence how available to other artists) his works were. Later nineteenth-century reproductions of his paintings, when not repetitions of those we have listed, reflect the presence of Reynolds's paintings in public exhibitions. We have listed such exhibitions up to 1900, as evidence of a painting's reputation, availability and ownership. After 1900 we have only listed those exhibitions whose catalogues make some valuable contribution to scholarship or provide a useful corpus.

Dimensions are given in centimetres, height before width. Paintings are on canvas unless another support is indicated. In the case of prints after Reynolds dimensions are taken from the plate-marks and include inscriptions.

After the main section of the Catalogue are placed entries for a number of sketches for Reynolds's paintings, some of which I feel sure are by him, others of which might be by him. After that some sketchbooks, studio props, and paintings by other artists are catalogued and then the satirical prints, divided into thematic groups, each of which is catalogued in chronological order. The titles given are those on the prints. Publication lines have been transcribed; other inscriptions are omitted. Dimensions are those of the image.

N.P.

Paintings by Reynolds

(with prints after his works)

1 Miss Grace Goddard

124 × 99 cm

Commander L. M. M. Saunders Watson

This picture of a little girl collecting flowers in her overskirt while walking in a landscape exemplifies Reynolds's early interest in the masters of seventeenth-century aristocratic portraiture. The roses in her right hand are derived from Van Dyck, the composition as a whole reminds us of Sir Peter Lely (compare the *Little Girl in Green* at Chatsworth) and the delicate silvery colours could well reflect the influence of Michael Dahl. Dahl died, a very old man, in 1743, the last link with the Stuarts whom he painted and with the Baroque style they had encouraged. At this early stage of his artistic development Reynolds has not, it must be admitted, entirely succeeded in uniting the brightly-lit figure with the dark leafy background, but he has, through a very careful modulation of the contours, managed to avoid the cut-out effect which characterizes the work of most of his rivals in the 1740s.

Aileen Ribeiro points out that the little girl is dressed 'in imitation of adult styles (even the pose with lifted-up overskirt is copied from the fashionable stance of an older woman), wearing a simplified version of adult costume, with

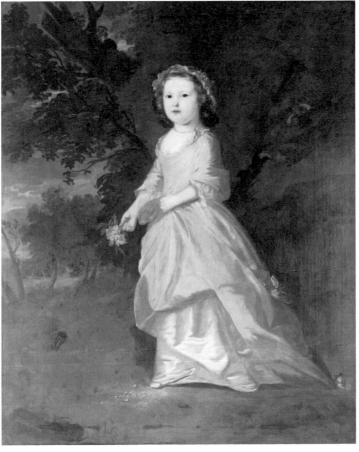

1

wide cuff and boned back-fastening bodice—the latter was thought necessary to keep the back flat, the shoulders back and to give the upright carriage which was an essential part of good breeding. The fashionable linen cap, edged with lace and trimmed with flowers, was known as a "round-eared" cap, shaped to curve round the face to ear-level.'

According to family tradition the portrait was painted about 1740, but a date around 1745 or 1746 seems more likely. The sitter was, as Mrs Brenda Cluer (cited in Plymouth 1973, no. 16) has ascertained, born in 1741. She was baptized on 29 June, and was daughter of the Rev. William Goddard, perpetual curate of Plympton, Reynolds's birthplace. She married while still a minor, on 10 June 1760, John Culme of Tothill, a distant relation, and her father performed the ceremony. She died in 1809. D.M.

PROVENANCE By descent to the present owner through the sitter's granddaughter, Elizabeth Culme, who married 1833 the Rev. Sir John Seymour, 2nd Bt; their son, Admiral Sir Michael Culme-Seymour, 3rd Bt, married 1866 Mary Georgiana, daughter of the Hon. Richard Watson of Rockingham Castle; taken to Rockingham by their grandson 1939.

EXHIBITED Park Lane 1937 (52); Plymouth 1973 (16).

LITERATURE Waterhouse 1941, p. 38; Mannings 1975, p. 221.

No early engraving recorded.

2 The Eliot Family

87 × 114 cm
The Eliot family

This portrait group is similar in character to the painting of the Radcliffe family by Hudson of *c.* 1741–2 (on loan to the Assembly Rooms, Bath), but it is also an early and surprising example of Reynolds's use of poses and compositions adapted from Van Dyck, a master on whom he was later to depend quite heavily, especially in the years immediately following his return from Italy. The main inspiration for this somewhat ingenuous little picture, dated in the old (but not original)

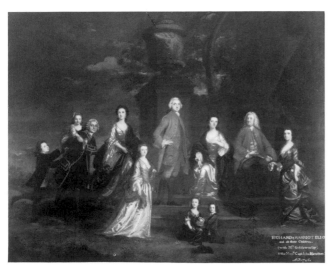

2 *reproduced in colour on p. 78*

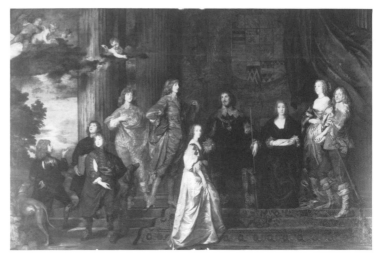

Fig. 46 Van Dyck, *The Pembroke Family, c.* 1634
(The Earl of Pembroke, Wilton House)

inscription to 1746, is the great Pembroke Family group at Wilton House (fig. 46), a picture widely admired in the eighteenth century and well-known through the engraving by Bernard Baron. However, the small scale of the Eliot Family, the loose handling of paint and the light-hearted mood invite comparison with another artist, one who was at the height of his powers in the 1740s, William Hogarth. Specifically, we should compare the Eliot Family with Hogarth's Cholmondeley Family group of 1732 (fig. 47),

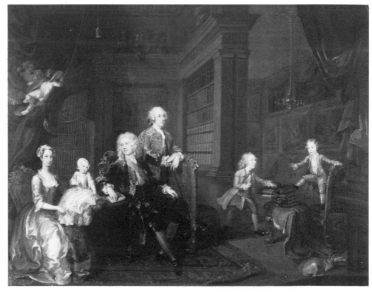

Fig. 47 William Hogarth, *The Cholmondeley Family,* 1732
(Trustees of the Tate Gallery, London)

showing the family together in their library. Reynolds's Eliot Family could almost be called an outdoor version of that picture. Not only does it make use of similar poses for some of the adults (similar because both pictures draw upon the same stock of poses handed down from the Renaissance) but

also because it includes some of the few children Reynolds ever painted romping instead of posing. The attraction of Hogarth was, however, a temporary one. Reynolds's subsequent essays in group portraiture were to be very different, though it is worth noting that the Marlborough Family, the climax of the type, painted thirty years later, still makes a contrast between dignified adults and playful children (Cat. 108).

The group consists of Richard Eliot (1694–1748), M.P. in several parliaments for St Germans and for Liskeard, and Auditor and Receiver-General to the Prince of Wales in Cornwall; his wife Harriot (1714–69), whom he married on 4 March 1726, and their children, together with two friends of the family: Mrs Goldsworthy and Captain the Hon. John Hamilton (for whom see Cat. 3). Richard Eliot is seated at the right; his wife sits next to him. Captain Hamilton, who married Mrs Eliot on 14 November 1749, carries one of the smaller children (perhaps Elizabeth, 1739–71, for whom see Cat. 8; or possibly Catherine, born 1743) on his shoulders. Richard (1733–46) runs in from the left. To the right of Captain Hamilton, Ann Eliot (1729–1810, for whom see Cat. 23) stands in the foreground in front of Mrs Goldsworthy. In the centre stands Edward, 1st Lord Eliot (1727–1804), and the two small children in the foreground are John (born 1741) and either Catherine or Elizabeth. At the extreme right, holding a garland of flowers, is Harriot (1731–76).

The picture is dominated by Edward, the heir, on account of his central position and his scarlet clothes which contrast with the silvers and shimmering blues and greens of the rest of the composition. Top centre is often the place, in family group pictures, for symbolic or heraldic features. Here, instead of the family arms displayed in Van Dyck's Pembroke Group, or the symbolic putti in Hogarth's Cholmondeley Family, Reynolds paints a carved urn with the inscription *amicitia* (friendship), which probably alludes to the presence of Hamilton and Mrs Goldsworthy, but perhaps also symbolizes his own relationship with his sitters. Such classical props and allusions recur in a number of later portraits by Reynolds.

This painting belonged to Mrs Eliot after her husband's death, and on 20 January 1769 she added a codicil to her will leaving 'the family conversation piece done by Reynolds with the two fine old Family Bibles' to 'my dear Mr Eliot' (information from Montague Eliot's MS Catalogue of the family paintings of 1923).

The 1st Lord Eliot was one of the artist's pall bearers.

D.M.

PROVENANCE By descent.

EXHIBITED Royal Academy 1876 (3).

LITERATURE Leslie and Taylor 1865, I, p. 29; Graves and Cronin, 1899–1901, I, pp. 284–5; Waterhouse 1941, p. 37; Mannings 1975, pp. 221–2.

ENGRAVED S. W. Reynolds, 1833.

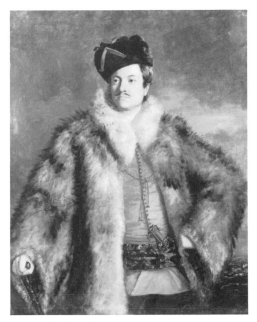

3 *reproduced in colour on p. 80*

3 Captain the Hon. John Hamilton

130 × 102 cm
The Trustees of the Abercorn Heirlooms Trust

According to Malone, who gives the date 1746, this was the first picture to bring the artist some measure of fame. Late in life Reynolds was struck by its high quality, and, Malone tells us, 'lamented that in such a series of years he should not have made greater progress in his art'. It is unusual among the artist's early male portraits in that the subject is in fancy-dress. Aileen Ribeiro points out that, although traditionally described as wearing the costume of a Russian boyar, 'Captain Hamilton is actually depicted in the dolman or tunic with slanting triangular flap below the belt, and twisted sash, of a Hungarian hussar; on his head he wears the appropriate fur busby, and the artist has given him a moustache—facial hair was not worn in the eighteenth century except by some regiments on the Continent. Over this uniform, the sitter wears a huge, collared coat, possibly of fox or wolf, such as was a necessary luxury in Russia, and also appears as part of the winter dress of the nobility in Central Europe.'

Hamilton was, in fact, a sailor whose career at sea was itself quite adventurous enough. As Lieutenant on the *Louisa* he attended George II on his return from Hanover in 1736. A storm wrecked his ship, and, when boats were sent to rescue him he refused to leave before his sailors, saying that in that common calamity he would claim no precedency, and he was the last to be taken off. He was soon appointed Commander, but on 18 December 1755 was tragically drowned when the boat in which he was going ashore from his ship, the *Vanguard*, overturned in Portsmouth harbour.

Captain Hamilton was a friend of the artist's local West Country patrons the Eliots (see Cat. 2) and after Richard Eliot's death he married his widow, Harriot, in November

1749. Reynolds painted him on at least two other occasions, once around 1747 (Collection of the Duke of Abercorn) and once around 1753, soon after returning from Italy (Private Collection; see Waterhouse 1941, pl. 8a and b). In Yale University Library is Reynolds's copy of the seventeenth-century French critic Roger de Piles's influential treatise, *Cours de Peinture par Principes* which he must have used while preparing his *Discourses*, with a note on the flyleaf: 'J. Reynolds the Gift of the Honble. Capt. Hamilton.'

Like the portrait of Lieutenant Ourry (Cat. 11), this portrait has a strongly Titianesque flavour, and may reflect the artist's interest in a picture like the *Man with the Red Cap* now in the Frick Collection in New York, a Titian which seems likely to have belonged to Paul Methuen in the eighteenth century, but whether Reynolds saw it as early as the 1740s we do not know. D.M.

PROVENANCE The sitter was father of John James, 9th Earl of Abercorn, created Marquess 1790; by descent.

EXHIBITED British Institution 1813 (43); Royal Academy 1875 (114); Park Lane 1937 (14).

LITERATURE Malone, in Reynolds 1798 I, p. x; Leslie and Taylor 1865, I, p. 28; Graves and Cronin 1899–1901, II, pp. 418–19; Waterhouse 1941, pp. 5, 37.

No early engraving recorded.

Fig. 48 Rembrandt, *Aristotle with a bust of Homer* (detail), 1653 (Metropolitan Museum of Art, New York)

4 The Reverend Samuel Reynolds

75.7 × 63.1 cm
City Museum and Art Gallery, Plymouth: Cottonian Collection

The Rev. Samuel Reynolds (1681–1745) was the painter's father. He was a Fellow of Balliol College, Oxford, and then Master of Plympton Grammar School from 1715 until his death on Christmas Day 1745. This portrait, the only one known of him, was almost certainly painted posthumously. The profile is rare in Reynolds's work, and may have been selected here because it has certain commemorative overtones. The sideways position gives to the subject a slightly remote quality; by looking away he lacks that direct communication with the spectator so often implied by a figure turning towards us, or meeting our gaze. It is just possible that the profile arrangement was, as Dr Balkan has argued, suggested by Arthur Pond's crude 1739 profile portrait of Dr Mead. But the much softer lighting used here invites a direct comparison with the work of Rembrandt himself, with, for instance, the softly-lit profile bust of Homer, contemplated so sadly by Aristotle in the famous picture in New York (fig. 48). Rembrandt's *Aristotle* belonged to Sir Abraham Hume, Bt, in 1815; Hume was a friend of Reynolds but it is highly unlikely that the Rembrandt was in his possession during Reynolds's lifetime, and the echoes which seem to occur here and elsewhere (e.g. *Self-Portrait with bust of Michelangelo*, Cat. 116) should perhaps be described as affinities rather than borrowings. D.M.

PROVENANCE Very Rev. Joseph Palmer, Dean of Cashel (the artist's nephew), died 1829; his son, Captain Palmer; William Cotton of Ivybridge; bequeathed 1853 to the City of Plymouth

EXHIBITED South Kensington 1867 (558); Plymouth 1951 (2); Plymouth 1973 (8).

LITERATURE Jewitt 1853, p. 1; Graves and Cronin 1899–1901, II, p. 816; Waterhouse 1941, p. 37; Balkan 1979, pp. 38–9; Mannings 1975, p. 216; White 1983, pp. 33–4.

ENGRAVED S. W. Reynolds 1822, 1823.

4 *reproduced in colour on p. 74*

5 Miss Frances Reynolds

76.7 × 63.6 cm
City Museum and Art Gallery, Plymouth: Cottonian
Collection

Frances ('Fanny') Reynolds (1729–1807) was the youngest of the painter's three surviving sisters. This is one of a small group of half-length portraits of members of his own family painted by Reynolds apparently *c.* 1746 at the time he returned to Plympton from London after the death of his father (see Cat. 4). Like the rest of the set it is softly painted in a gently Rembrandtesque manner, in an oval which is now barely discernible. The faint shaft of light from above left and the angle of her head give the subject a somewhat remote, spiritual air. When Reynolds set up his studio in 1753 after his trip to Italy, Frances came to London and acted as his housekeeper, firstly at his apartments in St Martin's Lane, then in Great Newport Street, and afterwards in Leicester Fields. Relations with her brother became increasingly strained. In the late 1770s her niece, Mary Palmer, later Marchioness of Thomond, took over the post.

Frances was an amateur painter whose works were exhibited at the Royal Academy and were praised by newspaper critics. She also made copies after her brother's pictures, and of these Reynolds himself said, rather unkindly, 'They make other people laugh, and me cry.' Her *Essay on Taste*, privately printed 1781, was commended by Dr Johnson, who was her devoted friend (see Whitley 1928, I, pp. 297–301). Cornelia Knight, who knew her, described her as 'an amiable woman, very simple in her manner, but possessed of much information and talent, for which I do not think every one did her justice' (Knight 1861, I, p. 8). Her piety, which is perhaps reflected in this early portrait, was a chief cause of the friction with her brother later in their lives.

Another portrait of Frances, half-length and wearing a veil, was engraved by S. W. Reynolds but is now untraced.

D.M.

PROVENANCE Very Rev. Joseph Palmer, Dean of Cashel (the artist's nephew), died 1829; his son, Captain Palmer; William Cotton of Ivybridge; bequeathed 1853 to the City of Plymouth.

EXHIBITED South Kensington 1867 (559); Plymouth 1951 (3); Plymouth 1973 (9).

LITERATURE Jewitt 1853, pp. 1–2; Graves and Cronin 1899–1901, II, pp. 817–18; Waterhouse 1941, p. 6, 37.

No early engraving recorded.

5

6 Self-portrait aged about twenty-three

75 × 62.2 cm
Private Collection

Reynolds returned to Plympton from London at the end of the year 1745 on the death of his father and the few examples of his work that date from this time show him slightly uncertain about the direction his art would take. This earliest self-portrait in oils must, on stylistic grounds, have been painted about 1746. Together with a still earlier pencil self-portrait (Plymouth 1973, no. 57) which represents him aged about seventeen, it belonged to Lady Thomond and may originally have been intended as part of the set of portraits of Reynolds's own family which he seems to have painted as a kind of memorial at a time when the family was losing, through death or marriage, its unity.

This is an important picture, for it stands together with the portrait of his sister Elizabeth (Cat. 9) at the point where we can see the emergence of a truly personal style after the experiments of the early 1740s. It shows the young artist in a gown like that worn by George Vertue in his bust painted by Richardson in the National Portrait Gallery (576), a picture which provides a further comparison. Whereas Richardson applied his paint in a solid, buttery way, Reynolds has built up a dense, glowing texture using small delicate touches. Reynolds's picture is so dark that the painted oval is barely discernible, but the tones on the cheeks and across the nose are warm and pinkish, and the artist's brown hair is worn long and curly. The hardness which some of Reynolds's earliest faces seem to have inherited from his master, Thomas Hudson, has disappeared. One is reminded of some of Rembrandt's earliest self-portraits, not only by the lighting, which is softer here, but also by the pose. D.M.

PROVENANCE Inherited by the artist's niece, Mary Palmer, afterwards Marchioness of Thomond; Mrs Gwatkin (Mary Palmer's sister Theophila); by descent.

EXHIBITED British Institution 1823 (42); South Kensington 1862; Leeds 1868 (1048); Grosvenor Gallery 1883 (2); Royal Academy 1956 (285); Birmingham 1961 (2).

LITERATURE Cotton 1856, p. 64; Leslie and Taylor 1865, I, pp. 30–1; Graves and Cronin 1899–1901, II, p. 790; Hudson 1958, p. 22; Mannings 1975, p. 219.

No early engraving recorded.

6

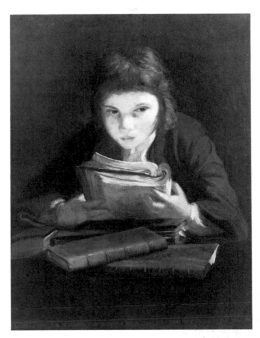

7 *reproduced in colour on p. 75*

7 Boy Reading

78.7 × 63.5 cm
Inscribed *1747/J. Reynold/Pinxit Nov* apparently replacing an
earlier inscription *REYN . . . PINXT*
Private Collection

This is Reynolds's earliest known experiment with a type
of picture, half-portrait, half-genre, which occurs in the
work of many eighteenth-century painters on both sides of
the Channel, and enjoyed a remarkable vogue with collectors
throughout the period. The *Boy Reading* is now dated 1747
but is clearly stated in the artist's studio sale as having been
painted in 1746. It may derive ultimately from Rembrandt's
Titus in Rotterdam (Bredius 120), a picture which was as
popular with the French *Rembrandtistes* as it was with the
English. In a period when more and more children were
learning to read, themes of absorption in and distraction from
a book become common in paintings and prints. Children
appear reading, either alone or in the presence of a tutor;
they frown with the effort of learning; their attention
wanders and they are represented daydreaming; finally, they
fall asleep. Greuze's *Boy asleep on his lesson book* at Montpellier
(fig. 49), exhibited at the Salon in 1755, represents the last
stage, and is not unlike this one in lighting and brushwork.
Greuze returned to the theme two years later with the *Boy
with lesson book* in the National Gallery of Scotland, a picture
which, though it is unlike this one in handling, is close to
it in subject-matter. Greuze's child partially covers the book
with his hands and looks away, as if trying to memorize its
contents. Reynolds's boy seems, like Rembrandt's *Titus*, to
be looking past the book as if lost in thought.

In the long series of fancy pictures which Reynolds painted
during the latter part of his career he seems to have returned

to this particular theme only once. A picture known as *The
Studious Boy*, which belonged to Lord de Tabley until 1827
and was last exhibited at the Grosvenor Gallery in 1883 (90)
was, however, quite different in composition. Another, *The
Schoolboy* (Cat. 105) painted in 1777 approaches the subject
but the result is very different. D.M.

PROVENANCE Greenwood's 16 April 1796 (36), bt Edridge for Sir Henry
Englefield; his sale Christie's 8 March 1823 (53), bt R. Pettiward; Lady
Hotham; sold to Welbore Ellis, 2nd Earl of Normanton, 1856; by descent.

EXHIBITED Royal Academy 1883 (221); Birmingham 1961 (4).

LITERATURE Malone, in Reynolds 1798, I, note p. xi; Northcote 1818, I,
pp. 20–1; Leslie and Taylor 1865, I, p. 30 and note; Graves and Cronin
1899–1901, III, p. 1115; Roldit 1903, p. 223; Waterhouse 1941, p. 37;
Waterhouse 1973, p. 46; White 1983, p. 34.

ENGRAVED G. Keating, 30 September 1784 (probably but not certainly
after this picture).

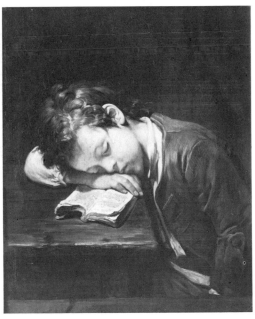

Fig. 49 Jean Baptiste Greuze, *Sleeping Schoolboy*, 1755
(Musée Fabre, Montpellier)

8 Miss Elizabeth Eliot

61 × 47 cm
The Hon. Mrs Hervey-Bathurst

By contrast with the Eliot family group (Cat. 2), this is a
solid piece of painting, and owes little or nothing to Van
Dyck. Like a number of Reynolds's pictures in the 1740s it
owes more to Rembrandt; the turban and pearls, as well as
the bright shape against the background, reflect the current
Rembrandt craze. The *Young Woman with flowers in her hair*
(Bredius 345), currently on loan to the National Gallery of
Scotland, is just one accessible example of a comparable pic-
ture by Rembrandt, though it is easy to find others. At the
same time, the way the neckline of the dress takes the shape

of an inverted pyramid may reflect an increased awareness of sculpture. Indeed, around the mid-century the finest portraits being created in England were the brilliantly-handled and very lifelike terracotta and marble busts by Roubiliac and Rysbrack. Reynolds, like Hogarth slightly earlier, was very much aware of their achievements.

Elizabeth Eliot (1739–71) was daughter of Richard Eliot and his wife Harriot. She could be about seven or eight years old in this picture, painted probably quite soon after *The Eliot Family* (Cat. 2) in which she also appears, perhaps as the child riding on the shoulders of Captain Hamilton who became her stepfather after Mr Eliot's death in 1748. Her brother Edward became the 1st Lord Eliot. On 8 August 1759 she married Sir Charles Cocks, later the 1st Lord

Somers, who died in 1806. Aileen Ribeiro observes that the costume—'a turban with jewelled decoration, and a dress with silk gauze scarf twisted round with pearls and with a central posy of flowers'—was fanciful for a child, but also points out that 'pearls, with their connotations of purity, were an acceptable form of jewellery for young girls, as well as being highly fashionable for women'. D.M.

PROVENANCE Sitter married Sir Charles Cocks, later the 1st Lord Somers; by descent.

EXHIBITED Birmingham 1961 (64); Plymouth 1973 (17).

LITERATURE Leslie and Taylor 1865, I, p. 34; Graves and Cronin 1899–1901, I, p. 182; Waterhouse 1941, p. 38; Mannings 1975, p. 222.

No early engraving recorded.

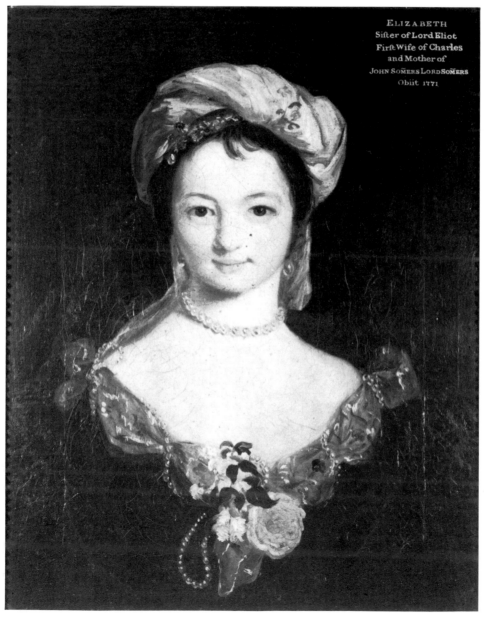

ELIZABETH
Sifter of Lord Eliot
Firſt Wife of Charles
and Mother of
JOHN SOMERS LORD SOMERS
Obiit 1771

8

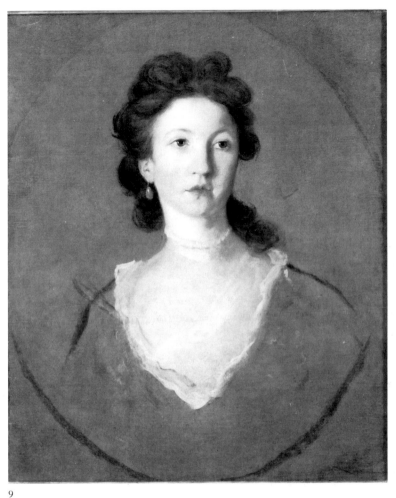

9

9 Elizabeth Reynolds, Mrs William Johnson

62.3 × 50.7 cm
Private Collection

Elizabeth Reynolds (1719–92), one of the two elder sisters of the artist, married William Johnson of Torrington in 1747. Although this might have been conceived as a companion piece to the portrait of Frances (Cat. 5) it is painted on a smaller canvas and the subject has been presented in a quite different way. Recent cleaning has revealed that it was painted over another apparently unfinished head, which suggests that it was painted separately, probably slightly later than the rather idealized portrait of Frances. The lively and confident brushwork in pictures like this, the modelling of the features without the use of outlines, relying on the exact placing of one tone against another, leave no reasonable doubt that young Reynolds had been looking keenly at the portraits of William Hogarth in London in the early 1740s. Although it is often described as a 'sketch', the portrait of Elizabeth Reynolds is simply unfinished, and it seems possible that work was interrupted by the sitter's marriage in 1747 and not resumed after she went away.

Her husband began respectably enough and was three times Mayor of Torrington, but later deserted his wife and children, leaving them in poverty, lived openly with another woman until at last, old and sick, he returned to his wife to be cared for until he died. In the course of this Rake's Progress he lost his own money and his wife's, and also some of Reynolds's. The enterprising Elizabeth, to the horror of her genteel relatives, had been eager to engage in 'merch-andizing' to rescue her family—she even proposed the coal trade (Radcliffe 1930, pp. x–xii, 35–7, 110–24).

Another half-length portrait of Elizabeth exists, wearing a turban and with pearls at her breast. This was engraved by G. H. Every in 1864 and was in the Metropolitan Museum, New York, until sold as 'British School' in 1956 (Waterhouse 1968, p. 166). D.M.

PROVENANCE The sitter's daughter Mary married the Rev. Peter Wellington Furse of Halsdon, Devon; Rev. William Johnson Yonge of Rockbourne, Hampshire; by descent.

EXHIBITED Park Lane 1937 (65); Plymouth 1951 (4); Birmingham 1961 (3); Plymouth 1973 (10).

LITERATURE Cotton 1856, p. 272; Graves and Cronin 1899–1901, II, pp. 816–17; Waterhouse 1941, p. 37; Mannings 1975, p. 216.

ENGRAVED S. W. Reynolds, 1822.

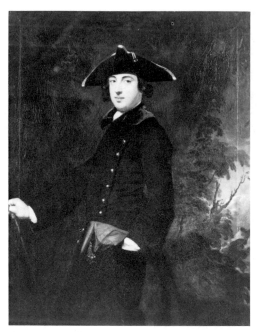

10 *reproduced in colour on p. 77*

10 William, Fifth Lord Byron (?)

123.5 × 98 cm
Newstead Abbey, Nottingham Museums

This is one of the most intriguing Reynolds discoveries of recent years, an early portrait which must, on stylistic grounds alone, have been painted before the artist's journey to Italy. The easy placing of the figure, the relaxed pose, the simplified planes of face, hands and coat all invite comparison with the first portrait of Keppel (fig. 2, p. 19) which Reynolds signed and dated 1749, or the portrait of First Lieutenant Ourry (Cat. 11) which may be slightly earlier. The background is also very characteristic of the late 1740s and early 1750s: the motif of 'blasted' trees against a bright patch of cloud occurs in the work of Reynolds's teacher, Hudson (e.g. *Theodore Jacobsen*, Coram Foundation, 1746), and in work by other pupils of Hudson such as Benjamin Wilson (e.g. *9th Viscount Irwin*, fig. 50), who was considered by some as a rival to Reynolds as late as the 1750s (Whitley 1928, I, p. 154).

The portrait is traditionally supposed to represent the Hon. John Byron (1723–86), grandfather of the poet. He was the second son of William, 4th Lord Byron, and had an extraordinary career. Shipwrecked off the coast of Chile as a seventeen-year-old midshipman in the *Wager*, a storeship in Anson's squadron, he made his way back to England after great hardships, and in 1768 published a *Narrative . . . account of the great distresses suffered by himself and his companions on the coasts of Patagonia, from the Year 1740, till their Arrival in England, 1746*. It seems that he crossed the English Channel to Dover towards the end of March 1746, and went straight to London to see his sister Isabella, who had married the 4th Earl of Carlisle and was living in Soho Square (Byron 1768,

p. 263). He was immediately promoted to Commander and on 30 December 1746 was made Captain of the *Syren* frigate. On 8 September 1748 he married Sophia, daughter of John Trevanion of Caerhays, Cornwall. After the Peace of Aix-la-Chapelle in October of the same year Byron's ship, the *St Albans*, was part of a squadron led by Captain Buckle off the coast of Guinea. He is not recorded again in England until 1753, when he commanded the *Augusta*, a guardship which was still at Plymouth in early 1755 (Campbell 1818, VI, pp. 305–6). Reynolds was, so far as we know, in London between 1753 and 1755. If this picture does represent Captain Byron it must have been painted in 1746–8, almost certainly before the introduction of naval uniforms in 1748 (see Cat. 19), and one would have expected at least a glimpse of

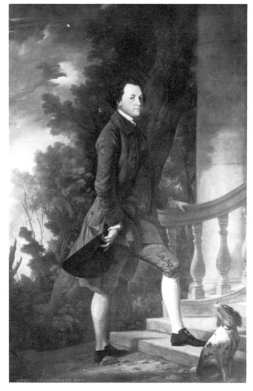

Fig. 50 Benjamin Wilson, *Charles, 9th Viscount Irwin*
(Temple Newsam House, Leeds)

the sea, if not some specific allusion to Captain Byron's South American adventures.

In fact there is nothing to suggest that this is the portrait of a seafaring man. As Aileen Ribeiro points out, the subject is wearing 'a good example of the English sporting/hunting frock, double-breasted and cut away to reveal the waistcoat beneath; blue was a popular colour for this kind of informal coat, made of woollen cloth, and here with a velvet collar. Over his single rolled-curl hairstyle (his own hair) he wears a three-cornered hat with a sharp front pinch, known as a Kevenhuller hat, a popular sporting and military style. A sporting influence in men's dress is evident in the middle years of the eighteenth century. Francis Coventry's novel

Pompey the Little (1751) describes a fashionable young gentleman whose estate was able to provide him with "a variety of riding frocks, Khevenhullar hats, Jockey boots and Coach-whips"; in the morning he always appeared in "a New-market frock, decorated with a great number of green, red or blue capes", carrying "a cane switch in his hand".'

Costume, pose and background, as well as Captain Byron's known movements during these years, make it altogether unlikely that he is the subject of Reynolds's portrait. A more likely candidate would be his brother, William, 5th Lord Byron (1722–98). In his early years at Newstead he was a keen collector of pictures, but in 1765 he killed a neighbour and relation, William Chaworth, in a drunken duel. He was tried for murder before the House of Lords, was acquitted, and became a recluse. In a deliberate and successful bid to ruin the inheritance of his son, who had married against his father's wishes, he wilfully neglected the house and sold off land, timber, and the family pictures (Train 1974, p. 39). It is true that this portrait has a Trevanion provenance (though this remains to be clarified), but in any case it would not be surprising if a portrait of the 5th Lord—the 'Wicked Lord' or 'Devil Byron'—were to be renamed by his impoverished heirs. A portrait of 'Foulweather Jack' (as Captain Byron was known to his sailors) was, perhaps, a more appealing object with which to decorate a drawing-room. D.M.

PROVENANCE Said to have belonged to the Trevanion family, Caerhays, Cornwall, until *c.* 1840; Sir Joseph Graves-Sawle; anon. sale, Sotheby's, 15 March 1978 (15), bt for Newstead.

Not previously exhibited.

LITERATURE *National Art-Collections Fund, 75th Annual Report, 1978*, 1979, pp. 46–7.

No early engraving recorded.

11 First Lieutenant Paul Henry Ourry

127 × 101.6 cm
The National Trust, Saltram (Morely Collection)

Paul Henry Ourry (1719–83) was Captain Edgcumbe's First Lieutenant at the time this picture was painted. He progressed to Commander in 1756, Captain in 1757 and eventually Admiral. From 1763–75 he was Member of Parliament for Plympton Earl and became Commissioner of Plymouth Dockyard. The black boy's name was Jersey.

This is an early essay in the manner of Titian, whose 'senatorial dignity' Reynolds praised in the Fourth Discourse (Reynolds 1975, p. 67). 'His portraits alone,' Reynolds declared, 'from the nobleness and simplicity of character which he always gave them, will intitle him to the greatest respect, as he undoubtedly stands in the first rank in this branch of the art.' And this was a favourite scheme of Titian's: a quietly-posed standing gentleman, shown three-quarter-length and set against a perfectly plain background. Ourry, with his glance directed away from the spectator,

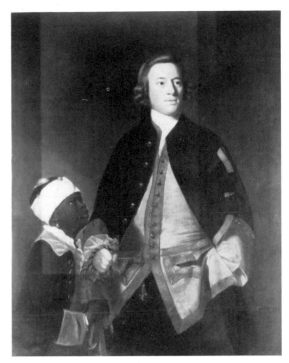

11 *reproduced in colour on p. 76*

with light on the face and with a gleam of white at collar and cuff, can be compared with a number of early Titians such as the *Young Man* in the Alte Pinakothek, Munich (517). The very striking motif of the black page, whose white turban glows so beautifully in the shadows, also derives from Titian. It can hardly be doubted that Reynolds knew the splendid portrait known as *Laura dei Dianti*, with her black page, now at Kreuzlingen. This was in Paris in the Orléans Collection during Reynolds's lifetime. Whether he saw a print (Titian's picture was engraved by Aegidius Sadeler before 1629) or one of the numerous copies that exist, we do not know. But the curious trick of using, for a male sitter, a composition or pose associated with portraits of women, which is what Reynolds seems to be doing here, was a device he resorted to on other occasions (Mannings, November 1984). *Ourry* is certainly closer to Titian than it is to any of the seventeenth-century derivations Reynolds is likely to have seen, such as Van Dyck's *Henrietta of Lorraine* (now at Kenwood but then, like *Laura dei Dianti*, in the Orléans Collection) or Sir Peter Lely's *Elizabeth Murray* at Ham House.

Reynolds and Ourry were in touch in later years. On 26 September 1772 Reynolds wrote to Ourry saying, 'I have had the honour of being elected an Alderman of Plympton for which I beg leave to return, to you in particular, my most hearty thanks' (Reynolds 1929, p. 32). A note in his pocket-book shows that in the following year, while on a visit to Devon, he dined with Captain Ourry on 27 September, and Ourry saw Reynolds when he was in London.

When David Wilkie visited Plympton in 1809 he noted that this portrait and the rather similar portrait of Captain Edgcumbe which is now in the National Maritime Museum (both hung then in the mayoralty room adjoining the Guild-

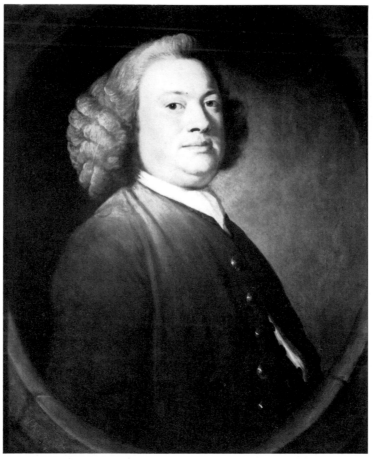

12

hall) 'were for composition as fine as anything Sir Joshua ever did afterwards' (Cunningham 1843, I, p. 240). D.M.

PROVENANCE Painted for the Corporation of Plympton for four guineas; acquired after the disfranchisement of the Borough in 1832 by the sitter's grandson, Montagu Edmund Parker of Whiteway; 2nd Lord Morley, c. 1854; by descent, until transferred to the National Trust, 1957.

EXHIBITED Plymouth 1951 (5); Royal Academy 1956 (204); Birmingham 1961 (5).

LITERATURE Cotton 1856, p. 125; Graves and Cronin 1899–1901, II, p. 714; Waterhouse 1941, pp. 37, 119; Gore 1967, pp. 34–5.

ENGRAVED S. W. Reynolds, 1834 (wrongly inscribed as of Richard, Lord Edgcumbe).

12 Unknown Gentleman

77.1 × 63.7 cm
Signed and dated 1748
Greater London Council, Marble Hill House

This signed and dated portrait, painted almost certainly at Devonport where Reynolds had a studio in 1746–9, provides a valuable index of his rapidly maturing style just a few months before he sailed for Italy in May 1749. From Kneller

and from his old master, Hudson, Reynolds had learnt the trick of setting a half-length portrait within a feigned oval. In his earliest portraits, for instance the Kendall portraits of 1744 (one of which, *Mrs Kendall*, was exhibited at Plymouth in 1973 [3]), he used a decorative scrolled oval. This framing motif became simpler and plainer around 1746, as can be seen in the portraits of his sister Frances (Cat. 5) and his father (Cat. 4). The *Gentleman* is placed within a masonry oval which, in virtue of its three-dimensional quality, helps to push the figure back slightly in space, an effect similar to that achieved by the use of a stone ledge or wall in another recently discovered picture, the *Unknown Youth* in the Barber Institute in Birmingham.

The plain, heavy quality of the stone oval is carried through the picture as a whole. The figure takes on, in fact, something of the weighty simplicity of sculpture, which is probably quite deliberate, for it seems likely that Reynolds was responding to the increased popularity of sculptured busts in the 1740s. At any rate, this realistic and sharply-modelled figure with bold shadows setting off the planes of forehead and cheek, and the bulk of the coat, marks a determined quest for independence from the rival style of Hogarth, whose softly-lit portrait of the actor James Quin in the Tate Gallery (fig. 51) illustrates a more complex rococo alternative. The point is underlined by one significant

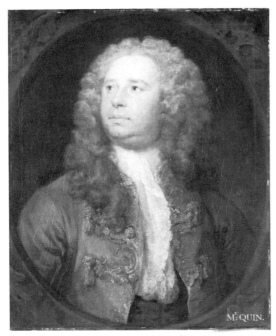

Fig. 31 William Hogarth, *James Quin, the Actor*,
c. 1740–5 (Trustees of the Tate Gallery, London)

detail: Reynolds originally painted the gentleman's wig lower, and, by pushing it back behind the line of the shoulder he has simplified the composition at that point.

The subject of this portrait has not been identified but he is not likely to have been of very high social status. As Aileen Ribeiro points out, his dress makes no pretensions to fashion: he wears a brown woollen coat, with buttons of pinchbeck (an alloy of copper and zinc, imitating gold). The long, powdered bob-wig with sausage-like curls to the shoulders was an informal or undress wig worn mainly by the professional and middle classes. Instead of the lace which would have been worn by a man of fashion, he wears a plain linen cravat knotted round his neck. D.M.

PROVENANCE William Yates, 1889; Sabin Galleries Ltd, 1972; Greater London Council, 1974.

EXHIBITED Plymouth 1973 (21).

LITERATURE Mannings 1975, pp. 221–2 and note; Kenwood 1975, no. 32.

No early engraving recorded.

13 Self-portrait Shading the Eyes

63 × 74 cm
National Portrait Gallery, London

Almost certainly painted just before, rather than just after, Reynolds's trip to Italy, the rather blunt simplification of light and shade around the mouth and nose, and the way the artist builds up a dense paint-surface across the lower part of the face may be compared with the *Boy Reading* (Cat. 7), which is dated 1747. Thin, feathery brush-strokes on the hair and left hand are also typical of Reynolds's technique in the

late 1740s. The suggestion, recorded by C. R. Leslie, that signs of the injury to his lip which he suffered on the way to Italy can be seen here, seems implausible. The odd, thick shape of Reynolds's lip is detectable in the earliest self-portrait drawn when he was about seventeen (Steegman 1942, pl. IIB) and in the portrait of his sister Elizabeth (Cat. 9), which suggests that it may have been a family trait.

Aileen Ribeiro points out that Reynolds, always a stylish dresser, here adopts the fashionable informal frock coat, with turned-down collar and plain sleeves, but without the elaborate cuff of full dress which could impede his work. Shades of brown and blue were particularly popular in the 1740s and Reynolds wears a brown coat with velvet collar and a blue silk waistcoat, worn *à la mode* open to mid-chest. His own loosely-curled hair is preferred to the more formal wig.

This is the only authentic self-portrait in which Reynolds represents himself actually painting, holding brushes and mahlstick and a type of palette with a handle (see Cat. 167a, b). Reynolds's intellectual ambitions, which increased after his return from Italy and particularly after he met Dr Johnson around 1756, encouraged him to present himself as a thinker, most notably in the numerous self-portraits wearing academic dress (e.g. Cat. 116). He adopts, furthermore, a slightly stern, self-important expression quite different from the innocent, almost worried look we see here.

The *Self-portrait Shading the Eyes* was particularly admired by Reynolds's pupil James Northcote who described it, oddly, as 'an attitude often chosen by painters when they

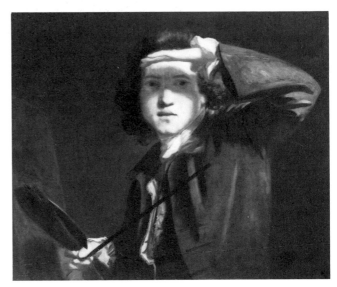

13 *reproduced in colour on p. 73*

paint their own portraits', and who not only used a print (stipple, in reverse, by R. Cooper) from it as a frontispiece to his biography of his master, but copied it into his picture, *Worthies of England* (1828, Thomas Coram Foundation, London). He also borrowed the pose for his own self-portrait (Plymouth Art Gallery) in which, however, he stands sideways instead of facing the spectator, and the hand does not cast a shadow. George Richmond's self-portrait in the

Fitzwilliam Museum, Cambridge, dated 1840 by an inscription on the back, is a later and an even closer borrowing.

The early history of this picture is not very clear. When engraved in 1795, probably in London, it already belonged to Thomas Lane of Coffleet. It is possible that the engraving was made and published by S. W. Reynolds at the time it was acquired by Lane, but we cannot be sure. At any rate, it was taken to Devonshire early in the nineteenth century and was seen by Northcote at Coffleet. Thomas Lane was magistrate for Devonshire and was High-Sheriff in 1784. He died in 1817 aged seventy-five. When S. W. Reynolds visited the Lanes soon afterwards he referred to them, in a letter dated 2 June 1821, as a family 'of great importance'. His host was the Rev. Richard Lane, 'whose father entertained at Cosfleet [sic], Johnson, Burke, Garrick, Sir Joshua Reynolds and Goldsmith' (Whitman 1903, p. 10).

About the time the *Self-portrait Shading the Eyes* was removed to Devonshire it was cut down. The original format is shown in the engraving of 1795 (fig. 52) and perhaps also

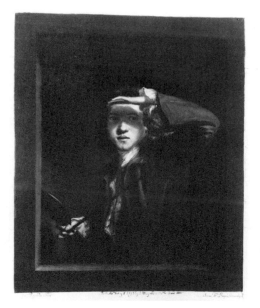

Fig. 52 Samuel Reynolds (after Reynolds, *Self-portrait, c.* 1748), mezzotint, 1795 (British Museum, London)

reflected in Northcote's derivation. Richmond's self-portrait, which is exactly square and very much a close-up, may reflect the altered shape of Reynolds's picture. If S. W. Reynolds's engraving does exactly reproduce the original format of the *Self-portrait Shading the Eyes*, we can calculate that approximately 16 or 17 cm have been cut off the top and 6 or 7 cm off the bottom. The resulting oblong is a very unusual shape for a half-length portrait and the crowded composition is untypical of Reynolds, who liked to leave more space around his subjects.

Although this seems an obvious example of Reynolds's early interest in Rembrandt, and has often been discussed as such, it is no slavish imitation, and no convincing source has been found in Rembrandt's etched or painted compositions.

Rembrandt painted numerous self-portraits in which the eyes are shadowed, sometimes by a wide-brimmed hat, but never by a hand. D.M.

PROVENANCE Thomas Lane of Coffleet by 1795; Christie's, 24 May 1845 (62); Joseph Sanders of Johnston Hall; his sale, Christie's, 15 May 1858 (40); National Portrait Gallery.

EXHIBITED South Kensington 1867 (517); British Council 1967; Plymouth 1973 (27).

LITERATURE Northcote 1818, I, note p. 304; Cotton 1856, pp. 59–60, 272; Leslie and Taylor 1865, I, p. 34; Graves and Cronin 1899–1901, II, pp. 790–1; Whitman 1903, pp. 3, 78; Waterhouse 1941, p. 39; Mannings 1975, p. 219; White 1983, p. 34.

ENGRAVED S. W. Reynolds, 1 February 1795; R. Cooper, 1813; S. W. Reynolds (a second time, undated).

14 Four Learned Milordi

63 × 49 cm
National Gallery of Ireland

In Rome in 1751 Reynolds painted a burlesque of Raphael's *School of Athens* (fig. 4), replacing the ancient philosophers with caricatures of British gentlemen and some of their parasites (antiquaries, tutors, doctors and dealers) then in the Holy City. Joseph Henry, whose name is written on the back of this canvas, was an Irish gentleman on a prolonged Grand

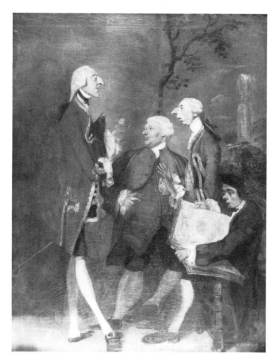

14 *reproduced in colour on p. 81*

Tour, acquiring landscapes by Vernet and Wilson, a portrait of himself by Batoni, and a reputation as an '*uomo assai erudito nella Antichità e en lettera*' (to quote the caption of the caricature of him by Ghezzi). Not surprisingly, many of his com-

panions in Rome who appear in this burlesque were also from Ireland: among them were Henry's future brother-in-law, Joseph Leeson, son of a Dublin brewer and afterwards Earl of Milltown, and the eminent arbiter of taste, Lord Charlemont.

Formerly in the Milltown Collection and hence probably executed for Leeson or his son are three other smaller caricature groups composed mostly of figures in the larger work, often in identical poses. These are listed and dated to the same year in a sketchbook by Reynolds. This painting is one of them. It represents the beanpole Thomas Brudenell, Lord Bruce of Tottenham, a friend of Lord Charlemont and a successful courtier who was in 1776 made Earl of Ailesbury. Amused by Lord Bruce's eloquence is the tubby John Ward of Helmley, Staffordshire (the only person here who was not in the School of Athens caricature), and amazed by it is the chinless Joseph Leeson junior. Joseph Henry himself appears seated, gaping over a folio open at a print of the ancient Roman sewer, the *Cloaca Maxima*. There is another version of the painting in a private collection in Ireland which may well be autograph. Aileen Ribeiro draws attention to the contrast between the 'formal bag wigs and chapeau bras' of Lord Bruce and Joseph Leeson and the plain suits of Joseph Henry (who also appears to wear his own hair unpowdered) and of Ward (who wears the short bob-wig of the professional classes). N.P.

PROVENANCE Painted either for Joseph Leeson or his son (who became 1st and 2nd Earls of Milltown); by descent; Milltown gift to the National Gallery in 1902.

Not publicly exhibited before 1900.

LITERATURE Cotton 1859 ('Notes and Observations'), pp. 8–9; Sutton 1956; O'Connor 1983.

No early engraving recorded.

15 Ralph Howard's Escapade

93.9 × 143.5 cm
Private Collection

It is not at first obvious what exactly this painting depicts. To the extreme left in the foreground a man struggles with the wheel of a stuck carriage. To the right of him, a monk, outstretched on the ground, extends a rosary towards the right. A gentleman (presumed in old accounts of the picture to be Ralph Howard) turns as he mounts the carriage to examine the incident to the right of the painting through his glass. A corpulent man beside him (presumed to be Howard's tutor, Dr Benson) points in the same direction. A footman mounted on the carriage blows a horn and, perhaps in consequence, a grey horse throws a postillion in a green coat. A boy falls from another horse in the opposite direction. (There is another head just visible below the rump of the boy.) In the right-hand foreground a lanky figure with a bandaged head wearing a sword and holding a purse (he is presumed to be Howard's courier) folds his arms defiantly and turns a snarling profile towards a man and woman

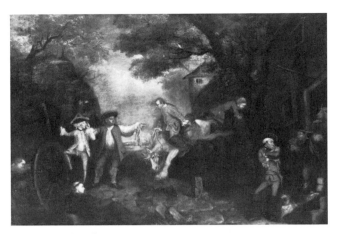

15 *reproduced in colour on p. 79*

lewdly gesturing in a doorway (presumed to be innkeepers). In the distance there is a building with a cross on its gable (perhaps a monastery).

This is one of the least familiar of the 'caricaturas' which Reynolds executed in Rome. Its authenticity has sometimes been disputed—with no good reason. It differs from the better-known examples in its narrative character and landscape setting but is reminiscent in handling, scale and colour of the earlier Eliot Family group (Cat. 2). It would seem to record a farcical episode which occurred to Ralph Howard (afterwards Baron Clonmore and Viscount Wicklow) on his Italian travels. Howard, like many of the other gentlemen in Reynolds's caricatures, was from Ireland. His agent James Russel, in a letter to him on 10 March 1752 (recently published by Cynthia O'Connor), wrote that 'upon some discourse I had with Mr Reynolds, he seemed very sorry he had lost your good graces; he has worked upon your picture since and really altered it for the better'. If, as seems likely, this refers to this painting then it is slightly later than the caricatures listed by Reynolds himself as painted in 1751. In a letter of 16 January 1753 Russel recorded that he had packed up the 'caricatura' together with a painting by Vernet for dispatch to Dublin. N.P.

PROVENANCE Painted for Ralph Howard; by descent.

EXHIBITED British Institution 1853 (124); South Kensington 1867 (346).

LITERATURE Cotton 1856, p. 67; Graves and Cronin 1899–1901, III, pp. 1054, 1229–30 (with erroneous information); Sutton 1956, p. 116; O'Connor 1983, pp. 7–8.

No early engraving recorded.

16 Catherine Moore

69.8 × 57.1 cm
The Iveagh Bequest, Kenwood (GLC)

Catherine Moore (died 1797) of Bromsgrove, Worcestershire, met William Chambers, future architect of Somerset House and first Treasurer of the Royal Academy (see Cat. 113) in the late summer of 1749. Chambers then left

to study at J. F. Blondel's celebrated Ecole des Arts in Paris where, less than two years later, Catherine rejoined him, and they spent two or three months together, although not yet married, in the summer of 1751. The couple were eventually married in Rome, at their lodgings in 73 Strada Felice (now Via Sistina) on 24 March 1753, and lived there for two years. Piranesi was their close neighbour. Their first child was born

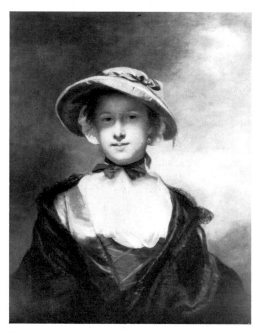

16 reproduced in colour on p. 82

5 July and christened Cornelia, and a second daughter, Selina, was born in the last months of 1754 or early in 1755 (Harris 1970, p. 6).

According to Northcote, Catherine Moore was painted in Paris in the autumn of 1752 and indeed she was not in Italy when Reynolds was there. The soft shadow over her eyes and the rather pretty colours, together with the precise edges to forms, may reflect the work of French *Rubénistes* like Jean Raoux (died 1734) whose work Reynolds is not likely to have seen before that date. It may be assumed that the painting came back to London in 1755 with Chambers and that Reynolds, seeing it again, was sufficiently pleased by it to wish to have it reproduced by McArdell. The resulting mezzotint was presumably marketed simply as a beautiful image rather than as a portrait because no name was engraved on it and the sitter was in any case no celebrity.

Aileen Ribeiro notes that although this portrait may have been painted in Paris, the sitter's dress with its firm corseting is particularly English. It is of greyish-purple satin with a stomacher of similar colour crossed by decorative lacing, and slipping off the shoulders is a hooded black silk mantle. The hat, of cream silk lined with blue, is worn over a linen cap, in, again, a distinctively English style; the cap would be retained indoors. Foreign visitors to England, while generally critical of Englishwomen's dress, made an exception for the charming way they wore their hats. D.M.

PROVENANCE By descent to Montagu Chambers QC; his sale, Christie's, 9 July 1886 (110) bt Asher Wertheimer; Agnew; Earl of Iveagh, 1887; 1st Lord Moyne, and bequeathed by him to Kenwood, where received 1946.

EXHIBITED Royal Academy 1879 (63); Birmingham 1961 (10).

LITERATURE Northcote 1818, I, p. 50 and note; Leslie and Taylor 1865, I, p. 86; Graves and Cronin 1899–1901, I, pp. 163–4; Waterhouse 1941, p. 38; [Murray], n.d., p. 30.

ENGRAVED McArdell, 1756; 'Corbutt' (Purcell); Spooner (in reverse); S. W. Reynolds.

17 Dr John Mudge FRS

77.5 × 66 cm
Rev. Arthur Mudge Cardale

According to Reynolds's early biographer, Northcote (who also painted Dr Mudge's portrait, and was a friend of the family), this picture was painted during the brief visit the artist paid to his native Plymouth on returning from Italy in 1752 and before setting up his studio in London. John Mudge (1721–93), son of the Rev. Zachariah Mudge, who also sat to Reynolds, was the painter's lifelong friend. They had, in fact, been at school together. Besides his practice as

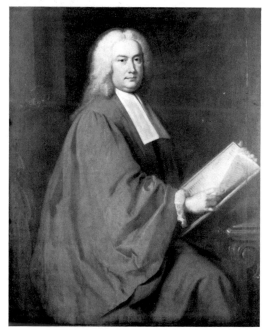

Fig. 53 Thomas Hudson, *Sir Edmund Isham, c.* 1743
(Magdalen College, Oxford)

a physician and surgeon in Plymouth, he was a mathematician and published a treatise on the manufacture of Reflecting Telescopes. In 1771 he was elected Fellow of the Royal Society for his work on smallpox inoculation. In 1784 he was made a Doctor of Medicine by King's College,

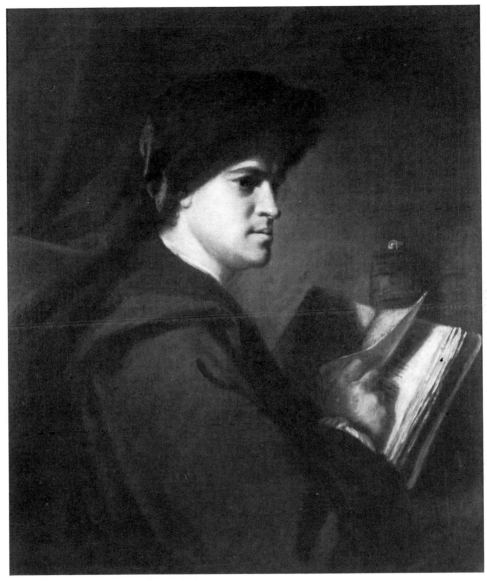

17

Aberdeen. Reynolds remained on terms of close friendship with the Mudge family all his life, entertaining them at his house in London, visiting them in Devon, and sending them a signed copy of each of his *Discourses* as it was published.

In the late 1740s and early 1750s Reynolds made a number of experiments with the style of Rembrandt, and this coincides with a widespread fashion. As the engraver and antiquary George Vertue noted in 1750–1: 'lately the prints [of] Rembrandt being here much esteemed and collected at any price, some particularly [were] sold at sales, very extraordinary' (Vertue [1933–4], p. 159). Paintings as well as prints were, Vertue goes on to say, known and closely imitated. However, as Christopher White has pointed out (1983, p. 45), what may well have been one of the most influential paintings, a portrait of a gentleman at his desk with books and papers, although attributed to Rembrandt

in the eighteenth century, was probably not by him at all. (It is now known only through an etching by Thomas Worlidge, cited by Vertue as one of Rembrandt's most active imitators.) Thomas Hudson, who owned this work, was surely influenced by it when he painted Sir Edmund Isham seated in a shadowy interior turning the pages of a book. The portrait, now at Magdalen College, Oxford (fig. 53), perhaps dates from the period when Reynolds was his assistant. D.M.

PROVENANCE Given to the sitter by the artist; by descent.

EXHIBITED Park Lane 1937 (45); Plymouth 1951 (7); Plymouth 1973 (25).

LITERATURE Northcote 1818, I, p. 52; Leslie and Taylor 1865, I, p. 89; Graves and Cronin, 1899–1901, II, p. 667; Waterhouse 1941, p. 38; White 1983, p. 35.

ENGRAVED W. Dickinson; S. W. Reynolds.

18 Giuseppe Marchi

73.5 × 62.3 cm
The Royal Academy of Arts

This was one of the first pictures Reynolds painted on his return from Italy. On seeing it, his old master, Hudson, is supposed to have said, 'By God, Reynolds, you don't paint so well as when you left.' Like the portrait of Dr Mudge (Cat. 17), it is strongly Rembrandtesque. As Christopher White has pointed out, Reynolds may have derived the turban (which Northcote calls 'Turkish') either from an etching, or from a painting such as *Uzziah Stricken with Leprosy*

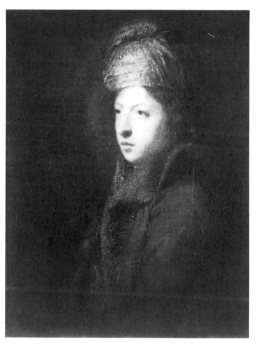

18 *reproduced in colour on p. 83*

(Chatsworth) which then hung in the London house of the 3rd Duke of Devonshire—whose portrait, we may note, Reynolds painted in 1753—or the so-called *Turk* now in the Metropolitan Museum, New York, but then in the Methuen Collection. In fact, there were numerous possible sources.

The technique is particularly interesting. The use of such thick impasto, especially on the turban, and the bold brushwork on the cloak, clearly imitated from the late work of Rembrandt, may be a deliberate reaction by Reynolds to the smooth style of J. E. Liotard, a Swiss pastelist who was, at precisely this time, enjoying a temporary vogue in London with his minutely-finished little portraits of royalty and aristocracy.

Giuseppe Marchi (1735–1808) met Reynolds in Rome and came to England at the age of about seventeen in 1752 to be his full-time studio assistant. As such he played a large part in Reynolds's production throughout his career. In addition to routine drapery-painting and studio jobs like setting the colours on his master's palette each morning, he seems

to have been one of Reynolds's most trusted copyists, and must be given credit for many of the replicas of popular pictures that issued from Reynolds's studio.

The close familiarity thus acquired with his master's technique made Marchi an invaluable repairer and restorer of Reynolds's pictures, and the lengthy obituary he received in the *Gentleman's Magazine* noted that, 'since the loss the world has sustained by the death of Sir Joshua, he has . . . been frequently employed to restore such as had suffered by neglect, which he did with great success'.

About 1770 he set up on his own as a portrait painter in London and then at Swansea, but was unsuccessful and returned to Reynolds. He also practised as an engraver. For some reason he was not mentioned in Reynolds's will, but, as reported in the *General Evening Post*, Mary Palmer, later Marchioness of Thomond and the painter's heiress, arranged that he should continue to receive the one hundred pounds a year that his master had always paid him (Whitley 1928, II, p. 159).

Aileen Ribeiro points out that 'to achieve the exotic "oriental" effect in this portrait, Reynolds has twisted a striped white silk sash with fringed ends (as worn, for example, to girdle the dresses of some of his female sitters) into a turban, into which is entwined a silk scarf. Over a blue gown, sashed at the waist, Marchi wears a crimson coat, lined with marten, and decorated with gold frogged fastenings; such a costume is more reminiscent of Central Europe (Poland in particular) than the "Levant kind of dress" mentioned in Marchi's obituary of 1808, although the links between them are close.'

At least three other portraits of Marchi are recorded, and are usually described as copies or versions of Reynolds's picture. The most interesting one, described when it hung at Roehampton House *c.* 1900, as a 'version' of the Royal Academy's picture, is in fact quite differently posed with the subject full-face and wearing a red turban (Lionel Speakman sale, Christie's, 6 May 1949 [123]). This could well be Marchi's self-portrait. D.M.

PROVENANCE In Marchi's sale at Squibb's, 1808 (44); bequeathed to the Royal Academy in 1821 by Henry Edridge ARA.

EXHIBITED British Institution 1853 (150); Manchester 1857 (67); Royal Academy 1884 (208); Birmingham 1961 (11); Royal Academy 1968 (899); Plymouth 1973 (26).

LITERATURE *Gentleman's Magazine*, 1808, p. 372; Northcote 1818, I, p. 53; Leslie and Taylor 1865, I, p. 100; Graves and Cronin 1899–1901, II, pp. 619–20; Waterhouse 1941, p. 39; Gerson 1942, p. 449; White 1983, pp. 23, 35.

ENGRAVED J. Spilsbury, 1761; R. Brookshaw; A. Wilson.

19 Commodore Augustus Keppel

238.8 × 147 cm
National Maritime Museum, London

This was the picture that made Reynolds's name. The Hon. Augustus Keppel (1725–86) was the son of the 2nd Earl of Albemarle and grandson of one of the young Dutch courtiers who had accompanied William III to England in 1688. Keppel was one of fifteen children. His sisters, the Ladies Caroline and Elizabeth (Cat. 44), sat to Reynolds, as did his mother (Cat. 33) and his brother, General William Keppel, though it might be argued that the family's favourite painter was Francis Cotes, who painted no fewer than eight of them between 1752 and 1764 (Johnson 1976, p. 24).

After sailing round the world with Anson in 1740, Keppel was promoted Lieutenant in 1744 and before the end of the year he was a Captain. In 1749 he was appointed Commodore of a squadron which was to treat with the Bey of Algiers, and he invited young Joshua Reynolds to accompany him to the Mediterranean. This gave the painter his big chance. He had been introduced to Keppel by his old benefactor, Lord Edgcumbe, and it was to His Lordship that he wrote, from Rome, of his good fortune in making the

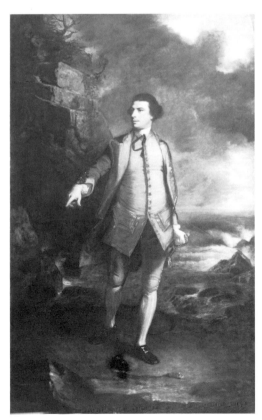

19 reproduced in colour on p. 87

trip, praising in particular the 'kind treatment and great civilities' he had received from Keppel (Reynolds 1929, p. 7). The great full-length, which was painted after Reynolds had

returned to London in 1752, seems to have been intended as a kind of tribute or thank-offering to Keppel, but was retained in the painter's house for some time so that 'sitters who came with more moderate intentions could see what possibilities of immortality were available' (Waterhouse 1973, p. 18).

Joseph Farington, who knew Reynolds, recalled that 'with this picture he took great pains, for it was observed at the time that, after several sittings, he defaced the work and began it again'. Recent X-rays have confirmed that Reynolds originally placed Keppel's head slightly further to the left, and set it at a different angle (fig. 54). This first head was taken to an advanced stage of completion, before the artist decided that the effect was wrong, and reworked the entire passage, altering the position of the hands at the same time. We can see that the original idea was for a much less formal pose, with the head tilting in line with the shoulders and carried slightly forward, setting up a more intimate rapport

Fig. 54 X-radiography of part of the portrait of Keppel
(Cat. 19) made by the Conservation Department
of the National Maritime Museum, London

with the spectator. That it turned out rather like the famous antique statue of the Apollo Belvedere was probably almost accidental, though not of course entirely so. The pose itself was already in circulation, one of the many 'stock' poses used by the drapery-painter van Aken: Ramsay's *Chief of MacLeod* at Dunvegan Castle and Hudson's *Gentleman* (said to be Charles Douglass), sold Christie's on 21 November 1975 (88), are two striking examples. At the time Reynolds's use of the Apollo seems to have passed unnoticed, and the artist himself would not have drawn attention to it, for we know from a passage in the Fifth Discourse that he considered the fusion of antique poses with modern dress to be a risky business. If it is to work it has to be carried right through in, as it were, the same tone of voice: 'the difference of stuffs,

... for instance, which make the cloathing, should be distinguished in the same degree as the head deviates from a general idea' (Reynolds 1975, p. 88). It was a question of pictorial unity. Not all critics have accepted that Reynolds was successful in this instance. F. G. Stephens, who seems to have been the first to suggest the derivation of the pose from the Apollo, thought 'the attitudinizing of the "wrecked Keppel" ... most unworthy of the man', and saw it as an example of the painter's 'theatrical manner' which he contrasted unfavourably with the more natural child portraits.

Augustus Keppel was a lifelong friend of Reynolds and was painted by him at least seven times, a series of images that charts the progress of his career from Captain, appointed Commodore, rising eventually to Admiral, and also the change from the slim figure who posed for the earliest portrait of 1749 (fig. 2) to the pot-belly and double-chin of later likenesses. An accessible later example is in the National Portrait Gallery (179), one of five portraits painted soon after Keppel was acquitted by the court martial which followed the indecisive Battle of Ushant in 1778, and given to John Dunning, one of his defence lawyers. The series also shows a change from the smooth, thin brushwork characteristic of the artist's early work to the crustier, denser impasto evident in many later portraits.

Some evidence of Reynolds's later style is already apparent in this painting, the best-known portrait of Keppel, walking along a stormy seashore. It was claimed by Northcote that this alludes to an incident in 1747 when, chasing a French privateer on the coast of Brittany, his ship the *Maidstone* struck a rock and was lost, he and his crew being made prisoners and sent to Nantes. Whether or not that is true—and there *is* wreckage in the background—Reynolds has handled this particular passage with wonderful vigour. The lighting scheme, inspired by the Tintorettos he had been studying so recently in Venice, provides a strong foretaste of the sort of effect he was much later to cultivate in such pictures as *Mrs Peter Beckford* (Cat. 132).

If Reynolds intended this picture to advertise his skills, he certainly succeeded. Malone, in his early biographical essay written soon after the artist's death, says it 'attracted the publick notice' and established him as 'the greatest painter that England had seen since Vandyck'. The aptness of the reference to Van Dyck is attested by such portraits as the whole-length in the Metropolitan Museum, New York, of the 2nd Earl of Warwick. At the same time the strong claim *Commodore Augustus Keppel* has to a pivotal position in mid-eighteenth-century portraiture rests on its forward-looking as much as on its traditional character. It anticipates, in certain respects, the dramatic force of Romantic portraiture in the age of Lawrence and Goya. Indeed, the 'Tempestuous sea and stormy shore' in this picture were taken by Henry Fuseli as an example of that favourite aesthetic category of the later eighteenth-century, the Sublime (Knowles 1831, II, p. 225).

The subtle greeny-grey colour scheme is most unusual in a picture of this type, as a comparison with other eighteenth-century naval portraits makes clear. The strong blue of his coat, which would normally have provided the dominant note in the picture, is visible only in a small area on the right

sleeve. In fact, one of the odd features of this portrait is the freedom with which the painter has rendered Keppel's costume. The general effect is not unlike that of the undress uniform of a captain but with breeches, waistcoat and facings of grey. It may be that Reynolds did have in mind the wreck of the *Maidstone* and was aware that this happened before the introduction of uniforms, but it has been pointed out by naval historians (e.g. Clowes 1897–1903, III, pp. 20–1) that although the wearing of the new regular uniform was made compulsory by an order dated 14 April 1748, it was several years before every officer—and every tailor—especially those serving abroad, could be fully instructed. An alternative suggestion is that the picture may show modifications to the new uniform that Keppel would like to have introduced himself (Archibald 1961, p. 77).

In recent cleaning, the position of the flap of Keppel's waistcoat has been altered. Reynolds must first have painted it as we see it now, but Fisher's mezzotint (Cat. 20) indicates that in the painting as Reynolds completed it the flap was blown back. D.M.

PROVENANCE Earls of Albemarle until 1888; Earl of Rosebery; his sale, Christie's, 5 May 1939 (114), bt Rowe; Sir James Caird, by whom presented to the National Maritime Museum 1939.

EXHIBITED British Institution 1832 (84), 1852 (137), 1864 (161); Royal Academy 1873 (199); Grosvenor Gallery 1883 (181); Royal Academy 1968 (87).

LITERATURE Malone, in Reynolds 1798, I, pp. xxii–xxiii; Northcote 1818, I, pp. 63–5; Reynolds 1819, p. 41; Leslie and Taylor 1865, I, pp. 105–6; Stephens 1867, pp. 7–8; Graves and Cronin 1899–1901, II, pp. 538–9; Waterhouse 1941, pp. 9–10, 39; Archibald 1961, p. 77; Waterhouse 1965, p. 31.

ENGRAVED E. Fisher, 20 November 1759 (inscribed *J. Reynolds pinxit 1752*).

EDWARD FISHER (after Reynolds)

20 The Hon. Augustus Keppel

45.9 × 35.3 cm
The Trustees of the British Museum

The present participle in the legend on his mezzotint, 'The Hon'ble Augustus Keppel commanding His Majesty's Ship Torbay Nov. 20th 1759', might suggest that Keppel is depicted in that capacity, but Fisher also supplies the date of the painting, or rather what Reynolds must have claimed was the date of the painting—1752. We suppose that the painting (Cat. 19) remained in Reynolds's studio, attracting admiration. Keppel certainly continued to occupy the public eye.

The artist noted in his pocket-book on 11 April 1759, 'Commodore Keppell speak about print' which suggests, although it does not prove, that the print was made on the painter's initiative. Fisher (1722–c. 1785), who probably got to work soon afterwards, was one of the leading Irish mezzotint engravers to work in London where he arrived in about 1758. He was, it seems, an intimate of Reynolds (Gwynn 1898, p. 35) and was certainly a neighbour in Leicester Fields (Little and Kahrl 1963, II, p. 433). He engraved twenty-eight of Reynolds's paintings, but Reynolds is said to have considered that some of his prints were 'injudiciously exact' (Northcote 1818, I, pp. 64–5). N.P.

LITERATURE Chaloner Smith 1878–83, no. 34 (i).

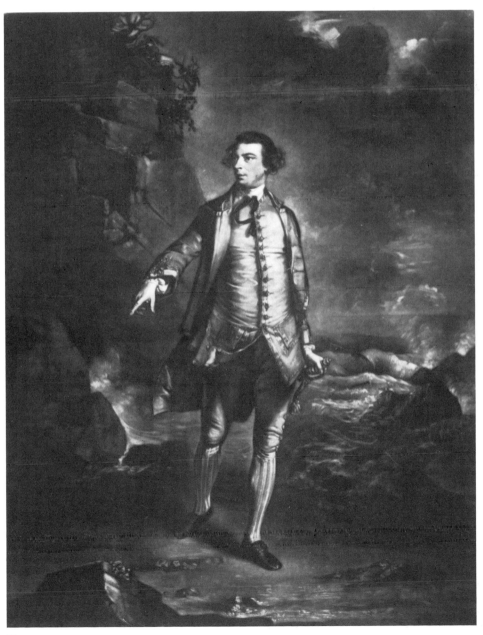

20

21 Lady Charlotte Fitzwilliam

73.6 × 60.9 cm
Signed and dated 1754
Executors of the 10th Earl Fitzwilliam

This fanciful portrait is of Charlotte, second daughter of William, 3rd Earl Fitzwilliam (born in 1746, she married in 1764,

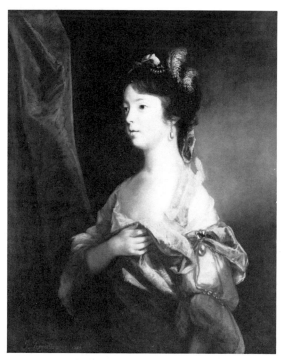

21 *reproduced in colour on p. 85*

Sir Thomas, later Baron, Dundas and she died in 1833). It is signed in yellow paint and in the artist's hand and dated 1754. On 14 July of that year, the artist wrote to the Countess, the sitter's mother, the following letter which is published here for the first time:

My Lady
 I ask pardon for keeping Lady Charlot's Picture so long, my time haveing been so much taken up in heads that I have scarce been able to do any drapery to any of my Pictures, but Lady Charlots is now finish'd and will be fit to be sent away in threeweeks time as it will take that time before it is thoroughly dry so as to be sent away without danger. I hope it will meet with your Ladyships approbation as it has of every body that has seen it, and that I am very proud of it myself the request I am going to make your Ladyship will show, which is to beg the liberty of having a Mezzotinto Print from it, which will be finish'd whilst the Picture is drying, so that it will not be detain'd on that account. If your Ladyship has no objection to having a Print taken from it I shall beg the favour to know what is to be writ under the Print. I remain
 Your Ladyships most humble
 & most obliged servant
Newport Street, July 14, 1754 J REYNOLDS

The print was made by McArdell and was dated 1754. It

was probably the first to be made after a painting by Reynolds and was certainly the only one ever recorded as published by him. We do not know what he would have had to pay McArdell to engrave the plate, but probably as much, if not more, than he was paid to paint the portrait (a decade later it would have cost from fifteen to twenty guineas—Copley and Pelham 1914, p. 58). The drapery which, as the letter informs us, was painted separately, is held up in a manner more appropriate for adult sitters with a bosom to conceal—or reveal—and it derives, as David Mannings has remarked, from Lely's Windsor Beauties of the 1660s.

 Aileen Ribeiro notes that 'the vogue for this kind of composite costume, with its soft, full, drapery, liberal amounts of muslin chemise, jewelled ornament, ribbons and feathers and floating scarves, was at its height in the period c. 1730 to c. 1760 and was encouraged by the widespread use of the drapery painter. It seems to have been something of a speciality of Joseph van Aken, who had been much employed by Reynolds's master Hudson.'

 Lady Charlotte sat for another portrait by Reynolds in 1764, shortly before and after her marriage. N.P.

PROVENANCE Painted for the 3rd Earl Fitzwilliam; by descent.

EXHIBITED Grafton Gallery 1895 (120).

LITERATURE Graves and Cronin 1899–1901, I, pp. 318–19; Waterhouse 1941, p. 39; Mannings 1973, pp. 186–7.

ENGRAVED McArdell, 1754; S. W. Reynolds.

22 Lord George Greville

90.2 × 73.7 cm.
Signed and dated 1754
Private Collection

Recent cleaning by John Brealey at the Metropolitan Museum has revealed this to be one of the most attractively coloured of Reynolds's early works—the vivid blue of the coat is an unusual colour for him (Mason recalled that Reynolds sometimes employed ultramarine—Cotton 1859, pp. 53–4—but Mr Brealey informs us that this is almost certainly Prussian blue). The flesh, however, has as usual bleached, and the slightly mauve tint to the lips is caused by the blue in the preliminary painting. The boy, like many young heirs in subsequent portraits by Reynolds, holds a book. In it we can read 'SYNTAX' (a word commonly given a broader grammatical meaning then than is the case today).

 The sitter is identified by the inscription on the painting (which is not impossibly by Reynolds) as the eldest son of Francis, first Earl Brooke, born in 1746. He succeeded his father as Earl Brooke and as Earl of Warwick in 1773 and died in 1816. Appointments are recorded for 3 and 7 May, and on 23 June 1755 there is a note 'a case to be made for Lord Greville', but the painting is signed and dated 1754 and must have been largely painted in that year, for which no pocket-book has survived. The boy's father sat in the winter

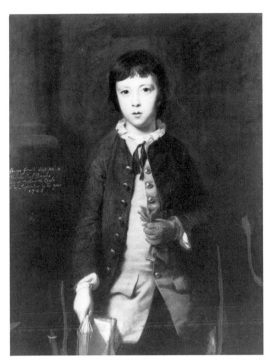

22 *reproduced in colour on p. 84*

in Reynolds's subsequent paintings—see Mannings, November 1984), was probably one which Reynolds himself admired because it was one of the first of his works to be engraved as a mezzotint, despite the obscurity of the sitter. Her identity was indeed omitted from the inscription on the engraving by McArdell and, in a pirated version by Purcell, she was given the fancy name of Lucinda.

The painting is listed in the artist's pocket-book for 1755 in the week commencing 27 January, and McArdell's engraving was published in this year; an old inscription, however, records 1754 as the date of the portrait.

This painting has more or less identical dimensions and features a similar horizon line to that in a portrait of Mrs

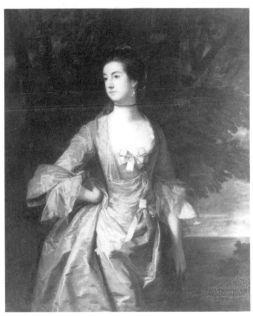

23 *reproduced in colour on p. 88*

of 1755 and his eldest sister in 1758 and 1759. The artist's anxiety concerning the names and styles of his noble sitters is reflected by a correction he made to the list of peers in his pocket-book for 1757 where Earl Brooke's son was erroneously printed as Lord Brooke.

Aileen Ribeiro points out that clothes worn by English boys were less formal and less like adult dress than on the Continent: 'instead of stock or cravat at the neck, the shirt collar, often frilled, was tied with a black silk ribbon, the ancestor of the modern tie. The hair was left to grow naturally rather than being dressed or curled in the adult way, and, in the middle years of the century, was cut fairly short, often with a fringe.' N.P.

PROVENANCE By descent.

EXHIBITED British Institution 1861 (157); Grosvenor Gallery 1883 (201); Birmingham 1961 (16).

LITERATURE Graves and Cronin 1899–1901, I, p. 397.

No early engraving recorded.

23 Mrs Hugh Bonfoy

124 × 100 cm
The Eliot family

Anne, the eldest daughter of Richard Eliot (born in 1729) was included by Reynolds in his painting of the Eliot family in 1746 (Cat. 2). She married Captain Hugh Bonfoy in 1751, was widowed in 1783 and died in 1816. This portrait of her, with a thoughtful air and gracious but assured pose (derived from the masculine portraits of Van Dyck and much repeated

Bonfoy's husband (also at Port Eliot) which, to judge by the costume, must have been made a decade earlier, and has generally been regarded as by Reynolds working in Hudson's manner, but might well be by Hudson himself. That Reynolds was acquainted with Bonfoy by 1749 is, however, suggested by the appearance of his name in the small Italian pocket sketchbook (Cat. 158). He seems to have remained in touch with Mrs Bonfoy, whose name crops up again in his pocket-book on 23 July 1781. N.P.

PROVENANCE By descent.

EXHIBITED Royal Academy 1882 (269).

LITERATURE Graves and Cronin 1899–1901, I, pp. 93–4; Leslie and Taylor 1865, I, p. 128; Waterhouse 1941, p. 38; Waterhouse 1968, pp. 117, 143.

ENGRAVED McArdell, 1754, Purcell; S. W. Reynolds.

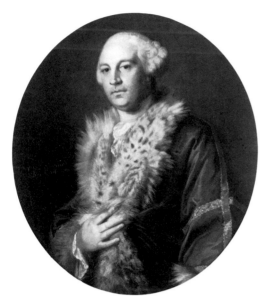

24 *reproduced in colour on p. 91*

24 The Hon. Charles Sloane Cadogan MP

91 × 78.5 cm
Earl Cadogan

The sitter was born in 1728. He enjoyed a succession of lucrative positions at Court (Keeper of the Privy Purse to Prince Edward of Wales, Surveyor of the Royal Gardens, Master of the Mint) and was Member of Parliament for Cambridge between 1749 and 1776, when he succeeded his father as 3rd Baron Cadogan. In 1800 he was created Viscount Chelsea and Earl Cadogan. On his death in 1807 the titles passed to

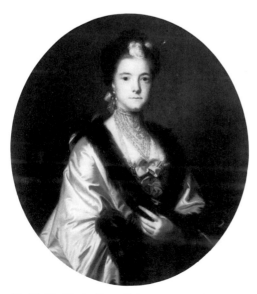

Fig. 55 Mrs Charles Sloane Cadogan, 1755 (Earl Cadogan)

his demented eldest son. Appointments for 'Mr Codogan' are recorded in Reynolds's pocket-book for 1755 on 5, 11, 19 and 26 February and 5 March, with cancellations on 6 February and 6 March. The fur-lined gown was doubtless favoured at that season of year, and his first wife, who sat five times in the same period, was painted with a muff (fig. 55). Aileen Ribeiro points out that the fur here is lynx and that 'these luxurious gowns were particularly popular in the mid-eighteenth century—between 1740 and 1760 there were some exceptionally cold winters—when a certain bulkiness in clothing was fashionable. They are often seen in Batoni's portraits and the fashion may have come from Italy.' (See also Ribeiro, December 1979.) The possibility that the pair of portraits was commissioned by Lord Cadogan, the sitter's father, is suggested by an appointment at Lord Cadogan's in Brudenell Street noted by Reynolds for 16 February 1755.

The couple's unfortunate heir was painted by Reynolds, also in a feigned oval frame to match.　　　　N.P.

PROVENANCE By descent.

EXHIBITED British Institution 1865 (121); Royal Academy 1879 (233).

LITERATURE Graves and Cronin 1899–1901, I, pp. 141–2; Waterhouse 1941, p. 39.

No early engraving recorded.

25 Mr Peter Ludlow

231 × 147 cm
The Marquess of Tavistock and the Trustees of the Bedford Estates

This is another painting inspired by Van Dyck, to whom Reynolds looked most intently for models of aristocratic portraiture in the first few crucial years after settling in London in 1753, as he worked to attract the patronage of the highest social class. The composition is clearly based on Van Dyck's whole-length of the Earl of Strafford, the original of which was at Wentworth Woodhouse, and of which several versions are known. Van Dyck's portrait was itself inspired by Titian's *Charles V* now in the Prado. Reynolds's *Ludlow* has a splendidly Venetian quality and has been compared, by Waterhouse, with Veronese.

Aileen Ribeiro describes the costume as follows: 'The sitter wears a sumptuous Hungarian hussar masquerade costume, of white embroidered in gold, the cap and jacket trimmed with ermine. The elements of this military uniform—the fur-trimmed busby with pendant cloth tassel, the dolman (tunic) with its row of tiny buttons and sometimes with braided, frogged fastenings, the pelisse (jacket) lined with fur and worn as a cloak, and the calf-length trousers sometimes with decorative pocket slits and braided—are transformed into a theatrical fancy dress. A very similar costume (in pink) can be seen worn by Garrick, painted by Thomas Worlidge in 1752 (Victoria and Albert Museum, London), in the role of Tancred, in James Thomson's play *Tancred and Sigismunda* first performed in 1745. That Tancred—who was a twelfth-

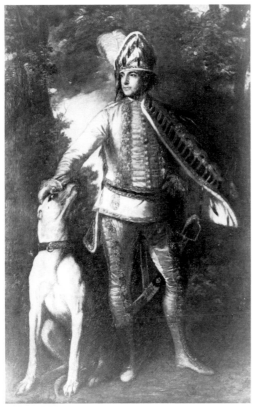

25 *reproduced in colour on p. 89*

century ruler of Sicily—was costumed as a Hungarian hussar, was probably due to British interest and involvement in the War of the Austrian Succession (1740–8); the Hungarian hussar regiments (originally a kind of irregular national militia) came to the aid of Britain's ally, Austria, and their glamorous costume and military exploits became familiar themes in English newspapers—a number of Roman Catholics, denied commissions in the British Army, entered the armies of the Holy Roman Empire. Interest in the war on the Continent helped in the adoption of the Hungarian hussar uniform as a popular masquerade costume, notably in the middle years of the eighteenth century.'

Peter Ludlow of Ardsallagh, Co. Meath, and Great Stoughton (1730–1803) was Member of Parliament (Whig) for Huntingdon in 1768–96. On 26 June 1753 he married Frances, daughter of the Earl of Scarborough. His name appears in Reynolds's pocket-book for 1755, at 10 o'clock on 14 February, with a note, 'whole day', which may indicate a long sitting but which could indicate a visit to Mr Ludlow (as he then was), perhaps out of London. Appointments follow on 15, 22 and 28 February, on 10 and 29 March, and on 4, 10 and 28 April. Ludlow sat next on 11 May and there is one more appointment six months later, on 30 October, which may have been for finishing touches but could have been simply to view the finished portrait or to arrange its collection. Meanwhile, the dog was being painted, and appointments are recorded specifically for 'Mr Ludlow's dog' or 'Mr L.'s dog' on 8, 11, 14, 17 and 19 April, and possibly also on 15 and 24 February and 10 April, when the note in the pocket-book is simply for 'dog'. There are also appointments for Lord Ludlow on 12 and 24 April and 2 May 1758 which suggests that there was either a second portrait or, more likely, that work was resumed on this one. Ludlow had been created Baron Ludlow of Ardsallagh on 19 December 1755 (he was subsequently made Viscount Preston of Ardsallagh and Earl of Ludlow). Lady Frances, his wife, had appointments in April and May 1758, probably for a portrait, although none of her is known. D.M.

PROVENANCE Probably Lord John Russell, later Earl Russell, who succeeded to the Ludlow estates on the death of the 3rd Earl of Ludlow 1842; 7th Duke of Bedford, *c.* 1856; by descent.

EXHIBITED Arts Council 1950 (45); Royal Academy 1968 (118).

LITERATURE Tavistock and Russell 1890, no. 265; Graves and Cronin 1899–1901, II, p. 597; Waterhouse 1941, pp. 10, 40; Waterhouse 1968, pp. 118–36, 155; Ribeiro, February 1977, pp. 111–16.

No early engraving recorded.

26 Captain Robert Orme

240 × 147 cm
Signed and dated 1756
The Trustees of the National Gallery, London

In May 1761 a visitor to the exhibition of the Society of Artists of Great Britain was particularly impressed by a picture of 'an officer of the Guards with a letter in his hand, ready to mount his horse with all that fire mixed with rage that war and the love of his country can give' (Whitley 1928, I, p. 175). The subject was Robert Orme (1725–90), a former ensign in the 34th Foot Regiment who transferred to the Coldstream Guards on 16 September 1745 and was promoted to Lieutenant on 24 April 1751. He was wounded in America while serving as aide-de-camp to General Braddock at the time Braddock was killed in an ambush by the French near Fort Dusquesne (modern Pittsburgh) in 1755. He returned to England that year and resigned from the Army in October 1756. Reynolds's painting is signed: *J. Reynolds pinxit 1756*; the pocket-book for that year is missing.

The composition, with the horse lowering its head, seems to derive, as Homan Potterton has suggested, from a rather slight drawing Reynolds made in Florence in 1752 (British Museum, Department of Prints and Drawings, 201.a.10) of a little-known early seventeenth-century fresco in the cloister of the Ognissanti in Florence. The pose of Orme himself, however, does not occur in the fresco, and may, like that of Keppel (Cat. 19), be adapted rather freely from the Apollo Belvedere. The result was displayed in the artist's studio and, as Northcote says, 'attracted much notice by its boldness', which was probably Reynolds's purpose, for this elaborate whole-length of a rather obscure soldier was never purchased by the sitter. The name Orme appears in the artist's pocket-book opposite the entries for the week commencing 5 October 1767 in what looks like a memorandum of notable works left on the artist's hands.

27 Miss Mary Pelham

69.2 × 57.1 cm
Private Collection

This well-preserved painting is an excellent example of the simple but striking presentation which Reynolds achieved in his smaller portraits of the 1750s. The inclined head and slight smile are also found in Ramsay's work of this date, but Reynolds's handling of the very liquid paint—the quick flourishes for the lace and the squiggle for the ear-drops—make Ramsay seem cautious.

Appointments for Miss M. Pelham are recorded in the artist's pocket-book for 1757 on 26 March and on 8, 11, 18, 22 and 27 April. The fact that her cousins, Mr and Mrs Thomas Pelham (later Earl and Countess of Chichester), were sitting earlier in the year and their child, also Miss Pelham, was sitting at the same time, is confusing. The portrait of Mary Pelham must have been commissioned together with one of the sitter's slightly older married sisters,

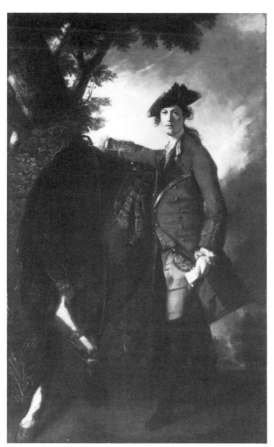

26 *reproduced in colour on p. 86*

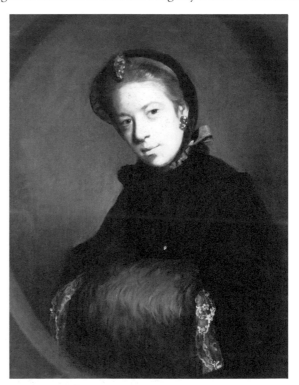

27 *reproduced in colour on p. 90*

The portrait was eventually bought from the artist by the 5th Earl of Inchiquin for one hundred guineas on 1 December 1777. Inchiquin himself had been an officer in the (Grenadier) Guards, retiring in 1756, the year this picture was painted. He seems to have bought it not because he had any particular interest in Captain Orme, but because he liked well-painted military pictures and admired this one enough to want to own it. He later married, as his second wife, Reynolds's niece, Mary Palmer.

Reynolds was sufficiently pleased with the pose of man and horse to repeat it three years later in his smaller portrait of Cornet, later Captain, Winter, now in Southampton Art Gallery. Nor was the impact of *Captain Orme* lost on other painters: the side-lighting, the angle of the hat silhouetted against the bright sky and the wide-awake look can be found echoed by military portraits well into the nineteenth century.

D.M.

PROVENANCE 5th Earl of Inchiquin, 1777; by descent to 5th Earl of Orkney; Orkney sale, Christie's, 10 May 1862 (62), bt by Sir Charles Eastlake for the National Gallery.

EXHIBITED Society of Artists 1761 (84: 'Whole length of a Gentleman'); British Institution 1860 (119).

LITERATURE Northcote 1818, I, pp. 65–6; Graves and Cronin 1899–1901, II, pp. 711–12; Waterhouse 1941, p. 41; Davies 1959, pp. 81–2; Cormack 1970, p. 156; Waterhouse 1973, pp. 18, 37; Potterton 1976, p. 106.

No early engraving recorded.

Grace, Lady Sondes, by their uncle Thomas Pelham, Duke of Newcastle, from whose executors on 14 July 1769 Reynolds received thirty guineas 'for Lady Sondes and Miss Pelham'.

Not much is known of Mary Pelham. Born in 1739, the youngest daughter of the Prime Minister Henry Pelham, she died unmarried in 1794. She refused the hand of her cousin John Shelley MP in 1760 (Namier and Brooke 1964, III, pp. 429–30) and possibly also that of Earl Gower in 1762 (Fitzgerald 1949–57, I, p. 147; II, p. 119). Her elder sister, Fanny (Frances) Pelham, was a brilliant and fashionable lady

who, having been forbidden by her father to marry the dissolute Lord March (for whom see Cat. 43), became one of the most reckless gamblers of the period (Robinson 1895, pp. 59–61; Wraxall 1884, V, p. 358). Fanny Pelham 'ruined herself & would have ruined her sister'. But the 'mild and excellent Mary's friends' forced her to live separately and so saved some of her fortune (Stuart 1928, pp. 24–7).

Aileen Ribeiro notes that Mary Pelham is 'dressed for winter. She is enveloped in a black silk mantle, which just allows the fine soft bobbin lace sleeve ruffles to be seen. A black silk hood tied under the chin is pushed back to reveal a small paste hair ornament or pompon (after Madame de Pompadour)—one of many French rococo fashions adopted in England in the 1750s. The muff is of a fur which it is hard to identify but which may be monkey skin.' N.P.

PROVENANCE Earl of Chichester by 1879 (probably having been in his family for over a century); sold to C. J. Wertheimer, May 1896; S. T. Gooden; F. Fleishman; by descent.

EXHIBITED Royal Academy 1879 (47).

LITERATURE Graves and Cronin 1899–1901, II, p. 738; Waterhouse 1941, p. 42; Cormack 1970 p. 130

No early engraving recorded.

28 The Hon. Horace Walpole MP

127 × 101.6 cm
Signed and dated 1757
The Marquess of Hertford

Horace Walpole was born in 1717, the fourth and youngest son of the great politician Sir Robert Walpole. Having returned from the Grand Tour in 1741 he toyed for a quarter of a century with politics, and dedicated himself for over half a century to antiquarianism, collecting and embellishing his gothic villa of Strawberry Hill at Twickenham. He died in 1797, as Earl of Orford (having inherited the title in 1791). Walpole chose to appear in this portrait as a man of letters, although he was not yet noted as a writer, and also as a collector, with the print (by C. Grignion after S. Wale) which he had commissioned of an ancient marble eagle excavated near the Baths of Caracalla in Rome. This bird was acquired by Cardinal Albani, who sold it to Walpole, together with its pedestal, in 1745 through the mediation of Walpole's Grand Tour companions John Chute and Horace Mann (see Walpole 1937–83, XIX, p. 66 and Michaelis 1882, p. 486). Walpole was not in general a collector of ancient art, but

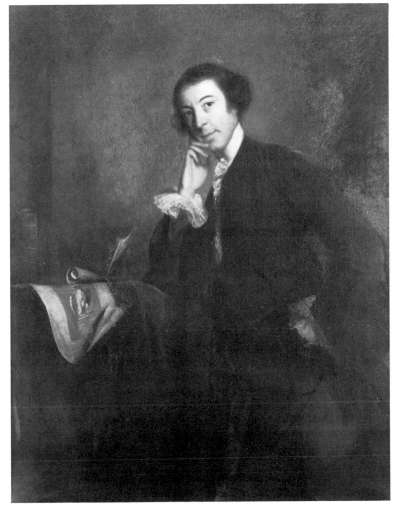

28

this curiosity was a typical acquisition and he was later to be a fervent admirer of the animal sculpture of Anne Damer.

Walpole must have sat to Reynolds for his portrait in 1756 (for which year no pocket-book survives) because in January 1757 Reynolds wrote in his pocket-book 'send home Mr Walpole to Mr Churchill'—from which we may also deduce that that portrait was a present for his illegitimate half-sister Lady Mary Churchill and her husband. This portrait is now in the Art Gallery of Ontario, Toronto. There is an appointment for Walpole on 30 August 1757 and two notes in late January and early February 1758: 'send home Mr Walpole' and 'send to Mr Walpole'. From this we may conclude that another version of the first portrait (the one exhibited here) was made in 1757. This was with the mezzotint engraver McArdell in early November of that year, as we know from an angry letter which Walpole wrote ordering the plate and all impressions to be removed, or at least locked up, because he had heard that the making of the print was known about. He intended it to be a 'private plate'—quite a common arrangement at that period, whereby the impressions could only be distributed by the sitter—and was greatly fussed that it was not secret as well as private. When the second portrait was returned by the engraver to Reynolds it was presented by Walpole to his first cousin, Francis Seymour Conway, afterwards 1st Marquess of Hertford. It differs from the first portrait chiefly in that it is signed and dated 1757 and the print of the eagle has been reversed.

There is a receipt of 1 February 1758 for forty-eight guineas from Walpole 'for two half-length portraits of himself being in full all demands by me'. There is no evidence of a third portrait in his pocket-books or ledgers, so there is no need to suppose that the replica of this portrait at Bowood (which is said to have belonged to Walpole's London agent Grosvenor Bedford) is by Reynolds, although it could be, and is certainly an early copy.

Aileen Ribeiro notes that Walpole, a careful but not a foppish dresser, is shown in 'a plain, rather formal and conservative suit, which sets off the fine lace of his shirt and sleeve ruffles'. N.P.

PROVENANCE 1st Marquess of Hertford; by descent.

EXHIBITED Birmingham 1961 (22).

LITERATURE Graves and Cronin 1899–1901, III, pp. 1023–25; Waterhouse 1941, pp. 41, 43, 120; Adams and Lewis 1970, pp. 15–17.

ENGRAVED McArdell, 1757; S. W. Reynolds.

29 Lady Caroline Fox

88 × 73 cm
Private Collection

Lady Caroline Lennox (1723–74) was the eldest daughter of Charles, 2nd Duke of Richmond (who was a grandson of King Charles II), and elder sister of the dangerously beautiful Lady Sarah Bunbury (see Cat. 48, 57). In 1744 she made a runaway marriage with Henry Fox, one of the leading politicians of the reign of George II, for which her parents took

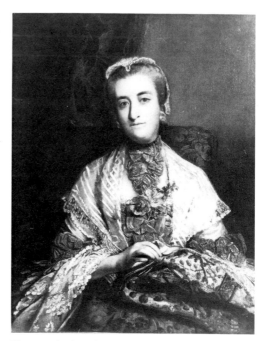

29 *reproduced in colour on p. 93*

four years to pardon her. Highly intelligent and amiable, she was also, like her husband (who amassed a vast fortune as Paymaster General), highly extravagant and indulgent towards her children, of whom the most notable was her second son, Charles James Fox (see Cat. 48, 135). Appointments for her as Lady Caroline Fox are recorded in

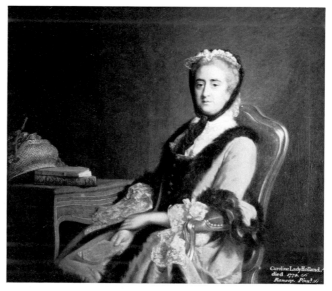

Fig. 56 Alan Ramsay, *Caroline, Lady Holland*
(previously Lady Caroline Fox), 1763–6 (Private Collection)

Reynolds's pocket-books on 17 and 23 March, 5 April, 6 May, 4 October 1757 and 11, 15 and 18 April and 14 July 1758 (cancellations on 10 May 1757, 25 April and 15 July 1758).

She was also painted by Ramsay (fig. 56). This was between 1763 and 1766, specifically for the gallery she had designed at Holland House—which suggests that Reynolds's portrait was kept in another house or at least another room. By then she was Lady Holland (Baroness Holland of Holland) in her own right and her husband was also Lord Holland (Baron Holland of Foxley). In both portraits she is engaged at her needlework, but it is typical of Reynolds that he presents her face so close to the picture plane that he has problems representing the projection of the lower part of her body, whereas Ramsay's figure is kept at a comfortable distance.

Aileen Ribeiro writes that the dress is typical of the highly ornamental taste of the 1750s: 'Lady Caroline wears a lace fly cap with pendant streamers (lappets) worn here pinned up, over hair tightly frizzed in the French manner. What we can see of her dress under the striped gauze mantle, is a ribboned and ruched bodice front and sleeves, and vast lace ruffles. Round her neck is a twisted blue ribbon tippet which tucks into the top of her bodice behind a nosegay of fresh flowers. Such flowers were kept fresh by a water-filled bosom bottle which Horace Walpole noted in 1754 as a new fashion from Paris.' N.P.

PROVENANCE Painted for Lord Holland; by descent.

EXHIBITED Grosvenor Gallery 1883 (74).

LITERATURE Graves and Cronin 1899–1901, I, p. 336; Leslie and Taylor 1865, I, p. 156; Waterhouse 1941, p. 43.

No early engraving recorded.

30 William, Duke of Cumberland

254 × 190 cm
The Duke of Devonshire and the Chatsworth House Trust

William Augustus, Duke of Cumberland (1721–65), third son of George II, was a general whose ruthless treatment of the Jacobites after the Battle of Culloden in 1746 earned him the nickname 'the Butcher'. However, the very large number of portraits that were made of him attests to his popularity in England. Indeed, the hostility with which he has since been regarded, coloured as it has undoubtedly been by the romanticized view so often taken of the Jacobites, was at least matched by the esteem in which he was held by the soldiers and statesmen who were his contemporaries.

It is impossible to say exactly when this particular portrait was painted. In the pocket-book for 1758 there is an appointment for 'The Duke' on 20 February, apparently for two hours rather than the one normal for a sitting at that date, and there were appointments for the 'Duke of Cumberland' on 6 and 20 March, the first of these also apparently for two hours. No sittings are recorded in 1759 or 1760, but then there occurs another appointment for 'The Duke' on 3 January 1761, at the odd hour of '11¼'. Opposite 6 January Reynolds noted 'A Copy of the Duke'. There was one more appointment on 27 July at eleven o'clock.

From the 1758 sittings, presumably, Reynolds did his best to produce a not undignified likeness of this rather unprepossessing man, who had become immensely fat and had all but lost the use of one eye after an illness he had suffered in Holland ten years earlier. His swollen face, particularly the left side, is evident in Rysbrack's fine marble bust of 1754 (Private Collection). He weighed, as we know from a strange lawsuit in which his weight was the subject of a wager, about twenty stone (Charteris 1913, p. 355). From Reynolds's basic face-mask a surprising number of portraits were developed, whole-length in Garter robes, three-quarter-length and half-length either in military uniform or in robes of the Garter. These were not, of course, always painted by Reynolds himself, but were produced in his studio. Several payments are recorded in the ledgers between 1762 and 1765, but it is not easy to connect them with specific portraits. Some copies were certainly ordered by members of the Duke's family, like Mary, Princess of Hesse, and Princess Amelia. Sir Oliver Millar (1969, p. 99) suggests that Amelia's picture may be the whole-length at Buckingham Palace. Cumberland and his sisters shared a genuine affection, fostered by two things: 'the care of their mother during her lifetime, and a common disapproval of their elder brother, Frederick Prince of Wales' (Charteris 1913, p. 76). Other copies were ordered by officers who had served under the Duke, including his inseparable companion George Keppel, 3rd Earl of Albemarle, the Duke's aide-de-camp at Fontenoy and bearer of the victorious dispatches from Culloden to London. A number of reduced versions of the whole-length pattern exist (for instance, National Portrait Gallery 229 and one recorded at Wistow Hall in the early nineteenth century in the collection of Sir Henry Halford, Bt, Physician Extraordinary to George III, now in the possession of Lord Cottesloe).

The full-size Chatsworth version of the portrait exhibited here is of very high quality and is considered by Waterhouse (1941, p. 45) to be the prime original. An entry in the ledger: 'Duke of Cumberland for the Duke of Devon [sic] £787 . . . paid in full' (omitted in Cormack 1970, p. 115) may refer to this picture, but as the entry occurs after 8 October 1765, and the 4th Duke of Devonshire had died on 2 October 1764, this, as Peter Day has suggested, is presumably a settlement by the guardians of the young 5th Duke for an unspecified number of pictures ordered by the 4th Duke before his death. (Reynolds's price for an original whole-length portrait had gone up to one hundred guineas after his move to Leicester Fields in 1761.)

The 4th Duke was First Lord of the Treasury and Prime Minister between 16 November 1756 and 2 July 1757. Earlier, in April 1755, he had proposed that Cumberland should be sole Regent during the King's absence in Hanover, and after Cumberland had signed the Convention of Klosterzeven on 8 September 1757, the terms of which so infuriated George II, it was Devonshire who tried to defuse the subsequent meeting between the King and his son. 'The first conversation between them,' he wrote to Henry Fox, 'will be terrible, and you will do well to prepare H.R.H. for it and to advise him to keep his temper if possible.' To no avail; the King's first words on seeing Cumberland are

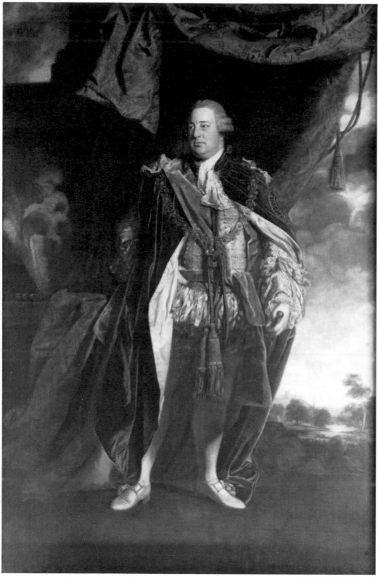

30

well known: 'Here is my son who has ruined me and dis-graced himself' (Charteris 1925, p. 311).

Aileen Ribeiro notes that the Duke is 'wearing the robes of the Order of the Garter, which dates back to the mid-fourteenth century. The most traditional element of the cos-tume (apart from the Garter itself) is the blue mantle which dates back to the inception of the Order; here, the Duke's is of blue velvet lined with white silk, with an embroidered cross of St George enclosed in a Garter on the left shoulder. Attached to the neck of the mantle are two large cords knot-ted in front, and on the shoulders are white ribbon bows to support the collar of the Order; this collar consists of twenty-six enamelled roses separated by gold knots with a jewelled pendant of St George (the "Great George"). Under the mantle, the surcoat is pushed back to reveal the elaborately trimmed under-habit. This was redesigned in 1661 (after the Restoration of Charles II); with a deliberate

attempt to produce a dignified "historic" costume, "the old trunk-hose or round breeches" of the sixteenth century, in cloth of silver, were decreed, along with a doublet of similar material. Although there is a vague resemblance to round trunk hose, the layers of ribbons are more like the trimming on mid-seventeenth century "petticoat" breeches; the roset-tes on the shoes (the shoes themselves are mid-eighteenth-century in style) are another seventeenth-century feature, as is the tall hat with huge plume of feathers.' D.M.

PROVENANCE Apparently painted for the 4th Duke of Devonshire; by descent.

EXHIBITED South Kensington 1867 (318); Grosvenor Gallery 1883 (178).

LITERATURE Leslie and Taylor 1865, I, pp. 162–3; Graves and Cronin 1899–1901, I, p. 215; Waterhouse 1941, p. 45; Cormack 1970, pp. 113–15; Kerslake 1977, I, pp. 64–9.

No early engraving recorded.

31 Miss Kitty Fisher

75 × 62.8 cm
The National Trust, Petworth (Egremont Collection)

Catherine Fisher (or Fischer) was reputed to have been the daughter of a German stay-maker. By 1760 a pamphlet addressed to her by 'Simon Trusty' claimed that 'Your Lovers are the Great Ones of the Earth, and your Admirers are the Mighty; they never approach you but, like *Jove*, in a shower of Gold.' He proceeded to accuse her of mercenary promiscuity and of an aversion to maternity, which she

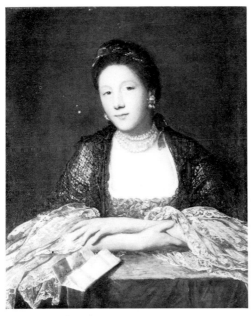

31 *reproduced in colour on p. 94*

avoided 'often perhaps by horrid means'. In the former year the town had been entertained by a satirical poem entitled 'Kitty's Stream or Noblemen turned Fishermen' and she had placed a notice in the *Public Advertiser* for 30 March objecting to the abuse she received in the newspapers and the way she was 'exposed in print shops'.

Appointments are recorded in Reynolds's pocket-book for 'Miss Fischer', 'Miss Fisher' or 'Miss Kitty Fischer' in that same year, 1759, for 18, 21, 24 and 26 April, 1, 4, 8, 9, 10, 17, 21 and 22 May (with a cancellation on 7 May; all but one of these appointments at half-past eight or nine o'clock in the morning), 27 and 30 May, 8 and 24 June, 22 August, 20 October, 29 November and 4, 10 and 12 December. More than one painting seems likely to have originated from these sittings, and since in this painting she holds a letter dated 2 June 1759 which commences 'My dearest Kit', we may assume that this painting was probably completed in the summer. The date has, in the past, been read as 1760, but 1759 is confirmed by the early mezzotints, the earliest of which, by Fisher, was published on 17 July 1759 (Russell 1926, p. 108), in which the date of 2 June 1759 can be read (although in one case it is changed to 1 January 1763, the

date of publication). 'Kit', however, may be repaint, for in the prints we read 'My dearest Life'.

It may be significant that according to the scandalous *Town and Country Magazine* (1771, p. 458) Kitty 'first made her appearance as a courtezan' under the auspices of Augustus Keppel, Reynolds's friend and patron; but we have no idea who commissioned this captivating picture. In any case it rapidly (and appropriately) became public property: the earliest mezzotint was copied by four other engravers and so must have been one of the bestsellers in the print shops of the period. Those by Houston were priced at two shillings. If Kitty Fisher objected to being 'exposed' in this way she seems not to have held it against Reynolds (see Cat. 34, 46).

The simple compositional formula, with crossed arms forming the base of a triangle, was frequently repeated by Reynolds in these years for more respectable sitters—earlier examples are the portraits of the Countess of Berkeley (engraved 1757) and of Lady Caroline Keppel. Aileen Ribeiro remarks that the painting is 'an excellent example of the restrained English version of rococo dress, with its emphasis on the textures of fabrics. A black net mantle covers the white silk sleeves, with their scalloped edges, of the dress with its bodice of ruched green silk, and the pose displays to maximum effect the triple ruffles of bobbin lace—lace then being a prized luxury. The styles of necklace most frequent in portraits of this period are the single row of pearls or, more formally, three or four rows of pearls fastened with a ribbon, as here. Kitty Fisher also wears clip-on earrings known in the eighteenth century as "snaps".' N.P.

PROVENANCE Acquired by the Earl of Egremont before 1837; by descent to the 3rd Lord Leconfield; accepted by H.M. Treasury in lieu of death duty 1967.

Never formerly in a special exhibition.

LITERATURE Graves and Cronin 1899–1901, I, p. 306; Leslie and Taylor 1865, I, pp. 163–4 (note), 173; Waterhouse 1941, p. 48.

ENGRAVED Fisher, 1759; Houston; Purcell; twice anonymously; also S. W. Reynolds.

32 Mrs John Spencer and her Daughter

76.2 × 63.5 cm
The Duke of Devonshire and the Chatsworth Settlement Trustees

Margaret Georgiana Poyntz (1737–1814) married in 1755 John Spencer (created Baron Spencer in 1761 and Earl Spencer in 1765), and their first child, Georgiana (later Duchess of Devonshire—see Cat. 102, 139), was born on 7 June 1757. This portrait was probably commissioned to celebrate this event. The child here appears only to be two years old, so this portrait must date from 1759. Mrs Spencer seems to have cancelled a twelve o'clock appointment (perhaps a sitting) and replaced it with another for six o'clock (certainly not a sitting) on 2 June of that year. There is a note of the price, thirty guineas, opposite this entry and this perhaps was what was settled at this meeting. Appointments

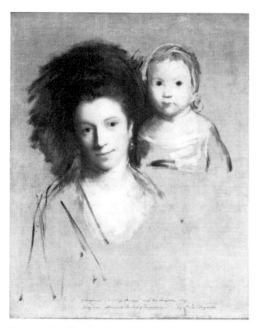

32 reproduced in colour on p. 97

then followed on 6, 18 and 20 June (with a note 'send to Mr Dawson' next to the last). Miss Spencer (presumably with her nurse) sat on 11, 13 and 15 June.

Often described as a sketch, this is in fact an unfinished painting. It seems not to have been the artist's practice to plan the composition on the canvas. We can only speculate as to why the painting was abandoned: the sitter may have wanted something larger; the child might have proved too restless. A much damaged painting at Castle Howard might be the portrait he did finish instead. The inscription in pen on the bottom of the canvas identifying the sitters must date from after 1774, when the little girl became Duchess of Devonshire.

The double portrait, now at Althorp, which Reynolds painted (fig. 8) of the same sitters soon afterwards is generally agreed to be one of the artist's greatest achievements. It was painted for the sitter's brother, William Poyntz of Midgham, and was probably completed in the autumn of 1761 when Lady Spencer (her husband was created Baron earlier that year) had appointments with the artist on 8, 10, 11 and 12 September. On the last date she was to come at eight o'clock and Miss Spencer at one o'clock. (It is striking that there are no other appointments recorded for Miss Spencer.) The portrait was paid for between 9 June and 1 July 1763 and cost seventy guineas (Cormack 1970, p. 136). Comparison with James Watson's mezzotint of 1770 suggests that the canvas has been cut down considerably on the top and on the right-hand side. So good as well as lovely does Lady Spencer appear here, and in the earlier unfinished portrait, that it comes as a rude shock to find her described as follows by the pen of Madame du Deffand a decade later: '*Elle m'a paru femme du grand monde, d'une politesse noble, prévenante, agréable, superficielle, facile, et rien de plus*' (Walpole 1937–83, v, p. 370). N.P.

PROVENANCE The canvas is endorsed with a note that it was bought at the last of the artist's studio sales in 1821 by John Bannister and then bought at Bannister's sale in 1822 by Jeffry Wyatt who gave it to his patron William, 6th Duke of Devonshire, presumably before 12 August 1824 when Wyatt began to style himself 'Wyattville'; by descent.

EXHIBITED British Institution 1861 (203); Grosvenor Gallery 1883 (199); Park Lane 1937 (63); Birmingham 1961 (31); Royal Academy 1968 (108).

LITERATURE Graves and Cronin 1899–1901, III, p. 916; Waterhouse 1941, pp. 47, 121.

No early engraving recorded.

33 Anne, Countess of Albemarle

126.5 × 101 cm
The Trustees of the National Gallery, London

Although some colour has fled from the face in this portrait as is usual with Reynolds's work of this period, the shadows there retain their transparency; the lights painted 'wet in wet' in the patterned black mantle are perfectly preserved; and the paint employed for the pattern of the skirt and for the lace retains its original relief and fluency, so that this is one of the most exciting of Reynolds's paintings to examine close-up. It is also one of the most arresting to encounter from a distance.

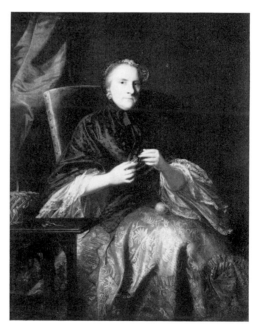

33 reproduced in colour on p. 92

The sitter, Lady Anne Lennox, was born in 1703, the second daughter of the first Duke of Richmond. She married in 1723 William-Anne van Keppel, the second Earl of Albemarle, who died in 1754 after a distinguished but ruinously extravagant diplomatic career. She was the mother of Reynolds's friend and patron Augustus Keppel (see Cat. 19,

60) and several of her other children were painted by Reynolds.

There are appointments for Lady Albemarle in the artist's pocket-books on 26, 27 and 29 September 1757 and on 28 April, 8, 19 and 26 May and 9, 19, 23 and 28 June 1759. There were cancellations in December 1757 and January 1758, May and June 1759 and a note opposite 9 June 1759 reads 'send to Lady Albe'. What is probably a debt of forty guineas is noted in Reynolds's first ledger on 18 November 1760. 'Lady Albemarle' is also written in his pocket-book at that date, perhaps indicating the dispatch of the painting. Payment by the executors of Lady Albemarle's son, the 3rd Earl, is recorded for 13 December 1773. It is worth pointing out that there are enough sittings recorded for two different portraits. If there were two, the earlier would not be recorded in the surviving ledgers if it was paid for as early as 1759.

Reynolds in this period often painted women at their 'work'—Lady Albemarle's niece Lady Caroline Fox (Cat. 29) is a good example. Lady Albemarle herself is 'knotting' at a light table of the slightly gothic type made by Chippendale in the mid-1750s. Aileen Ribeiro points out that 'knotting, that is making, with the aid of a small shuttle, a decorative linen braid which could be sewn on to fabric, was a pastime acceptable at Court and on many social occasions, providing with the excuse of work, a chance to show off the graceful attitudes of the hands'. She also notes that both the 'black spotted silk mantle' and the 'three-dimensional trimmings on the dress' reflect earlier French fashions, and that 'the dress, probably a damask, has a swirling rococo design which was slightly old-fashioned for the late 1750s, but there was often a gap between the buying of expensive silks and their making up'.

We know from family letters that Lady Albemarle spent much of 1759 in a 'furious passion' because one of her daughters, Lady Caroline, had eloped with Robert Adair, a surgeon who acted as the family doctor (Fitzgerald 1949–57, I, pp. 196–8). She did not become less formidable as she grew older, but she was loved as well as revered. In 1780 after a stroke she made a complete recovery—the fashion for being electrified agreed 'vastly well with her' (ibid. II, p. 309)—and in the winter of 1782 she was alarming her friends by consuming champagne and cold partridge pie after midnight (Walpole 1937–83, XXXIII, p. 387). She died in 1789. N.P.

PROVENANCE Painted for the 3rd Earl of Albemarle; by descent to the 7th Earl by whom sold 1888 to Agnew; acquired by the National Gallery in the same year.

EXHIBITED Royal Academy 1873 (77); Grosvenor Gallery 1883 (67); Birmingham 1961 (25).

LITERATURE Graves and Cronin 1899–1901, II, pp. 578–9; Waterhouse 1941, p. 43; Davies 1959, pp. 83–4; Cormack 1970, pp. 10, 144; Potterton 1976, pp. 21–6.

No early engraving recorded.

34 Miss Kitty Fisher in the Character of Cleopatra

76.2 × 63.5 cm
The Iveagh Bequest, Kenwood (GLC)

The famous courtesan Kitty Fisher (for whom see Cat. 31) is here portrayed as the libidinous Queen of Egypt who, to impress the Roman general Mark Antony at a feast, dropped a giant pearl into a glass of wine and drank it, dissolved. This role may not have been the sitter's idea, but she must have consented to it. Her voracity was notorious and when Casanova met her in London in 1764, covered in diamonds and waiting to go to a ball, he was told that she had once clapped a £20 note into a bread and butter sandwich and consumed it (Bleackley 1923, p. 144). It is interesting that

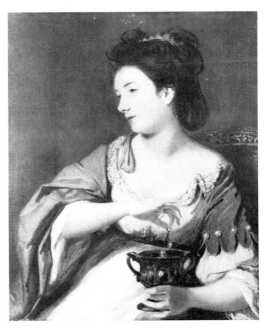

34 reproduced in colour on p. 99

a little later Reynolds painted a rival courtesan, Nelly O'Brien, leaning against a pedestal upon which the episode of Danae receiving Jupiter in a shower of gold coins is depicted as if carved in relief (this is no longer legible in the painting in the Hunterian Museum, Glasgow, but can be clearly seen in the mezzotint by James Watson). Reynolds's painting was not the only fanciful tribute to Kitty. Nathaniel Hone's painting (fig. 57), exhibited in 1765 at the Society of Artists exhibition, shows her concealing her charms with a flimsy scarf whilst a kitten fishes for goldfish in a bowl which reflects a window crowded with eager spectators.

However, without the evidence of the prints which are given the title used here, it may be doubted whether Reynolds's painting would have been recognized as a likeness of Kitty Fisher, or indeed considered as a portrait at all. Reynolds certainly would have known of Hogarth's *Sigismonda mourning over the heart of Guiscardo* (fig. 58), which

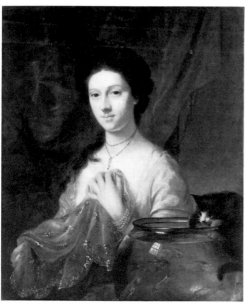

Fig. 57 Nathaniel Hone, *Kitty Fisher*, 1765
(National Portrait Gallery, London)

had been painted by June 1759 (when the patron refused it because of the high price), and he may have conceived of this as a work in the same mode which, however, was just enough of a portrait to be acceptable. The date of 1759 was given to Reynolds's portrait at the British Institution exhibition of 1813, and if this is correct then it was perhaps painted after June when Cat. 31 was signed. (All appointments for Kitty in 1759 are listed in the entry for Cat. 31.) A note

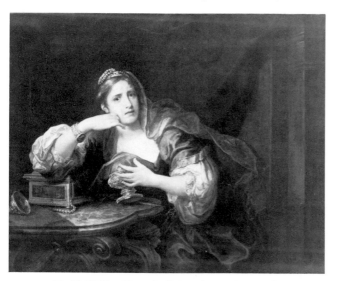

Fig. 58 William Hogarth, *Sigismonda mourning over the heart of Guiscardo*, 1759
(Trustees of the Tate Gallery, London)

opposite the entries in Reynolds's pocket-book for the week commencing 17 December reads 'Miss Fisher's Picture is for Mr Charles Bingham'. This must be Sir Charles Bingham, Bt, later Lord Lucan. An entry in Reynolds's ledger records

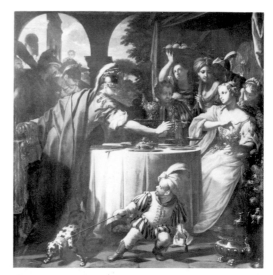

Fig. 59 Francesco Trevisani, *The Banquet of Antony and Cleopatra*
(Galleria Spada, Rome)

payment by him of ten guineas before 1 December 1760 and another for ten guineas on 19 March 1774 as the sum 'remaining for Miss Fisher' (Cormack 1970, pp. 111, 145). The portrait exhibited here may well have been the one made for him. In favour of this hypothesis is an entry in the artist's ledger for July 1776 of thirty-five guineas from 'Mr Parker for Sir Charles Picture sent to Saltram' (Cormack 1970, p. 161). The Cleopatra was certainly at Saltram in the early nineteenth century.

As was first noticed by Edgar Wind, the pose of the sitter is derived very closely from that adopted by Cleopatra in a painting by Trevisani in Palazzo Spada in Rome (fig. 59). Reynolds customarily made drawings of separate figures in complex compositions, and we suppose he consulted one such in an old sketchbook for this painting—the slaty blue and green of his colouring is nothing like the Trevisani, and he surely did not expect the debt to be detected.

For another portrait of Kitty Fisher see Cat. 46.　　N.P.

PROVENANCE Perhaps painted for Sir Charles Bingham, Bt; in the collection of the 2nd Lord Boringdon (son of the 1st Lord, the artist's friend, John Parker) by 1813; by descent to the Earls of Morley; sold Christie's, 3 June 1876 (43), to Howard for Baron Ferdinand de Rothschild; sold to Agnew 1888, bt Lord Iveagh 22 November 1888; presented to Kenwood 1946.

EXHIBITED British Institution 1813 (132, 141 in some catalogues); South Kensington 1862 (68), 1867 (670); Royal Academy 1876 (39); Munich 1979 (122).

LITERATURE Graves and Cronin 1899–1901, I, pp. 307–8; Wind 1938–9, p. 183; Waterhouse 1941, pp. 45, 121; [Murray] n.d., p. 25.

ENGRAVED Fisher, Houston, James Watson and S. W. Reynolds.

35 Viscount Milsington

75 × 62.3 cm
Private Collection

This portrait is typical of the engaging directness of presentation, freshness of handling and simplicity of both composition and colour favoured by Reynolds in the late 1750s. The composition is an equilateral triangle: the colours are essentially a brilliant arrangement of brown, black and white—the

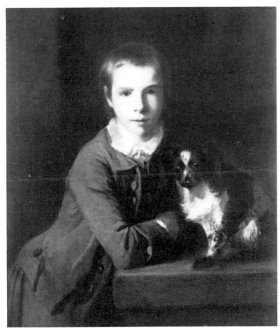

35 reproduced in colour on p. 96

relationship between the white fur of the dog and collar of the boy is particularly happy. The sitter is William Charles Colyear, second son of Charles, 2nd Earl of Portmore, who was born in 1745 and became Viscount Milsington in 1756, on the death of his elder brother, and Earl on the death of his father in 1785. He died in 1823. The boy's father had sat to Reynolds in 1758 and his portrait survives in the same collection with the same provenance. Appointments for 'Lord Melsington' were noted in the artist's pocket-book on 15, 19, 23 and 31 October and 3, 9 and 15 November 1759. There seem to have been no separate sittings for the spaniel.

Arthur Pond's pastel portraits of boys (Lippincott 1983, pp. 80, 178) perhaps suggested the use of the dog here, but Pond had never exploited to a comparable degree the arresting device of rival pairs of eyes confronting us. N.P.

PROVENANCE Presumably inherited by the son of the sitter who died in 1835 and then by his widow who died in 1845; Rev. F. H. Dawkins, Christie's, 28 February 1913 (42), bt A. Wertheimer; Christie's, 18 June 1920 (49), bt in.

EXHIBITED Birmingham 1961 (29); Royal Academy 1968 (116).

LITERATURE Graves and Cronin 1899–1901, II, pp. 648–9; Waterhouse 1941, p. 46.

No early engraving recorded.

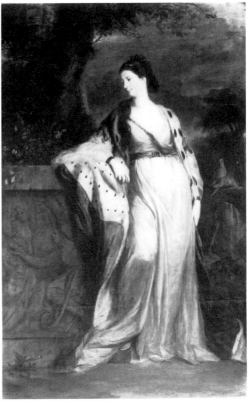

36 reproduced in colour on p. 101

36 Elizabeth Gunning, Duchess of Hamilton and Argyll

238.5 × 147.5 cm
Lady Lever Art Gallery, Port Sunlight (Merseyside County Council)

This is one of Reynolds's earliest experiments with the full-blown exhibition picture, that is to say, a large, boldly-painted picture designed to make the maximum impression when displayed on the overcrowded walls of eighteenth-century exhibitions. It was indeed shown in the earliest public exhibition of paintings in London, the Society of Artists of Great Britain in 1760, and the fame of the subject together with the simplicity and strength of the composition ensured that Reynolds's contribution would attract the attention of both public and critics. Like a number of portraits from the late 1750s and early 1760s, it shares certain features with the work of Reynolds's main rival at that time, Allan Ramsay, whose rather similarly-posed *Lady Louisa Conolly* is dated 1759 (Smart 1952, p. 106). But closer inspection shows that Reynolds has drawn cleverly on the work of several earlier artists. The curving pose had attracted his attention six years earlier when he sketched one of the five *Virtues* by Tintoretto in the church of Santa Maria dell'Orto in Venice (British Museum, LB 13 f. 65 rev.). For the idea of placing the figure against a sculpted plinth he did not have so far to look, for this has been derived from Kneller's famous 'Hampton Court

The fact that Paris's choice led, as Joseph Spence explained, to 'the loss of his own life, the sufferings of all his friends, and of his country . . .' (Spence 1747, p. 143) does not seem to have deterred patron or painter, and may well have amused the sitter.

The Gunning sisters were the most celebrated beauties of their time. They were daughters of Colonel John Gunning of Castle Coote, Ireland, and Bridget Bourke. Elizabeth (1733–90), the subject of this picture, was the second daughter. In a letter to Sir Horace Mann, dated 27 February 1752, Horace Walpole describes her marriage, after a 'violent' courtship, to James, 6th Duke of Hamilton, the ceremony being performed at half an hour after midnight on St Valentine's Day with the ring of a bed-curtain, as the bridegroom, straight from the gaming-tables where he had just lost £1200, was in a hurry (Walpole 1937–83, xx, pp. 302–3). When the bride was presented at Court the enthusiasm to catch a glimpse of her was so great that the 'noble mob in the Drawing-Room clamboured on tables and chairs to look at her' (ibid. p. 311). The Duke, an altogether disreputable character, died on 17 January 1758, fulfilling, by a strange irony, the destiny of the shepherd Paris, and his widow remarried less than twelve months later. Her second husband was John Campbell, 5th Duke of Argyll. It was a match which, as Walpole pointed out, reconciled contending clans, the great houses of Hamilton and Campbell. From 1761–84 Elizabeth Gunning was Lady of the Bedchamber to Queen Charlotte, and in 1776 was created a peeress of Great Britain, Baroness Hamilton of Hambledon in her own right.

Aileen Ribeiro describes the costume in this portrait as 'a dress of white muslin, with a cross-over bodice, possibly another example of Reynolds's use of the bedgown to achieve a "timeless" effect. This is worn under an open ermine-lined robe of red velvet with short, scalloped sleeves which is a generalized version of the "close-bodied kirtle clasped before" which was the coronation dress of peeresses (see, for example, Reynolds's portrait of Isabella Countess of Erroll, 1763, in Glasgow Art Gallery). Accurately depicted, however, is the red coronation mantle, on which her arm rests, with its four rows (powderings) of ermine indicating her status as the wife of a duke. Her fashionable looped chignon of hair is unloosed to flow in "classical" style over her shoulder, a curious anticipation of the artificial ringlets which were worn at the coronation of George III in 1761.'

Close scrutiny of the artist's pocket-books shows a number of entries which may be related to this portrait. At one o'clock on 16 January 1758, one hour before Elizabeth Gunning's first (cancelled) appointment, a 'Mr Gunning' appears in the book. Elizabeth's name next appears on 20 January, but then not again until 1759 when there are appointments for 2, perhaps 3, 9 and 15 January, 2 February and 2 June. The picture was, of course, exhibited the following spring, but further entries as late as 1764 suggest that the picture remained in Reynolds's possession: one on 2 January, one on 6 April, and another on 14 April. The last two have a note scribbled on the opposite page: 'to send to her Grace'. The entry on 14 April indicates an appointment at five

Fig. 60 Laurent Delvaux, personification of Longevity from the Monument to Dr Hugo Chamberlen, completed 1731 (Westminster Abbey, London)

Beauties', and perhaps most particularly from the *Countess of Dorset* with her ermine-lined cloak arranged across the top cornice. The result is a powerfully sculptural image, reminiscent of the allegorical figures that sometimes flank eighteenth-century tombs. The Chamberlen monument in Westminster Abbey is an example that would have been easily accessible to any artist working in London (fig. 60). And the comparison can be extended much further. The entire sequence of shapes descending from her right hand, guided by the thin white line where the edge of the ermine lining is set against the red of her cloak, enclosing as it does the shadowed passages below her knee, is classical—more than merely an imitation of an antique style of sculpture, although it is worth remembering that in March 1758 the Duke of Richmond opened his private collection of casts after antique sculpture to students.

The relief on the side of the plinth shows the shepherd Paris, who, in the familiar classical story, chose Venus as the most beautiful of the three goddesses. The identification of the sitter with Venus is further underlined by the presence at her side of the doves, the usual attribute of the goddess.

o'clock, which would be late for a sitting, and there seems to be one final appointment on 21 April. What may be the second and final payment, a modest twenty-five guineas, is recorded in Reynolds's ledger against the date 13 April 1764. By then his price for a whole-length was one hundred guineas, but of course this portrait had been ordered in 1758, if not earlier.

Although Elizabeth Gunning sat for her portrait between her two marriages, it does seem likely to have been commissioned by the Duke of Hamilton before he died. It appears in a Hamilton inventory of 4 September 1793, in the possession of her son, the 8th Duke (information from Professor Waterhouse). Reynolds would have been keen to paint this sensation of London society because he knew it would attract attention at the exhibition. It inspired, in fact, a spate of whole-length portraits of classically-draped ladies leaning on plinths. The Duchess of Hamilton was herself painted again in 1767 as Venus, this time by Francis Cotes, and now, of course, for the Argylls (still at Inveraray Castle). George Romney's adoption of the mode is well attested by a portrait like that of Lady Beauchamp-Proctor, painted in 1782–3 (collection of I. F. Raphael c. 1904).

A replica of Reynolds's *Duchess of Hamilton*, formerly at Northwick Park, was sold at Christie's on 25 June 1965 (76), and is now in the Yale Center for British Art. What has been described as a sketch was presented by Mr H. K. S. Williams to the California Palace of the Legion of Honor in San Francisco. D.M.

PROVENANCE By descent; Hamilton Palace Sale, Christie's, 6 November 1919 (49); Gooden and Fox, for W. H. Lever, 1st Viscount Leverhulme.

EXHIBITED Society of Artists 1760 (47: 'A Lady; whole length'); Edinburgh 1883 (208); Grosvenor Gallery 1883 (26); New Gallery 1891 (130), 1899 (173); Royal Academy 1980 (31).

LITERATURE Leslie and Taylor 1865, I, pp. 102, 181; Graves and Cronin 1899–1901, II, pp. 421–2; Bleackley 1905, pp. 158 ff., 227 ff., 198 ff.; Tatlock 1928, I, pp. 60–1; Waterhouse 1941, p. 11; Cormack 1970, p. 124; Mannings 1973, pp. 188–91; Waterhouse 1973, p. 22; Johnson 1976, pp. 52, 54.

No early engraving recorded.

37 The Rev. Laurence Sterne

127.3 × 100.4 cm
Signed and dated 1760
National Portrait Gallery, London

Laurence Sterne (1713–68), after an impoverished and peripatetic childhood, was sent by his cousin to Cambridge University. He was thus enabled to take Orders, and as Vicar of Sutton-in-the-Forest between 1738 and 1759 he began his extraordinary, whimsical novel *The Life and Opinions of*

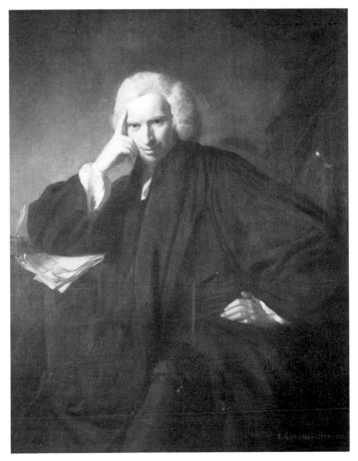

37

Tristram Shandy. The first two volumes appeared in the first days of 1760 and created a sensation unprecedented in English literature. Sterne, when he came to London on 4 March, found himself a celebrity. Appointments with Reynolds are recorded in the painter's pocket-book for 20 March and 3, 6, 19 and 21 April. The title of his novel (which went into its second edition on 3 April) is among the papers painted beside him, together with the date, 1760.

Opposite 21 April (the last sitting?) in Reynolds's pocket-book may be read 'Mr Fisher Engraver'. This is surely a memorandum that the painting should be sent immediately to be engraved, and in fact a long letter by Thomas Gray commenced on the following day notes that the picture is 'now engraving' (Tovey 1900–12, II, p. 137). There would have been every incentive to get the likeness of such a fashionable man quickly into the print shop windows together with the preachers, pugilists, politicians, actresses, courtesans and admirals of the day. Opposite the week commencing 5 May is another memorandum 'Mr Fisher', perhaps indicating that the painting was ready to be returned. Fisher's mezzotint was in the Society of Artists exhibition of 1761 where Reynolds also exhibited the painting—identifying the sitter in the catalogue. If we assume that Reynolds had a share in Fisher's profits then we can confidently endorse Kerslake's suggestion that he painted Sterne as a speculation. The painting in any case seems not to have been commissioned. It was presumably still in the artist's hands in 1768 when he exhibited it again. The first recorded owner, the Earl of Upper-Ossory, was a close friend and an executor of the artist. Reynolds gave him the right to take the painting of his choice from his studio.

The claim that there are other later portraits by Reynolds of Sterne (Cross 1929, pp. 351, 483) is based on the assumption that appointments with Sterne in Reynolds's pocket-books for 11 June 1764 and 1 March 1768 indicate sittings. The former is at eight o'clock, which could possibly be an early sitting but could also be an evening social engagement. The latter is for four o'clock, the dinner hour.

Aileen Ribeiro remarks that Sterne wears a 'clerical bob-wig and a wide-sleeved black Geneva gown with white bands of lawn partially concealed by a black preacher's scarf. Under the gown he wears a double-breasted cassock, held by a sash at the waist.'

The format of the portrait is typical of Reynolds's early paintings of men of letters (compare especially the portrait of Horace Walpole, Cat. 28). The sitter's knee does not project as effectively as Reynolds intended and the lights and shadows in his black clothes are now less visible than they are in Fisher's mezzotint, but the painting retains great character, especially on account of the 'subtle evanescent expression of satire around the lips'. He appears, as a visitor to the 1761 exhibition observed, 'in as facetious a humour as if he would tell you a story of Tristram Shandy'. The proposal that the pose derives from a reversal of a drawing which Reynolds had made from a portrait in Florence seems overingenious (Mitchell 1942, p. 36).

It seems that Sterne developed an interest in Reynolds's theory of painting in the period that he sat for his portrait

for he adapted a passage from one of the artist's anonymous essays in the *Idler* in the next part of *Tristram Shandy* (Holtz 1967, pp. 179–80). N.P.

PROVENANCE The Earl of Upper-Ossory by 1801; bequeathed in 1823 (or given previously) to his nephew, 3rd Baron Holland; acquired (perhaps in exchange) by the 3rd Marquess of Lansdowne from Lady Holland in 1840; by descent to the 6th Marquess who left it to his widow, Baroness Nairne; by descent to Lord Mersey from whom acquired 1975 by the National Portrait Gallery.

EXHIBITED Society of Artists 1761 (82: erroneously as 'Dr.' Sterne) and again at the Society's extraordinary exhibition in 1768 (97); British Institution 1813 (99), 1823 (18), 1841 (83); South Kensington 1867 (373); Royal Academy 1871 (36); Grosvenor Gallery 1889 (65); New Gallery 1891 (207); Park Lane 1937 (16); Royal Academy 1951 (24), 1968 (112); Munich 1979 (123).

LITERATURE Leslie and Taylor 1865, I, pp. 192–3; Graves and Cronin 1899–1901, III, pp. 933–5; IV, p. 1418; Whitley 1928, I, pp. 174–5; Cross 1929, pp. 209–25; Waterhouse 1941, p. 48; Kerslake 1977, pp. 260–3; White 1983, p. 36.

ENGRAVED Fisher 1761; S. W. Ravenet; S. W. Reynolds.

JAMES MCARDELL (after Reynolds)

38 Miss Frances Ann Greville and her Brother, as Psyche and Cupid

50.5 × 35.3 cm
The Syndics of the Fitzwilliam Museum, Cambridge

Northcote (1818, I, p. 66) specifically mentions the painting (now Private Collection) which this print reproduces as causing a great sensation. More than any other of Reynolds's paintings it introduced a poetic type of full-length portrait which was soon adopted for ladies as well as their children.

Miss Greville had appointments in 1760 on 17 and 18 September (cancelling one on the 16th) and Master Greville on 19 and 21 September. Two payments are recorded in the ledger: one in 1760 for seventy guineas and another on 22 May 1764 (Cormack 1970, pp. 121–2, who however omits the seventy guineas). Miss Greville (1744–1818) was the only daughter of Fulke Greville. In 1766 she married John Crewe (who was created Baron Crewe forty years later). She was to become a prominent leader of Whig society, a warm supporter of Fox, and was acknowledged as one of the greatest beauties of her time. She was painted by Reynolds in several subsequent works. The brother represented here is probably William Fulke Greville who entered the Navy and died in 1837. His figure was cut out of the canvas apparently after a quarrel with his father at some time before 1794 and was replaced by a tripod. The cut-out portion was preserved and, having passed through several collections, was eventually resewn into the original canvas in the 1860s (see Graves and Cronin 1899–1901, I, pp. 398–9). Although described as Hebe in the last century, Miss Greville represents Psyche and the vase she carried—adapted by Reynolds from one designed by Polidoro da Caravaggio in the early sixteenth

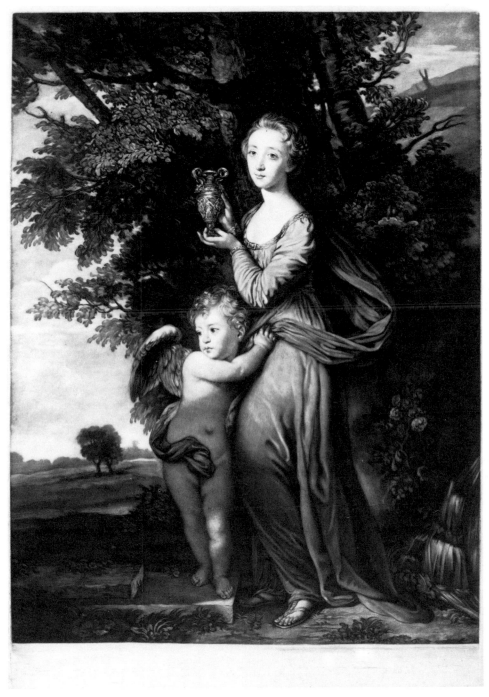

38

century—is meant to represent the one which she had to carry back from the underworld.

The second state of this engraving carries the publication date of 25 July 1762 but an early state (such as this) had been included as no. 160 (entitled 'Young lady and brother') in the Exhibition of the Society of Artists which opened on 17 May, as we know from Horace Walpole's annotations. McArdell was, together with his fellow Irishman, Richard Houston, the most significant figure in the great revival of mezzotint engraving which took place in London in the 1750s. Before his early death at the age of thirty-seven in 1765 he had reproduced nearly forty of Reynolds's portraits including the first one that the painter had engraved (Cat. 21). Reynolds seems to have been on easy terms with him and painted his portrait (now in the National Portrait Gallery). N.P.

LITERATURE Chaloner Smith 1878–83, no. 93 (i) ; Goodwin 1903, no. 90 (i).

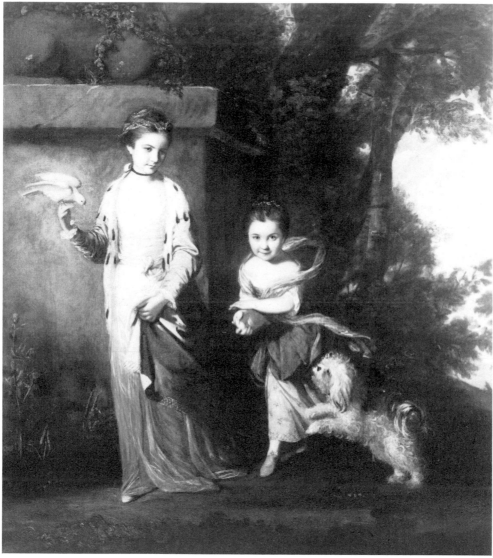

39

39 The Ladies Amabel and Mary Jemima Yorke

195 × 170 cm
The Cleveland Museum of Art,
Bequest of John L. Severance, 1942

Philip, 2nd Earl of Hardwicke, and Lady Jemima Campbell had no sons but two daughters, painted here as children, perhaps in the grounds of Wrest Park, the family seat in Bedfordshire. Lady Amabel Yorke was born on 22 January 1751, and in 1772 married Alexander Hume Campbell, Lord Polwarth. She succeeded her mother as Baroness Lucas in 1779, was created Countess de Grey in 1816, and died on 4 May 1833. Lady Mary Jemima Yorke was born on 9 February 1756, and in 1780 married Thomas, 2nd Lord Grantham. She died on 7 January 1830. Her eldest son, Thomas Philip, succeeded his aunt in 1833 as Earl de Grey and Baron Lucas.

This painting passed to him after his aunt's death and descended in the de Grey-Lucas branch of the family.

It is impossible to identify any sittings for this portrait in the artist's pocket-books but a payment of eighty guineas was entered in his ledger some time between 13 January and 24 March 1761 for 'Lady Grey's Children'. Walpole saw the picture in Lord Royston's house in St James's Square (Lord Royston was the children's father, who succeeded as 2nd Earl of Hardwicke in 1764) but said this was in 1761; Waterhouse has pointed out that Walpole may have mistaken the date, as he also mentions the mezzotint by Fisher which was published in 1762 (it is, however, just possible that the earliest impressions of the print were available in 1761). Nicholas Penny has pointed out that the evidence of the engraving (fig. 61) suggests that the canvas has been cut at the top. In the painting only the lower part of a sculptured animal may be detected on the plinth—cropping of a kind most unusual in Reynolds's work—but in the print this animal is clearly

a garlanded sphinx. The relative size of the children and the landscape in the print is also closer to that in Reynolds's portrait of two of the Methuen children with their pets (Corsham Court) of 1758–9, which in many ways anticipates this portrait and was probably completed about a year earlier. The motif of girls holding doves, which inspired Ogborne's stipple print of Lady Mary Jemima alone, published with the title 'Protection', may have been suggested to Reynolds by the well-known statue in the Capitoline Gallery at Rome known as 'Girl protecting a dove'. Pictures of Lady Amabel

Fig. 61 Edward Fisher (after Reynolds, *The Ladies Amabel and Mary Jemima Yorke*, 1761), mezzotint, 1762 (Fitzwilliam Museum, Cambridge)

also exist which are copied either from Reynolds's canvas or, more likely, from engravings. One which came from the collection of Lady Lucas in 1917 was sold at Christie's on 15 October 1948 (127) and bought by the Earl of Hardwicke. A small copy or sketch of the entire composition (but in its present format and without the sphinx) was sold at Sotheby's on 11 July 1984 (52). D.M.

PROVENANCE Painted for Philip, 2nd Earl of Hardwicke; by descent to Nan Ino, 9th Baroness Lucas and 12th Baroness Dingwall; sold Christie's, 26 May 1922 (78), bt Agnew; M. Knoedler & Co., New York; John L. Severance, Cleveland, Ohio.

EXHIBITED British Institution 1813 (21); Suffolk Street 1833 (73); Royal Academy 1875 (139); Grafton Gallery 1895 (154).

LITERATURE Cotton 1856, p. 36; Graves and Cronin 1899–1901, III, p. 1084; Toynbee 1928, p. 40; Waterhouse 1941, pp. 50, 121; Cormack 1970, p. 121; Waterhouse 1973, p. 46; Cleveland Museum of Art 1982, pp. 210–12.

ENGRAVED E. Fisher, 1762; S. W. Reynolds; V. Green (Lady Amabel only, reversed); J. Ogborne, 1793 (Lady Mary Jemima only, as 'Protection').

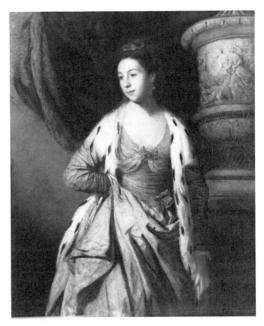

40 *reproduced in colour on p. 98*

40 Rebecca, Viscountess Folkestone

124.5 × 99 cm
Signed and dated 1761
The Earl of Radnor

Rebecca Alleyne was born in Barbados in 1725, the daughter of a wealthy settler. She married in 1751 William Bouverie MP, the widower of her close friend and second cousin. He became Viscount Folkestone on the death of his father in the same year and was created Baron Pleydell-Bouverie and Earl of Radnor in 1765. She died in 1764. Appointments for Lady Folkestone are recorded in the artist's pocket-book for 1760 on 1, 5, 7, 11, 14, 19 and 21 March with a note 'Send to Lady Folkestone' added on 11 March. A note opposite the week commencing 14 April reads 'Dead collur Lady Folkestone' (referring to the draperies? or to a copy?) and opposite 28 April Reynolds noted 'Lady Folkestone to be sent home on Thursday'—that is, 1 May. The painting seems to have been exhibited at the Society of Artists that year. However, there are also appointments for 17 January and 20 February 1761, the latter cancelled, so perhaps the painting was sent back for revision. The alternative explanation—that Reynolds refers here to the Dowager Lady Folkestone for whose portrait he was paid in the same period—can be discounted because this painting was dated 1761. A second payment for Lady Folkestone of thirty guineas is recorded in the artist's ledger as apparently made before October 1762.

Lady Folkestone's pose is very similar to that which Reynolds had employed in his portrait of Mrs Bonfoy (Cat. 23) and in several other female portraits of this size. It derives, as David Mannings has pointed out, from Van Dyck's male portraiture. Aileen Ribeiro notes that both Lady Folkestone and Mrs Bonfoy 'have the bodice of their dress decorated with silk rosettes' but that in this case 'Reynolds

has added an ermine-lined over-gown, which, with the asymmetry caused by the hitching up of the skirt of the dress, gives an oriental effect of a kind much favoured in Turkish masquerade costume at that period'. The seascape in the Bonfoy portrait is replaced by a classical urn adorned with a relief of hunting nymphs. The mood is also more tender. The painting has recently been cleaned and the spotted silk veil, which is attached with jewels to her hair, flows over her shoulder and loops up to her bosom, can now be perceived. This is the sort of feature which has often been entirely lost in Reynolds's paintings by over-cleaning. Revisions to the outline of the projecting elbow which Reynolds found difficult to draw are now visible. N.P.

PROVENANCE By descent.

EXHIBITED Society of Artists 1760 (without number); Royal Academy 1873 (115); Arts Council 1972 (218).

LITERATURE Graves and Cronin 1899–1901, I, pp. 102, 320–1; Squire and Radnor 1909, II, pp. 68–9; Waterhouse 1941, p. 48; Cormack 1970, p. 119.

No early engraving recorded.

41 A 'Conversation'

52.5 × 81.2 cm
City of Bristol Museum and Art Gallery

This painting, of an unusual scale for Reynolds, was commissioned by Horace Walpole (see Cat. 28) as a record of three friends who during the 1750s spent Christmas and Easter with him, forming an 'out-of-town party' at his villa, Strawberry Hill. Walpole in his own description of his villa in 1784 recorded the painting as in the 'Refectory': 'Over the chimney, a conversation, by Reynolds, small-life: Richard, second Lord Edgcumbe, is drawing at a table in the library at Strawberry-hill; George James Williams is looking over him; George Augustus Selwyn stands on the other side with a book in his hand.'

For Selwyn see Cat. 63. George 'Gilly' Williams (1719–1805), the son of a prosperous lawyer, husband of the daughter of the Countess (but probably not the Earl) of Coventry and uncle of a wife of Lord North, lived a life of elegant unemployment supported by sinecures which these connections secured for him. 'Dick' Edgcumbe (1716–61) was the son of the first Lord Edgcumbe of Mount Edgcumbe in Cornwall and succeeded to this title in 1758. He was a Lord of the Admiralty in 1755–6 and Privy Councillor from 1756 until his death. He dabbled in verse and in art (hence the porte-crayon) but was most noted for his addiction to cards, at which he lost fabulous sums. The first Lord Edgcumbe was an important patron of Reynolds, and Richard Edgcumbe knew Reynolds as a child and is said to have encouraged him to paint his earliest work on sailcloth (Cotton 1856, p. 31; Hine 1867, pp. 197–8); nevertheless, it cannot have pleased Reynolds that Richard Edgcumbe was a keen promoter of his rival Liotard (Northcote 1818, I, p. 59). Edgcumbe's coat and aile-de-pigeon wig were, Aileen

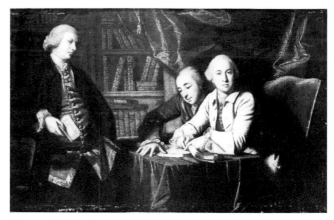

41 *reproduced in colour on p. 102*

Ribeiro notes, more at the height of fashion than Selwyn's dress and frizzed bob-wig.

After Edgcumbe's death Walpole, in a letter of 30 December 1761, asked a friend 'Did you see the charming picture Reynolds painted for me of him, Selwyn and Gilly Williams? It is by far one of the best things he has executed' (Walpole 1937–83, IX, p. 417). As a convivial group of cultivated men it looks back to the Roman caricatures and also anticipates Reynolds's much larger portrait of the Hon. Henry Fane and his guardians (Metropolitan Museum, New York) completed 1766, but commenced it seems in 1762, and of course his later portraits of the Society of Dilettanti (Cat. 109, 110).

Appointments are recorded for 'Mr. Williams' on 22 October 1757 and 3 and 26 May and 28 November 1759. Appointments for 'Mr Edgcumbe' are recorded on 28 and 30 November 1757 and for Lord Edgcumbe on 27 and 28 February and 7 and 14 March, and on 24 December 1759 there is a memorandum concerning his drapery. On 10 May 1760 there is a note 'send to Lord Edgcumbe' and there are further entries on 17 May 1760 and 26 January 1761 (confusingly, his brother Commander Edgcumbe, later the 3rd Lord, was sitting in the same period). Appointments for Selwyn are recorded on 24 and 28 May, 4, 12 and 26 June, 4 and 7 July, 11 August (no time given) and 27 November 1759. On 17 January 1761 there is a note 'send to Mr Selwine' and there are appointments on 19, 20 and 23 May (the last of these for three hours). Not all the appointments noted here for Edgcumbe and Selwyn are likely to have been for this painting. A note in the pocket-book on 24 June 1761, 'Mr Walpole's picture to be finished' probably refers to this painting and an undated note 'Mr Walpole's conversation picture to be finished' in a memorandum book (Private Collection) certainly does. A second payment of twenty guineas in the ledger was made, apparently previous to 1762, by 'Mr Walpole' for 'Lord Edgcumbe's picture'. N.P.

PROVENANCE Painted for Horace Walpole; bequeathed to Mrs Damer; 6th Earl Waldegrave 1811; by descent to Lord Carlingford; Strawberry Hill sale, Robins, 18 May 1842 (43), bt by J. M. Smith; by 1843 Henry Labouchère (later Lord Taunton) of Stoke Park; bt from Taunton's son-in-law, E. A. V. Stanley, by H. Buttery for F. P. Schiller 6 May 1920; bequeathed to Bristol 1946.

EXHIBITED British Institution 1843 (40); South Kensington 1868 (824); Plymouth 1951 (29); Birmingham 1961 (34); Plymouth 1973 (37).

LITERATURE Walpole 1784, p. 3; Graves and Cronin 1899–1901, I, p. 276; Waterhouse 1941, p. 45; Hilles 1967, p. 145; Cormack 1970, pp. 118, 139; Fothergill 1983, pp. 74–82.

No early engraving recorded.

42 Garrick between Tragedy and Comedy

148 × 183 cm
Private Collection

David Garrick (1717–79), the greatest figure in the British eighteenth-century theatre, studied under Dr Johnson and accompanied him to London in 1737. He began his acting career in October 1741, playing at Goodman's Fields, but the earliest portrait that we have of him, which dates from

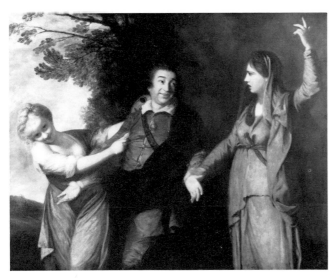

42 *reproduced in colour on p. 115*

about that time and shows him standing against a pile of books and papers with a quill in his hand, represents him as an author rather than as an actor (National Theatre Company, attributed to J. B. van Loo). Indeed, he wrote more than forty dramatic pieces, mostly now forgotten, including adaptations of Shakespeare, and a lively comedy which is still produced, *The Clandestine Marriage*, on which he collaborated with George Colman the elder. One of Reynolds's most popular portraits of Garrick (of which a number of versions survive) celebrates this side of his talents, showing him seated at a writing desk, hands clasped on a paper bearing the word 'Prologue', eyes twinkling as they meet the spectator's.

Garrick, who took over as manager of Drury Lane in 1747, was acutely conscious of the value of pictures as advertisements. He sat to every painter of note and to many who are now little more than names. He was painted in oils and

in watercolours, drawn in pencil and in pastels, modelled in wax and in terracotta; his likeness appeared on playing-cards and medals, and from a medal it was adapted to a blue jasper plaque by Wedgwood and Bentley. In 1762, the year that Reynolds's *Garrick between Tragedy and Comedy* was exhibited at the Society of Artists, the actor gave Zoffany his first important commission, a scene from *The Farmer's Return* with Garrick represented on stage in one of his most popular roles. Together with its companion piece, a scene from *Venice Preserv'd* (both today in the collection of Lord Lambton), this launched a new type of picture, the theatrical conversation piece, and, as Professor Waterhouse observed, 'it is a reasonable hypothesis that the inventor of this genre was Garrick himself . . . [who] saw how pictures of this character, popularized by engravings, would be the best publicity in the world'. In addition to his importance as one of the new breed (with Rich, Beard, Foote and Colman) of professional managers and as a playwright, Garrick introduced improvements in stage-lighting and scenery, removed spectators from the stage itself, and cultivated a naturalistic style of acting which superseded the ponderous, histrionic style of the older generation. In 1749 he married a Viennese dancer, Eva Marie Violetti, with whom he appears in a double-portrait by Reynolds which is now in the National Portrait Gallery.

According to Beattie, Reynolds declared that he had 'begun and finished' the portrait of *Garrick between Tragedy and Comedy* 'in a week'. The artist's pocket-book for 1761 suggests that it probably took a little longer: there are appointments at nine o'clock for Garrick on 20, 22, 26 and 29 May and 2 June. Other appointments that year were as follows: 1 March (a Sunday and apparently a social engagement), 8 May (ten o'clock—perhaps an initial discussion of the portrait?), 12 June (eight o'clock, possibly a very early sitting), 11 and 13 July (half-past ten and one o'clock, so possibly sittings).

The earliest description of the painting comes from Horace Walpole's *Book of Materials* (in which he collected information, mainly about painting): '1761. Reynolds has drawn a large picture of three figures to the knees, the thought taken by Garrick from the judgment of Hercules. It represents Garrick between Tragedy and Comedy. The former exhorts him to follow her exalted vocation, but Comedy drags him away, and he seems to yield willingly, though endeavouring to excuse himself, and pleading that he is forced. Tragedy is a good antique figure, but wants more dignity in the expression of her face. Comedy is a beautiful and winning girl—but Garrick's face is distorted, and burlesque. Lord Halifax has given him £300 for it!' The past tense may be misleading and the price was probably in guineas: the artist's ledgers record a payment of fifty guineas by Halifax between 12 September 1765 and 27 September 1766, and there are three subsequent notes under his name for a hundred, for another hundred, and for another fifty guineas.

Lord Halifax's secretary when the portrait was painted was the playwright Richard Cumberland, whose comedy *The Brothers* ran successfully at Covent Garden in 1769 with an epilogue which included the following lines:

Who but has seen the celebrated strife,
Where Reynolds calls the canvas into life,
And 'twixt the Tragic and the Comic muse,
Courted of both, and dubious where to choose,
Th' immortal Actor stands?

It seems likely in fact that Cumberland, who apparently had in the early 1760s entire charge of Lord Halifax's finances (Williams 1917, p. 35), inspired this otherwise rather unexpected purchase.

Edward Edwards, an early critic, calls the picture Reynolds's 'first attempt in historical composition'. The 'Choice of Hercules' is a very old subject, deriving from a tale by the Greek Sophist Prodicus, a contemporary of Socrates, and its pictorial history can be traced, as Panofsky showed, back to the Middle Ages. Lord Shaftesbury's treatise published in 1712 discussed the correct classical presentation of the subject and Xenophon's *Memorabilia*, which contains the original story, was a recommended school textbook in this period, all of which helped to make Reynolds's picture more easily comprehensible then than it is now. It has recently been argued (by Mannings, 1984; and independently by Busch, 1984) that Reynolds took the broad lines of his composition not from any earlier representation of the 'Choice of Hercules' but from Guido Reni's *Lot and his Daughters* (fig. 62). Whether he saw the original picture in Rome in the Lancellotti Palace (it is now in the National Gallery, no. 193) we do not know, but several copies exist

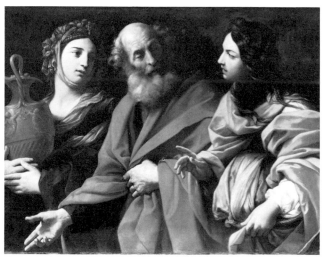

Fig. 62 Guido Reni, *Lot and his Daughters*
(Trustees of the National Gallery, London)

including one at Holkham and another in the Royal Collection, both of which would have been accessible to him. But Reni's picture has, like the 'Choice of Hercules' as traditionally represented, a dramatic seriousness lacking in *Garrick between Tragedy and Comedy*. The swaggering, humorous figure of Garrick has an almost bacchanalian quality which suggests that Reynolds also had in mind a picture like the *Drunken Silenus supported by Satyrs* by Rubens which he probably knew through a copy which was then, and still is, at Knole (the best-known version—fig. 63—of this composi-

Fig. 63 Studio of Rubens, *Triumph of Silenus*
(Trustees of the National Gallery, London)

tion, which was produced in Rubens's studio, is in the National Gallery, no. 853).

It has frequently been pointed out that Reynolds has painted the two Muses in different styles, so that the picture can be interpreted on another level as a personal statement in which the artist hesitates between the styles of Reni (Tragedy) and Correggio (Comedy), between the public exhibition style typified by such pictures as the *Duchess of Hamilton and Argyll* (Cat. 36) and the private or intimate style of, for instance, the *Countess of Albemarle* (Cat. 33), or *Kitty Fisher* (Cat. 31). In fact the figure of Comedy may also owe something to a verse translation of Prodicus's 'Choice of Hercules' published in 1747 by Joseph Spence in his book, *Polymetis*. Comedy ('Pleasure' in Spence's rendering),

. . . unguarded rov'd her eye . . .
All soft and delicate, with airy swim
Lightly she danc'd along; her robe betray'd
Thro' the clear texture ev'ry tender limb,
Height'ning the charms it only seem'd to shade.

The way that Comedy looks at the spectator may reflect the lines:

Then all around her cast a careless glance,
To mark what gazing eyes her beauty drew.

Her hairstyle, slightly tousled and reminiscent of the bacchante in Rubens's *Silenus*, is quite different from that worn by Tragedy. This detail owes less to poetry than it does to contemporary fashion. The way her hair is curled at the front and coiled up at the back into a loose bun would have seemed a bit old-fashioned by the mid-century, in contrast to the more up-to-date way that Tragedy's hair is combed back from her forehead and decorated with sleek plaits, wound across her head and allowed to hang down across her shoulder. There may even be a 'moral' point to this. 'A lock of hair falling . . . cross the temples,' wrote Hogarth, in his *Analysis of Beauty*, published only eight years earlier, 'and by that means breaking the regularity of the oval, has an effect too alluring to be strictly decent, as is very well known to the loose and lowest class of women . . .' (1955, pp. 51–2).

A similar contrast is offered by the drapery colours used. Comedy's drapery is a pale, washed-out pinky-mauve, the sort of colour favoured by the painters of the waning rococo style. Tragedy by contrast is dressed in a warm blue, the sort of colour that Reynolds thought appropriate to the Grand Style, and already preferred by the younger generation of artists who were, in the next decade, to lay the foundations of European neo-classicism. Aileen Ribeiro points out that Tragedy has her head and arms covered, suitably, as for mourning dress.

But Reynolds's picture was never meant to be taken too seriously and certainly not too solemnly. It is a joke, essentially a parody: it compliments Garrick by associating him with an elevated classical subject, but since he is no Hercules it makes an amusing comment on the difference between the modern world and the world of epic.

The popularity of *Garrick between Tragedy and Comedy* led to a number of copies being made, mostly reduced in size. There is, for example, one in the Garrick Club; another was in the Brownlow Sale at Christie's on 3 May 1929; a third was in the collection of Colonel Weld at Lulworth Manor; and a fourth, formerly attributed to Benjamin West, belongs to the Shakespeare Memorial National Theatre Trust (exhibited Arts Council 1975, no. 33). Garrick's monument in Westminster Abbey, made by Henry Webber and unveiled in May 1797, includes whole-length figures of Tragedy and Comedy, with the actor placed between but above them and pushing aside curtains with a dramatic gesture. Prints of Reynolds's portrait were also very popular, and not just in England. George Colman wrote to Garrick from Paris in 1765: 'There hang out here in every street, pirated prints of Reynolds's Picture of you which are underwritten, "L'Homme entre le Vice et la Vertu"' (Oman 1958, 252).

For a caricature which reflects this painting see Cat. 195; for another portrait of Garrick see Cat. 69. D.M.

PROVENANCE Bt from the artist by George Montagu-Dunk, 2nd Earl of Halifax; bt after his death by John Julius Angerstein, in whose family it remained until after 1872; bt by Agnew; Lord Rothschild before 1899.

EXHIBITED Society of Artists 1762 (88: 'Mr Garrick, between the two muses of tragedy and comedy'); British Institution 1813 (32), 1843 (26), 1851 (70); South Kensington 1867 (594); Royal Academy 1872 (78); 45 Park Lane 1937 (88); Royal Academy 1951 (18).

LITERATURE Edwards 1808, p. 188; Hamilton 1831, vol. I (unpaginated); Beechey 1835, I, pp. 156–7; Cotton 1856, p. 70; Leslie and Taylor 1865, I, p. 205; Graves and Cronin 1899–1901, I, pp. 350–1; Panofsky 1930, note I p. 133; Wind ('Borrowed Attitudes') 1939, pp. 182, 184; Wind ('Giordano Bruno . . .') 1939, p. 262; Waterhouse 1941, pp. 12, 48, 50; Waterhouse 1953, p. 158; Moore 1967, pp. 332–4; Hilles 1967, pp. 146–7; Cormack 1970, pp. 123, 154; Waterhouse 1973, pp. 21–2; Mannings, spring 1984, pp. 259–83; Busch 1984, pp. 82–99.

ENGRAVED E. Fisher, 1762; C. Corbutt; A. Cardon, 1811; S. W. Reynolds; Normand *fils*.

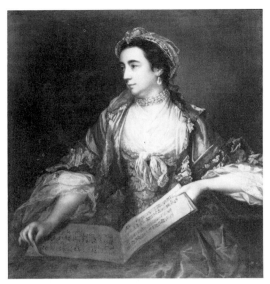

43 *reproduced in colour on p. 106*

43 The 'Contessa' della Rena

99 × 91.5 cm
The Earl of Rosebery at Dalmeny House, near Edinburgh

'La Rena' was the wife of a Florentine wine merchant. She was 'known by all the young English' visiting the city and also associated for a while with the Marquis de Marigny and the Marquis de Machault. She came to England with the dissolute Earl of Pembroke at the end of 1757, picking up *en route* a bogus title (Walpole 1937–83, XXI, pp. 156, 162). By 1759 she was protected by William Douglas, third Earl of March, a notorious rake who was most at home at the races and the opera. The end of her liaison with Lord March may be dated to January 1767 when Selwyn, March's crony (see Cat. 63) returned with La Rena from Paris. Lord March, who was at Newmarket, wanted Selwyn to explain to La Rena that he was now attached to La Zamparini, a fifteen-year-old dancer at the opera—'I love her [La Rena] vastly but I like this little girl' (Robinson 1895, pp. 291–314). Early in 1769 La Rena was back in Tuscany (Walpole 1937–83, XXIII, pp. 106–7, 119). A decade later Selwyn, when in Italy, reported that she was rich but very much aged: he couldn't be bothered to call on her (Kerr 1909, p. 245). For a scandalous account of March and La Rena see Cat. 200.

Although Lord March's interest in horse-racing and dancing girls has attracted more attention from his biographers, he was always a great lover of opera (Wraxall 1884, IV, p. 359). The cleaning of this portrait of his mistress in 1980 revealed, in addition to the exciting mauves and the spontaneous handling, some of the notes and words for the music she holds. It is headed 'Dal Sig. Giardini'. The stage-manager, composer and virtuoso violinist Felice de' Giardini (1716–96) was a dominant but controversial figure in the musical world of London between 1750 and 1780. In a letter of 1766 to Selwyn March refers to Giardini as an enthusiasm he shares with La Rena. Does La Rena look out of the painting at a

companion portrait? If so, it is interesting that Giardini sat for a portrait by Reynolds in July and August 1760. It was not completed but there is an engraving of it by S. W. Reynolds (Whitman 1903, p. 48, no. 111) and a drawing perhaps by Reynolds of Giardini is in the Ashmolean Museum (Brown 1982, no. 1513).

The sitter's opulence is clear from the abundant ruffles and ribbons then at the height of fashion—Aileen Ribeiro notes that 'ruched ribbons are used even for trimming the silk hooded cape' and that she wears 'a slightly twisted pearl choker, fastening, as was the custom, with a ribbon at the back' as well as an earring of a single pearl (pendeloque). In view of the sitter's character it is significant that the white fichu is modestly knotted on the bosom and that the 'lappets or streamers' are pinned up to the 'round-eared' cap 'in a style which was, by this time, thought to be rather matronly'.

Appointments for 'La Rene', 'Signora Rene', 'Signora Rena' and 'Contessa della Rena' are recorded in the artist's pocket-books for 6 July, 14, 15 and 17 August, 27 November and 8 December 1759; 1 April and 18 and 20 September 1760; and 11 September 1761. A second payment of twenty guineas is recorded in February 1762—'Madame La Rena for Lord March'. First payment may be the sum of £23.12s.6d paid by Lord March on 16 December 1760. Since this sum is a little more than twenty guineas, it perhaps includes the cost of the 'Carlo Marat Frame for Madame La Rena' specified in a note in Reynolds's pocket-book opposite the week commencing 9 July 1760.

The 'Marat' or 'Maratta' frame referred to here is doubtless the one in which the painting now hangs. The evidence of the pocket-books suggests that Reynolds preferred frames of this type which were named after the Roman seventeenth-century artist Carlo Maratta, who seems to have favoured them. They involved much less carving than the rococo frames, known as 'French frames', which were the alternative for Reynolds's clients in 1760, and were also easily made, since the moulding was unmodified or only slightly modified at the corners. Since Reynolds's portraits were of standard sizes, the frames could presumably be purchased 'off the peg'. Reynolds's frame-maker was said to have been Cribb in Covent Garden (Leslie and Taylor 1865, I, note p. 182). For frames see also Cat. 175. N.P.

PROVENANCE Painted for the 3rd Earl of March (later 4th Duke of Queensberry); by 1867 William Angerstein; by 1899 the Earl of Rosebery; his sale 5 May 1939 (113), bt in; by descent.

Never formerly exhibited.

LITERATURE Leslie and Taylor 1865, I, note p. 177; Graves and Cronin 1899–1901, II, p. 787; Waterhouse 1941, p. 47; Cormack 1970, pp. 128, 134.

No early engraving recorded.

EDWARD FISHER (after Reynolds)

44 Lady Elizabeth Keppel

58.1 × 36.2 cm (slightly trimmed)
The Trustees of the British Museum

This elaborate and splendid mezzotint (priced, in this state, at the very high sum of fifteen shillings) reproduces one of the most admired of all Reynolds's portraits, now to be seen at Woburn Abbey. For the engraver Edward Fisher see Cat. 20. The sitter is identified and the circumstances explained by a Latin inscription on the step: 'Elisabetha Keppel Comitis Albemarliae Filia Regiis Nuptiis Adfuit'.

Lady Elizabeth Keppel (1739–68), daughter of the Earl and Countess of Albemarle (see Cat. 33) and brother of Reynolds's friend and patron the future Admiral (see Cat. 19), was a bridesmaid at the Royal Wedding in 1761; she is painted in the dress which she wore on this occasion and adorning with flowers a terminal statue of Hymen (the Roman god of marriage) who holds a crown (in reference to the Royal Wedding). She is assisted by a black servant. The learned character of this poetic conceit is reinforced by lines from Catullus's hymn (Carmen LXI) for marriage of Junia and C. Manlius Torquatus: 'Cinge tempora floribus/suave olentis amaraci' ('garland your forehead with flowers of the fragrant red marjoram') and then the refrain (incorrectly) 'Adsis o Hymenae Hymen; Hymen o Hymenaee'. We are reminded of the poetic conceit which inspired the painting of Fox and two ladies (Cat. 48) at the same date.

There were appointments for Lady Elizabeth on 28 September and 5, 7 and 10 October, also appointments for a 'negro' on 15 and 17 December, 1761. Walpole described the painting as just finished and as much admired on 30 December (Walpole 1937–83, IX, p. 417) but more sittings may have been needed and there are appointments on 3 and 20 January. The painting was then exhibited as no. 87 ('A whole length of a lady, one of her Majesty's bride maids') at the Society of Artists exhibition which opened on 17 May 1762. Payment in two instalments of forty guineas is recorded, the first undated, indicated as a payment made by the sitter's brother, Lord Albemarle, the second dated 4 July 1765 (Cormack 1970, pp. 125–6). On 7 June 1764 Lady Elizabeth married Francis, Marquess of Tavistock, heir of the Duke of Bedford—a triumphant alliance for the Keppels. But the Marquess died after a riding accident in 1767 and she died, broken hearted, in the following year. Reynolds in painting this portrait was at once advertising through its most nubile representative the loyalty and the great eminence of the family of his chief patron and at the same time demonstrating what court portraiture might be in his hands.

It was later claimed that the dress was the work of the drapery painter Peter Toms (Edwards 1808, p. 54), but such allegations are notoriously unreliable and this dress is richer in surface than the work generally associated with this talented specialist. N.P.

LITERATURE Chaloner Smith 1878–83, no. 36 (5).

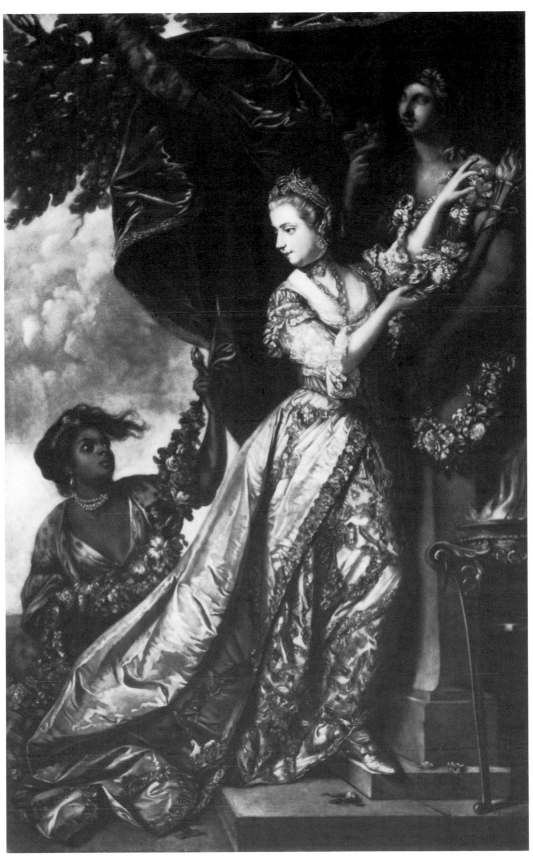

44

45 Lord Middleton

236 × 145 cm
The Lord Middleton

Francis Willoughby was born on 25 January 1726 and succeeded as 3rd Baron Middleton on 1 August 1758. He died unmarried on 16 December 1774 at Wollaton (where this portrait hung until early in the present century).

Entries in Reynolds's pocket-book on 12, 14, 16 and 19 October 1761 may be connected with this portrait, and there

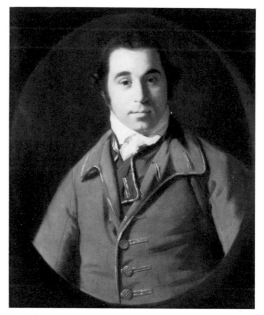

Fig. 64 Mr Willoughby, 1761 (Lord Middleton)

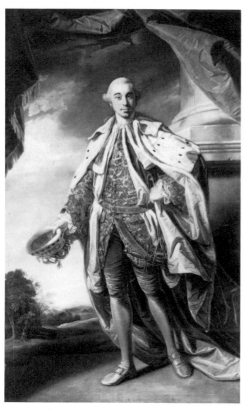

45 reproduced in colour on p. 100

follows an appointment on 23 November preceded by a memorandum 'Send to Lord Middleton'. More appointments are indicated on 25 and 28 November, on 2, 4, 7 and 30 December 1761, on 1, 4, 5 and 6 January 1762 (added to the end of the book for 1761) and on 7 and 22 January 1762. The name also appears opposite 20 January 1762 in the accounts column. On 15 May 1762 there is a note: 'send home Lord Middleton'. An oval portrait (fig. 64) which also belongs to the family and which is also traditionally supposed to represent the 3rd Lord Middleton (and looks very like him) seems more likely to represent his younger brother Thomas, whose name also appears in Reynolds's pocket-book in October 1761: in fact every time Lord Middleton had an appointment in that month 'Mr Willowby' had one immediately afterwards. The oval cost twenty guineas and payment is recorded in the ledger in the form of a single instalment on or after 1 April 1762. Payments for the whole-length may be distinguished because we know that

Reynolds's price for a portrait of this size in 1761–2 was a hundred guineas, and between 25 April 1761 and 20 April 1762 we find four payments against Lord Middleton's name, two of forty guineas and two of ten guineas. (There is also a note that the frame cost £3.13s.6d.) It is tempting to see the first payment of ten guineas as some sort of deposit. A contemporary account of J. B. van Loo's portrait practice in London in the late 1730s describes clients putting their names down six weeks ahead in order to secure a sitting (Rouquet 1755, p. 38). But the interpretation of the documents is complicated by the fact that George Brodrick, 3rd Lord Midleton, was having his portrait painted in March, April and May 1757 and Reynolds uses the same spelling for both sitters. Midleton's portrait, formerly at Peper Harow, was paid for after 15 May 1762 and cost thirty guineas.

In his superb whole-length of Lord Middleton, Reynolds has made use of a pose employed more than once by Van Dyck, most notably in the whole-length at Knole of Edward Sackville, Earl of Dorset. However, by shifting the background plinth from the left to the right side of the canvas and lowering the eye-level, he achieves a sense of sprightly action lacking in the Van Dyck.

Aileen Ribeiro describes Lord Middleton's costume as follows: 'He wears the coronation robes of a baron. These consist of a red velvet mantle with two rows (powderings) of ermine on white miniver, and a tunic, also of red, edged with fur and lined with white silk. He holds in his hand his coronet of red (turned rather purplish) velvet with six "pearls" (i.e., silver balls) and edged with a band of ermine. His coat is a superb brocaded silk (probably French), trimmed with silver thread lace, gold thread, tinsel and sequins. His stockings are of white silk, so are his shoes which are fastened with gold buckles. A large part of this costume survives. The present Lord Middleton has the red velvet

mantle lined with silk taffeta, now rather yellow and some-what worn. The "miniver" is in fact white rabbit with fake ermine tails of black bristle (this was a frequent economy in the eighteenth century due to the expense of pure miniver and ermine); the same trims the coronet which also survives, though the velvet is modern. The red velvet breeches and the brocaded coat are on loan to the Museum of Costume in Nottingham. The coat, a yellow silk, brocaded with flowers in colours, and with gold and silver, is in splendid condition; it is interesting to note that, since only the front would be visible, the back is made of plain yellow silk shorter than the front.' D.M.

PROVENANCE By descent.

Not previously exhibited.

LITERATURE Leslie and Taylor 1865, I, p. 202; Graves and Cronin 1899–1901, II, p. 644; Cormack 1970, pp. 128–9.

No early engraving recorded.

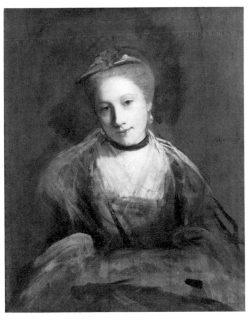

46 reproduced in colour on p. 95

46 Miss Kitty Fisher

75 × 59.7 cm
Private Collection

This unfinished portrait, said to be of the courtesan Kitty Fisher in the artist's studio sale, is of similar size to the paint-ing of 1759 at Petworth (Cat. 31). The pose is similar but the head is now larger and the seductive expression more affectionate and less arch. In 1765 Kitty became the second wife of John Norris of Hempsted Manor, Benenden, Kent. She is sometimes supposed to have died in 1767 but was still remembered in London in 1769 when a letter signed

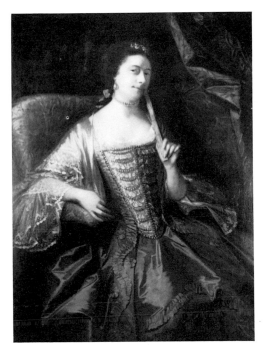

Fig. 65 Kitty Fisher, c. 1759 (Private Collection, on loan to the National Gallery of Art, Cape Town)

'Fresnoy' was published in the *Middlesex Journal* addressed to Reynolds and including insinuations concerning his rela-tions with her: 'Have you received a frown from salacious Catherine, the tailor's maid, or is the affection of the fair creature alienated from you entirely since her elevation to matrimony—from you, alas! and many others? ... Catherine has sat to you in the most graceful, the most natural, attitudes, and indeed I must do you the justice to say that you have come as near the original as possible' (Whitley 1928, I, p. 252).

In addition to the Petworth portrait of 1759 and the Ken-wood portrait, probably also of that year, which are certainly of Kitty, there is the seated lady with a fan (fig. 65) datable to the same period on grounds of costume, traditionally iden-tified as a portrait of her and similar in facial features. There are also half-length portraits said to be of her at Bowood and at Shane's Castle in which incongruously she wears ermine—the former was bought for the Marquess of Lans-downe in one of the last studio sales (25 May 1821 [35]) as 'Lady with a Parrot, the head nearly finished'—the latter was sold by the artist after Kitty's death to Mr Crewe and speci-fied as a portrait of her (Cormack 1970, p. 148). There are other versions and variants of these. A portrait of her (or at least of another Miss Fisher!) was acquired from the artist in 1782 by the Duke of Rutland (ibid. p. 162) but probably perished in the Belvoir Castle fire in 1816. These portraits are all carefully discussed by Kerslake (1977, I, pp. 74–6).

What is remarkable is the fact that so many of the portraits of Kitty seem not to have been commissioned or at least, if commissioned, were left on the artist's hands. This fact does give some support to the scandalous suggestion of 'Fresnoy'—although there is another explanation which is

that Kitty's liaisons lasted less time than it took Reynolds to paint her, and her jilted lovers did not want to be reminded of her.

Three appointments are recorded for Kitty in the artist's pocket-book for 1760—2 February and 25 and 31 December—far fewer than in 1759 (for which see Cat. 31). No appointments are recorded in 1761 but in 1762 her name appears on 8, 14, 19 and 21 January and 2 February. The pocket-book for 1763 is missing. In 1764 she had appointments on 20 July and in 1765 on 28 November. In 1766 on 30 September at twelve o'clock there is a note 'Miss Fisher in Hambledon Street'. In 1767 she married Mr Norris and the name Norris appears in pencil on 21 May; and on 23 and 27 May there are appointments for a Mr Norris—as also in January and February 1770. But despite claims to the contrary there is no indication of a sitting for Mrs Norris (although there is one on 4 September for a Mrs Morris). However, there is a payment of fifty guineas recorded for Mrs Norris after 14 July 1769 in his ledgers (Cormack 1970, p. 130). There is a technical note concerning a portrait of Kitty Fisher apparently made in 1766 at the end of the artist's first surviving ledger (Cormack 1970, p. 141).

Aileen Ribeiro points out that the informal dress—'day cap' and single black neckband—and above all, the dressing of the hair suggest a date in the early 1760s. N.P.

PROVENANCE Reynolds's studio sale, Greenwood's, 14 April 1796 (67), bt John Proby, 1st Earl of Carysfort; by descent.

EXHIBITED Royal Academy 1881 (58); Park Lane 1937 (58); Royal Academy 1956 (290); Royal Academy 1968 (131).

LITERATURE Leslie and Taylor 1865, I, note p. 165; Graves and Cronin 1899–1901, I, p. 308; Borenius and Hodgson 1924 (90); Waterhouse 1941, p. 57.

No early engraving recorded.

47 Harry Woodward

75 × 62.3 cm
Lord Egremont

Harry Woodward (1717–77) was one of the leading actors of the mid-eighteenth century, excelling especially in comedy. He left Drury Lane at the end of the 1758 season to act as co-manager of an unsuccessful new theatre in Dublin and only reappeared on the London stage in 1763 (*Dictionary of National Biography*). If this is correct, he must have made visits to London because appointments are recorded by Reynolds for 5 September 1759, 11 and 14 July 1760, 5 and 7 October 1761, and 8 November 1762. These may have continued in 1763, for which year, however, no pocket-book survives. A second payment of £26.5s (including the cost of a frame—£1.5s) is recorded in the artist's first ledger under the sitter's name for 5 December 1765.

Reynolds has painted Woodward in 'vandyke' costume of the sort he wore in Garrick's productions of old comedies by Shakespeare and Jonson: Woodward's Mercutio was especially admired and might be represented here. However,

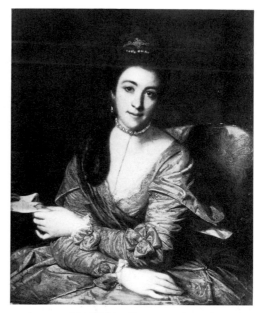

Fig. 66 Kitty Hunter, c. 1760
(Present whereabouts unknown)

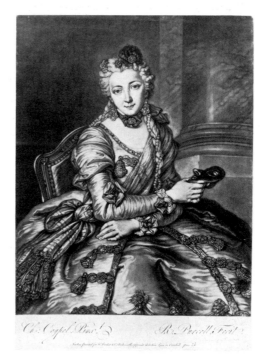

Fig. 67 R. Purcell (after Louis Surugue, after Coypel, *Madame de Mouchy*), mezzotint
(Fitzwilliam Museum, Cambridge)

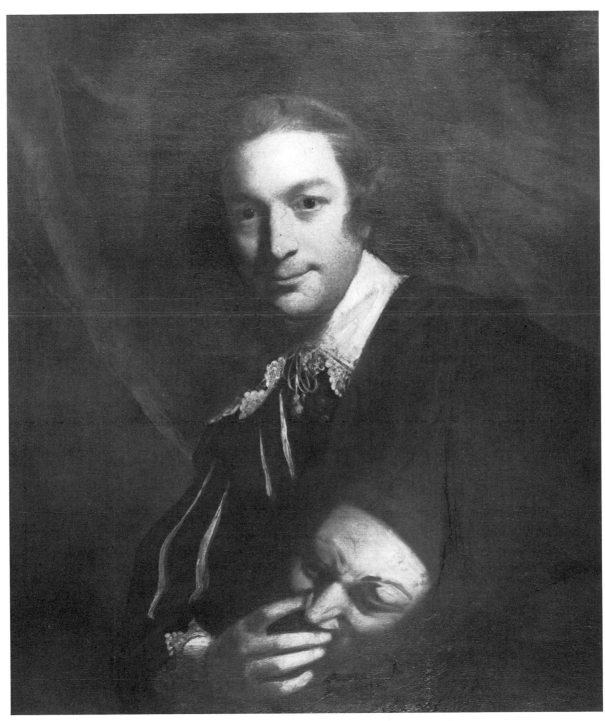

47

vandyke costume was also popular with non-actors and so too was the action of holding a mask. Indeed, the suggestion here that the mask has just been lowered is also found in Reynolds's contemporary portrait of Charlotte (Kitty) Hunter (fig. 66) and was perhaps derived from a mezzotint by Purcell made in reverse from a line-engraving by Surugue of 1746 of Coypel's portrait of Madame de Mouchy (fig. 67).

N.P.

PROVENANCE Given by the sitter to 'Stacey, an ex-jockey, the landlord of the Bedford Arms, a famous whist-player, with whom he lodged'; Earl of Egremont before 1837; by descent.

Never previously exhibited.

LITERATURE Smith 1828, II, p. 343; Leslie and Taylor 1865, I, pp. 165–6, 177–8; Graves and Cronin, 1899–1901, III, pp. 1067–8; Waterhouse 1941, p. 47; Cormack 1970, p. 139.

ENGRAVED James Watson; C. Townley.

48 Charles James Fox, Lady Sarah Bunbury and Lady Susan Fox Strangways

233 × 145 cm
Private Collection

Charles James Fox (1749–1806), later famous as a Whig politician, is shown here as a youth of thirteen, together with his cousin, Lady Susan Fox Strangways (1743–1827). They are walking in the garden of Holland House beneath a window, out of which Charles James's young aunt, Lady Sarah Lennox (1745–1826) who married Sir Thomas Charles Bunbury, Bt, during the progress of this picture, is shown leaning forward and pointing to a dove, held up towards her by Lady Susan.

Lady Sarah (for another portrait of her see Cat. 57) was born on 14 February 1745 and lost both her parents at the age of six. For some years she was looked after by her grandmother, Lady Cadogan, after which she went to Holland House and was brought up by her eldest sister, Lady Caroline Fox, later the first Lady Holland (Cat. 29). There she met and befriended Lord Holland's niece, Lady Susan Fox Strangways, just two years older than herself, and they remained close friends for the rest of their lives. At the age of fifteen she attracted the attention of the young King George III, and he is said to have come near to proposing marriage to her. Her own marriage to Sir Thomas Charles Bunbury, which took place on 2 June 1762 in the chapel of Holland House, ended in February 1769 when she eloped with her cousin, Lord William Gordon, and in 1776 she and Sir Charles were divorced. On 27 August 1781 she married, as his second wife, Colonel the Hon. George Napier, by whom she was the irreproachable mother of eight children of whom the three elder sons became famous generals.

Lady Susan, eldest daughter of Stephen Fox, 1st Earl of Ilchester (who was the brother of Henry Fox, Lord Holland), was born on 12 February 1743. Her marriage was a romantic one. William O'Brien, a handsome but penniless young Irish actor, who had been assisting in the private theatricals at Holland House, was not considered at all a suitable match by Lord and Lady Ilchester. Lady Susan was sitting for her portrait to Catherine Read, and on the morning of 7 April 1764 she started out for the artist's studio but instead met O'Brien by appointment. They drove to St Paul's Covent Garden church and were married. From O'Brien's house at Dunstable they announced their elopement to Lady Susan's horrified parents. In September they went to America but returned to England in 1771. It turned out to be a very happy marriage.

Henry Fox, 1st Lord Holland, had four sons: Stephen ('Ste'), Henry (who died in infancy), Charles James and Henry Edward. Charles James Fox was born on 24 January 1749. His father was already tenant of Holland House but did not buy it until 1767. A precocious child, adored by his parents, Charles was, at the age of five, reading every play he could get his hands on, and by the age of fourteen was

eagerly attending debates in the House of Commons. As a schoolboy at Eton (where his Leaving Portrait by Reynolds still hangs) he was renowned for his eloquence and wit, an early example of which is, as Nicholas Penny has pointed out, commemorated in this picture. In a letter dated 24 October 1761, Lady Sarah wrote to Lady Susan, of whom Charles was at the time a fervent admirer, as follows: 'Oh Lord! only think, I had almost forgot the most important thing in my letter. Charles Fox has made some lattin verses that were sent up for good; the purport of them is to desire a pigeon to fly to his love Susan, & carry her a letter from him, & that if it makes haste, it will please both Venus its mistress & him. There now, are not you proud, to have your name wrote in a scholar's exercise?' (Ilchester 1901, I, p. 114). A few months later Lady Sarah sent her friend 'a translation of Charles's verses, done by an Eaton boy, they are very pretty ...' (ibid. p. 119). The verses, which were later printed in *Musae Etonenses* (London 1795, I, pp. 216–17) are somewhat verbose, running to seventeen couplets in all. The dove is addressed in the first couplet, and praised for its ability to avoid all obstacles in its flight, as well as for its discretion:

Garrulitas nostrae quondam temeraria linguae
Indicio prodit multa tacenda levi:
At tibi vox nulla est.

('The indiscreet chatter of our tongue at times betrays, by some slight disclosure, many things that ought to be kept quiet; but *you* have no voice.') And the poet continues a few lines further on:

Nempe alis invecta tuis, tibi semper amores
Fidit in amplexus Martis itura Venus.

'Doubtless Venus, borne along by your wings, is ever confiding her loves to you, as she is about to go to the embraces of Mars'—translated by Dr Edwards who detects an echo here of Ovid, *Metamorphoses*, xiv, 597, where Venus is described as borne along through the breeze by yoked doves. Earlier interpretations of this picture have referred to the amateur theatricals which were a well-known feature of life at Holland House, and it has been suggested that the paper Fox holds may have been his part in a play which he, together with the ladies, are shown rehearsing. The lower half of the composition does in fact resemble *Garrick between Tragedy and Comedy*, without the figure of Comedy. Reynolds had completed this picture a few months before the first sittings are recorded for the Fox group (see Cat. 42).

Some time between 18 February 1764 and 12 August 1765 Reynolds recorded a payment of £120 received from 'Lord Holland for Lady Susan Strangways/Lady Sarah Bunbury & Mr Charles Fox'.

Lady Sarah's name appears in Reynolds's pocket-book in 1762 on 8, 14, 17, 21, 26 and 30 April, and on 4, 10 and 13 May. Lady Susan had appointments on 26 April (immediately after Lady Sarah) and 13 May (also following Lady Sarah); while a note on 8 May says: 'Send to Lady Susan Strangways'. An appointment on 21 July for 'Mr Fox' may refer to Charles's elder brother, Stephen, afterwards 2nd Lord Holland, but 'Mr Charles Fox' is referred to unambiguously on 27 July and 18 October. On 6 May at five o'clock

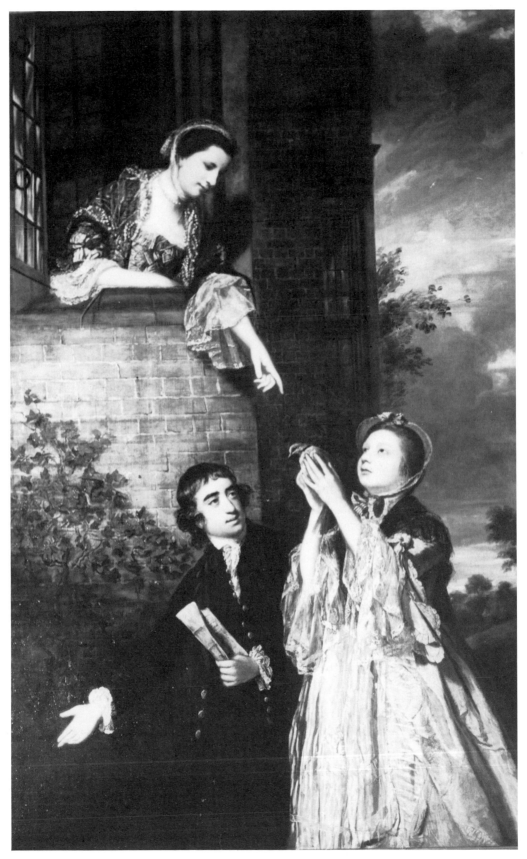

48

a visit to Holland House seems to be indicated; this may have been social or it may have been in connection with this picture, which is unusual among Reynolds's portraits in depicting a specific location (the outside of Holland House) and also seems to have been designed for a specific location within it. On 5 September 1762 Lady Holland referred to the picture, in a letter, in a way which suggests that it was finished—she noted that the artist had made Lady Susan 'very near if not quite as pretty . . . as Sal'. A year later she alluded to the painting's intended position in her new gallery—'the two full-lengths over the chimney are for Louisa, and the picture of Sal, Lady Sue and Charles, done by Reynolds'. This tells us that it was to be hung (and may always have been intended) as a pendant for Ramsay's portrait of Lady Louisa Connolly of 1759 (Fitzgerald 1949–53, I, pp. 338, 388—references supplied by Nicholas Penny).

There is no surviving pocket-book for 1763, but the painting is unlikely to have been revised after it was engraved in the former year. Appointments for 'Mr Fox' in 1764 (9, 10, and 12 October) cannot be connected with this picture, and may refer to his brother's sittings for the three-quarter-length portrait formerly at Holland House (repr. Ilchester 1901, I, facing p. 192). An appointment for Lady Sarah Bunbury (as she now was) on 28 June 1764 at six o'clock cannot be for a sitting; one on the following day at one o'clock may be. Twenty years later Reynolds painted a noble three-quarter-length of Charles James Fox (see Cat. 135).

Aileen Ribeiro points out that Fox wears 'a plain frock suit, and, to go with this informal attire, his own hair with a fringe, and falling to the shoulders. On more formal occasions, such as at the theatre, he would have his hair dressed in the French style, "*coiffé en aile de pigeon* and powdered" (Ilchester 1901, I, p. 131). Both ladies are dressed in the French style with its fondness for three-dimensional trimming and fluttering silk gauze. Lady Sarah wears a fashionable headdress called the Ranelagh mob, a kind of lace or gauze cap "clouted about the head, then crossed under the chin, and brought back to fasten behind, the two ends hanging down like a pair of pigeon's tails. This fashion is copied from the silk handkerchiefs which market women tie over their ears, roll about their throats, and then pin up the nape of their necks" (*London Chronicle*, 1762). Over her dress—the stomacher front is ruched—she wears a silk gauze shoulder mantle edged with blonde (silk) lace. Her interest in the details of dress is revealed in her letters; a few years after this portrait was painted she urges her friend Lady Susan to copy the "French dress", which includes "a little black handkerchief very narrow over the shoulders", which can be seen here, made of black lace. Lady Susan's dress is already totally in the French style; it is a sack dress, trimmed with ribbon flounces in serpentine rococo curves, the skirt being covered by a striped silk gauze apron. Her cap is wired to stand out in wings on top of the head, dipping in the middle where it is trimmed with a ribbon which matches that tying under the chin.' D.M.

PROVENANCE The 1st Lord Holland; by descent.

EXHIBITED British Institution 1820 (14); Manchester 1857 (55); Royal Academy 1871 (115), 1895 (127), 1956 (294), 1968 (111).

LITERATURE Leslie and Taylor 1865, I, pp. 195–6; Trevelyan 1880, pp. 53–4; Graves and Cronin 1899–1901, I, pp. 334–5; Ilchester 1937, pp. 82–3; Waterhouse 1941, p. 50; Cormack 1970, p. 122.

ENGRAVED J. Watson, 1762.

49 George Clive with his Family and an Indian Maidservant

140 × 171 cm
Gemäldegalerie, Staatliche Museen Preussischer Kulturbesitz, Berlin (West)

That this picture represents the family of George Clive of Whitfield (1720–79) and not, as previously thought, that of his famous cousin Robert Clive of Plassey, has been estab-

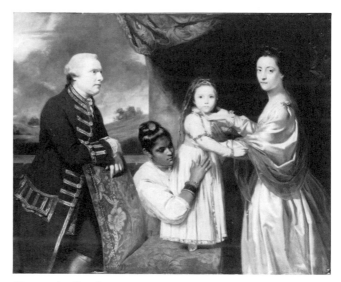

49 *reproduced in colour on p. 103*

lished by Professor Bock continuing the research of David Posnett of the Leger Gallery, who pointed out the resemblance between the father here and a portrait at Allensmore which is known to represent George Clive. This gentleman, son of the Rev. Benjamin Clive, vicar of Duffield, Derbyshire, entered Parliament in 1763 as Member for Bishop Castle having, like his cousin, made a fortune in India. In the same year he married Sidney Bolton (1740–1814) of Louth, Ireland, and built a house, Mount Clare, at Roehampton, Surrey. It is possible that he sat to Reynolds in 1763; the pocket-book for that year is missing but several appointments are noted for Mrs Clive: on 9 March 1764 (no time specified) and on 7 and 17 March (in both cases at six o'clock) 1766—not 1765, as claimed in earlier publications. The name Mr C. Clive is jotted down in a list opposite 31 March 1765.

Closer inspection suggests—and this is confirmed by X-rays—that the canvas consists of two pieces joined by a vertical seam to the right of Clive himself. If the picture was in fact begun in 1763 and the figure of Clive was painted first,

it may be that the original commission was for a pair of three-quarter-length portraits, husband and wife, rather like the earlier pair of Mr and Mrs Francis Beckford in the Tate Gallery. When their eldest daughter was born in 1764 the Clives decided to have a family group instead. Not surprisingly, the composition which has resulted is unusual for Reynolds, but it has been designed with great skill. On the right the distinct group of the mother, child and nurse, framed by the sumptuous hangings and the richly-patterned chair, corresponds with the private or domestic side of the Clive family's life. The little girl occupies the focal point of this group, both protected from and displayed to the spectator by the delicate hand gestures of her mother and her Indian nurse. To prevent the composition falling into two separate halves Reynolds has overlaid the two-part compositional grouping with a three-part colour scheme: brown on the left, red and white in the middle, and pale grey on the right.

A comparison with the almost exactly contemporary portrait group by Zoffany of John, 14th Lord Willoughby de Broke, and his family helps further to define the monumental and Baroque character of Reynolds's picture. Here again we see the father leaning on the back of the chair, and the motif of the standing child who looks out at the spectator. But in contrast to Zoffany's neat, tightly-ordered little genre scene with its proliferation of cosy domestic details, Reynolds fills his canvas with large figures whose spatial proximity is cancelled by their psychological distance from us, and by the stage-like artificiality of their setting.

Of particular interest is the colourful and exotic jewellery being worn by the child and her nurse. Evidently the artist, or more probably one of his assistants, has been instructed to render this accurately. It is Indian, like the child's light cotton dress (*anjarika* or *jama*) with its blue and silver decorated borders, and the silk veil (*chaddar*) over her head. The bracelet with its pendant (*bazuband*), worn according to Indian custom round her upper arm, displays an arrangement of nine stones (*nauratna*), representing the nine planets with special significance in Indian astrology. The nurse (or *ayah*) must, to judge from her physical appearance and from the type of jewellery, come from southern India, perhaps from the region around Madras. Her hairstyle and necklace, with its triple pendant (*tali*), tell us that she was married. The medallion in her hair is apparently of magical significance. Her bracelet is of ivory (*manjistha*) decorated with black and gold.

Aileen Ribeiro points out that although Clive himself is formally dressed in a brown suit heavily trimmed with gold braid, and with a powdered bag-wig, his wife's satin dress, with soft ballooning sleeves tightening to the wrist and jewelled clasp on the shoulder, is a studio garment. D.M.

PROVENANCE Thomson sale, Squibb's, London, 21 June 1817; John W. Brett's sale, Christie's, 23 June 1858 (123: withdrawn); Lord Francis Egerton, 1st Earl of Ellesmere; by descent; Christie's, 18 June 1976 (116), bt Leger Gallery by whom sold to Berlin.

EXHIBITED Cologne 1984 (1).

LITERATURE Waagen 1854, II, p. 53; Graves and Cronin 1899–1901, I, pp. 179–80; Waterhouse 1941, p. 52; Leger Gallery Catalogue 1977, no. 9; Bock 1977, pp. 163–73.

ENGRAVED S. W. Reynolds, 1835.

50 Philip Gell
236 × 145 cm
Private Collection

The type of outdoor hunting portrait, showing the subject whole-length and life-size, derives from such masterpieces as Van Dyck's *Charles I à la chasse* in the Louvre, and its immediate precursors in Jacobean courtly painting. The adaptation of this genre to the English country gentleman has usually been considered as the achievement of Reynolds's rival, Gainsborough, whose whole-length of William Poyntz, leaning against a tree with a gun in his hand and a dog at his feet (Althorp) was exhibited at the Society of Artists in 1762 (30). Gainsborough's picture may well have inspired Reynolds. As Professor Waterhouse puts it, Reynolds was sensitive to competition and was determined to beat every competitor at his own game. However, in this case it seems that Reynolds had already commenced his picture before Gainsborough's *Poyntz* was exhibited. The pose of Philip Gell is certainly very different from Gainsborough's *William Poyntz*, and has been taken fairly straightforwardly from Van Dyck's magnificent portrait of Algernon Percy, 10th Earl of Northumberland, which hung at Cassiobury Park, Hertfordshire, in the eighteenth century.

Aileen Ribeiro points out that although Gell is posed with gun and dog, he is not dressed for hunting but instead wears a semi-formal embroidered French frock suit, white stockings and buckled shoes. This seems consistent with his reputation as a smart young man about town. He was born in 1723 and died in 1795. His name appears in Reynolds's pocket-books on 17 and 18 December 1760, 9, 13 and 16 May, and 13, 17 and 22 June 1761 but not at all in 1762. The pocket-book for 1763 is missing, but that the picture was finished that year is confirmed by the following receipt: 'Receiv'd June 28, 1763, from —— Gell, Esq., the sum of eighty Guineas being the [word missing, almost certainly 'second' or 'final'] payment for his portrait, by me, J. Reynolds. £84' (quoted by Graves and Cronin, but now untraced). Reynolds's price for a whole-length at that date was a hundred guineas, but there is no record of the first instalment of, presumably, twenty guineas, which the artist would have required before starting work. The earliest surviving ledger was started in June 1760 and this payment was perhaps made before that date. Gell's name appears again in the pocket-book against 8 June 1768, which may have been a visit connected with sending the picture home, for on 2 August 1768 is a note of his address, 'Philip Gell Esqr at Hopton nr. ashbourn Derbyshire'.

A small whole-length study in oils on paper, which was sold at Christie's on 13 July 1984 (102) and now also belongs to Lt-Col. J. Chandos-Pole, is considered by Waterhouse to be one of the very few surviving *modelli* of the sort that Reynolds may, at least occasionally, have painted for the sitter's approval before starting work on the full-size canvas. Gell's younger brother John (1740–1805), who joined the Navy and commanded the *Monarca* in the East Indies in 1782, was also painted by Reynolds (in 1786; National Maritime Museum, GH.168) and rose to the rank of Admiral. The 'Miss

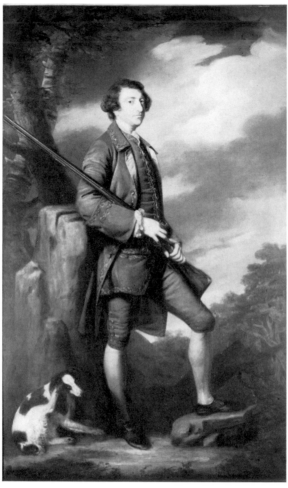

50

Gell' whose name appears in the pocket-book in 1769 has not been identified but may have been a professional model.

D.M.

PROVENANCE Inherited *c.* 1863 by Henry Chandos-Pole-Gell of Radburne Hall, Derby, from the Gells of Hopton Hall; by descent.

Not previously exhibited.

LITERATURE Graves and Cronin 1899–1901, I, p. 355; Waterhouse 1973, pp. 23, 39, 47.

No early engraving recorded.

51 Mrs Thomas Riddell

239 × 148.5 cm
Laing Art Gallery, Newcastle upon Tyne
(Tyne and Wear County Council Museums)

Elizabeth Margaret (1730–98), only daughter and heiress of Edward Horsley Widdrington of Felton Park, Northumberland, married Thomas Riddell of Swinburne Castle also in Northumberland, in 1760. She must have sat for this portrait in 1763, but the pocket-book for that year is missing. There

is, however, a note opposite 22 October 1766: 'Thomas Riddle/at Swinburn Castle/Northumberland' which may be connected with the payment of one hundred guineas by 'Mr Riddle' recorded in the artist's ledger on 18 November 1766. No portrait of Mrs Riddell's husband is recorded, so this almost certainly indicates payment by him for her portrait.

The informal composition, with the figure placed off-centre, walking with her basket of flowers as if unaware of the spectator in a natural landscape setting, is quite new in whole-length portraiture, normally committed to grander effects. The unassertive, almost shy expression on her face adds to the 'private' quality of the image, explained by the fact that the picture, unlike, for instance, *Lady Sarah Bunbury* (Cat. 57), was not intended for public exhibition at the Society of Artists. The unusually thin, transparent handling of paint, especially in the background, and the delicate colours invite comparison with Reynolds's rival in the early 1760s, Gainsborough, and looks forward in certain respects to Gainsborough's *Countess Howe* at Kenwood.

Aileen Ribeiro points out that the 'lingering influence of the rococo in dress can be seen in the embroidered gauze shoulder mantle, in the sleeve flounces, and in the ruched and puckered surface of the white satin gown which is

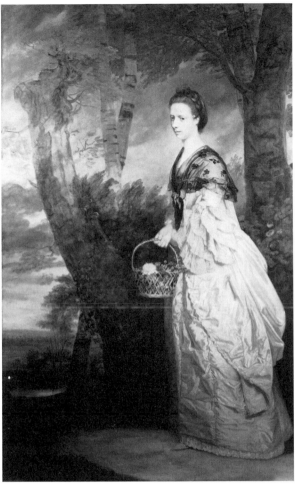

51

bunched up at the back in anticipation of the swagged, bustle effect of the fashionable polonaise styles of the 1770s.' D.M.

PROVENANCE By descent to R. C. Riddell, from whom purchased by the Laing Art Gallery 1966.

EXHIBITED Royal Academy 1880 (131); Birmingham 1961 (38); Royal Academy 1956 (299).

LITERATURE Graves and Cronin 1899–1901, II, p. 824; Waterhouse 1951, p. 262; Cormack 1970, p. 134; Waterhouse 1973, p. 23.

No early engraving recorded.

52 Mrs Richard Hoare and Child

76 × 63.5 cm
Museum of Fine Arts, Boston, Charles H. Bayley Picture and Painting Fund

Susanna Dingley (1743–95) married on 24 June 1762 Richard Hoare of Boreham House, Essex, a partner in Hoare's Bank. A portrait, long in the possession of this couple's descendants and now in the Wallace Collection in London, must have been commissioned to celebrate the fruit of this union. In it Mrs Hoare is represented whole-length, cradling her child,

as she sits on a weedy bank in a wood, wearing a soft gown (apparently of Indian muslin, Aileen Ribeiro observes) embroidered with sprigs of flowers in gold. The child has been identified as the couple's son, Henry, who was born on 7 April 1766 and died on 9 March 1768 but is, as John Ingamells has remarked, more probably Susanna, who was born first and also died in 1768. Appointments are not recorded in the artist's pocket-books, but that for 1763 is missing—and the end of 1763 is perhaps the most likely date for the portrait. A payment of seventy guineas is recorded in the artist's ledger on 12 September 1765.

The unfinished version of the portrait exhibited here is of uncertain status. A letter of 2 February 1933 in the Wallace Collection files recorded that in 1900 an old label on the painting described it as an original sketch by West. However, it surely is not by West, and the real problem is whether it is a first trial by Reynolds abandoned when he (or the sitter or her husband) determined on a larger format and a silvan setting, or whether it is a repetition by Reynolds. Such a repetition might have been intended to avoid problems posed by the projecting legs and seated posture in the larger picture, or indeed might have been intended by the artist as a record of a part of the completed painting he was happiest

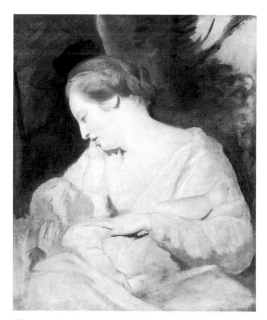

52 *reproduced in colour on p. 108*

with. The fluency and confidence of handling are found in autograph repetitions such as the Minneapolis *Child Baptist* (Cat. 101), whilst the absence of any calculations, hesitation or revision in composition would be surprising in a first trial. Nevertheless, there is the fact, noted by Ingamells, that Reynolds has included, or at least left space for, the shoulder of Mrs Hoare beyond the child's raised arm, whereas in the completed work it is now apparent that he changed his mind and painted this shoulder out.

The artist has drawn with the brush in mauve and then applied grey shadow which is nearly black under hand and chin. To the grey of the hair a single streak of blue has been added. The white scumbling is relatively heavy. The sinuous rhythm of the hand (prominently displaying the wedding ring in the finished painting) is very suggestive of Correggio, whose works provide a possible source for the technique of largely monochrome underpainting. N.P.

PROVENANCE Earls of Ellesmere by 1900; on loan to City Art Gallery, Manchester 1961–76; Ellesmere Settlement sale, Sotheby's, 18 June 1976 (118); Sotheby/Parke Bernet, 21 January 1982 (28), bt for Boston.

Never formerly included in a special exhibition.

LITERATURE Cormack 1970, p. 123; Ingamells 1985, pp. 141–2.

Never engraved.

53 Master Thomas Lister

231 × 147.5 cm
Bradford City Art Galleries and Museum; Gift of
H.M. Treasury, 1976

Waterhouse has suggested that the first idea for the unusual pose of this portrait of a boy may have come from a drawing by Reynolds, probably after Salvator Rosa, in the Herschel Album (Cat. 160). We may note that the cross-legged stance occurs in several well-known antique statues, and had been popular with painters and sculptors working in Britain for more than thirty years. What is striking here, in comparison with earlier examples, is that by shifting the boy's weight still further and raising his right arm above his head, the diagonal is emphasized and the artist has created what seems an entirely novel composition. It is a composition which does, nevertheless, invite comparison with certain classical statues. The whole sequence of angles from the knees up to the shoulders, the angle of the raised arm and the placing of the left elbow, seem remarkably close to the *Apollo Sauroctonos* or 'Lizard Slayer'. This statue was described by Pliny and exists in the form of several copies, and although it did not become famous until slightly later (Haskell and Penny 1981, p. 152) it would not be the first time Reynolds made use of unfamiliar, even obscure, prototypes. *Miss Kitty Fisher in the character of Cleopatra* (Cat. 34) and *Captain Robert Orme* (Cat. 26) are just two examples from the present exhibition. In fact, the marble copy of the *Apollo Sauroctonos* which is now in the Louvre was in Rome, in the Villa Borghese, when Reynolds was there in 1750–2. By an odd coincidence the subject of the statue was not fully recognized until it was discussed by Winckelmann in the same year, 1764, that Reynolds painted Thomas Lister. The suitability of the *Apollo Sauroctonos* lies in the fact that it represents the god as a youthful, rather languorous figure. Just as the adult *Apollo Belvedere* provided Reynolds with the pose of the

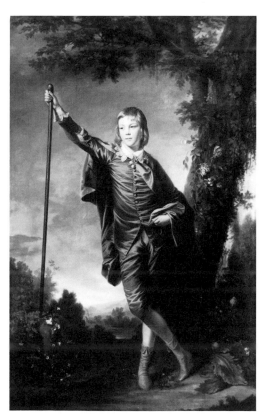

53 *reproduced in colour on p. 105*

heroic *Keppel* (Cat. 19), so the classical type of youthful god has inspired this very striking portrait of a twelve-year-old.

Aileen Ribeiro notes that 'there are a number of references in the 1760s and 1770s to boys and young men adopting vandyke dress as a kind of informal costume; the long, naturally arranged hair worn by boys in the period was not dissimilar to the hairstyles worn by Van Dyck's male sitters in the 1620s and 1630s. It was also an artistic convention for sitters to be painted in this costume, and it is impossible to be sure if this is a real suit or a studio prop. Certainly the most usual type of vandyke costume depicted by Reynolds was a plain doublet with a single slash or opening in the sleeve, matching breeches and a short cloak which fastens under the lace-edged collar. Master Lister's suit is of brown satin; his brown ankle boots or theatrical buskins (rather like those worn by Van Dyck's *Sir John Suckling* in the Frick Collection) are part of the deliberately pastoral mood contrived by Reynolds in imitation of the early seventeenth century.' As Nicholas Penny has pointed out, the painting of the clothes and of the landscape is very similar to what is found in the portraiture of Francis Cotes at this date and should perhaps be attributed to Peter Toms, who worked occasionally for Reynolds until about 1762, but apparently almost exclusively for Cotes from about 1763/4 until 1770 (Johnson 1976, pp. 16–17). I have come to question whether the portrait is by Reynolds at all. Comparisons made possible by this exhibition should settle the matter.

Thomas Lister was born at Gisburne on 22 March 1752, the eldest son of Thomas Lister, a Member of Parliament, and Beatrix Hulton. He was elevated to the peerage on 26 October 1797 as Baron Ribblesdale of Gisburne Park, Yorkshire, where the family had lived for five hundred years. In 1789 he married Rebecca Fielding. He died on 22 September 1826. Appointments for 'Master Lister' are found in the artist's pocket-book for 1764 on 7, 12 and 23 April (with a cancellation on 26 April) and 1 May. A single payment only is recorded in the ledgers—it was for thirty guineas and was made on the date of the first appointment. A Miss Lister was sitting in 1765 and on 2 September of that year Reynolds noted Mrs Lister's address in Blake Street, York. That Reynolds painted Master Lister is not in question but thirty guineas and four sittings suggest a half-length, perhaps a companion to the half-length portrait of Miss Lister (engraved by S. W. Reynolds), rather than an ambitious full-length like this. D.M.

PROVENANCE By family descent until sold by Agnew 1889 to Samuel Cunliffe-Lister, later 1st Lord Masham; by descent to the Earl and Countess of Swinton; presented to Bradford Art Gallery by H.M. Treasury, June 1976.

EXHIBITED Grosvenor Gallery 1883 (20); Royal Academy 1968 (71).

LITERATURE Graves and Cronin 1899–1901, II, p. 588; Waterhouse 1941, p. 54; Cormack 1970, p. 127; Waterhouse 1973, p. 46.

No early engraving recorded.

54 Anne Dashwood

132 × 117.5 cm
Signed
The Metropolitan Museum of Art, New York;
Gift of Lillian S. Timken, 1950

It had long been a convention in English portraits for ladies, especially young ones about to be married (or available for marriage), to be painted as shepherdesses. What distinguishes this from similar portraits by Hudson (fig. 14) and others is the solemn mood created by the pensive expression and by the colours, especially of the sky which although blue in the lower part of the painting is dark grey behind the head. Since

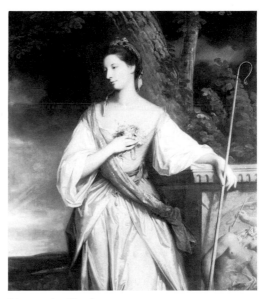

54 *reproduced in colour on p. 104*

cleaning, the effect of the brighter colours—the ribbon picking up the blue sky, the pinks and the honeysuckle which she presses to her breast and the rubies on her dress—has been restored and various revisions to the length of the crook, to the form of the belt, and to the contour of the dress to the left may be discerned. That the portrait was originally larger is suggested by the cutting of the pedestal (where the artist has signed the painting). The relief here depicts a sleeping nymph touched with an arrow held by a winged figure (presumably Psyche awakened by Cupid). A fragment purporting to represent two lambs cut from the landscape in this painting was offered for sale at Christie's on 13 June 1859 (161). It has been assumed that the painting was full-length but it might have been only a little longer and broader.

Anne, second daughter of Sir James Dashwood, Bt, Member of Parliament for Oxford, and sister of the Duchess of Manchester (Cat. 72), was reported as engaged to be married to John Stewart, styled Lord Garlies, Member of Parliament for Morpeth, on 12 April 1764 (Walpole, 1937–83, XXXVIII, p. 369). She seems to have sat only three times to Reynolds on 21 May, 2 and 7 June. The wedding was on 13 June. No payment is recorded for the painting in the artist's ledgers.

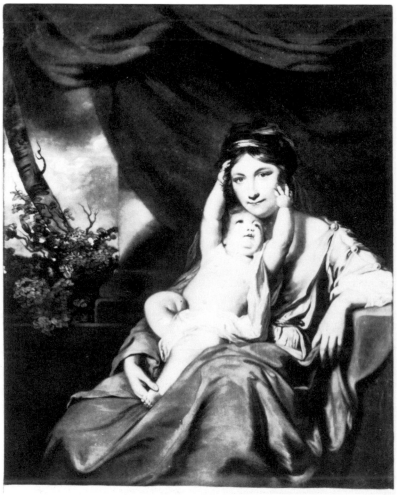

55

Her husband, who succeeded as 7th Earl of Galloway in 1773, died in 1806. She died in 1830. A recent article by Gourlay and Grant proposes ingeniously but unconvincingly that Miss Dashwood is standing by the tomb of Lord Garlies's first wife.

Aileen Ribeiro notes that Reynolds has combined 'the notion of classical drapery' in this portrait with the 'idea of Arcadian dress deriving from sixteenth-century Italian peasant dress with its sleeveless bodice and huge white chemise sleeves', but has also included some contemporary fashions—'the slightly rising hairstyle entwined with pearls and ribbons' and the gauze scarf 'knotted, military-fashion, on the hip'. N.P.

PROVENANCE W. W. Burdon of Newcastle before 28 June 1862 when sold at Christie's (31) to Cox; sold by Gillot 27 April 1872 (292) to Colnaghi; by 1904, Mrs Charles Stewart; by 1911, Captain Courtenay Stewart; by 1941, W. R. Timken; given by Lillian Timken to the Metropolitan Museum in 1950.

Not publicly exhibited before 1900.

LITERATURE Graves and Cronin 1899–1901, I, p. 343; Waterhouse 1941, p. 53; Gourlay and Grant 1982, pp. 169–89.

No early engraving recorded.

JAMES WATSON (after Reynolds)

55 Mrs Edward Lascelles and Child

50.1 × 35.1 cm
The Trustees of the British Museum

55a Giovanni Battista Franco, *Virgin and Child in a Landscape*

Anne, eldest daughter of William Chaloner of Guisborough in Yorkshire, sister of Mrs Hale (see Cat. 61, 62), married on 12 May 1761 Edward Lascelles (created Baron Harewood in 1796 and Earl of Harewood in 1812) who was the younger cousin and the heir of Edwin Lascelles, the builder of Harewood House. A daughter, Frances, was born in June 1762 and, perhaps to celebrate this event, Mrs Lascelles sat for her portrait. Appointments are recorded on 17, 21 and 23 December 1762. Her husband also had appointments on 21 and 23 December: his portrait (fig. 86, p. 347) was clearly designed as a companion to hers. (Both paintings are now in the gallery at Harewood House.) The artist's pocket-book for 1763 has not been traced. On 10 January 1764 Mrs Lascelles gave birth to a boy. On 20 February, 9, 11 and 12 April and 9, 14 and 22 May appointments are recorded for

her and on 17 and 19 May there seem to have been appointments for 'Miss Lascelles' although the 'Miss' is not clear. A 'Mr. Lascelles' appears in the pocket-book in the same period. On one occasion a 'Mr. Lascelles Senior' is recorded—i.e. Edwin Lascelles. A first payment of sixty-two guineas is noted after 7 April 1764 for the pair of portraits and a second half payment for the same amount is recorded with no date in Reynolds's second surviving ledger which was begun 12 May 1772 (Cormack 1970, pp. 127, 157).

It is curious that this portrait, but not that of Edward Lascelles, was engraved. The print is undated but likely to date from shortly before the last payment and was perhaps issued with that of Mrs Hale, also by James Watson (for whom see Cat. 62). N.P.

LITERATURE Chaloner Smith 1878–83, no. 87 (i); Goodwin 1904, no. 31.

The mezzotint of Mrs Lascelles is here displayed beside an etching (reinforced with engraving) by the Venetian sixteenth-century artist Giovanni Battista Franco (Cat. 55a, fig. 94; lent by the Visitors of the Ashmolean Museum, Oxford). As discussed (p. 347) in John Newman's essay 'The Conjuror Unmasked', Nathaniel Hone detected this as the source for the motif of the child throwing his arms round Mrs Lascelles's neck in Reynolds's portrait. Nicholas Penny

points out that lot 387 in Reynolds's studio sale (Phillips, 8 March 1798) consisted of eleven 'historical' prints by 'B. Franco'. J.N.

JAMES FINLAYSON (after Reynolds)

56 David Stewart, Lord Cardross

38.2 × 28 cm
Rob Dixon

56a James Watson, after Van Dyck, *Paulus Pontius*

Appointments for Lord Cardross are recorded in Reynolds's pocket-book on 7, 10, 13 and 17 December 1764. Evidently Reynolds misread his own writing because a payment of seventeen guineas was entered against the name 'Lardross' in his ledger some time between 8 December 1764 and 16 May 1767. The sum of fifty guineas (with £30.10s cancelled) was entered against Lord Buchan on 23 August 1768 (Cormack 1970, pp. 112, 126). Lord Cardross succeeded as Earl of Buchan on 1 December 1767.

This is the first recorded state of this mezzotint after Reynolds's portrait and was published on 22 November

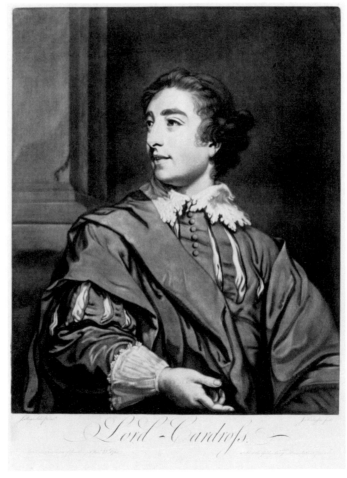

Lord Cardross.

56

1765. In later impressions the date is retained but the sitter's title is changed. The painting (now in the National Gallery of South Africa) was exceptionally expressive. No previous English portraitist in the eighteenth century, with the exception of Knapton, had given sitters radiant eyes, parted lips and a perplexed frown like this—or such an air of participating in a lively conversation. If we were not informed that the sitter was a lord we might suppose him an actor in character. The vandyke costume also suggests performance.

LITERATURE Chaloner Smith 1878–83, 3 (i).

The pose is very closely based on Van Dyck's portrait of Paulus Pontius of which a mezzotint by James Watson was published at about the same date—an impression is displayed here (Cat. 56a, fig. 88; lent by the Syndics of the Fitzwilliam Museum, Cambridge). Nathaniel Hone included this portrait pointedly among the fluttering prints in *The Conjuror*, his satirical attack on Reynolds, as is suggested in John Newman's essay (p. 346). N.P.

57 Lady Sarah Bunbury Sacrificing to the Graces

242 × 151.5 cm
The Art Institute of Chicago,
Mr and Mrs W. W. Kimball Collection

In a letter to Dr Sleigh which, though undated, must have been written in 1765, James Barry wrote that Lady Sarah Bunbury sacrificing to the Graces was one of the pictures in that year's exhibition which had most impressed him. It was, he thought, one 'of Mr Reynolds's best works' (Barry 1809, I, p. 22), and a favourable opinion was also recorded by a French visitor, P. J. Grosley (Whitley 1928, I, p. 209). The subject may, however, be both wittier and more subtle than the title, as given in the Society of Artists catalogue, indicates. Dr Frederick Cummings has advanced the theory that it concerns the friendship between Lady Sarah Bunbury and Lady Susan Fox Strangways (for biographical details see Cat. 48), who may be identified with the second figure. Lady Sarah, wearing a robe entirely invented by Reynolds, belted with a fringed sash under the bust, casts her offering on the flames before an image of the three Graces, a symbolic representation of *Amicitia* or perfect friendship, as expounded in traditional emblem books like Ripa's *Iconologia* which we know Reynolds, like most eighteenth-century artists, used. Roses climbing the pedestal allude to the pleasantness and charm that should exist between friends, while the nudity of the Graces signifies that friendship conceals nothing and is without deceit. The ever-green myrtle held out by one of the Graces signifies that friendship continually propagates itself (see Cat. 58 for another opinion). It would be a mistake, however, to take it all too seriously: the mock-heroic is an aspect of Reynolds's work which has not been given sufficient weight by critics (see, however, Moore 1967, pp. 350–1). Lady Sarah, according to Mrs Thrale, 'never *did* sacrifice to the Graces; her face was gloriously handsome, but she

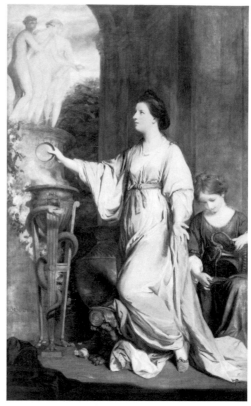

57 *reproduced in colour on p. 111*

used to play cricket and eat beefsteaks on the Steyne at Brighton'.

Art historians have been inclined to place this picture into the forefront of early neo-classicism, and connect it with the recent discoveries at Herculaneum, but both stylistically and iconographically it belongs firmly enough to the mainstream of European classicism revived in Italy during the Renaissance period. The persistence of that older tradition, in some ways modified but still a controlling force throughout the eighteenth century, even at the height of the rococo period, is attested by the popularity of sacrificial themes of this type. In France, Carle Van Loo painted *Le Sacrifice à l'Amour* for Julienne in 1760 and contributed *L'Offrande à l'Amour* to the 1761 Salon (6). Joseph Vien took up the theme with his *Sacrifice sur l'autel de l'Amour*, exhibited in 1763. Reynolds's *Lady Sarah Bunbury* may itself have exerted some influence both in painting and in sculpture. Angelica Kauffmann's *Sacrifice to Vortigern* of 1774 at Stourhead may reflect this composition; a picture of a Vestal Virgin in the Thyssen-Bornemisza Collection, by an unidentified artist close to Kauffmann, certainly does. And John Flaxman's monument to Mrs Sarah Morley, *c.* 1784, in Gloucester Cathedral, may also reflect this image which we know was widely admired.

The traditional character of Reynolds's picture is underlined by unmistakable echoes of seventeenth-century Italian painting. Lady Sarah's head has been idealized in a way reminiscent of Guido Reni—compare, for example, *Cleopatra* at Hampton Court—while the architectural back-

ground has, in contrast to the later portrait of Mrs Beckford (Cat. 132), some features in common with Pietro da Cortona's fresco of St Bibiena refusing to sacrifice to pagan idols, which Reynolds would have seen in Rome. The tripod with its serpent is illustrated and described in Montfaucon's encyclopaedic textbook of Greek and Roman imagery.

Lady Sarah probably sat for this picture in 1763 but the pocket-book for that year has not survived. Appointments are recorded in 1764 on 28 and 29 June, but the first was at six o'clock, so was presumably an evening social engagement, and the second, for one o'clock, was cancelled. Her name occurs again on 17 and 22 January 1765, which might indicate finishing touches in preparation for the forthcoming exhibition at which the picture was shown. Nor is it easier to identify precisely payments in the artist's ledgers, from which we can see that Sir Charles Bunbury was buying family portraits and at least one fancy painting from Reynolds between 18 November 1766 and 12 April 1773. On 2 February 1769 Lady Sarah's name is entered together with the sum of 250 guineas—much more than was normal for a whole-length portrait at that date. (The cancelled payment of fifty guineas opposite this entry in Cormack's transcription relates to the entry before.) On 22 November 1770 Reynolds noted a payment of two hundred guineas from Sir Charles and further down the same page apparently at some date between 3 June 1771 and 9 May 1772 he noted 'Sir Charles Bunbury for Lady Sarah', but with no payment entered. Sometime after 11 December 1772 and before 12 April 1773 a payment of £197.10s is recorded from him with the note that this leaves two items unpaid (the portraits of Sir William and Mr Bunbury)—the same information was given in a recapitulation of the account with Bunbury made in the new ledger which Reynolds first opened in May 1772. In this entry 250 guineas is again given as the price 'for Lady Sarah'. There follows the note that it has been paid.

Sir Charles's fortunes fluctuated dramatically with the performances of his racehorses—his relationship with Lady Sarah also changed. On 19 February 1769 she eloped with Lord William Gordon, not long after she had given birth to his daughter. Sir Charles forgave her and after she had parted from her lover wished to take her back, which explains why he kept the portrait, but they remained separated and the divorce proceedings begun in March 1769 were passed by the House of Lords in 1776. Ironically, Lady Sarah's wedding ring is very prominent.

Reynolds must have known the couple quite well since he stayed with them between 7 and 10 April 1768.

Nicholas Penny points out that careful examination of the paint surface reveals that Lady Sarah's robes (which Leslie and Taylor supposed to have faded in colour) were extended by the artist to conceal some anatomical problem with her companion's feet, and also that the admiring critic 'I.N.' writing in 1765 regretted the 'over-sized rotule' of Lady Sarah's left knee. D.M.

PROVENANCE By descent to Sir Henry Charles John Bunbury of Barton Hall and Mildenhall, Suffolk; C. J. Wertheimer, who sold it at Christie's, 10 May 1912 (63), bt Sulley; Henry Reinhardt Gallery, New York, until 19 October 1915, bt by Mrs W. W. Kimball, who gave it to the Art Institute of Chicago in 1922.

EXHIBITED Society of Artists 1765 (104: 'A lady sacrificing to the graces, whole length'); Detroit and Philadelphia 1968 (6).

LITERATURE Leslie and Taylor 1865, I, pp. 247–8; Graves and Cronin 1899–1901, I, pp. 124–5; Wind 1931, pp. 217–18; Waterhouse 1941, pp. 12, 56; Burke 1959, pp. 10–11; Irwin 1966, pp. 77, 88, 152, 155; Cormack 1970, pp. 112–13, 145.

ENGRAVED Fisher, 1766; S. W. Reynolds (S. Cousins).

EDWARD FISHER (after Reynolds)

58 Lady Sarah Bunbury Sacrificing to the Graces

59.6 × 36.7 cm
The Syndics of the Fitzwilliam Museum, Cambridge

The second state of this mezzotint gives the publication date as 8 November 1766 but impressions such as this were available a day or two earlier for the sitter wrote to her close

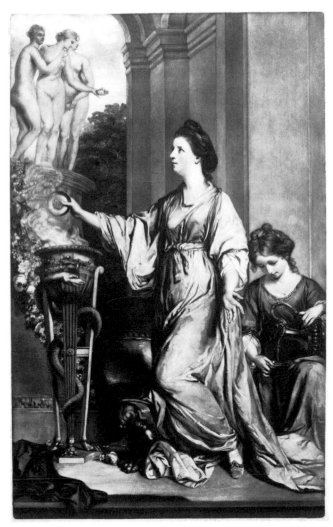

58

friend Lady Susan O'Brien, then in America, on 6 November 1766: 'I shall send you over my print colour'd; it's the first I could get done, I hope you will like it.' (Rob Dixon points out that such a coloured print was perhaps overpainted in oil.) In a subsequent letter she mentions that she is also sending an uncoloured one for Mr O'Brien (Ilchester 1901, I, pp. 202, 207, 212). For the painting see Cat. 57; for the engraver see Cat. 20.

It may be that this print and that of Lady Elizabeth Keppel (Cat. 44) were published together. The themes are related and both ladies were royal bridesmaids. It should be pointed out that it would be odd for Lady Sarah to write to her friend as she did if the portrait was, as some modern authors have supposed, a double portrait of the two of them. In any case this would not have been likely. Lady Susan was in America by the end of 1764 and Lady Sarah would not have permitted her dear friend to be cast as a mere acolyte. Also, the acolyte does not resemble her closely. The Graces in any case do not necessarily allude to friendship. N.P.

LITERATURE Chaloner Smith 1878–83, no. 6 (1); Russell 1926, no. 6.

JAMES WATSON (after Reynolds)

59 The Duchess of Marlborough and her daughter, Lady Caroline Spencer

45.1 × 32.2 cm
The Trustees of the British Museum

59a Adamo Scultori, after Michelangelo, *Eleazar*

Caroline Russell (1743–1811), the only daughter of John, 4th Duke of Bedford, married George, the 4th Duke of Marlborough, on 23 August 1762: a daughter, Lady Caroline Spencer, was born on 27 October, 1763, and a portrait (now at Blenheim Palace) was commissioned to celebrate this event. This was perhaps discussed by the Duke when he sat for his portrait in March 1764, and may have been started when Reynolds was a guest at Blenheim Palace between 1 and 20 July that year. The Duchess cancelled appointments on 5 and 10 December, but seems to have kept one on 14

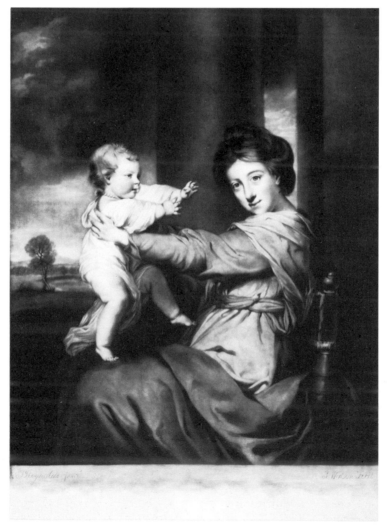

59

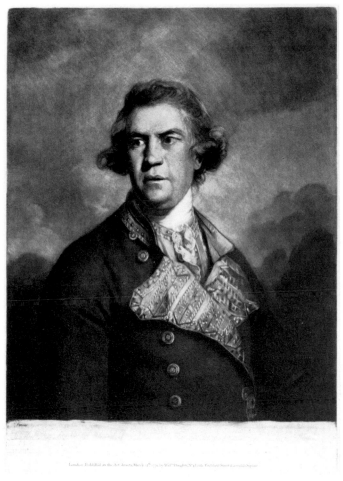

60

December, in 1764. She also cancelled appointments on 18 March and 3 May, but seems to have kept them on 19 and 23 March and 4 May 1765. The second state of this mezzotint (which identifies the sitters) gives the publication date as 20 May 1768. The painting would therefore have been ready for dispatch to Blenheim Palace by that date which explains why payment for it appears to have been made in that month. The publishers were James Watson, the engraver (for whom see Cat. 62) and Boydell in partnership. The beauty of the painting or the celebrity of the sitter made this a highly popular print. A copy signed H. Fowler (a pseudonym of Purcell) also appeared in 1768 and one by Houston appeared in the following year. For another portrait of the Duchess and her daughter see Cat. 108. N.P.

LITERATURE Chaloner Smith 1878–83, no. 99 (1); Goodwin 1904, no. 56 (1).

The mezzotint is here displayed beside an engraving by Adamo Scultori (Cat. 59a, fig. 91), no. 46 in the series of Ancestors of Christ after the frescoes by Michelangelo in the Sistine Chapel. As discussed in the essay 'The Conjuror Unmasked' (p. 347), Nathaniel Hone detected that this was the source of the Duchess's playful pose. J.N.

WILLIAM DOUGHTY (after Reynolds)

60 The Hon. Augustus Keppel, Admiral of the Blue

45.4 × 32.5 cm
The Trustees of the British Museum

Keppel, long before he was promoted Admiral, had been Reynolds's friend and patron (see Cat. 19). Accused by his envious second-in-command of a reluctance to engage the French fleet at the indecisive Battle of Ushant in 1778, he was tried by court martial. This was popularly interpreted as a Government move to discredit the patriotism of the Whig opposition to which Keppel was attached, for the Admiral's courage and experience were well-known. His acquittal on 12 February 1779 caused much jubilation. Reynolds immediately wrote saying that he had 'taken the liberty, without waiting for leave, to lend your picture to an engraver, to make a large print from it' (Reynolds 1929, p. 68). The engraver was his pupil, Doughty (see Cat. 80). Antony Griffiths has pointed out that the print, which would have been made as quickly as possible, was published on 12 March 1779, which suggests that a month was 'the minimum

time necessary to scrape a plate of this size' (British Museum 1978, p. 149). Possibly a more experienced engraver could have worked even faster. Such points of course depend upon the inference that Reynolds took the liberty when he wrote the letter. However, the scratched inscription on the early state describes Keppel as 'Commander in Chief of a Squadron of Her Majesty's Ships, employed and to be employed in the Channel soundings &c in the year 1778', which suggests that it was commenced in that year. In any case this print certainly is, as Griffiths observes, the 'only documented case of Reynolds selecting the engraver'. It was published by Watson and Dickinson (for whom see Cat. 94). The portrait from which Reynolds let Doughty work was one for which the Admiral seems to have sat in 1764 and 1765 (appointments are recorded on 13 August 1764, and 13 and 27 May, 25 June and 20 August 1765). Versions of the painting are in the National Maritime Museum, London, and in the Burton Collection. Reynolds presumably had one version in his studio. Keppel soon afterwards commissioned Reynolds to paint a new portrait in six versions for presentation to his principle political protectors and allies (Leslie and Taylor 1865, II, p. 230).

For caricatures of Keppel see Cat. 187, 188 and 191.

<div align="right">N.P.</div>

LITERATURE Chaloner Smith 1875–83, no. 3 (2).

61 Mrs Hale as 'Euphrosyne'

236 × 146 cm
The Earl of Harewood

Mary Chaloner (1743–1803) was sister-in-law of Edward Lascelles, later 1st Earl of Harewood. This spectacular portrait was commissioned and paid for by his older cousin, Edwin Lascelles, Member of Parliament successively for Scarborough, Northallerton and York. Edwin was created Baron of Harewood in 1790 but died without leaving an heir, whereupon the barony became extinct and he was succeeded in his estates by his cousin. It was for Edwin that the great Palladian mansion of Harewood was built, and for whom Robert Adam created some of his finest interiors. Into one such interior, the Music Room (fig. 68), enriched with decorative paintings by Biagio Rebecca and Antonio Zucchi, Reynolds's appropriately light-hearted image fits perfectly. Euphrosyne ('Good Cheer') was one of the Three Graces, companions of Venus who were represented clothed as well as nude in ancient art, as Reynolds would have learnt from such standard authorities as Montfaucon. But it is clear from the title, 'L'Allegro', at the foot of Watson's mezzotint, that the painter had in mind Milton's famous poem of that name which features the 'Goddess fair and free' and 'the frolic wind' which here tugs at her fashionable chignon causing her hair to stream out: 'Haste thee, Nymph, and bring with thee/Jest and youthful Jollity'. It has been suggested (see Munby 1947 and Cat. 62 here) that the pose of Mrs Hale may have been taken from a print after Raphael's *St Margaret*

in the Louvre, but an equally likely source would seem to be Kneller's well-known and admired portrait of the Countess of Ranelagh, one of the 'Hampton Court Beauties'.

Mary Chaloner married, on 11 June 1763, Colonel (afterwards General) John Hale of the Light Horse, later Governor of Londonderry, by whom she had twenty-one children. Appointments are recorded for Miss Chaloner in Reynolds's

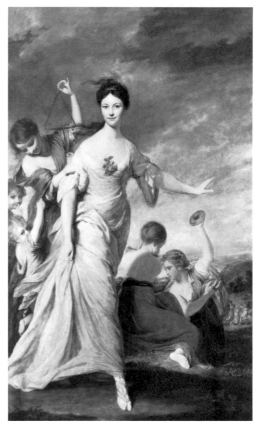

61 *reproduced in colour on p. 110*

pocket-book for 1762 on 6, 13 and 17 July (apparently from twelve o'clock to four o'clock on the latter date), 2, 6, 9 and 15 November, and 18 December. The pocket-book for 1763 is lost. There are appointments in 1764 on 25 January, 24 February and 1 August for 'Mrs Hales'. A Colonel Hale, probably but not certainly her husband, had an appointment with Reynolds on 10 August 1764. It is worth noting that Reynolds recorded what seem to be numerous dinner and supper engagements with 'Mrs Hale' in subsequent years (1777, 1780, 1782 and 1786).

It is by no means certain that the 1762 entries are connected with *Mrs Hale as 'Euphrosyne'*. Reynolds's price for a whole-length portrait at that date was a hundred guineas, and the payments—which undoubtedly refer to this picture—are for a higher sum. Nicholas Penny considers that the extra figures in the picture and its special poetic character provide an adequate explanation of this, but it is striking that 150 guineas became the standard charge for a full-length in 1764, and 150 guineas is what Edwin Lascelles paid for this (in two

Fig. 68 Robert Adam, The Music Room, Harewood House, Yorkshire

instalments, one between 30 May 1770 and 22 May 1773 and the other on 1 May 1781). Perhaps, then, *Mrs Hale as 'Euphrosyne'* was begun in 1764, and it may be that the 1762 sittings indicate no more than that an earlier portrait was started, perhaps subsequently to be abandoned.

A payment of twelve guineas made before 8 December 1764 seems likely to have been for a whole-length frame. It is worth bearing in mind the replanning of the interiors at Harewood with which Edwin Lascelles was busy during this period. We know that Robert Adam, whose actual designs for the interiors are dated 1765–71, was being consulted earlier, possibly in connection with the Music Room. Perhaps Lascelles, having arranged for a portrait of Miss Chaloner in 1762, subsequently changed his mind either about the type of picture he wanted, or its size, and ordered a new design, which would better fit with his new schemes of interior decoration. The result was *Mrs Hale as 'Euphrosyne'*, which may therefore be redated 1764–6.

When exhibited in 1766 a critical pamphlet by 'I.N.' praised the attitude as 'spirited and striking' but found the lady's foot too small. Nicholas Penny remarks that to achieve a sense of continuous movement Reynolds has cropped a figure, a practice which he specially notes in his commentary on Du Fresnoy should be avoided 'unless circumstances are very particular' (Reynolds 1798, II, pp. 234–5); also, the distant revellers derive from Poussin. D.M.

PROVENANCE Painted for Edwin Lascelles; by descent.

EXHIBITED Society of Artists 1766 (136: 'A Lady; whole length'); British Institution 1813 (56), 1850 (54); Royal Academy 1886 (147).

LITERATURE Leslie and Taylor 1865, I, p. 261; Graves and Cronin 1899–1901, II, p. 414; Borenius 1936, no. 413; Waterhouse 1941, p. 52; Munby 1947, p. 84; Cormack 1970, pp. 127, 157–8.

ENGRAVED James Watson; R. Purcell; Lambertine; S. W. Reynolds.

JAMES WATSON (after Reynolds)

62 Mrs Hale as 'Euphrosyne'

62 × 38 cm
The Syndics of the Fitzwilliam Museum, Cambridge

62a Louis Surugue, after Raphael, *Saint Margaret*

This mezzotint reproduces the painting (Cat. 61) exhibited at the Society of Artists in 1766. James Watson (*c.* 1740–*c.* 1780) was, after the death in 1765 of his compatriot McArdell (who was probably his master) and before his

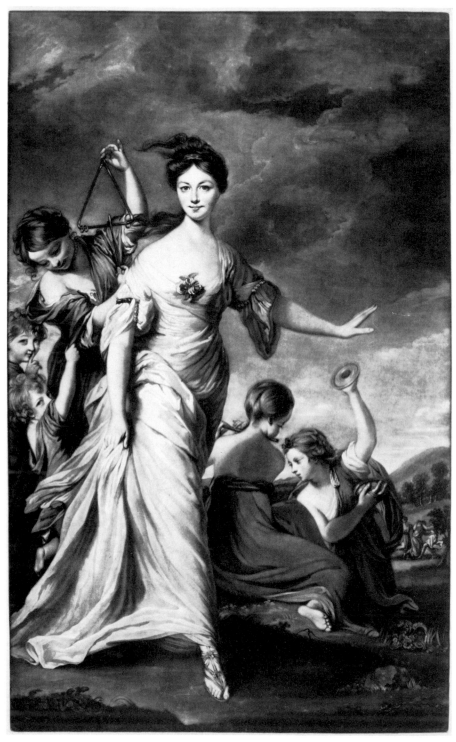

62

retirement in 1778, the engraver most closely associated with Reynolds, and as many as sixty of his plates are after Reynolds's paintings. This particular engraving must have been made by 1768 because a batch of 'prints of Mrs Hale' to the value of five guineas was ordered for the sitter's sister, Mrs Lascelles (Cat. 55), in that year (Cormack 1970, p. 128).

Another batch, of the same size, was ordered at a later date by Mr Lascelles, the cousin (Reynolds evidently supposed him the brother) of Edwin Lascelles who had commissioned the painting (ibid. p. 157)—this may perhaps be related to the entry in the artist's pocket-book on 17 January 1772—'Mrs Hale's print'. These entries show how Reynolds acted

as a supplier of prints to the sitter's family. In some cases he perhaps personally superintended the distribution of 'private plates'. Ryland and Boyer, the publishers whose names appear on this impression (with an address they employed before 1770), had been declared bankrupt in 1771. I owe this point to Rob Dixon, who has also demonstrated that this print is in fact a complete reworking of Chaloner Smith no. 70 and not a separate print, as had been assumed.

<div style="text-align: right">N.P.</div>

LITERATURE Chaloner Smith 1878–83, no. 69; Goodwin 1904, no. 43.

The print of Mrs Hale is here displayed beside Louis Surugue's engraving of Raphael's *Saint Margaret* in the French Royal Collection (Cat. 62a, fig. 96; lent by the Courtauld Institute of Art). As discussed in the essay 'The Conjuror Unmasked' (p. 348), Hone seems to have suggested this as the source for the pose of Mrs Hale. There were earlier prints of the Raphael but this was the most recent. J.N.

63 George Selwyn

99 × 76 cm
The Earl of Rosebery at Dalmeny House, nr Edinburgh

George Augustus Selwyn (1719–91), the younger son of parents with high Court positions under George II, spent an extravagant youth in Oxford (whence he was expelled for gross blasphemy) and Paris (to which he frequently returned), and then settled down to a convivial bachelor life, dozing in the House of Commons and active at the card tables of the clubs of St James's. He was noted for his languid manner; his sharp wit; his indifference to female society; his very close attachment—described as a 'sentimental sodomy'—with Lord March (for whom see Cat. 43) and the Earl of Carlisle; his great devotion to children (and especially to 'Mie-Mie', an illegitimate child of Lord March); and his passion for attending executions, exaggerated accounts of which inspired Edmond de Goncourt to create the character of George Selwyn in *La Faustin* (Roscoe and Clerque 1899; Kerr 1909; Bickley 1928, I, p. 4; Fothergill 1983, pp. 82–105).

Selwyn moved in some of the same social circles as Reynolds and was painted by him five times, but he was not an unqualified admirer of Reynolds, whose colouring he considered inferior to Lely's (Roscoe and Clerque 1899, p. 97). From the late 1750s date the conversation piece of Selwyn and two friends painted for Horace Walpole (Cat. 41) and another portrait (for which a payment was made in 1761), and between 1769 and 1770 he was painted with Lord Carlisle (Castle Howard); there is also a later portrait perhaps of 1783 (see Sotheby's, 9 November 1955, lot 113). The portrait catalogued here belongs to the mid-1760s and may be connected with the £50 received by Reynolds, between August 1764 and June 1765 from 'Lord Holland for Mr Selwin'. Selwyn was a political ally of Lord Holland and a friend of the Holland family, keeping an

avuncular eye on their eldest son 'Ste' in Paris. There is an appointment in the artist's pocket-book for 17 March 1764, but in April Selwyn left England for France and did not

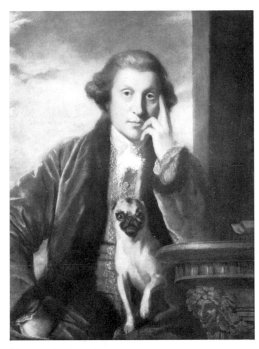

63 *reproduced in colour on p. 107*

return for a year. In 1766 there are appointments for 22 and 25 February, 20, 26 and 29 March, 8, 12, 17, 22 and 25 April and 3 May. There are several appointments for dogs in April, May and June of this year, some or all of which might be for Râton, Selwyn's beloved pug, who makes so memorable an appearance here and cleverly carries the colour of the sky into the lower half of the picture. This double confrontation of human and canine eyes invites comparison with the earlier portrait of Lord Milsington (Cat. 35). The pose is reminiscent of Sterne (Cat. 37), but Selwyn fills more of the canvas and seems, as it were, closer to the beholder, which is typical of Reynolds's portraiture in the 1760s. The frame is of a distinctive kind involving rings, ribbons and threaded swags fashionable in France in the 1770s and 1780s and introduced to England by Sir William Chambers. By about 1770 similar ones had been designed for Selwyn's friend Lord Carlisle at Castle Howard, as we know from the album of drawings by John Linnell (Victoria and Albert Museum, E.172–1929; Hayward 1969, p. 103, fig. 133). The foreshortening of the table suggests that the painting was intended to be hung quite high. N.P.

PROVENANCE ? Lord Holland; the Duke of Queensberry sale 10 July 1897 (97), bt A. Wertheimer; by 1899 the Earl of Rosebery; Rosebery sale, Christie's, 5 May 1939 (bt in); by descent.

Never exhibited before 1900.

LITERATURE Graves and Cronin 1899–1901, III, p. 875; Waterhouse 1941, p. 55; Cormack 1970, p. 123.

No early engraving recorded.

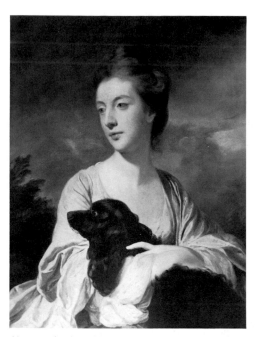

64 *reproduced in colour on p. 112*

64 Lady Charles Spencer

76 × 63 cm
Goodwood House, by courtesy of the Trustees

The subtle harmony of pinks (in the cheeks and the dress)
and browns (pale in the eyes and warm in the hair) which
is continued in the pinky-brown of the grey sky and is con-
trasted with the lustrous black of the spaniel make this one
of Reynolds's most beautiful surviving paintings. There is

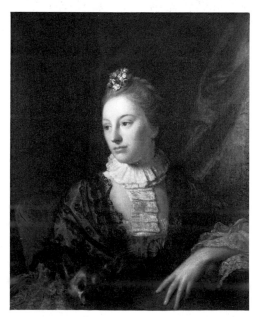

Fig. 69 Alan Ramsay, *Lady George Lennox, c.* 1760
(Private Collection)

more contrast, movement and volume in the figure than had
been the case with his portraits of this format in the late 1750s
(cf. Cat. 29, 31, 33): the pose may have been developed from
Ramsay's portrait of Lady George Lennox (fig. 69) which
Reynolds would have known both in the original and from
the popular mezzotint engravings made of it (there were no
fewer than five plates made).

 The sitter was Mary Beauclerk (1743–1812), daughter of
Vere, Lord Vere, and half-sister to Aubrey, Duke of St
Albans, who in 1762 married Charles Spencer, second son
of the 3rd Duke of Marlborough. Her name appears in
Reynolds's pocket-book in a list opposite 17 March 1766 and
there are appointments on 18 and 28 April and 1, 8, 13 and
24 May that year. The painting must have been completed
by early February 1767 since Finlayson's mezzotint of it was
published on 2 March and a payment of £36.15s for Febru-
ary 1767 is recorded for Lady Charles Spencer. It was
surmised by Graves and Cronin that this sum was paid by
the Duke of Richmond. He was not a relative; the painting
was, however, hanging at Goodwood, pendant with the
same sized portrait of the Duchess (Cat. 65), by 1822.

 For a later portrait by Reynolds of this sitter see Cat. 96.

N.P.

PROVENANCE At Goodwood by 1822; by descent.

Never exhibited before 1900.

LITERATURE Jacques 1822, p. 61; Graves and Cronin 1899–1901, III,
p. 923; Waterhouse 1941, p. 58; Cormack 1970, p. 136.

ENGRAVED Finlayson, 1767; 'John Pott'; S. W. Reynolds.

65 Mary, Duchess of Richmond

76 × 63 cm
Goodwood House, by courtesy of the Trustees

Mary, eldest daughter and co-heiress of Charles Bruce, Earl
of Ailesbury (who features prominently in Reynolds's cari-
cature group, Cat. 14), was born in 1740, married, in 1757,
Charles, third Duke of Richmond, and died in 1796. Her
eulogistic obituarist claimed that 'though nursed in all the
luxury and splendour which rank and opulence could pro-
cure, and gratified with every object of human avidity and
ambition', she remained pious and modest (*Gentleman's
Magazine*, 1796, ii, p. 970). This image of contented domes-
ticity worthy of Chardin, showing her severely dressed, her
hair tightly braided, with eyes only for her tambour, seems
to support this claim. Contemporaries, however, remarked
rather on her pretty and merry face, and her good health
and good humour. Her acute sister-in-law, Lady Holland
(Cat. 29) suspected a lack of sensibility and imagination. She
was also capable of mischief, helping, for instance, to
organize the adulterous affair of her sister-in-law Lady Sarah
Bunbury (Cat. 48, 57; see Fitzgerald 1949–53, I, pp. 38, 178,
226, 253, 307, 568). Aileen Ribeiro notes that the 'brown
woollen riding habit with its severe cut, turned-down collar
and waistcoat was an article of clothing originally taken from

the masculine wardrobe which was by the 1760s increasingly worn for a wide range of informal occasions'.

The Duchess sat in 1758 and early in 1760, probably for the portrait for Holland House (Private Collection). Appointments in the artist's pocket-books which may be connected with this portrait (and perhaps with another) are recorded on 16 and 17 (cancellations on 19, 20 and 22) November 1764; 17 and 26 January, 26 February and 13 and 16 May 1765; 18 March, 23 April, 12 and 13 (cancellation

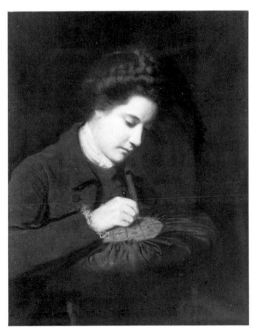

65 reproduced in colour on p. 113

on 14) May and 9 and 18 June 1766; and 10 and 29 June 1767. Her name also appears under 6 June 1768 but without a time (this is also true of 18 June 1766). Reynolds wrote in his ledger for 28 May 1764 'Dutchess of Richmond I believe paid' and after 3 December 1768 and before December 1770 noted 'Dutchess of Richmond sent to Lord Holland'. N.P.

PROVENANCE Painted for the 3rd Duke of Richmond; by descent.

Never exhibited before 1900.

LITERATURE Jacques 1822, p. 61; Graves and Cronin 1899–1901, II, p. 823; Waterhouse 1941, pp. 57, 122; Cormack 1970, p. 134.

No early engraving recorded.

66 Warren Hastings

127.5 × 102 cm
National Portrait Gallery, London

Warren Hastings (1732–1818), Governor-General of Bengal and chief creator of the British Empire in India, was represented in a vast number of images throughout his long life. As John Kerslake points out, he must be one of the few great

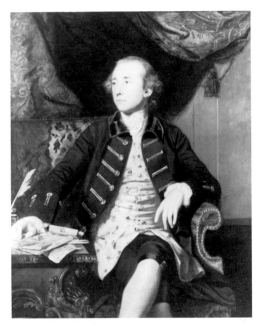

66 reproduced in colour on p. 109

men of the period to have been painted by Reynolds, George Romney and Sir Thomas Lawrence. He posed for the sculptor Thomas Banks, whose brilliant marble bust is, together with Romney's sombre whole-length of 1795, in the Commonwealth Relations Office. Lawrence painted him more than once. His study of 1811 in the National Portrait Gallery is quietly moving; it shows the aged Hastings who had by then left public life and his troubles far behind and was living peacefully as a country gentleman at his ancestral seat at Daylesford, Gloucestershire. But although he is known to us through more than sixty portrait-types, the vast majority of these dates from after his final return to England in 1785 and the seven-year trial which all but ruined him (for which see Cat. 192, 193). None is quite like Reynolds's brittle, elegant three-quarter-length which gives a rare glimpse of the sitter in mid-career.

This portrait, thinly painted on a rough-toothed canvas, dates from a rather shadowy four-year period spent by Hastings in England between June 1765 and the end of March 1769 when he sailed once more for India. During this time he lived well, though his own tastes in food and clothes were plain, and his household bills tell us he bought, amongst other things, landscape pictures from Anthony Devis (half-brother of the better-known Arthur Devis). His coachmaker's bills show that his post-chaise was painted 'a pleasant pompadour' and his arms, embellished with green and gold wreaths, were emblazoned on the side. Something of this fashionable elegance seems reflected in Reynolds's portrait. The sitter is exquisitely but not ostentatiously dressed. His dark blue silk frock-coat, with its velvet collar and trimmings of gold braid, is set off by the pale cream waistcoat which, with its delicate floral design, is either of printed cotton or painted silk and is likely to be of Indian origin. The glimpse of French needlepoint lace at neck and wrists, the cut velvet upholstery of the settee, the reefed curtain and the carved table all serve

to enrich the surface patterning of this portrait to a degree which is unusual in Reynolds's work. A similar if not identical pattern of upholstery appears in the portrait of the Clive family (Cat. 49) and so was probably, like the silk damask curtain, part of the furnishings of Reynolds's studio. John Hardy has drawn attention to a settee at Knole, with walnut cabriole legs and arms of a scroll shape very like the one on which Hastings sits, which dates from about 1720 and which is upholstered in cut velvet ornamented with a similar type of bold flower pattern. Reynolds often painted people sitting at tables, but he usually covered the table itself with some sort of cloth. The gilt ornament displayed here is reminiscent of the type of accessory favoured by French portrait painters like Rigaud, and it is possible that Reynolds, perhaps at the request of the sitter, referred to a painting or a print for this. Unlike the other accessories, this table—a gilt wood console or pier table supporting a marble slab with a gadrooned gilt brass border—does not seem to occur in other pictures by Reynolds. However, Nicholas Penny has pointed out that such a table does feature in Angelica Kauffman's portrait of Reynolds (Cat. 169).

This portrait was painted at an interesting stage in the careers of both artist and sitter. Both had won rapid early successes and both were soon to achieve almost unprecedented fame and fortune. Consolidating his position as the leading society portrait painter in the land, Reynolds has approached his task with due care, seeking above all to present an attractive image. Yet it is not implausible to detect something, at least, of the restless instability, the tension that characterized Hastings at this period of his life. On the surface it is undoubtedly one of the painter's most colourful and even decorative compositions, but the pale face with the already thinning fair hair seems the pivotal point of a composition built up from many busy shapes and sharp angles. The sitter's health cannot have been good during this period, for the clothes he bought were too small for him when he got back to India. The London tailors had measured him when 'reduced by sickness', and a chemist's bill, dating from this time but not paid for seven years, testifies to the purchase of emetics, sudorifics and 'stomach drugs' (Feiling 1954, pp. 55–6).

There are appointments noted in the artist's pocket-books for 3, 7, 12 and 18 March, 14 and 28 April, 5 May and 19 June 1766, then a long gap until one more appointment on 9 February 1767. The portrait was paid for on 9 October 1768 and cost seventy guineas. Reynolds seems to have tried to keep in touch with Hastings after the latter returned to India. A letter from the painter's nephew, Samuel Johnson, to his sister Elizabeth Johnson, dated 27 January 1775, refers to Reynolds sending Hastings 'a Discourse' (Radcliffe 1930, p. 35).

(Mr John Hardy, Dr Aileen Ribeiro and Miss Natalie Rothstein kindly advised on the costume and furniture in this picture.) D.M.

PROVENANCE G. Watson Taylor 1823; his sale, Christie's, 25 July 1832 (148), bt Newton; 2nd Lord Northwick; by descent to Capt. E. G. Spencer Churchill; acquired by H.M. Government and allocated to National Portrait Gallery 1965.

EXHIBITED British Institution 1823 (36); Park Lane 1937 (57); Royal Academy 1968 (129).

LITERATURE Graves and Cronin 1899–1901, II, pp. 449–50; Borenius 1921, p. 137; Waterhouse 1941, p. 58; Kerslake 1966, pp. 160–1; Cormack 1970, p. 123.

ENGRAVED T. Watson, 1777; M. Zell, 1786.

THOMAS WATSON (after Reynolds)

67 Warren Hastings Esq. Governor General of Bengal, &c.; &c.

45.5 × 33 cm (slightly trimmed)
David Alexander

The title given here is the one in the inscription on the second state which also carries the publication date of 20 March 1777. Thomas Watson (1741–81), no relation of James Watson, was one of the leading mezzotint engravers of the 1770s

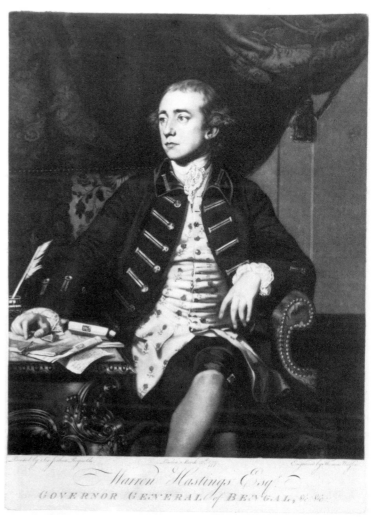

67

and 1780s. He formed a partnership with William Dickinson in 1779. For the painting, which dates from a decade earlier, see Cat. 66. The print was published because of the public notice attracted by Hastings's activities as Governor General of Bengal. Hastings himself was in India when the print appeared, but the painting must have remained in England.

<div style="text-align: right">N.P.</div>

LITERATURE Chaloner Smith 1878–83, no. 19; Goodwin 1904, no. 29; Russell 1926, no. 19 (i).

JOHN DIXON (after Reynolds)

68 Miss Sarah and Miss Elizabeth Crewe

50.3 × 35.5 cm
The Trustees of the British Museum

68a Marcantonio Raimondi, after Raphael, *Parnassus*

The girls here gracefully entwined in a park setting in front of an oversize replica of the antique Medici vase were the daughters of John Crewe MP who died in 1752: the portrait was commissioned by their brother, also John Crewe, later Lord Crewe (for whom see Cat. 38). Elizabeth married Dr Hinchcliffe, later Bishop of Peterborough, and Sarah married Obediah Langton soon after this painting was completed. The young ladies are not distinguished one from another in Reynolds's pocket-books, but perhaps sat consecutively. That seems the best explanation for the appointments recorded for 'Miss Crewe' on 13, 25 and 31 March and 7, 11 and 15 April in 1766, each on two consecutive hours. There was also a single appointment on 17 March and on 7 May 1766 and one on 12 March 1767. Since the painting was seen at Crewe Hall in 1769 it is likely to have been engraved before then. Payment for the painting is perhaps included in the hundred guineas entered on 22 June 1768 under the name 'Mr. Crew' in the artist's ledgers (Cormack 1970, p. 116). The differences between the proportions of this image and that of the painting (Private Collection) and the differences in the appearance of the landscape in print and painting are more likely to reflect changes to the latter than liberties in the former. John Dixon (1740–1811) was exhibiting in London early in 1766 but retired from professional practice in 1775 after marrying money. He was the last of

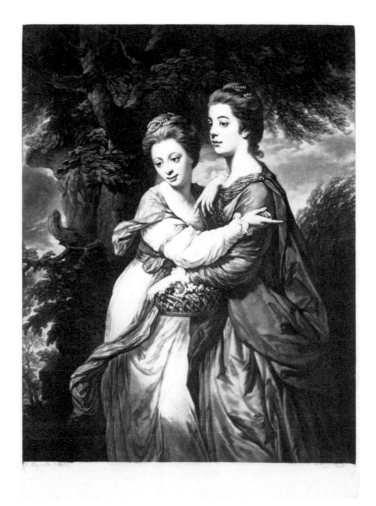

68

the great school of Irish mezzotint engravers to make a reputation in London. Appointments with him or with another Dixon are recorded in Reynolds's pocket-books on 8 February 1765 and 6 September 1766. N.P.

LITERATURE Chaloner Smith 1878–83, no. 12 (1); Russell 1926, no. 12 (2); British Museum 1978, no. 117.

The mezzotint is here displayed beside Marcantonio Raimondi's engraving after a preliminary design by Raphael for the fresco of Parnassus in the Stanza della Segnatura in the Vatican (Cat. 68a, fig. 100; lent by the Trustees of the British Museum). As discussed in the essay 'The Conjuror Unmasked' (p. 350), Nathaniel Hone made the acute and convincing suggestion that Reynolds derived the elegantly interlocking poses of the Crewe daughters from the group of Muses to the right of the figure of Apollo. There are drawings by Raphael for the fresco itself but the Muses were modified there and in this case his source must have been a print.

Nicholas Penny points out that a 'Mount Parnassus, from Raphael, by M. Antonio' was lot 1311, and another was lot 1416 in Reynolds's studio sale (Phillips, 20 and 21 March 1798). J.N.

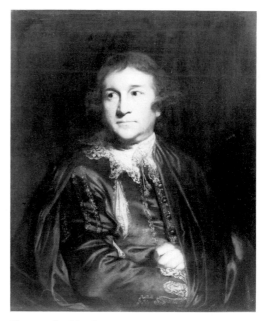

69 reproduced in colour on p. 114

69 David Garrick in the Character of Kiteley

79.8 × 64.1 cm
Signed and dated 1768 on back of canvas
H.M. The Queen

The great actor David Garrick (for whom see Cat. 42) is here portrayed as Kiteley, the obsessively jealous merchant in Ben Jonson's comedy *Every Man in his Humour* first performed in 1598 with—as Garrick would have known—Shakespeare in the cast and probably taking this part. The play was rewritten and revived by Garrick in 1751 and was a great success. He last appeared in the part in 1776. The moment represented by Reynolds is, as Finlayson's mezzotint engraving informs us, Act II Scene I when Kitely resolves to be vigilant of his wife: 'Yea, every look or glance mine eye ejects/Shall check occasion . . .'. This is probably Reynolds's earliest portrait of an actor in a familiar part—unless Woodward is so depicted (Cat. 47). The impasto of the lace and the subtle variations of the cool, slightly mauve brown colour of the satin vandyke costume are well preserved—the 'old English manner' of dress was a noted feature of Garrick's production of this play. Aileen Ribeiro points out that 'for greater dramatic impact (and to aid visibility on an imperfectly lit stage), the costume with its slashed front and fake slashes on the sleeves, is trimmed with tinsel braid'.

Appointments for Garrick are recorded in the artist's pocket-book on 17, 20 and 26 May, 3, 7 and 9 June and 10 November 1767. Two of these are on Sundays and one is at half-past eight, which suggests the sitter's busy life—as does also one of his surviving letters to the artist (Little and

Kahrl 1963, I, pp. 346–7). More work seems to have been done on the painting, however, for it is signed and dated 1768 on the back of the unlined canvas. The print by Finlayson was published on 1 February 1769. Sittings, apparently for another portrait, began again later in the year (on 10 February and 9 and 15 June). For other portraits of Garrick by Reynolds see Cat. 42. N.P.

PROVENANCE Said to have been presented to Edmund Burke by the artist; Burke's sale, Christie's, 5 June 1812 (93), bt by Lord Yarmouth for the Prince Regent; by descent.

EXHIBITED British Institution 1827 (27); Royal Academy 1876 (57); Plymouth 1951 (40).

LITERATURE Leslie and Taylor 1865, I, p. 282; Graves and Cronin 1899–1901, I, p. 350; Waterhouse 1941, p. 59; Millar 1969, pp. 102–3, no. 1021.

ENGRAVED Finlayson, 1 February 1769 (as a pair, Rob Dixon notes, with Finlayson's print after Hone's painting of La Zamperini in the character of Cecchina).

70 Lord Rockingham and his Secretary, Edmund Burke

145.4 × 159.1 cm
The Syndics of the Fitzwilliam Museum, Cambridge

This unfinished picture gives us a fascinating glimpse of Reynolds's working methods. After his stay in Italy between 1750 and 1752 he tried to achieve Venetian effects by using glazes of transparent colour over a basically monochrome underpainting. The head of Burke (left) exemplifies this underpainting. We can compare it with the description by William Mason of Reynolds at work on a head a few years earlier: 'On his light-coloured canvas he had already laid a ground of white, where he meant to place the head, and

which was still wet. He had nothing upon his palette but flake-white, lake, and black; and without making any previous sketch or outline he began with much celerity to scumble these pigments together, till he had produced, in less than an hour, a likeness . . .' (Leslie and Taylor 1865, I, pp. 109–10). The figure of Rockingham is slightly more resolved, but the curtain, the still-life details of table, inkstand and papers, and the chair with its meticulously recorded brass studs have been filled in by an assistant. The sweeping lines with which Rockingham's pose has been sketched are typical of Reynolds's own handling and can be discerned in many finished pictures (an example in this exhibition is *Lady Bamfylde*, Cat. 106).

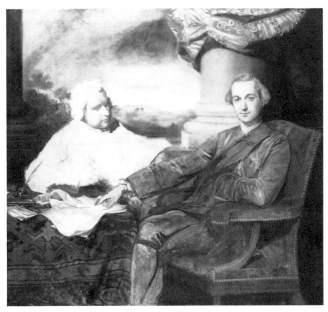

70 *reproduced in colour on p. 117*

The state of these heads suggests no more than one or two sittings each before the commission was abandoned. Appointments are recorded in Reynolds's pocket-books for both sitters but it is impossible to connect them for certain with this particular picture. During the same period Reynolds painted the whole-length of Rockingham in Garter robes which became well-known through numerous copies and variants (for the original in the Fitzwilliam family see Waterhouse 1941, p. 58); similarly, the appointments for Burke could refer to sittings for the half-length in the same collection (ibid. p. 59). Nevertheless, it is valuable to record the references. Rockingham's name (spelt Rockingam) occurs on 18 November, 19 and 23 December 1766, and on 23 May (in the accounts column) and 1, 2 and 6 June 1768. Appointments for 'Mr Burk'—it should be remembered that Reynolds knew more than one member of the family—are recorded in 1766 on 2 January, 11 September and 3 October (but in each case at four o'clock or half-past four, so were probably not for sittings); also on 29 November (no hour specified), and on 27 August there is a note 'Send to Mr Burk'. There are more appointments on 27 August, 12

September (but this is possibly 'Mrs Burk'), 13 September (cancelled), 24 October (again possibly 'Mrs Burk') and 19 December (no hour specified) in 1767; on 10 March and 25 August (no hour specified and simply 'Burks') 1768; on 11 February (at four o'clock, so probably not for a sitting), 1 April (no time), 8 May 1769; and in 1770 on 29 May (accounts column) and 2 June (possibly 'Mrs Burk'). There are also appointments for Burke before 1766 and after 1770, most of them more likely to be social dates than portrait sittings.

Charles Wentworth, 2nd Marquess of Rockingham (1730–82), leader of the Whig opposition to Bute, formed his short-lived first ministry in 1765, greatly assisted by his Irish secretary, Edmund Burke (1729–97). Rockingham's collection of pictures at Wentworth Woodhouse included a famous double-portrait by Van Dyck of the Earl of Strafford with his secretary, Sir Philip Mainwaring; this painting in its turn is deeply indebted to similar double-portraits by Titian and Sebastiano del Piombo known to Reynolds (Jaffé 1966). A double-portrait of another Prime Minister, Henry Pelham, and his secretary by John Shackleton (now Private Collection, Mexico; Kerslake 1977, II, pl 618), also imitated from the Van Dyck, had been engraved by Houston in 1752 (fig. 70). It is tempting to see the unfinished *Rockingham and*

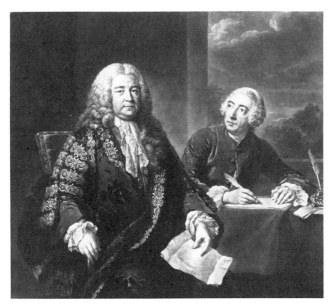

Fig. 70 Richard Houston (after J. Shackleton, *Henry Pelham with his Secretary*), mezzotint, 1752 (Fitzwilliam Museum, Cambridge)

Burke as a commemoration of the sitter's administration which lasted only from July 1765 to July 1766.

Burke, son of an attorney, born in Dublin on 12 January 1729, was one of the leading political and literary lights in Reynolds's circle. His *Philosophical Enquiry into the Origin of Our Ideas of the Sublime and Beautiful* was published in 1757. In about 1758, according to Malone (Prior 1860, p. 434), Burke met Reynolds and they remained close friends for the rest of the painter's life. Burke was an original member of

the Club (later known as the 'Literary Club') founded on Reynolds's suggestion in 1764; in 1773 Burke founded another dining club, to include William and Richard Burke as the Literary Club was considered rather too exclusive. This less famous club also had Reynolds, Johnson and Garrick among its members. In July 1774 Burke wrote to James Barry, a young Irish painter Burke and his friends had sponsored on his Italian travels, to say 'a picture of me is now painting for Mr Thrale by Sir Joshua Reynolds' (Barry 1809, I, p. 237). Numerous other portraits of Burke exist, mostly copies based either on Earl Fitzwilliam's oval picture already mentioned, or on the later rectangular picture, also half-length, painted for Thrale's gallery at Streatham (Armstrong 1900, plate facing p. 16).

In 1768 Burke purchased an estate of six hundred acres together with a Palladian house and farm at Beaconsfield. The house contained fine pictures, including seven Poussins which Reynolds valued at £700, a Titian and much sculpture, and the whole venture cost Burke thirty years of financial embarrassment. When his son Richard read for the Bar, Reynolds paid his first year's fees. The death of Reynolds in 1792 left the Burke family grief-stricken. Besides leaving his old friend £2,000, the artist cancelled a bond which he held for a similar amount. After the funeral, when Burke rose (at the request of the painter's family) to thank the Academicians for attending, he broke down and was unable to speak. Under the terms of the will Burke was appointed an

executor, and also one of the guardians of Reynolds's niece and heiress, Mary Palmer. When she married a few months later the ceremony took place in Burke's house. D.M.

PROVENANCE Studio sale, Christie's, 26 May 1821 (14), bt Coles; Thomas Phillips RA, by whom sold Christie's, 9 May 1846 (12), bt Sir Francis Grant PRA; his sale, Christie's, 28 March 1879 (84), bt Sir Frederick Leighton PRA; his sale, Christie's, 13 July 1896 (335), bt Fairfax Murray, by whom given to Fitzwilliam Museum, 1908.

EXHIBITED Grosvenor Gallery 1883 (197).

LITERATURE Graves and Cronin 1899–1901, I, p. 131 and II, pp. 838–9; Magnus 1931, p. 28; Waterhouse 1941, p. 58; Buttery, in Hudson 1958, p. 249; Goodison 1977, no. 653.

No early engraving recorded.

JAMES WATSON (after Reynolds)

71 Edmund Burke Esq.

37.5 × 27.3 cm
The Trustees of the British Museum

For Burke see Cat. 70. The print includes the publication date of 20 June 1770. Burke was then the most eloquent opponent of the Tory government on the floor of the House of Commons and in pamphlets—his *Thoughts on the Present*

71

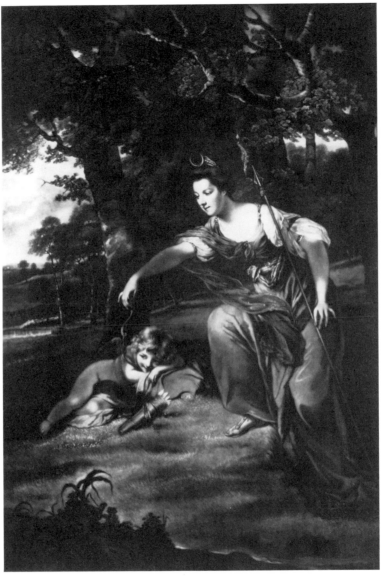

72

Discontents, for example, appeared in the same year as this print. Appointments for Burke are recorded under Cat. 70. The portrait on which this mezzotint is based is now in the collection of the Countess Fitzwilliam at Milton. There is no record of payment for it and it was perhaps presented to the sitter whose widow bequeathed the family portraits to the Fitzwilliams—the family of Burke's great aristocratic patron. Whereas the painting is set in a feigned oval, this has been converted here into a circle.

For James Watson see Cat. 62. For Burke see also caricatures Cat. 190, 192 and 194. N.P.

LITERATURE Chaloner Smith 1878–83, no. 20 (1); Goodwin 1904, no. 69.

JAMES WATSON (after Reynolds)

72 The Duchess of Manchester and her son Lord Mandeville in the character of Diana disarming love

61.7 × 40.7 cm
The Trustees of the British Museum

72a Stefano [Étienne] Baudet, after Albano, *Diana and her Nymphs disarming Cupids*

The painting (today at Wimpole Hall, Cambridgeshire) which this print reproduces was exhibited (as no. 89) at the first exhibition of the Royal Academy in 1769 and, according to the *St James's Chronicle*, 'chiefly attracted the attention of

connoisseurs'—although not the approval of all of them, for Walpole annotated his catalogue with the observation 'bad attitude'. The management of the foreground space is, indeed, almost as unhappy as the anatomy, and the conceit is both laboured and tasteless; but there may have been felicities in the colouring and even in the expressions which the deterioration of the paint surface and repeated restorations have destroyed.

The sitter (1741–1832) was the eldest daughter of Sir James Dashwood (and hence a sister of Anne Dashwood, see Cat. 54). She married George Montague, 4th Duke of Manchester, on 23 October 1762. Her son George, Viscount Mandeville, was born on 11 November 1763 and died in 1772. This painting in its curious way celebrates his arrival. Appointments for the Duchess are recorded on 16 February (no time), 2 and 4 April 1764; on 30 (no time) and 31 May, 3 and 6 June 1766; 12 and 14 March, 26 May, 1 and 5 June 1767; and 3 May 1768. A payment in 1768 (after 20 August and before 8 November) for £78.5s and another for 28 June 1771 for £78.15s are recorded in the artist's ledger (Cormack 1970, p. 129). If the painting was sent to Kimbolton Castle in 1771 the print is likely to have been made before that date.

For James Watson see Cat. 62. N.P.

LITERATURE Chaloner Smith 1878–83, no. 97 (i); Goodwin 1904, no. 45; Russell 1926, no. 97 (2).

The mezzotint is here displayed beside an engraving by Stefano Baudet dated 1672 after Francesco Albano's painting of the Disarming of Cupid (Cat. 72a, fig. 85; lent by the Trustees of the British Museum). As discussed in the essay, 'The Conjuror Unmasked', Hone recognized that Reynolds had derived the poses of both the Duchess and her son from figures in Albano's painting—which was also engraved by Benoît Audran (see p. 346). J.N.

73 Samuel Johnson

76.2 × 63.8 cm
Signed and dated 1769 on back of canvas
Lord Sackville

As Reynolds assumed a position of one of the leading artists in London, Samuel Johnson (1709–84) made an equivalent (but far less well rewarded) reputation in the world of literature and scholarship—his tragedy *Irene* was produced in 1749; his poem *The Vanity of Human Wishes* appeared, to rather more applause, in the same year; between 1750 and 1752 he published the popular twice-weekly *The Rambler*; and his *Dictionary* of the English language appeared, to great acclaim, in 1755. Reynolds, who was precise about such matters, claimed after Johnson's death that he had been an 'intimate friend' of Johnson for thirty years, which means that they met in 1754; but it is possible that they did not actually meet until a year or so later (Hilles 1936, note pp. 12–13). Johnson declared Reynolds to be 'the most invulnerable

man he knew; whom, if he should quarrel with him, he should find the most difficulty how to abuse'. Johnson helped to form Reynolds's mind, whereas Reynolds had little influence on Johnson's—not least because Johnson had no interest in the visual arts. Johnson, however, certainly had a profound respect for Reynolds's native intelligence. For other portraits and caricatures of Johnson see Cat. 80, 196, 198, 199.

Reynolds's earliest portrait of his friend is the one (now in the National Portrait Gallery) probably of about 1757. It seems to have been uncommissioned, which was highly unusual, and was subsequently given by the artist to his and Johnson's close friend, James Boswell. The portrait exhibited here was perhaps the next. It has two companions. When shown at the Royal Academy in 1770 it made a pair with a portrait of Oliver Goldsmith (a version of which is Cat. 79 here). This was surely a deliberate reference to the Professorships of Ancient Literature and Ancient History at the Royal Academy to which (thanks to Reynolds's influence) the two writers had been appointed early in the same year. However, when the mezzotint engraving by James Watson of this portrait of Johnson was published on 10 July 1770 it was accompanied by another of identical size of a self-portrait by Reynolds. This was surely an indication of their friendship.

Profile portraits are relatively rare among Reynolds's work but were appropriate for sages such as Johnson (or, earlier, Mudge—see Cat. 17) who are engaged in their own thoughts rather than conversing or concerned with us. Reynolds did depict the social side of Johnson, appropriately in a portrait for the great hostess Mrs Thrale (see Cat. 80) and he also wrote dialogues which very ably parody his friend's conversational manner. More relevant for the painting exhibited here is the passage in Reynolds's remarkable literary portrait of Johnson in which he commented on the 'strange antic gesticulations' in which Johnson engaged when alone, and which suggested to Reynolds 'a mind preying on itself' (Hilles 1952, pp. 61–90; also Boswell 1934–50, I, p. 144). The gestures here are surely intended as a dignified version of these 'gesticulations'.

When Johnson sat for this portrait is not clear. There is no sitting on 12 August 1765, as has been claimed, and the appointment on 10 August would probably have been for dinner. There are appointments on 20 and 24 December 1766, 10 January and 18 and 27 April 1769 (this last, again, probably for dinner). Four sittings might have been sufficient, but as a close friend Johnson surely need not have made formal appointments. The portrait is signed and dated 1769 on the back of the canvas and there is also a note recording its acquisition by the Duke of Dorset in that year. Also, a note in Reynolds's ledger on the technique of this painting and that of Goldsmith appears to date from 10 July 1769. However, an appointment is recorded for Johnson on 14 May 1770, perhaps to revise the portrait for the Academy Exhibition. Reynolds sent a studio copy to Johnson's stepdaughter in Lichfield, where Johnson was touched to see it in 1771 (now at Harvard University).

The paint has cracked severely on the face; there is crinkling in the brown habit and much deterioration and darken-

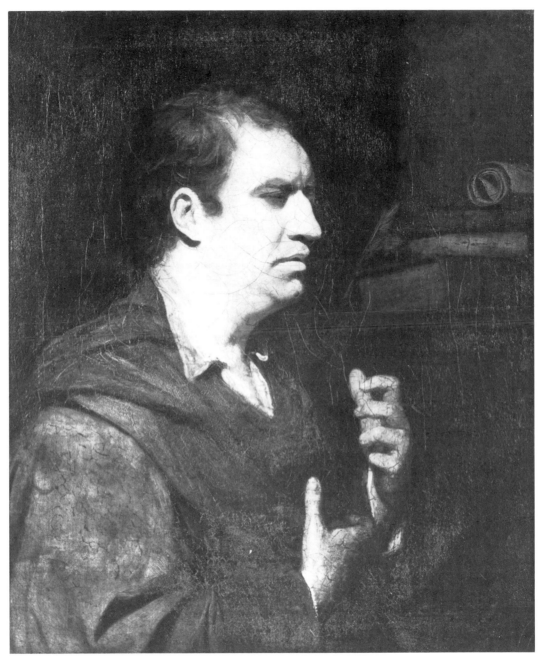

73

ing of the surface due to bitumen in the shadows, with the result that the left sleeve and part of the right hand cannot now be clearly discerned. The image, however, retains much of its original power. N.P.

PROVENANCE Purchased by the Duke of Dorset, 1769; by descent.

EXHIBITED Royal Academy 1770 (150: 'Portrait of a Gentleman'); British Institution 1817 (98); New Gallery 1891 (205); Royal Academy 1968 (26).

LITERATURE Northcote 1818, I, pp. 234–5; Leslie and Taylor 1865, I, p. 412; Graves and Cronin 1899–1901, II, pp. 519–20; Boswell 1934–50, IV, p. 448; Waterhouse 1941, p. 61; Cormack 1970, p. 143; Arts Council 1984 (69).

ENGRAVED J. Watson, 1770.

74 Thomas Townshend and Colonel Acland (The Archers)

236 × 180 cm

The Trustees of the Tetton Heirlooms Settlement

Outdoor portraits, in which the figures are represented whole-length against a background of trees, are common in eighteenth-century British painting. Hudson, Ramsay, Hoppner and Raeburn painted young men posing with bows and arrows. Yet Reynolds's *Archers* is unique. There are echoes here of the great hunting portraits of the Baroque, and, further back, of the late *poesie*, or mythological subjects,

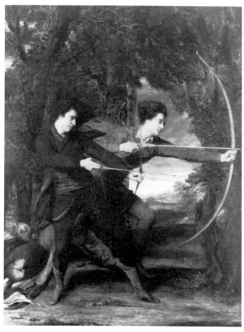

74 *reproduced in colour on p. 119*

of Titian, of the goddess Diana pursuing the hapless Actaeon through a turbulent, encrusted forest. The richly-worked gold edging to the green coat, the dead game and the distant landscape all contribute to this Venetian or Flemish-baroque atmosphere. Yet the composition itself, with the figures compressed into a shallow space, overlapping and set parallel to the picture-plane, is as tightly organized as a classical relief.

In the hands of a less intelligent painter the effect could easily have been slightly ridiculous. Fanny Burney describes a visit to the home of one of Reynolds's neighbours in Leicester Fields, Sir John Ashton Lever, on 31 December 1782. She thought her host very eccentric: 'he looks full sixty years old, yet he had dressed not only two young men, but himself, in a green jacket, a round hat, with green feathers, a bundle of arrows under one arm, and a bow in the other, and thus, accoutred as a forester, he pranced about; while the younger fools, who were in the same garb, kept running to and fro in the garden, carefully contriving to shoot at some mark, just as any of the company appeared at any of the windows.

After such a specimen of his actions,' she concludes rather primly, 'you will excuse me if I give you none of his conversation' (Burney 1842–6, pp. 222–3—reference supplied by Nicholas Penny).

John Dyke Acland was the eldest son of Sir Thomas Acland, Bt, and Elizabeth Dyke of Tetton in Somerset. He was born on 18 February 1746 and on 3 June 1770 married Lady Christian Harriot Caroline Fox Strangways, a cousin of Charles James Fox (see Cat. 48). Major in the 20th Foot Regiment and Colonel of the Devon Militia, Acland died on 31 October 1778 aged only 32 and during the lifetime of his father. His companion in Reynolds's picture, Thomas Townshend, was the eldest son of the Hon. Thomas Townshend and Albinia Selwyn. He was born on 24 February 1733 and on 19 May 1762 married Elizabeth Powys. Having made the Grand Tour together, the two friends decided to be painted together.

Appointments for 'Mr Ackland' are recorded in the artist's pocket-book for 25, 27, 28 and 30 January, 2 February, 22 March and 5 August of 1769. 'Lord Sidney' also had an appointment on 5 August an hour earlier and one on 12 August. During August Reynolds also noted appointments for 'Archers' on 1, 2, 4, 7 (for two hours), 14, 18 and 21 August, which may have been shorthand for double-sittings but more probably refers to models he used for the unusually active poses.

The painting was exhibited at the Academy in 1770 where Walpole noted: 'trees very fine'; but, as Tom Taylor recounts, the friends quarrelled, 'and each declined paying for it and taking it home'. At the time of Acland's death the *Archers* remained uncollected in Reynolds's studio. The debt of £300 was, however, settled in June 1779 and the picture has remained in family possession.

Townshend was raised to the peerage on 6 March 1783 as Baron Sydney of Chislehurst, Kent; on 11 June 1789 he was further created Viscount Sydney of St Leonard's, and he died on 13 June 1800. (It is odd that in both Reynolds's ledger and his pocket-book Townshend is referred to as 'Lord Sidney'.)

Aileen Ribeiro points out that 'this costume, of wrap-over tunic held in place by a wide sash, theatrical tights and calf-length buskins, is an invention by Reynolds, a mixture of "historic" and stage dress. It is not related to the military-style uniforms (usually green) which were adopted from the 1780s when archery was revived as an adult sport.'

D.M.

PROVENANCE 2nd Earl of Carnarvon (son-in-law of Acland); by descent until sold at Christie's, 22 May 1925 (110), bt for a member of the Acland family, Mrs Mervyn Herbert; thence by descent.

EXHIBITED Royal Academy 1770 (145: 'Portraits of two gentlemen'); British Institution 1813 (59); R.B.A. Gallery, Suffolk Street 1834 (43); British Institution 1851 (116); Royal Academy 1881 (181); 1951 (71); Birmingham 1961 (47).

LITERATURE Leslie and Taylor 1865, I, p. 348; Graves and Cronin 1899–1901, I, pp. 7–8; Waterhouse 1941, pp. 16, 60; Cormack 1970, p. 144; Waterhouse 1973, p. 26.

No early engraving recorded.

75 The Hon. Mrs Edward Bouverie of Delapré and her child

160 × 167.6 cm

The Earl of Radnor

The sombre colouring, the contrived pose reminiscent of the figures frescoed by Michelangelo in the lunettes of the Sistine Chapel, the antique draperies and sandals, and the learned furniture (the vase is copied from the prints after Raphael's pupil Polidoro da Caravaggio) combine to make this representative of the highest type of portraiture as Reynolds

conceived it. There is nothing familiar in it, except perhaps, Aileen Ribeiro suggests, the white chemise with its embroidered cuff.

The sitter was Harriot, only daughter of Sir Everard Faw-kenor KB. In 1764 she married, by special licence at the age of fourteen, the Hon. Edward Bouverie, fifth son of the 1st Viscount Folkestone, who succeeded his eldest brother (the 2nd Viscount, for whom see Cat. 40) as Member of Parlia-ment for Salisbury. In 1764 Edward Bouverie also bought Delapré Abbey near Northampton (Wake and Pantin 1959, p. 11) and it was for his new marital home that he doubtless commissioned this portrait. An old photograph of the

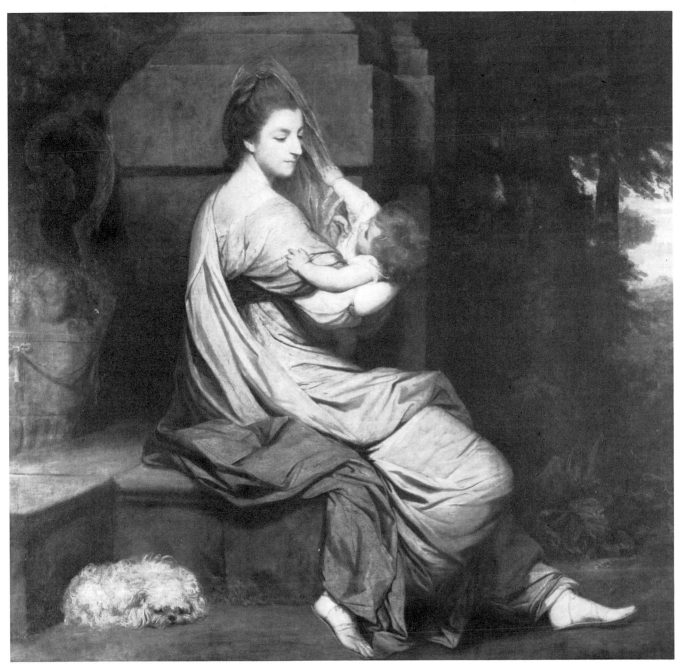

75

face senza oil and the boys head. the rest painted con olio and afterwards glaced with varnish and colour except the Greca (?) which was glazed with oil and then varnished the vail and white linnen finish senza. . . .' The reference to the boy's head confirms that the child is Edward. Perhaps Reynolds did not at first know the sex of his infantile subject.

In the 1770s and 1780s Mrs Bouverie, as the friend of Mrs Crewe, was at the centre of opposition Whig society and her husband was an intimate of the Prince of Wales. After his death in 1810 she married Lord Robert Spencer, third son of the 3rd Duke of Marlborough (see Cat. 108). She died in 1825. N.P.

PROVENANCE By descent to General Edward Bouverie who, to prevent its inheritance by J. A. S. Bouverie, bequeathed the painting in 1871 to his kinsman the Earl of Radnor; by descent.

EXHIBITED Royal Academy 1770 (146: 'Portrait of a Lady and Child'), 1876 (108).

LITERATURE Leslie and Taylor 1865, I, p. 347; Graves and Cronin 1899–1901, I, pp. 104–5; Squire and Radnor 1909, II, pp. 53–5; Waterhouse 1941, p. 60; Cormack 1970, pp. 112–13, 142.

ENGRAVED James Watson, 30 September 1770: S. W. Reynolds, 1820.

Fig. 71 Dining-room of Delapré Abbey near Northampton: chimneypiece, picture-frame and cornice of *c.* 1770–80, decorative panels *c.* 1870

dining-room shows a chimneypiece and above it a plaster frame dating from about 1770 surrounded by decorations of a later period (fig. 71). These features survive, concealed by shelves (the Abbey now serves as Northamptonshire County Record Office), and the frame has been found to correspond with the dimensions of this portrait.

Mrs Bouverie was the intimate companion of the beautiful Mrs Crewe (for whom see Cat. 38) and they were painted together contemplating a tomb marked 'ET IN ARCADIA EGO' in a portrait exhibited at the Royal Academy in 1769. The portrait of Mrs Bouverie with her child was exhibited in 1770, the year in which the engraving was published (on 30 September).

Appointments are recorded for 6, 8, 14, 23 and 27 February and 4, 9, 14, 16 and 22 March 1770. An appointment for 28 March was cancelled, as was one on that day for 'Miss Bouverie' for whom there were also appointments on 10 and 17 April. This 'Miss Bouverie' may be the child in the portrait who has, however, traditionally been taken for Edward, her eldest son (1767–1858). An agreement for a whole-length of 'Mrs Boverie' costing 150 guineas is recorded in the artist's ledger apparently in February 1769. Payments were on 21 April 1769 and 12 January 1770.

Also in the artist's ledger is a rather alarming note on the experimental techniques employed here: 'Mrs Boverie the

76 Lord George Seymour Conway

62.2 × 46.2 cm
Private Collection

George (1763–1848), seventh son of Francis Seymour Conway, Earl and afterwards 1st Marquess of Hertford, was about six years old when this portrait was painted. The pose, with the right hand across the chest, was a traditional one, deriving ultimately from Titian's experiments with half-lengths. It was taken up, with variations, by a whole series of portrait painters, especially in the North: by Holbein, Rembrandt, Van Dyck, Philippe de Champaigne, Lely and Kneller, amongst others. Reynolds is likely to have taken it directly from Van Dyck's *Iconography*, a set of engraved portraits we know to have been in his possession and which provided him with a useful stock of poses. The quiet mood of this little portrait, suitable for a young child, has been achieved by turning the head slightly away while avoiding the rather assertive sideways tilt of the head favoured by many earlier painters, and shows how sensitive Reynolds could be to the needs of particular subjects.

Aileen Ribeiro stresses the accuracy of the vandyke costume. 'The doublet with wide collar edged with bobbin lace, the asymmetrically draped cloak, and the buff leather gauntlet, derive from masculine costume of the 1630s. Such a costume is obviously a studio conception, very different in feeling from the less accurate interpretations of vandyke costume which might have been actually worn, by Master Lister [Cat. 53], or Charles William Henry, Earl of Dalkeith [Cat. 104].'

Several other members of this large family (there were thirteen children) were painted by Reynolds. Two of Lord

George's sisters are in the Wallace Collection, while the Green Drawing Room at Ragley Hall contains portraits of his father (Royal Academy 1785, no. 71), his eldest brother Francis, Viscount Beauchamp, afterwards 2nd Marquess (Eton Leaving Picture, 1759, with the College in the background, exhibited Birmingham 1953, no. 61), and bust portraits of his brothers Lord Henry and Lord Robert, both in vandyke costume.

Lord George was born on 21 July 1763, and on 20 July 1795 married Isabella, daughter of the Hon. and Rev. George Hamilton. He became a soldier and Member of Parliament for Oxford in 1784 and of Totnes in 1796. He died on 10 March 1848. 'Conway Lord Hertfords son' is written but

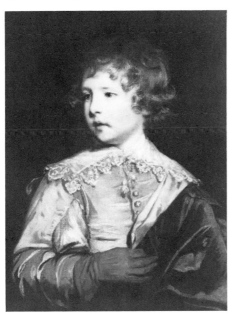

76 *reproduced in colour on p. 120*

cancelled on 28 February 1770 in the artist's pocket-book. Appointments for him—now described as 'Master Conway'—occur on 5, 6 and 7 March and 1 May; another appointment on 8 August was cancelled, apparently because of the artist's visit to York (7–16 August). On 18 August Reynolds wrote 'Master Conway to be finished'. A payment of thirty-five guineas is recorded in the ledger for 12 November. Edward Fisher's exceptionally fine mezzotint was published on 17 August 1771. A copy of Reynolds's portrait was put up at Christie's on 15 June 1866 (91), and was bought in by the owner, Henry Farrer FSA. D.M.

PROVENANCE Painted for the sitter's father, afterwards 1st Marquess of Hertford; by descent to the 7th Marquess; sold 1938 by Spink's to H.M. King Carol of Roumania; bequeathed to his mistress Madame Lupescu; sold by her to a lady resident in Mexico City who bequeathed it to her niece, resident in Portugal; Christie's, 27 March 1981 (150), bt Agnew's, who sold it to present owner.

EXHIBITED Worcestershire Exhibition 1882; Grosvenor Gallery 1883 (202); Guildhall 1890 (191); 45 Park Lane 1937 (50).

LITERATURE Graves and Cronin 1899–1901, I, pp. 191–2; Waterhouse 1941, p. 61; Cormack 1970, p. 116.

ENGRAVED E. Fisher, 17 August 1771; J. Watts; S. W. Reynolds.

77 A Young Black

78.7 × 63.7 cm
Menil Foundation Collection, Houston

This fresh and well-preserved painting—surely an unfinished work rather than a preparatory sketch—has, like the numerous inferior versions derived from it, been described as a portrait of Omai, the Polynesian (see Cat. 100), which it patently is not, and also, more persistently, and plausibly, as a portrait of Francis (Frank) Barber, the beloved servant and principal heir of Dr Johnson. It may, however, be a mistake to think of it as a portrait in the usual sense. There is, in any case, no contemporary evidence that Reynolds painted Frank Barber and the single appointment for him in the pocket-books which Leslie and Taylor, followed by Graves and Cronin, cite for April (in fact 23 April) 1767 reads 'Franks' and thus probably refers to the members of the Franks family Reynolds was painting at that date. There are no clear references to black sitters or models in Reynolds's surviving pocket-books save two entries for 'negro' on 15

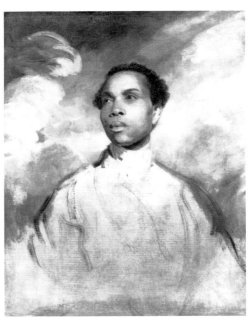

77 *reproduced in colour on p. 116*

December and 18 December 1761 which have been connected with the black servant (a female, however) in the portrait of Lady Elizabeth Keppel at Woburn (see Cat. 44), which we know he was then finishing.

Sir George Beaumont, who knew Reynolds well, described (or authorized the description of) this painting—or at least of a painting of this type—as 'Sir Joshua's black servant' when it was exhibited at the British Institution (of which he was a Director); it was only called Frank Barber after 1850. Northcote informs us that Reynolds, in about 1769, had had a black footman 'for several years', and that he was represented 'in several pictures, particularly in one of the Marquess of Granby, where he holds the horse of that General' (1818, I, pp. 203–6). Sittings by the artist's servants

do not appear in the pocket-books. Unfortunately there is no close similarity between this young man and the more youthful black pages in the version of the Granby portrait in the Royal Collection (St James's Palace) or in the portrait of Count Schaumberg Lippe, also of the mid-1760s (and also in St James's Palace)—nor with those who appear in his portraits of the 1780s. It is exceedingly hard to date this study on stylistic grounds, but c. 1770 seems likely. The great number of versions of the painting can be explained by Reynolds encouraging his students to copy it and certainly also by the opportunities provided for copying by the British Institution to which it was several times lent. N.P.

PROVENANCE Probably the 'study of a black man's head' bt at Reynolds's studio sale, Greenwood, 15 April 1796 (53) by Sir George Beaumont, Bt, which still belonged to the Beaumont family in 1884; the painting exhibited here was certainly with Colnaghi by 1902; Knoedler 1902–4; Jacques Doucet sale, Galerie Petit, Paris, 6 June 1912 (174), bt Pardinel; François Coty sale Galerie Charpentier, Paris, 30 November 1936 (28), bt by the Hon. Mrs Reginald Fellows; Comtesse A. de Castéja; Hôtel Drouet sale 20 October 1983 (12), bt for present owner.

EXHIBITED Beaumont's painting was exhibited British Institution 1813 (140), 1823 (41), 1861 (177); Manchester 1857 (58); Royal Academy 1877 (290); Grosvenor Gallery 1883 (42).

LITERATURE Graves and Cronin 1899–1901, I, p. 49; Reade 1912, pp. 103–9; Waterhouse 1941, pp. 66, 124.

No early engraving recorded.

78 Mrs Abington as 'Miss Prue'

76.8 × 63.7 cm
Yale Center for British Art, Paul Mellon Collection

This painting is not what it was: the surface has been flattened, hence the grainy texture of the flesh, and the pink dress and blue sky are less vivid in colour. Nevertheless, the effect of the black bracelets in relation to the pinks and whites and greys is startling; so, too, are the presentation and expression.

There are numerous earlier portraits of men leaning informally over a chair-back—one with which both Reynolds and his sitter would certainly have been familiar was the portrait of Garrick by Angelica Kauffman, now at Burghley, which was exhibited at the Free Society of Artists in 1765. There are, however, no earlier female portraits of this kind because such manners were considered improper for a lady. It is only possible here because Mrs Abington is represented in the part of 'Miss Prue', the wanton rural ingénue in Congreve's play Love for Love: hence also the vulgarity of the thumb in her mouth.

There is no attempt to set the play, which dates from 1695, in its own period. The chair is of the 'ribbon-back' type being made in the 1770s by Thomas Chippendale and Aileen Ribeiro points out that the net trimmings and lace flounces, black silk bracelets and conically piled powdered hair were the very latest fashion in dress. London fashion was indeed set by Mrs Abington's stage costumes, and her contract with

Drury Lane theatre in 1781 stipulated an annual allowance of £500 for her wardrobe.

Mrs Abington had appeared in the part of Miss Prue in December 1769 and in 1770 to great applause. There is an

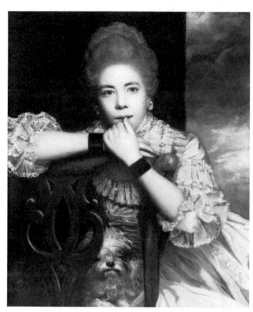

78 reproduced in colour on p. 123

appointment for her in the artist's pocket-book for two o'clock on 1 March 1771 and Reynolds noted below 'Ruffle for the Picture at 12 Alexander hair dresser Haymarket'. Appointments followed briskly on 6, 8, 11, 15 and 19 March and 6 April, and the painting would have only just been dry enough to be sent to the exhibition in the following month. Payment for £18.7s.6d is noted in the artist's ledger for 12 April. This is half of thirty-five guineas, which was probably the full price. It is very surprising that it was not quickly engraved. (Some sources erroneously claim that there were sittings in May 1771.)

Frances (Fanny) Barton was born in poverty in about 1737 and died in Pall Mall in 1815. A flower-seller ('Nosegay Fan') in the 1740s and a prostitute by the early 1750s, she made her stage début in 1752, but only became a great name in Dublin after she had married James Abington, her music master (who was soon paid to keep his distance). She was educated by her lover, Mr Needham, Member of Parliament for Newry, and on her return to London in the early 1760s she became a leader of fashion as well as the leading actress of the period. She excelled especially in new comedies and those of the Restoration period, her greatest triumph being the part of Lady Teazle in Sheridan's School for Scandal. Her caprices and vanity drove Garrick to despair and she greatly offended Goldsmith, but she successfully cultivated men of letters who were not connected with the stage and enticed the most severe moralists and fussy bachelors to her supper table (neither Dr Johnson nor Horace Walpole resisted). Reynolds was devoted to her and, despite his reputation for meanness, took forty places in the front boxes for her benefit performance on the snowy evening of 27 March 1775. There

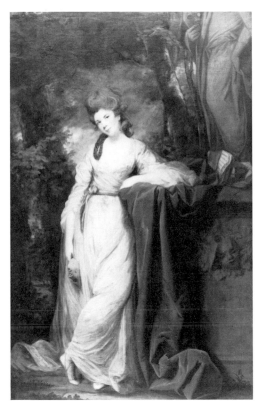

Fig. 72 Mrs Abington as the Comic Muse, c. 1768, revised 1773 (Waddesdon Manor)

is, however, no shred of evidence that he was one of her lovers, as has recently been proposed by Musser. (For biography and gossip about her see Haslewood 1790, II, pp. 1–18; Northcote 1818, I, p. 127; Piozzi, 1861, I, p. 102; Boswell 1934–50, II, pp. 321, 324, 330, 349; Little and Kahrl 1963, II, pp. 880–1; III, pp. 942–3, 962, 987–8, 990–1, 1079; Walpole 1937–83, XXXIX, p. 323.)

Reynolds's earliest known painting of Mrs Abington is the superb full-length of her as Thalia, the Comic Muse, now at Waddesdon Manor (fig. 72; Waterhouse 1967, pp. 67–8). A mezzotint of it by James Watson was published on 17 August 1769 but it is unlikely that all twenty-six appointments recorded in the pocket-books between 11 August 1764 and 6 June 1768 are for this work and the payments made in this period exceed the cost of a full-length. There are ten appointments for Mrs Abington recorded between 5 December 1771 and 8 May 1772, which must be for the portrait of her wearing a cardinal cloak (formerly in the Carrington and Butler Collections), of which a mezzotint by Judkins was published on 20 May 1772 (Goodwin 1904, no. 5), and of which a sketch also survives (Sotheby's, 10 November 1982, lot 41). There are other appointments recorded in October 1772 and in the early months of 1773, which Waterhouse has convincingly explained as for the repainting of the face and hair of the full-length as Thalia which now differ considerably from their appearance in Watson's print. Five appointments between 28 June 1781 and 29 May 1784 are probably for the superb portrait of her in the part of Rox-

alana in *The Sultan*, exhibited at the Royal Academy in 1784 and apparently presented by Reynolds to her (Smith 1845, pp. 201–2). Subsequent appointments on 10 February 1786 (at seven o'clock) and 1 November 1787 (at five o'clock) were surely social. N.P.

PROVENANCE By 1813 at Saltram, Devon, in the possession of the son of the artist's friend, John Parker; by descent to the 3rd Earl of Morley; sold to Sir Charles Mills, Bt (later Lord Hillingdon) in 1877 according to a MS Catalogue of the Saltram Collection but perhaps at Christie's, 29 April 1876 (extra lot); Hillingdon sale, 23 June 1972 (116), bt Agnew; sold December 1972 to Paul Mellon by whom presented to the British Art Center.

EXHIBITED Royal Academy 1771 (161: 'Portrait of a Lady, three quarters'); British Institution 1813 (103); South Kensington 1867 (601); Grosvenor Gallery 1883 (9); Guildhall 1899 (181); 45 Park Lane 1937 (56); Birmingham 1961 (50); Royal Academy 1951 (72), 1968 (126).

LITERATURE Leslie and Taylor 1865, II, pp. 114–15; Graves and Cronin 1899–1901, I, p. 4; Waterhouse 1941, p. 61; Cormack 1970, p. 109; Cormack 1983; Musser 1984.

ENGRAVED S. Cousins, 1822.

79 Oliver Goldsmith

76.2 × 64.1 cm
The Marquess of Tavistock and Trustees of
the Bedford Estates

Oliver Goldsmith, the son of an Irish clergyman, rejected for the Church, and failed in medical practice, suddenly achieved success, after years of hack journalism, as the author of *The Citizen of the World* in 1762. He met Reynolds in the same year and they became intimate friends. Goldsmith dedicated his poem *The Deserted Village* to Reynolds and Reynolds dedicated the print of his painting *Resignation* to Goldsmith and also obtained for him the honorary Professorship of Ancient History at the Academy. Mrs Thrale noted, tartly, that Reynolds 'lent him money, loved his company, and a little laments his death' (Piozzi 1951, I, p. 80), but Northcote remarked that Goldsmith's death in 1774 was 'the severest blow Sir Joshua ever received—he did not paint all that day' (Hazlitt 1830, p. 169). Reynolds arranged for the monument to Goldsmith to be erected in Westminster Abbey and drafted an acute literary portrait of his friend (Hilles 1952, pp. 44–59) which reveals remarkable sympathy for the poet's vulnerability (see also Boswell 1934–50, I, note pp. 412–13). This is also conveyed by the painting which the artist's sister considered 'a very great likeness' but the 'most flattered picture she ever knew her brother to have painted'.

A portrait was exhibited at the Academy in 1770 ('Portrait of a Gentleman', no. 151), companion with one of Dr Johnson, and a note on the technique of both paintings suggests that they were completed in 1769 (see Cat. 73). An appointment for Goldsmith is recorded in Reynolds's pocket-book for 29 January 1768, possibly for a sitting, although other appointments in that year and the next seem to be social (either outside daylight hours or with no specific time given). As with Johnson and Burke, we must suppose that Goldsmith

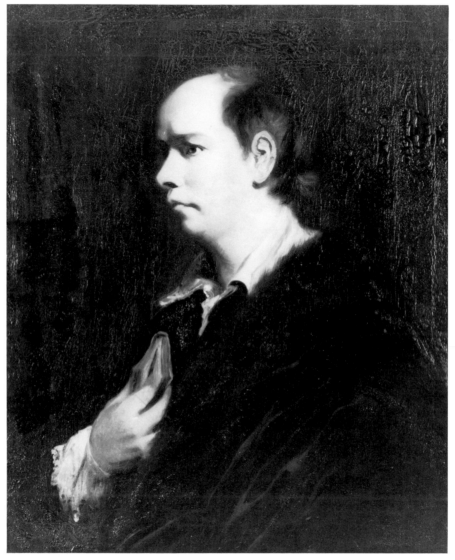

79

knew the artist well enough to make chance calls during periods (such as the summer months of 1769) when he was not busy with other sitters.

Northcote is quite explicit that the original portrait is the painting at Knole. This version, which comes from the Breakfast Room at Woburn Abbey, was acquired by the Duke of Bedford at the 1816 sale of the Thrale portraits at Streatham and was described by Mrs Thrale herself as a duplicate (Piozzi 1861, II, p. 170). It is inscribed 'Oliver Goldsmith 1772 Reynolds fecit', on an old label on the stretcher, evidently in Mrs Thrale's hand and once apparently signed by her. Given that it was intended to hang with original portraits in a room where his own friends constantly sat, it is likely to be a duplicate painted by Reynolds himself—a view supported by its high quality. In neither this nor the Knole painting, however, are the original forms of the cloak which Goldsmith wears as clear as they are in the version (perhaps a studio replica) in the National Portrait

Gallery. Aileen Ribeiro points out that 'the open linen collar recalls the dress of the early seventeenth century and the way that the folds of the shirt are depicted at the wrist almost looks like a spiky vandyke lace cuff'. Clothes of this sort were considered especially appropriate for artists and writers— perhaps especially writers of comedies—but there is no suggestion of fancy dress, only of classical gravity, in the companion portrait of Johnson. N.P.

PROVENANCE Painted for Henry Thrale; his widow, Mrs Piozzi; sold with the contents of Streatham Park, Squibb, 10 May 1816 (60), bt for the Duke of Bedford; by descent.

EXHIBITED British Institution 1813 (122); Royal Academy 1968 (35); Arts Council 1984 (68).

LITERATURE Northcote 1818, I, pp. 325–6; Leslie and Taylor 1865, I, pp. 349 (note), 361; Tavistock 1890, no. 254; Graves and Cronin 1899–1901, I, p. 369; Waterhouse 1941, p. 61; Cormack 1970, p. 143.

No early engraving of this version recorded.

WILLIAM DOUGHTY (after Reynolds)

80 Samuel Johnson LLD

45.1 × 32.8 cm
The Trustees of the British Museum

This mezzotint, published on 24 June 1779, reproduces the portrait of Johnson (now in the Tate Gallery) which Reynolds painted for the library of Henry Thrale's house at Streatham—part of the series which included Cat. 79, 85 and 125. It depicts Johnson in his normal daily dress and conveys the mental power which he applied to ordinary conversation. Johnson, in letters of October 1778 to Mrs Thrale, refers to sittings for his portrait by Reynolds which, he observed,

'seems to please everybody, but I shall wait to see how it pleases you'. This need not mean that this particular portrait was for her, and Mrs Thrale's own annotations to her edition of Johnson's letters remarked that the Streatham portrait dated from 1772. Topham Beauclerk paid Reynolds for a 'copy of Mr. Garrick and Dr. Johnson' (surely two copies, not a double portrait) in February and November of 1779 (Cormack 1970, p. 145). The Beauclerk portrait of Johnson is similar to the Streatham painting, although it can hardly have been an ordinary copy if several sittings were needed for it. The problems, which have not been solved, are most fully discussed by K. K. Yung (Arts Council 1984, pp. 117–18). If Reynolds was copying the Thrale portrait he would have had it sent to his studio from Streatham, and in that

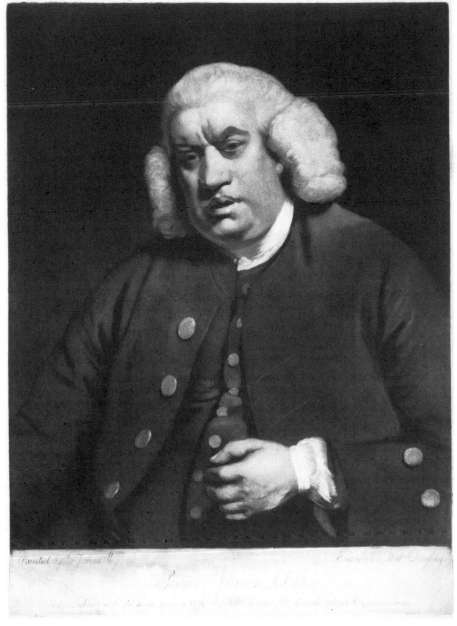

80

case it would have been convenient for Doughty to make his mezzotint at the same time. In fact all the Streatham portraits seem to have been in Reynolds's studio in the second week of July 1780 when he was described as 'touching up' the series and also as having 'already ordered the frames'. The paintings were at Streatham by January 1781 (Burney 1842–6, I, p. 416; II, p. 5). For other portraits and caricatures of Johnson see Cat. 73, 196, 198 and 199.

William Doughty (1757–80) was a protégé of the poet and friend of Reynolds, William Mason. He studied with Reynolds between 1775 and 1778 and then seems to have attempted to make an independent career first in York, then in Ireland. On his return to London, probably at the end of the year, Reynolds encouraged him, as he had also encouraged Marchi, to take up mezzotint engraving. North-cote recalled (Fletcher 1901, p. 232) that Reynolds's enthusiastic comment upon seeing this plate—'I would advise you by all means to stick to mezzotint'—was mistaken by

Doughty as an indirect hint to give up painting. In 1780 Doughty married one of Reynolds's servants, left for India, was captured by the French and Spaniards and died at Lisbon (for his career generally see Ingamells 1964, pp. 33–7). N.P.

LITERATURE J. Chaloner Smith 1875–83, no. 2 (2); Russell 1926, no. 2 (3).

81 Miss Mary Meyer in the Character of Hebe

130 × 100 cm
The National Trust—Rothschild Collection, Ascott

Although the mezzotint engraving of this painting was simply entitled 'Hebe', it was exhibited as a portrait of a young lady as Hebe—an idea quite popular in the portraiture

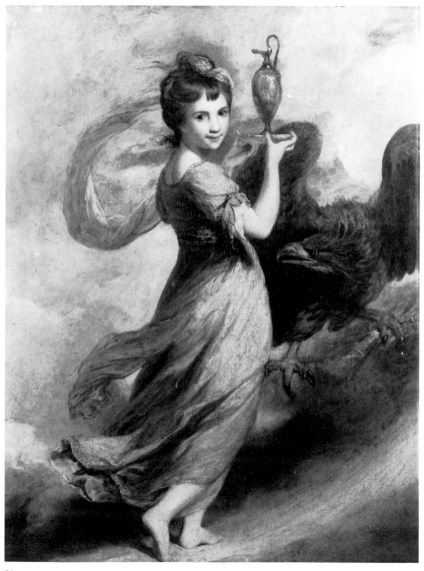

81

of the period. Hebe, who served nectar to Jupiter (represented here in the shape of an eagle), seems to have done nothing improper, so ladies were content to be associated with her, and their husbands and fathers were doubtless gratified by the theme of gracious and decorous service to male needs. Reynolds had painted Mrs Pownall as Hebe in 1762 and he exhibited a portrait of Mrs Musters as Hebe in 1785 (fig. 35); Cotes exhibited a picture of young lady in the character of Hebe in 1769 (exhibited at the Royal Academy of Arts, no. 28); West painted Mrs Worrell as Hebe in about 1770 (Tate Gallery, London) and Romney painted Elizabeth Warren as Hebe in about 1776 (National Museum of Wales). This painting then is slightly unusual in representing a girl rather than a woman. She was the second daughter of Jeremiah Meyer, the leading miniaturist in Britain in this period and a prominent member of the Royal Academy.

Appointments for Miss Meyer are recorded on 2 and 5 August, 17 and 19 September, 7 and 15 October, 4, 7 and 11 December 1771 and 27 January 1772. No payment is recorded in the artist's ledgers and perhaps her father did work for Reynolds in exchange. There is, indeed, a note in Reynolds's pocket-book opposite 9 January 1764: 'Mr Meyers concerning the miniature', and opposite 23 May: 'Mr Meyer to amend the miniature'. There is also a memorandum opposite the entry for 21 November 1761: 'Send to Meyers indenture'. Reynolds was close to the family. In January 1783 he recommended to his nephew in India Jeremiah's son, George, describing him as 'the son of a particular friend of mine' (Reynolds 1929, pp. 97–8).

Details of the Meyer family are to be found in the Journals of Mrs Meyer's friend, Mrs Papendiek (1887, II, pp. 43–6). The eldest daughter was Charlotte who was plain and

Fig. 73 Anon. (after Parmigianino, *Circe*), chiaroscuro woodcut (Ashmolean Museum, Oxford)

'idiotish', and Mary was said to be ill-tempered and attempted to run away from home. This seems hardly surprising in view of their father's regret that they were girls and his decision to send them away to board at an early age,

to give them only the most basic education and only plain, rough clothes. But the existence of this portrait suggests that the parental attitude was not so simple.

Walpole annotated his Academy exhibition catalogue with the observation that the pose was taken from a print of Fortune 'I think by Goltzius, but far more airy and graceful'. What he had in mind is not clear, but Reynolds's source was surely a design by Parmigianino of Circe (fig. 73) known both as an engraving by Bonasone and as a chiaroscuro woodcut. The eagle was presumably painted from the stuffed bird in the studio mentioned by Northcote (1818, II, p. 32): its right claw collides uncomfortably with the girl's gracious contour. Traces of pink in the sky above the girl's head perhaps indicate the original line of the billowing diaphanous scarf. The painting of the highlights of the dress is achieved by dragging dry paint of a creamy colour over russet pink—a particularly effective example of this type of handling in Reynolds's work. N.P.

PROVENANCE Painted for Jeremiah Meyer; by descent to the Delafield family of Bath from whom bt, 1873, by Baron Lionel de Rothschild; by descent.

EXHIBITED Royal Academy, 1772 (205. 'Portrait of a Young Lady in the character of Hebe'); British Institution 1813 (28—added to the exhibition); Royal Academy 1873 (39).

LITERATURE Leslie and Taylor 1865, I, pp. 427, 444–5; Graves and Cronin 1899–1901, II, pp. 642–3; Waterhouse 1941, p. 62.

ENGRAVED Jacobe, 1780.

82 Count Hugolino and his children in the Dungeon, as described by Dante . . .

125 × 176 cm
Lord Sackville

Count Ugolino (spelt 'Hugolino' by Reynolds) tells his story in Dante's *Inferno*, Canto XXXIII. Imprisoned in a tower with his two sons and two grandsons his fate dawns on him after a terrible dream—listening for the gaoler whom he expects to bring food, he hears the door below bolted. Then follow the lines which Reynolds supplied (with slight inaccuracies) in the Royal Academy Catalogue when he exhibited the picture there in 1773 and which are also inscribed on the canvas, as recent cleaning reveals:

Io non piangeva, sì dentro impetrai:
 piangevan elli; ed Anselmuccio mio
 disse: Tu guardi sì, padre! Che hai?—
Per ciò non lagrimai nè rispos'io
 tutto quel giorno nè la notte appresso

which may be translated:

Turned to stone I could not cry,
 but heard *them* cry and my Anselmo say,
 'Father, how you do stare! But why?'
I could not weep—all through that day,
 and through the night—and I did not reply.

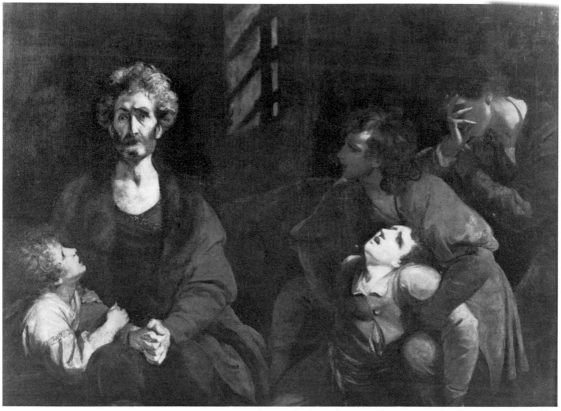

82

In the following days the children beg him to feed on their flesh and then die one by one. Starvation eventually overcomes grief. Reynolds illustrates the moment Anselmo speaks. The background of the painting has darkened considerably but originally revealed the dawn light entering the barred window—an image which plays a powerful and repeated part in the Count's narrative.

Northcote, who posed for the boy with his hand on his face, claimed that before 1771 (he arrived in the studio in May of that year) the painting was only a half-length canvas of an isolated figure and that it was either Burke or Goldsmith who urged Reynolds to develop the painting into a narrative. There are a number of other expressive single figures painted from the same model (George White, a paviour from Yorkshire, for whom see Whitley 1928, II, pp. 265–6) and the canvas on this painting has been extended. Nevertheless, if Northcote is right he has the wrong date. Sittings for 'child', 'Beggar child' and in one instance 'Hugolino Boy' (3 December) may be found in Reynolds's pocket-book for 1770, which surely suggests that at least one child was already thought of. At the back of the same pocket-book is a memorandum 'Hugolino—Mr Dixon', which suggests that Reynolds was already thinking of an engraver (although John Dixon's mezzotint was not published until 4 February 1774). Furthermore, the narrative that we see is described in the *Annual Register* for 1770 (II, pp. 194–5) as 'now painting'. On 12 and 15 June 1770 Reynolds noted 'Beggar Hugolino' in his pocket-book and on 19, 23 and

27 June, 2, 4, 7, 10, 13 and 30 July and 4, 6, 27 and 30 August 1770, 'Hugolino'. There are also appointments for George White on 5 June 1770 and 10, 16 and 23 September and 25 October 1771, as well as numerous entries for 'Beggar'. If Northcote's story is correct then the original study might date from as early as 1766, when Reynolds made a note in the back of his pocket-book of a painting of a beggar made in October (and also recorded an appointment for a beggar on 20 August). More probably, Reynolds's decision to extend the canvas was not related to a change in the subject, but simply reflected his decision to include more figures.

When exhibited in 1773 *Count Hugolino* attracted much interest, but not only approval. The *Middlesex Journal* (27–9 April 1773) felt that the subject was too disgusting for the visual arts and in its following number reprinted an attack on the painting first published in the *Morning Chronicle* by 'Fabius pictor', attributing the painting's existence to a decline in portrait 'business' and claiming that shown in France or Italy such a painting would be regarded as a joke. The painting remained in the artist's studio until 2 August 1775 when the Duke of Dorset, who collected more of the artist's fancy and history pictures than anyone else, is recorded in the artist's ledger as paying four hundred guineas for it.

Dante was not, in 1770, the popular author in England that he had become by the end of the eighteenth century and the *Annual Register*, in describing the painting in that year, considered the subject as likely to be unfamiliar to most

readers. However, the subject was almost as obvious for an ambitious painter in England as the Death of Socrates was for a painter in France at a slightly later date. This was because the leading English theorist on art, Jonathan Richardson, had, in one of his treatises (1719, pp. 26–35), discussed the episode as it was treated in a chronicle, in Dante's poem, in a relief sculpture which he believed to be by Michelangelo, and as it might be painted. He dwelt on 'the Pale and Livid Flesh of the Dead, and Dying Figures, the Redness of Eyes, and Blewish Lips of the Count, the Darkness, and Horrour of the Prison'. Richardson had first inspired Reynolds to be a painter and surely he did not need Burke or Goldsmith to remind him of this passage.

Count Hugolino enjoyed great fame and was enormously influential not only in England, but also in France, making possible, for example, Guérin's masterpiece, *The Return of Marcus Sextus*. It was, however, much criticized in the nineteenth century. Fuseli noted that the pathetic Anselmo was a 'blooming strippling' whose health seemed oddly unimpaired by the circumstances (Knowles 1831, I, p. 385) and Hazlitt, who considered this to be the only 'pleasing and natural figure', claimed that it had 'no relation to the supposed story' (Hazlitt 1873, p. 34). There is no good reason to think that the figure of Ugolino had some topical political significance, as supposed by Frances Yates. N.P.

PROVENANCE Purchased by the Duke of Dorset in 1775; by descent.

EXHIBITED Royal Academy 1773 (243: title as above); British Institution 1813 (31), 1823 (48), 1833 (14), 1843 (48), 1851 (56); Royal Academy 1873 (46), 1895 (97).

LITERATURE Cumberland 1806, p. 258; Northcote 1818, I, pp. 278–83; Knowles 1831, I, p. 385; Leslie and Taylor 1865, II, pp. 20–1; Graves and Cronin 1899–1901, III, pp. 1218–21; Waterhouse 1941, p. 63; Yates 1951; Cormack 1970, p. 150.

ENGRAVED Dixon, 1774; S. Cousins.

JOHN DIXON (after Reynolds)

83 Ugolino

50.4 × 62 cm
The Trustees of the British Museum

83a Adamo Scultori, after Michelangelo, *Aminadab*

This superb mezzotint was published by Boydell on 4 February 1774 and exhibited at the Society of Artists exhibition as no. 83 on 25 April of the same year. (For Dixon see Cat. 68; for the painting reproduced see Cat. 82.) It seems to have been one of the few mezzotints after Reynolds which

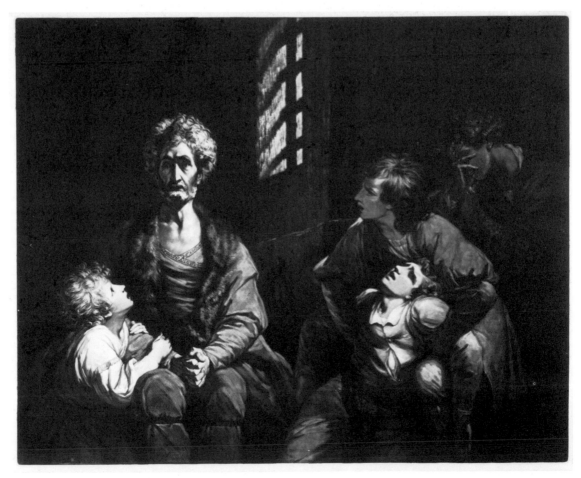

83

was priced as high as the large plates after his full-length portraits of society beauties—that is, at fifteen shillings. N.P.

LITERATURE Hamilton 1874, p. 121.

The mezzotint is here displayed beside an engraving by Adamo Scultori—no. 60 in the series of Ancestors of Christ after the frescoes by Michelangelo in the Sistine Chapel (Cat. 83a, fig. 90). As discussed in the essay 'The Conjuror unmasked' (p. 347), Nathaniel Hone implied that Reynolds derived the pose of Ugolino himself from this source. These prints were the most convenient way of studying Michelangelo's inventions even for artists like Reynolds who had been to Rome—see also Cat. 59 and 59a. J.N.

JOHN RAPHAEL SMITH (after Reynolds)

84 The Infant Jupiter

49.7 × 35.3 cm
The Trustees of the British Museum

84a Carlo Maratta, *The Infant Christ adored by Angels*

Reynolds's painting of the infant Jupiter—'a sturdy young gentleman sitting in a doubtful posture' (Hazlitt 1873, p. 33)—was exhibited at the Royal Academy in 1774 (225) and this mezzotint engraving was published in the following year on 20 May (the date given on the third state; 5 June is given on the fourth state) and exhibited at the Society of Artists in 1776. The painting seems to have been paid for

84

by the Duke of Rutland in May 1782—one hundred guineas is given as the sum owed and £100 as the sum paid (Cormack 1970, p. 162). It was among the paintings destroyed by the fire at Belvoir Castle in 1816.

John Raphael Smith (1752–1812) engraved forty-one plates after Reynolds between 1774 and 1784. N.P.

LITERATURE Frankau 1902, pp. 147–8.

The mezzotint is here displayed beside the etching after Carlo Maratta of the Infant Christ adored by Angels from which Reynolds derived his infant Jupiter (Cat. 84a, fig. 97, National Galleries of Scotland). The borrowing, as discussed in the essay 'The Conjuror unmasked' (p. 348), was detected by Nathaniel Hone. Nicholas Penny points out that there were numerous prints after Maratta in Reynolds's collection (studio sale, Phillips, 5–26 March 1798, lots 19, 20, 75, 85, 322, 329). J.N.

85 Guiseppe Baretti

73.7 × 62.2 cm
Private Collection

The handling in this portrait is exceptional, and so too is the condition of the surface. The black dashes for the eyebrows, the red in the nostril, the lights on the buttons, the monocle and, above all, the creases of the waistcoat are

85 *reproduced in colour on p. 122*

executed with spontaneity and decision; the paint retains its relief and the colours their strength and there is no evidence of suffering from either restorers or from Reynolds's own rash technical experiments. The vigorous characterization would have been indecorous in the portrait of a social superior, and unlikely except in the portrait of a friend.

Giuseppe, or Joseph, Baretti (1719–89), from Turin, had

achieved a minor literary reputation in Italy before he came to London in 1751. Within a couple of years he was part of the circle of Reynolds and Johnson. In 1760, when his highly successful *Dictionary of the English and Italian Language* was published, he returned to Italy. Having multiplied his enemies but also greatly increased his fame with his polemical periodical *Frusta Letteraria*, he returned to settle in England in 1766. He attracted much notice with his *Travels through Spain, Portugal and France* (the engaging, egotistical style of which Reynolds parodied in a manuscript, published as an appendix by Hudson in 1958), and still more notice by stabbing a pimp to death with his pocket-knife in a street brawl in 1769. His acquittal of the charge of murder was due to testimonials given to the court by Burke, Garrick, Johnson and Reynolds.

Thanks to Reynolds, Baretti was appointed Secretary for Foreign Correspondence at the Royal Academy in the same year as his trial (Hilles 1936, p. 40) and it was in this capacity that he wrote the official *Guide* to the Academy when its new premises were opened. He also translated Reynolds's *Discourses* into Italian (ibid. pp. 53–60). Baretti was introduced by Johnson to the wealthy Thrale family with whom he resided between 1773 and 1776 as tutor in Italian and Spanish to their children (Piozzi 1861, 1, pp. 92–109). Henry Thrale commissioned this portrait from Reynolds for the series in his library at Streatham Park (payment for the series was made in large blocks, see Cormack 1970, p. 164).

On 14 August 1773 James Beattie and his wife dined with Reynolds and his sister. 'Baretti was there,' wrote Beattie in his diary, 'whose picture Sir Joshua has just finished. It is a very fine performance, and took up just eight hours in painting' (Beattie 1946, p. 82—reference supplied by David Mannings). Evidently as a friend Baretti did not need to make proper appointments since no clue to this is given by the pocket-book. The summer months, of course, were not busy for Reynolds.

The portrait was exhibited at the Academy in 1774. Reynolds would certainly have known of the startling portrait of Baretti which James Barry had shown at the Academy in 1773 (fig. 74; Pressly 1981, pp. 68–9, 238), and he probably also already sensed Barry's increasing resentment of his pre-eminence in the art world. Both artists emphasize the defective vision of the sitter as a means to convey his ferocious intelligence, but the impoverished Barry casts Baretti as a scholar in a garret whilst the affluent Reynolds depicts him as a critic in a library chair. As Aileen Ribeiro points out, Baretti, whose own vanity and interest in sartorial psychology are clear from his writings, sat in 'a plain brown English cloth frock coat and a white silk waistcoat. His own hair is worn with the back hair or queue turned up on itself and tied round the middle—the catogan style then favoured by the "macaronis", as ultra fashionable young men were then known.' Baretti had earlier been painted by Subleyras in an equally impressive portrait recently acquired for the Louvre.

If Reynolds's portrait was sent to Streatham Park after the Academy exhibition of 1774, it must have been returned to Reynolds, who was described as 'touching up' the series and

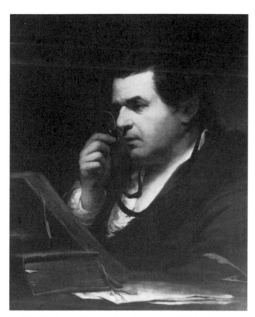

Fig. 74 James Barry, *Joseph Baretti*, exhibited 1773
(John Murray Publishers Ltd)

also as having 'already ordered the frames' in the second week of July 1780. It was then at Streatham by 4 January 1781. Baretti's portrait seems to have hung next to that of Thrale himself (Piozzi 1861, I, pp. 177–8). When he walked out of their home in disgust the Thrales did not take it down. Nor, remarkably, did Mrs Thrale destroy it when, after her second marriage, Baretti viciously and remorselessly abused her in a series of articles in the *European Magazine* (ibid. I, pp. 301–15). N.P.

PROVENANCE Painted for Henry Thrale; his widow, Mrs Piozzi; sold with the contents of Streatham Park, Squibb, 10 May 1816 (65); bt George Watson Taylor; Christie's 13 June 1823, bt in; sold 1832 by Robins to Taylor acting for the Marquess of Hertford; exchanged by 1843 for a portrait by Reynolds of Lady Irwin in Holland House; Lady Holland; by descent.

EXHIBITED Royal Academy 1774 (223: 'Portrait of a Gentle-man, three-quarters'); British Institution 1813 (119), 1843 (52); South Kensington 1867 (567); Royal Academy 1871 (37); Grosvenor Gallery 1883 (73); 45 Park Lane 1937 (76); Royal Academy 1951 (77), 1968 (113); Detroit and Philadelphia 1968 (8); Arts Council 1984 (85).

LITERATURE Burney 1842–6, I, p. 416; II, p. 5; Leslie and Taylor 1865, II, p. 76; Graves and Cronin 1899–1901, I, pp. 49–50; Waterhouse 1941, p. 64.

ENGRAVED T. Watts, 1780; T. Hardy, 1794; W. Bromley, in reverse; S. W. Reynolds, in miniature.

86 Self-Portrait in Doctoral Robes

76 × 63.5 cm (framed as an oval)
Private Collection

On 9 July 1773 Reynolds was made Doctor of Civil Law at the University of Oxford. He was elected Mayor of his native Plympton in September of the same year. This portrait

of himself in his new doctoral robes presided at the Mayor's feasts held in the Corporation dining-room adjacent to the Guildhall, at once an apology for his absence and a substitute for his presence. Sir William Elford reported that he had hung it between portraits of Commissioner Ourry and Captain Edgcumbe, which served as dark foils to its brilliance—Reynolds, we are told by Northcote, was amused that Elford seemed not to realize that these dark portraits were also his work (see Cat. 11).

Letters about the portrait written by Elford in old age to a Mrs Treby and by her to the Plymouth artist and dealer Nicholas Condy and by Condy to the 4th Earl of Egremont (all of which survive in the possession of descendants of the latter) shed much new light on the picture's history. Elford recalled that it was in 1782 or 1783 or 1784 that he 'received a letter from Sir Joshua Reynolds, just before the time of choosing the Mayor, stating that he had long & often made a promise to Lord Mount Edgcumbe & Commissioner Ourry to send them his portrait to be placed in the Guildhall at Plympton—that he had painted the picture, *which was begun & finish'd in the same day*, & should send it off in a packing case directed to me, & begging that I would, as secretly as might be, get it hung up before the ceremony of choosing the mayor took place—there was a disappointment as to the surprize by the picture not arriving in time, & some other circumstances attending the transaction . . .'. There is no need to doubt the veracity of any of this except the date. The

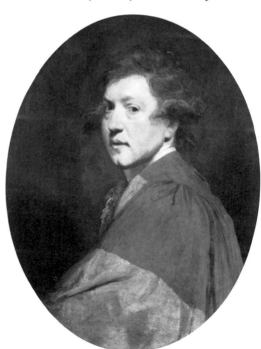

86 *reproduced in colour on p. 121*

'other circumstances' concerned the hanging of the picture and the fact that 'saw dust & other foul matter' from the packing case had 'stuck to the varnish'. This of course is also evidence of the haste with which Reynolds had dispatched the picture. It has previously been assumed that Reynolds

presented the painting after he had been elected, although if so, he could have taken it with him on his visit to Plympton that autumn.

Mrs Treby pointed out that when Reynolds sent these portraits—'it was long before the days of reform'—he would have identified the Corporation entirely with the two families of Ourry and Edgcumbe. The Corporation of Plympton was disfranchised in 1832 and the Corporation of Plymouth then sought to dispose of this picture. Lord Morley (of Saltram) claimed that it should be given to him in compensation for privileges he had lost with the disfranchisement (he did in fact acquire the portrait of Ourry, Cat. 11). Lord Mount Edgcumbe also had a strong claim to the painting and was prepared to pay for it—but not the 150 guineas at which the work was valued by Messrs Woodburn. This also turned out to be too much for the National Gallery and for Sir Robert Peel, and the portrait did not reach this sum at Christie's—it was alleged that purchasers had been inhibited by the opinion of the President of the Royal Academy, Martin Archer Shee, that the painting was a mere preliminary sketch. After some haggling, Lord Egremont, who was anxious to add paintings by Sir Joshua to his collection at Silverton Park (which he intended to rival Petworth, the seat of the previous Earl), seems to have paid the 150 guineas in the summer of 1838.

The painting, despite its difficult journey to Plympton, is in good condition—its preservation surprised Wilkie and Haydon when they saw it in 1809 (Haydon 1960–63, v, p. 580). It will immediately be seen that abundant use has been made of vermilion both in the robes and in the florid face. We know from Northcote that Reynolds had, at an earlier date, a strong prejudice against this pigment and had preferred the lakes and carmines which have fled, leaving so many of his faces ghostly. A note on the technique in the back of his ledger reads 'My own Picture sent to Plimpton, Cera poi verniciato [smudged] senza olio—colori: Cologns earth [also known as Cassel earth, a dangerous brown pigment], vermillion the cloth varnished first with copalvarnish white and Blue [cancelled] on a common colouring cloth on a raw cloth'. It is clear from the next note that Reynolds made another version of the self-portrait at the same time, probably the painting today in the Tate Gallery. None of the numerous other versions is likely to be autograph. N.P.

PROVENANCE Painted for Plympton Corporation; Christie's, 7 July 1835 (173), bt in; sold to 4th Earl of Egremont 1838; Egremont sale, Christie's, 21 May 1892 (88), bt in; by descent.

EXHIBITED Plymouth 1951 (47); Birmingham 1961 (56).

LITERATURE Northcote 1818, I, p. 303; Cotton 1859 ('Some Account'), pp. 92–7; Leslie and Taylor 1865, II, p. 36; Graves and Cronin 1899–1901, II, pp. 796–7; Cormack 1970, p. 169.

No early engraving recorded.

87 Dr James Beattie: 'The Triumph of Truth'

122 × 155 cm
University of Aberdeen

James Beattie (1735–1803), Professor of Moral Philosophy at Marischal College, Aberdeen, travelled to London in the spring of 1773. At the height of his short-lived fame as the author of the *Essay on the Immutability of Truth*, he hoped to extract a pension from the King. 'To this end,' observes his modern editor, Ralph Walker, 'he directed all his energies, determined to leave, if necessary, no official unpestered and no man of influence unplagued.' The first meeting with Reynolds recorded in his diary is on 17 May, and on 3 June he records sitting for his portrait by Miss Reynolds, who, he wrote, 'wishes to engage her brother Sir Joshua to take another picture of me, and is sure he will do it, if he can by any means find time'. That evening Beattie and his wife dined at the house of Mr Vesey (an Irish Member of Parliament and friend of Burke) 'where there was much company,' including Reynolds who talked about Beauty and recommended to Beattie his *Three Letters to the Idler*. On 5 June Reynolds showed him his pictures and presented him with a *Discourse*. They conversed some more about art, and Beattie sat another hour to Miss Reynolds. Further sittings are recorded. On 30 June Beattie was presented to the King, who told him he had read his book and approved of it greatly.

On 9 July Beattie and Reynolds, together with thirteen others—mostly political henchmen of Lord North—were awarded the honorary degree of Doctor of Civil Law at Oxford. The ceremony, which Beattie describes in detail in his diary and in letters to friends, took place in the Sheldonian Theatre under Robert Streeter's ceiling painting of the 'Triumph of Truth and the Arts'. The coincidence seems to have escaped Beattie but may well have provided Reynolds with an idea for the portrait of Beattie that he was, according to his sister, already planning. 'Of those that received this degree at the same time with me,' wrote Beattie, 'Sir Joshua Reynolds & I were the only persons (so far as I remember) who were . . . distinguished by an encomium and applause extraordinary.'

On 11 August Beattie and Reynolds dined together and afterwards went to 'the Queen's House' (later rebuilt as Buckingham Palace) to see the Raphael Cartoons. They discussed Beattie's portrait. 'Sir Joshua proposes,' wrote Beattie in his diary, 'to paint an Allegorical picture representing me and one or two more lashing Infidelity &c. down to the bottomless pit, and desires me to think on the contrivance of it.' On 14 August he noted that 'Sir Joshua is determined soon to begin the Allegorical picture , if he can possibly find time.' Two days later, work started:

'MONDAY 16 AUGUST. Rainy & gloomy throughout. Breakfasted wt. Sir Joshua Reynolds, who this day began the Allegorical picture mentioned the 11th current. I sate to him five hours, in which time he finished my head, and sketched out the rest of my figure:—the likeness is most

87

striking and the execution masterly. I stand at one end of the picture dressed in a Doctor of Laws gown & band, & wt. the *essay on Truth* under my arm; the figure as large as life: the plan is not as yet fixed for the rest of the picture, but Sir Joshua means to finish it wt. all expedition, and proposes a print to be done from it.—Though I sate five hours, I was not in the least fatigued; for, by placing a large looking glass opposite to my face, Sir Joshua put it in my power to see every stroke of his pencil; and I was greatly entertained to see the progress of the work; and the easy and masterly manner of the Artist, which differs as much from that of all the other painters I have seen at work, as the execution of Giardini differs from that of a common fiddler.'

This seems to have been Beattie's only sitting—it is curious that it was not recorded in the artist's pocket-book. Beattie was ill next day 'with a colick and gripes', and worse the day following. Reynolds must have continued working on the picture that week without the sitter; on 21 August Beattie recorded that 'Lady Mayne & Miss Grahame called . . . on

their way to Sir J. Reynolds's to see this new picture, which is advancing apace, and gives great satisfaction to all who see it.' On 23 August he dined with the painter and noted that 'the picture still advances. The angel representing Truth is a most beautiful figure.' On 8 September the Beatties began the long journey back to Aberdeen.

Reynolds must have changed his mind about including other portraits (if that is what he meant) in the composition. As a single portrait, *The Triumph of Truth* seemed to some people a piece of excessive flattery, and the presence of Voltaire amongst the demons of error earned the scorn of, most notably, Goldsmith. In ten years, he told Reynolds, Beattie and his book will be forgotten, whereas Voltaire's fame will live for ever, to the painter's disgrace as a flatterer. Northcote, who was an assistant in Reynolds's studio and says he painted the draperies in this picture, insists that Beattie himself cannot be blamed, 'as the head alone was the only part of it that was finished when the Doctor left London' (he may have been wrong about that, as we have seen).

It is certainly true that the composition was decided by the artist. 'He is very happy in this invention,' Beattie wrote to Mrs Montagu, 'which is entirely his own.' In fact the composition clearly derives, as Northcote records, from a Venetian picture described as 'a fine picture by Tintoretto, of a subject somewhat similar, which is in the King's library at Buckingham House'. Both artist and sitter must have looked at this picture, now identified as the *Expulsion of Heresy* by Palma Giovane and hanging at Hampton Court (fig. 75), when they visited the 'Queen's House' on 11 August. 'As to the portrait of Voltaire,' says Northcote, 'that

Fig. 75 Palma il Giovane, *Group portrait with an allegory of the expulsion of Heresy* (H.M. The Queen)

Sir Joshua certainly intended to represent in the group, for I well remember, at the time, his having a medal of him, from which he copied the likeness. But as to Hume, I am as certain that he never intended to place him in the picture.' This may seem odd, for Beattie's *Essay* was an attack on Hume, not Voltaire, and in his diary Beattie records Hume's supposed consternation (there is, of course, not the slightest reason to think that Hume took Beattie's *Essay* seriously enough to be upset by it). In fact, as Edgar Wind pointed out, Voltaire was regarded by his younger contemporaries as the predecessor of Hume and Gibbon in the new anti-heroical approach to history, and this 'genealogy' was sufficiently well established in the public mind for all three writers to be instantly recognized in the group of 'sceptics and infidels' as Beattie calls them in a letter to Mrs Montagu (Wind 1939, note 1 p. 116). When Reynolds wrote to Beattie on 22 February 1774 to say the picture was almost finished ('there is not above a day's work remaining to be done') he remarked that 'Mr Hume has heard from somebody, that he is introduced in the picture, not much to his credit; there is only a figure covering his face with his hands, which they may call Hume, or any body else; it is true it has a tolerable broad back. As for Voltaire, I intended he should be one of the group.'

The figure of Truth, habited, as Beattie described her in a letter to Mrs Montagu, 'as an angel, with a sun on her breast' is an equally intriguing figure. We would expect her

to carry a sword, but Reynolds has given her scales, perhaps an allusion to the classical figure of Equity. In his popular *Dialogues upon the Usefulness of Ancient Medals*, Addison discusses this symbolic figure and quotes Dryden: 'But thou, no doubt, canst set the business right, / And give each argument its proper weight: / Know'st with an equal hand to hold the scale' (op. cit. pp. 51–2). Reynolds's figure is not based very closely on Palma's; in fact, with its outstretched hand over the heads of the victims it is closer to the angel who hovers over the *Expulsion of Adam and Eve* painted by Masaccio in the Brancacci Chapel in Florence. This would seem an unlikely source for an eighteenth-century painter, but in fact Reynolds knew the frescoes well and discussed them in his *Discourses*.

The painting dates from the moment when, with an eye on the bare walls of St Paul's, Reynolds perhaps hoped to appear as a defender of the Anglican establishment. Professor Murray remarked, 'he translated a propagandist picture of the Counter-Reformation into the language of the Anglican dispensation—elegantly symbolized by the substitution of scales for a sword—and his translation was not then, and is not now inferior to the original.' D.M.

PROVENANCE Given to Beattie by the artist, 1776; Beattie's niece, Mrs Margaret Glennie; her daughters, Helen and Margaret Glennie; bequeathed by Miss Margaret Glennie to the University of Aberdeen, 1881.

EXHIBITED Royal Academy 1774 (221: 'The Triumph of Truth, with the Portrait of a Gentleman'); British Institution 1846 (19), 1862 (146); South Kensington 1867 (686); Royal Academy 1956 (304).

LITERATURE Northcote 1818, I, pp. 299–303; Leslie and Taylor 1865, II, pp. 29–33; Graves and Cronin 1899–1901, I, pp. 65–6; Reynolds 1929, pp. 39–40; Wind 1931, pp. 196–9; Mandowsky 1940, pp. 195–201; Waterhouse 1941, pp. 18, 64; Murray 1944, pp. 227–9; Walker 1944, pp. 224–6; Beattie 1946, p. 83; Waterhouse 1973, p. 47.

ENGRAVED J. Watson, 1775; T. Gaugain, 1805 and 1807; F. Bartolozzi.

CHARLES WILKIN (after Reynolds)

88 Cornelia

50.9 × 39 cm
The Trustees of the British Museum

Augusta Anne, daughter of the Rev. Francis Ayscough, Dean of Bristol, was married in 1769 to Sir James Cockburn, Bt (c. 1729–1804), as his second wife. She had appointments with the artist on 1, 8 and 9 September in 1773. Reynolds then went on a trip to the West Country but on his return appointments for Master Cockburn (it could be either of her two elder boys) are noted for 13, 20, 21 (cancelled), 22 and 27 October and 11, 12, 23 and 24 November. Reynolds also had an appointment with Sir James on 24 November at three o'clock. There was a final appointment for Lady Cockburn on 8 December, perhaps with her younger boy ('Chi . . .' is added). Northcote recalled that the macaw, curtain and landscape were an afterthought (1818, II, pp. 29–30). The macaw was a favourite pet in Reynolds's household at this

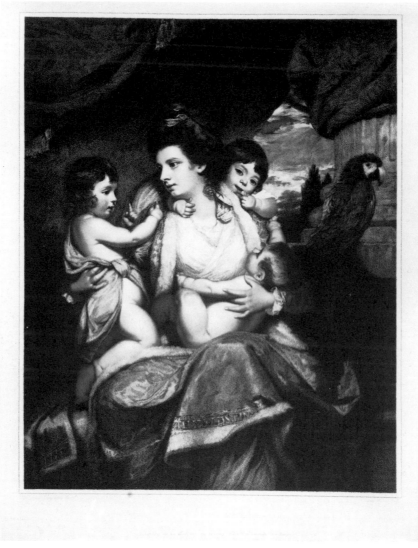

88

date and when Hannah More met Dr Johnson there in 1774 Johnson had it perched on his hand (Roberts 1834, I, p. 48). Reynolds's pleasure in the painting is reflected in his decision to sign it on the hem of Lady Cockburn's robe (Cotton 1856, p. 167); he also dated it 1773. The painting, which is now in the National Gallery, London (Davies 1959, pp. 84–5), was exhibited at the Royal Academy in 1774 (no. 220: 'Portrait of a lady with three children') and Reynolds was paid £183. 15s (including frame) in March of that year (Cormack 1970, p. 148).

Lady Cockburn died aged eighty-eight in 1837, having seen her three eldest boys all achieve considerable eminence. James, the kneeling child (born 21 March 1771) became a General and the 9th Baronet; George, who embraces his mother (born 22 April 1772), became an Admiral and the 10th Baronet and William, the baby (born 2 June 1773), became an eminent churchman and the 11th Baronet.

The painting was etched by Wilkin (1750–1814) in stipple which was his preferred, and also an increasingly fashionable, manner of printmaking. The print was published on 1 December 1791 and in subsequent states entitled *Cornelia* (the Roman mother of the Republican period who boasted that her children were her only jewels). Sir James apparently would not permit his wife's name to be exposed in public; the topical references in the portrait were minimal, which made the change possible. Graves and Cronin (1899–1901, IV, p. 1283) published an interesting advertisement by Wilkin to the effect that Reynolds had permitted him to exhibit a proof of the print in the exhibition of his Old Master paintings ('Ralph's Exhibition'). This must have been in April or May 1791. The principal parts only were finished but they were, he hoped, sufficient to attract orders and the print would be ready for delivery by the following December.

N.P.

LITERATURE Hamilton 1874, pp. 69–70.

89 Charles Coote, Earl of Bellomont KB

245 × 162 cm
National Gallery of Ireland

The subject of this, one of Reynolds's most spectacular portraits, is gorgeously dressed as a Knight of the Bath, with gold collar and pendant and on his left shoulder the Star of a Knight Grand Cross of the Order. His robe (the original red used by the artist has unfortunately faded to pink) is worn, as Aileen Ribeiro points out, over a surcoat of matching silk with a coat and breeches of white satin, and with the remarkable silk hat with its panache of towering white ostrich plumes (of the same model as that engraved in John Pine's book, *The Procession and Ceremonies of the Installation of the Knights of the Bath on the Institution of the Order, 17 June 1725*, published in 1730). The Order of the Bath, although it had roots in the Middle Ages, was revived in 1725, as a wholly new order of chivalry modelled closely on the more ancient Order of the Garter (see Cat. 30). It was Sir Robert Walpole who, for purely political ends, persuaded George I to create this new prize to be bestowed, initially at any rate, to his own nominees. He took one of the red ribands himself to encourage acceptance of this as an alternative to the blue riband of the Garter (Nevinson 1954, p. 159).

Lord Bellomont was made a Knight of the Bath for his part in quelling an insurrection in the north of Ireland. His investiture was performed by the Lord Lieutenant at Dublin Castle on 16 January 1764. In the background of Reynolds's portrait can be seen the helmets and banners of recently invested Knights, while the sitter's own banner (with its emblematic coot) stands beside him.

Reynolds must have welcomed this commission, fully appreciating the decorative effect of such pictures. They could be relied upon to make the maximum impact, both on the overcrowded walls of the Royal Academy where this was first shown in 1774, and subsequently when hung in dignified and spacious country-house settings.

'Sir Joshua,' wrote Northcote to his brother Samuel on 27 October 1773, 'is about a very fine whole-length of Lord Bellamont [*sic*], who was shot by Lord Townshend in a duel' (Whitley 1928, II, p. 295). The duel, in which Bellomont received a bullet in the groin, occurred on 2 February 1773, and was by no means the only scandalous incident in the career of this Valmont-like figure, who on one occasion seduced a respectable tradesman's daughter by means of a sham marriage, his servant performing the service disguised as a parson.

Charles, Lord Coote, Baron of Coloony, was baptized on 12 April 1738, son and heir of Charles Coote and Prudence Geering. He was Member of Parliament for Co. Cavan in 1761–6. Soon after being made Knight of the Bath he succeeded his cousin, the 3rd Earl. He married Emily Mary Margaretta, daughter of the Duke of Leinster on 20 August 1774. In 1780 Sir Herbert Croft expressed in print his regret that Bellomont's virtues had not 'kept pace with his comliness or his bravery', and in 1786 he was characterized, again

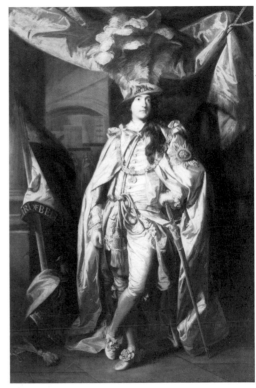

89 *reproduced in colour on p. 118*

in print, as 'the Hibernian Seducer'. From a letter written by the Marquess of Buckingham on 13 May 1789, in which he is referred to as 'that madman', it appears that he was then separated from his wife, and that the King had desired him to take her back to his house. Lady Bellomont was also painted by Reynolds; two payments of 150 guineas for portraits of 'Lord and Lady Bellamont' [*sic*] are recorded in the artist's ledger against the date 2 February 1778. Appointments for Lord Bellomont are recorded in the pocket-book for 1773—on 30 August, 3, 7 and 10 September—and it is possible that there were further sittings in 1774, but the pocket-book for that year is missing. Lord Bellomont died on 20 October 1800. Nicholas Penny notes that the splendid carved frame, of a type favoured by Palladian architects, appears to be original. D.M.

PROVENANCE By descent to Sir Charles Coote; his sale, Christie's, 3 July 1875 (51), bt Doyle, for National Gallery of Ireland.

EXHIBITED Royal Academy 1774 (219: 'Portrait of a nobleman in the robes of the order of the Bath; whole length').

LITERATURE Leslie and Taylor 1865, II, pp. 46–7; Graves and Cronin 1899–1901, I, p. 79; Waterhouse 1941, p. 64; Cormack 1970, p. 147; Burke 1976, p. 206.

No early engraving recorded.

90 *reproduced in colour on p. 124*

90 The Montgomery Sisters: 'Three Ladies Adorning a Term of Hymen'

233.6 × 291 cm
The Trustees of The Tate Gallery, London

The painting represents the three daughters of Sir William Montgomery: Barbara (?1757–88), the youngest, on the left gathering flowers; Elizabeth (1751–83), the eldest, in the centre, handing a garland of flowers to the third sister, Anne, Lady Townshend (?1752–1819), who decorates a statue of Hymen, the Roman god of marriage.

The circumstances of the commission are recorded in detail by Northcote. The Right Hon. Luke Gardiner, Member of Parliament for Co. Dublin and member of the Privy Council in Ireland (who had sat to Reynolds in February and March of 1773), wrote to the painter from Dublin on 27 May 1773 a letter delivered by his fiancée, Elizabeth Montgomery, who, he declared 'intends to sit to you with her two sisters, to compose a picture, of which I am to have the honour of being the possessor. I wish to have their portraits together at full length, representing some emblematical or historical subject.' The 'idea' and the 'attitudes' or poses of the figures would be entrusted to the artist. Gardiner goes on to assure Reynolds that the ladies 'will not spare their time, in order to render this picture in every particular a most superior production'. The artist would, furthermore, benefit from the opportunity of conveying to posterity the likenesses of three sisters each of whom represented a different kind of beauty. The marriage of Elizabeth Montgomery and Luke Gardiner took place on 3 July and soon afterwards Reynolds, obviously delighted with the commission, wrote back, apologizing for the delay and saying that 'this picture is the great object of my mind at present'. He had now finished the heads of the ladies, and he explained that the subject, 'the adorning a Term of

Hymen with festoons of flowers, ... affords sufficient employment to the figures, and gives an opportunity of introducing a variety of graceful historical attitudes'.

For these 'historical attitudes' Reynolds turned to the classical tradition, but the result, as we should expect, is wholly characteristic of Augustan England and perhaps even slightly tongue-in-cheek. As Gombrich writes, 'The resounding language of classical coinage which Poussin has made his natural idiom has become a graceful play. . . . The boisterous Maenads have become elegant Graces, the pagan rite of fertility has become a respectable occasion.' It was, indeed, this very playfulness that failed to appeal to some later critics. F. G. Stephens, the former Pre-Raphaelite, thought it 'a singularly whimsical design' in which 'the ladies skip with the most absurdly artificial airs . . . they charm no one now.' In fact the poses of Barbara and Elizabeth are very close to two figures in a print, identified by Martin Davies as a *Sleeping Silenus* by Natalis after Romanelli, which, although probably unfamiliar, did not escape the eagle eye of Nathaniel Hone (see Cat. 91).

It is difficult to know how much significance Reynolds intended the spectator, even within the privacy of the family circle, to read into his emblematical design, but it seems more than coincidence that Anne, Sir William's second daughter who was already married when the picture was commissioned, should be placed at the right of the group as having passed the statue of the god of marriage (Gombrich 1942, p. 43). And should we see in the colours worn by the ladies an allusion to the seasons? Spring, according to the emblem books, should be dressed in white, summer in yellow, and autumn in warm reddish-brown (Hope 1967, p. 4).

Ann Hope has also pointed to the close similarity between the poses of the three ladies and some illustrations of emblematic figures that appeared in a new edition of Ripa's *Iconology* published in sections from 1776 onwards. Her suggestion that the architect George Richardson, who designed these plates, showed Reynolds his preliminary sketches in time for the painter to incorporate them into his picture does not, however, seem entirely convincing. It is surely more likely that the influence ran the other way, and that Richardson's *Spring*, for instance, was adapted from the figure of Lady Townshend, and not vice versa. Lady Townshend seems in fact to be based on a nymph in the *Bacchanal* by Poussin (now in the Musée des Beaux-Arts, Reims) which Gombrich has already posited as a major source. It was certainly a pose that caught the imagination of Reynolds's contemporaries. A similar figure appears on the relief decorating the chimneypiece in the Portico Drawing Room at Apsley House, designed by Robert Adam *c.* 1775, and which includes the Three Graces, one of whom is crouching to pick flowers. In 1776/7 George Romney, just returned from Italy and at the height of his powers, depended upon the same prototype for the figure at the right of his *Gower Children*, now in the Abbot Hall Art Gallery, Kendal. Romney cannot have seen Reynolds's portrait at the Royal Academy in 1774, and was presumably using Watson's print.

Three Ladies adorning a Term of Hymen is one of Reynolds's largest and most elaborate attempts at what he himself calls

the 'great style', and as he points out in his last Discourse, delivered in December 1790, 'as this great style itself is artificial in the highest degree, it presupposes in the spectator, a cultivated and prepared artificial state of mind' (Reynolds 1975, p. 277). It is consistent with such an approach that the draperies should be, as Aileen Ribeiro points out, totally subservient to the overall design. Although Anne's white dress is not dissimilar in broad outline to a fashionable *déshabillé*, the dresses worn by the other two ladies make no sense as garments which were ever actually constructed. The hairstyles, as is so often the case, are closer to contemporary fashion, with their loops and plaits; in 1773 ladies were not yet piling their hair up to the heights we see in, for example, *Lady Bampfylde* (Cat. 106) or the *Marlborough Family* (Cat. 108).

Appointments for 'Miss Montgomerie' are recorded in Reynolds's pocket-book on 7, 8, 9 and 11 June 1773; for 'Miss Barbara' on 10 June 1773; and for Lady Townshend on 12, 14, 15 and 16 June, 2 and 3 July and 9, 11, 12, 13 and 26 November. The pocket-book for 1774 is missing. Payment of 450 guineas by 'Mr Gardiner, for His Lady and Sisters' is entered in the artist's ledger before July 1776.

In 1867 F. G. Stephens described the picture as 'ravaged by restoration' and Mr Christopher Holden confirms that it has indeed been restored many times. Even since Stephens wrote the varnish has been stripped and replaced no fewer than three times and the canvas has been relined. For the question of preliminary sketches see Cat. 154. D.M.

PROVENANCE Luke Gardiner; by descent to Charles John Gardiner, Earl of Blessington, who bequeathed it to the National Gallery, 1837; transferred to the Tate Gallery, 1968.

EXHIBITED Royal Academy 1774 (216: 'Three ladies adorning a Term of Hymen; whole-length'); British Institution 1833 (42 of section devoted to Reynolds); South Kensington 1862 (59).

LITERATURE Northcote 1818, I, pp. 290–3; Stephens 1867, pp. 8–9; Graves and Cronin 1899–1901, III, p. 980; Reynolds 1929, pp. 35–6; Gombrich 1942, pp. 40–5; Munby 1947, p. 84; Davies 1959, pp. 79–80; Hope 1967, p. 4; Cormack 1970, p. 153.

ENGRAVED T. Watson, 1776.

THOMAS WATSON (after Reynolds)

91 The Three Montgomery Sisters Adorning a Term of Hymen

55.9 × 68.6 cm
Rob Dixon

91a Michael Natalis, after Francesco Romanelli, *The Slumbering Silenus Tied up with Tendrils*

For the painting reproduced by this mezzotint see Cat. 90. A later state of this print carries the publication date of 1 March 1781 but Russell (1926, no. 6) recorded an early state scratched with the date 1 January 1776 and a proof of the

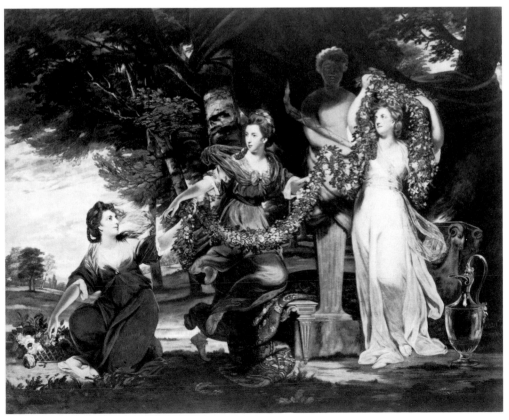

91

engraving was no. 283 at the exhibition of the Society of Artists of Great Britain which opened on 18 April 1776. This is a proof state before the title and before the inscription space was cleaned. For Thomas Watson see Cat. 67. N.P.

LITERATURE Chaloner Smith 1875–83, no. 6; Goodwin 1904, no. 26 (i); Russell 1926, no. 6 (i).

The mezzotint is here displayed beside an engraving (Cat. 91a, fig. 102) by M. Natalis after Francesco Romanelli's painting of Silenus sleeping (from Vergil's *Eclogues*, VI, lines 13ff.) which Nathaniel Hone astutely recognized as the chief source for Reynolds's painting. Hone labels the print Pietro da Cortona. Not all impressions are inscribed with Romanelli's name and Hone may have guessed that Romanelli's master, Pietro da Cortona, was responsible. As discussed in the essay 'The Conjuror unmasked' (p. 351), Hone suggested that Reynolds had also taken a pose from a print after a lost painting by Titian, but this is less convincing. Nicholas Penny points out that lot 51 of Reynolds's studio sale (Phillips, 5 March 1798) consisted of fourteen 'historical prints' after 'Romanelli etc.' J.N.

92 Cupid as Link Boy

76 × 63.5 cm
Albright-Knox Art Gallery, Buffalo, New York.
Seymour H. Knox Fund, through special gifts to the fund by Mrs Marjorie Knox Campbell, Mrs Dorothy Knox Rogers and Mr Seymour H. Knox, Jr, 1945

93 Mercury as Cut Purse

76 × 63.5 cm
The Faringdon Collection Trust, Buscot

Whereas some of Reynolds's fancy pictures are sentimental, others are witty, playful or erotic—pre-eminently these two pictures, painted and sold and always meant to hang together. The link boy was a torch carrier who guided people through the unlit streets of eighteenth and early-nineteenth-century cities. His association with Cupid, the god of love, occurs naturally enough, for Cupid sometimes holds a torch instead of the more usual bow and arrows. Dickens, and even more his illustrator, Hablot K. Browne ('Phiz'), relied on these traditional associations when they featured a link boy in a farcical scene involving an imagined elopement in Chapter 36 of *The Pickwick Papers* (1836–7). On a more serious level, the sexual exploitation which would have been a hazard of the boy's work is clearly indicated in Rochester's poem of 1680, 'The Disabled Debauchee' (cited by Crown 1984, note 10). Furthermore, link boys were notorious little thieves, and those most likely to suffer at their hands were the very people who trusted them as guides—an obvious parallel to the traditional role of Cupid. Mercury was also a messenger and guide, and was sometimes represented with a purse because he was also the god of commerce. In the

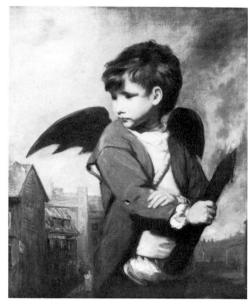

92 *reproduced in colour on p. 127*

second book of Ovid's *Metamorphoses* (lines 678–709) he is a thief, stealing cattle from Apollo while that god is distracted by thoughts of love. Reynolds's adaptation of this motif to a child pickpocket is, like *Cupid as Link Boy*, in rather a similar spirit to his earlier parody, now in Dublin, of Raphael's *School of Athens*: the gods brought down to earth, in this case in eighteenth-century London. The phallic shape of the torch and the lewd gesture with the left hand of Cupid are obvious enough and we also notice the encounter between two cats on the roof of the house at the left edge of the composition.

Mercury as Cut Purse must be seen in the same light, but the way he holds the purse makes it clear that the encounter is over. He is, in a double sense, 'spent'. Hogarth's realistic renderings of the 'Before and After' theme (Fitzwilliam Museum, Cambridge) and similar subjects illustrated by French engravers in this period, had alerted the public to this type of symbolism. Aileen Ribeiro describes Mercury as carrying 'one of the most popular forms of netted purses, known as a wallet purse. This consists of a tube of fabric (here netted silk) closed at each end with a horizontal slit in the middle of one side; the contents were placed through the slit and allowed to fall into the tube, which was then carried by the middle.' The erotic nature of such an object would have been as obvious as the broken crockery in the fancy pictures by Greuze.

When *Mercury* was exhibited in 1937, Professor Waterhouse dated it to 1774, which was confirmed as the date of both pictures when Mr St John Gore discovered Reynolds's receipt amongst the Knole archives deposited in the County Record Office at Maidstone, Kent (A 243/4): 'Recieved [*sic*] Novr. 23rd 1774 from His Grace the Duke of Dorset the sum of one hundred and twenty guineas for three Pictures of Blackguards.' As Nicholas Penny points out, this probably corresponds with three entries recorded against the Duke's name in the artist's ledger apparently at some date between

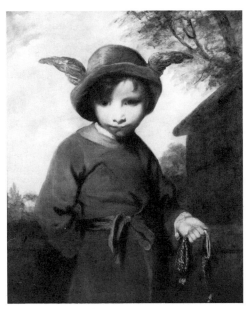

93 *reproduced in colour on p. 126*

12 May 1772 (when the ledger was opened) and 2 August 1775, one for a 'Beggar Boy', another for the same, and a third for a 'Beggar Boy with a child'—the first two items for £35 and the last for fifty guineas. The correspondence would be exact if the £35 were converted into guineas. The third painting must have been the *Beggar Boy and Sister* exhibited at the Royal Academy in 1775 (238) and once at Knole but now with the *Mercury* in the Faringdon Collection.

The Duke of Dorset was one of Reynolds's imaginative patrons. He purchased his ambitious history painting *Hugolino* (Cat. 82) and several other fancy paintings (*Boy with a drawing*, the *Calling of Samuel*, the *Gipsy*, *Lesbia*) as well as portraits of eminent musicians, authors (see Cat. 73), actors and the dancer 'La Bacelli' (who was his mistress), and his Chinese page, Wang-y-Tong. In addition, whilst serving as Ambassador in Paris the Duke acquired a Venus from Reynolds for a French marquis. An English newspaper reporting this transaction waggishly observed that 'the Duke had her for four hundred—others he had, cost him infinitely more' (quoted Reynolds 1929, note p. 155). The Duke had indeed more of a reputation as a rake than as an art collector; and the *Cupid* and *Mercury* suggest that he, too, could make jokes about this.

Reynolds made a technical memorandum some time after 15 August 1774 in his ledger concerning these paintings: 'Blackguard Mercury and Cupid—Black and Verm. [vermilion]: afterwards glazed.' They are both similar in their unusually simple technique and unencrusted surface and in their colouring, which, in both cases, is remarkably well preserved. D.M.

Catalogue 92

PROVENANCE 3rd Duke of Dorset, 1774; by descent to Lord Sackville, who sold it to Agnew's, 1894; Alexander Henderson, later 1st Lord Faringdon, 1895; J. Pierpont Morgan soon after 1895; Knoedler & Co., New York; bt from them by the Albright-Knox Gallery, 1945.

EXHIBITED British Institution 1817 (60), 1823 (12), 1840 (85); Royal Academy 1875 (16), 1896 (20); frequently since, including Royal Academy 1968 (115).

LITERATURE Graves and Cronin, 1899–1901, III, p. 1140; Waterhouse 1941, p. 69; Cormack 1970, pp. 150, 169; Paulson 1975, p. 90; Nash 1979, pp. 174–5; Crown 1984, pp. 159–67.

ENGRAVED J. Dean, 15 August 1777; S. W. Reynolds.

Catalogue 93

PROVENANCE 3rd Duke of Dorset, 1774; by descent to Lord Sackville who sold it to Agnew's, 1894; Alexander Henderson, later 1st Lord Faringdon; by descent.

EXHIBITED British Institution 1817 (58), 1823 (65), 1840 (83); Royal Academy 1875 (6), 1896 (18); 45 Park Lane 1937 (81); Agnew 1965 (13).

LITERATURE Graves and Cronin 1899–1901, III, pp. 1173–4; Waterhouse 1941, p. 69; Cormack 1970, p. 169; Gore 1982, p. 20.

ENGRAVED J. Dean, 2 April 1777; S. W. Reynolds.

WILLIAM DICKINSON (after Reynolds)

94 Mrs Sheridan in the character of St Cecilia

50 × 35.1 cm
The Syndics of the Fitzwilliam Museum, Cambridge

Elizabeth Anne Linley was, when she married Richard Brinsley Sheridan in 1773, considered to possess one of the most beautiful voices in Britain: hence the role Reynolds gave her in his famous portrait (now at Waddesdon Manor). Her husband would not permit her to perform in public, but Reynolds's painting was exhibited in public—it was no. 222 ('A Lady in the Character of St Caecilia') at the Royal Academy's exhibition in 1775 and this print after it was shown at the exhibition of the Society of Artists of Great Britain which opened on 18 April in the following year as no. 206 ('Portrait of a lady as St Cecilia'). The publication date on the second state is given as 21 May 1776.

The artist's pocket-books are missing for 1774, 1775 and 1776. Waterhouse (1967, pp. 86–8) suggested that Mrs Sheridan was sitting in 1774. If so, she was still sitting early in 1775. The artist's nephew, Samuel Johnson, reported at the end of February 1775: 'Her picture is going forwards, and I assure you 'tis a sight quite worth coming from Devonshire to see, I cannot suppose that there was ever a greater Beauty in the world, nor even Helen or Cleopatra could have exceeded her' (Radcliffe 1930, pp. 39, 60). Reynolds, in 1790, considered it the best picture he had ever painted (Reynolds 1929, pp. 190–1).

In 1775 Sheridan was at the height of his fame: his comedy *The Rivals* and his opera *The Duenna* were both performed in this year and in 1776 he acquired Garrick's share in the Drury Lane Theatre. He could therefore easily have convinced himself that he could afford to commission a portrait of his wife. It may, however, not have been a commissioned painting. In any case, Reynolds sold it to Sheridan in 1790

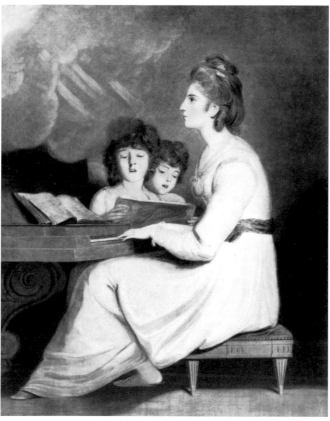

94

(the payment is dated February—Cormack 1970, p. 140), charging £150 although he correctly observed that he could have sold it for £500. Mrs Sheridan also sat for the Virgin in Reynolds's painting of the Nativity for the New College window (Mason in Cotton 1859, p. 58).

William Dickinson (1746–1823) was a mezzotint and stipple engraver who became more and more absorbed in the business of printselling rather than printmaking. In 1776, the year this print appeared, he went into partnership with Thomas Watson (see Cat. 67).

See Cat. 204 for a caricature related to the painting. N.P.

LITERATURE Chaloner Smith 1875–83, no. 74 (iii—printed in colours, with some tinting).

95 Saint Cecilia

279 × 160 cm
Signed and dated 1775
Los Angeles County Museum of Art, William Randolph
Hearst Collection

This painting of the patron saint of music playing upon a harp, an instrument associated with Wales, was commissioned from Reynolds by the great Welsh landowner Sir Watkin Williams Wynn, Bt, for the Music Room of his new London house (fig. 76) in 20 St James's Square (now the headquarters of the Distillers Company), designed by Robert

Adam. A plan and sections of the room signed by Adam on 24 August 1773, showing the proposed colours of pea-green with pale mauve panels relieved with ornament of white stucco, is faintly annotated in pencil 'Pannells on each side of chimney are intended for pictures of St. Cecilia &c as specified in the memorandums. Over Doors on each sides of Organ was prepared also to have Heads of great Musicians.

Fig. 76 Robert Adam, *The Music Room, 20 St James's Square, London*

Over the Door at the end the Muses that honour the Tomb of Orpheus. The other Pannells to have Stucco Ornaments with lyre Girandols introduced.' Adam has drawn a picture of St Cecilia in the space to the right of the chimney (similar to the painting but with an organ rather than a harp) but in the other space he has written 'St Cecilia'—the painting eventually placed there was the work of Nathaniel Dance. The subject of Dance's painting was reported as an Apollo in April 1774 (by Lady Knight, quoted by Whitley), but was in fact an Orpheus and was exhibited at the Royal Academy in that year. Reynolds intended to exhibit his St Cecilia in that year also, but the painting may not have been ready (it is dated 1775); he may also have already determined to exhibit his portrait of Mrs Sheridan as St Cecilia (Cat. 94) and did not wish to seem too addicted to the subject.

According to a receipt in the Wynnstay manuscripts (1952 Collection, 115/7, National Library of Wales) Reynolds was paid 150 guineas for the painting on 19 April 1775 and this is confirmed by the ledgers. (Dance received two hundred guineas, but he also painted decorations elsewhere in the room, as did Antonio Zucchi.) The Williams Wynn family occupied 20 St James's Square until 1906 and the paintings were probably removed then or soon afterwards. The spaces where they hung were subsequently redecorated *en suite* with the other panels in the room.

Northcote, in his conversations with Hazlitt, implied that Dance had chosen his own subject, in which case it is likely that Reynolds did so too. In sentiment *St Cecilia* owes a little to Domenichino but it is hardly, as Leslie and Taylor alleged, a 'plagiarism' and the rich textures of the paint owe nothing to that artist. Northcote believed that Reynolds spoilt the painting by working on it for too long. The pinky lilac and

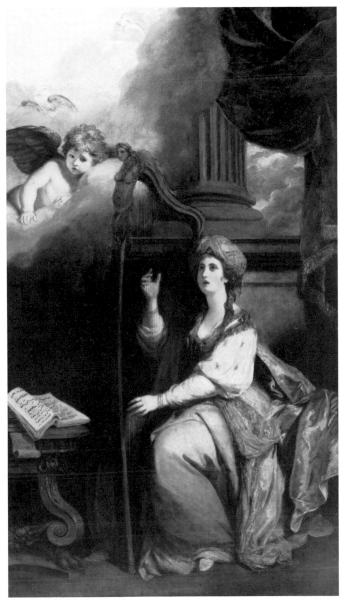

95

greeny blue revealed in the dress by the recent cleaning are clearly related to the original colour scheme of the room.

Sir Watkin (1749–89) was probably the most munificent patron of music and painting in Britain in the last twenty years of his life. When in Rome on the Grand Tour in 1768–9 he had commissioned large paintings of *Bacchus and Ariadne* from Batoni and of *Perseus and Andromeda* from Mengs. These surely were, as Anne French has suggested, companion pieces (Kenwood 1982, p. 60) and so this commission anticipated his policy for the Music Room.

Before he set out for Rome he had begun to sit to Reynolds for a full-length portrait with his mother (Tate Gallery). When there he sat to Batoni for a whole-length portrait with his travelling companions (National Gallery of Wales), and as soon as he returned he married and sat to Reynolds for a full-length portrait with his wife (Private Collection). Reynolds painted his second wife with her children (also Private Collection), probably soon after he completed the *St Cecilia*, and, after that, painted her husband among the Dilettanti (Cat. 109), and the eldest child as St John (Private Collection). For Sir Watkin's patronage generally see Ford 1974. N.P.

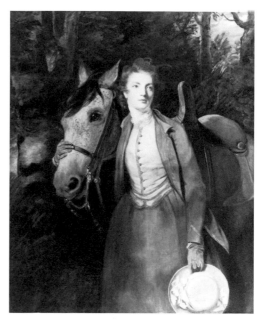

96 *reproduced in colour on p. 131*

PROVENANCE Painted for Sir Watkin Williams Wynn; Wynn sale Sotheby's, 5 February 1947 (77), bt for W. R. Hearst; given by W. R. Hearst to the County Museum 1949.

EXHIBITED British Institution 1813 (24—added to the exhibition), 1847 (8); Manchester 1857 (72); British Institution 1866 (1).

LITERATURE Hazlitt 1830, p. 271; Leslie and Taylor 1865, II, p. 146; Graves and Cronin 1899–1901, III, p. 890; Whitley 1928, II, p. 166; Waterhouse 1941, p. 66; Sheppard 1960, I, pp. 164–8; Waterhouse 1967, pp. 86–8; Cormack 1970, p. 166.

No early engraving recorded.

96 Lady Charles Spencer in a Riding Habit

140 × 112 cm
Private Collection

This very little-known portrait was painted about 1775 (the pocket-books for 1774, 1775 and 1776 are missing) and would probably have cost seventy guineas—a 'second payment' of fifty guineas is recorded in April 1775. The picture was engraved in 1776. Lady Charles Spencer had been painted by Reynolds before (see Cat. 64). This second and larger portrait is also set out of doors and is equally informal in pose, but she now wears a smart red riding habit and places a neatly-gloved hand round the nose of a grey horse. The problem of including a horse in a portrait without the animal dominating the picture-space was a tricky one, but one that Reynolds tackled and solved on a number of occasions with considerable flair. As so often, there are echoes of Van Dyck. Reynolds seems to have had at the back of his mind the figure of the attendant holding the king's horse in the well-known whole-length of Charles I *à la chasse*, in the Louvre. How-

ever, this is not a 'borrowing' but rather a comparable solution to a similar pictorial problem.

Aileen Ribeiro points out that throughout the eighteenth century, 'women wore a feminine version of the male three-piece suit for riding; such habits were made by male tailors and not by dress-makers. Another masculine feature was the use of woollen cloth for the fashionable habit (woollen and woollen-mixture materials were usually worn by working and middle-class women for their ordinary dress). The jacket follows the cut of the man's frock coat, decorated with braid and with a small turned-down collar; the skirt is of matching material. The waistcoat, also trimmed with braid, fastens in the masculine way from left to right. More practical for actually riding than the high feathered hat (see Lady Worsley, Cat. 118) is the low-crowned round hat, also taken from the masculine wardrobe, but here with the feminine addition of ribbon trimming.' D.M.

PROVENANCE The sitter's husband, Lord Charles Spencer, bequeathed the picture in 1820 to his nephew, the 1st Baron Churchill; by descent to Lord Churchill's grandson, the 1st Viscount Churchill, who sold it before 1899 to Baron Alphonse de Rothschild; by descent.

EXHIBITED British Institution, 1813 (101, fourth catalogue); International Exhibition, South Kensington, 1862 (71).

LITERATURE Graves and Cronin 1899–1901, III, pp. 923–4; Waterhouse 1941, p. 66; Cormack 1970, p. 163.

ENGRAVED W. Dickinson, 1776; S. W. Reynolds.

97 Master Crewe as Henry VIII

139.7 × 110.5 cm
Private Collection

'Is not there humour and satire,' wrote Walpole, 'in Sir Joshua's reducing Holbein's swaggering and colossal haughtiness of Henry VIII to the boyish jollity of Master Crewe?' This is one of the best known of Reynolds's essays in the mock-heroic, and may be connected with a story recalled by his pupil, Northcote. Reynolds was viewing pictures in a nobleman's house, in company with a number of other people. Amongst the party was a little girl who, whenever they stopped to look at a particular picture, placed herself in the same pose and adopted the air and manner of the subject of the picture, and all unconscious that she was being watched. Reynolds was amused by this performance, done, as he told Northcote, 'with so much innocence and true feeling, that it was the most just and incontrovertible criticism that could be made on the picture' (Northcote 1818, II, pp. 43–4).

As Aileen Ribeiro points out, 'Henry VIII was a favourite historical character in the eighteenth century. Salmon's Royal Waxworks near Temple Bar showed, among their tableaux, Henry VIII introducing Anne Boleyn to Court; Shakespeare's play was frequently performed. It was a popular masquerade costume—"We have had a crowd of

97 *reproduced in colour on p. 128*

Henrys the Eighth and Wolseys . . .", commented Walpole at a masquerade in 1770. Holbein's Henry VIII (taken from van Leemput's copy of the 1537 Whitehall mural) is reproduced in the most important masquerade pattern book of the eighteenth century, Thomas Jefferys's *A Collection of the Dresses of Different Nations, Antient and Modern, particularly*

after the Designs of Holbein, Vandyke, Hollar and others, 1757 and 1772 (II, p. 193). This was probably Reynolds's source. The Jefferys engraving (reversing the pose, of course) has slightly simplified some details of the costume, omitting for example, the jewelled chains and the codpiece. Adapting this as fancy dress, Reynolds also omits the codpiece, and appears to misunderstand the way that in the original there is an open-skirted sleeveless tunic which curves slightly upwards from the waist, and is worn over a braided embroidered jewelled doublet with white silk slashes on the chest and sleeves. Reynolds has put the boy in a kind of tunic with a highly decorated top and a plainer skirt which does not open down the front. Features of the original which Reynolds retains are the jewelled hat with feathers, the silk ribbon holding the dagger, and the embroidered garter (from the Order of the Garter) on the left leg. The bulky square coat (the trimming on the sleeves of the original Holbein has been omitted) is lined with sable. Master Crewe's hair, while of course unlike that of Henry VIII, is, with its square cut and fringe, rather like that of a fashionable young man *c.* 1510. Contemporary features which place the portrait in the last quarter of the eighteenth century, are the child's shoes, and his green coat which lies on the stool beside him.' Nicholas Penny has pointed out that when the painting is seen in a raking light it is clear that the spaniel sniffing at its master's unusual garb was painted on top of the coat and so was perhaps an afterthought.

The sitter was John, afterwards 2nd Lord Crewe (1772–1835), eldest son of the great Whig hostess so frequently depicted by Reynolds (see Cat. 38). The portrait was completed by 23 January 1776 when Boydell published Smith's engraving of it but the pocket-books for 1774, 1775 and 1776 are missing. It was exhibited at the Academy in 1776 and on 14 February 1777 'Mr Crewe' is recorded as paying a hundred guineas 'for his son'. A 'sketch', said to be for this picture, was in the possession of a Mrs Burney at Brighton in the last century. Reynolds's *Master Crewe* was frequently exhibited in that period and inspired William Holman Hunt's fancy-dress portrait of young Edward Wilson known as 'The King of Hearts' (exhibited at the Tate Gallery 1984, no. 121). D.M.

PROVENANCE Painted for John, afterwards the 1st Lord Crewe; by descent.

EXHIBITED Royal Academy 1776 (239: 'Portrait of a boy in the character of Henry the Eighth'); British Institution 1813 (74), 1833 (17), 1843 (51), 1852 (91), 1866 (108); Royal Academy 1895 (129); Grafton Gallery 1895 (128) and frequently since, including 45 Park Lane 1937 (12); Royal Academy 1951 (78), 1968 (117).

LITERATURE Leslie and Taylor 1865, II, p. 157; Stephens 1867, p. 51; Graves and Cronin 1899–1901, I, p. 210; Waterhouse 1941, p. 66; Cormack 1970, p. 148; Waterhouse 1973, p. 28; Paulson 1975, p. 88.

ENGRAVED J. R. Smith, 1776; S. W. Reynolds.

98 *reproduced in colour on p. 129*

98 Miss Crewe

137 × 112 cm
Private Collection

The subject is supposed to have been Frances, the elder daughter of Mrs Crewe (see Cat. 38), who was probably born in 1767 and died at the age of eight. Judging by her apparent age in the portrait she might have sat in 1774 or 1775—years for which the artist's pocket-books are missing. Probably begun as a companion to the portrait of her brother (Cat. 97), which was certainly complete by 1776, this painting was not exhibited and may even have been left unfinished (parts of the drapery are in any case remarkably summary) because the sitter died.

Miss Crewe, as Aileen Ribeiro notes, 'wears a white muslin dress over a pink underskirt, and with a wide sash at the waist. Over this is worn a black silk pelisse, lined with satin and edged with lace; this was a cloak with slits for the arms. For extra protection against the weather, she wears a black silk calash, a folding hood built up on arches of cane, large enough to cover the big, elaborate caps or headdresses which women and girls wore in the 1770s.'

The gushing enthusiasm of earlier generations for pictures like this has led to an over-reaction in our own time, and, as a result, Reynolds's portraits of pretty children are in danger of being under-appreciated. The truth is that they are highly original creations which owe little to earlier masters; the subjects are seen with a sympathetic but, at the same time, sharp eye, the paint is handled with directness and fluency and the resulting design is—and this is especially true of *Miss Crewe*—powerful by any standards. D.M.

PROVENANCE Painted for John, afterwards the 1st Lord Crewe; by descent.

EXHIBITED British Institution 1866 (110); Royal Academy 1895 (13); Grafton Gallery 1895 (121); 45 Park Lane 1937 (10); Royal Academy 1968 (119).

LITERATURE Graves and Cronin 1899–1901, I, p. 211; Waterhouse 1941, pp. 65, 124; Waterhouse 1973, p. 28.

No early engraving recorded.

99 View from Sir Joshua Reynolds's House, Richmond Hill

69.8 × 90.8 cm
The Trustees of the Tate Gallery, London

Very few landscapes by Reynolds are recorded. Before he went to Italy in 1749 he is said to have painted a view of Plymouth Sound which is still at Port Eliot, and Northcote refers to later examples: one in the collection of Sir Brooke Boothby (for whom see Cat. 147); one in the Pelham Collection; a couple bequeathed by Reynolds to his family doctor, Sir George Baker; and a few which, like the landscape exhibited here, were sold in the last studio sales.

Purchased by Samuel Rogers the poet, this picture hung in Rogers's house in St James's Street, Westminster, where Mrs Jameson saw it and noted that it was 'painted strongly, in the manner of Rembrandt, which . . . is hardly in character with the scene'. Waagen also described it as being in the style of Rembrandt, and when he saw it a few years later in Mr Baring's collection he developed the comparison a little further. 'Here,' he wrote, 'in the glowing tone and warm reflection of an evening sky, we are reminded of Rembrandt.' An alternative suggestion (e.g. Hudson 1958, p. 57) is that the artist was influenced by a picture in his own collection, *The Return of the Ark*, by the seventeenth-century French painter, Sébastien Bourdon (now National Gallery, no. 64). In fact Reynolds's picture seems to have little in common with the seventeenth century. It would be more logical to see it in purely eighteenth-century terms as an experiment in the fashionable mode of the Picturesque. It is ironic that almost exactly one month after Birch's engraving was published (1 July 1788) Gainsborough, the supreme exponent of the Picturesque mode, died (2 August) and in December Reynolds devoted his fourteenth Discourse to his rival's art.

Samuel Rogers told John Mitford that Reynolds did not care about the landscape and scenery of Richmond, 'he always wanted to get back to town among *people*' (Whitley 1928, II, p. 197). But Fanny Burney's description of a dinner party held at the house in June 1782 gives a slightly different impression. The party included Mr and Mrs Edmund Burke, Gibbon, Miss Palmer, and several others. Some went for a walk, and 'after our return to the house . . . the "Knight of Plympton" was desiring my opinion of the prospect from his window, and comparing it with Mr Burke's . . .' (Burney 1842–6, II, pp. 143–8). Wick House, from which this view is supposed to have been taken, was built for Reynolds by Sir William Chambers in 1771–2 (see Stirling 1950, pp. 1426–31).

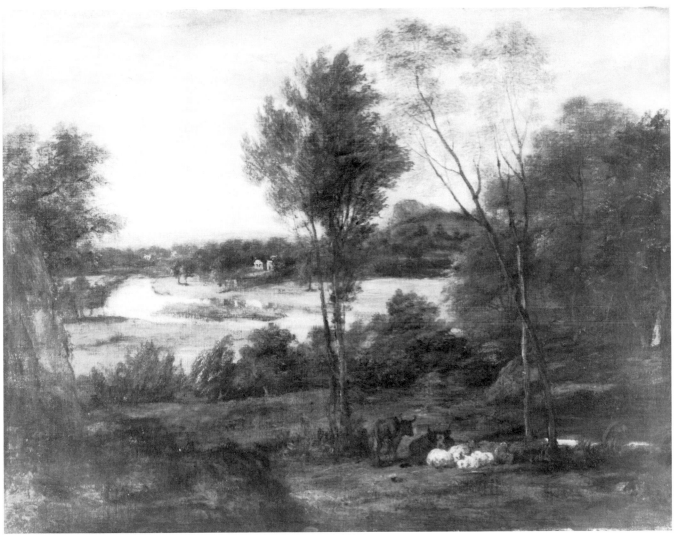

99

Colonel Grant believed that landscapes by Reynolds are less scarce than has usually been supposed, and claimed to have identified a dozen. However, very few can be attributed on secure grounds and it must be remembered that there were other artists in the late eighteenth century, for instance the engraver Samuel William Reynolds, painting landscapes in a very similar style. Nicholas Penny points out that when discussing landscape with Boswell, Reynolds in his old age specified that he had done one of Richmond: the qualification 'not very well' in Boswell's notes must be the artist's own verdict (Hilles 1952, p. 21). D.M.

PROVENANCE Studio sale, Christie's, 18 May 1821 (63), bt by Samuel Rogers; his sale, Christie's, 2 May 1856 (702), bt Bentley; Thomas Baring by 1857; by descent to Lord Northbrook and Maurice Baring; presented to the National Gallery by the National Art-Collections Fund, 1945 (no. 5635); transferred to the Tate Gallery, 1951.

EXHIBITED Society for Promoting Painting and Design, Liverpool 1783; British Institution 1813 (110), 1823 (6); Royal Academy 1870 (148); Grosvenor Gallery 1883 (165); 45 Park Lane 1937 (49).

LITERATURE Malone in Reynolds 1798, I, p. xxxv; Edwards 1808, p. 199; Northcote 1818, II, p. 184; Jameson 1844, p. 410; *Art Union*, IX, 1847, p. 84; Waagen 1854, II, p. 75; 1857, p. 100; Rogers 1856, p. 87; Stephens 1867, pp. 20–1; Graves and Cronin 1899–1901, III, pp. 1233–4; Waterhouse 1941, p. 80; Grant 1957–61, II, p. 156.

ENGRAVED W. Birch, 1 July 1788 (with the title given here); J. Jones, 1800.

100 Omai

236.2 × 144.8 cm
The Castle Howard Collection

The subject was a young South Sea Islander whose personal charms won the favourable notice of the officers of the *Discovery* and the *Adventure* when they anchored off Huahine during Captain Cook's second voyage in August 1773. When they asked his name he replied 'O Mai', which means 'of the family of Mai', and the officers, mistaking the particle 'o' for a part of the name, called him 'Omai'. (For a similar reason, Tahiti was 'Otaheite' to eighteenth-century Europe.)

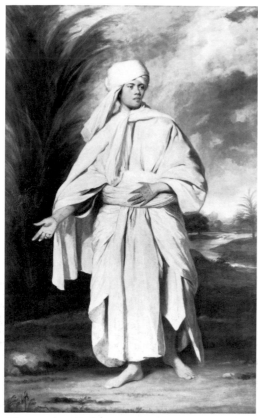

100 *reproduced in colour on p. 130*

Captain Furneaux, Cook's second-in-command, proposed to Omai that he return to England with them; Omai agreed—a remarkably courageous decision—and Lieutenant Burney, brother of Fanny Burney, the novelist, and son of the great musicologist (Cat. 125), was given the job of teaching him English. 'From the day in 1774 when the *Adventure* tied up at Spithead, to be met by no lesser personages than Lord Sandwich, First Lord of the Admiralty, and Sir Joseph Banks, President of the Royal Society and acknowledged expert on the Pacific, Omai became the talk of the town and the subject of approving comment in the magazines' (Luke 1950, p. 497; see also Boswell, 1934–50, III, p. 8). He was seen, quite wrongly, as an example of that popular object of eighteenth-century curiosity, the 'noble savage'. In fact, as Sir Harry Luke, former High Commissioner for the Western Pacific, pointed out, Omai came from a society in many ways as formal, ritualistic and complex as that of Western Europe, with sharply defined class distinctions and a code of manners rigidly enforced by public opinion. 'Somebody observed,' recalled Mrs Thrale of Baretti (for whom see Cat. 85) that 'when he play'd at Chess with Omai, You would [have] thought Omai the Christian, and Baretti the Savage' (Piozzi 1951, I, p. 48).

In Reynolds's portrait Omai wears an entirely imaginary garment and a turban which gives him a vaguely Indian appearance. Under the Tahitian sun he would have worn virtually nothing, and these voluminous robes, together with the gesture with his right hand and the placing of the feet,

are perhaps intended to evoke ancient statues of standing orators, philosophers and magistrates in their togas.

Reynolds's picture cannot be dated by reference to the pocket-books, for these are missing for the years 1774, 1775 and 1776. When it was shown at the Academy in 1776 Walpole thought it 'very good', and the critic in the *Morning Post* admired it as a 'strong likeness'. In fact, critical reception has been consistently favourable. Waagen thought it one of Reynolds's finest pictures, and Professor Burke goes even further: 'for a memorable moment,' he writes, 'the classical and romantic tendencies of the eighteenth century are fused in perfect reconciliation, so that the picture becomes a kind of summation.'

What is sometimes described as a study for this picture, an oval bust portrait without the turban and with loose shoulder-length hair, is in the Yale University Art Gallery (Tinker 1938, p. 57). Another head and shoulders, this time in what appears to be military uniform and wearing a bizarre white and pink turban decorated with a crescent (!) was sold at Sotheby's on 3 July 1963 (10), and is illustrated in Sir Harry Luke's article cited above (on p. 499). Portraits of Omai by other artists exist, including an impressive print published by Bartolozzi in October 1774, showing him full length in similar robes based on a drawing by Nathaniel Dance.

After two years in England, Omai took up Captain Cook's offer of a return passage to his own land. In the first book of his poem *The Task* (1785), William Cowper movingly imagined the mixed feelings that he must have experienced upon his return. And in the same year Omai's life and adventures inspired one of the most successful pantomimes of the century, *Omai, or a Trip round the World*, which was first performed at Covent Garden on 20 December 1785.

In 1789 Captain Bligh visited Huahine in the *Bounty*—just before the mutiny—and learned that Omai was dead. D.M.

PROVENANCE Studio sale, Greenwood's, 16 April 1796 (51), bt by Bryan; Frederick, 5th Earl of Carlisle by 13 August 1796; thence by family descent.

EXHIBITED Royal Academy 1776 (236: 'Omiah: whole length'); Birmingham 1961 (63).

LITERATURE Manners 1813, p. 92; Waagen 1854, III, p. 323; Leslie and Taylor 1865, II, pp. 104–6; Graves and Cronin 1899–1901, II, pp. 707–8; IV, p. 1639; Tinker 1938, pp. 56–8; Waterhouse 1941, pp. 66, 124; Luke 1950, pp. 497–500; Burke 1976, p. 205; Joppien 1979, pp. 81–136.

ENGRAVED J. Jacobé, 1777; S. W. Reynolds.

101 The Child Baptist in the Wilderness

125.73 × 101.28 cm
Minneapolis Institute of Art (Christina N. and Swan J. Turnblad Memorial Fund)

Reynolds exhibited a *St John* at the Royal Academy exhibition in 1776 (no. 243) which is likely to be identical with the *St John* sold to Lord Granby on 26 April of the same

year for one hundred guineas (Cormack 1970, p. 153) together with a *Samuel* for the same price, both of which seem to have been among the paintings destroyed by fire at Belvoir Castle on 26 October 1816. *St John* was probably an infant (the *Samuel* certainly was) and was surely the painting engraved by Grozer in 1799. Two other infant St Johns were in Reynolds's studio sale (Greenwood's, 16 April 1796), one of which is now in the Wallace Collection—the other is perhaps the one at Arbury. 'Studies' for the subject of St John were sold by the artist's niece, the Marchioness of Thomond, on 26 May 1821 (33 and 33a), one of which had been exhibited at the British Institution in 1813 (no. 79). Waterhouse has proposed that the painting catalogued here

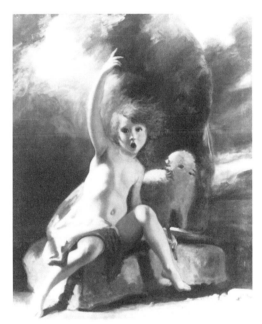

101 *reproduced in colour on p. 150*

might be one of these studies, for it is certainly unfinished. The cross was completed by a dealer's restorer, probably in the 1880s, to correspond with the Wallace Collection painting, and the lamb was also repainted facing the other way and with its mouth shut. Now the repaint has been removed the painting emerges as remarkably free and fresh, slightly worn in the child's face, with highly successful effects of light (painted quite heavily) and shadow (painted very thinly) on the boy's flesh. The artist has not yet determined whether to paint a rock or a cloud behind.

Northcote recalled hearing the urchins who served as models for Sir Joshua call out when they were tired: to hold this pose and wide-awake expression must have been very hard. The only references to the subject in the pocket-books are the entries for 17 and 20 December 1770 'Child St John', and a technical note, in the ledgers relating to a 'St John' also appears to date from 1770 (Cormack 1970, p. 143). However, the raised arms and split legs (and, in this version, the flowing hair and open mouth) are more characteristic of Reynolds's art in 1780 than in 1770.

The pose has been described as a 'plagiarism from Guido', which it is not, and as a combination of several Raphaels (Mitchell 1942, p. 39), which is hardly likely, but the painting was certainly an exercise in the manner of the Old Masters (Murillo in particular comes to mind). It was the Old Masters which were on Reynolds's mind rather than the New Testament when he painted devotional subjects, even when these were ecclesiastical commissions. N.P.

PROVENANCE Earl of Arran by 1872; Arran sale Puttick and Simpson, 15 July 1885, bt Sir J. Charles Robinson; sold 1886 to Sir Francis Cook, Bt; Cook sale Sotheby's, 25 June 1958 (68), bt Gribble; Sotheby's, 15 July 1964 (129), bt J. H. Weitzner; acquired by the Institute of Art, 1968.

Not included in public exhibition before 1900.

LITERATURE Leslie and Taylor 1865, II, p. 149; Graves and Cronin 1899–1901, IV, p. 1460; Waterhouse 1941, p. 67; Waterhouse 1968; Ingamells 1985, no. 48.

No early engraving recorded (of this version).

VALENTINE GREEN (after Reynolds)

102 Georgiana, Duchess of Devonshire

55.4 × 34 cm
The Syndics of the Fitzwilliam Museum, Cambridge

Reynolds's celebrated portrait of the Duchess of Devonshire (today in the Huntington collection, California) which was exhibited at the Royal Academy in 1776 (no. 233: 'Portrait of a Lady; whole-length') was painted for her parents, the Earl and Countess Spencer, probably as a companion for the full-length portrait of her brother George, Lord Althorp, in vandyke dress, also exhibited at the Academy in that year. By the early nineteenth century both pictures hung at the south end of the great gallery at Althorp on either side of the great Van Dyck double portrait of the Earls of Bedford and Bristol, and it seems likely that this arrangement was planned by the artist. The Dowager Countess Spencer paid three hundred guineas for the two portraits on 8 December 1783 (Cormack 1970, p. 164).

The enchanting child whom Reynolds had painted with her mother (Cat. 32) had developed into a remarkable, if unorthodox, beauty by the summer of 1773 when she and her friend Mrs Crewe (see Cat. 38) were the talk of Paris (Walpole 1937–83, V, pp. 362, 367). She married George, Duke of Devonshire, in 1774 and quickly became the 'Empress of Fashion'. She is here depicted with the plumed coiffure—a fashion which had been pioneered by Mrs Abington in the winter of 1774 (ibid. XXII, pp. 216–17). For a later portrait see Cat. 139; for caricatures of her see also Cat. 205 and 206.

This impression of Valentine Green's mezzotint reproduction of the portrait has been faintly but very effectively tinted pink in the flesh and ribbons of the dress and blue in the sky; it has also been trimmed (the original dimensions were 62.9 × 38.5 cm). The publication date was 1 July 1780 and

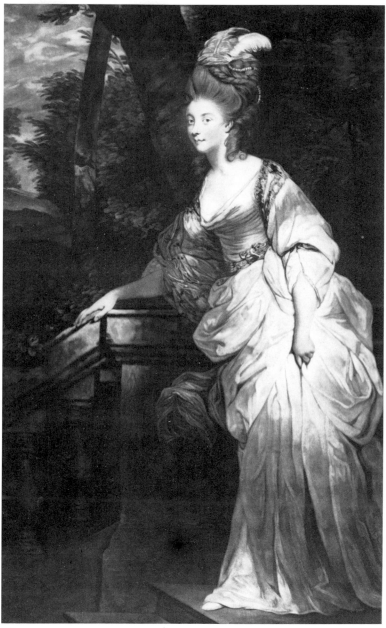

102

it appeared together with a print of the Duchess of Rutland (fig. 43)—surely intentionally, as they belonged to opposite political camps and were known as the 'rival duchesses' (see, for instance, Burney 1842–6, II, p. 57). They formed the second pair in the remarkable serial publication of prints by Green after Reynolds entitled *Beauties of the Present Age* which had commenced at the end of the former year. Each print cost fifteen shillings but twelve shillings to subscribers, with an extra charge for tinted impressions.

Valentine Green (1739–1813), who made his reputation with mezzotints of Benjamin West's history pictures, was in 1773 appointed Mezzotint Engraver to the King, and, in 1775, Engraver Associate at the Royal Academy and Engraver to the Elector Palatine. Between 1778 and 1783

(when he quarrelled with Reynolds over the right to engrave the portrait of Mrs Siddons, Cat. 134) he made nineteen mezzotints after Reynolds. Green, like Thomas Watson and Dickinson, the other leading English mezzotint engravers of the 1770s and 1780s, was more involved in publishing than had been the Irish mezzotint engravers active in London in the 1750s and 1760s. When engaged in engraving a highly ambitious series of prints of the Düsseldorf gallery, Green's property was destroyed by besieging troops. His market, which was dependent upon a peaceful Europe, was also destroyed. N.P.

LITERATURE Chaloner Smith 1875–83, no. 37 (2); Whitman 1902, no. 102 (2).

103 Mrs Lloyd

236 × 146 cm
Private Collection

Joanna, third daughter and co-heiress with her four sisters of John Leigh of Northcourt House, Isle of Wight, was twice married. In 1775 she married Richard Bennett Lloyd of the Foot Guards and Reynolds's portrait wittily commemorates the event. Since she writes the name 'Lloyd' on a tree, the

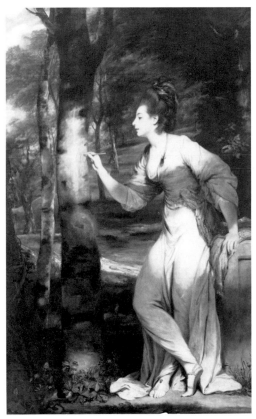

103 *reproduced in colour on p. 133*

portrait must date from after her engagement, if not after the wedding; it was exhibited at the Royal Academy in 1776. Her second husband, Francis Love Beckford of Basing Park, Hampshire (whose father's portrait by Reynolds hangs in the Tate Gallery), was cousin to William Beckford of Fonthill, who was also painted by Reynolds. The sittings for this picture, with one possible exception, are not recorded, as Reynolds's pocket-books for 1774, 1775 and 1776 are missing. The exception is an appointment for 'Mrs Loyd' at two o'clock on 23 May 1777. By that date the picture had been exhibited, but it is not impossible that the artist wanted to make some minor alteration, perhaps at the request of the sitter, before it was sent home. Two payments, both of seventy-five guineas, are recorded in Reynolds's second existing ledger; the first is undated but the second was in June 1777.

The motif of a lady carving her true love's name on the bark of a tree was especially popular in Italian Baroque painting, where it usually illustrated the story of Angelica and Medoro from the epic poem *Orlando Furioso* by Ariosto. It continued to occur widely in the eighteenth century, in the work of, for example, Sebastiano Ricci, Boucher, Giambattista and Giandomenico Tiepolo, Bendedetto Luti and Benjamin West (see Lee 1977). However, in almost all these cases the figures of Angelica and Medoro are shown seated or reclining, and are not likely to have inspired Reynolds's composition. On the other hand, a picture by Francesco Imperiali, *Erminia carving her true-love's name* (from Canto 7, Stanza 17, lines 1–4 of Tasso's poem, *Gerusalemme Liberata*), in which the lady crosses her feet and rests her left hand in a way not unlike Mrs Lloyd, seems a more likely source. Imperiali's picture was in Dr Mead's sale in London in 1754 (Clark 1964, p. 233) and it is therefore highly likely that Reynolds knew it. We can be less sure about Fragonard's tiny picture, *The Souvenir*, in the Wallace Collection (p. 382). This is a slightly reduced version of a lost original of 1773–6 which was, therefore, painted at exactly the same time as *Mrs Lloyd*, but there is no reason to think that it was known to Reynolds. For the actual pose of Mrs Lloyd Reynolds took Raphael's famous drawing of *Adam Tempted*, which had been etched in reverse, that is to say, in the direction of *Mrs Lloyd*, for Crozat's *Recueil d'Estampes*, in 1763. In one of his 'Commonplace Books' preserved at the Yale Center for British Art (MS 33, p. 67) Reynolds noted the price of 'Crozat's works' in a list of books sold in Paris.

In view of these pictorial sources it is perhaps rather an academic point whether the artist had a specific literary source in mind. In Shakespeare's *As You Like It*, which was revived at Drury Lane in 1740 and remained popular throughout the eighteenth century, Orlando announces (Act III, Scene 2) that he will 'carve on every tree / The fair, the chaste, and unexpressive she'. Later, Jaques says to him: 'I pray you mar no more trees with writing love-songs in their barks'. Verses are carved on trees by a love-sick young man in Thomas Lodge's *Rosalynde* (1590) which was Shakespeare's main source, and Lodge presumably took the idea from one of the Italian sources already referred to.

The popularity of this composition is attested by the large number of reduced copies that exist, both whole-length and, even more frequently, bust-length, to include the motif of writing on the tree. None of the copies so far identified seems to be by Reynolds himself, though two small whole-lengths do exist of sufficiently high quality to be attributed with some plausibility to Reynolds's studio. One very richly painted example is in the Musée Cognacq-Jay in Paris (see Burollet 1980, p. 180); another was lent by Henry Harris, Esq., to the Reynolds exhibition at 45 Park Lane in 1937 (no. 75). Nicholas Penny notes that a painting of Angelica and Medoro by Reynolds which is recorded in one of his studio sales (Greenwood's, 15 April 1796, lot 61) might have been a sketch for this portrait.

Aileen Ribeiro notes that Mrs Lloyd 'is dressed in what the *Morning Post* described as "a loose fancy vest"—in short one of Reynolds's fanciful, generalized "classical" gowns, tied round the waist with a fringed silk sash. Equally classical

are the delightfully impractical blue sandals, but the hairstyle's height is in accordance with current fashion; Samuel Johnson, Reynolds's nephew, found in London in 1776 that "the Ladies' heads, without stretching an inch, were a yard high reckoning from their chin, or their lowermost hair behind" [Radcliffe 1930, p. 198].' D.M.

PROVENANCE Andrew Arcedeckne MP, 1831; Rev. Mr Ward; his sale, Christie's 29 May 1869 (102), bt Agnew; Baron Lionel de Rothschild MP; by descent.

EXHIBITED Royal Academy 1776 (234); British Institution 1831 (80); Royal Academy 1873 (59), 1887 (37); 45 Park Lane 1937 (79) and frequently since, including Royal Academy 1951 (103); Birmingham 1961 (62); Royal Academy 1968 (82).

LITERATURE Leslie and Taylor 1865, II, p. 155; Graves and Cronin 1899–1901, II, pp. 589–90; Waterhouse 1941, pp. 18, 66; Cormack 1970, pp. 157–8.

ENGRAVED S. W. Reynolds, 1835.

104 Charles, Earl of Dalkeith

141 × 112 cm
Duke of Buccleuch and Queensberry KT

The sitter's name and the date, 1777, are inscribed in the lower right corner, but no appointments are recorded for the sitter in the artist's pocket-book for that year and sittings may have been in the preceding year (the pocket-books for

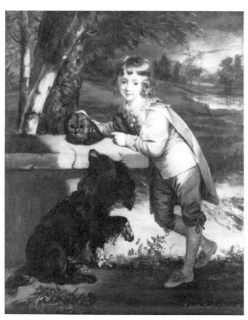

104 *reproduced in colour on p. 132*

1774, 1775 and 1776 are missing). The portrait was almost certainly exhibited at the Royal Academy in 1777, together with its companion portrait of the boy's sister, *Lady Caroline Scott as 'Winter'* (fig. 77). The two canvases, identical in size, were paid for together in August 1783: 'Duke of Bucclieugh

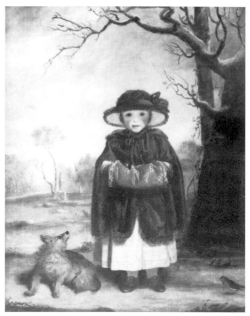

Fig. 77 Lady Caroline Scott as Winter, probably exhibited 1777
(Duke of Buccleuch and Queensberry, Bowhill)

[*sic*], for his Son and Daughter £147', and hang together at Bowhill. In contrast to the cold, slightly rusty ochres, browns and whites of 'Winter', the *Earl of Dalkeith* is a colourful composition, with the rich green grass and blue sky of summer.

The subject was the eldest son of the 3rd Duke of Buccleuch; he was born on 24 May 1772, married in 1795 Harriet, daughter of the 1st Viscount Sidney, and succeeded as 4th Duke of Buccleuch in 1812. He and his wife were good friends of Sir Walter Scott and *The Lay of the Last Minstrel*, with its reference to 'sweet Bowhill', was dedicated to him. The Duke died on 20 April 1819.

Animals and birds often feature in eighteenth-century portraits. In the companion picture there is a robin hopping in the snow and a terrier looks expectantly up at the little girl muffled against the cold, as if to direct our attention to her. In the *Earl of Dalkeith* Reynolds seems almost to poke fun at that same convention by shifting our attention to the owl. As a result we are made aware of more than just the sitter, and Reynolds has, once again, succeeded in creating a picture which is more than a mere portrait. The owl, of course, symbolizes learning and the spaniel perhaps alludes to the sporting life, but we need not take the boy's 'choice' too seriously.

A number of portraits by Reynolds can be seen at Bowhill, including the Earl of Dalkeith's father (three-quarter-length in a green suit, painted in 1768) and a lavish whole-length of his mother together with his sister, Lady Mary Scott (Royal Academy 1773, no. 234). What was described as a 'sketch' for the *Earl of Dalkeith*, on canvas 18.6 × 16 cm, was lent to the Grosvenor Gallery in 1883 (96). D.M.

PROVENANCE By descent.

EXHIBITED Possibly Royal Academy 1777 (287: 'Portrait of a young

nobleman'); Manchester 1857 (69); South Kensington 1868 (864); Grosvenor Gallery 1883 (132); 45 Park Lane 1937 (74); Royal Academy 1951 (69).

LITERATURE Graves and Cronin 1899–1901, I, p. 225; Waterhouse 1941, p. 68; Cormack 1970, p. 146.

ENGRAVED V. Green, 1778; S. W. Reynolds, 1834.

105 The Schoolboy

90 × 70 cm
Private Collection

Lord Warwick paid fifty guineas for this painting on 7 March 1779 and hung it in his library in Warwick Castle. It must, however, have been painted before 31 October 1777 when the mezzotint of it was published. The patron may have had a particular liking for this type of half-portrait, half-genre study. He later bought Rembrandt's *Achilles* (or *Alexander*), now in Glasgow, from Reynolds himself, and after Reynolds's death he acquired Rembrandt's *Standard Bearer*, which had also belonged to Reynolds and is now in the

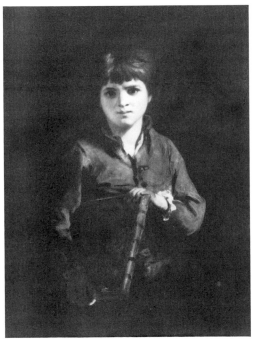

105 *reproduced in colour on p. 134*

Metropolitan Museum of Art, New York. *The Schoolboy*, which was engraved with that title in 1777, seems, with its rich, warm colour-scheme highlighted with glimpses of white at neck and wrist, deliberately Rembrandtesque. However, a comparison with the *Boy Reading* (Cat. 7), painted thirty years earlier, shows how much more subtle Reynolds's later essays in this vein had become. It is revealing to compare, for instance, the way he has painted the hands in the

two pictures. In such details Reynolds now demonstrates a liquid and flexible type of baroque handling similar to that used in the exactly contemporary portrait of *Lady Bampfylde* (Cat. 106). Both look forward to such Rubensian studies as the bust portrait of *Master Hamilton* (Cat. 131) painted in 1782.

According to the artist's friend, William Mason, the subject of this picture was one of Reynolds's favourite models, an orphan 'beggar boy' who made and hawked cabbage nets. He also posed for the *Infant Samuel* (the original version, destroyed in the Belvoir Castle fire, was exhibited at the Royal Academy in 1776, no. 244). 'This boy (at the time about fourteen) though not handsome, had an expression in his eye so very forcible, and indicating so much sense, that he was certainly a most excellent subject for his pencil. The figure standing with a portfolio, is almost his absolute portrait.'

Another version of the painting, of a smaller format, with the figure terminated below the boy's left arm, on a canvas with an excise stamp of 1774, and perhaps a repetition by Reynolds, was recently in a private collection in Kew.

D.M.

PROVENANCE 2nd Earl of Warwick; by descent.

EXHIBITED British Institution 1817 (93), 1833 (45), 1843 (43); Manchester 1857 (64); British Institution 1861 (160); South Kensington 1862 (134); Grosvenor Gallery 1883 (192); Birmingham 1961 (67). (Entitled 'The Student' in 1817, 1833 and 1843.)

LITERATURE Field 1815, p. 216; Waagen 1854, III, p. 216; Mason, in Cotton 1859 ('Notes and Observations'), p. 57; Leslie and Taylor 1865, I, p. 385; Graves and Cronin 1899–1901, III, p. 1203; Cormack 1970, p. 166; Waterhouse 1973, pp. 26–7, 48; White 1983, pp. 37–8.

ENGRAVED J. Dean, 31 October 1777; S. W. Reynolds.

106 Lady Bampfylde

250.8 × 147.9
The Trustees of The Tate Gallery, London

Catherine, eldest daughter of Admiral Sir John Moore, Bt, was born in 1754 and died in 1832. In February 1776 she married Charles Warwick Bampfylde who succeeded as 5th Baronet in August of that year, and Reynolds's portrait presumably commemorates her marriage. Her husband was Member of Parliament for Exeter. She was mother of the 1st Baron Poltimore at whose seat, Poltimore Park in Devon, the picture hung until after 1885. Her brother-in-law, John Codrington Warwick Bampfylde, an amateur musician, appears with George Huddesford in a double portrait by Reynolds in the Tate Gallery (754).

Lady Bampfylde is a splendid piece of baroque portraiture, powerfully organized around a few long, sweeping diagonals, which pre-dates Reynolds's trip to the Low Countries by about five years, and reminds us that Rubens and Van Dyck had always played an important part in the evolution of his style. If it was perhaps Rubens rather than Van Dyck who taught Reynolds to see these transparent shadows, it is nevertheless true that the rapid movements of the delicately

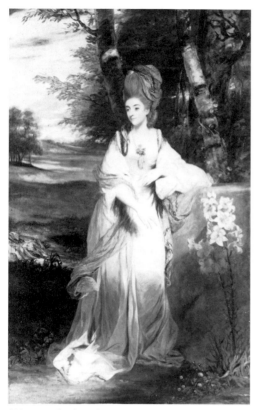

106 *reproduced in colour on p. 136*

pink hands and the swirling scarf can be matched in numerous pictures by Van Dyck. Nor is the baroque character of *Lady Bampfylde* restricted to details: the whole composition, pivoting on the short horizontal of her left forearm, is built up as a series of carefully judged angles. Once this is realized, we can appreciate the skill with which the artist has calculated such details as, for instance, the precise tilt of her head.

When this picture was first exhibited, the 'harmonious softness' of the colouring was praised by the critic in the *Morning Post* of 27 April 1777, but the same writer criticized the drawing of the right arm and commented not unfairly that 'a little fall of water in the background is one of Sir Joshua's daubs without its usual effect'. Costume historians are inclined to shake their heads over pictures like this for, as Aileen Ribeiro points out, 'Lady Bampfylde's white muslin dress has no visible means of fastening, and is trailing on the ground so as to make walking impossible. Reynolds might have had a simple, informal wrapping gown as a prototype; Mary Isabella, Duchess of Rutland, painted in 1780–1 in a similar white muslin dress with gold fringe on the shoulders, stated that Sir Joshua made her try on eleven different dresses before he painted her "in that bedgown" [Leslie and Taylor 1865, I, p. 248 — the picture was destroyed by fire in 1816 — but see fig. 43]. It is a tribute to Reynolds's diplomacy that he was able to persuade his female sitters into this kind of generalized costume in a period when dress was elaborately made and embellished; the hair is, however, the most sensitive barometer of fashion, and whether or not

Reynolds liked the exaggerated hairstyles of the late 1770s, he was powerless to diminish their height or complicated arrangement.'

Sittings for this portrait are not recorded. The pocket-book for 1776 is missing, and although there is an appointment on 10 April 1777 the picture must have been virtually finished by then as it was exhibited that month at the Royal Academy. D.M.

PROVENANCE By descent to the 2nd Lord Poltimore; sold before 1899 to Agnew's; Alfred de Rothschild, by whom bequeathed to the National Gallery, 1918; transferred to the Tate Gallery, 1949.

EXHIBITED Royal Academy 1777 (283: 'Portrait of a Lady; whole length').

LITERATURE Graves and Cronin 1899–1901, II, pp. 46–7; Waterhouse 1941, p. 67; Davies 1946, p. 126; Cormack 1970, p. 147.

ENGRAVED T. Watson, 1779.

107 Lady Caroline Howard

143 × 113 cm
National Gallery of Art, Washington.
Andrew W. Mellon Collection 1937.1.106

Lady Caroline, daughter of the 5th Earl of Carlisle and his countess, Margaret Leveson (daughter of the 1st Marquess of Stafford), was born on 3 September 1771, and is shown here aged about seven. The painting was exhibited in the spring of 1779 but must have been complete at least a few weeks before 7 December 1778 when Valentine Green's mezzotint is dated. Lady Caroline probably sat earlier in that

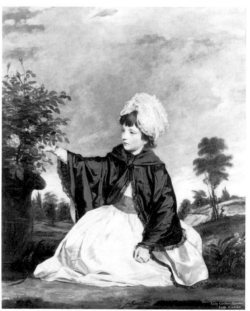

107 *reproduced in colour on p. 141*

year, for which the artist's pocket-book does not survive. A single payment of seventy guineas is recorded in the artist's ledger in July 1783. Lady Caroline married John, 1st Earl of Cawdor, in 1789 and died in 1848.

Lady Caroline plucks a small rose, just starting to open, which is a compliment to her own budding beauty—the colour of the roses is repeated in her cheeks. Reynolds delighted in the movements and actions of children; Malone tells us (in Reynolds 1797, I, p. lii) that 'it was one of his favourite maxims that all the gestures of children are graceful, and that the reign of distortion and unnatural attitude commences with the dancing-master.' Ironically, it was the pose of Lady Caroline that attracted one hostile comment in a newspaper: 'she seems to be curtseying to the rose-bush, or to be deprived of the lower part of her limbs, and is a most unpleasing figure.' Obviously she is sitting on her heels, but it must be admitted that the conflicting viewpoints do create a rather odd effect (the child has been drawn slightly from above, as one would expect, but placed against the low horizon Reynolds normally gives his outdoor portraits).

The fresh, cold colour-scheme and the somewhat hard-edged treatment of the costume are most unusual, but the low placing of the figure in relation to the frame, leaving a broad expanse of cold blue sky, can be matched in other portraits fom the late 1770s and 1780s. The cream and white of the clouds and blue of the sky are ingeniously echoed in Lady Caroline's clothes. Aileen Ribeiro notes that her dress is of white muslin, her sash of blue silk, her hooded mantle of black silk lined with white satin and edged with black lace, and her cap of white net and lace 'with the lappets pinned up on the crown of the head, forming a kind of turban'. She points out that girls 'were encouraged to wear long mittens (which were more practical than gloves) in order that their hands and arms should remain soft and white' and that Lady Caroline's mittens are of cream silk lined with white silk. In painting them Reynolds has evidently worked the paint with the handle of his brush. D.M.

PROVENANCE Painted for Frederick, 5th Earl of Carlisle; purchased in February 1926 by Andrew W. Mellon, who bequeathed it to the National Gallery of Art, 1937 (no. 106).

EXHIBITED Royal Academy 1779 (252: 'A young lady; whole length'); British Institution 1824 (162), 1851 (118); Irish Institution, Dublin, 1856 (20).

LITERATURE Graves and Cronin 1899–1901, II, pp. 487–8; Waterhouse 1941, p. 70; Cormack 1970, p. 149.

ENGRAVED V. Green, 1778; S. W. Reynolds.

108 The Marlborough Family

318 × 289 cm
His Grace The Duke of Marlborough

This is, in Waterhouse's words, the 'most monumental achievement of British portraiture, the one occasion when Reynolds was able to demonstrate the full possibilities of applying the historical grand style to portraiture'.

George, 4th Duke of Marlborough (1739–1817), is seated at the left of the picture wearing the collar of the Garter and holding a cameo portrait head of the Emperor Augustus in his left hand (fig. 78). He rests his right hand on the shoulder

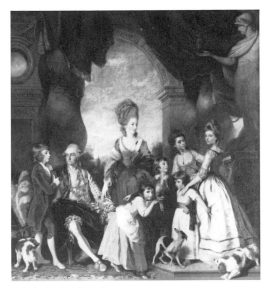

108 *reproduced in colour on p. 137*

of his eldest son, George, Marquess of Blandford (1766–1840), who holds one of the morocco cases which contained the Duke's collection of gems. Two years after this portrait was painted the Duke published a selection of his favourite gems in the first of two volumes illustrated with engravings by Bartolozzi after drawings by Cipriani. Father and son are therefore united by a shared absorption in the masculine world of classical collecting and connoisseurship. The Duke had been painted twice before by Reynolds, in 1762 (Blenheim) and 1764 (Wilton; replica at Blenheim).

Fig. 78 Antique cameo of the deified Augustus in a Renaissance setting (Romisch-Germanisches Museum, Cologne)

Caroline, Duchess of Marlborough (1743–1811), stands in the centre of the picture and, by the placing of her right hand and the turn of her head, links the group of father and son with a second group, that of her two eldest daughters, on

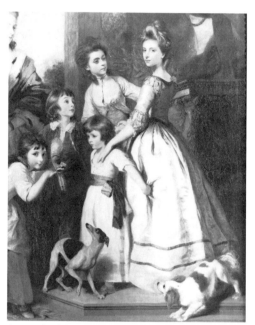

108 *(detail)*

her left. The Duchess was daughter of the Duke of Bedford and had been painted three times before by Reynolds: once before her marriage, as Lady Caroline Russell (the picture is still at Woburn); next, with her first baby, Lady Caroline, dancing on her lap (Blenheim; for the engraving see Cat. 59); and around 1776, whole-length, in her peeress's robes.

The young lady on the extreme right is Lady Caroline Spencer, afterwards Lady Clifden (1763–1813), who rests her left hand on the shoulder of the youngest child, Lady Anne, afterwards Countess of Shaftesbury (1773–1865). Lady Anne shrinks back in fright from a grotesque mask held up mischievously by her sister, Lady Charlotte, afterwards Lady Charlotte Nares (1769–1802). This motif was engraved as an independent picture by Schiavonetti in 1790, and (in reverse) by Turner entitled 'The Ghost'. Behind Lady Anne and looking towards Lady Caroline is Lady Elizabeth (1764–1812) who married her cousin, the Hon. John Spencer, and the small boy standing at the Duchess's elbow is Lord Henry (1770–95), who also features, together with his sister Lady Charlotte, in the famous group known as 'The Young Fortune-Teller' exhibited at the Royal Academy in 1775 and now in the Huntington Art Gallery in California. Lord Henry's brilliant diplomatic career was cut short when he died of fever at Berlin in his twenty-fifth year. In fact, apart from the Marquess of Blandford and the youngest child, Lady Anne, the Duke outlived everyone in the picture. When Lady Anne, by then Countess of Shaftesbury, died in 1865 she was, at the age of ninety-two, almost certainly the last of Reynolds's sitters to survive.

In order to arrange successfully eight figures (and three dogs) on an imposing architectural stage, the artist has established three separate but interrelated groups. The masculine pair of father and son has already been pointed out; its

formal, even hierarchical nature is established by the Duke's pose, a traditional one which had been much used in the seventeenth century for nobles and high Church dignitaries. Hogarth used it earlier in the eighteenth century for the figure of Lord Malpas, who presides over his family in the small painting of the Cholmondeley family (see fig. 47, p. 164). The second sub-group is focused on the eldest daughter at the opposite side of the canvas, and the Duchess links these masculine and feminine worlds. The third group consists, of course, of the children with the mask, and much of the interest of the picture springs from the contrast between adult formality and childish playfulness, a device which was also used by Hogarth, most strikingly perhaps in the Cholmondeley group. Two figures, Lady Charlotte and Lady Caroline, meet the spectator's eye, thereby providing points of entry into the picture-space. There are several classical allusions, not in the way figures are posed, but in the presence of the statue (supposed to represent the first Duke, for whom Blenheim was built) holding a winged figure of Victory, in the display of gems, and in the game with the comic mask (a motif which occurs on classical gems and sculpture, in a well-known etching by Della Bella and in a famous painting by Poussin).

We do not know when Reynolds was commissioned to paint this portrait. An oil sketch in the Tate Gallery (no. 1840) and an unpublished pen and ink drawing in the Beinecke Rare Book and Manuscript Library, Yale University (MS Vault Uncat. Tinker, p. 43—drawn to our attention by Kirby Talley) indicate an early stage in the planning, presumably before sittings commenced. In both the Duchess is shown seated. The pocket-books from 1774–6 are missing but appointments with the Duke and Duchess in 1777 are frequent: 23 January, 22 March, 4, 7, 9, 12, 21 and 25 April, 12 and 22 May, and 24 (cancelled) and 27 November. A few of these may have been social but most were probably for sittings. Also in that year Reynolds stayed at Blenheim Palace, setting out on 13 August and returning on 4 September. He worked at the portrait there, and no doubt above all at painting the children who, however, also had an appointment in London on 31 October. The pocket-book for 1778 is missing but since Reynolds is known to have altered the painting after its exhibition in that year, it is worth noting that he was again at Blenheim on 28 September 1779, apparently staying until 6 October. It would seem likely that he supervised the painting's hanging on this visit. Payment of seven hundred guineas was recorded, apparently (it is not as clear as it seems in Cormack) on 26 January and certainly before February 1780.

Aileen Ribeiro describes the costumes in the picture as follows: 'The most sumptuous costume is that worn by the Duke in Garter robes; the silver tissue sleeved habit, trimmed with gold and silver ribbons, and the ribboned trunk hose are depicted with meticulous detail. His legs are elegant in white silk hose and clearly visible on his right leg is a ribboned knee rose, a larger version of that worn on his shoe, residual elements of early seventeenth-century costume. His blue velvet Garter mantle is draped over one shoulder and his right knee; on the far left can be seen his Garter hat trim-

med with white ostrich feathers and a black heron feather (aigrette). The costume of the Duchess is a typical Reynolds-ian, vaguely classical cross-over white gown, with gold fringe on the shoulders and sashed at the waist. A blue mantle lined with ermine indicates her status; it is not a real garment. Her towering hair is lightly powdered, and topped with a gold gauze scarf. The Marquess of Blandford wears a suit of red velvet lined with squirrel fur; it looks similar to that worn by Lord Henry. Both boys, according to the English custom, have their frilled shirt collars open. Lord George's white silk shoes are interesting for they have red heels, a French court fashion dating from the later seventeenth century and worn at Court and on formal occasions until the mid-eighteenth century, when they fell into disuse; they were revived in the 1770s as a macaroni fashion by Charles James Fox. Lady Caroline wears a tight-bodiced robe *à l'anglaise* in creamy-pink satin, trimmed with blue ribbon and gold lace. Lady Elizabeth wears a white dress, the inverted v-shaped bodice edged with gold and fastened with a blue bow; round her neck is a black silk ribbon (a revival of a Jacobean style). Both girls have modest, unpowdered interpretations of the popular high-piled hairstyle. The smallest daughter, Lady Anne, has a white muslin dress fastening at the front with buttons and lacing and a blue sash. A stage further, in sartorial terms, is the dress of Lady Charlotte, possibly her first adult, coloured dress of pink taffeta, but with a child's back-fastening striped white silk over-gown.'

When this picture was shown at the Royal Academy in 1778 it was criticized by Horace Walpole, who—very characteristically—disliked the more formal elements such as the portrait of the Duke and the effect of the red curtain, but praised the children and the dogs. The critic in the *Morning Post* admired the variety of poses, 'the persons artfully detached and their several employments ingeniously appropriate'. Waagen, writing in the mid-nineteenth century, thought it a fine work, and particularly praised the arrangement of the figures and the animation of the heads. Northcote mentions a small copy of the picture made by Powell soon after the original was complete, the sight of which prompted Reynolds to return to his painting and change the background.

There were two very ambitious earlier family portraits at Blenheim by Closterman and Hudson which must have suggested the commission of this group, which, in its turn, inspired one of the greatest of Sargent's paintings, also to be seen at Blenheim. D.M.

PROVENANCE Painted for the 4th Duke; by descent.

EXHIBITED Royal Academy 1778 (246: 'Portraits of a nobleman and his family'), 1888 (120).

LITERATURE Northcote 1818, II, p. 83; Smith 1828, II, p. 295; Waagen 1854, III, p. 130; Leslie and Taylor 1865, II, pp. 196–9, 213–14; Stephens 1867, pp. 11–12; Graves and Cronin 1899–1901, II, pp. 626–8; IV, p. 1366; Waterhouse 1941, p. 69; Waterhouse 1953, p. 169; Burke 1959, p. 13; Cormack 1970, p. 159; Scarisbrick 1980, pp. 152–4.

ENGRAVED C. Turner, 1815.

109 & 110 Two Portraits of Members of the Society of Dilettanti

Each 196.8 × 142.2 cm
The Society of Dilettanti, London

The Society of Dilettanti was founded in 1732 as a dining club for gentlemen who had travelled to Italy, its purpose apparently to perpetuate the youthful high spirits as well as the cultural pursuits associated with the Grand Tour. Patrons of Italian Opera, they subsequently turned their attention to the sponsorship of archaeology, but they wished also to encourage living artists and proposed during the 1740s and 1750s to found an Academy of Art in London. They elected George Knapton as their first official 'limner' and he painted, between 1741 and 1749, twenty-three portraits of members, many of them in fancy-dress—as saints, gondoliers, cardinals, Turks and Romans—and all of them in animated poses. On Knapton's resignation in 1763 James Stuart was appointed in his place but he did nothing and was replaced in 1769 by Reynolds, who had been elected a member of the Society in 1766, proposed by Lord Charlemont whom he had known in Rome. The artist's pocket-books record his frequent attendance at the Society's Sunday dinners where he would have met many of his friends and sitters. It was probably due to his influence that the Society paid for prize-winning students from the Royal Academy to travel to Italy.

This Society resembled the Literary Club, which Reynolds himself had founded, in that its members came from all political parties. It also encouraged gentlemen of relatively modest means and some of the richest men in Britain to mix on equal and familiar terms. This equality is one of the themes of Reynolds's two group portraits—and was a severe compositional constraint. All sitters paid the same and would have expected to be equally conspicuous. Reynolds also strove to emulate the convivial (if not the carnival) character of Knapton's early pictures. The first of the two groups is the more unified in composition, although one figure does look like an afterthought. The chair in the left foreground of the second painting surely was an afterthought.

The idea of a group portrait seems to have been first suggested at the dinner of 12 January 1777, which we know that Reynolds attended, and it was no doubt discussed at subsequent meetings. The first of the portraits, indeed, may be intended to record the reception into the Society of Sir William Hamilton which took place on 2 March of that year. (Sir William was already known to Reynolds through their common involvement in the art market—Reynolds 1929, pp. 26–8.) Separate sittings for the individuals in both groups commenced at the close of April and stopped at the end of June 1777, resuming again presumably in the London Season of 1778 (but the artist's pocket-book for 1778 does not survive). The pictures were completed either early in January, or possibly in March, 1779. The artist was reprimanded by the Society for not having returned the 'toga' in February 1778 (Dilettanti MSS., vol. I, fol. 251) and in December 1778

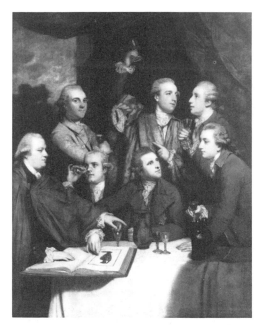

109 *reproduced in colour on p. 138*

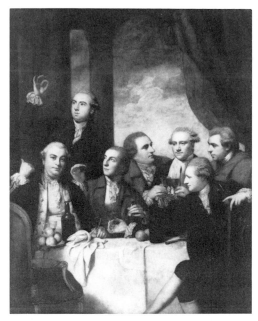

110 *reproduced in colour on p. 139*

again reprimanded, doubtless in a jocular spirit, for not having completed the paintings.

In the first painting Sir William Hamilton, wearing the Order of the Bath, is shown pointing to one of the magnificent folio volumes publishing his and other collections of Greek vases, the final, fourth one of which had appeared in the previous year. Standing beside him, to our left, is Mr (later Sir) John Taylor who holds up in a meaningful way a mysterious object which Sir Brinsley Ford has identified as a lady's garter of the period—a common subject of lewd male merriment which perhaps explains why the painting was not exhibited to mixed society at the Royal Academy. Also standing, and immediately behind Hamilton, is Mr Richard Thompson in the richly embroidered Robes of the Arch Master. In profile beside him and apparently in conversation with him is Walter Spencer-Stanhope. John Smyth of Heath Hall, Yorkshire, is perched on the side of the table on our right. To Hamilton's right, seated drinking, is Stephen Payne-Gallway of Toft's Hall, Norfolk; and to the extreme left, wearing the so-called 'toga'—in fact a cloak— as President for the evening and pointing to the vase is Sir Watkin Williams Wynn (for whom see also Cat. 95).

Whereas the theme of the first painting is the Society's enthusiasm for ancient vases, that of the second is its relish for ancient gems—common to both is the simultaneous delight in vintage claret. In the second painting the figure seated on the left gesturing over his shoulder is Lord Mulgrave. Behind him, holding a gem up to the light, is Thomas Dundas, later Lord Dundas. The Earl of Seaforth is seated beside Lord Mulgrave, also holding a gem; behind him to the right is Charles Greville (Hamilton's nephew); next, to our right, is John Charles Crowle, Secretary to the Society, wearing black legal gown and white bands, and touching glasses with these two is Joseph (afterwards Sir Joseph) Banks.

Lord Carmarthen (afterwards Duke of Leeds) is seated to the right, extending his hand across the table and holding a gem.

Appointments are recorded in the pocket-books as follows: Hamilton (1, 3, 6 [cancelled], 7, 10, 12, 13, 16, 18 and 21 June 1777—probably not only for this portrait); Taylor (24 March, 12, 16, 17, 18, 23 and 28 June 1777); Thompson (26, 28 and 30 June 1777); Stanhope (28 April 1777); Smyth (perhaps the Smith who sat on 23 February, 5, 10, 13, 19 and 24 March 1779, although this is later than everyone else—no sittings are recorded for Smyth, and we know that Reynolds spelt Smyth as Smith.); Payne-Gallway (as Mr Payne, 13 May 1777); Sir Watkin (3, 9, 11, 14 and 16 June 1777); Dundas (28 and 30 April, 26 and 30 May; 9 and 21 June 1777); Seaforth (26 April, 1, 5, 7, 15, 20 and 23 May 1777); Greville (9, with Banks, and 20 May; 7, 13, 17 and 18 June 1777); Crowle (14, 19, 22, 27 and 30 May, 20, 24 and 27 June 1777); Carmarthen (9, 11, 13 and 27 June 1777); Mulgrave (6 May and 2 June 1777); Banks (9, with Greville, and 23 May; 3 and 5 June 1777, 2 January 1779). A note at the end of the pocket-book for 1777 records a payment on 9 April of twenty-nine guineas by Mr Smith, noted as one of the Dilettanti. Payments for thirty-five guineas are clearly recorded in the ledger from Hamilton (Cormack 1970, p. 155), Taylor (p. 165), Smyth (p. 163), Dundas (p. 151), Carmarthen (p. 149) and Banks (p. 146); Greville, Sir Watkin, and Stanhope may have paid (pp. 153, 167, 164); Thompson, Payne-Gallway, Seaforth, Crowle and Mulgrave seem not to have done so.

The condition of the paintings was considered alarming in 1805 and they were cleaned, repaired and in parts repainted under the superintendence of West and Lawrence in 1820.

N.P.

PROVENANCE Painted for the Society, at present on loan to Brooks's Club.

EXHIBITED British Institution 1846 (93, 98); South Kensington 1868 (940, 941); Grosvenor Gallery 1883 (21, 32); Royal Academy 1956 (294); Birmingham 1961 (69, 70); Arts Council 1972 (220, 221—addenda in Catalogue pp. 911–12).

LITERATURE Leslie and Taylor 1865, II, pp. 64, 186–9; Graves and Cronin 1899–1901, I, pp. 251–5; Cust 1914, pp. 221–3; Harcourt-Smith 1932, pp. 69–75; Waterhouse 1941, p. 69; Cormack 1970, pp. 146, 149, 151, 153, 155, 163, 165, 167.

ENGRAVED C. Turner and W. Say.

111 Master Parker and his Sister Theresa

142 × 111 cm

The National Trust, Saltram (Morley Collection)

The many fine paintings by Reynolds remaining at Saltram, near the artist's native Plympton, testify to the productive nature of his long friendship with the Parker family. He was particularly attached to John Parker, who became the 1st Lord Boringdon in 1784, the father of these two children. During the 1770s and 1780s we find his name very frequently in the pocket-books; such jottings often relate to social engagements. Reynolds also stayed at Saltram during his summer excursions to the West Country.

On 26 March 1779 the children's aunt, Anne Robinson, wrote to tell her brother Lord Grantham, then Ambassador to Spain, that John and Theresa 'have been to sit today to Sir Joshua for the first time since their colds'. She goes on to say: 'It will not be finished for some time, but will be a very fine picture, and very like. I cannot well describe the composition of it, but they are very near kissing—an attitude they are very often in.' On 14 April she wrote, 'You cannot imagine how much the picture of the children improves. Sir Joshua said that the boy's head was the finest he had ever done.' There are records of appointments for 'Mr Parker', probably social engagements, in the artist's pocket-book on Sunday 31 January and 4 February 1779. 'Master Parker' had an appointment, probably the first sitting, on 13 February (together with his sister), and then also on 22 and 24 February, 1, 6 and 26 March, 24 April (again with his sister), 18, 22 (with his sister) and 27 May, and on 9 June. 'Miss Parker' is entered in the book on 13 (with her brother), 17 and 22 (immediately after her brother) February, 24 (with her brother) and 27 April, 1, 4, 13 and 22 (with her brother) May, and 2 June. Appointments with 'Mr. Parker' on 23 and 26 February, 27 March, and 21 May and for 'Mrs Parker' on 9 March, all at times in the early evening or late afternoon, suggest how frequently the artist saw the family at home, and doubtless the children playing together. In July of 1779 Reynolds entered the sum of two hundred guineas in his ledger as paid by 'Mr Parker, for his two children'.

Recent studies of the family and of children in this period (e.g. Stone 1977) have suggested that there was a new emphasis among the upper classes on domestic affection. This is reflected in family groups painted by artists like John Singleton Copley, Johann Zoffany and Daniel Gardner, and

is very evident in this and other paintings by Reynolds. Given Reynolds's predilection for Rembrandt, it is tempting to see the poses that he employed as an adaptation of the clasping gesture in *The Jewish Bride* (Rijksmuseum), but the similarity must be coincidental as that picture does not seem to have been known in eighteenth-century England.

John Parker, who was born on 3 May 1772, is represented wearing, as Aileen Ribeiro points out, a popular colour—brilliant red or scarlet—for boy's frock-coats in the 1780s, whilst his sister Theresa, who was born on 22 September 1775, 'wears the virtual uniform of little girls at this date, white muslin dress, with a touch of colour in the pink ribbon trimming her frilled cap, and the pink sash round her waist. This kind of simple colour scheme—basically white with a contrasting coloured sash—anticipates adult feminine dress

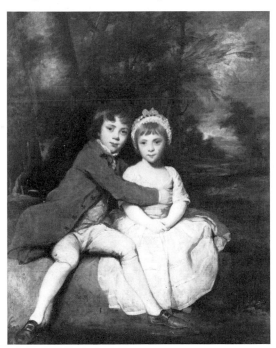

111 *reproduced in colour on p. 140*

of later in the decade, such as, for example, that worn by Maria Gideon' (Cat. 142).

The boy grew up to a political career, and never shared his father's interest (reflected at Saltram) in collecting. He succeeded to the barony in 1788 on the death of his father and was created 1st Earl of Morley on 29 Novembe 1815. He died on 14 March 1840. Theresa married the Hon. George Villiers in 1798, and died in 1856. D.M.

PROVENANCE John Parker (father of the John Parker depicted); by descent to the Earls of Morley; transferred to the National Trust, 1967.

EXHIBITED British Institution 1813 (45); South Kensington 1867 (787); Royal Academy 1876 (24); Grosvenor Gallery 1883 (145); 45 Park Lane 1937 (31); Plymouth 1951 (48).

LITERATURE Leslie and Taylor 1865, II, p. 224; Graves and Cronin 1899–1901, II, pp. 730–1; Waterhouse 1941, p. 73; Gore 1967, pp. 19–20; Cormack 1970, p. 161.

ENGRAVED S. W. Reynolds, 1820.

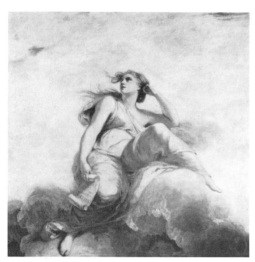

112 *reproduced in colour on p. 143*

112 Theory

172.7 × 172.7
The Royal Academy of Arts

This is Reynolds's only ceiling painting. It was made for the coved ceiling of the library of the new premises of the Royal Academy in Somerset House, the work of Sir William Chambers (Cat. 113). As detected by Leslie and Taylor but not, it seems, by the artist's contemporaries, the position of the legs and the pattern of the drapery are derived from the angel above the planet Mars in the mosaic designed by Raphael for the cupola of the Chigi Chapel in S. Maria del Popolo in Rome, of which Reynolds had made a sketch or of which he owned a print. Reynolds may also have had in mind the beautiful allegory by Titian which adorns the ceiling of the library of San Marco in Venice.

The painting was described thus by Reynolds's friend Joseph Baretti (Cat. 85) in his official guide: 'The Center-Painting represents the *Theory of the Art* under the form of an elegant and majestick female, seated in the clouds, and looking upwards, as contemplating the Heavens. She holds in one hand the Compass, in the other a Label, on which this sentence is written: *THEORY is the Knowledge of what is truly NATURE.*' Baretti proceeded to elucidate Cipriani's paintings in the coves as representing Nature (a lady nursing one child and simultaneously exhibiting herself to infant artists, etc.); History (a lady with trumpet engraving on a shield, etc.); Allegory (with the emblems of Navigation, Commerce, Fortune, Victory, etc.); Fable (with various poetic monsters such as the sphinx, pegasus, a satyr). It is interesting that other early accounts entirely misinterpret Cipriani's work.

Reynolds's figure also surely caused some head-scratching. Who would have any idea of her identity if she did not carry the 'label'? Theory does, however, succeed in appearing to float, and the crossing diagonals of the composition would have tied together the four corners of the room. The open pose and the flowing hair are highly typical of Reynolds's

work in about 1780, such as his portrait of Lady Jane Halliday (Waddesdon Manor) engraved in 1779, where the subject appears to be about to be blown off a hilltop in a gale.

Chambers's plans for the Academy's new building were approved and signed by Reynolds, as President, on 4 October 1776 (Royal Academy MS. Proceedings, III, p. 27), so he is likely to have begun to plan the painting about then. A receipt from the Lords of the Treasury for the modest sum of thirty guineas is dated 5 August 1779. A note of payment for the same amount is entered in the artist's ledgers after an entry dated November 1779 and before one dated August 1780 as 'from Sir William Chambers'—were there two payments, or is this disordered book-keeping, or a delay on the part of Chambers? In any case the canvas was certainly *in situ* in time for the first exhibition in the new building in 1780, and the painting is listed in the back of the pocket-book for 1779 (opposite page 192) with the names Dickinson and J. R. Smith (the latter cancelled) opposite. Evidently Reynolds was planning to have it engraved by one of these two mezzotinters, although nothing came of this.

Grozer's mezzotint of 1785 clearly shows twin points radiating from Theory's head, perhaps intended as an open divider. This is not apparent in the painting today.

The artist's studio sale on 16 April 1796 at Greenwood's included an 'unfinished study of Design, half-length' (lot 20) and 'The Theory of the Arts' (lot 66). N.P.

PROVENANCE Painted for the Royal Academy, Somerset House; removed with that institution to the National Gallery in 1837 and then to Burlington House in 1869.

EXHIBITED British Institution 1845 (165); Birmingham 1961 (72); Royal Academy 1968 (898).

LITERATURE Baretti 1781, p. 17; Northcote 1818, II, p. 84; Leslie and Taylor 1865, II, note p. 288; Graves and Cronin 1899–1901, III, p. 1148; IV, p. 1480; Waterhouse 1941, pp. 71, 125; Croft-Murray 1969, pp. 16, 18–19; Cormack 1970, p. 149.

ENGRAVED J. Grozer, 29 March, 1785; S. W. Reynolds (as 'Design').

113 Sir William Chambers RA

127 × 101.5 cm (on wood)
The Royal Academy of Arts

This portrait was presented to the Royal Academy as a 'diploma piece' by Reynolds and as an ornament for the new rooms in Somerset House of which Sir William Chambers was himself the architect. Chambers is portrayed in a 'formal red velvet frock coat with turned-down collar and narrow sleeves of a sort then worn everywhere except at court and with a full-dress wig' (Ribeiro). Behind him is the new Strand front of Somerset House (one half of which was occupied by the Academy).

The painting was hung in the Assembly Room and, as Sidney Hutchison pointed out, a drawing by Chambers for this room, in Sir John Soane's Museum, suggests that from an early stage it was planned to flank the chimneypiece with

a self-portrait by Reynolds (Cat. 116) on the other side. The portrait must have been completed at least a month before 1 December 1780 when Valentine Green's mezzotint engraving was published. There were perhaps sittings in 1778, for which year the artist's pocket-book does not survive. The appointment with Chambers for Christmas Day 1779 (no hour given) was probably social, and that for 16 April 1780 was at the dinner hour, but there were appointments for 28 July, 4 August and 28 November which could have been sittings.

There is also an earlier, unfinished portrait by Reynolds of Chambers of uncertain date (National Portrait Gallery). Intermediate between these two is an unfinished painting on

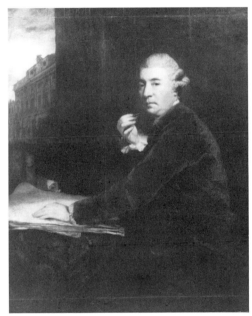

113 *reproduced in colour on p. 135*

wood in the reserve collection of the Musée des Beaux-Arts, Bordeaux, attributed to Raeburn (D.52.7.2), drawn to our attention by Dr D. B. Brown, which is surely by Reynolds and surely of Chambers (fig. 79). Like the Academy portrait, this has a Classical building back left and shows him with a *porte crayon* raised to his mouth but in less formal dress, without a wig, looking up as if seeking inspiration.

Sir William Chambers (1723–96), born in Sweden but educated in England, after much travelling as a merchant devoted himself to architecture, studying in Italy between 1750 and 1755, and then settling in London. In Rome he married Catherine Moore, who had previously been painted by Reynolds in Paris (Cat. 16), so the two men must have known each other in this period. His *Treatise on Civil Architecture* may be compared with Reynolds's *Discourses*: both saw themselves, and strove to be seen by others, as heir to an elevated European tradition. However, unlike Reynolds, Chambers enjoyed Royal favour. The relationship between the two men was close but never easy and sometimes hostile (see Hudson 1958, pp. 94–5, 165). It was Chambers whose schemes had made possible the foundation of the Royal

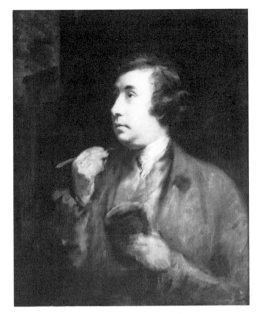

Fig. 79 Sir William Chambers
(Musée des Beaux-Arts, Bordeaux)

Academy. His appointment as Treasurer was made by the King, to whose ear he had access, and because of his connection with the Court Reynolds is said to have complained that Sir William was 'vice-Roy over him' (Farington 1978–84, VI, p. 2467). Chambers designed Reynolds's villa at Richmond between 1771 and 1772 but he must have noted how closely Reynolds was working both before and after this date with his great rival, Robert Adam (see especially Cat. 61, 95).

N.P.

PROVENANCE Painted for the Royal Academy.

EXHIBITED British Institution 1813 (13), 1843 (15); Manchester 1857 (53); South Kensington 1867 (544); Royal Academy 1870 (7), 1890 (126), 1968 (895).

LITERATURE Graves and Cronin 1899–1901, I, p. 163; Waterhouse 1941, pp. 71, 125; Harris 1970, p. 173.

ENGRAVED Valentine Green, 1780; S. W. Reynolds.

114 King George III
115 Queen Charlotte

Each 274 × 183 cm
The Royal Academy of Arts

That the monarch should agree to sit to him was requested by Reynolds as a condition of his acceptance of the Presidency of the Academy—or so it was reported. If the King was truly convinced of Reynolds's qualifications then he would, Reynolds believed, be bound to bestow this privilege hitherto reserved for his rivals. It would in fact have been unlikely that the King would refuse to sit to the President of the Academy, of which he was the Patron, how-

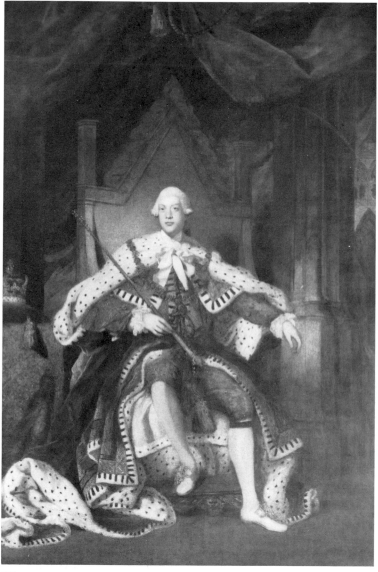

114

ever much he disliked Reynolds. State portraits of both King and Queen were considered indispensable ornaments of the new premises which the King had granted the Academy in Somerset House and Reynolds's imposing but dull paintings were hung in the Council Room when the Academy opened for its Exhibition in the Spring of 1780. It is possible, but improbable, that sittings took place in 1778, for which year the artist's pocket-books do not survive. The King and Queen certainly sat in 1779—appointments for the King are recorded on 21 and 26 May and for the Queen on 6, 8, 10 and 13 December. A mere two sittings for the King perhaps reflects his aversion to the artist, but the first looks as if it was for one and a half hours and the second could have been for even longer. Considering the labour lavished on the paraphernalia, it is safe to suppose that the Queen's portrait at least was not complete before 1780. Payment of two hundred guineas for the pair was recorded in the artist's ledger

after September 1779 and before August 1786. After Ramsay's death in 1784, when Reynolds became the official supplier of Royal portraits to Governors and Ambassadors, his studio produced replicas of those exhibited here—many are listed at the end of his second ledger (Cormack 1970, pp. 167–8). N.P.

PROVENANCE Painted for the Royal Academy, Somerset House; removed with that institution to the National Gallery in 1837 and then to Burlington House in 1869.

EXHIBITED The King: British Institution 1813 (1), 1843 (4); South Kensington 1867 (447); Royal Academy 1872 (272), 1873 (278). The Queen: British Institution 1843 (10); South Kensington 1867 (444); Royal Academy 1872 (273), 1873 (279).

LITERATURE Northcote 1818, I, pp. 84–5; Graves and Cronin 1899–1901, I, pp. 165–6, 356; Waterhouse 1941, p. 71; Cormack 1970, p. 157.

ENGRAVED The King: Dickinson and Watson, 25 April 1781. The Queen: Bromley.

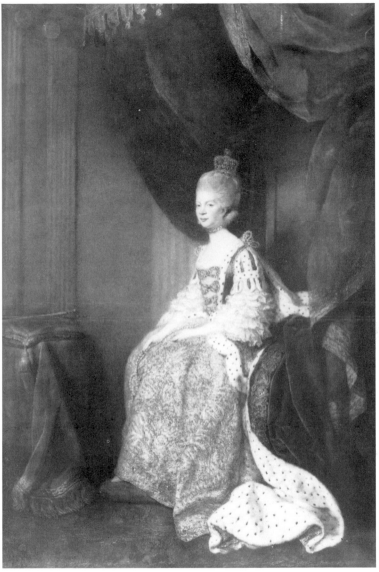

115

116 Sir Joshua Reynolds DCL

127 × 101.6 cm (on wood)
The Royal Academy of Arts

Reynolds paints himself in the manner of Rembrandt, in a pose which (as David Mannings points out) is derived from Van Dyck's engraved portrait of Adam De Coster, and beside a version or cast of the bust of Michelangelo by Daniele da Volterra. It was probably the 'bust in plaister of M. Angelo' which was not sold with Reynolds's other casts after his death but was lot 78 at Christie's on 19 May 1821 (the studio sale after his niece's death). Reynolds had become increasingly attached to Michelangelo's art and his seal consisted of that artist's head engraved in intaglio by Burch (Cotton 1856, note p. 187). Reynolds also exhibits himself in academical robes—originally with far more red in them, as can be seen from the miniature reproduction by Bone at

Windsor Castle, made in 1804 partly with the intention of making a record of colours which were already fading (Smith 1828, II, p. 292). The robes are those of a Doctor of Civil Law, a degree conferred on the artist by the University of Oxford in 1773. As Aileen Ribeiro points out, his hairstyle and 'the cut of his red silk suit edged with fur (possibly skunk)' suggest a date closer to 1780 than 1773, but at the same time the fur, and still more obviously the velvet hat, evoke the self-portraits of Rembrandt.

The self-portrait was intended to hang together with the portrait of Sir William Chambers (Cat. 113) in the Assembly Room of the Academy's new premises in Somerset House, one on either side of the chimney. There is apparently no record of the exact date at which the painting entered the Academy's Collection, but the mezzotint after it by Valentine Green was published on 1 December 1780 (together with one after the portrait of Chambers). The fact that the portrait

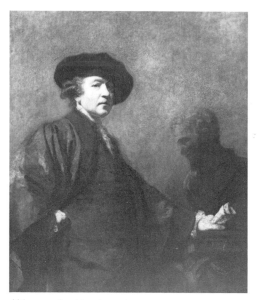

116 *reproduced in colour on p. 142*

Reynolds sold the first version of this self-portrait to the Duke of Rutland (we know that a self-portrait of this sort perished in the fire of 1816 at Belvoir Castle) and then made another version for the Academy. N.P.

PROVENANCE Painted for the Royal Academy.

EXHIBITED British Institution 1813 (76), 1843 (6), 1846 (15); Manchester 1857 (48); South Kensington 1867 (550); Royal Academy 1870 (81); Grosvenor Gallery 1883 (5); 45 Park Lane 1937 (18); Arts Council 1949 (13); Royal Academy 1956 (284).

LITERATURE Northcote 1818, II, p. 89; Graves and Cronin 1899–1901, III, p. 803; Waterhouse 1941, pp. 64, 123.

ENGRAVED Valentine Green, 1780; S. W. Reynolds.

VALENTINE GREEN (after Reynolds)

117 Sir Joshua Reynolds

48.1 × 38 cm
The Trustees of the British Museum

of Chambers rather than this was presented as a Diploma Piece suggests that it was finished first. It is also possible that

For the painting see Cat. 116. For Valentine Green see Cat. 102. The print was published by the engraver on 1

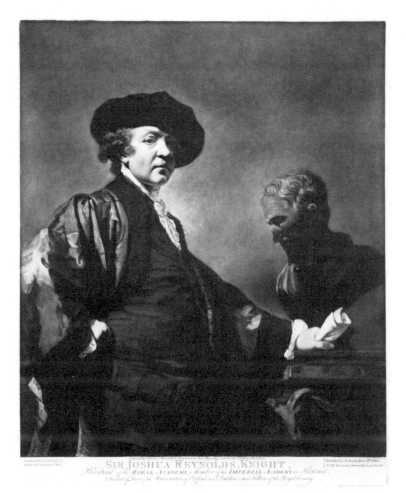

117

December 1780. Its second state includes in its inscription the information that the portrait was painted 'for the Royal Academy' in that year. N.P.

LITERATURE Chaloner Smith 1875–83, no. 110 (1); Whitman 1902, no. 105 (1); Russell 1926, no. 110 (2).

118 Lady Worsley

236 × 144 cm
The Earl of Harewood

This is one of Reynolds's most spectacular female portraits. Ladies had been painted in riding costume since the seventeenth century—Kneller's fine whole-length of the Countess of Mar in Edinburgh comes to mind—but rarely with so powerful an effect of pure colour, the deep warm red perfectly set off by the cooler greeny-brown landscape. The riding habit worn by Lady Worsley was adapted from the uniform of her husband's regiment, the Hampshire Militia, of which he became Colonel in 1779.

Aileen Ribeiro notes the woollen jacket in this portrait, 'with its military revers, fastened by hooks and eyes at the chest, and sloping away to the sides, follows the cut of a man's coat. It is worn over a white silk waistcoat which fastens from left to right. On her head Lady Worsley wears a black beaver hat trimmed with ostrich feathers. The new freedom given to women by their adoption of masculine clothes (some women, according to the *Gentleman's Magazine* for 1781, even went so far as to wear the breeches, common for equestriennes on the Continent), caused a freedom of gait—along with the new low-heeled shoes—which some commentators, like Elizabeth Montagu, found unfeminine; in Bath in 1780 she found that "the misses waddle and straddle and strut and swagger about the streets here, one arm akimbo, the other swinging" [Blunt 1925, ii, p. 82].' The fashion must be seen against the background of war preparation in 1778, of ladies attending military reviews and wearing regimental colours. The *London Chronicle* of 23–6 May 1778 credited the fashion to the Duchess of Devonshire and Lady George Sutton, whose husband was Colonel of the Nottinghamshire Militia. On 16 March 1779 Dr Johnson was asked for his opinion on a poem which complimented the Duchess of Devonshire 'walking across Coxheath, in the military uniform' (Boswell 1934–50, III, p. 374).

Seymour Dorothy Fleming, daughter of Sir John Fleming, Bt, of Brompton Park, married on 15 September 1775 Sir Richard Worsley, Bt, of Appuldurcombe, Isle of Wight, a keen art collector, later last British Envoy to the Venetian Republic. He was a friend of Reynolds, who visited Appuldurcombe on 26 June 1773. It seems likely, for reasons we shall presently consider, that Sir Richard and Lady Worsley began sitting for their portraits in the last months of 1775, soon after their marriage (Reynolds's pocket-books for that year and the following are missing) but the first appointments for Lady Worsley of which we have a record

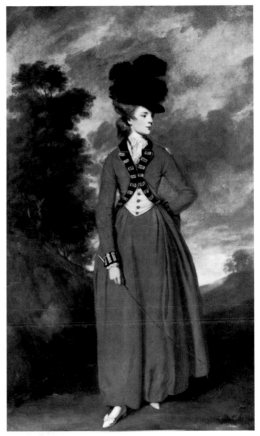

118 *reproduced in colour on p. 144*

are in 1777. On 9 February the name 'Mrs Worsley' is noted in the artist's pocket-book, but whether or not this has any connection with this picture remains unclear. Lady Worsley's name is entered on 11 February, 27, 28 and 29 March, 15 July, and 1, 3, 4 and 6 December. The pocket-book for 1778 is missing, and her name occurs next on 18 April 1779. That was a Sunday and at eight o'clock, which if in the morning was exceptional for a lady of fashion and is more likely to have been for an evening social engagement. Three appointments in June, 8, 12 and 15, may be for sittings. Lady Worsley's portrait, but not that of her husband, was exhibited at the Academy in 1780.

It is when we turn to Reynolds's ledgers that the problems begin. On 16 January 1776 Lady Worsley's name is entered against a payment of 150 guineas. This represents, as we know from a letter Reynolds wrote on 9 September 1777, his total price for a whole-length (Reynolds 1929, p. 56). Immediately underneath this entry are the words 'Frame paid', 'Ditto' (i.e. Lady Worsley again) and another sum of 150 guineas. This may be a slip of the pen, though there are separate reasons for thinking that Reynolds painted two whole-length portraits of this sitter. In April Sir Richard's portrait was paid for, again 150 guineas. It seems likely that none of these ledger entries refers to the Harewood portrait, because five years later, in June 1781, Reynolds wrote: 'Lady Worsley, in a riding-habit; given to Mr. Lascelles', and

entered—but not in the paid column—'150' (guineas presumably; erroneously transcribed as £150 in Cormack).

There is a good reason why this splendid portrait should have been given away. On 22 February 1782, in the Court of King's Bench, before Lord Mansfield, Sir Richard brought an action against one of the officers in his own regiment for criminal conversation with his wife. There followed a trial which displayed aristocratic morality in a lurid light (see caricatures Cat. 203) and concluded with Sir Richard receiving a mere shilling's damages.

There is also a good reason why the painting should have been given to 'Mr Lascelles'. Edwin Lascelles (afterwards 1st Lord Harewood) had married Lady Worsley's mother, Jane Fleming, and it was through this marriage that Lady Worsley's portrait passed to the Earls of Harewood. When Sir Richard died in 1805 leaving no male heir, his portrait passed to his niece's husband, the Earl of Yarborough, and was removed to Brocklesby Park where it still hangs (fig. 80). At the same time, as noted in the *Gentleman's*

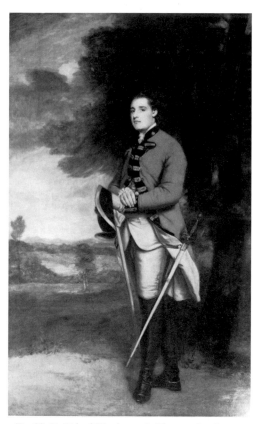

Fig. 80 Sir Richard Worsley, probably completed 1777
(The Earl of Yarborough, Brocklesby Park)

Magazine (1805, ii, pp. 781–2), a jointure of £70,000 reverted to Lady Worsley, who, one month later, married Mr J. Louis Couchet.

It is hard to explain why full payment for Lady Worsley's portrait should have been made as early as 1776, unless there was another whole-length portrait of her, perhaps companion with the portrait of Sir Richard. It is true that no

such portrait seems to survive, but it could very easily have been destroyed by her irate husband. The entry in the ledger in June 1781 which mentions the riding-habit so specifically must refer to the Harewood portrait, and the note of 150 guineas, not apparently paid, presumably represents the sum Reynolds had hoped to obtain for the work, but from whom is not clear. There are other examples of Reynolds painting two major portraits of a great society beauty in the same period; he might even have done so on his own initiative in this case. D.M.

PROVENANCE Edwin Lascelles, 1st Lord Harewood; by descent.

EXHIBITED Royal Academy 1780 (102: 'Portrait of a Lady'); British Institution 1851 (138); Royal Academy 1886 (157), 1968 (78).

LITERATURE Leslie and Taylor 1865, II, p. 218; Graves and Cronin 1899–1901, III, p. 1070; Borenius 1936, p. 167; Waterhouse 1941, p. 71; Waterhouse 1953, p. 159; Cormack 1970, p. 166; Waterhouse 1973, p. 48.

No early engraving recorded.

119 Fortitude
120 Justice

Each 223.5 × 83.8 cm
Private Collection

Reynolds agreed in July 1777 to a proposal put to him by Joseph Warton on behalf of Dr John Oglander, the Warden of New College, Oxford, that he should prepare designs for the large west window of the College's gothic Chapel to be painted on glass by Thomas Jervais. He visited the Chapel, probably in August on his way to Blenheim Palace, and made his plan as follows: the four Cardinal Virtues flanking the three Christian ones, each in a separate light along the lower range—Temperance (facing right), Fortitude (facing outward), Faith (facing right and looking up), Charity (the central group facing in, out, up and down), Hope (facing left and looking up), Justice (facing outward) and Prudence (facing left); and, above, a large scene of the Adoration of the Shepherds flanked by extra shepherds in the separate lights (among them the likenesses of both Reynolds and Jervais; see fig. 18).

Although the College had no more than drawings in mind, Reynolds produced finished paintings as being better suited to his way of working, better for the glass painter and, of course, works of art in their own right which he could exhibit and sell. The paintings were exhibited between 1779 and 1781 at the Royal Academy—Justice in 1780 and Fortitude in 1781—but they must have been completed by 25 April 1780 when the glass paintings after them were exhibited in Cockspur Street. All the figures, except for the Adoration of the Shepherds, also seem to have been paid for by—or soon after—May 1780. All the glass, including the Adoration, was exhibited in Pall Mall in May 1783. These and other exhibitions of glass painting with back lighting inspired the experiments with transparencies by Gainsborough and were generally admired, but the effect

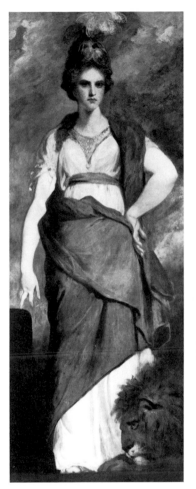

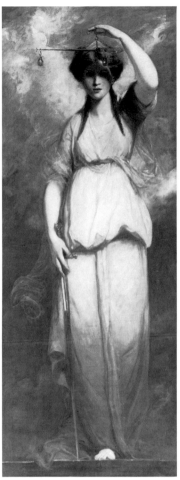

119 *reproduced in colour on p. 146* 120 *reproduced in colour on p. 147*

note on *Justice* would appear to be dated October 1778. *Fortitude* had cracked somewhat but the shadows of the warm brown drapery have survived and the way that the pink is heightened to red in the lips and girdle and toes is highly enticing. The artist's niece Elizabeth (Betsey), daughter of Mrs Johnson (see Cat. 9), is supposed to have been the model for *Fortitude*, but she seems only to have been resident with her uncle between March and September 1776 (Radcliffe 1930, pp. 187, 200–6). The softness of *Fortitude*'s draperies provide no clue that they are derived from a famous antique marble statue (fig. 81; Haskell and Penny 1981,

Fig. 81 Episcopius (Jan de Bisschop), *Cesi Amazon* (or Juno), prior to restoration, engraving

of the painted glass was found to be far less magical in the Chapel, when set up there later in 1783 (see Walpole 1937–83, II, p. 170; XXIX, p. 301; XXXIII, p. 417). Reynolds's paintings, however, were among his most valued works: the Duke of Rutland purchased the Adoration for twelve hundred guineas (destroyed by fire at Belvoir Castle), and Lord Normanton paid £3,565 for the Virtues.

In a period when female personifications were generally designed merely to please the eye, Reynolds created a *Fortitude* whose whole pose, including, indeed above all, the tips of her fingers (on the broken but untoppled column which is her attribute) suggests security and resolution, and a *Justice* as finely balanced in her body as in her thoughts. As the anonymous author of *A Candid Review of the Exhibition* of 1780 pointed out (p. 24), the shadow falling over the eyes of *Justice* serves as a substitute for the traditional blindfold. The point of the blindfold was that Justice was unswayed by superficial evidence: Reynolds indicates that she has eyes only for the balance. Even the highlight on the keen edge of the sword contributes to the intellectual content of the figure.

Reynolds made technical notes of the medium, and in particular the amount of wax employed on these figures—the

242–3). There is a preparatory pen and ink study for *Fortitude* in the Lucas album. The engraving showes how Justice's plaits originally curled around her breasts. N.P.

PROVENANCE The Marchioness of Thomond (née Mary Palmer, the artist's niece); Reynolds's studio sale 26 May 1821 (69) and (66), bt for the Earl of Normanton; by descent.

EXHIBITED Fortitude: Royal Academy 1781 (402); British Institution 1813 (65); Royal Academy 1882 (132). Justice: Royal Academy 1780 (157); British Institution 1813 (69); Royal Academy 1882 (166).

LITERATURE Northcote 1818, II, pp. 103–9; Waagen 1857, pp. 370–1; Mason, in Cotton 1859 ('Notes and Observations'), p. 58; Leslie and Taylor 1865, II, p. 227; Graves and Cronin 1899–1901, III, pp. 1186, 1188; Roldit 1903, pp. 206–24; Reynolds 1929, pp. 58–61; Waterhouse 1941, pp. 71, 72; Cormack 1970, pp. 160, 168; Reid 1983.

ENGRAVED G. J. & T. G. Facius, 1 June 1782; S. W. Reynolds.

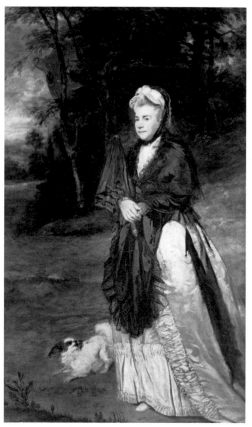

121 *reproduced in colour on p. 145*

121 Mary, Countess of Bute

236 × 145 cm
Private Collection

In his comments on the year 1779, C. R. Leslie noted that the quality of Reynolds's work was never higher, and referred to the whole-length of the Countess of Bute walking in the garden with an umbrella in her hand as 'a proof how little inclined the painter was, sometimes, to sacrifice character to beauty'. This superb but little-known portrait, which has not been exhibited publicly for more than a century, demonstrates the most sympathetic side of Reynolds's art, and as an apparently uncontrived, direct and informal whole-length portrait it is unsurpassed in the eighteenth century.

Mary (1718–94), only daughter of Edward Wortley-Montagu, married on 24 August 1736 John 3rd Earl of Bute, an unpopular Prime Minister notorious for his influence over the young George III. On 3 April 1761 Lady Bute was created Baroness Mount Stuart of Wortley, Co. York. When she died on 6 November 1794 at her house at Isleworth, her obituary noted that 'she survived her lord (by whom she had five sons and six daughters) not three years, and her eldest son not ten months; and by her death the Hon. James Wortley Montague obtains possession of his grandfather's fortune, £20,000 per annum' (*Gentleman's Magazine,* LXIV, ii, p. 1061).

Appointments are recorded in Reynolds's pocket-books for 9 and 13 December 1777, 13 November 1779 and 12 December 1780. She probably sat in 1778 but the pocket-book for that year is missing. The picture hung originally in the library at Luton Hoo, and is recorded there in a catalogue drawn up in 1800. The 3rd Earl of Bute had purchased the house and estate in 1762, and there stood at that time in the grounds a plain Tuscan pillar topped by an urn, described in an early Victorian guide-book as 'peculiarly beautiful'. Whether this provided Reynolds with his first idea for a background, or whether the urn we can still see in the picture was just one of Reynolds's regular studio props, we do not know. At any rate the painter changed his mind and covered the urn with trees, but it is now partly visible, as is the outline of part of the pedestal.

On 7 April 1786 Reynolds recorded payment of 150 guineas for this picture, which corresponds with his price for a whole-length ordered before 1782. Professor Waterhouse has pointed out that it seems consistent in style with work of the mid-1780s, and it is true that the pocket-books do not survive for 1783 and 1785. Possibly Reynolds worked over the picture, making the alterations which are evident, not long before it was paid for and sent home.

Aileen Ribeiro notes that 'as an older woman, the Countess has a more modest and less exaggerated hairstyle than fashion would normally dictate in the late 1770s. Her open robe is of plain silk with a train, and a ruched silk trimming (robing) down the side; the skirt is of the same silk, with a flounce at the hem. The fashionable skirt width, created both by the heavy satin and hip pads, means that for outdoors a cloak is the most practical garment. Here the sitter wears a black silk écharpe cloak hooded, and edged with black spotted net. Although the umbrella was just beginning to be accepted by Englishmen at this period, parasols (to protect the complexion from sun and wind) had been carried by women throughout the eighteenth century, though they rarely appear in portraits. The whiteness of the hands could either be protected by gloves, or, as here by silk mittens; on her left hand can be seen a spotted silk mitten.' D.M.

PROVENANCE By descent.

EXHIBITED British Institution 1823 (55); Royal Academy 1870 (71).

LITERATURE Leslie and Taylor 1865, II, p. 279; Graves and Cronin 1899–1901, I, p. 137; Waterhouse 1941, p. 69; Cormack 1970, p. 146; Waterhouse 1973, p. 48.

ENGRAVED W. Greatbach (in part), 1830.

122 The Ladies Waldegrave

143.5 × 168 cm
The National Gallery of Scotland, Edinburgh

The painting represents three daughters of James, 2nd Earl Waldegrave and Maria Walpole, illegitimate daughter of Sir Edward Walpole, Horace Walpole's brother. They are, from left to right, Lady Charlotte Maria (1761–1808), Lady

Elizabeth Laura (1760–1816) and Lady Anna Horatia (1762–1801). The picture was commissioned by Horace Walpole (for whom see Cat. 28), who described its genesis in a letter to William Mason 28 May 1780: 'Sir Joshua has begun a charming picture of my three fair nieces, the Waldegraves, and very like. They are embroidering and winding silk. I rather wished to have them drawn like the Graces adorning a bust of the Duchess [their mother, re-married] as the Magna Mater—but my ideas are not adopted; however I still intend to have the Duchess and her two other children as Latona, for myself.' Taken in isolation this last sentence has been solemnly misinterpreted by almost every subsequent writer. In fact it occurs in a letter which is, from the opening sen-

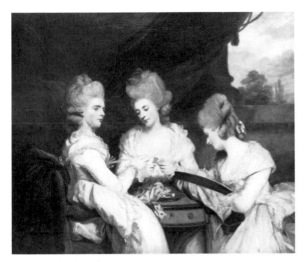

122 *reproduced in colour on p. 125*

tence, flippant even by the writer's own standards, and must, as Nicholas Penny has pointed out, be taken as an ironic dig at Reynolds's aspirations to the Grand Manner with which Walpole had little sympathy. As a painting of three sisters it was bound to invite comparisons with the earlier *Montgomery Sisters* (Cat. 90) which Walpole dismissed at 'stale'.

Reynolds has produced a monumental, yet at the same time intimate, conversation piece, in which Lady Horatia is shown concentrating on her tambour while Lady Maria, holding a skein of silk, looks up as if she had just become aware of the presence of the painter. When he saw it at the Royal Academy in May 1781 Walpole thought it 'a most beautiful composition; the pictures very like, and the attitudes natural and easy'. But increased familiarity with the picture as it hung in the refectory at Strawberry Hill led Walpole to a more critical view. The hands, he told Mason in a letter 10 February 1783, are abominably bad, 'and though the effect of the whole is charming, the details are slovenly, the faces only red and white; and his [i.e. Reynolds's] journeyman, as if to distinguish himself, has finished the lock and key of the table like a Dutch flower-painter'. Although Waagen specifically praised the 'admirably painted table' it is difficult to disagree with Walpole on this; yet it would be a pity if the discrepancy he rightly notes between the broad, almost abstract handling of the

masses and the tight, fussy details of the furniture is allowed to spoil our enjoyment of the picture today. The composition has considerable power, as F. G. Stephens observed in the long entry he contributed to the catalogue of a major one-man show of Reynolds's work held at the Grosvenor Gallery in 1883–4. The artist has produced, Stephens decided (writing as he was in the age of Whistler and Albert Moore), 'what is now called a study in white'.

Appointments for 'Lady Laura Waldegrave' (sometimes noted simply as 'Lady Laura') are recorded in the artist's pocket-book of 1780 for 22 and 25 May (possibly also 11 May but the writing is smudged), 2, 8, 19 and 22 June (with 6 June faintly and 15 June boldly cancelled). Appointments for 'Lady Waldegrave' possibly refer to the two younger sisters and commenced earlier. They were for 1, 5, 8, 9, 13, 16 and 19 May. In the following year on 2 March there is an appointment for 'Lady Waldegrave'—possibly another sitting as the artist prepared the painting for exhibition. The year after that, on 7 June 1782, Reynolds recorded a payment by Walpole of three hundred guineas for 'The Lady Waldegraves' and this is confirmed by a surviving receipt.

Aileen Ribeiro observes that at this date 'fashion was moving towards a kind of simplicity which, if not strictly classical, was far less dominated by trimmings and patterned textiles, which perhaps explains Reynolds's preparedness to paint it. He has depicted the Waldegrave sisters in white muslin, *the* fashionable textile of the decade. They appear to be wearing the popular robe *à l'anglaise*, tight-fitting at the bodice, and bouncing out over the hips; the sleeves are long and tight to the wrist, and they all wear white fichus over their shoulders. The all-over softness and downiness of dress in the 1780s is echoed in the lightly powdered hair; although it is still built up over pads (or false hair), the height and rigidity of the 1770s has given way to a softer and less tightly curled style. On the table lies an embroidered silk knotting bag, which would hold both the implements for knotting [see Reynolds's *Lady Albemarle*, Cat. 33], other forms of handicraft, and items such as handkerchieves, scent etc—in short, the ancestor of the modern handbag.'

A watercolour of the Refectory, Strawberry Hill, by John Carter of 1788 (illustrated in Crook 1973, p. 1599) shows the painting hanging in its original, relatively simple, frame, on a pale blue wall opposite the earlier, smaller, conversation piece (Cat. 41) which Reynolds had painted for Walpole.

D.M.

PROVENANCE Painted for Horace Walpole, great-uncle of the sitters; bequeathed to Mrs Damer; 6th Earl Waldegrave 1811; by descent to Lord Carlingford; Strawberry Hill Sale, Robins, 18 May 1842 (35); Daniel Thwaites by 1886; by descent to Lord Alvingham, from whom bt by the National Gallery of Scotland in 1952.

EXHIBITED Royal Academy 1781 (187: 'Portraits of three ladies'); British Institution 1823 (15), 1856 (157); South Kensington 1867 (452); Grosvenor Gallery 1883 (27); Agnew's 1899 (11); Royal Academy 1951 (82).

LITERATURE Waagen 1857, p. 152; Leslie and Taylor 1865, II, pp. 294–6; Graves and Cronin 1899–1901, III, pp. 1017–19, 1430; Walpole 1937–83, XXIX, pp. 45–6, 138, 285; Waterhouse 1941, p. 72; Cormack 1970, p. 166; Thompson and Brigstocke 1970, p. 81; Waterhouse 1973, p. 12.

ENGRAVED V. Green, 1781.

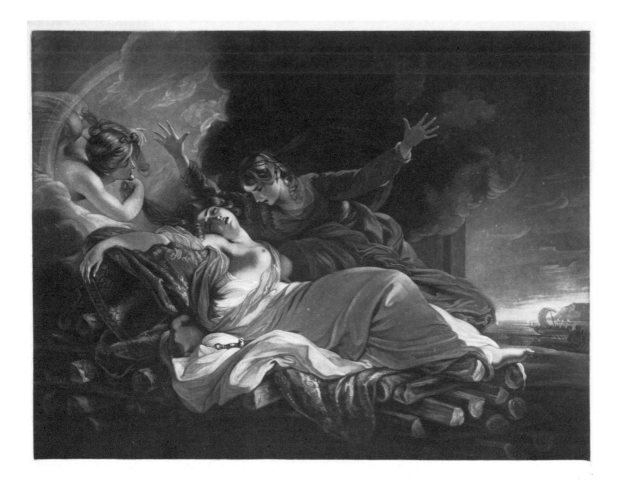

123

JOSEPH GROZER (after Reynolds)

123 The Death of Dido

49.5 × 59.3 cm
The Trustees of the British Museum

At the close of the fourth book of Virgil's *Aeneid*, Dido, Queen of Carthage, deserted by her new husband, the Trojan hero Aeneas, orders her sister Anna to place their bridal bed and his arms and robes upon a pyre, ostensibly to perform a magic rite. Dido then climbs upon the pyre and falls upon Aeneas's sword. Anna returns, first reproaches, then laments, and embraces her sister who attempts in vain to rise and then seeks for light in heaven, finds it, and swoons. Juno, in pity, dispatches Iris to release Dido's soul from agony. To do this Iris cuts a lock of Dido's hair at which her life 'flowed out in the turbulent air'. This is the celebrated poetic episode which Reynolds chose to illustrate in a painting which he exhibited at the Royal Academy in 1781 (no. 160) and which is today in the Royal Collection (Millar 1969, p. 106).

The painting was admired but usually with qualifications—*The Earwig* found the Queen's face inadequately expressive and the anatomy dislocated but the

colouring superb (quoted Cotton 1856, p. 156). The *Morning Herald* felt that Anna's expression bordered upon the burlesque (quoted Graves and Cronin 1899–1901, pp. 1146–7). Fuseli, who was acute at detecting artistic debts, noted that Reynolds adopted the 'clamourous grief of Anna from Daniel di Volterra' (Knowles 1831, I, p. 386) and in this century Edgar Wind noted that the pose of Dido was adapted from that of Psyche in one of the episodes designed by Giulio Romano for the Sala di Psyche in the Palazzo del Te in Mantua (Wind 1938–9, pp. 182–3). It is possible that the appointments for a model, Miss Elizabeth Wateredge of King Street, Covent Garden, on 18 and 23 March (and perhaps on 14 March when her address is noted) in 1781 are for Dido, but Reynolds was also said by Stothard to have built a model pyre and to have used a lay figure (Leslie and Taylor 1865, II, pp. 326–7).

A note at the end of the pocket-book for 1779 (opposite page 192) reads 'Dido—Mr. Doughty' which suggests that Reynolds was at work on the painting in that year and wanted Doughty to engrave it, but Doughty (for whom see Cat. 80) had left the country in 1780 and at the end of the pocket-book for 1781 we read 'Dido—Dickinson', suggesting that Reynolds wanted Dickinson to engrave it, or at least

to publish it. It was, in fact, engraved by Grozer, a little known artist who worked in both mezzotint and stipple between 1786 and 1797. Since it was published on 9 May 1796, long after Reynolds's death, he was unlikely to have selected Grozer for the job. N.P.

LITERATURE Hamilton 1874, p. 111; Chaloner Smith 1875–83, no. 25.

FRANCESCO BARTOLOZZI (after Reynolds)

124 Thais

54.3 × 33.5 cm
The Trustees of the British Museum

By 1776 a leading London procuress, Charlotte Hayes, had in her clutches 'Miss Emily', a beautiful girl whom she had first spied as a twelve-year-old urchin leading her blind father through the streets. Miss Emily was taught to walk with grace (but not how to read or write), and launched into the 'great world'. Her history is recorded in the memoirs of William Hickey (1913–25, I, pp. 249–64, 321–2; III, pp. 139–40; IV, p. 488). By 1780 she had set the town on fire. Reynolds's painting of her was exhibited at the Academy exhibition (as no. 10) in 1781, entitled simply *Thais*. (Thais was an Athenian courtesan who persuaded Alexander the Great to burn the Royal Palace of Persepolis.) Gossip, reported or invented by *The Earwig*, had it that Reynolds painted Emily setting the 'Temple of Chastity on fire', thereby revealing her true character, out of irritation that she did not pay the full price for the picture, but Fanny Burney reported that she sat at the desire of the Hon. Charles Greville (Burney 1842–6, II, p. 14).

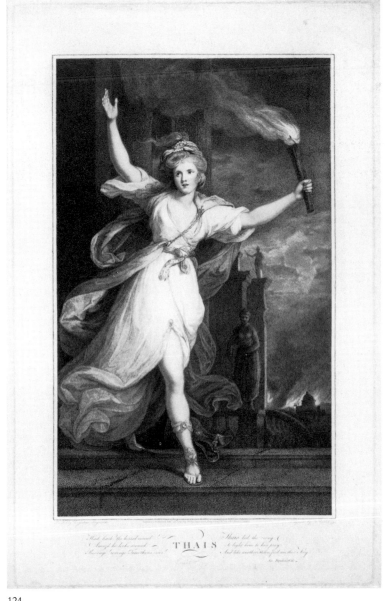

124

Reynolds's pocket-book for 1781 records a dinner engagement with Mr Greville on 1 April at which the portrait was probably discussed since he jotted down 'Frame for Thais' opposite. There is also a note of the dimensions of the frame on 18 or 19 April and at the end of the book a note 'Thais—to Mr. Greville'. In his ledger a payment of £157.10s by Greville for 'Thais and his own picture' is recorded (Cormack 1970, p. 153). That *Thais* cost a hundred guineas, as Northcote claimed (1818, II, pp. 119–20), is confirmed by another, cancelled entry on the former page of the ledger (not transcribed by Cormack).

Charles Greville was second son of the first Earl of Warwick, brother of Lord George Greville (see Cat. 22) and had been painted by Reynolds among the Dilettanti (see Cat. 110). Payment for *Thais* would seem not to have been made before 1783. In May 1782 Emily herself had accompanied the most faithful of her protectors, Bob Pott, son of the eminent surgeon, to India, where, after consuming excessive amounts of iced water, she died. The distraught Pott spent thousands on a mausoleum for her. Greville, heavily in debt, soon sold her painting which is now at Waddesdon Manor (Waterhouse 1967, pp. 92–4). He was by 1783 fully occupied with Emma Hart (the future Lady Hamilton).

Francesco Bartolozzi (1728–1815), whose print after the painting is shown here, was the leading practitioner in Europe of the dot and stipple manner. Reynolds must have known him well since he had painted his portrait between 1771 and 1773. Bartolozzi had enjoyed considerable success in Italy prior to coming to London in 1764 to make prints of the Guercino drawings in the Royal Collection. In 1802, when the boom in the London print trade was over, he left for Lisbon where he spent the last years of his life. Reynolds recorded an appointment with Bartolozzi on Sunday 31 March 1782, and reminded himself 'to call on Bartollozzi' opposite the entry for 6 September in his pocket-book for 1784. This print, however, was published on 20 February 1792.

The poetry in the legend is taken from Dryden's *Alexander's Feast; or the Power of Musique. An Ode in Honour of St. Cecilia's Day* of 1697 which was, during the eighteenth century, one of the most famous poems in the language. It describes how the lyre and voice of Alexander's court musician Timotheus inspired Alexander and Thais to fire the Palace. It was probably this ode rather than any ancient source that inspired Reynolds. N.P.

LITERATURE Hamilton 1874, p. 95; de Vesme and Calabi 1928, no. 1356 (4).

125 Doctor Charles Burney

74 × 61 cm
National Portrait Gallery, London

This portrait was acclaimed at the Royal Academy exhibition of 1781 as a 'strong likeness' (the *St James's Chronicle*) and a 'formidable likeness' (the *Morning Herald*). 'Excellent,'

wrote Walpole in his copy of the catalogue. The flickering dashes of paint in the lips and eyebrows, perhaps inspired by the example of Hals, are typical of Reynolds's portraiture in the 1780s, and convey, as does the improvised baton of a roll of sheet music, the act of listening to music as effectively as any portrait ever painted.

The sitter is Charles Burney (1726–1814), musician and historian, chiefly remembered for his *History of Music* (1776–89) and as the father of Fanny Burney (Madame d'Arblay) the novelist. He was a member of the Club (founded by Reynolds) and, after 1776, one of the circle which dined with the Thrales, for whose library at Streatham this portrait was commissioned. It was the last to be put up there; indeed,

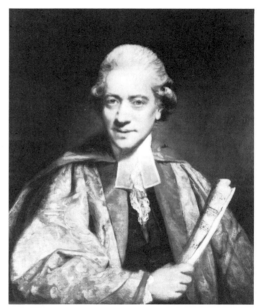

125 *reproduced in colour on p. 149*

Thrale himself had died before it was hung. A letter from Mrs Thrale to Fanny Burney of 4 January 1781 noted that Reynolds had sent the series of pictures to Streatham Park and that Mr Thrale then 'ordered your father to sit tomorrow, in his peremptory way; and I shall have the dear Doctor every morning at Breakfast'. This would seem to suggest that the first sittings were, most unusually, not in the artist's studio but at Streatham Park. A letter of 11 January announces: 'your father sits for his picture in the Doctor of Music's gown and Bartolozzi makes an engraving from it. Sir Joshua delights in the portrait.' There is no indication of these sittings in the artist's pocket-book, although there is an engagement with Burney on Sunday 7 January (at no specified hour). Mrs Thrale paid £35 for the painting (less than the sitter supposed) at a date between 10 February and 11 July 1781—presumably after 4 April when her husband died. To judge from Mrs Thrale's series of poems inspired by the portraits it was placed between those of Baretti (Cat. 85) and Burke (Piozzi 1861, II, pp. 170, 178). By 1788 Mrs Thrale considered Burney to be 'treacherous' (ibid. I, p. 301), but the portrait was not removed.

Two copies of the portrait were made, as soon as the pictures were completed, by Edward Francis Burney, a relative of the sitter (he also made small copies of Reynolds's New College window designs—see Cormack 1970, p. 143). One was for presentation to Padre Martini of Bologna who had apparently requested a portrait long before; the other was for Dr Hayes, Professor of Music at Oxford University. The copies survive in the Liceo Musicale and the Music School of Bologna and Oxford respectively. Oxford University had awarded Burney a doctorate of music in 1769 and he wears the appropriate hood and gown in the portrait, perhaps because Reynolds knew that a copy was destined for Oxford, perhaps because he found cream damask and strawberry silk impossible to resist. Formal dress is not otherwise found in the Streatham series. N.P.

PROVENANCE Painted for Henry Thrale; his widow, Mrs Piozzi; sold with the contents of Streatham Park, Squibb, 10 May 1816 (66); purchased by Dr Charles Burney (son of the sitter); by descent to Miss Burney; purchased from J. C. Burney-Cumming by the National Portrait Gallery, June 1953.

EXHIBITED Royal Academy 1781 (no. 16: 'Portrait of a Gentleman'); British Institution 1813 (118), 1848 (116); South Kensington 1867 (690); Royal Academy 1877 (116).

LITERATURE Burney 1842–6, II, pp. 5–6; Leslie and Taylor 1865, II, p. 625; Graves and Cronin 1899–1901, I, p. 134; Waterhouse 1941, p. 72; Piper 1954, p. 179; Cormack 1970, p. 164; Arts Council 1984, no. 56.

ENGRAVED Bartolozzi, 1781 (for the frontispiece of Burney's *History of Music*); S. W. Reynolds.

126 Lady Catherine Pelham-Clinton

139.7 × 114 cm
The Earl of Radnor

Reynolds's portrait of Lady Catherine Pelham-Clinton feeding poultry is, like the later portrait of Master Henry Hoare ('The Young Gardener') in Toledo, Ohio, an example of eighteenth-century pastoral romanticism. This was not new; wealthy ladies had been painted as milkmaids and shepherdesses since the seventeenth century, and the cult was to receive its most celebrated form in France, in the dairy built for Marie Antoinette in 1785 at Rambouillet. As early as 1770–1 Reynolds had shown interest in the mode when he painted Mrs Pelham (no relation of the little girl in this picture) 'feeding poultry' in a whole-length portrait at Brocklesby (fig. 12, & see Cat. 156). The adaptation of this highly artificial mode of presentation to life-size, whole-length portraits of children is, however, one of Reynolds's most distinctive contributions to portrait painting in the 1780s. These confident, expensively dressed, lovingly-nurtured children of the rich are, as Patricia Crown has pointed out (1984, pp. 159–65), in stark contrast to the beggar-children being painted at the same time by Reynolds (compare *Cupid as Link Boy*, Cat. 92, or *Beggar Boy and Sister*, also bought by the Duke of Dorset and now at Buscot Park) and by Gainsborough, whose melancholy, barefoot *Girl with Pigs*

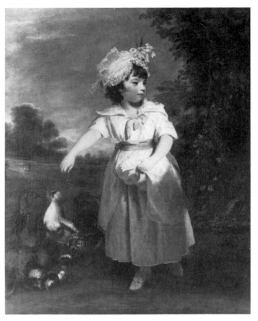

126 *reproduced in colour on p. 152*

was exhibited at the Royal Academy in 1782, and was bought by Reynolds (now at Castle Howard). Lady Catherine, in her absurdly frivolous cap—'a confection', as Aileen Ribeiro describes it, 'of lace, net and flowers perched on her simple, naturally waving curls'—is only pretending to feed the poultry. She is just as much concerned to display her white muslin gown and ribbon sash which anticipates in its up-to-the-minute simplicity of style and fabric the neo-classical gowns of the revolutionary years.

Lady Catherine, born on 6 April 1776, was the only daughter of Henry Fiennes Pelham-Clinton, Earl of Lincoln, and Frances Seymour-Conway. Portraits of her mother and her aunt (Lady Elizabeth Seymour-Conway), by Reynolds, are in the Wallace Collection. For portraits by Reynolds of her uncles and her grandparents see the entry for Lord George Seymour Conway (Cat. 76). Lady Catherine's name appears in Reynolds's pocket-book on 18 and 21 May 1781. Payment of a hundred guineas is recorded in the ledger in March 1782: 'Lady Lincoln for her Daughter'. The child's father had died when she was two years old. There seems to be no record of payment for the splendid frame which was doubtless designed by an architect rather than supplied by the painter. Lady Catherine married on 2 October 1800 William Pleydell-Bouverie, Viscount Folkestone, afterwards 3rd Earl of Radnor. She died on 18 May 1804.

A copy of this picture is recorded (J. B. West sale, Christie's, 20 May 1843, lot 33, bought in). D.M.

PROVENANCE The sitter married Lord Folkestone, afterwards 3rd Earl of Radnor, in 1800; by descent.

EXHIBITED British Institution 1823 (52); Royal Academy 1876 (263), 1934 (162), 1968 (121).

LITERATURE Graves and Cronin 1899–1901, I, pp. 178–9; Squire and Radnor 1909, II, pp. 97–8; Waterhouse 1941, p. 73; Cormack 1970, p. 158.

ENGRAVED J. R. Smith 1782; S. W. Reynolds.

FRANCESCO BARTOLOZZI (after Reynolds)

127 Lord Chancellor Thurlow

50 × 37.9 cm
The Trustees of the British Museum

Edward Thurlow (1731–1806), the son of a parson, after an unruly childhood and expulsion from University, succeeded as a barrister and entered Parliament. He was appointed Solicitor General in 1770, and was created Lord Chancellor and raised to the peerage in 1778. The fact that Reynolds painted his portrait damages assumptions concerning the artist's close identification with Whig circles, for Thurlow was a consistently servile supporter of the Crown, a steady advocate of the war with the American colonies and an opponent of Burke and Fox. The latter insisted on Thurlow's resignation as Lord Chancellor when he formed a coalition government in 1783, but Thurlow was reinstated under Pitt (see Cat. 193).

The painting, which is now at Longleat, was apparently completed with three sittings in three days on 29, 30 and 31 October 1781. Payment of one hundred guineas was recorded in the artist's ledger in May 1782 (Cormack 1970, p. 149), in which month the work was exhibited at the Royal Academy as no. 158 ('Portrait of a Nobleman') and was much admired for its animation—the critic of the *Morning Herald* (quoted Graves and Cronin 1899–1901, III, p. 971) fancied he heard the Lord Chancellor breathe. A print by Bartolozzi (for whom see Cat. 124) was published promptly on 27 April 1782 but the letters are only scratched so the impressions would have been few; the next state with engraved letters carries the publication date of 25 May. The print consists of an etching reinforced by engraving—etched stipple is employed only for flesh, wig and lace. N.P.

LITERATURE Hamilton 1874, p. 53; de Vesme and Calabi 1928, no. 916 (3).

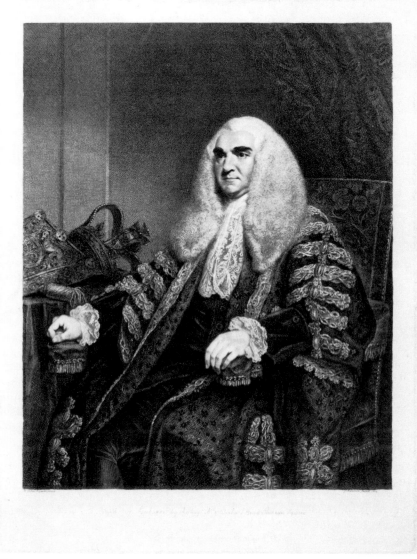

127

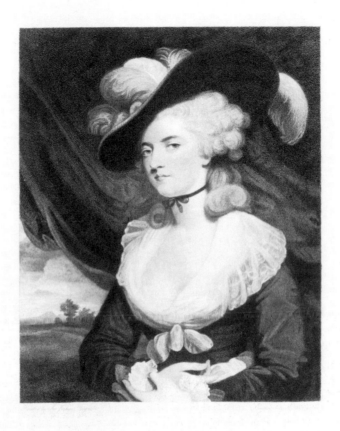

128

WILLIAM DICKINSON (after Reynolds)

128 Mrs Robinson

38.1 × 27.9 cm
Rob Dixon

Mary Darby (1758–1800), the beautiful and talented child of an impoverished but educated family, was tutored for the stage by Garrick. This career was briefly interrupted by her marriage at the age of fifteen to Mr Robinson. Her poetry then attracted the patronage of the Duchess of Devonshire (see Cat. 102, 139) who encouraged her début as Juliet in 1776. She enjoyed considerable popularity in the theatre during the following four years, but she withdrew from the stage—although not from the public eye—when she became, briefly, the mistress of the Prince of Wales who had wooed her as 'Florizel' when she was in the part of Perdita in Garrick's version of Shakespeare's *Winter's Tale* (see the caricatures Cat. 189, 191). She was subsequently the mistress of Colonel Tarleton (see Cat. 129) and of Charles James Fox (see Cat. 135), but resisted the advances of the Duc de Chartres (see Cat. 137). Her literary efforts (which included poetic tribute to Reynolds's 'polish'd pencil's touch divine')

attracted considerable applause, but she died crippled and poor.

Mrs Robinson had fourteen appointments with Reynolds in 1782: 25, 28 and 30 January, 1, 5, 21, 25 and 28 February, 5 and 25 March, 5 April and 17, 19 and 28 August. (It will be noted that the appointments she had with Reynolds in the first two months of 1782 correspond closely with those for her lover, Colonel Tarleton.) Some, perhaps all, of the first eleven of these may have been sittings for the painting of her included in the Royal Academy exhibition of that year (no. 22: 'Portrait of a Lady'). The painting (now at Waddesdon Manor) was in Reynolds's studio sale (Greenwoods, 16 April, 1796, no. 9) and so, if commissioned, was not paid for. However, this stipple engraving after it by Dickinson (for whom see Cat. 94) was published on 1 July 1785, and there are numerous copies and variants, some of them studio works. This is the second state of Dickinson's print with the title in open etched letters. By 1785 Reynolds had also painted the more melancholy portrait in the Wallace Collection engraved in 1787 by Birch with the title *Contemplation* (see Ingamells, 1985, p. 45). N.P.

LITERATURE Hamilton 1874, p. 128.

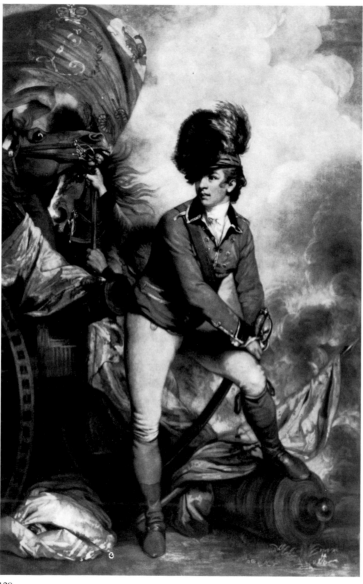

129

JOHN RAPHAEL SMITH (after Reynolds)

129 Lieutenant-Colonel Tarleton

63 × 39.5 cm
The Trustees of the British Museum

Bannastre Tarleton (1754–1833) was the third son of a mayor of Liverpool whose family had long been traders in sugar, cotton and slaves. He was educated for the law but entered the Army and made a name for himself (and lost two of his fingers) in the campaigns in South Carolina during the American War of Independence. He returned to London early in 1782 and appointments with him for 28 and 30 January, 1, 4, 8, 11, 12 and 13 February and 11 April are recorded in the artist's pocket-book. His horse may have also 'sat' on 11 April. Reynolds also made a memorandum on 15 April to 'send to' Colonel Tarleton. The painting was in the Royal

Academy exhibition in the following month as no. 139: 'Portrait of an Officer'. It was also shown at the Liverpool Exhibition for promoting Painting and Design in 1783 (Gamelin 1894, p. 130). An entry in Reynolds's ledger after 10 July 1782 and before 4 January 1785 records the picture's dispatch to the sitter's mother 'near Liverpool (to Exors)' — the parenthesis may refer to executors. The sum of two hundred guineas is also noted. It is odd, therefore, that John Tarleton requested Clayton Tarleton to pay 250 guineas to the artist for the painting in March 1791 (Liverpool Public Library, Tarleton Papers 28/i). Tarleton had by then become a Member of Parliament. He was promoted Major-General in 1794, Lieutenant-General in 1801, General in 1812, and was made a baronet in 1818. For a caricature of Tarleton see Cat. 189.

The painting, which is now in the National Gallery in London, shows Tarleton wearing the uniform of his own

troop, in the midst of battle, adjusting his leggings and thereby assuming an attitude reminiscent of the famous antique statue of Hermes (then believed to represent Cincinnatus) of which a version had recently entered the Shelburne Collection and a cast of which was a prominent feature of the Academy schools (Haskell and Penny 1981, pp. 183–4). John Raphael Smith's mezzotint engraving (published on 11 October 1782) of the painting displayed here was much admired by Reynolds who is said to have exclaimed 'it has everything but the colour' (reminiscence of William Carey in *Ackermann's Repository*, 1827, IX, p. 43). N.P.

LITERATURE Chaloner Smith 1875–83, no. 161; Frankau 1902, no. 345 (1); Russell 1926.

130 Colonel George Coussmaker

238 × 146 cm

The Metropolitan Museum of Art, New York; Bequest of William K. Vanderbilt, 1920

Reynolds's greatest rival, Gainsborough, moved to London in 1774 and portraits like *Dr Beattie* (Cat. 87) and *The Mont-*

130 *reproduced in colour on p. 154*

gomery Sisters (Cat. 90) exhibited in that year show the President emphasizing those qualities in his work that set him apart. He knew that Gainsborough could not, and would not wish to, compete with his own heavier, more classical

sense of form and his stronger colours. However, as the years went by Reynolds seems to have relaxed somewhat, and when Colonel George Kein Hayward Coussmaker (1759–1801) of the Grenadier Guards posed in 1782 Reynolds designed an airy picture, warm yet light in colour and informal in pose, which can be compared with a number of well-known whole-lengths by Gainsborough, especially the portrait of Colonel St Leger (Royal Collection) which was shown in the Academy that same year (*Coussmaker* was not exhibited in Reynolds's lifetime). This is not to suggest that Reynolds's picture is in any sense an imitation of his rival's style. The vigorous, Rubensian handling which so powerfully unifies every part of the composition—horse, tree, sky, uniform, sword—the total avoidance of finicky still-life details of the kind that are so noticeable in pictures like the *Ladies Waldegrave* (Cat. 122), exhibited the previous year, are wholly characteristic of Reynolds's late style. It might be described as a tribute to Gainsborough; it is not a capitulation to him. Certainly the slant of the figure, the crossed legs, the feathery tree, seem like a direct answer to those who might have suggested—and occasionally voices are still heard to suggest—that he could never achieve his rival's grace and stylishness. The way that Reynolds has constructed a sculpturesque group, internally complex yet self-enclosed, has been well analysed by Professor Paulson (1975, p. 91).

The first appointment for Colonel Coussmaker recorded in the artist's pocket-book is on 9 February 1782, and on the same day a first payment of £100 is entered in the ledger. Reynolds was able to give the portrait special attention because he had few other sitters at this period. Coussmaker's name occurs again on 11, 13, 15, 18, 19, 20, 23 and 27 February, 5, 8, 14 and 28 March (all at two o'clock, half-past two or three o'clock, and so almost certainly all sittings) and 1, 3, 6 and 10 April. Meanwhile, appointments were noted for Coussmaker's horse at half-past nine in the morning on 1 and 9 April. There are two further entries which simply say 'horse', which could have been Coussmaker's, but it is worth remembering that Lieutenant-Colonel Tarleton was sitting from February to April and his portrait, now in the National Gallery (see Cat. 129), includes horses. (Where did Reynolds paint them? Surely not in the studio.)

The second payment for Colonel Coussmaker's picture was entered in the ledger some time after May 1782 and apparently before July 1783; one hundred guineas with a separate note of the cost of the frame, ten guineas (the present frame is unlikely to be original). There is an additional appointment with Coussmaker on 25 March 1788. D.M.

PROVENANCE Col. Coussmaker married the daughter of Lord de Clifford in whose family the portrait descended until 1884, when bt by C. J. Wertheimer; William K. Vanderbilt; by whom bequeathed to the Metropolitan Museum 1920.

EXHIBITED British Institution 1813 (65); Royal Academy 1875 (159).

LITERATURE Graves and Cronin 1899–1901, I, p. 199; Waterhouse 1941, p. 74; Cormack 1970, pp. 148–9; Paulson 1975, p. 91; Baetjer 1980, I, p. 154.

No engraving recorded before that of 1874 (by James Scott).

131 Master Hamilton

68.5 × 55 cm

National Gallery of Scotland, Edinburgh

Following his visit to the Low Countries in the summer of 1781 Reynolds, now approaching sixty, developed a more spirited type of handling which shows a rekindled interest in Rubens. The shift in his style that resulted can be seen in a number of portraits painted during the first few months after he returned to London. Well-known examples include the dramatic whole-length of Tarleton (Cat. 129) in the National Gallery and the pretty half-length at Althorp of Lavinia Bingham, both shown at the Royal Academy in 1782. Less well-known is this small portrait of Alexander Hamilton aged fourteen, apparently painted in 1782 when there are appointments in the artist's pocket-book for 'Mr Hamilton' on 13, 15 and 16 April. William Beckford paid £50 for 'Master Hamilton' at some date between 4 July 1781 and January 1783. He had an appointment with Reynolds at the same time as Hamilton on 15 April 1782. Nicholas Penny suggests that Hamilton appealed to the pederast in

131

Beckford; but also to the genealogist and snob, for they were distantly related.

This is a beautifully resolved essay in the style of Rubens's portrait-busts, warm-toned with pinkish lights reflected on the chin and nostrils. The boy's brown hair is thinly and loosely painted over the thicker impasto of the collar of his red velvet frock coat, and the paint on the face is quite lean, so that the grain of the canvas is visible. Aileen Ribeiro points out that the informality of boys' dress in Britain was admired by foreign visitors and was, by the mid-1780s, being adopted on the Continent. Pastor Moritz, visiting England in 1782, the year of this portrait, found boys with their 'bosoms open, and their hair cut on their forehead, whilst behind it flows naturally in ringlets This free, loose and natural dress is worn until they are eighteen, or even till they are twenty' (Moritz 1924, p. 81).

Alexander Hamilton was born on 3 October 1767 and was British Ambassador in St Petersburg 1806–7. He married, on 26 April 1810, Susannah Euphemia, daughter and heiress of William Beckford of Fonthill who, as noted, had commissioned this portrait. Hamilton succeeded as 10th Duke in 1819 and was Lord High Steward of England at the coronation of Queen Victoria. 'Never was such a *magnifico* as the 10th Duke,' Lord Lamington recalled, '. . . when I knew him he was very old, but held himself straight as any grenadier.' Lady Stafford, in a letter to her son, mentions 'His great Coat, long Queue, and Fingers cover'd with gold Rings,' and his foreign appearance. He was a lavish collector of pictures, books and manuscripts; when Waagen visited Hamilton Palace in the mid-nineteenth century he described the collection as the chief object of his journey to Scotland. The Duke died on 18 August 1852. An obituary notice observed that he was a Whig, but not much use to his party; 'with a great predisposition to over-estimate the importance of ancient birth . . . he well deserved to be considered the proudest man in England' (*Complete Peerage*, IV, p. 274). D.M.

PROVENANCE Painted for William Beckford, who bequeathed it (together with Cat. 133 and his own portrait by Reynolds) to his daughter, Susannah Euphemia, wife of the sitter; Hamilton Palace sale, Christie's, 6 November 1919 (51); Lady Invernairn, who offered it to the National Gallery of Scotland; accepted after her death, 1956.

EXHIBITED British Institution 1823 (33), 1861 (198); Grosvenor Gallery 1883 (99); New Gallery 1891 (107); 45 Park Lane 1937 (51).

LITERATURE Lansdown 1893, p. 10; Graves and Cronin 1899–1901, II, pp. 420–1; Waterhouse 1941, p. 74; Cormack 1970, p. 146; Thompson and Brigstocke 1970, p. 81.

Not apparently engraved before 1864.

132 Mrs Peter Beckford

239 × 148 cm
Lady Lever Art Gallery, Port Sunlight (Merseyside County Council)

The Hon. Louisa Pitt (1754–1791) was the second daughter of George Pitt, Member of Parliament for Dorset and later 1st Baron Rivers. On 22 March 1773 she married Peter Beck-ford, Member of Parliament for Stapleton, Dorset. It was a wretched marriage. 'She was a creature of a fiercely passionate nature, a spirit all compact of fire; he was a cynical man of the world with the looseness of principle and the hardness of temper of the typical eighteenth-century "fine gentleman"' (Oliver 1932, p. 36). She had no sympathy with her husband's fox-hunting interests and soon discovered a fellow-spirit in her husband's young cousin, William Beckford of Fonthill, acting as his chief confidant and go-between in the love affair he was then pursuing with his young cousin, William Courtenay. Unfortunately she fell hopelessly in love with Beckford, a man who seems to have been incapable of caring deeply for anyone but himself. Her broken heart probably accelerated her decline as much as the tuberculosis from which she suffered, and the sad progress of both can be traced through her numerous letters.

Her name occurs in Reynolds's pocket-book on 12 June 1781, but further sittings were delayed by her poor health, and because the painter left London on 24 July on the first stage of his journey to the Low Countries and was not back in London until mid-September. 'As my looks are entirely recovered,' she wrote to her neglectful lover on 28 July after a visit to Tunbridge Wells, 'I intended to sit once or twice to Sir Joshua during my stay in Town, but he is unfortunately gone abroad, so that I must wait till next year when I may perhaps look ill again.' And she continues more glumly, 'Tho' the waters have been of service to me I am far from being quite well' (Oliver 1932, pp. 73–4). Further appointments are recorded in the pocket-book for 2, 8, 27 (probably, but not quite legible) and 28 March, 9, 27 and 29 April and 1, 3, 9 and 31 May 1782. This last appointment would perhaps have been to supply the last touches before the portrait was sent to the Royal Academy exhibition.

Louisa's last, hopeless letters to William Beckford date from 1784; he spent the next ten years mostly abroad, and when she died in Florence in April 1791 he seems hardly to have noticed. This extraordinary painting seems to synthesize the tastes both of her husband—whose classical interests inspired him to write *Essays on Hunting with an Introduction describing the method of Hare-hunting among the Greeks* (1781)—and of William Beckford, author of the weirdly imaginative eastern tale, *Vathek* (1786–7). The thundery broken shadows that fall across this strange scene create a mood reminiscent of the religious dramas of Tintoretto, and which would have appealed strongly to William Beckford. The light does not glow, but retains instead a substantial, encrusted opacity. The colours are most artfully disposed; the dark golden-yellow of her dress is echoed throughout the composition, in the convoluted forms of the tripod, and even in the distant trees. Appropriately, Mrs Beckford's direct but oddly distant glance seems not to invite our approach, but rather to warn us off.

It is possible that William Beckford himself collaborated with artist and sitter in planning this picture. He, too, was sitting to Reynolds for his portrait, a bust-length (now in a Private Collection) exhibited at the Royal Academy in 1782 (10). Soon after Louisa's first recorded sitting he wrote to her, on 6 July 1781: 'When shall I see you again moving

132

about the slopes in all the flow of your beautiful antique drapery?' (Oliver 1932, p. 71). It is perhaps unlikely that he had this picture in mind, but fancy-dress and play-acting occupied an important place in their strange relationship. Aileen Ribeiro notes that Reynolds's 'considerable experience in combining the classical and the fashionable has resulted in a simple gown fastening at the waist with a wide sash, and with the long tight sleeves to the wrist typical of the 1780s. By now headdresses and hairstyles were becoming simpler, so that fashion almost seems to be following Reynolds; the *Town and Country Magazine* in 1779 [cited by Leslie and Taylor 1865, II, p. 227] gives credit to the artist in the move away from elaborate coiffures.' 'Sir Joshua,' William Beckford told a visitor to his tower on Lansdown Hill

at Bath where the picture hung in 1838, 'took the greatest pleasure and delight in painting that picture, as it was left entirely to his own refined taste. The lady was in ill-health at the time it was done, and Sir Joshua most charmingly conceived the idea of a sacrifice to the Goddess of Health. Vain Hope! Her disorder was fatal.'

D.M.

PROVENANCE William Beckford of Fonthill; bequeathed to his daughter, Susannah, Duchess of Hamilton; Hamilton Palace sale, Christie's, 6 November 1919 (50), bt Gooden and Fox for W. H. Lever, 1st Viscount Leverhulme.

EXHIBITED Perhaps Royal Academy 1782 (? 186); British Institution 1861 (183); Grosvenor Gallery 1883 (31); Edinburgh 1883 (154), 1886 (1471); New Gallery 1891 (159); Royal Academy 1955 (396); Arts Council 1972 (219); Royal Academy 1980 (32).

LITERATURE Lansdown 1893, p. 9; Graves and Cronin 1899–1901, I, p. 75; Tatlock 1928, I, p. 61; Waterhouse 1941, p. 73.

Not engraved until 1861 (by F. Bromley).

133 The Lamb Children

239 × 146 cm
The Trustees of the Firle Estate Settlement

During the 1780s Reynolds painted half a dozen groups of aristocratic children frolicking in a park setting. This portrait of the three sons of the first Lord Melbourne is one of the most animated. It seems not to have been liked—or at least not to have been paid for—by the father and was bought from the artist's executors by the 5th Earl Cowper, who had married Emily Lamb, sister of the boys in the picture.

The eldest boy in the picture, Peniston, born on 3 May 1770, became Member of Parliament for Hertfordshire and died unmarried in 1805. The title therefore went to William,

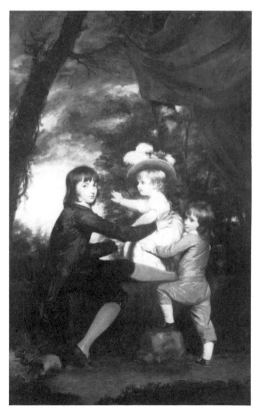

133 *reproduced in colour on p. 153*

who is shown to the right of the composition, who was born on 15 March 1779, and was Prime Minister when the young Queen Victoria came to the throne. His wife attained a certain degree of celebrity as a novelist under the title of Lady Caroline Lamb, besides notoriety for her devotion to Lord Byron. William died on 24 November 1848. The youngest

brother, with the feather in his hat, was Frederick James, born on 17 April 1782; he later enjoyed a successful diplomatic career. In 1841 he married the Countess Alexandrina, daughter of the Count of Maltzau; he succeeded as 3rd Lord Melbourne in 1848 and died on 29 January 1853.

Peniston had been painted by Reynolds before, when a baby in his mother's arms. That picture, exhibited at the Royal Academy in 1773, was engraved by Dickinson with the title 'Maternal Affection' and hangs, together with the Lamb brothers, at Firle Place. The group portrait, to judge by the age of the sitters, probably dates from 1783, for which year the artist's pocket-book does not survive.

Aileen Ribeiro points out that the painting illustrates 'the three main types of costume worn by boys in the last quarter of the eighteenth century. The eldest boy, Peniston, wears a three-piece suit of black silk—unusually formal clothes for his age group. William, helping to support his baby brother Frederick, wears a buff-coloured "skeleton suit", a practical English invention which consisted of a pair of trousers buttoning on to a matching short jacket. Such a costume would have been worn as an intermediate stage between the white baby frock (generally worn until the age of about three) and the adoption of the adult suit, which took place at about the age of eight years. The baby Frederick wears a white, back-fastening muslin frock tied around the waist with a pink silk sash; with his side-tilted round hat trimmed with ostrich feathers and ribbons, his costume is virtually indistinguishable from that of a small girl of the same age.' D.M.

PROVENANCE Bt from Reynolds's executors by the 5th Earl Cowper; by descent to the 6th Earl's granddaughter, Lady Desborough, and at Panshanger until 1952 when inherited by Viscountess Gage.

EXHIBITED British Institution 1813 (138: third catalogue), 1843 (33); Royal Academy 1881 (136); 45 Park Lane 1937 (1); Royal Academy 1968 (80).

LITERATURE Waagen 1857, p. 346; Graves and Cronin 1899–1901, II, p. 561; Waterhouse 1941, p. 77.

ENGRAVED Bartolozzi, 30 March 1791 (at first as 'The Affectionate Brothers'); S. W. Reynolds, 1831.

FRANCIS HAWARD (after Reynolds)

134 Mrs Siddons as the Tragic Muse

63.3 × 45.6 cm
The Trustees of the British Museum

For a replica of the original painting reproduced by this print see Cat. 151. The popularity of the star depicted and the success of the picture guaranteed a big sale for any print after it and the astute engraver and publisher Valentine Green was quick to request the right to make one. Reynolds said that he would do what he could, but that the sitter might have other ideas, which, as it turned out, she did. At her behest the job was given to Haward, an engraver who had abandoned mezzotint for stipple engraving. The print was pub-

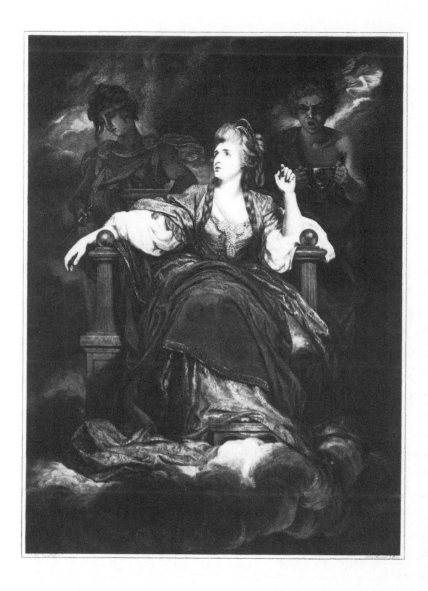

134

lished on 4 June 1787 and dedicated to the King in the following year. Exhibited here is the second state, before the addition of the royal arms which that dedication entailed. The dramatic lighting in the painting would have been better reproduced in mezzotint, but it was possible to take more impressions from a stipple engraving.

Valentine Green's indignant letters to Reynolds are printed in full in the *Literary Gazette and Journal* for 1822, pp. 85–6. Antony Griffiths has expertly expounded their implications for our understanding of the proprieties and initiatives in reproductive printmaking at this date (British Museum 1978, pp. 38–9). N.P.

LITERATURE Hamilton 1874, p. 131.

JOHN JONES (after Reynolds)

135 Charles James Fox

50.5 × 35.4 cm
The Syndics of the Fitzwilliam Museum, Cambridge

Fox seems to have sat to Reynolds for his portrait in 1783 (for which year the artist's pocket-book does not survive). It was exhibited at the Royal Academy in 1784 as no. 108 ('Portrait of a Gentleman'). The artist's ledger records that one hundred guineas were paid in 1784 and that the painting was given to Mr Crewe who was one of Fox's closest political allies (see Cat. 38). He later presented the painting to Thomas Coke, another ardent Foxite Whig, and it remains at his seat, Holkham Hall. A copy of the painting was made, probably

by Reynolds himself, for Mrs Armstead (Fox's mistress and later his wife) for which another hundred guineas were paid on 20 April 1789. Many other copies were painted.

There is an undated letter from Fox to Reynolds headed 'Monday night, St. James' Street' (Cotton 1859, p. 69), which must have been written shortly before the Academy exhibition opened, in which Fox asked to have 'one of the papers upon the table in my picture docketed "A Bill for the better regulating the Affairs of the E. I. Company &c."'. He was anxious not to encourage anyone to suppose he wished to avoid 'public discussion upon a measure which will always be the pride of my life'. (There must therefore have been a suggestion that this should *not* be included.) He also proposed that another paper might be docketed 'Representation of the Commons to the King March 15 1784'. Reynolds obliged and these words were also carefully transcribed in the mezzotint made of the painting in the autumn by John Jones (active between 1784 and his death in 1797).

This was published on 1 November 1784, but the plate was quickly exhausted and others had to be engraved to meet the demand of Fox's fervent admirers and of these this version, published 1 November 1789, is an example.

For Fox in this period in his political career see Cat. 190, 191 and 192; for an earlier portrait by Reynolds see Cat. 48.

N.P.

LITERATURE Chaloner Smith 1875–83, no. 28; Russell 1926, no. 28a (1).

136 James Boswell

75 × 62.2 cm
National Portrait Gallery, London

James Boswell (1740–95), the intimate friend and devoted biographer of Samuel Johnson, met Reynolds through

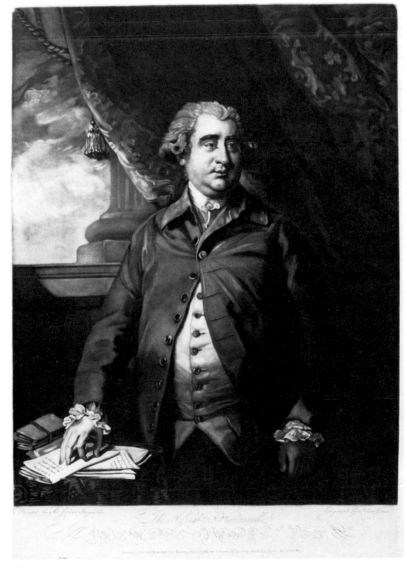

135

Goldsmith in 1769. Boswell was then enjoying considerable celebrity as the author of *An Account of Corsica*. Thereafter Boswell was always part of Reynolds's circle and in his last years Reynolds seems to have particularly valued his company. The artist's niece and housekeeper Mary Palmer complained that Boswell stayed too late in the evenings, but acknowledged that he was always welcomed. Reynolds ardently encouraged Boswell to complete his *Life of Johnson* which the writer eventually dedicated to him. Boswell seems to have been deterred from writing a biography of Reynolds by his friend's lack of Christian faith and a conviction that he had been in the wrong in his quarrel with the Royal Academy (Hilles 1952, pp. 13–21). For caricatures of Boswell see Cat. 198 and 199.

The circumstances of this portrait's commission are recorded by a letter written by Boswell to the artist on 7 June 1785 in which he admits that his debts are such that he cannot afford 'any expensive article of elegant luxury. But in the mean time, you may die, or I may die; and I should regret very much that there should not be at Auchinleck [that is, his ancestral home] my portrait painted by Sir Joshua Reynolds, with whom I have the felicity of living in social intimacy.' He proceeds to propose to pay for it out of his fees as a barrister, or at any rate in five years' time. Boswell

had recently been called to the English Bar and hoped to make money.

Reynolds's pocket-book for this year is lost but we know from Boswell's journal that he dined with Reynolds on this same day and we may surmise that he took the letter with him. On 5 July Boswell had his first sitting in the morning. He had an afternoon appointment as well, which he had to cancel. They met at dinner, however, and arranged to attend a hanging at dawn the next day (Reynolds had never seen an execution before and his attendance was noted in the newspapers). Afterwards they had breakfast together at Boydell's and looked at his collection of drawings. On 8 and 15 July and on 10 September Boswell breakfasted with Reynolds and sat afterwards. The last appointment was for the picture to be finished and was also the date on which Reynolds signed the letter of 7 June agreeing to the terms, although he can hardly have thought it likely that he would be paid.

A mezzotint of the painting was published on 17 January 1786, more than a year before it was exhibited at the Royal Academy. It could easily have been borrowed back from Boswell, who seems to have kept it in London despite his intention to keep it at Auchinleck.

Aileen Ribeiro points out that although 'a showy dresser

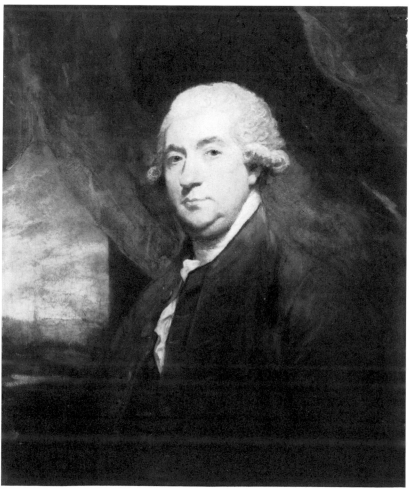

136

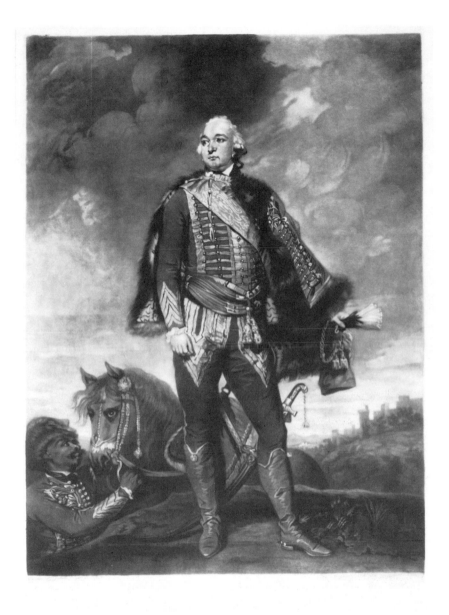

137

in his youth with a penchant for light colours, Boswell in middle age adopted the prevailing English taste for a dark cloth coat and upon the matte surface of this Reynolds has represented the powder fallen from his frizzed wig, in a manner which was then an accepted part of a gentleman's appearance.' N.P.

PROVENANCE Painted for James Boswell; by descent to the 7th Lord Talbot of Malahide; given to Sir Gilbert Eliot in 1949; sold by his son, Sir Arthur Boswell Eliot, Bt, Sotheby's, 7 July 1965 (125), purchased for the National Portrait Gallery.

EXHIBITED Royal Academy 1787 (113: 'A gentleman; three quarters'), Arts Council 1975 (96).

LITERATURE Leslie and Taylor 1865, II, pp. 476–7; Graves and Cronin 1899–1901, I, pp. 99–100; Waterhouse 1941, p. 79; Boswell 1928–34, XVI, pp. 104–6, 109, 120, 123, 278 (note); Boswell 1976, pp. 194–5.

ENGRAVED John Jones, 17 January 1786.

JOHN RAPHAEL SMITH

137 His most Serene Highness Louis Philippe Joseph Duke of Orleans First Prince of the Blood Royal of France

65 × 45.3 cm
David Alexander

The notoriously debauched Duc de Chartres, on his visits to England in the 1780s, disgusted respectable society; but the Prince of Wales came to like him and, during the Duc's fourth visit, commissioned a full-length portrait of him from Reynolds. Sittings had begun by 30 May 1785 (the pocket-

book for 1785 is missing but see Reynolds 1929, p. 124) and we suppose that the portrait was completed by 13 September when payment of £262.1s was recorded for the 'Duke of Charters' (Cormack 1970, p. 149).

The Duc d'Orléans, as he was by then styled, sat beneath his own portrait at the Royal Academy banquet in the following year (Whitley 1928, II, p. 67). The painting (no. 85: 'His Royal Highess the Duke of Orleans') was almost as much of an attraction at the exhibition as was Thomas Lawrence's painting of Satan. Mrs Papendiek (1887, II, p. 252), who described the crowds round the portrait, also recorded the rumour that the Prince of Wales had 'sat in return for this vile fellow to Madame Le Brun who had lately come to England'—that is, had already been painted by Madame Vigée Lebrun for the Duc. However, it was certainly intended that Reynolds should paint the Prince for the Duc (see below). Reynolds was quoted as observing that the breeding of the Prince was revealed by his capacity to stand gracefully with his arms unemployed—something which he had found to be very rare. This suggests (but does not prove) that the Prince had posed standing in the artist's studio and had not merely sat for his face to be painted as was certainly the usual practice.

The portrait was taken down from the walls of Carlton House when the Prince, as Philippe Egalité, gave his support to the Revolution and voted for the death of his cousin the King of France, but it was made available for artists to copy. The portrait was severely damaged (but not, as is often claimed, destroyed) by fire in 1824. (For the fullest account of the painting see Millar 1969, pp. 104–5.) John Raphael Smith's mezzotint was published on 30 March 1786—that is, shortly before the painting was exhibited. As Smith was 'Engraver to the Prince of Wales' it was doubtless considered his privilege.

Reynolds wrote to the Duke of Rutland on 30 May 1785 that he had begun a whole-length portrait of the Duc de Chartres 'for the Prince of Wales and the Prince is to sit for him'. It would seem very likely that the portrait of the Prince of Wales now in the collection of the Duke of Norfolk was the one intended for the French Prince, especially since the black page was said to have been an addition to the picture suggested by him (Whitley 1928, II, p. 80). This portrait was exhibited at the Royal Academy in 1787 as no. 90, a year after that of the French Prince, and the hypothesis that it was intended for France may explain why it stayed in the artist's studio until after his death when the Prince bought it. N.P.

LITERATURE Chaloner Smith 1875–83, no. 125 (i) (see also his section of additions and corrections).

138 Joshua Sharpe

126 × 100 cm
The Viscount Cowdray

This impressive portrait was painted for Admiral Sir Edward Hughes, friend and client of the sitter. Sharpe, who died in 1786, the year this portrait was exhibited, was a distinguished conveyancing lawyer. The paper beside the artist's familiar silver inkwell (see Cat. 162) is inscribed 'Draft/W. Peach others/Sir Eᵈ Hug[hes]'. Sir Edward paid for the picture, together with four others including his own whole-length which is now at Greenwich, a total of £577.10s, on 30 July 1786. The pocket-book for 1785 is missing, and it is probable

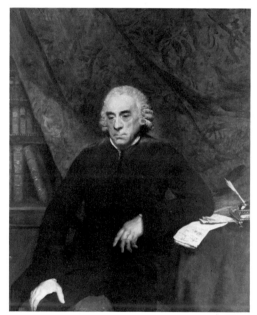

138 *reproduced in colour on p. 148*

that Sharpe sat during that year—certainly no appointments for him are recorded in the early months of 1786.

Waterhouse contrasts this sober portrait with the more ornamental treatment accorded twenty years earlier to Warren Hastings (Cat. 66). Although the low, off-centre placing of the figure and the air of deep contemplation may owe something to a picture like Rembrandt's *Old Man in an Armchair* which was in the Duke of Devonshire's Collection at Chiswick House in Reynolds's time (now National Gallery, no. 6274), it would be a mistake not to see how new and original Reynolds's *Joshua Sharpe* is. Earlier seated three-quarter-lengths like *Percival Pott* (exhibited at the Royal Academy in 1784; St Bartholomew's Hospital, London) may be said to have paved the way, but they lack the feeling of intense absorption which pervades *Joshua Sharpe*. Reynolds himself told Northcote that this mood was not achieved through any great imaginative skill on his part, but by making a straightforward copy, like a still-life, of the attitude into which the old man had placed himself. But this should not be taken too literally; as C. R. Leslie very properly remarks, Reynolds, 'like all men of true genius, was perfectly

simple, and found his best things come so easy that he shrank from taking any credit for them'.

A full-sized copy of this portrait was sold at Christie's on 30 September 1977 (139), another (?) at Sotheby's on 23 July 1983 (24). D.M.

PROVENANCE Sir Edward Hughes; E. H. Ball 1817; Lady Burke 1829; Mrs Vulliamy 1854; John Malcolm of Poltalloch 1883; Christie's 5 July 1929 (144), bt Leggatt Bros, from whom bt by the present Lord Cowdray's father 1931.

EXHIBITED Royal Academy 1786 (178); British Institution 1817 (128), 1854 (116); Grosvenor Gallery 1883 (168).

LITERATURE Northcote 1818, II, p. 211; Leslie and Taylor 1865, II, pp. 474–6; Graves and Cronin 1899–1901, II, pp. 879–80; Waterhouse 1941, pp. 19, 77; Waterhouse 1953, p. 170; Cormack 1970, p. 155; Waterhouse 1973, pp. 32–3.

ENGRAVED C. H. Hodges, 1786; S. W. Reynolds; J. Sayce.

139 Georgiana, Duchess of Devonshire, with her Daughter, Lady Georgiana Cavendish

113 × 140 cm
The Duke of Devonshire and the Chatsworth Settlement Trustees

The glorious climax of Reynolds's late Baroque style, this famous picture represents the successful culmination of the experiments he had been making in Rubensian handling and composition since his trip to the Low Countries in 1781, if not earlier. The scribbled brushwork on the Duchess's hair and the thick, vigorous impasto on the child's dress attest to the artist's careful study of the great masters of the seventeenth century, especially Van Dyck and Rubens. Mothers playing with their children do occur in earlier art, and this particular pose with one hand raised as if to tease or pat the baby occurs in a group by Kneller which was at King's Weston in the eighteenth century. Professor J. D. Stewart has suggested (1971, p. 57) that there may be a classical source for this motif. Certainly Reynolds would have known two possible sources illustrated in Winckelmann's *Monumenti antichi inediti*, published in 1767 (vol. 1, pl. 54, pl. 143). Waterhouse has pointed out that when Reynolds painted this lady as a child with *her* mother (for which see Cat. 32 and fig. 8) he created a serene High Renaissance composition, but this has now, twenty-five years later, given way to 'a lively and dramatic style akin to Rubens's baroque'. This is one of the best preserved of Reynolds's late works. Apart from a slight darkening in tone, the delicate modelling of the heads and the forms of the drapery, all achieved by glazing, seem as fresh as when painted.

Georgiana (1757–1806), known as 'the Beautiful Duchess of Devonshire', daughter of the first Earl Spencer, married the 5th Duke in 1774. Her daughter Georgiana (1783–1858) married the 6th Earl of Carlisle in 1801. The Duchess's reputation seems to have been based less on perfection of face or figure than on her vivacity and radiant good nature, which

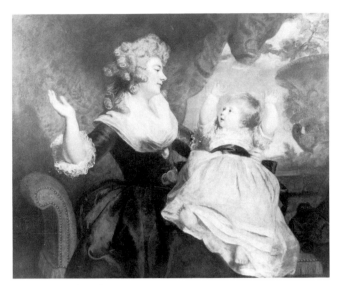

139 *reproduced in colour on p. 157*

appealed to the Prince of Wales among others. 'For she is,' wrote her mother in a letter to Lord Nuncham in September 1773, 'without being handsome or having a single good feature in her face, one of the most showy girls I ever saw' (Whitley 1928, II, p. 397). An earlier whole-length of her by Reynolds was shown at the Royal Academy in 1776 (233) and is now in the Huntington Art Gallery at San Marino (see Cat. 102 here). Gainsborough's pretty whole-length of her is in the National Gallery, Washington. (See also the caricatures Cat. 205 and 206.)

Entries in Reynolds's pocket-books indicate appointments for the Duchess on 3, 5 (possibly for two hours), 6 and 8 July, and on 22 and 23 November 1784. Lady Georgiana's name occurs on 8, 10 (incorrectly as Lady Georgiana Spencer), 13 and 31 July and 3 August in the same year. The pocket-book for 1785 is missing. The Duchess's name is entered again in April 1786 for a series of appointments on 5, 9, 10, 13 (possibly with the Prince of Wales), 15 (no time), 16 (Sunday), 17 and 18 of the month. A single appointment on 3 February 1787 need not have been for a sitting, and earlier appointments in 1780 (8 February, 18 March and 27 May) and 1781 (30 March and 17 April) should perhaps be associated with a head and shoulders sketch, unfinished, which also belongs to the Duke of Devonshire (Waterhouse 1941, pl. 216b).

Aileen Ribeiro points out that 'women's dress in the 1780s assumed a simplicity and relative absence of trimming which must have appealed to Reynolds'. The Duchess was obliged to wear mourning black for her father but what is notable is that her dress is very plain and 'only enlivened by a starched white muslin fichu fastened over the breast'. In accordance with this taste are the 'lightly powdered loose curls which had by this date replaced the rigid curls and towering swathes of the 1770s and early 1780s'.

There is a copy of this picture at Windsor Castle by William Etty. D.M.

PROVENANCE Painted for the 5th Duke of Devonshire; by descent.

EXHIBITED Royal Academy 1786 (166: 'Portraits of a lady and child'); British Institution 1813 (100), 1861 (203); South Kensington 1862 (60), 1867 (773); Grosvenor Gallery 1883 (81); Guildhall 1892 (116); Grafton Gallery 1894 (123); Birmingham 1900 (66); and frequently since, including Royal Academy 1951 (99), 1968 (128).

LITERATURE Graves and Cronin 1899–1901, I, pp. 248–9; Strong 1901, p. 21; Waterhouse 1941, pp. 19, 77; Waterhouse 1953, p. 170; Buttery in Hudson 1958, p. 249.

ENGRAVED G. Keating, 19 May 1787; P. Lightfoot; S. W. Reynolds.

140 The Infant Hercules

303 × 297 cm
The Hermitage, Leningrad

Commissioned in 1785 by Catherine II, Empress of Russia, through the agency of Lord Carysfort, British Ambassador in St Petersburg, and exhibited at the Royal Academy in 1788, *The Infant Hercules* is one of Reynolds's largest, most ambitious and most elaborately prepared compositions. The rather tubby infant Hercules is shown lying in his cradle with his baby brother Iphicles, upon wolf-skins and with a lamb's fleece coverlet which Iphicles has kicked off. Two poisonous snakes have been sent by the goddess Juno, who hated Hercules because he was the child of her faithless husband, Jupiter, and the mortal Alcmena. Juno appears in the clouds with her peacocks, top right. Alcmena, roused by the screams of Iphicles, rushes in from the right with her attendants. Her pose is Poussinesque; in fact she seems to have been adapted rather cleverly from the *Massacre of the Innocents* (Chantilly), a copy of which appeared at Christie's on 25 February 1773 (first day, lot 6), and again on 13 June 1785 (58). A very similar borrowing occurs in one of Reynolds's earlier history pictures, the *Death of Dido* (Cat. 123).

The whole composition reminds one of a picture which had occupied Reynolds's thoughts for several years, the *Nativity* (fig. 26, p. 45) for the central panel of the west window of New College, Oxford. Professor Tinker calls the *Infant Hercules* 'an unconscious parody' of the *Nativity*. Alcmena's husband, Amphitryon, King of Mycenae and father of Hercules's twin brother, stands at the left of the composition. With his sword raised, astonished by the child's supernatural powers, he has arrived too late to play any effective part in the drama. At the extreme left of the composition is one of Reynolds's oddest creations, the blind seer Tiresias, adapted—with the aid of a huge beard—from a portrait (Cat. 73 here) which he had painted many years before of his now deceased friend, Dr Johnson. Tiresias is shown predicting Hercules's future triumphs.

On 20 February 1786 Reynolds wrote to the Duke of Rutland: 'I have received a commission from the Empress of Russia to paint an historical picture for her, the size, the subject, and everything else left to me. . . . The subject I have fixed on . . . is Hercules strangling the serpents in the cradle, as described by Pindar, of which there is a very good translation by Cowley.' He may by then already have started, for there is an entry in the pocket-book on 12 January 1786 (a

Sunday): 'Boy for Hercules', and another on 19 January: 'Hercules'. Also in that month Mary Palmer, the artist's niece and housekeeper, wrote to her cousin in Calcutta that Sir Joshua was more 'bewitched' than ever with his art and was 'just going to begin a picture for the Empress of Russia'. On Wednesday 6 December 1786 occur the words 'Infant Hercules'. These appointments are all at ten o'clock in the morning. Most of the work seems to have been done during the second half of 1787. 'Hercules' is noted, and always at ten o'clock on 19 and 30 June, 2, 9, 16, 19 and 26 July, 4

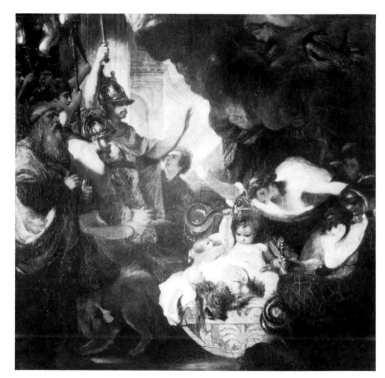

140 *reproduced in colour on p. 151*

and 11 August, 26 and 29 September, and 3, 8, 10 and 15 October. There are seldom any other engagements on these dates, and although some of these entries may refer to sittings for models, others could imply resolutions to keep these days clear of portrait engagements.

The *Infant Hercules* is the most conspicuous example of the sort of picture that Reynolds, towards the end of his career, really wanted to paint. This was a commission that gave him, as his letter to the Duke of Rutland emphasized, almost total freedom as regarded subject, size 'and everything else'. Reynolds explained in a letter to Prince Potemkin why he chose this unusual subject; '*J'ai choisi le trait surprenant de la valeur d'Hercules encore enfant, parce que le sujet fait allusion (au moins une allusion éloignée) à la valeur non enfantine mais si connue de l'empire Russe.*' (Tiresias, therefore, has been introduced to prophesy the future greatness of the Russian empire.)

Walpole apparently suggested an entirely different subject

to him, and was rather piqued when Reynolds ignored his advice. He described Pindar's story as 'an old threadbare tale'. Reynolds 'ought to have chosen a subject that either related to Russian or English history. There was one that would have embraced both countries and complimented both, viz., the moment when Peter the Great in the dock yard at Deptford addressed himself to work as a shipwright.' It sounds like a picture by Frith or Millais, and it is not surprising either that Tom Taylor should have commended the suggestion, or that Reynolds rejected it (see Walpole 1937–83, XXXI, p. 243; 1978, p. 18). In any case, by July 1786 Reynolds was, as he wrote to Lord Ossory, 'entirely occupied with the composition of the Hercules'. When Walpole saw the picture in August 1787, 'I did not at all admire it: the principal babe put me in mind of what I read so often, but have not seen, *the monstrous craws*: Master Hercules's knees are as large as, I presume, the late Lady Guilford's. *Blind* Tiresias is *staring* with horror at the terrible spectacle.' The critic in the *St James's Chronicle*, reviewing the Academy exhibition for 1788, described the *Infant Hercules* as 'dignified and splendid', and thought the figure of the infant 'finely conceived'. This figure which, it is pleasant to observe, was used in Victorian times to advertise Woodward's Gripe Water, was said by C. R. Leslie to have been copied from 'an old German wood-cut' in his possession which had belonged to Reynolds. Two small pencil and brush drawings in the British Museum (Binyon 1898–1907, LB5a, and LB5b), and a pen drawing in the Lucas album (Herrmann 1968, p. 652, fig. 6) are perhaps preliminary studies for this figure (the latter was indeed published as such in the *London Monthly Magazine* in 1839), but it seems likely that Reynolds did most of his exploratory sketching on the canvas itself. Northcote recalled Reynolds telling a friend that 'there were ten pictures under it, some better, some worse'.

If contemporary critics had reservations about the *Infant Hercules*, practising artists were, on the whole, enthusiastic. Fuseli, writing anonymously in the *Analytical Review* in 1788 (pp. 218–19), thought it 'sublime in its conception, grand, though not correct, in its style of design, and vigorous in its colour'. 'It possesses,' wrote James Barry, 'all that we look for, and are accustomed to admire in Rembrandt, united to beautiful forms, and an elevation of mind, to which Rembrandt had no pretensions' The figures of Tiresias and Juno he thought 'truly sublime'. F. G. Stephens, Pre-Raphaelite painter-turned-critic and not entirely free of that movement's suspicion of 'Sir Sploshua', nevertheless admitted this to be 'conceived with the greatest vigour and spirit; . . . the only first rate example' of this type of work in Reynolds's œuvre. He was, presumably, talking about the mezzotint by James Walker—or to subsequent prints—the original painting, after being exhibited at the Academy in 1788, was dispatched to Russia, and has until now never returned to this country.

Payment was slow; it was not until after the artist's death that his executors received 1,500 guineas; however, the Empress sent Reynolds a gold snuff-box adorned with her profile in low relief, set in diamonds (Hudson 1958, p. 198).

Several versions, whether studies by Reynolds himself or copies by other artists, exist of the single figure of the infant with the snakes. One which is documented by an entry in the ledger in June 1791 (Cormack 1970, p. 152) was bought at the high price of 150 guineas from Reynolds himself by the Earl Fitzwilliam. This picture, engraved by Heath (1810), Ward (1819) and S. W. Reynolds, was exhibited at the British Institution in 1813 (100, third catalogue) and at the Grosvenor Gallery in 1883 (175). Another, described by Tom Taylor as 'the original sketch', was sold at the Thomond sale on 26 May 1821 (33B). A third was seen, and criticized by Waagen (1854, III, p. 210) in Lord Northwick's Collection at Thirlestaine House, Cheltenham; it was exhibited at the Grosvenor Gallery in 1883 (56) and was in the Northwick Park sale at Christie's on 25 June 1965 (lot 77). At least two other versions of the single figure with the snakes are recorded in nineteenth-century sale catalogues but cannot now be traced. More interesting—and puzzling—is the small grisaille copy on paper, stuck on to canvas, of the entire composition which was sold at Greenwood's on 16 April 1796 (32) and is now in the Philadelphia Museum of Art (cat. 831). Although this is of good quality, it seems to have been copied from an engraving rather than from the original painting—but it was described in the sale catalogue as 'the first design'.

D.M.

PROVENANCE Painted for Catherine the Great.

EXHIBITED Royal Academy 1788 (167).

LITERATURE [Fuseli] 1788, pp. 218–19; Malone, in Reynolds 1798, I, note 29 p. xlv; Barry 1809, I, note pp. 553–4; Northcote 1818, II, pp. 214–19; Leslie and Taylor 1865, II, pp 482–4; Stephens 1867, pp. 27–9; Graves and Cronin 1899–1901, III, pp. 1160–2; Reynolds 1929, pp. 149, 151, 155; Walpole 1937–83, XXXI, p. 243; XXXIII, pp. 571–2; Tinker 1938, pp. 64–6; Waterhouse 1941, p. 80; Irwin 1966, p. 77; Hilles 1967, pp. 164–5; Hilles 1970, pp. 267–77; Waterhouse 1973, pp. 34–5; Walpole 1978, pp. 17–18; Dukelskaya 1979, no. 125.

ENGRAVED James Walker, 1 January 1792; C. H. Hodges, 1793; S. W. Reynolds.

141 Colonel Morgan

195.6 × 147.3 cm
National Museum of Wales

The colour and handling of this portrait are astonishing. The coat is scarlet with very dry flesh pink dragged over it in an irregular way and with stabs and dashes of dark wine-red in the shadows. It has been proposed that the painting is in fact unfinished and lacks the final glazes which Reynolds provided after his portraits returned from the 'drapery-man'. This hypothesis can be excluded because the painting was both paid for and exhibited. The tediously reiterated assumption that Reynolds *never* painted draperies seems to be founded on the fact that he frequently did not paint them. His authorship here is all the more probable because of the extreme boldness, which would be extraordinary in a mere drapery painter. Instead of awaiting final glazes, it is possible that they have been removed in cleaning. In any case the

horseman in the distance on the left must originally have been more visible. In composition the portrait is obviously similar to Cat. 153, where the uniform is also very freely painted (with the blue on top of the scarlet).

George Catchmaid Morgan (1740/1–1823) was promoted to Major-General on 28 April 1790. He sat to Reynolds early in 1787: there are appointments in the pocket-book on 15, 16, 19, 22, 24 and 26 January and 4 and 7 February—each at ten o'clock, except the last two which were at nine o'clock, a regularity only made possible by the scarcity of other sitters in this period. Reynolds received two hundred guineas on 15 April 1788 and the painting was sent to the Academy exhibition in that year where it was admired as a 'good likeness' and for its 'truly military aspect' by *The London Chronicle*. Possibly Colonel Morgan was known to Reynolds

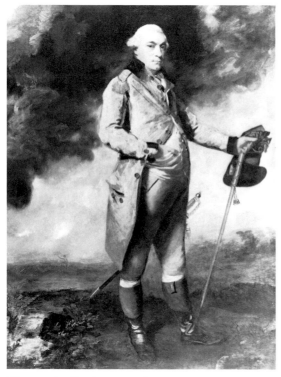

141 *reproduced in colour on p. 156*

earlier in his life. A payment of twelve guineas to 'Col. ['Major' deleted] Morgan' recorded in the artist's ledger between 28 July 1762 and 28 February 1763 (Cormack 1970, p. 129) cannot concern him, but there is also a payment for 28 September 1776 of twenty-five guineas for 'Coll. Morgan a copy' (ibid. p. 159), which dates from a year after he was promoted Lieutenant-Colonel. N.P.

PROVENANCE G. T. Elliot's sale, Christie's, 23 July 1881 (240), bt in; Christie's, 22 February 1890 (84), bt Fitzhenry; after 1916 and before 1946, Lord Tredegar; purchased by National Museum of Wales, 1960.

EXHIBITED Probably Royal Academy 1788 (146: 'Portrait of an Officer, full-length'); Birmingham 1961 (85).

LITERATURE Graves and Cronin 1899–1901, II, pp. 665–6; Waterhouse 1941, p. 79; Cormack 1970, p. 159; Waterhouse 1973, no. 116.

No early engraving recorded.

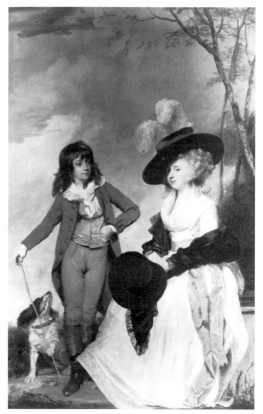

142 *reproduced in colour on p. 155*

142 Miss Gideon and her Brother, William

240 × 148 cm
The Viscount Cowdray

Maria Marow Gideon was born on 22 November 1767 and married the 11th Lord Saye and Sele in 1794. Her name appears in Reynolds's pocket-books on 14, 20, 23 and 25 September 1786, on 14 May 1787 and on 6 February 1788. She died on 5 September 1834. Her brother, William, born on 22 May 1775, became a colonel in the Army and died unmarried on 17 September 1805, in the lifetime of his father. His name occurs in the pocket-book on 2 and 13 November and 14 December 1786—an entry for 'Mr Gideon' on 22 September 1786 may refer to him, although Reynolds otherwise styled him 'Master'. The father had an appointment on 28 April 1787 and payment of £300 is entered in the ledger on 21 June 1787: 'Sir Samson Gideon, for his Son and Daughter'. The daughter's appointment on 6 February 1788 may have been a final sitting before the picture was sent for exhibition. Lady Gideon, significantly, had an appointment on 11 February.

In his last years Reynolds responded sympathetically, and even enthusiastically, to the images of high fashion. As Aileen Ribeiro points out, 'Maria Gideon is extremely up-to-date in her black and white ensemble, white muslin dress with long, tight sleeves, matching fichu over the breast, black silk

stole, black beaver hat with white ostrich feathers—even her hair, with its elaborately dishevelled curls, is powdered white. The only touch of colour is her dress is her sash of blue watered silk. Her brother is dressed in what William Hickey would have called "the hightest ton" with his cutaway coat, short double-breasted waistcoat, buff-coloured breeches and jockey boots. Maria Gideon holds his black round hat with its flat-topped crown and uncocked brim which, except for the most formal occasions, had replaced the three-cornered hat by the 1780s.' In order to take full advantage of the rich pattern made by the clothes, the painter has set his subjects against a plainer sky than usual and introduced only a slight suggestion of spindly trees, not wishing to detract from the bold masses of the figures.

Among the artist's revisions which have become visible are adjustments to the outline of the dress and to the boy's cane and hand. D.M.

PROVENANCE Painted for the sitters' father, Sir Sampson Gideon; thence by descent to Sir Culling Eardley, 1861; Mrs Culling Hanbury, Bedwell Park, 1900; Agnew's, 1919, from whom bt by the 1st Viscount Cowdray.

EXHIBITED Royal Academy 1788 (226: 'Portraits of a young lady and her brother'); British Institution 1861 (166); Royal Academy 1968 (84).

LITERATURE Waagen 1857, p. 282; Graves and Cronin 1899–1901, I, p. 361; Waterhouse 1941, p. 80; Cormack 1970, p. 154.

No early engraving recorded.

JOHN JONES (after Reynolds)

143 His Royal Highness the Duke of York

61.1 × 38.8 cm (measurement within stipple border)
The Trustees of the British Museum

The Prince of Wales, in a letter to his brother Frederick, Duke of York, of 16 May 1784, announced his intention of keeping space in his house for portraits of him and of 'Billy' (William, Duke of Clarence). This portrait, now in Buckingham Palace, probably resulted from this resolution (Millar 1969, pp. 101–2). Appointments for the Duke of York are recorded in the artist's pocket-book on 19, 22 and 24 November 1787 and 1 January 1788 (but given in the pocket-book for 1787) and on 26 January, 2 and 8 February 1788. The portrait was exhibited at the Royal Academy exhibition in 1788 (no. 88, with the title given here). There seems to be no reference to the painting in the artist's ledgers and payment was probably settled posthumously by Reynolds's executors.

The stipple engraving by Jones shown here was published on 18 December 1790. It may be that this portrait was intended as a pendant for that of the Prince of Wales discussed in Cat. 137 (when it was clear that the latter portrait would

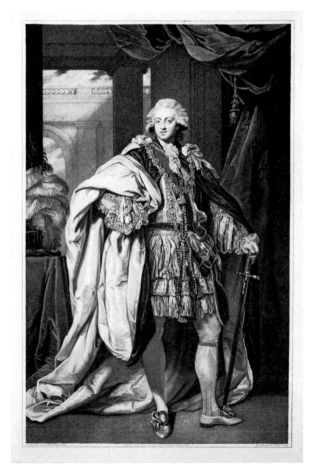

143

not go to France). In both Reynolds captured something of the splendour of Veronese; contrast Cat. 183 and 184, which show the Duke in less glorious roles. N.P.

LITERATURE Hamilton 1874, p. 74.

144 Dr John Ash

241.3 × 147.3 cm
Governors of the Birmingham General Hospital

John Ash (1723–98) was an eminent physician in Birmingham. He helped to found and largely planned the General Hospital there of which he was first physician. He was also a man of wide intellectual interests who had turned his mind to mathematics and botany as therapy after his own attacks of lunacy. In 1787 he moved to London where he was made Fellow of the College of Physicians. The governors of the General Hospital must have determined to perpetuate his presence in Birmingham by means of portraiture: they were perhaps aware of Reynolds's portrait of another physician, Percival Pott, exhibited at the Academy in 1784 and engraved—a painting presented to Saint Bartholomew's Hospital in London. On 22 April 1788 Reynolds wrote to George Birch, one of the governors of the Birmingham General Hospital, acknowledging receipt of one hundred guineas which was the preliminary half-payment for the portrait. (The payment was also entered in the ledger.) Reynolds told Birch that he proposed to commence the painting in '2 or 3 days time'. Appointments for Ash commence in the artist's pocket-book six days later on 28 April and continue on 1, 6, 12 and 22 May, 2, 6, 9, 26 and 30 June and 7 July. The second payment of a hundred guineas was entered in the ledger in January of the following year (with a note opposite, not transcribed in Cormack, which reads 'Frame paid &cr').

Aileen Ribeiro notes that Ash is wearing 'the gown of a

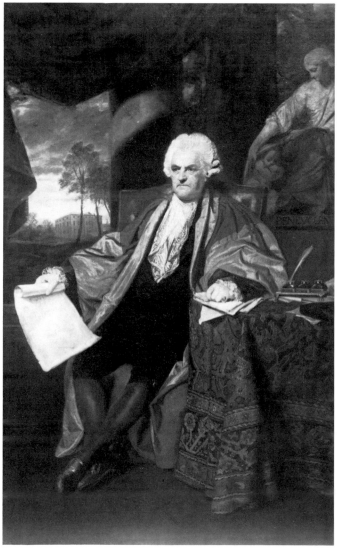

144

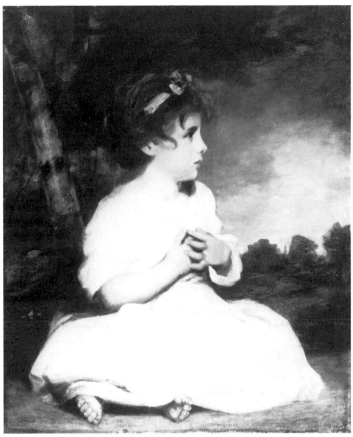

145

Doctor of Medicine, over a black velvet suit, with a formal lace cravate (probably of French needlepoint) and a heavily-powdered wig with rigid side curls of the sort that was already old-fashioned for the late 1780s'. Very prominent on the small finger of his clenched left hand is a ring set with a large stone (indicated by a dash of blue and white paint) surrounded by diamonds. He holds a ground plan of the hospital which appears also in the distance (a view perhaps derived from a topographical print). The plinth of the statue of a seated woman behind him is inscribed BENEVOLENT[IA]. In Bartolozzi's print it is clear that she is extending her mantle to protect a child crouched beside her.

On 3 June 1789, 5 May and 3 November 1790 Reynolds noted in his pocket-book evening engagements with 'the Eumelian Club'. This was a convivial learned society which met in the Blenheim Tavern in Bond Street to which several of Reynolds's friends—most notably Charles Burney, Richard Payne Knight and James Boswell—also belonged. It had been founded by Ash and its name is derived from the Greek for an Ash tree. N.P.

PROVENANCE Painted for the General Hospital; not always displayed there (in 1867 on loan to King Edward's School).

EXHIBITED Royal Academy 1888 (39); Birmingham 1961 (86).

LITERATURE Graves and Cronin 1899–1901, I, pp. 32–3; Reynolds 1929, p. 182; Waterhouse 1941, p. 80; Cormack 1970, p. 144.

ENGRAVED Bartolozzi, 1 March 1791.

145 The Age of Innocence

75.5 × 63 cm
City Museum and Art Gallery, Plymouth

Reynolds's fancy painting of vulnerable infantile faith was engraved by J. Grozer in 1794 with the title *The Age of Innocence*. The painting has been dated to 1788 by Graves and Cronin, which is perfectly possible. The child is five or six years old and there was a family tradition that the model was Offy, the daughter of the painter's favourite niece (also named Offy), who was born in 1782. The most famous version of the painting is now in the Tate Gallery. It was presented in 1847 to the National Gallery by Robert Vernon who had acquired it for a vast sum (£1,596) at Jeremiah Harmann's sale (Christie's, 18 May 1844, lot 133). It was in Harmann's possession by 1813 and was probably the 'Innocence' sold to Elwin at the artist's studio sale (Greenwood's, 16 April 1796, lot 13).

The spontaneous and solid execution of this version (which is in far happier condition than the one in the Tate Gallery) suggests that it is by Reynolds. If it is an early copy, it is of exceptional quality and gives a better impression than does the Tate Gallery painting of the artist's intention. It is perhaps mistaken to think that there were 'originals' of the fancy pictures as there were originals of the portraits. Northcote states that Reynolds worked on two versions of such

pictures alternately (1818, II, p. 7), and there is good evidence in his ledgers, in his studio sales and in Northcote that he repeated many of them subsequently. When he did so, the first version or versions may not always have been the best—indeed, they may often have been the most laboured on, and may also have been more liable to deterioration as a consequence of his experimental technique. The Minneapolis version of *The Child Baptist* (Cat. 101) is better than any other, but is unlikely to have been the first version. It is also true that Reynolds probably felt free to let his pupils copy his fancy pictures because they were uncommissioned, and so studio versions are to be expected.

It is tempting to identify this version with the 'Innocence (unfinished)' sold at the artist's studio sale (Greenwood's, 15 April 1796, lot 59, to Ford) but there is no evidence that it is unfinished. The first recorded owner, Colonel Long, was nephew of the great collector Charles Long, Lord Farnborough (1760–1838); but if Charles Long owned this version (and an old label on the frame claims that he did so) he did not exhibit it at the British Institution and did not list it among the finest paintings in his collection which he bequeathed to the National Gallery. David Mannings points out that F. G. Stephens mentions a version in the Earl of Lonsdale's collection exhibited at the British Institution in 1833. N.P.

PROVENANCE Colonel S. Long; his sale, Christie's, 11 May 1882 (156), bt in; Colonel Long's daughter, the Hon. Mrs R. M. W. Dawson; her daughter, Norah Phoebe Dawson; her sale, Christie's, 1 March 1946 (68), bt in; bequeathed to Miss Calmady Hamlyn by whom presented to Plympton to hang in the Old Town Hall; transferred 1984 to Plymouth City Art Gallery.

Never previously exhibited.

LITERATURE Graves and Cronin 1899–1901, III, p. 1129; Hudson 1958, p. 125.

No engraving of this version.

146 Master Hare

77 × 63.5 cm
Musée du Louvre

The subject of this brilliant portrait, so freely painted that it may almost be described as a sketch, was Francis George Hare, eldest son of Francis Hare Naylor of Hurstmonceaux and Georgiana, daughter of the Rt Rev. Jonathan Shipley, Bishop of St Asaph. He was born on 6 January 1786 and was two years old when he posed for this portrait. His name appears in Reynolds's pocket-book on 8, 9, 13, 16, 21 and 24 May, and 19 and 27 June 1788. The picture was apparently commissioned by his mother's sister, Anna, Lady Jones, wife of the celebrated orientalist, Sir William Jones, but no record of payment has been discovered. Francis George Hare married, on 29 April 1828, Anne Frances, daughter of Sir John Dean Paul, 1st Bt. He died on 6 January 1842. As Aileen Ribeiro points out, 'he wears a white muslin frock (with back-fastening) with a sash, similar to the costume worn by

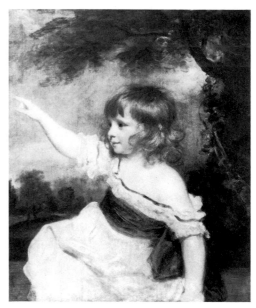

146 *reproduced in colour on p. 158*

small girls. Boys were not generally put into breeches until they were about three or four years old, although this could take place as late as seven years old.'

The somewhat tangled history of this picture in the nineteenth century (it was the subject of a lawsuit in 1869 at Westminster Hall concerning its ownership) is complicated by the existence of at least one and possibly as many as three replicas. One was lent to the New Gallery in 1899 (184) by Lionel Phillips, and another belonged to W. H. Milligan and was sold at Christie's on 8 June 1872 (63); in 1906 what seems to have been the Milligan version was donated to the Metropolitan Museum of Art, New York by George A. Hearn—this was 'deaccessioned' by the Museum in September 1972 and sold by Sotheby Parke Bernet, New York (78) on 15 February 1973. D.M.

PROVENANCE Painted for the sitter's aunt, Lady Jones (died 1829); Mrs Louisa Shipley (died 1839); Mrs Townshend, who gave it in 1841 to surviving nephews of Mrs Louisa Shipley, one of whom, Julius Hare, bequeathed it in 1855 to Mrs Augustus Hare; after lawsuit in 1869 ownership passed to another branch of the family; Baron Alphonse de Rothschild, by whom bequeathed to the Louvre, 1905.

EXHIBITED British Institution 1845 (64); Royal Academy 1872 (62); École des Beaux-Arts, Paris, 1897.

LITERATURE Graves and Cronin, 1899–1901, II, pp. 435–6; IV, p. 1334; Demonts 1922, p. 181; Waterhouse 1941, p. 80.

ENGRAVED R. Thew, 25 March 1790 (3rd state entitled *Infancy*); S. W. Reynolds.

147 Penelope Boothby

75 × 62 cm
Private Collection

Sir Brooke Boothby, 7th Baronet, married in 1784 Susannah, daughter and heiress of Robert Bristoe. Penelope, their only child, was born on 11 April 1785. Appointments for her appear in Reynolds's pocket-book at one o'clock on 1, 3, 5 and 8 July 1788, the picture (which cost fifty guineas) having already been paid for in May of that year. Boothby, who had himself been painted by Reynolds, must have known the artist well. He wrote to him from Paris (where he was staying with Reynolds's great patron, the Duke of Dorset) on 26 January 1788 urging him to permit Jacques-Louis David, whose works he much admired, to exhibit at the Royal Academy in London (manuscript recently discovered at the Royal Academy). He announced his intention of returning to London at the end of April and the date of the payment suggests that he commissioned Reynolds soon afterwards to make this portrait.

Less than three years later, on 19 March 1791, Penelope died, and her heart-broken parents commissioned a monument from the sculptor Thomas Banks which stands in Ashbourne Church, Derbyshire, representing the child asleep.

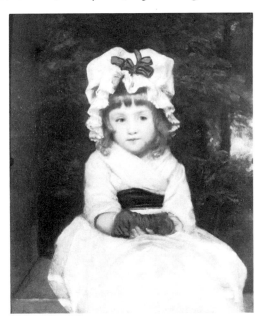

147 *reproduced in colour on p. 159*

The model for this, when shown at the Royal Academy in 1793, moved Queen Charlotte to tears. Penelope's father, a member of the literary circle at Lichfield which included Miss Seward, Erasmus Darwin, Thomas Day and Richard Lovell Edgeworth, was a friend of Rousseau. He published a collection of verses in 1796 entitled *Sorrows Sacred to the Memory of Penelope*, illustrated by Fuseli whom he also commissioned to paint her soul (Wolverhampton Art Gallery).

This is one of Reynolds's most successful child-portraits, original in conception and brilliant in execution. It is for the most part thinly painted in a technique learnt from Rubens, as we can see from such details as the treatment of the small shadowy areas around the eyelids and nostrils, using delicate touches of red-brown. Like his younger Spanish contemporary, Goya, Reynolds makes effective use of black and white, the latter applied with a few heavily-loaded brush-strokes over a thin ground of transparent grey.

Reynolds's picture inspired one of the most popular of Victorian images, for Millais's famous *Cherry Ripe*, painted in 1879, was a portrait of Miss Edie Ramage who had attended a fancy-dress ball that year dressed as Reynolds's *Penelope Boothby*, and was then painted in the same costume. Aileen Ribeiro points out that 'over the white muslin frock of childhood, Penelope Boothby wears a matching white fichu crossed over the chest. The impression of the small girl borrowing the clothes of her mother or sister is given by the mob cap, a cap with puffed-out crown to accommodate the wide, rising hairstyles of the 1780s, but which looks over-large on the flat, natural hair of the child.' The portrait has sometimes been known as 'The Mob Cap'—a title also given to other paintings by Reynolds. D.M.

PROVENANCE By descent to the Rev. Sir Brooke Boothby, 10th Bt, who sold it 1846 in compliance with the will of his father who died that year; bt at Phillips 1851 by Mr Windus of Tottenham; his sale, Christie's, 26 May 1859 (48), bt Lord Ward, afterwards 1st Earl of Dudley; bt by Agnew's, 25 April 1884 apparently from Christie's but no sale is recorded on that date; sold to Daniel Thwaites, 30 April 1884; by descent.

EXHIBITED South Kensington 1862 (70); Royal Academy 1871 (385), 1885 (55); Agnew's 1899 (12).

LITERATURE Cotton 1859 (*Some Account*), p. 66; Graves and Cronin 1899–1901, I, p. 96; Waterhouse 1941, p. 80; Cormack 1970, p. 147.

ENGRAVED T. Park, 1789.

CAROLINE WATSON (after Reynolds)

148 The Death of Cardinal Beaufort

57.4 × 41 cm
The Trustees of the British Museum

This etching, published on 25 March 1790, reproduces one of the paintings which Reynolds made for the Shakespeare Gallery of Alderman Boydell. The painting (which survives in a severely deteriorated condition at Petworth) was on display in the Gallery in May 1789 and payment of five hundred guineas for it is recorded in the artist's ledger between 22 June 1789 and December 1790. In the catalogue of the Gallery, printed early in 1790, it was no. XXIII.

The episode from Act III, Scene iii of *Henry VI Part II* which Reynolds illustrated provided two severe challenges to the artist: the extreme expression of the dying Cardinal and the realization of a figure of speech in the depiction of a demon by his head. The King exclaims:

O thou eternal Mover of the heavens,
Look with a gentle eye upon this wretch!
O, beat away the busy medling fiend,
That lays strong siege unto this wretch's soul
And from his bosum purge this black despair!

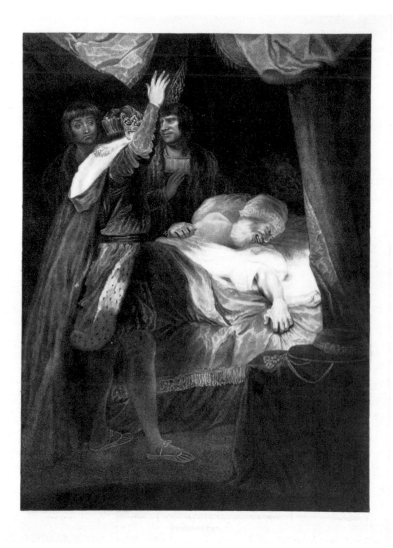

148

The Earl of Warwick then adds: 'See, how the pangs of death do make him grin.' Neither grin nor fiend generally pleased, both being considered grotesque rather than pathetic (see, for example, Walpole 1937–83, XV, p. 206 and Hazlitt 1873, pp. 253–4). The demon appears in the early states of this print, such as the one exhibited here, but was removed from the painting itself and from the plate when republished on 1 August 1792 to serve as Plate 17 in Boydell's second volume of the illustrations to Shakespeare.

The over-obvious dependence of the composition and the pose of the King upon Poussin's famous *Death of Germanicus* was censured by a newspaper critic (Graves and Cronin 1899–1901, III, p. 1145).

Caroline Watson, the engraver, was the daughter of James Watson (for whom see Cat. 62). The choice of etching rather than mezzotint was doubtless conditioned by Boydell's anxiety for a large edition. N.P.

LITERATURE Hamilton 1874, p. 108; Roe 1971, pp. 118–21; Friedman 1976, pp. 118–21.

149 Self-portrait

75.2 × 63.2 cm (on wood)
H.M. The Queen

Edmond Malone describes this self-portrait by Reynolds of about 1789 as 'extremely like him' and notes that it represents him 'exactly as he appeared in his latter days, in domestick life'. 'He was in stature rather under the middle size,' Malone says, 'of a florid complexion, and a lively and pleasing aspect; well made, and extremely active'. As far as the dress is concerned, Reynolds would, as Aileen Ribeiro puts it, 'have agreed with Lord Chesterfield that a man should be "well dressed according to his rank and way of life", neither being over-subservient to the whims of fashion, nor indifferent to dress. The artist's high-collared frock coat and wide-lapelled waistcoat, allowing the muslin shirt frill to be seen, are modest interpretations of the fashionable style. A concession to advancing years is the adoption of a wig, though it is loosely curled in imitation of the natural hair.' He wears the

same, or a very similar wig in his portrait by Gilbert Stuart painted in 1784, which now hangs in the National Gallery of Art, Washington. 'His appearance,' says Malone, 'at first sight impressed the spectator with the idea of a well-born and well-bred English gentleman.' However, there may be a touch of pious flattery here, for other accounts suggest a distinct lack of polish, an almost rustic quality which was noticed and recalled later by Cornelia Knight. 'His pronunciation was tinctured with the Devonshire accent,' she noted in her autobiography, remembering her childhood in London where she knew the painter's young niece, Offy; 'his features were coarse, and his outward appearance slovenly' (Knight 1861, I, p. 9).

This is the only one of Reynolds's numerous self-portraits which represents him wearing spectacles. At least two pairs of silver spectacles survive which belonged to the artist (see Cat. 166). They show that he was short-sighted, and although without them he would have been able to read small print without too much difficulty he would not have been able to see his sitters properly. Normally, therefore, from late 1782, when he suffered 'a violent inflammation of the eyes' (see Reynolds 1929, p. 97) he must have worn spectacles when painting. That he did not actually need to wear them when painting his own portrait, standing close to a mirror, is indicated by an even later self-portrait which exists

and about which something will be said presently. In January 1790 Reynolds is described as wearing spectacles with one glass opaque, but there seems an implication that he could still paint a little (Whitley 1928, II, p. 125). He was soon, however, forced to give up.

This has often been described as the last self-portrait, but there is, in fact, another self-portrait of Reynolds in old age, without spectacles, surely the one described by Boswell as having 'a sort of *pulled up* look' (Hilles 1952, p. ix), which has a better claim (Private Collection; exhibited at the Royal Academy in 1956, no. 283). Maria Edgeworth saw it in the possession of Mrs Gwatkin (Reynolds's niece, Offy), in 1831, and described it as 'the last he ever drew', but in poor condition, 'all going—risen in great black cracks and masses of bladdery paint' (Edgeworth 1971, p. 507). A still later likeness was painted, just before Reynolds's death, by the Swedish artist C. F. von Breda for the Royal Swedish Academy in Stockholm (Steegman 1942, pl. I). Although von Breda approached his task with sympathy and respect he saw an old and despondent figure slumped in his academic robes and the result lacks the vitality that friends recognized in the *Self portrait* exhibited here. Malone remembered how fit Reynolds had been up until the last few months; indeed, in September 1791 he and Reynolds, when returning to London from a visit to Burke's home at Beaconsfield, had left their

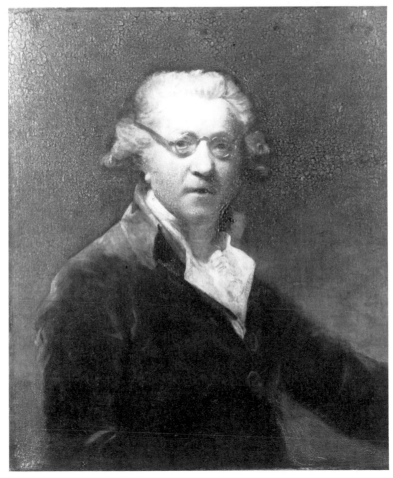

149

carriage and walked five miles on a warm day, without the painter complaining of any fatigue. 'He had at that time, though above 68 years of age, the appearance of a man not much beyond 50, and seemed as likely to live for 10 or 15 years as any of his younger friends.'

The popularity of this image is attested by the enormous number of versions that exist. Most are feeble nineteenth-century copies, but a few are of good quality and were certainly produced in Reynolds's studio even if they were not painted by him. On 4 October 1790 Reynolds wrote to the Duke of Leeds, a fellow member of the Literary Club and later one of the painter's pall-bearers, to say that 'the Picture which I have the honour of sending by the bearer, is, either as a subject, or as a Picture scarce worth hanging however it is very flattering to me that Your Grace is of another opinion' (Reynolds 1929, p. 207). This was described by Edmond Malone as a 'duplicate' of the picture exhibited here. Other duplicates were given to Malone himself (now at Kenwood, no. 29), to the Rev. William Mason (lent to an exhibition at Dublin in 1957 by Senator E. A. McGuire) and, according to an early nineteenth-century source, Edmund Burke (Royal Collection, see Millar 1969, no. 1032). Good early copies include one said to come from the collection of Sir George Beaumont (Christie's, 10 December 1937, lot 144), one at Dulwich which Waagen thought 'superior, and more powerful in colouring' than the one exhibited here (Waagen 1854, II, p. 348), and one in Berlin. Sir Oliver Millar lists many more versions, including enamels and chalk copies of the head alone. These chalk drawings have occasionally been described, certainly wrongly, as studies for the original oil portrait. That the picture exhibited here is indeed the original we can infer from the fact that when, in June 1812, the Prince Regent acquired the version which had belonged to Burke (Royal Collection no. 1032, already mentioned) Lady Thomond, knowing that the Burke portrait was a copy, immediately gave this, 'the best portrait he ever painted of himself' (as she described it) to the Prince. 'The deep sense I have of your Royal Highness's goodness to my uncle,' she wrote, 'and your gracious condescension in accepting his portrait from my hand, will ever be a source of the most heartfelt satisfaction, since it must be accompany'd with the idea that it is his patron (and may I presume to say his friend) who thus honours his memory' (Aspinall 1938, I, p. 120).

The physical deterioration of this nevertheless moving and impressive self-portrait is due to Reynolds's unorthodox methods of painting. He had by this time become very careless about his materials. He mixed wax with his pigments, used quick driers, and came to rely extensively on bitumen, a tar-like substance which gives a rich, glowing effect when first applied but which never quite dries. The resulting traction-cracks are sadly evident here, not only in the background but even on shadowed flesh-tones. D.M.

PROVENANCE Given to George IV in June 1812 by Reynolds's niece, Mary Palmer, Marchioness of Thomond.

EXHIBITED British Institution 1820 (30), 1826 (4); 1827 (67), 1833 (1); Manchester 1857 (307).

LITERATURE Malone, in Reynolds 1798, I, note 45 p. lxxvii; Northcote 1818, II, p. 245; Waagen 1854, II, p. 24; Graves and Cronin 1899–1901, II, pp. 804–5; Waterhouse 1941, p. 80; Steegman 1942, p. 34; Millar 1969, pp. 98–9, no. 1088; Waterhouse 1973, p. 48.

ENGRAVED C. Watson, 1 March 1789; G. Clint, 1799; S. W. Reynolds.

150 Puck

101.6 × 81.3 (on wood)
Executors of the 10th Earl Fitzwilliam

The story of how this picture came into existence is told by the antiquary William Cotton, whose grandfather visited Reynolds's studio in the company of Alderman Boydell, founder of the Shakespeare Gallery in Pall Mall. Reynolds had already painted Macbeth and the Witches for him and was working on The Death of Cardinal Beaufort (Cat. 148, 152). But Boydell was, in the course of the visit, 'much taken with the portrait of a naked child, and wished it could be brought into the Shakespeare. Sir Joshua said it was painted from a little child he found sitting on his steps in Leicester Fields. My grandfather then said: "Well, Mr Alderman, it can very easily come into the Shakespeare, if Sir Joshua will kindly place him on a mushroom, give him faun's ears, and make a Puck of him." Sir Joshua liked the notion, and painted the picture accordingly.' As it stood, the picture of the naked child would have been considered a fancy picture for which Reynolds's price at that time was fifty guineas. With ears and mushroom and figures (now only just visible) of Titania and Bottom in the background, it became a history picture and Reynolds charged the Alderman—admittedly a very wealthy man and a publisher as well as a collector—a hundred guineas. The entry in the ledger, made some time between 22 June 1789 and December 1790, reads: 'Mr. Alderman Boydell, for the Fairy ["Puck" added above], or Robin Goodfellow £105.0.0.'

The most successful of Reynolds's Shakespearean pictures, Puck was seen at the Academy in 1789 by Walpole who described it as 'An ugly little imp, but some character, sitting on a mushroom half as big as a millstone.' In the nineteenth century it was criticized, rather oddly, as being too realistic and not fantastic enough. Stephens, for instance, while praising it as 'inexhaustible of character, splendidly spirited as a portrait of a gleeful baby, brimming over with life', yet complained that it was 'not a Puck at all,—as such, indeed, really an absurd picture'. For a really convincing image of Shakespeare's goblin, he added with true Pre-Raphaelite loyalty, one turns to Woolner's statuette (exhibited at the Tate Gallery, The Pre-Raphaelites, 1984, no. 2). In the early and mid-nineteenth century a number of men claimed to have been the child whom Reynolds painted. One of them, according to a report in the Illustrated London News on 7 June 1856, was a former porter at Elliott's brewery in Pimlico, and he had been present at the Rogers sale when Puck was sold to Lord Fitzwilliam. Another, according to C. R. Leslie, was the son of Reynolds's frame-maker, Cribb. Probably the

150

picture was based on studies of more than one child. At least one study of the head only is recorded (Christie's, 16 February 1856, lot 28; 14 April 1864, lot 408; 24 November 1874, lot 109; 19 January 1945, bought by A. Tooth & Sons for a high price). D.M.

PROVENANCE Painted for Alderman Boydell's Shakespeare Gallery; Boydell sale, Christie's, 20 May 1805 (15), bt Seguier, for Samuel Rogers; Rogers sale, 2 May 1856 (714), bt by 5th Earl Fitzwilliam; by descent.

EXHIBITED Royal Academy 1789 (82: 'Robin Goodfellow'); British Institution 1813 (60), 1823 (24), 1843 (49), 1854 (133), 1860 (184); Manchester 1857 (75); Royal Academy 1890 (162); Plymouth 1951 (56).

LITERATURE Jameson 1844, p. 409; Waagen 1854, II, p. 75; Cotton 1956 pp. 174–5; Leslie and Taylor 1865, II, p. 504; Stephens 1867, pp. 30–2; Graves and Cronin 1899–1901, III, pp. 1189–91; Whitley 1928, II, p. 393; Waterhouse 1941, p. 81; Cormack 1970, p. 147; Waterhouse 1973, p. 35.

ENGRAVED Schiavonetti, 29 September 1799; S. W. Reynolds; C. Heath, 1827.

151 Mrs Siddons as the Tragic Muse

239.7 × 147.6 cm
Signed and dated 1789
The Governors of Dulwich Picture Gallery

Sarah Kemble (1755–1831) was the eldest of twelve children. Among her brothers were the actors John Philip, Charles and Stephen. She married William Siddons in 1773 and attracted the attention of Garrick the following year; he employed her at Drury Lane in 1775–6. Her first season in London was, however, a failure and it was not until 1782 that she established herself as the leading tragic actress in the country. She was often painted, notably by Gainsborough (National Gallery 683), by William Beechey 'with the Emblems of Tragedy' (National Portrait Gallery)—a picture that, when it was exhibited in 1794, was seen as a challenge to Reynolds, by G. Stuart, by Sir Thomas Lawrence (both National Portrait Gallery), and by many others. She retired from the stage in 1812.

This is a replica of the original portrait by Reynolds of *Mrs Siddons as the Tragic Muse* which was exhibited at the Royal Academy in 1784 and is now in the Huntington Art Gallery, San Marino, California. Throughout the nineteenth century some confusion existed concerning these two versions. Hazlitt, for example, said (but gave no evidence) that the Dulwich replica was painted by one of Reynolds's pupils, William Score, that the original is larger than the copy (it is very slightly smaller), and was sold by Reynolds to 'Mr Calonne' for two or three hundred pounds. Taylor added to the confusion by identifying the replica with the picture recorded in the ledger as sold to Desenfans in February 1790 for £735. The correct account was given by Whitley, and the salient points are as follows.

In the spring of 1783 Valentine Green, hoping to engrave the picture, exchanged letters with Reynolds. One interesting fact to emerge from the correspondence is that the owner of the portrait to whom he necessarily applied first was not the artist and not Mrs Siddons but Sheridan. It seems that Sheridan, then managing Drury Lane with Mrs Siddons as his leading lady, may have commissioned the portrait as an advertisement. But if so, Sheridan never collected the picture, for it remained in Reynolds's studio after the exhibition of 1784 and Whitley found several references in contemporary newspapers to the fact that the artist was unable to sell it, as well as to the very high price he wanted—one thousand guineas. In 1790 it was bought by M. de Calonne, formerly Minister of Finance to Louis XVI, who had fled to England in 1787. The purchase was made through his agent, Desenfans, and the transaction was entered in the artist's ledger. On 15 April 1789 a newspaper, the *Star*, reported that 'Sir Joshua has agreed to copy his picture of Mrs Siddons: his payment a Reubans valued at £500. The original Sir Joshua values at £1,000.' This 'copy' (exhibited here) was for Desenfans himself, and the fact that it was paid for with a painting explains why no reference is made to it in the artist's ledger.

The original is dated 1784, the Dulwich replica 1789. How much of the replica was painted by Reynolds himself is diffi-

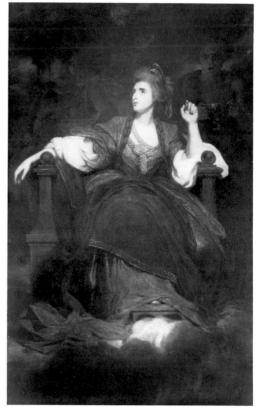

151 *reproduced in colour on p. 160*

cult to say, but it is worth remembering that his health was now failing and three months later his eye began 'to be obscured'. The fact that he signed and dated the portrait so conspicuously does suggest, at least, his close supervision. Mrs Siddons's own account of the origin of the composition is, as Professor Murray remarks, 'probably no more untruthful than is usual in the memoirs of actresses': 'When I attended him for the first sitting, after many more gratifying encomiums than I dare repeat, he took me by the hand, saying, "Ascend your undisputed throne, and graciously bestow upon me some grand Idea of the Tragick Muse". I walked up the steps and seated myself instantly in the attitude in which She now appears. This idea satisfied him so well that he without one moments hesitation determined not to alter it. . . . He . . . most flatteringly added, "And to confirm my opinion, here is my name, for I have resolved to go down to posterity upon the hem of your garment."' Thomas Campbell records this story in his *Life* of the sitter, published in 1834, and also recalls her plea that Reynolds should not heighten the complexion lest it would not accord 'with the chilly and concentrated musings of pale melancholy'.

Samuel Rogers, however, gave a different account: 'I was at Sir Joshua's studio,' he told Campbell, 'when Mrs Siddons came in, having walked rapidly to be in time for her appointment. She threw herself, out of breath, into an armchair, having taken off her bonnet and dropped her head upon her left hand—the other hand drooping over the arm of the chair. Suddenly lifting her head she said, "How shall I sit?"

"Just as you are," said Sir Joshua, and so she is painted.' Still another account was given by the painter Thomas Phillips, who said that Mrs Siddons told him she was already posed by the artist when she turned her head to look at a picture on the studio wall, whereupon Reynolds saw the advantage of this accidentally altered position and painted it. It must be said that none of these stories—and there are others—is very convincing. The artist may well, with his usual diplomacy, have let her think that she had herself determined the pose, but it is obvious that the whole composition was most carefully contrived.

As C. R. Leslie pointed out, Reynolds could well have taken his central notion of representing her as the Tragic Muse from a poem written in her praise by William Russell, and published early in 1783, probably just before the first sittings (the pocket-book for 1783 is missing), entitled 'The Tragic Muse: A Poem Addressed to Mrs Siddons'. Her pose is, of course, based on Michelangelo's figure of the prophet Isaiah from the Sistine Ceiling, a borrowing recognized by early admirers like Sir Thomas Lawrence, while the figure behind her right shoulder holding the dagger is taken from a similarly placed companion of Jeremiah. Professor Wark noticed that the figure holding the cup (the cup and dagger are traditional attributes of Melpomene, the Muse of Tragedy as illustrated in standard emblem books) seems to have been modelled on 'Fright', as represented in John Williams's 1734 translation of Le Brun's popular treatise on the passions. A chalk drawing in the Tate Gallery (no. 1834) may be a self portrait of Reynolds pulling a face in the mirror, possibly a study for this figure. Such a process of schema and correction, of convention and observation—and not without a glint of humour—would be very characteristic of Reynolds. For these two figures hovering behind Mrs Siddons's throne he has turned to Aristotle's classic definition of Tragedy, so familiar in the literary circles in which he moved, as 'an imitation of some action that is important, entire, and of a proper magnitude ... effecting through pity and terror the correction and refinement of such passions'. And it was as Pity and Terror (not Crime and Remorse, as later writers supposed) that Mrs Siddons's contemporaries interpreted them. The picture is painted with the rich, dark tonality of Rembrandt, as Waagen noted.

This fine picture has perhaps suffered by being too extravagantly praised by early critics. James Barry called it 'The finest picture of the kind, perhaps in the world, indeed it is something more than a portrait ...'. His opinion was widely shared. In view of this, it is perhaps surprising that it did not inspire more painters to attempt similar compositions. In contrast to the way its 'roots' reach back to the High Renaissance, Mrs Siddons as the Tragic Muse handed on a limited legacy to the nineteenth century.

It is amusing to discover that the sitter was wheeled along the stage as the Tragic Muse in a production of Garrick's Jubilee at Drury Lane in 1785, but it is also instructive, reminding us how close the links sometimes were between painting and stage practices. Earlier portraits of actors like Cibber, Quin and Garrick (e.g. 'Kitely', Cat. 69) evoke the intimacy of the early Georgian theatre in which the per-

former stood well forward of the proscenium arch surrounded by a small audience close enough to watch his facial expressions. But theatres increased in size, and developments in artificial lighting enabled the huge space of the auditorium to be darkened and the performers, now pushed back behind the frame of the proscenium arch, to be dramatically lit within the setting of elaborate, illusionistic scenery. Reynolds's portrait should be seen within that context, for she addresses us with a new sense of scale and distance, and—again by comparison with earlier theatrical portraits—a different kind of rhetoric, a rhetoric that culminates in Lawrence's apocalyptic whole-length portrait of Mrs Siddons's brother, John Philip Kemble as Coriolanus (Guildhall Art Gallery, London).

Other copies of Mrs Siddons as the Tragic Muse are recorded, but only one has any plausible connection with Reynolds. That was a version of the bust only which was sold at the Thomond sale on 18 May 1821 (38). The same picture, or another, was at Elvaston Hall in 1823 (Neale 1823, VI, unpaginated) and was sold at Sotheby's on 22 April 1964. Whole-length copies include those recorded in the Harvey Collection at Langley Park in 1931, in the Normanton Collection at Somerley, and in the possession of Robert Tait or Tate (this was described by Henry Graves, who saw it at the National Portraits exhibition at South Kensington in 1868, as 'bad').

Aileen Ribeiro describes Mrs Siddons's costume as totally imaginary, 'conforming to the fashions of the early 1780s only in the fairly pointed and corseted bodice, and the slightly puffed out hairstyle; in the latter case, the actress wears false hair including long plaits, for it was customary for tragic heroines to wear their hair long [compare the corresponding figure in Garrick between Tragedy and Comedy, Cat. 42]. At about the time that this portrait was painted, Mrs Siddons writes in her Reminiscences: "Sir Joshua often honoured me by his presence at The Theatre. He approved very much of my costumes and my hair without powder My locks are generally braided into a small compass so as to ascertain the size and shape of the head, which to a Painter's eye was of course an agreable departure from the mode. My short waist too was to him a pleasing contrast to the long stiff stays and hoop petticoats which were then the fashion even on the stage, [and] obtained his unqualified approbation" [Siddons 1942, p. 19]. Mrs Siddons exaggerated her own importance in the movement towards reform in stage costume; not until the 1790s, when fashion was moving towards a kind of classical simplicity, did dress in the theatre follow suit. In the 1780s depictions of the actress in theatrical roles show her in the usual elaborately trimmed gowns with a long train (another sine qua non for a tragic part), and the large, complex hairstyles which were part of current fashion.' D.M.

PROVENANCE Acquired from the artist by Noël Desenfans; bequeathed to Sir Francis Bourgeois, 1807; Bourgeois bequest to Dulwich College, 1811.

EXHIBITED International Exhibition 1862 (110); Hayward Gallery 1975 (98).

LITERATURE (all versions of the picture) Barry 1809, I, note p. 553; Northcote 1818, I, p. 246; II, pp. 181–2; Hazlitt 1824, p. 123; Jameson

1844, pp. 279–81; Waagen 1854, II, p. 172; Leslie and Taylor 1865, II, pp. 420–6; Graves and Cronin 1899–1901, III, pp. 892–9; IV, p. 1411; Whitley 1928, II, pp. 3–13; Reynolds 1929, pp. 103–5, 245–8; Baker 1936, pp. 75–7; Waterhouse 1941, p. 75; Cormack 1970, p. 164; Wark 1971, pp. 42–57; Paulson 1975, pp. 83–6; Burke 1976, pp. 208–9; British Museum 1978, pp. 38–9, 55; Weinsheimer 1978, pp. 317–28; Murray 1980, p. 104; White 1983, p. 38.

ENGRAVED J. Bromley, 1832.

ROBERT THEW (after Reynolds)

152 Macbeth and the Witches

63 × 49.2 cm
The Trustees of the British Museum

The engraving, which was published on 1 December 1802, reproduces the first of the paintings which Reynolds began for the Shakespeare Gallery of Alderman Boydell (now at Petworth in a severely deteriorated condition; fig. 20). The commission was accepted by November 1786, when Boydell left a banknote for £500 on the artist's table as an incentive (according to Reynolds's own account in a letter to the Duke of Rutland of 13 February 1787—Reynolds 1929, p. 174). The sum is also entered in his ledger (Cormack 1970, p. 146) as 'for a picture of a scene in Macbeth, not yet begun'. The painting was not included in Boydell's catalogue of his gallery in March 1790 and was still in the studio at the artist's death, when his executors agreed on a price of one thousand guineas. However, a newspaper reported that it was nearing completion in September 1789.

Reynolds has endeavoured to represent the supernatural machinery introduced by Shakespeare in the first scene of the fourth act of *Macbeth*: thunder, a cavern, witches round a boiling cauldron conjuring apparitions at the demand of Macbeth. It will be found that all the grotesque objects itemized by the witches are present. The gothic bone throne is perhaps the most interesting piece of furniture in any of Reynolds's paintings. This sort of terrible and visionary episode was much favoured by painters at that period. Fuseli, indeed, illustrated the same part of the play for Boydell at the same date (possibly Boydell had not heard from Reynolds as to the exact subject he was to paint).

In physique and physiognomy the witches are derived from Michelangelo's muscle-bound Sybils on the ceiling, and from his devils on the altar wall, of the Sistine Chapel, whilst Reynolds also intended to emulate Titian's great nocturnal *Martyrdom of Saint Lawrence* and the spatial turbulence and broken lights of Tintoretto. The thrust of Macbeth's left arm into the picture space is particularly reminiscent of the latter artist.

A 'sketch for the large picture of Macbeth' was lot 47 in the artist's studio sale (Greenwood's, 14 April 1796).　　N.P.

LITERATURE Hamilton 1874, p. 114; Friedman 1976, pp. 118–21.

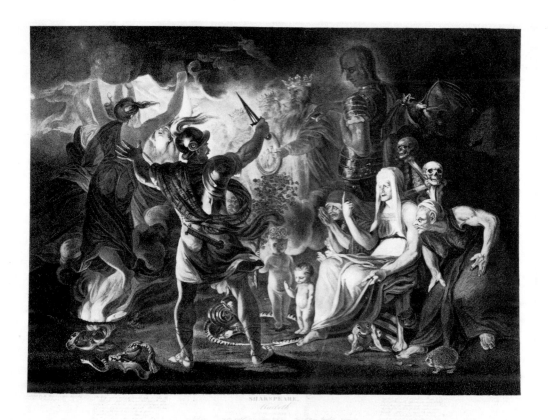

152

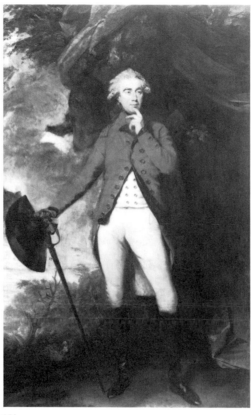

153

153 Lord Rawdon

240 × 147.9 cm
H. M. The Queen

This is one of the last pictures Reynolds painted before he lost his sight, and it is one of his most impressive achievements. Francis Rawdon-Hastings, 2nd Earl of Moira and 1st Marquess of Hastings (1754–1826), appears in Reynolds's pocket-book as Lord Rawdon on 26 and 28 June, and 2, 5, 10 and 12 July 1789. Three of these appointments were on Sundays (28 June, 5 and 12 July) and all were at ten o'clock—so, too, was an appointment for 1 July which was cancelled and the word 'Trial' written instead. This presumably referred to a trial the artist attended, although if so, it was not that of Warren Hastings which was adjourned on that day.

In the accounts column opposite 13 July there is the following note on the sitter's uniform: 'Lord Rawdon/White Waistcoat single breasted/a small blue Collar/and small Buttons/Epaulet/white Breeches/double breasted Coat/Buttons at equal distance.' On 13 July itself is a note of a more ominous kind, in which the artist recorded that his eye 'began to be obscured'. Lord Rawdon is, therefore, one of the last portraits on which the sixty-six-year-old artist worked with a sitter in front of him. On the twenty-sixth of that month a newspaper critic voiced his hopes that Reynolds would be able to finish the picture, and on 26 September another newspaper reported that 'Lord Rawdon's *head* is

done—and, what is extraordinary, with Sir Joshua, in two sittings. The figure, drapery, and landscape are sketched out, and in their first colour—so may be safely as well as easily finished.' It is sometimes assumed that by this time Reynolds was painting no more than the heads and was leaving the rest of his portraits to be completed by assistants like Giuseppe Marchi. However, there are signs that Reynolds altered the outline of the hat and the arrangement of the curtain in the background, and in any case it is clear that whatever help he may have received with details of costume or background, none of his assistants had a sufficiently powerful imagination to create this magnificent picture. *Lord Rawdon* was commented on by several newspaper critics when it was shown at the Academy in 1790. It seems generally to have been considered a good likeness.

Sir Oliver Millar records two enamel copies dated 1790 and 1792, both at Windsor, and a drawing after this picture which was sold at Christie's on 9 February 1960 (lot 27B), all by William Grimaldi. D.M.

PROVENANCE Painted for Frederick, Duke of York (in exchange for a portrait of the Duke, according to a newspaper report, 4 May 1790); Duke of York's sale, Christie's, 7 April 1827 (107), bt Seguier for George IV.

EXHIBITED Royal Academy 1790 (94: 'Portrait of a nobleman'); British Institution 1813 (92), 1827 (144), 1846 (50); Birmingham 1961 (88).

LITERATURE Graves and Cronin 1899–1901, II, pp. 783–5; Waterhouse 1941, p. 82; Millar 1969, no. 1023; Cormack 1970, p. 163; Waterhouse 1973, p. 34.

ENGRAVED J. Jones, 1792.

Sketches and Sketchbooks

154a & b Sketches for the Portrait of the Montgomery Sisters

(a) 16.5 × 24.2 cm (wood covered with a gesso ground)
The Hon. Chrisopher Lennox-Boyd
(b) 59.4 × 91 cm
Mrs E. Broughton-Adderley

Cat. 154a is partly drawn in pen and partly scratched out in pen through a roughly brushed black pigment. Some white oil-paint has been added. Cat. 154b, which was drawn to my attention by Sir Oliver Millar, is a larger work executed in oils. Both may well have been compositional sketches made in the early summer of 1773 for the great triple portrait (Cat. 90)—perhaps to show to Luke Gardiner, who commissioned the picture. The triple portrait is certainly a painting for which we could expect that such sketches were made. N.P.

PROVENANCE (a) Christie's, 22 November 1974 (167). (b) About 1870 in the possession of Mrs Wardlaw Reid; by descent.

Neither sketch has been considered in the literature on Reynolds.

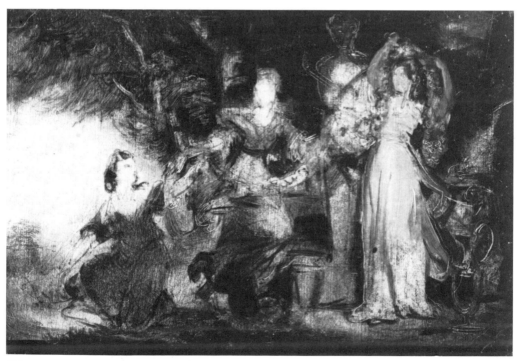

154a

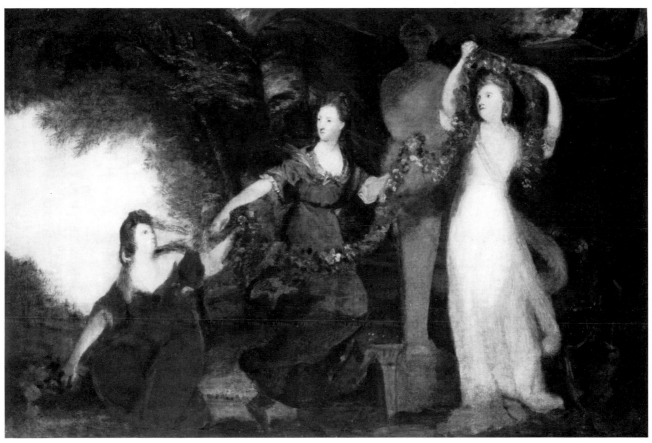

154b

155 A Series of Five Sketches of Portraits

Dimensions given below
The Syndics of the Fitzwilliam Museum, Cambridge

These sketches, kindly drawn to my attention by David
Scrase, relate to the following portraits by Reynolds (the
order is that in which the sketches are now arranged): the
Hon. Miss M. Monckton; Sir John Molesworth; Lord
Richard Cavendish; Mrs John Buller of Morval; Henry
Frederick, Duke of Cumberland. Their respective dimen-
sions are as follows: 16 × 10 cm; 16.3 × 11.7 cm;
19.2 × 14.4 cm; 15.5 × 12.1 cm; 15.8 × 9.1 cm. In each case
the works are executed with sepia applied by both pen and
brush on paper. Some white oil-paint is employed in all of
them except the first and it is conspicuous in the second and
fourth. In style the sketches are of a similar character. In no
case is there any evidence of creative struggle, such as we
might expect in preliminary work, and there is no significant
variation between any of the sketches and the finished paint-
ings. The urn behind Miss Monckton, to take one telling
detail, is surely a short-hand indication of the complex object
in the painting rather than a first rough idea for it. So these
are records of the portraits—sketches from, not for them.

Sittings for the portraits were as follows: Monckton 1777

155i

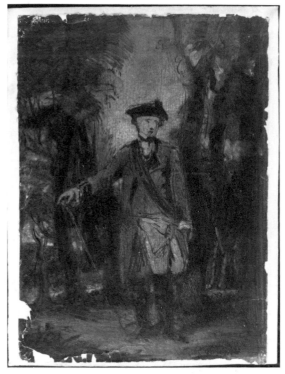

155ii

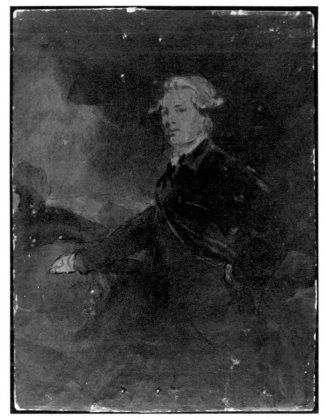

155iii

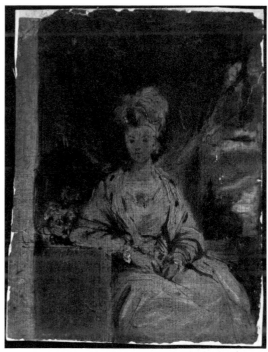

155iv

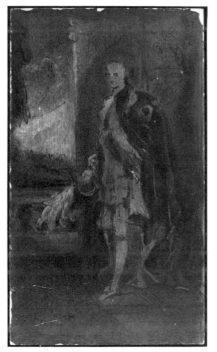

155v

and 1779; Molesworth 1762 and 1766; Cavendish 1780; Buller 1771 and 1772; Cumberland 1772 and 1773. We would perhaps have expected more of a change in the artist's own handling over a period of at least fifteen years and yet it does tally with what we know of his style of drawing. To me it seems likely that they are by Reynolds. If it is agreed that the sketches are made after the original paintings then the only reasonable alternative to Reynolds as the artist is someone consistently in his studio: for after the finished portraits left the studio they remained geographically dispersed (they were not reassembled in one of the great Reynolds exhibitions of the last century). It must be added that the portraits were all engraved, although in the case of Molesworth and Buller not before 1822 and 1823. The sketches do not look as if they were made from engravings, but the possibility should not be excluded.

The provenance of the sketches in the last century is not known but those of Monckton, Buller and Cumberland are all endorsed with what may be the same lot number, '201 no. 9'. N.P.

PROVENANCE Given to the Museum in 1919 by Miss Evelyn Brooke, from the collection of her father, the Rev. Stopford A. Brooke.

Not engraved; never previously exhibited; not discussed in the Reynolds literature.

156 A Sketch, preparatory for, or a record of, the Portrait of Mrs Pelham feeding Poultry

30.5 × 24.1 cm (on paper or board)
Private Collection

There are differences between this composition and that of the finished portrait (fig. 12) but they are minor and concern only the landscape (the opening top left, and the water in the middle distance), and cannot be taken to prove or even to suggest that this attractive sketch is a *modello* preparatory

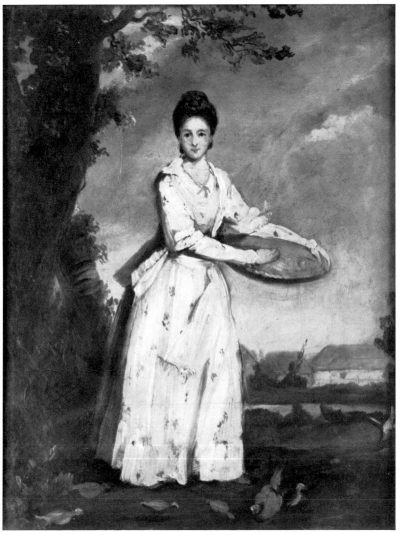

156

for, as distinct from a record of, the finished painting. In handling the sketch does seem quite close to that of the sketch of the Montgomery sisters (Cat. 154b) and to that of the sketch (indisputably preliminary and by Reynolds) in the Tate Gallery for the group portrait of the Marlborough Family. The fact that the sketch has long belonged to the same family as the portrait itself should not be taken as evidence of authenticity. Families with more than one house often commissioned miniature replicas (no. 164 at Brocklesby is certainly a replica of the finished portrait) and when a sketch comes on to the art market the owner of the finished painting is commonly contacted and often buys. This does all the same look as if it might have been painted by Reynolds.

The portrait is of Mrs Charles Pelham. She commenced sitting in 1770 when still Miss Sophia Aufrère. There are appointments for her on 17, 19, 20 and 24 July and either before or after each there are appointments for her fiancé, Mr Pelham. On 3 August there is an appointment for Mrs Pelham (also after a sitting for him). No appointments are recorded for 1771, 1772, or 1773, but more work may well have been done early in 1774 before the portrait was sent to the Academy (as 218: 'Portrait of a Lady').

The mezzotint engraving by Dickinson may also be dated to that year—it was exhibited (as no. 204: 'Whole length of a Lady') at the Society of Artists exhibition in 1775. Reynolds had an engagement with the sitter's father on 25 March 1770 which may have been to discuss the portrait, but perhaps also to discuss other interests since Aufrère's activities as a collector/dealer are mentioned by Reynolds on 17 June of that year in a letter to Sir William Hamilton (Reynolds 1929, p. 27). A payment of one hundred guineas was made on 11 June 1774 (Cormack 1970, p. 132). N.P.

PROVENANCE In the Yarborough family for over a century—endorsed '1884 June 9/The Earl of Yarborough/Mrs Pelham feeding chickens'.

Not engraved, never formerly exhibited, and not discussed in the Reynolds literature.

157 A Sketch, preparatory for, or a record of, the Portrait of Mrs Billington as St Cecilia

45.6 × 27.8 cm (on laminated cardboard, apparently composed of linen pulp and glue, covered with a gesso ground)
Albright-Knox Art Gallery, Buffalo, New York; Gift of the Stevens Family, in memory of Mary Reed Stevens

This may be a *modello*—that is, a sketch preparatory for the full-length 'Portrait of a celebrated figure' which Reynolds exhibited as no. 181 at the Royal Academy in 1790 (now in the Beaverbrook Art Gallery, Fredericton, New Brunswick; fig. 24). But in common with other sketches which have good claim to be considered in this category there is no major difference between this composition and

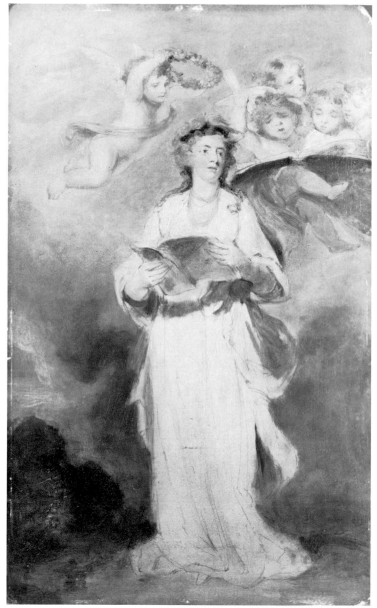

157

that of the completed work. This suggests (although it does not prove) that such sketches are diminutive records: as such they might still be by Reynolds. Like some of the smaller sketches in the Fitzwilliam Museum (Cat. 155) and also like the larger sketch for the portrait of the Duchess of Buccleuch and her daughter (both sketch and painting are at Bowhill) this is half a drawing and half an oil-sketch. Pencil drawing is evident almost everywhere and the dress takes its colour from the gesso ground, although some white paint is applied in the upper portion. The face is more finished than in any other equivalent work and the drawing better than is usual for Reynolds. The varnish may be original and may have been intended to give tone to the painting, although not, of course, to the degree we now see.

The 'celebrated figure' is Mrs Billington. She was the daughter of Carl Weichsell, a noted windplayer, and first attracted notice as a prodigy performer and composer. Having married John Billington in 1783 she went to Dublin and enjoyed great success there both as an actress and a singer. She so captivated Reynolds's great patron, the Duke of Rutland (who was then Lord Lieutenant), that the Duchess is said to have engineered the singer's return to London where, between 1786 and 1792, she starred at Covent Garden Theatre. She toured Italy in triumph in 1794 but returned to London (with a new husband) and sang there from 1801 to 1811 when she retired. She died in Italy in 1818. (Haslewood 1790, II, pp. 187–98; Wraxall 1884, v, p. 33; Royal Academy 1982, no. 122.)

Mrs Billington sat for her portrait in 1789: appointments are recorded on 31 March, 24 and 29 April, 2, 7 and 30 May and 1, 5, 15 and 20 June—on 26 March her name appears, but with no time, and on 15 April there is an appointment for her and her husband, half-deleted. On 20 May at half-past six Reynolds had what was probably a social engagement with her—or was this perhaps to hear her sing? She paid two hundred guineas in two equal instalments, in March 1789 and after June 1789 (Cormack 1970, pp. 145, 147).

As mentioned already, the portrait was exhibited at the Academy in 1790, but it could be admired in the artist's showroom three months earlier, and it is described, as a work he was finishing, in August 1789 (Whitley 1928, II, p. 123). The *Public Advertiser* for 28 April 1790, giving readers advance notice of the painting, described Mrs Billington as holding the 'Hallelujah' in her hand. This helped justify the angelic escort which, however, one critic censured: 'were the Bishop of London to speak we apprehend he would pronounce it an improper mixture of the sacred and profane.' Joseph Haydn, however, suggested that the angels should not have been singing at all, but listening to *her* angelic voice (Whitley 1928, II, p. 129).

A drawing by Reynolds in the Lucas Album of a group of angels, annotated as connected with this painting, does include a similar angel, with music supported on a raised knee. It is in fact a source for the painting, not a sketch for it—it is a drawing made by Reynolds of a portion of the Vault of the Sala di Psiche in the Palazzo del Te in Mantua designed by Giulio Romano. The same vault also provided him with a source for the *Death of Dido* (Cat. 123). N.P.

PROVENANCE Probably the work sold by Alexander Nasmyth, Christie's, 12 March 1847 (49), bt by Charles Birckbeck Horner; Horner sale, Christie's, 10 February 1862 (39), bt by Cox; Christie's, 15 February 1869 (147), bt by Parsons; before 1977, Stevens family, Buffalo (and said to have been in the collection of Miss Alice Stevens of Washington D.C. for about 50 years).

Not engraved, never formerly exhibited, and not discussed in the Reynolds literature.

158 Pocket Sketchbook used by Reynolds in Italy *c.* 1750–2

15.2 × 10.1 cm
Private Collection

The sketchbook is open at fol. 148 to display a characteristic sketch, quite rapidly executed in graphite, of Comity, one of the two seated allegorical figures in the Sala di Costantino

158

painted soon after Raphael's death by his pupils, probably employing cartoons, and certainly consulting drawings by Raphael. N.P.

PROVENANCE Probably lot 62 at the sale of the artist's niece, the Marchioness of Thomond, 26 May 1821; bt by John Herschel and presented to the Gwatkin family; given by Robert Lovell Gwatkin to John Reynolds Gwatkin in 1835; by descent.

LITERATURE Waterhouse 1973, p. 45.

159

159 Pocket Sketchbook used by Reynolds in Italy

25.5 × 20.4 cm
Private Collection

The sketchbook is open at fol. 36 to show a typical quick and approximate note made by the artist in graphite of a detail from Correggio's famous Altarpiece, *Il Giorno* (now in the Galleria of Parma, but in Reynolds's day recently transferred to the Cathedral there), showing the angel who turns over the pages of a book for the delight of the infant Christ. The smiling faces and melting contours of Correggio were from this time onwards always admired by Reynolds. The artist was in Parma early in July 1752. N.P.

PROVENANCE as for Cat. 158 but probably lot 61 in the 1821 sale.

LITERATURE Waterhouse 1973, p. 45.

160 Album of drawings mostly by Reynolds

(open to display one of his Roman Studies)
41.2 × 28.5 cm (this sheet)
Mrs R. A. Lucas

The contents of this album are very miscellaneous but it includes many drawings ascribed to Reynolds (and in some cases inscribed as by him) which must belong to his years of study in Rome (1750–52) and which are of a character which we would not suspect from his pocket sketchbooks (Cat. 158, 159). This sheet, slightly discoloured by adhesive, shows studies made in orange-red chalk (there are some traces of graphite and a liver-red chalk also) of expressive heads from the confused army of Huns on the right-hand side of Raphael's fresco of the *Repulse of Attila* in the *Stanza d'Elio-doro* of the Vatican. The heads are quite close to each other in the fresco but not related as they appear here. It would not have been easy to make these studies from engravings—they were probably made on the spot; and we know that Reynolds studied a good deal in the *Stanze*. He was not an accomplished draughtsman: the stroke is broad but lacks both precision and vitality in the contour, and the modelling is woolly.

The two subsequent sheets in the album, drawn with the same chalk upon the same paper, feature other heads from the same part of the same fresco and are followed by a head in black chalk of the Emperor Constantine from the centre of the fresco (executed by Raphael's pupils) of the Battle of Constantine in the adjacent room. This dedication to Raphael is not marked by a comparable interest in Michelangelo: indeed, there is nothing in Reynolds's notes or drawings to suggest that during his residence in Italy Michelangelo had assumed the supreme importance for him that he certainly possessed from about 1770.

As opened, it is possible to see two studies in black chalk on the verso of the drawing on the former page—a careful

160

study of a hand, perhaps from the life, and what might be a bearded head in profile. N.P.

PROVENANCE Composed of drawings purchased at the sale of the artist's niece, the Marchioness of Thomond, 26 May 1821 (52, 54, 55, 58–60) by John Herschel; by descent.

LITERATURE Herrmann 1968.

161 Experiments with varnishes and oil pigments on canvas

60.9 × 50.8 cm
The Royal Academy of Arts

W. T. Whitley records (1928, I, p. 151) that a certain J. L. Rutley, who retired in 1914 and inhabited the house in Great Newport Street which had been occupied by Reynolds in the 1750s, described how his grandfather had preserved as relics canvases upon which Reynolds had 'arranged specimens of various pigments for experimental purposes'. These he had presented to his friend Sir Thomas Lawrence who had been 'much interested in them and kept them until his death, after which they were lost sight of for a time. But they reappeared at Christies many years later and are now preserved at the Royal Academy'. This canvas was in fact bought by the Academy in 1878. The implication that it dates from early in the artist's career may be mistaken since it testifies to the experimentation with vehicles and varnishes which was most characteristic of a later period. In addition to various varnishes, gums, oils and wax the following pigments have been identified here: asphaltum, prussian blue ('turchino' in Reynolds's notes), orpiment, yellow lake and red lead. Their superimposition suggests that the experiments were conducted over a considerable period. Presumably the point was to test the permanence of the colours. N.P.

PROVENANCE See above.

LITERATURE York 1973 (102).

Furniture and Personalia

162 Silver Standish

25.4 × 16.5 cm
Private Collection

This stand with claw feet and gadrooned edge and three glass containers (intended for ink, for drying sand and for quills) stamped with the date letter for 1760, probably by Edward I. Aldridge (and perhaps John Stamper who had been, and may still have been, his partner), appears beside numerous seated males portrayed by Reynolds (see, for example, fig. 10 and Cat. 66, 70, 135, 138, 144 here). The earliest example may be the portrait of William Pulteney, Earl of Bath, of 1761. The artist did not bother to vary his props—nor do we suppose that he often bothered to paint them himself.

N.P.

PROVENANCE Inherited by Reynolds's niece, Mrs Gwatkin (née Theophila Palmer); by descent.

163 Sitter's Chair

103 cm high
The Royal Academy of Arts

This chair was given in January 1794 by the artist's niece (Mary Palmer) and her husband—by then Lord and Lady Inchiquin—to James Barry, who had been successively protégé, resentful rival, and polemical adversary of Sir Joshua, but was by then his belated defendant. On Barry's death in 1806 it was inherited by Dr Edward Fryer, Barry's friend and biographer. 'Twelve months after the death of Dr. Fryer,' recalled J. T. Smith (1828, II, pp. 68–70), 'I found by a catalogue of his household property, that Sir Joshua Reynolds's throne-chair was inserted for sale by auction . . . I considered it my duty, as an artist, to apprise Sir Thomas Lawrence of its approaching exposition . . . the lot was actually about to be knocked down for the paltry sum of ten shillings and sixpence, just as the rescuing bidder [presumably Smith himself] entered the room; which enabled him, after a slight contest of biddings, to place the treasure on that very day by Sir Thomas's fireside in Russell-Square.' The chair then passed by purchase into the ownership of successive presidents of the Royal Academy until, in 1879, it was presented to the Academy by Lord Leighton.

The chair appears to have been part of a suite of furniture which, since it begins to feature in the artist's work in the 1760s, has been plausibly proposed as made for the painting room which he added to the house in Leicester Fields after he acquired it in 1760. John Harris suggests that Chambers may have designed both the extension and the furniture. The low stool which features, for example, in Reynolds's portraits of *Master Crewe*, the *Montgomery Sisters* and *Mrs Sheridan* (Cat. 97, 90 and 94) also has straight tapering legs, square in section and fluted like pilasters, and a rail treated like a doric frieze. Such an architectural design was remarkable in furniture of the 1760s, at once reviving some of the monumentality of Kent and anticipating some of the severity of Bonomi.

N.P.

PROVENANCE see above.

EXHIBITED Royal Academy 1968 (880).

LITERATURE Harris 1970, p. 223.

164 Easel

188 cm high
The Royal Academy of Arts

This handsomely carved mahogany easel was presented to Reynolds by William Mason in thanks for the annotations which the painter supplied for the poet's translation of du Fresnoy's *Art of Painting*, published in 1783. Although said to have been his favourite easel, it can only have been so for his last years.

N.P.

PROVENANCE Thomond sale, Christie's, 26 May 1821 (54); presented to the Royal Academy by Sir Francis Grant PRA.

165 'Chinese Chippendale' Cheval glass fire-screen

122 cm high
Private Collection

Thought to have been partially converted by Reynolds into a looking-glass, this item of furniture may have been used by the artist to reflect lights on to the sitter's face, but its chief function is recorded by an old label on it—'This cheval-glass belonged to Sir Joshua Reynolds and was kept in his painting room and placed at an angle so that all his sitters on looking into it saw the progress of their portrait.' The use of a looking-glass for this purpose is recorded by Beattie (see Cat. 87). N.P.

PROVENANCE Inherited by Reynolds's niece, Mrs Gwatkin (née Theophila Palmer); by descent.

166 Pair of Silver Rimmed Spectacles and Shagreen Case

Private Collection

The learned entry contributed by the owner to the Plymouth exhibition catalogue in 1973 (no. 91) informs us that the 'lenses have a strength of −4.75 dioptres. A similar pair, once on loan to the Royal Academy and now in the possession of his family, have a strength of −.40 dioptres, which shows that Reynolds was short-sighted. He could not have read the large letters of a modern oculist's test card but would have been able to read the small print of a book without spectacles.' Like other artists (Luca Giordano and Chardin), he painted himself wearing them (Cat. 149) and presumably, at least in the 1780s, generally wore them whilst painting. N.P.

PROVENANCE Inherited by Reynolds's niece, Mrs Gwatkin (née Theophila Palmer); by descent.

EXHIBITED Grosvenor Gallery 1883 (223); Plymouth 1973 (91).

LITERATURE Graves and Cronin 1899–1901, II, p. 814 (8); IV, p. 1397 (11); Hudson 1958, p. 207.

167a & b Palettes

(a) 44.2 cm long (including handle)
The Royal Academy of Arts
(b) 43.2 cm long (including handle)
Private Collection

Both palettes have handles rather than the thumb-holes which have since become standard. Reynolds seems usually to have preferred a handle—see Cat. 13. Leslie and Taylor mention one palette of his with a 'handle made by prolonging one side', but most were, it seems, paddle-shaped like those exhibited here. (a) is said to have been given by Reynolds to his young friend, the accomplished amateur and great collector Sir George Beaumont, who gave it to Sir Thomas Lawrence at whose studio sale it was acquired by Constable, who in turn presented it to the Academy. (b) was (according to an old label) once part of a cabinet of the artist's painting materials belonging to J. Reynolds Swatkin whose grandmother was the artist's niece.

W. PINK (after Agostino Carlini)

168 'Smugglerius'

148.6 cm long
The Royal Academy of Arts

Agostino Carlini (c. 1735–90) came to London, probably from his native Genoa, in about 1760 and soon obtained a modest reputation as a sculptor, modeller and cast maker. He exhibited at the Royal Academy (of which he was a foundation member) between 1769 and 1787 and seems to have been closely involved in the teaching there, designing an 'apparatus' (probably a pointing machine) which was adopted by the Schools in 1771 and in 1783 succeeding Moser as Keeper of the Schools. His most notable contribution, however, was to cast the corpse of a hanged criminal, said to have been a smuggler, which had been flayed and set by Dr William Hunter, the Academy's first Professor of Anatomy, in the pose of the famous antique statue of the *Dying Gladiator* (Haskell and Penny, 1981, pp. 224–7)—a cast of which was in the School's collection. This *écorché*, christened facetiously by the students 'Smugglerius', seems to have been made in 1775 when it is described in a letter by the young sculptor John Deare. However, the cast exhibited here is inscribed 'Moulder W. Pink British Museum'. W. Pink exhibited at the Academy between 1828 and 1845 and seems to have been official 'formatore' to the British Museum before the Brucciani family, so this figure is likely to be the 'anatomical figure, in the position of the "dying gladiator"' which the Royal Academy Council agreed to purchase on 20 December 1834 for thirty-five guineas. If it was not made from Carlini's moulds or after the original cast, it is certainly an imitation of Hunter's idea.

Piers Rodgers points out that Reynolds (who was deeply interested in the conduct of the Academy Schools and indeed in artistic education although not himself in practice a teacher) is likely to have played a part in the genesis of this figure. It certainly provokes reflections of the kind he encouraged on the relations between the ideal (as represented by antique sculpture) and the model (which he recommended the artist never to neglect), and assisted the extraction of general principles from the specific individual. The President refers several times to *The Gladiator* in his *Discourses* but he seems always to mean the *Fighting Gladiator* of the Borghese Collection (Haskell and Penny 1981, pp. 221–4). N.P.

LITERATURE Whitley 1928, I, p. 277; II, pp. 285–6; Morgan 1964, pp. 63–4; Kemp 1975, pp. 16–17.

168 (front)

168 (back)

Works by Other Artists

ANGELICA KAUFFMANN

169 Sir Joshua Reynolds

127 × 101.6 cm
Signed and dated *Angelica Kauffmann pinx. 1767*
The National Trust, Saltram (Morley Collection)

Born in Switzerland in 1741, Angelica Kauffmann travelled to Italy once her career as a painter was firmly established; when in Rome in 1763 she soon attracted the admiration of English visitors. She exhibited at the Free Society of Artists in 1765 and 1766 and in the latter year arrived in London in person. In a letter of 10 October 1766 she described Reynolds as one of her 'kindest friends' who 'is never done praising me to everyone'. She added that 'as proof of his admiration for me, he has asked me to sit for my picture to him, and, in return, I am to paint him'. It may be that her first sitting to him was on 30 June 1766 when 'Miss Angelica' appears in his pocket-book but with no time; or, more likely, on 1 October, when her name appears again with the added word '*Fiori*' ('flowers' in Italian), again with no time. There is also, on 17 October, the entry 'Miss

169

Angel'—a suggestive abbreviation. The implication of her letter of 10 October is that sittings by Reynolds to her had not then yet taken place. No appointments with her or for her were recorded in his pocket-book between 17 October and the end of the following year. However, the portrait is dated 1767.

Gossip had it that Sir Joshua had more than an artist's admiration for Angelica and that she forgot her former attachment to Nathaniel Dance and rejected the passionate advances of Fuseli in anticipation of his proposal. Others claimed that she rejected Reynolds's advances. In any case, in November 1767 she married the scoundrel 'Count' Horn. This did not cut her off from Reynolds: an engagement with her is recorded in his pocket-book at three o'clock on Sunday 26 November 1769 and another at twelve o'clock on 14 December in that year. Her name also appears in the pocket-book on 3 June 1773, on Sunday 1 February 1777 and at nine o'clock on both 20 and 26 October 1777. Reynolds's portrait of Angelica, formerly at Althorp, was repeated in numerous versions, some of them perhaps produced in his studio.

It is significant that Angelica's portrait was commissioned by Reynolds's close friend John Parker who at the same date, and perhaps encouraged by Reynolds, commissioned huge history paintings from her which are still to be seen at Saltram—five of these were exhibited at the Academy in 1769. The portrait is very different from Reynolds's self-portraits, but is very suggestive of him as he appeared to another accomplished young woman. We read in Fanny Burney's diaries of Reynolds's 'expressive soft and sensible' countenance and 'gentle unassuming and engaging manners' (Burney 1842–6, I, p. 108).

The placing of the hand, which recalls the portraiture of Bronzino, is quite unlike Reynolds's own practice; so also is the detail of the still-life which includes a version of Daniele da Volterra's bust of Michelangelo (early evidence of Reynolds's special esteem for this artist) and, among the books and papers, *The Traveller* published in 1764 by Reynolds's great friend Goldsmith, *The Idler*, a periodical produced by Dr Johnson, in which Reynolds's first theoretical writing had been published in 1759, and a print of an antique statue. N.P.

PROVENANCE Painted for John Parker (later Lord Boringdon); by descent to the Earls of Morley; transferred to The National Trust in 1957.

EXHIBITED Royal Academy 1876 (45); Kenwood 1955, pp. 15–16.

LITERATURE Leslie and Taylor 1865, I, p. 260; Graves and Cronin 1899–1901, II, p. 272; Manners and Williamson 1924, pp. 20–3, 26–7, 200; Gore 1967, p. 46.

NATHANIEL DANCE

170 Sir Joshua Reynolds with Angelica Kauffmann

16.5 × 24.1 cm (pencil on paper)
The Earl of Harewood

As mentioned in Cat. 169, Nathaniel Dance was supposed to have had reason to be bitter about the regard in which

170

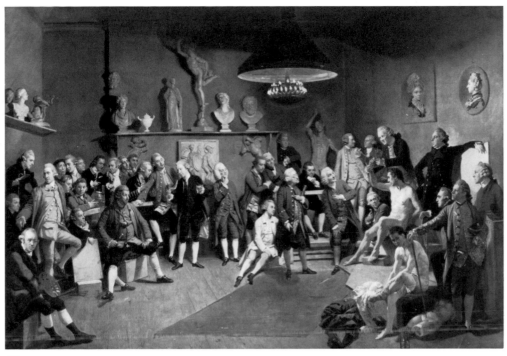

171

Angelica held Sir Joshua, whose eminence in the world of art was in any case inevitably resented by his rivals. This drawing, like Hone's painting (Cat. 173), was intended to expose the couple to ridicule, but it is the deafness and frigidity of the President rather than his artistic pretensions which are Dance's target. A separate study of the profile of Angelica by Dance is in the British Museum. She endeavours earnestly to engage the President in conversation, her hand on her heart as she does so, whilst ostensibly engaged in painting his portrait. He holds a large snuff-box. The woman with a guitar is perhaps a deliberately inattentive chaperone. The drawing probably dates from 1766 or 1767.

PROVENANCE Described in 1936 as 'until lately in the possession of the artist's family'. Presented, presumably not long before that date, to the Earl of Harewood by Dr Borenius.

LITERATURE Borenius 1936, p. 117; Kenwood 1977, no. 19.

JOHANN ZOFFANY

171 The Academicians of the Royal Academy

100.7 × 147.3 cm
H. M. The Queen

Zoffany's painting provides a valuable record of the rooms in Old Somerset House with which the King early in 1771 provided the Royal Academy to accommodate its schools (the fullest account of the amenities will be found in Whitley 1928, I, pp. 273–6). A model is being positioned for the second of the two poses of the evening life-class by the Keeper of the Schools, directed by the two 'visitors' whose duty it was to supervise on these occasions; the first model meanwhile dresses. Instead of the students one would expect to see here are all the Academicians, with the exception of George and Nathaniel Dance and Gainsborough—Mary Moser and Angelica Kauffmann, however, are represented only in effigy on account of the male nude. Walpole in 1773 noted that Gainsborough and Dance had 'disagreed' with Reynolds, which may explain their absence. Zoffany is the figure on the extreme left with the palette. Reynolds is compositionally prominent but by no means dominant—he is the unimposing, if dapper, gentleman listening with an ear-trumpet to the Academy's Secretary, Francis Milner Newton, who leans over the arm of the Treasurer, Sir William Chambers.

Reynolds had done much to promote Zoffany—a fact for which his public pronouncements on art do not prepare us. Zoffany's painting of Garrick with Burton and Palmer in *The Alchemist* was an enormous success at the Academy exhibition of 1770. 'Sir Joshua agreed to give a hundred guineas for the picture; Lord Carlisle half an hour after offered Reynolds twenty to part with it, which the knight very generously refused, resigning his intended purchase to the Lord, and the emolument to his brother artist' (Smith 1828, I, pp. 62–3); cf. Northcote 1818, II, p. 178). N.P.

PROVENANCE Presumed to have been painted for George III; in the Royal Collection ever since.

EXHIBITED Royal Academy 1772 (290), 1968 (12); National Portrait Gallery 1976 (74).

LITERATURE Millar 1969, no. 1210.

GIUSEPPE CERACCHI

172 Bust of Joshua Reynolds

69.2 cm high
Royal Academy of Arts

This marble bust was presented to the Royal Academy in 1851 by Henry Labouchère, afterwards Lord Taunton, a considerable collector of sculpture. It is inscribed 'Cirachi Sculpsit. Roma'—oddly, because the portrait was not modelled in Rome nor could the original marble, or any version in marble, have been cut there by Ceracchi, who, however, did come from Rome. He arrived in England in 1773, finding work with Agostino Carlini who was much employed by the leading architects—together with Carlini he was commissioned by Chambers to carve the figures on the attic of Somerset House, and he made reliefs in composition for Robert Adam. Ceracchi also taught the art of sculpture to the Hon. Mrs Damer and exhibited bust portraits at the Royal Academy between 1776 and 1779. He moved to America in 1791 and made portraits of the heroes of that newly independent nation. By the mid-1790s, he was in Florence and soon after that in Paris where, having been involved in a plot to murder Bonaparte, he was guillotined in 1801 (Gunnis 1953, pp. 89–90; Baretti 1781, p. 6; J. T. Smith 1828, II, pp. 119–21).

Ceracchi's portrait of Reynolds was one of his best known works and J. T. Smith specifically mentions that it was 'sold by the figure-casters'. At Christie's on 19 May 1821 (the studio sale after Lady Thomond's death) lot 76 was 'A fine

original bust of Sir Joshua Reynolds, in statuary, and wooden terminal pedestal to ditto'. It was bought by G. Watson Taylor for £168. This was probably the bust exhibited here, but if so, it is curious that the sculptor's name was not given in the catalogue. Perhaps the bust was inscribed subsequently, which would explain the anomalous 'Roma' and the odd spelling which, significantly, is that used by Malone (Reynolds 1819, I, p. lxxix) and Northcote (1818, II, p. 6) when they refer to the bust. Had Ceracchi carved this bust himself it is surely unlikely that he would not have signed it. Was the marble version cut by another sculptor for Lady Thomond employing Ceracchi's original terracotta or a cast? The Royal Academy is recorded as once possessing a terracotta version (perhaps the one Malone says was sold by Greenwood in 1792) dated 1778 but it cannot be traced. The plaster bust of Reynolds normally placed above the cornice in the Octagon gallery turns out on close examination not to be taken from the marble but from a slightly different and smaller prototype—very likely the lost terracotta.

The artist's pocket-book for 1778 has not been traced. An appointment with 'Ceracchi' is recorded by Reynolds on 16 July 1779 at an illegible address ('[?] Well Street No. 15') at five o'clock, which is not likely to have been for a sitting. However it is read, the address does not correspond with any of those given by the sculptor in the Academy catalogues.

The portrait is very closely modelled on the antique busts of Caracalla (Haskell and Penny 1981, pp. 171–2), except that martial ferocity has been converted into the inquisitive alertness characteristic of the slightly deaf. N.P.

172

173

NATHANIEL HONE

173 The Conjuror

145 × 173 cm
The National Gallery of Ireland

Born in 1718, Nathaniel Hone was five years older than Joshua Reynolds. The two artists had known each other in Italy. Hone achieved a reputation as a miniaturist and attracted attention with his oil-paintings of fancy subjects. But he failed to compete with Reynolds in the field of full-size portraiture and seems to have resented not only his rival's success, but also his pretentions. He may have been particularly embittered by the fact that he was not among the Royal Academicians who in 1773 had been proposed as candidates to adorn St Paul's Cathedral with history paintings—an incident alluded to by the nude figures cavorting in front of the Cathedral to be seen in the background of this painting when Hone submitted it to the Academy's exhibition of 1775 with the title 'The Pictorial Conjuror, displaying the Whole Art of Optical Deception'. Although at first accepted, it was soon objected to, chiefly, it seems, on account of these figures which included, it was alleged, Angelica Kauffmann. Hone

denied that he had intended to paint her and offered to make alterations (and did in fact later replace the nude revellers with a drinking party) but the painting was ordered to be removed. No doubt by then it was recognized that the fraudulent old alchemist converting Old Master prints into modern art in the foreground was a satire on the President. Hone exhibited the painting instead in a studio show, with considerable success.

John Newman, in his essay 'The Conjuror Unmasked' below, demonstrates in detail how ingenious the attack on Reynolds was. N.P.

PROVENANCE Artist's Posthumous Studio sale, Hutchins, 3 March 1785; the collection of a 'French nobleman', Christie's, 1 May 1790 (48); bt by Edward Knight of Wolverley; John Knight (Nephew and heir of Edward) by whom offered for sale Phillips, 23 March 1819 (36) and 17 March 1821 (8); by descent to Major Eric A. Knight, by whom sold Christie's, 1 December 1944 (39); bt John Maker, Enniscorthy, Co. Wexford; Colnaghi by 1952, from whom acquired 1966 for the National Gallery in Ireland.

EXHIBITED Royal Academy 1775 (withdrawn); Hone's exhibition 1775 (55); Royal Academy 1951 (29); Kenwood 1955 (29); Royal Academy 1968 (680).

LITERATURE Pasquin 1796, p. 9; Whitley 1928, I, pp. 273, 276; Munby 1946, pp. 24–6; 1947, pp. 82–4; Butlin 1970.

Reynolds and Hone

'The Conjuror' Unmasked

John Newman

Since the rediscovery of Nathaniel Hone's *The Conjuror* (Cat. 173) in the 1940s it has twice been the subject of articles in *The Connoisseur*. In December of 1947 A. N. L. Munby published the picture, and discussed the nature of Hone's attack on Sir Joshua Reynolds; in 1970 Martin Butlin published the sketch acquired in 1967 by the Tate Gallery (fig. 82) and drew on the evidence of contemporary newspapers to reveal a great deal about the uproar provoked by the public exhibition of the picture in 1775.[1] Munby identified a number of the prints which fall down into the flames at the wave of the conjuror's wand, and the paintings by Reynolds derived from them; but, as he himself admitted, there is more to be said about Reynolds's reliance on prints after the Old Masters as sources of inspiration and the accuracy or otherwise of Hone's denunciation. A closer analysis of the shower of prints does, I think, help to throw some revealing light on Reynolds's working methods.[2]

In the spring of 1775 Sir Joshua Reynolds was at the height of his prestige. The Royal Academy, of which he was President, had been established for seven years. At the annual Academy exhibitions the paintings he showed maintained a level of quality combined with variety not attained by any of his contemporaries. Every December since 1769 (with the exception of 1773) he had delivered a discourse at the Academy prize-giving in which he endeavoured to stamp his philosophy of art on the minds of the students.

In December 1774 the theme of the President's Discourse had been imitation. He had emphasized that the imagination cannot work in a vacuum, but needs material to work on: 'Invention is one of the great marks of genius; but if we consult experience, we shall find, that it is by being conversant with the inventions of others, that we learn to invent; as by reading the thoughts of others we learn to think.' There must be imitation not only of nature and of the ancients but of the works of other artists. Reynolds calls this last sort of imitation 'the borrowing a particular thought, an action, attitude, or figure, and transplanting it into your own work'. And he goes on, 'this will either come under the charge of plagiarism, or be warrantable, and deserve commendation, according to the address with which it is performed.' And finally: 'But an artist should not be contented with this only; he should enter into a competition with his original, and endeavour to improve what he is appropriating to his own work. Such imitation is so far from having any thing in it

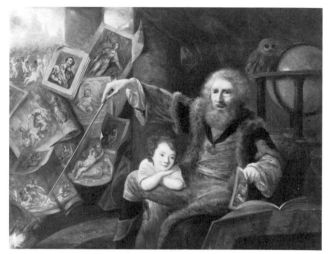

Fig. 82 Nathaniel Hone, *Sketch for the Conjuror*, ?1774
(Trustees of the Tate Gallery, London)

of the servility of plagiarism, that it is a perpetual exercise of the mind, a continual invention. Borrowing or stealing with such art and caution, will have a right to the same lenity as was used by the Lacedemonians; who did not punish theft, but the want of artifice to conceal it.'[3] Frank words indeed! How vulnerable they would make the President to any envious fellow-artist who could demonstrate that he lacked sufficient artifice to conceal his own 'borrowing or stealing'!

Nathaniel Hone was born in Dublin in 1718, and thus was five years older than Reynolds. He emigrated to England and established himself in practice by painting miniatures, but during the 1760s and 1770s was in London attempting, with much less success than Reynolds, to build up a career as a portraitist on the scale of life. Nevertheless, by 1768 his reputation secured him election as one of the founder Academicians.

In April 1775, four months after the Discourse quoted above, Hone submitted to the annual exhibition of the Royal Academy an ambitious subject picture entitled *The Pictorial Conjuror, displaying the Whole Art of Optical Deception.*[4] The picture was at first accepted, but then rejected after Angelica Kauffmann had complained that it involved a libel on herself: she alleged that certain nude figures in the top left-hand cor-

ner of the painting included an identifiable depiction of her-self. Hone thereupon removed these figures (although they may still be seen in the sketch) and repainted them as the fully-clothed wine bibbers we see today, and later that summer held a private exhibition of seventy of his pictures, including *The Conjuror*. We shall return to Angelica at the end, but the main purpose of this essay is to examine the nature and effectiveness of Hone's attack on the President of the Royal Academy.

The main figure in the painting is a bearded and grizzle-haired wizard wearing a Rembrandtesque fur-lined coat. With his right hand he waves a wand, thereby causing a shower of engravings to flutter down into a fire just visible in the bottom left-hand corner; out of the flames a painting in a gilded frame is shown beginning to emerge. In his left hand he holds another engraving propped on an open tome, the title of which reads: ADVANTAG/EOUSCOPIES/FROM VARIOU./MAS From a comfortable position leaning on his right knee, a pert little girl gazes across at the engraving which he holds.

The identity of the girl is not immediately apparent; but the conjuror nobody could have failed to identify as the President himself. Reynolds's self-portraits were characteristically Rembrandtesque.[5] The conjuror's physiognomy is not, admittedly, Reynolds's, but that of his model, old White the paviour, whose melancholy visage, wild hair and piebald beard were familiar to Londoners from recent exhibits by Reynolds, *A Captain of Banditti* (Private Collection) in the 1772 Academy exhibition and the important *Count Hugolino and his Children* (Cat. 82) exhibited in 1773. Furthermore, as a critic in the *London Evening Post* on 9 May 1775 observed, three of the engravings clearly relate to paintings recently exhibited by Reynolds. The reviewer concluded: 'There is no doubt but the above picture was meant indirectly to charge with plagiarism the first portrait painter perhaps this country ever produced.'[6]

To establish how substantial the charge was, it is necessary to identify first the paintings by Reynolds to which the shower of prints refers, and then the prints themselves, which Hone has entitled with the names of various Old Masters, Raphael, Michelangelo, Titian, Battista Franco, Pietro da Cortona, Albano, Van Dyck and Maratta (fig. 83).

The three Reynolds paintings which the contemporary reviewer identified from the shower of prints had all been exhibited recently at the Royal Academy, the *Hugolino* in 1773, the *Infant Jupiter* (Cat. 84) and the *Montgomery Sisters* (Cat. 90) in 1774. The pose of Reynolds's *Hugolino* is similar to the frontally seated figure in the print under the conjuror's hand inscribed 'M. Angelo'. The *Infant Jupiter* is reminiscent of the seated infant in the large engraving entitled 'Carlo Maratti'. The Montgomery sisters were portrayed in the *Three Ladies adorning a term of Hymen*, the President's most ambitious exhibit in 1774. This picture involves two engravings, one entitled 'Piet da Cortona', the other rolled up beside it and labelled 'Titian'.

Besides these three, six other paintings by Reynolds are referred to, if we discount the fragmentary and untitled engraving at the left of Hone's picture. Of these six only

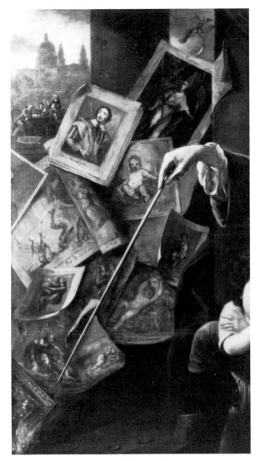

Fig. 83 Detail from Cat. 173

one had been exhibited at the Royal Academy. This was the portrait of the Duchess of Manchester and her son as Diana disarming Cupid (Cat. 72), a particularly frigid and contrived essay in the Bolognese high style shown at the first exhibition of the Royal Academy in 1769. The engraving which refers to it is the half-torn sheet at the bottom of the shower, entitled 'Albano'. The figure of the crouching Duchess is in reverse of Reynolds's painting, and the recumbent baby, Lord Mandeville, is in the pose of the putto on the other half of the sheet about to be torn away. The portrait had, like so many of Reynolds's pictures, been engraved in mezzotint, by which means it remained accessible to students and connoisseurs.

Of the five other pictures which remain to be identified, all had been published in mezzotint, although they had all been painted as long ago as the early or mid-1760s. The portrait of the Duchess of Marlborough and her child, painted in 1764–5 and engraved in mezzotint in 1768 by James Watson (Cat. 59) is to be compared with the other engraving in Hone's picture inscribed 'M. Angelo'. The portrait of Miss Sarah and Miss Elizabeth Crewe, painted in 1766–7 and engraved by John Dixon (Cat. 68), is clearly the picture referred to by Hone's depiction of a print of two girls reclining against one another with the title 'Raphael'

on its right-hand edge. The large print, lower right in Hone's picture, inscribed 'Battista Franco', is equally clearly related to the portrait of Mrs Lascelles and her child, of 1762–4, of which a mezzotint was published by James Watson (Cat. 55). The large print at the top, labelled 'Raphael', one can easily recognize as after the *St Margaret* in the Louvre. No portrait by Reynolds seems to be derived directly from this pose. The nearest, already suggested by A. N. L. Munby, is the portrait of Mrs Lascelles's sister, *Mrs Hale as 'Euphrosyne'*, painted at the same time, 1762–4, and still today, like its companion, belonging to the Lascelles family. James Watson also published an engraving of this (Cat. 62). The top halves of the figures match well enough, but not the poses of the legs. The last labelled print in Hone's picture, the 'Vandyke', can be related with numerous portraits by Reynolds of sitters in vandyke dress and in poses derived from Van Dyck—a notable example is, indeed, the portrait of *Edward Lascelles* (fig. 86), the companion painting to that of Mrs Lascelles.

of Reynolds's borrowings. As the latter is the issue of more particular interest to historians of eighteenth-century painting, we will deal with the pictures in a different order.

Reynolds shows the Duchess of Manchester (fig. 85) as Diana disarming her infant son of a cupid's bow. This may today be considered a tasteless conceit; but it is hardly surprising that the painter looked back for his motif to Francesco Albano's celebrated painting in the French Royal Collection, *Diana's nymphs disarming cupids*. In style, too, a Bolognese model was appropriate for what was, as Waterhouse has pointed out,[8] an essay in the Bolognese manner. The Albano was engraved at least twice, by Stefano Baudet in 1672 (fig. 84), when the picture was still in Palazzo Falconieri in Rome, and again by Benoît Audran in the eighteenth century after it had reached the Louvre. But, as Hone suggests by showing the print torn, Reynolds has brought together two figures from different parts of the picture, not merely lifted a single group.

Fig. 84 Stefano (Etienne) Baudet (after Francesco Albano, *Diana and her Nymphs disarming Cupids*), engraving, 1692 (Cat. 72a; British Museum, London)

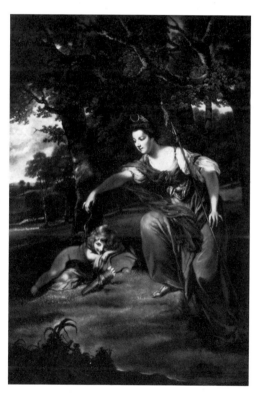

Fig. 85 James Watson (after Reynolds, *The Duchess of Manchester with her son Lord Mandeville in the character of Diana disarming Love, 1764–8*), mezzotint, *c.* 1769 (Cat. 72; British Museum, London)

This, however, was neither exhibited nor engraved and Hone's specific target here has been proposed as Reynolds's portrait of David Stewart, Lord Cardross, painted in 1764 and known to a large public from the mezzotint by Finlayson of 1765 (Cat. 56)—a suggestion made by Munby.[7]

Thus, of these nine paintings by Reynolds, only four, the three identified by the reviewer in the *London Evening Post* together with the portrait of the Duchess of Manchester, are likely to have been familiar as original pictures. The rest, even though all had been engraved, look rather as if they are thrown in as makeweights, to enlarge the shower of engravings to plausible proportions.

Turning now to identify the Old Master prints from which the Reynoldses are alleged to derive, there are two things to bear in mind, first the degree of Hone's accuracy in identifying Reynolds's sources, and secondly the nature

The relationship of Reynolds's portrait of *Lord Cardross* (fig. 87) to its Van Dyck prototype is no less close. Van Dyck's portrait of Pontius would have been familiar to Reynolds's contemporaries not only from the artist's own etching but from a mezzotint published in London by James Watson (fig. 88) some time before 1767[9]—possibly when Finlayson's mezzotint of Reynolds's portrait appeared—so this is not a case of plagiarism or concealed borrowing.

There is one more Reynolds painting under attack in which the borrowing can be accounted for along similar lines. *Count Hugolino and his Children* (fig. 89) was the earliest of a number of attempts by Reynolds to achieve a dramatic history piece. A borrowing from Michelangelo for the pose of the Count himself was surely appropriate, lending the

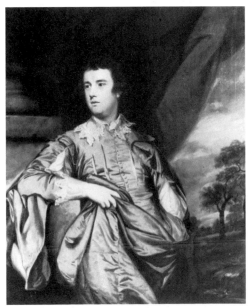

Fig. 86 Edward Lascelles, 1762–4
(The Earl of Harewood, Harewood House)

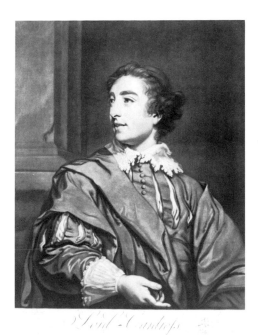

Fig. 87 James Finlayson (after Reynolds, *Lord Cardross*, 1764), mezzotint, 1765 (Cat. 56; Private Collection)

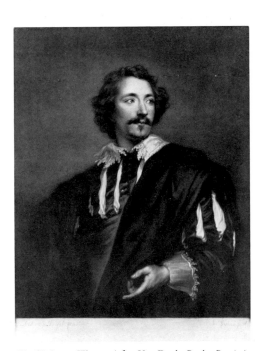

Fig. 88 James Watson (after Van Dyck, *Paulus Pontius*), mezzotint, *c.* 1765 (Cat. 56a; Fitzwilliam Museum, Cambridge)

picture a Michelangelesque *terribiltà*. Reynolds therefore used one of the figures of the ancestors of Christ in the lunettes below the ceiling of the Sistine Chapel, as it was recorded in Adamo Scultori's mid-sixteenth-century engraving (fig. 90), one of a set of seventy-two which reproduce the whole range of Michelangelo's *ignudi* and ancestors in a handy form much used by students. The first edition of this was published in about 1575 and the last in 1773.

These three borrowings, it can be argued, if recognized, enhance the effect of Reynolds's paintings. They are surely not examples of theft which the artist should strive to conceal. But when we turn to the other paintings to which Hone directs his assault we find borrowings of a different sort.

In the shower of engravings floats a second one from Scultori's set of figures after Michelangelo's frescoes in the Sistine Chapel. This is of the group of three figures in the left of the lunette, inscribed 'Eleazer and Mathan' (fig. 91). The seated figure holding a child at arms' length is quite clearly the source for the pose of the *Duchess of Marlborough with her Daughter* (fig. 92). Modern critics had pointed out this borrowing even before *The Conjuror* was rediscovered. But this is an arbitrary borrowing, there being no connection in style or mood between Reynolds's portrait and its Michelangelesque model.

Similarly Reynolds, as Hone discloses, has based his portrait of Mrs Lascelles and her baby son (fig. 93) on the magnificent print by Battista Franco of the *Virgin and Child in a Landscape* (fig. 94). Here, too, a striking motif is repeated,

but between the engraving and the painting the mood has been disastrously trivialized. Franco created a sense of foreboding in the Virgin's lowered eyes and St John's grave gaze, so that the playful gesture of the Christ Child throwing his arms round his mother's neck is felt as poignant in its innocence. Reynolds must surely have assumed that his con-

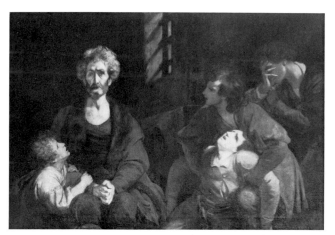

Fig. 89 *Count Hugolino and his Children*, exhibited 1773
(Cat. 83; The Lord Sackville, Knole)

Fig. 91 Adamo Scultori (after Michelangelo, *Eleazar*),
engraving, *c.* 1574 (Cat. 59a)

Fig. 90 Adamo Scultori (after Michelangelo, *Aminadab*),
engraving, *c.* 1574 (Cat. 83a)

Fig. 92 James Watson (after Reynolds, *The Duchess of
Marlborough with her Daughter*, 1764–5),
mezzotint, 1768 (Cat. 59; British Museum, London)

temporaries would not be familiar with the model on which he was drawing, but that they would give him credit for an invention which displayed in an unhackneyed way the lovable nature of Mrs Lascelles.

Reynolds's source for the pose of Mrs Hale (fig. 95), the sister of Mrs Lascelles, is, as we have seen, less easily established. Hone's suggestion is the *St Margaret* in the Louvre, a well-known picture which had been engraved more than once (fig. 96). But this may be wrong, since the poses only half correspond, and Reynolds used Mrs Hale's dancing posture, with one leg pushed straight out in a turning movement, more than once, first in his portrait of Master Thomas Pelham of 1759, and again as late as 1781 in his portrait of Viscountess Crosbie. It seems more likely that Reynolds

derived this thrice-repeated pose from a source which did not need adaptation, perhaps from something he had seen in Italy and recorded in a sketchbook.

Reynolds certainly did not scruple to draw on the same source more than once. The etching after Carlo Maratta of the *Infant Christ adored by angels* (fig. 97) which Hone correctly identifies as Reynolds's model for his *Infant Jupiter*

Fig. 93 James Watson (after Reynolds,
Mrs Edward Lascelles, 1762–4), mezzotint, *c.* 1770
(Cat. 55; British Museum, London)

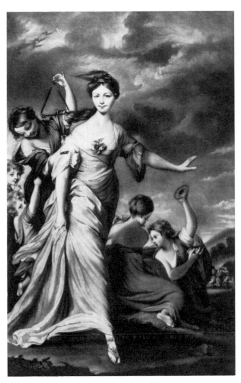

Fig. 95 James Watson (after Reynolds,
Mrs Hale as Euphrosyne, exhibited 1766), mezzotint,
c. 1768 (Cat. 62; Fitzwilliam Museum, Cambridge)

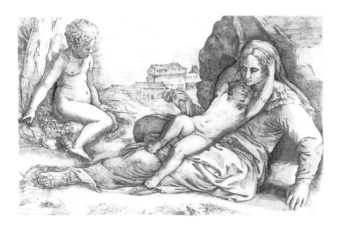

Fig. 94 Giovanni Battista Franco, *Virgin and Child
in a Landscape, c.* 1550, etching and engraving
(Cat. 55a; Ashmolean Museum, Oxford)

(fig. 98) is a case in point. In the 1780s it is recalled by the
Infant Dr Johnson (Bowood) and by the *Infant Hercules* of 1788
(see Cat. 140), while Maratta's angel heads are used in the
portrait of Frances Ker Gordon (1787) now in the Tate
Gallery.

The two remaining portraits alluded to by Hone's paint-
ing, the double portrait of the Crewe sisters and the triple
portrait of the Montgomery sisters, raise issues of greater
subtlety. The print labelled 'Raphael' in the conjuror's
shower, which clearly refers to Reynolds's portrait of the
Crewe sisters (fig. 99), has no counterpart, to my knowledge,

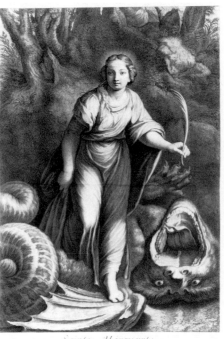

Fig. 96 Louis Surugue (after Raphael, *Saint Margaret*,
reversed), engraving (Cat. 62a; Courtauld Institute
of Art, London)

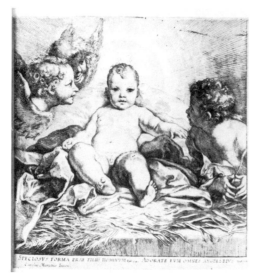

Fig. 97 After Carlo Maratta,
The Infant Christ adored by Angels, etching
(Cat. 84a; National Galleries of Scotland)

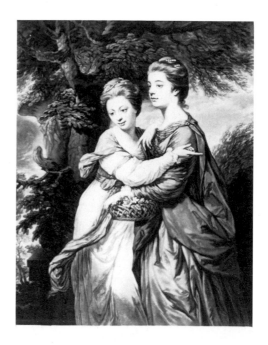

Fig. 99 John Dixon (after Reynolds, *Miss Sarah and Miss Elizabeth Crewe*, 1766–7), mezzotint, c. 1768
(Cat. 68; British Museum, London)

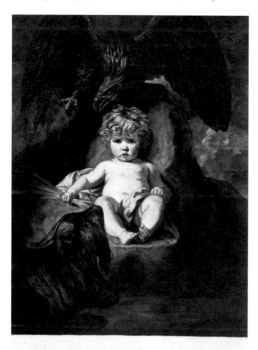

Fig. 98 John Raphael Smith (after Reynolds,
The Infant Jupiter, exhibited 1774), mezzotint, 1775
(Cat. 84; British Museum, London)

Fig. 100 Marcantonio Raimondi (after Raphael,
Parnassus), engraving (detail)
(Cat. 68a; British Museum, London)

in genuine engravings after Raphael. But in Marcantonio Raimondi's engraving of a preliminary design by Raphael for the *Parnassus* in the Stanza della Segnatura, which differs in a number of details from the executed fresco, there is a group of three muses to the right of Apollo (fig. 100). Bring the left-hand figure of this group towards the right-hand figure, eliminating the central one, and there, almost exactly, are the poses of the Crewe sisters. Reynolds found in this

Raphaelesque group the makings of the tenderly intertwined arrangement in which he so felicitously set his two fashionable young ladies. It is to Hone's credit that he has spotted Reynolds's highly imaginative transformation; and it of course means that the object labelled 'Raphael' in Hone's painting is a mock-up and does not represent, like the others so far discussed, an existing Old Master engraving.

Finally, most complex of all are the derivations of

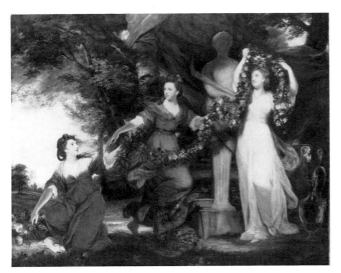

Fig. 101 The Montgomery Sisters
(Three Ladies Adorning a Term of Hymen),
1773–4 (Cat. 90; Trustees of the Tate Gallery, London)

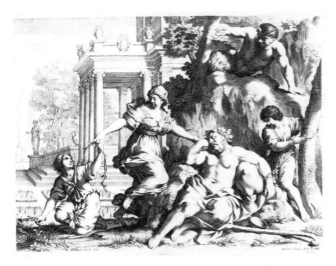

Fig. 102 Michael Natalis (after Francesco Romanelli,
The Slumbering Silenus Tied up with Tendrils), engraving (Cat. 91a)

temple which are depicted in the engraving, so there is no doubt about this identification.[11] Why then does he label it 'Piet da Cortona'? The engraving is inscribed along the lower edge, within the field of the print itself, not in a separate margin, 'Fr. Romanell. Viterb. delin.' and with the engraver's name, 'Michael Natalis fecit Romae'. Romanelli was Pietro da Cortona's closest follower, so it would be understandable to confuse his work with that of his master. One can even find the combination of kneeling figure and rising figure in Pietro da Cortona, for instance in the Barberini ceiling, the decoration of which was widely disseminated in engravings (fig. 103). One must ask whether Hone

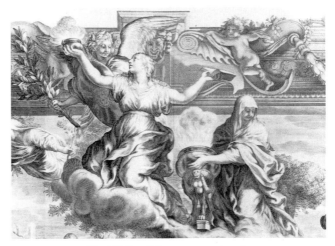

Fig. 103 Detail from an engraving after
Pietro da Cortona's
ceiling fresco in the Palazzo Barberini, Rome

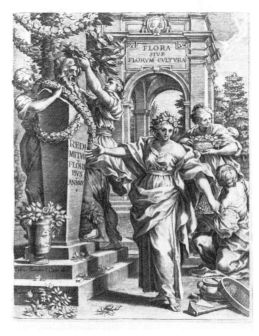

Fig. 104 Engraved frontispiece after a design
by Pietro da Cortona from Flora sive Florum Cultura

Reynolds's portrait of the Montgomery sisters, the Three Ladies Adorning a Term of Hymen (fig. 101—see also Cat. 90). It is a painting over which we know the artist took considerable trouble. To the commission of Luke Gardiner, the fiancé of the eldest sister, for 'their portraits together in full length, representing some emblematical or historical subject', Reynolds responded: 'I have every inducement to exert myself on this occasion.'[10] It is consequently of particular interest to discover whether Hone has been able to disclose the precise nature of the President's exertions.

Hone correctly identifies the source for the left-hand and central figures. It is an engraving after Romanelli, of a Vergilian subject, from the sixth Eclogue (fig. 102). Two young shepherds find Silenus lying in a drunken stupor and bind him with the garlands that have fallen from his head. Hone indicates the legs of Silenus and the columns of the

did not deliberately insert the wrong name in order to widen his attack. In particular he may have had in mind Pietro da Cortona's frontispiece to a gardening manual entitled *Flora sive Florum Cultura* (fig. 104), in which figures are shown wreathing a term with garlands of flowers, the motif which Reynolds had chosen for his portrait of the Montgomery sisters. Hone's full insinuation then would be that Reynolds had taken the motif from Pietro da Cortona and the poses from his pupil.

The strength of his point is increased when we recall Reynolds's earlier portrait on this theme, Lady Elizabeth Keppel as a royal bridesmaid (Cat. 44), which has striking similarities of pose with the Flora frontispiece, in the way the main figure steps on the pedestal base and reaches up to put a wreath over the head of the term while a subordinate figure crouches beside. Nevertheless, one would feel more confident that Hone was really being as sophisticated as this if he had correctly identified the source for the pose of the third Montgomery sister. But this is the one instance in which he is definitely wrong. He suggests that the standing sister is in a pose derived from an engraving after Titian's lost painting of *The Holy Family on the Flight into Egypt*, the pose of the servant reaching up to gather dates (fig. 105). But closer than that is a figure in a second print after Romanelli, also of a Virgilian subject (fig. 106). This is from the *Aeneid*, Book VI, and shows Aeneas, guided by the doves of Venus, reaching up to pluck the golden bough which he is to hold on his visit to the Underworld. The

from two engravings of completely irrelevant subjects, two of the three figures in question being male, not female. Nevertheless, Romanelli had imbued them with a somewhat affected elegance, which Reynolds seized on as appropriate for his purposes, and from them he created a delightfully coherent composition, rising with perfect ease and grace from left to right.

The Conjuror then, by the relative accuracy of its attack, really has done the President some damage, although it is impossible to tell how much of its accuracy was appreciated by those who viewed it in 1775. For us, however, it raises a deeper criticism of Reynolds's art. William Blake, as Antony Blunt has demonstrated, borrowed poses from the Old Masters as freely as Reynolds.[13] Scultori's engravings after Michelangelo, in particular, were for him a favourite source of inspiration. And among Blake's marginal notes in his copy of Reynolds's *Discourses* we find the following: 'The Bad Artist Seems to Copy a Great deal. The Good one Really Does Copy a Great deal,' and 'Servile Copying is the Great Merit of Copying.'[14] Yet Blake did not endorse Reynolds's advice. On the contrary, he despised Reynolds and all that he stood for. For Blake, copying from the Old Masters was a way of stimulating the imagination. By assimilating the expressive postures which they had invented, Blake strengthened his own ability to express emotions, mystical experiences and philosophical ideas in visual terms. For Reynolds, on the contrary, as Hone's examples have shown, all too often the intrinsic qualities of the motif borrowed

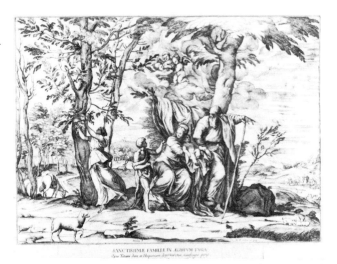

Fig. 105 Nicolas Cochin (after Titian, *The Holy Family on the Flight into Egypt*), engraving

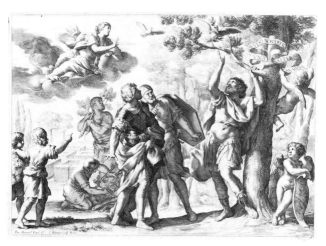

Fig. 106 C. Bloemart (after Francesco Romanelli, *Aeneas and the Golden Bough*), engraving (Rijksmuseum, Amsterdam)

correspondence of the poses is so exact that there can be no doubt of this second derivation from Romanelli; and it tells us something about Reynolds's filing-system.[12]

Yet, although Hone did not completely crack the secret of the *Three Ladies*, he has demonstrated that this, one of Reynolds's happiest masterpieces, can be portrayed as a scissors-and-paste job. The poses of the three figures are taken

were of little or no interest. Reynolds appropriated the art of the high renaissance and baroque masters primarily in order to pander to the self-esteem of British high society. The frankness about the artist's working methods which Reynolds displays in the Sixth Discourse is, at any rate in part, the frankness of cynicism. His defence is familiar: the only pictures which the British public will buy from British

artists are portraits; so portraiture must be elevated by grafting it on to the tradition of the Old Masters. He is prepared then to grasp the lower prize because the higher seems out of reach. This is not to deny Reynolds the praise he richly deserves for raising British portraiture to an entirely new level of resourcefulness and sophistication. It is rather to admit that he is not in any genuine sense heir to the great tradition he ransacked so freely.

It merely remains to repeat the question: who is the little girl in Hone's painting leaning on the conjuror's knee, and why is she looking at an engraving?

Angelica Kauffmann presented to the Accademia di San Luca in Rome a bust portrait of herself in the character of *Hope*, leaning on an anchor. This self-portrait first became known in London in February 1775, two months before Hone exhibited his picture, in the form of an engraving in reverse published by William Wynne Ryland (fig. 107).[15] One is tempted to suggest that Hone's little girl is none other than the hopeful Angelica.[16] Her cheeky posture, chin on hands, looks like a travesty of the yearningly meditative pose in which the lady artist had depicted herself. The gossips had linked Angelica's name with Sir Joshua's for years, so we cannot be surprised if the caddish Hone has introduced her into the middle of his picture. Yet it would have been too humiliating for Angelica to have acknowledged the likeness, so she demanded that the picture be removed from the Royal

Reynolds, Hone is saying, is leading his lady love into bad ways. The print is clearly after Raphael's *Virgin with the Diadem* (fig. 108). It has proved impossible to find a painting by Angelica Kauffmann which borrows from this Raphael composition in the same way that Reynolds himself borrowed from the Old Masters, though there are several examples in her work of one figure bending over another in a pose reminiscent of Raphael's *Virgin* (fig. 109).[17] Hone

Fig. 108 François de Poilly (after Raphael or his school, *The Virgin with the Diadem*), engraving, *c.* 1660

Fig. 107 William Wynne Ryland (after Angelica Kauffmann, *Hope*), stipple engraving, 1775

Academy's exhibition on different grounds, that the female figure among the nudes in the top left-hand corner was meant for her. Hone was happy to paint out these figures and substitute the ones we see today, for that left the real parody of Angelica untouched.

If the girl is meant for Angelica, we can understand why the conjuror is shown propping up a print for her to see:

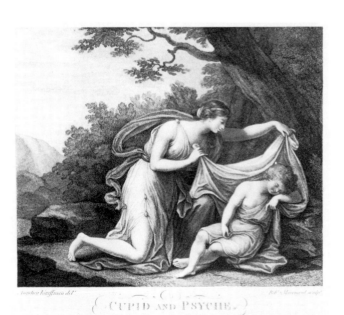

Fig. 109 Robert Marcuard (after Angelica Kauffmann, *Cupid and Psyche*), stipple engraving

may have thought the motif a notorious cliché of hers. Nicholas Penny suggests that since at the same time as lifting this print the conjuror points with his wand to the print of the disarming of the cupids, Hone may also be suggesting that Reynolds combined the theme of the Raphael with that of the Albano in his portrait of the *Duchess of Manchester*.

According to J. T. Smith, the sculptor Nollekens told Hone, 'You know it was your intention to ridicule her, whatever you or your printed paper and your affidavits may say; however, you may depend on it *she* won't forget it, if Sir Joshua does.' After Hone's death, at the sale of his effects in March 1785, Smith noted, 'I saw Sir Joshua Reynolds most attentively view the picture of the Conjuror for full ten minutes.'[18] We can be sure that the President recognized the accuracy of Hone's satire against himself, and yet we are entitled to suspect that he nevertheless made his examination of the picture with perfect equanimity.

NOTES

1. Munby 1947; Butlin 1970.
2. This essay was first delivered as a public lecture at the Courtauld Institute of Art in October 1975. After subsequent delivery in March 1980 at the National Gallery, Dublin, it received the benefit of vital correction by Hilary Pyle. I also wish to acknowledge the help of James White before I had seen Hone's picture for myself. For other discussions of Reynolds's visual sources see Wind 1939, pp. 182–5; Gombrich 1942 and Herrmann 1968.
3. Reynolds 1975, pp. 98, 106–7.
4. Butlin 1970, p. 6.
5. I am indebted to Michael Kitson for this point.
6. Butlin 1970, p. 6.
7. Munby 1947, pp. 24–5.
8. Waterhouse 1941, p. 61.
9. Chaloner Smith 1878–83, p. 1531, no. 119.
10. Reynolds 1929, pp. 35–6.
11. The Romanelli engraving was first identified as Reynolds's source by Martin Davies (Davies 1959, note 8 p. 80).
12. The pair of engravings are conveniently reproduced together in B. Kerber, 'Kupferstiche nach Gianfrancesco Romanelli', *Giessener Beiträge zur Kunstgeschichte*, II, 1973, pp. 153–4.
13. Blunt 1943, 190–212.
14. For Blake's annotations see the appendix to Reynolds 1975, p. 294.
15. I am grateful to John Sunderland for drawing my attention to this self-portrait.
16. A suggestion already tentatively made by Butlin, op. cit.
17. Manners and Williamson 1924, plates facing pp. 49, 52, 56, 92.
18. Smith 1828, I, p. 156.

'Characters and Caricatures'

The Satirical View

Diana Donald

The section of this exhibition devoted to caricature introduces into the company of paintings by Reynolds a class of works which in his day would not have been allowed to pass the door of the Royal Academy. Their presence calls for an explanation: what possible comparison can there be between the exalted ideals of the first President of the Royal Academy and the Grub Street cynicism of the satirists? How can the aristocratic imagery of Reynolds's portraits be associated with the crudely insulting view of the same people in the caricatures? At first sight the contrast seems to be total, as though the two forms of artistic expression were the products of different worlds, with the satires representing a popular sub-culture, a hostile gesture against wealth and privilege. In reality, the antithesis is neither so simple nor so complete. Both the works of Reynolds and those of the satirists were bought by the same rich and politically powerful section of the public; the difference in their views of society reflects a dichotomy in the consciousness of that dominant class itself.

London in the late eighteenth century became a show city, where the palatial assembly rooms, the spectacles and expensive shops impressed foreigners as enviable indications of the country's prosperity. The promotion of the arts, including the prodigious growth of the print trade, can be seen as an aspect of this 'consumerism'. When Sophie von la Roche visited London in 1786,[1] she joined the crowds who viewed Reynolds's paintings in the gallery at his house, sifted through the huge stock of prints at publishers such as Boydell's, and laughed at the many satires in the specialist caricature shops of the West End (Cat. 181). Art, in many forms, became conspicuous and fashionable, especially as a result of the growing number of exhibitions.

In 1770 Horace Walpole told Sir Horace Mann about this latest manifestation of 'our luxury and extravagance',[2] which he classed with the follies of the fops who paid half a guinea a day for a nosegay. 'The rage to see these exhibitions is so great, that sometimes one cannot pass through the streets where they are. But it is incredible what sums are raised by mere exhibitions of anything; a new fashion, and to enter at which you pay a shilling or half a crown' Several prints and drawings conveyed the novelty of the experience (Cat. 175, 179) and ironically contrasted the elegancies of 'high art' with the human imperfections of the visitors. Hard on the heels of the first exhibition of the Royal Academy

followed the first exhibition of caricatures, held by Matthew Darly in about 1773, to be followed by many other more or less permanent displays (Cat. 181). Satirical prints, which until then had commonly taken the form of small illustrations to magazines and broadsides, began to emulate the visual attractiveness of paintings, and were often based on drawings by aristocratic amateurs, or designed by artists trained in the Academy's school.[3]

'High art' and 'low art' drew especially close in the case of the great number of prints reproducing Reynolds's paintings, which might often be seen in the same shops as the caricatures. In the surviving 1775 catalogue of Sayer and Bennett's Fleet Street wholesale and retail business[4]—not an 'up-market' publisher—mezzotints after Reynolds accounted for about a quarter of the firm's stock of quality prints, and were listed together with cheaper copies of them and with 'droll, humorous and entertaining prints' and political satires. A similar juxtaposition of the uplifting and the scurrilous (in art and in life) can be seen in views of the windows of print shops like that of Carington Bowles (Cat. 176) and, as in many of the scenes of exhibitions, one feels that the point of the image is precisely this amusing incongruity. Goldsmith's Chinese philosopher[5] had noted the distinction between real worth and popular notoriety:

My pursuit after famous men now brought me into a print-shop. Here, thought I, the painter only reflects the public voice. As every man who deserved it had formerly his statue placed up in the Roman forum, so here, probably, the pictures of none but such as merit a place in our affections are held up for public sale. But, guess my surprise, when I came to examine this depository of noted faces! All distinctions were levelled here, as in the grave, and I could not but regard it as the catacomb of real merit. The brick-dust man took up as much room as the truncheoned hero, and the judge was elbowed by the thief-taker; quacks, pimps and buffoons increased the group, and noted stallions only made room for more noted strumpets . . . the walls were covered . . . with the little self-advertising things of a day, who had forced themselves into fashion, but not into fame. I could read at the bottom of some pictures the names of ——, and ——, and ——, all equally candidates for the vulgar shout, and foremost to propagate their unblushing faces upon brass

The key idea, then, is *reputation*: portrait prints and caricatures catered in different ways for the public's avid interest in political faction, literary controversy, and sexual scandal, which was stimulated by the freedom of the Press (for those who could afford newspapers and pamphlets). The reputation of a public man might be enhanced by the 'puffing' of his friends and hirelings, and by the idealization of a Reynolds portrait, but it could equally fall a victim to detraction and ridicule. So also the idols of the *ton* might pay the price of their constant exposure in the spotlit world of high society; too reckless a display of extravagance or too open a flouting of the social code were punished by cruel personal attacks (Cat. 200, 203) and women who entered the arena of public life were especially vulnerable (Cat. 205, 206). The slandering of the fashionable courtesans, on whom the portraits of Reynolds and Gainsborough conferred so much éclat (Cat. 31, 34, 43, 124), was given the pretext of sanctimonious reflections on public morality. Yet sometimes one feels that, despite the obvious motives of profit and spite (George Cruikshank once compared his execution of amateurs' sketches for caricatures to 'the washing of other people's dirty linen'),[6] this unbridled expression of 'popular opinion' did indeed have a 'judicial power' over those who might scorn other sanctions.[7] Satire fulfilled 'that design which the liberal spirit of our law cannot reach, and the necessary politeness of Modern Religion dare not undertake'.[8]

Portrait prints from Reynolds

Before looking more closely at this phenomenon, something further must be said of the extraordinary importance of engravings from Reynolds's paintings which Nicholas Penny has already emphasized in his essay. It should be seen in the context of 'the rage . . . for prints of English portraits' which Walpole noted in the letter quoted above, among the other fashions of the day. This collecting mania was stimulated by Granger's *Biographical History of England* (1769–74) for which Walpole was the adviser, and led to the practice of 'Grangerising', that is, extra-illustrating Granger's book itself, and other historical works, with portrait engravings. The vogue for portrait prints might be ridiculed—a satire of 1814[9] treated it as one of the 'infatuations' by which City merchants with surplus wealth might aspire to the 'instinct of the higher class', along with the enthusiasm for 'collecting caricatures . . . the productions of Gillwray's [*sic*] prolific genius'. But it represents the serious and growing interest in both physiognomy and English history in the later eighteenth century, which gave a consequence to the art of portraiture that can be easily overlooked if one registers only the contempt of the more vocal champions of history painting. That this patriotic interest in the likenesses of famous Englishmen of the past extended into an appreciation of the additions made by Reynolds and his contemporaries to the memorials of history, is clear from the correspondence of Walpole with his friends.[10] His 'collection of heads' included several by Reynolds, and there was a constant exchange of such portraits among the intellectuals and leading families

of the day. Dr Johnson, hardly a collector in the ordinary sense, left at his death 146 portrait prints, 61 of them framed and glazed, including a number after Reynolds.[11] It is characteristic of him to have stressed the social virtues of portraiture, and to have expressed the hope that Reynolds would not turn his attention to painting mythology.[12] Mutual admiration and affection also seem to have inspired Walpole and his circle in their presents of portraits, many of them 'private prints' intended only for circulation among relatives and friends. In practice, however, it was difficult to maintain the distinction between private and public: in 1787 Walpole was dismayed to hear that MacArdell's print from Reynolds's portrait of him (Cat. 28) had been copied for a magazine. 'It was originally my own fault—I had no business to be an author—but if one will make an exposition of one's self, one must not complain, if one's head serves for a signpost.'[13]

Others were less fastidious. Of the four hundred-odd prints from the portraits of Reynolds published during the artist's lifetime, often from paintings already shown at the Academy, many must have been intended to promote the careers or broadcast the achievements of the sitters. It is hard to believe that 'Bloody Tarleton' (Cat. 129) took time off from the racecourse and gambling tables to sit to Reynolds, purely from a love of art or a sense of social obligation. Evidence that Reynolds's works could serve the purpose of political propaganda is provided by the case of Keppel (Cat. 60 and below). Garrick certainly used his portraits (Cat. 42) as valuable publicity material, and Sheridan, as manager of Drury Lane, would no doubt have welcomed the enormous success of *Mrs Siddons as the Tragic Muse* (Cat. 134). The portraits of fashionable courtesans were equally prominent, and as late as 1828 Henry Angelo assured his readers that 'Emily Pott as Thais' (Cat. 124) could be had 'in most of the print-shops in town'.[14] The moralists tut-tutted over this flaunting of the amours of the nobility (Cat. 207). The author of *To Sir Joshua Reynolds, on his portrait of Miss Kemble, in the exhibition at the Royal Academy* (1784)[15] tactfully praised him for celebrating at least some examples of female virtue:

> While hands obscene, at vicious Grandeur's call,
> With mimic Harlots clothe th'indignant wall,
> Destructive snares for youthful passion spread,
> The slacken'd bosom and the faithless bed . . .

Familiarity with Reynolds's portrayals did not depend only on the large-scale fine mezzotints. Cheaper copies abounded, like the small mezzotints advertised by Carington Bowles (Cat. 176) in 1784 at sixpence plain, one shilling coloured, 'A Number of them always kept ready framed and glazed at the Lowest Prices'. It seems likely, although probably now impossible to prove, that the mezzotints after Reynolds also served as prototypes for those large popular woodcuts which Thomas Bewick in his *Memoir* remembered as 'so common to be seen, when I was a boy, in every Cottage & farm house throughout the whole country . . . sold at a very low price . . . the portraits of emminent [*sic*] Men who had distinguished themselves in the service of their country,

or in their patriotic exertions to serve mankind', including many military commanders and admirals. Reductions of Reynolds's images were made for biographies and author portraits. The first portrait of Johnson was engraved as the frontispiece for Boswell's *Life*, and Heath's plate was, according to Boswell, carefully corrected by Reynolds himself,[16] while the Streatham portrait (Cat. 73) was adapted for Johnson's *Lives of the Poets* in 1779. Others, like that of Walpole, were diffused through journals, notably the *European Magazine*, and these widely circulated book and magazine illustrations proved handy sources for the satirists (Cat. 189). Prints after Reynolds were also applied to a wide variety of ornamental purposes. As early as 1773, a sale catalogue lists several 'Paintings on Glass, Elegantly framed' from prints of Reynolds's portraits; works of this kind were 'very excellent articles for country trade and exportation . . . kept ready for merchants' orders'. Tarleton as depicted by Reynolds reappeared on a transfer-printed creamware jug,[17] and *Miss Kitty Fisher in the character of Cleopatra* (Cat. 34) was miniaturized in a print to decorate a watchcase.[18] There has been much emphasis on Reynolds the prestigious man of letters, or Reynolds the supplier of luxury commodities to a privileged élite;[19] but clearly his art was, in one sense, at least as 'popular' as that of the caricaturists.

'Characters' and types

Surveying this varied repertory, one is struck by the emergence of certain ideal types. The reviewers of the Academy exhibitions were conscious of them, and praised Reynolds for the appropriateness with which the individual sitter was made to represent the ideal. No doubt this tendency was strengthened by Reynolds's practice of keeping a collection of the prints in his studio as a guide to the preferences of sitters. One might compare the types with the rough-and-ready categories used in the catalogues of print-sellers such as Sayer and Bennett's: 'Royal Personages' . . . 'Statesmen, eminent Land and Sea Officers, Patriots, Chancellors, Judges &c. who have distinguished themselves, to the present Time' . . . 'The most celebrated Beauties of the present Time'[20] Mrs Robinson expressed a similar notion in her *Monody to the memory of Sir Joshua Reynolds* (1792) which is enlightening just because it represents a conventional view:

The Statesman's thought, the infant's cherub mien,
The Poet's fire, the Matron's eye serene;
Alike with animated lustre shine,
Beneath thy polish'd pencil's touch divine.

To point out this element of type-casting is not to depreciate the extraordinary subtlety of his insights into personality, nor the variety of his embodiments. It is because Reynolds could combine an impression of immediacy with 'that correspondence of figure to sentiment and situation, which all men wish, but cannot command'[21] that his best portraits seemed to his contemporaries to be more than portraits, to convey an inspiring sense of human nobility. The spell was strongest when Reynolds could invoke patriotic feeling, in

his stirring portrayals of military and naval leaders, which seemed to symbolize the united achievements of the country, not only those of the individual, and are the most convincingly heroic of all his images, even including the history paintings.

It is interesting to analyse the artist's intentions and his public's reactions in the light of the many complex and overlapping meanings of the word 'character' in the eighteenth century. From Johnson's definitions and contemporary literature, it is evident that it could describe not only the personal qualities of an individual, but also the idea of moral reputation, the characteristics associated with a particular profession or position in life, and an abstract or fictional identity assumed by someone, for example on the stage or in an allegory. The eighteenth-century perception of character, as of morality, was essentially social, and stressed the public sphere of action. It is clearly pertinent to Reynolds's approach to portraiture: his aim was to epitomize achievement or social role, not to uncover the hidden springs of the individual's unique psychology, as the twentieth century might demand. Even in the exhibited portraits of his friends, Johnson, Goldsmith and Garrick, the character conveyed is overwhelmingly that of the great thinker, poet or actor: surpassing qualities of mind transcend personal defects.

Many of the sets of satirical prints issued in the 1770s have titles which offer a suggestive analogy (perhaps also referring to Hogarth's famous 'Characters and Caricaturas'): *Darly's Comic-Prints of Characters Caricatures Macaronies &c. Conversations and Satires upon the follies of the Age* The idiom of satire, like that of serious portraiture, was based on the approximation of individuals to recognizable types. There might be an element of compromising intimate revelation, a contrast of the public and the private man; as one satirist observed,[22] 'no man was ever considered as an Hero by his Valet-de-Chambre . . . the greatest men possess their littlenesses'. But what mattered was 'fame', a word which, like 'character', then carried more than one meaning, signifying not only celebrity, but public report of an individual's conduct. In this submission to the opinion of the world, the complexities of character and situation were accommodated to stereotypes which recur obsessively: in place of the naval hero, the patriot, the philosopher or the matron as celebrated by Reynolds, we have the self-seeking minister (Cat. 188, 190), the venal pensionary (Cat. 174, 196), the political turncoat or hypocrite (Cat. 192, 194), the fool of fashion (Cat. 208, 209), the brazen adulterer (Cat. 183, 203).

One intriguing pamphlet, *A poetical epistle to Sir Joshua Reynolds* (1777) volunteered suggestions which, if accepted, might have brought Reynolds's approach even closer to that of the graphic satirists. The writer applauded in portraits by Reynolds the 'Addition of Character, whether Historical, Allegorical, Domestic or Professional' which 'calls forth new sentiments to the Picture; for by seeing Persons represented with an appearance suited to them, or in employments natural to their situation, our ideas are multiplied, and branch forth into a pleasing variety, which a representation of a formal Figure, however strong the resemblance may be, can never afford'. However, he went on to propose to Reynolds

a more pointed use of allegory and symbolism, such as one often finds in the satirical prints.

> And SATIRE too demands thy aid—
> To make the vicious Great afraid,
> To pale the glowing tints of Pride,
> To urge Contrition's flowing tide,
> To paint the lives of shameless Men
> She to thy pencil yields the pen . . .

This is satire in the Johnsonian sense of moral censure. The author's ideas for pictures that Reynolds might paint include one of Garrick fêted by Fame and the Muse of Drama, but beset by 'the serpent Flatt'ry'. Burke should be painted in the Commons in the full flow of oratory, and surrounded by 'Emblems of exalted Sense,/Of Genius, Wit and Eloquence'.

> But 'mid th'inestimable heap
> Let PARTY–RAGE be laid asleep . . .

Fox, the debauchee, was to be led to the 'bright abodes of Virtue' by Repentance and greeted by Hope. It is noteworthy that just at this time James Barry actually attempted something very similar, in allegories such as the 'Portraits of Barry and Burke in the Characters of Ulysses and a Companion fleeing from the Cave of Polyphemus', shown at the Academy in 1776, and the print of 'The Conversion of Polemon', 1778, dedicated to Fox and identifying him optimistically with the young reveller converted to a life of virtuous public service by hearing the philosopher Zenocrates.[23] Reynolds himself, after the critical reception of his *The Triumph of Truth* in 1774 (Cat. 87), was evidently wary of risking again such specific allusions to political or intellectual controversies of the day, from which the artist could stand accused of misjudgement, sycophancy or attachment to party. His allegories were more often pleasing 'Characters' of actresses or society beauties, of which the appropriateness could not be impugned.

Praise and dispraise: The portraits and the satires

Reynolds's apotheoses, then, were only impressive when greatness was affirmed by the public voice. Flattery was easily detectable when the sitter's familiar character or appearance was too obviously discrepant with the idealizing image on the wall of the Royal Academy, or in the window of the print shop. Reynolds was repeatedly satirized on this score, notably by 'Anthony Pasquin'. He figures as 'Sir Varnish Dundizzy' in Pasquin's *The Royal Academicians, a farce . . .* (1786),[24] and 'Truth' 's verdict is that

> In the grouping and disposition of his portraits he has wonderfully contrived to add a certain air of dignity that is inexpressible in language, and unknown to the original . . . he transfuses, without violating the likeness, the graces of his own correct fancy into the unmeaning countenance of Vanity and Folly . . . it is by no means unusual to dis-

cover the exact features of your half-witted acquaintance so happily delineated by the charming pencil of elegant Truth, that every muscle in their visage appears to be governed by an enlightened mind; and the wanton leers of meretricious beauty are softened by the same magic into the irresistible dimples of the love-inspiring *Hebe* . . .

A portrait of the Prince of Wales (Duke of Norfolk) has failed to please because, as Sir Varnish explains, 'I put a little common sense in the expression of the booby's countenance, which it seems destroyed the likeness so much, that his dearest relations did not know him.'

Jokes like this might be expected: it is more surprising to find Reynolds's first biographer expressing a similar view:

> . . . at this time there were no historical works to make a demand upon the painter's skill A true taste was wanting; vanity, however, was not wanting; and the desire to perpetuate the form of self-complacency crowded his sitting room with women who wished to be transmitted as angels, and with men who wanted to appear as heroes and philosophers. From Reynolds' pencil they were sure to be gratified. . . .[25]

Implicit in many of the criticisms and satires is an indictment not only of the artist's mercenary motives, but of the corrupt values of the aristocracy itself, which preferred self-glorification to the patronage of improving historical works. It was not only Blake, in his famous annotations of the *Discourses* of Reynolds, who saw taste and politics as inextricably linked.

A consideration of this background of scepticism and disillusion makes it easier to understand the relationship between Reynolds's portraits and the satirical view of the public figures he painted. The indignant nineteenth-century critic who accused Gillray of living 'like a caterpillar on the green leaf of reputation'[26] may have underestimated the degree to which, in eighteenth-century England, that leaf was likely to be already withered by hostile newspaper 'paragraphs' and political invective, libellous pamphlets and scandal-mongering gossip at the tea-tables of 'the great'. This was especially so in the case of politicians. The corruptness of a ramshackle electoral system and the prevalence of political patronage gave rise to general cynicism, not only among those who felt themselves excluded, but in the repartee of polite society. In the famous picture auction scene in *The School for Scandal* (1777)[27] Charles Surface cheerfully disposes of portraits of 'two brothers . . . Esquires, both members of Parliament, and noted speakers, and what's very extraordinary, I believe this is the first time they were ever bought or sold'. Few statesmen could maintain an unquestioned reputation for principle and integrity. This may be one reason, as suggested above, why Reynolds very seldom portrayed politicians in their public functions. An interesting exception is his portrait of Fox (Cat. 135). It is probable that Reynolds wanted to efface any provocative reference to the controversial East India Bill, which had just brought down the Fox-North coalition ministry. In a letter of April 1784 Fox felt it necessary to insist on its inclusion, since 'the omis-

sion might be misconstrued into a desire of avoiding the public discussion'. Fox was determined to go down in history with this image as the patriot who had defied the hostility of the King and the machinations of the nabobs, and the print would no doubt have been assured of a wide sale to his Whig following. The satirists hired by Pitt and the Court party, meanwhile, were giving a different view (Cat. 190, 191), and the avalanche of witty and deflating anti-Fox prints in 1783–4 was thought at the time to have contributed materially to his downfall. Burke, who was to suffer in the same way (Cat. 192, 194) sought to convince the Commons that Fox

> ... has put to hazard ... his interest, his power, even his darling popularity This is the road that all heroes have trod before him. He is traduced and abused for his supposed motives. He will remember, that obloquy is a necessary ingredient in the composition of all true glory ... that calumny and abuse are essential parts of triumph.[28]

Reynolds must have found it almost as difficult to embody an acceptable concept of royalty, at a time when the extent of the King's power was one of the most contentious issues in politics, and the scandals surrounding the Royal Family were the talk of the town (Cat. 182, 183, 186). The empty pomp of his royal portraits, in which one feels that the artist did not convince even himself, makes an extraordinary contrast with the caricatures of the King and Queen (Cat. 185), many of them inspired by the satirical verse of 'Peter Pindar'. The satirist, in antithesis to the fashionable portrait painter, made money through insult, and much satire may have had no more serious motive. 'Peter Pindar' confessed:

> At royal follies, lord! a lucky hit
> Saves our poor brain th'expence of wit;
> At Princes let but Satire lift her gun,
> The more their feathers fly, the more the fun ...[29]

The public was prepared to countenance the grossest abuse, and, at least until the political upheavals of the 1790s, the Court and authorities were remarkably tolerant, an attitude only to be explained by the limited circulation of these expensive pamphlets and prints, and by the difficulties of ensuring a conviction.

If the eighteenth-century view of statesmen and royalty was often equivocal, patriotic fervour ensured a warm response to Reynolds's portraits of military and naval commanders, the embodiments of resolute authority. Nevertheless, even these images of heroism which he bequeathed to posterity must in some cases have seemed questionable to his contemporaries. The American war divided loyalties in England, and the control of politicians over appointments to high command in the services could lead to open conflicts. The stirring portraits of Keppel which Reynolds rushed into the print shops in 1779 to celebrate the Admiral's acquittal at court-martial (Cat. 60) fed the enthusiasm of the triumphant Whigs, rioting in the streets of London. But Keppel in the satires was a coward protected by rank and his political connections (Cat. 187, 188); in one of Gillray's prints he hauls

down the British flag with the words: 'He that Fights and runs away,/May live to fight another day.'[30]

The attitude of the satirists

From this analysis of a few examples, it might seem that the polarity of satires and idealizing portraits corresponded directly with the propaganda war of factions, resolving the confused realities of political life into simple black and white.[31] But Reynolds in his approach to portraiture played on deeper emotions than the shifting allegiances of politics, and seemed to express the inspiring view that humanity at large was capable of great deeds and virtues. Herein lies the real contrast to the mental world of satirists like Gillray, whose interpretations of events reveal a profound cynicism and moral pessimism 'an art without a hero'.[32] The layers of irony in his prints make it impossible to discern his own opinions, although writers have tried hard to make him, at different times, a convinced radical Whig,[33] or, alternatively, the voice of 'the populist reaction'.[34] Such efforts reflect the trend since the nineteenth century to see the cartoonist as a personality in his own right, committed to a cause or at least to a point of view, and therefore estimable. Given the conditions of eighteenth-century politics and publishing, this approach to Gillray and his contemporaries is anachronistic. A close analysis of the activities of the professional or paid artists (as distinct from the upper-class amateurs), in as far as they can be individually identified, indicates that they 'changed sides' as often as their publishers or covert sponsors changed—often, in the 1780s, with bewildering frequency. The cynicism about politics itself, the manœuvring, fickle allegiances and peculation which were believed to be endemic to it, smirched the 'scribblers and etchers' (Cat. 174) whom the politicians, using a long spoon, employed.

Here again, there is a fascinating antithesis to the 'high art' ambience of Reynolds: while he became, in Burke's words, 'one of the most memorable men of his time ... the first Englishman who added the praise of the elegant arts to the other glories of his country',[35] Gillray and his colleagues were despised as hacks. Reynolds preached a universality, a devotion to the immutable principles of great art, which ensured the artist's fame in perpetuity: satire was local, topical, ephemeral, and for that reason alone was discredited as a form of artistic expression. Reynolds and the other Academy artists basked in the atmosphere of connoisseurship which distinguished individual styles and merits: the satirists were frequently anonymous and, at least until the 1790s, Gillray seems to have worked in a wide variety of manners and disguises. That he did emerge as a recognizable and, indeed, powerful figure in his maturity is a reflection of the enormous popularity and significance of satire in late eighteenth-century England; but his celebrity was never of the kind to earn the personal respect of more than a few of his contemporaries, and, in comparison with Reynolds, very little is known about him. Henry Angelo, who knew him well, says that Gillray appeared

> ... to care no more for the actors in the mighty drama

which he depicted, nor for the events which he so wonderfully dramatised, than if he had no participation in the good or evil of his day ... if he could supply the wants of his mouth by the industry of his hand, he was fulfilling all the moral and physical obligations of his nature ... His aberrations were more the result of low habits and the want of self-esteem, than from malignity, envy or meanness. He was a careless sort of cynic, one who neither loved nor hated society.[36]

Yet Angelo was not alone in admiring Gillray's 'daring species of dramatic design, that extraordinary graphic hyperbole' ... even if few would have cared to claim that it 'almost met in its highest flights the outposts of the creations of Michael Angelo'.[37] While cultural and social prejudice usually excluded him, with a few grudging exceptions, from the recorded aesthetic debates of his time, the growing emphasis on spontaneous invention in art clearly heightened the actual enthusiasm for his work and that of Rowlandson.

Aesthetic theory and the reception of caricature

What the satirists had to contend with, fundamentally, was the classical basis of visual aesthetics and the academic hierarchy of subject-matter, only gradually being challenged as a result of the changing sensibilities and conditions of the late eighteenth century. In the words of du Fresnoy's *Art of Painting*, as translated by Mason in the edition of 1783 with Reynolds's notes, 'taste, like morals, loves the golden mean'. Good taste, based on reason and idealized nature, was the hallmark of the upright man, and lofty subjects were to be preferred to those that degraded the mind—'No sordid theme will verse or paint admit'.[38] In Dryden's preface to du Fresnoy, alluding to Horace's *Art of Poetry*, comic or grotesque art was placed in contradistinction to the ideal: 'the better is constantly to be chosen'.[39] Jonathan Richardson, who so profoundly influenced Reynolds and the connoisseurs, maintained that:

Instead of making *Caricaturaes* of Peoples Faces (a Foolish Custom of Burlesquing them, too much used) Painters should take a Face, and make an Antique Medal, or Bas-Relief of it, by divesting it of its Modern Disguises, raising the Air, and the Features. . . . Some People may fancy 'tis of Use to them to Depreciate, and be out of Humour with every thing; 'Tis of none to Painters: They ought to view all things in the Best Light. . . .[40]

The close identification of art with morals, now coloured by radical politics, is equally clear in the writings of the history painter, James Barry, at the end of the century. In his *Letter to the Dilettanti Society*, Barry quoted his own Academy lecture on colour, with its fulsome tribute to the achievements of Reynolds, and the high ideals he had sought to inculcate:

How melancholy to reflect, that from all the immense wealth which, for a long time past, has been accumulated by the industry, ingenuity, and extensive commerce of the

country, that, in the squandering or circulation of so many millions, so little has been done towards the intellectual entertainment of the public or of posterity! With respect to the arts, our poor neglected public are left to form their hearts and their understandings upon those lessons, not of morality and philanthropy, but of envy, malignity, and horrible disorder, which every where stare them in the face, in the profligate caricatura furniture of print-shop windows, from Hyde Park Corner to Whitechapel.[41]

This 'poor neglected public', however, had little use for Barry's kind of elevated history: satire, disdained by the theorists, was in actuality closer to the predilections of the age. The Academy, taking its lead from the President's *Discourses*, might exhort young artists to scorn present wealth for the future glory awaiting the history painter (Cat. 178, 180); practical exigencies, however, frequently drove them to the print publishers. A satirist of 1785, writing as an artist, complained:

Whene'er my brains in the sublime would dabble,
My bowels ruin all with wibble-wabble . . .
Since, when I've plann'd some arduous thing,
The fame of which would honour bring
To my dear country which I feign would prop,
A printseller thrusts in his head,
And bribes my guts to intercede
For some vile etching to disgrace his shop.[42]

'Peter Pindar' described scurrilities of the 'Tête-à-tête' type (Cat. 200) cheekily nestling among the 'angels, sinners, saints of Mr WEST', the King's History Painter, in the print shops.[43] There was a contrast in style conformable to the contrast in moral tone; the 'horrible disorder' Barry described in the caricatures was not only descriptive of political strife, but a calculated affront to the grand simplifications of Reynolds and other academic painters, just as their often crude technique and gaudy colouring ignored the refined insipidity of the Bartolozzi school of engravers. In imagination, vitality and response to character they must often have seemed superior to their 'high art' counterparts. Even Reynolds, with his brilliant grasp of characteristic expression and gesture, sometimes suffered in the comparison. His portrait of Fox (Cat. 135) was discussed by George III, no friend to either artist or sitter, but with no cause to love the caricaturists either: 'Yes—yes, very like, very like. Sir Joshua's picture is finely painted—a fine specimen of art; but Gillray is the better limner. Nobody hits off Mr Fox like him—Gillray is the man—for the *man of the people*. Hey! my lord—hey! Like as my profile on a tower halfpenny—hey!'[44]

Parody and burlesque

If the caricaturists were free of the decorous conventions of academic art, they might mimic those conventions with devastating effect. The mock-epic was a well-worn form of literary satire throughout the eighteenth century. It began to make an appearance in satirical prints in the 1780s, when academy-trained artists like Gillray and Rowlandson entered

the field, when the growth of exhibitions and print shops gave art much wider currency, and when caricature became fashionable with a sophisticated clientele. It was associated with an irony which is strikingly different from the traditional symbolism of moral contrasts in the anti-ministerial prints of earlier decades. The witty allusiveness which first notably appeared in the prints attacking Fox in 1783–4 (Cat. 190, 191) had its counterpart in Parliamentary rhetoric and pamphlet propaganda. An anti-Pitt pamphlet accused him of manipulating opinion:

> You have, indeed, the whole *starling*-tribe at command, who need but little incitement to yelp . . . *cursed coalition*! . . . In short, sir, were the majority of the House of Commons possessed of taste enough to prefer a splendid passage from Shakspeare [*sic*] or Milton, to solid reasoning, or disposed to receive conviction, on East-Indian innocence and integrity, from a burlesque application of sacred writ, the cause would undoubtedly be your own. . . .[45]

Pretensions to patriotic high-mindedness were easily mocked by a burlesque of the grand style (Cat. 192, 193), and the prosaic homeliness of George III's household took on comic bathos through the invocation of a more heroic past (Cat. 185). Very often—more often than the twentieth-century spectator has yet been made aware—the satires were parodies of particular works familiar to the eighteenth century in engravings, through which they took on a many-layered humour and significance. Sometimes lampoons of individuals allude sarcastically to the idealizing attributes of their portraits by Reynolds (Cat. 189, 197). At other times it is Reynolds's flowery allegorical manner itself which is imitated, to ridicule the caricatured victims (Cat. 204, 208), recalling Hogarth's observation that humour arises 'when improper or incompatible excesses meet'.[46] It is noticeably the work of contemporary academy painters, especially West, Fuseli and Reynolds himself, not the work of venerated Old Masters, which is burlesqued, suggesting a critique of the painful eccentricities of the history paintings of the time, and producing what Gillray called the 'Caricatura-Sublime'.[47] Gillray's wicked travesty of the Boydell Gallery pictures (Cat. 180) works through its literalism, 'quoting' the most bizarre figures with just enough metamorphosis to make them preposterous, a parallel to the witty distortions of his personal caricatures. But it owes its venom to the complex bitterness of the satirists, who resented both the rich pickings of the print publishers, and the social rank of the King's History Painter or of the President of the Royal Academy. Especially they resented the Academy's snobbish attitude towards engravers, who were excluded from full membership and barely represented in its exhibitions, despite their crucial importance to the painters, notably to Reynolds himself. According to Farington, Reynolds

> would not admit that works purely imitative [engravings] should be classed with original productions, or that the professors of the former were entitled to the distinctions granted to the latter, which requires more profound study and greater powers of mind.[48]

This assumption particularly infuriated the engravers; Robert Strange pointed out that if engravers were men 'of no genius,—servile copiers—and consequently not fit to instruct in a royal academy', then the same could be said of the majority of the painters, who were incapable 'of drawing a figure, with either propriety, taste or elegance' in the higher reaches of historical art.[49] Reynolds was on dangerous ground in claiming originality as the distinctive quality of academic painting. Even without Hone's 'Conjuror' (Cat. 173), it would be clear that charges of plagiarism were the commonest method by which critics and satirists tried to find the Achilles' heel of this notoriously invulnerable man, in a manner which recalls the relentless teasing of poor Sir Fretful Plagiary in Sheridan's *The Critic* (1779). Despite Reynolds's justification of imitation in the *Discourses*, which sometimes strikes a defensive note, the tide of romanticism, of belief in the powers of inborn genius, was running against him. Barry, in his anti-Reynolds phase of the 1780s, talked scathingly of 'pouring the same water from one vessel to another'.[50] The author of *Observations on the present state of the Royal Academy* (1790) also dwelt on Reynolds's plagiarism; his historical pictures, especially, 'too often consist of borrowed parts, not always suited to each other'.[51]

Meanwhile the outsiders, the despised caricaturists, delighted the public by the freshness of their improvisations. What better method could they find of satirizing Reynolds and 'high art' than by borrowing his methods and imitating the imitator? The strained and artificial idiom of late eighteenth-century history painting involved steering a precarious course between the vapidity induced by over dependence on the art of the past, and a banal naturalism which was held to degrade the grand style. Despite the advice in the *Discourses* to avoid the triviality of 'particular' nature, in practice Reynolds needed to work up his history pictures from an embarrassingly close and laborious study of posed models. Gillray and Rowlandson faithfully copied this disjunction of the general and the particular, their personal caricatures often providing a comic discordance with the heroic forms pastiched from the grand style (Cat. 192, 208). When Reynolds declared 'hints may be taken and employed in a situation totally different from that in which they were originally employed',[52] the satirists took him at his word.

The satirical element in Reynolds

The critics of Reynolds's methods were particularly struck by the literalism and nakedness of many of his borrowings from the Old Masters. Walpole in his *Anecdotes of Painting* provided the most famous and convincing defence:

> When a single posture is imitated from an historic picture and applied to a portrait in a different dress and with new attributes, this is not plagiarism, but quotation; and a quotation from a great author, with a novel application of the sense, has always been allowed to be an instance of parts and taste.[53]

This intentional discrepancy between borrowed style and

living actuality becomes a kind of 'humour and satire'. Walpole instances *Master Crewe as Henry VIII* (Cat. 97), where the Tudor king's 'swaggering and colossal haughtiness' is reduced to the 'boyish jollity' of the sitter. It is as though Master Crewe has donned historical fancy-dress for a masquerade, satirizing not only a style of art but also a style of government which the eighteenth century had rejected. Many years ago Edgar Wind pointed out that Reynolds was more successful in such obviously witty translations of 'the sublime into the fashionable' than he was in the solemn eclecticism of his history paintings, and actually suggested that the mode originated in 'pictorial burlesque'.[54] It is a surprising thought that Reynolds's early parody of *The School of Athens* (fig. 4) in which absurdly caricatured English connoisseurs impersonate Raphael's philosophers, is one of the most striking anticipations of the mentality and methods of the graphic satirists. The decorousness with which the Montgomery sisters paid homage to marriage (Cat. 90) gained a more subtle frisson for those who recognized the compositional source in a scene of pagan drunkenness. On the other hand, a well-known courtesan could be painted in the grand style as Cleopatra or Thais (Cat. 34, 124) and many of Reynolds's other reworkings of traditional themes introduced a piquant element of sexual innuendo (Cat. 92, 93), a wry comment on the morals of eighteenth-century society akin to that of the caricaturists. He was, in practice, much more a child of his satirical age than is suggested by the elevated tone and classical enthusiasms of the *Discourses*.

The caricatures by Reynolds himself are an interesting case in point. Northcote discussed them with Hazlitt, in a conversation in which they evidently compared Reynolds with Gillray, 'a great man in his way'. When Reynolds was young, said Northcote, his skill in caricature could have earned him a living:

> But he found it necessary to give up the practice. Leonardo da Vinci, a mighty man . . . had a great turn for drawing laughable and grotesque likenesses of his acquaintances; but he threw them all in the fire. It was to him a kind of profanation of the art. Sir Joshua would almost as soon have forged as he would have set his name to a caricature.[55]

How much of this was artistic piety, and how much professional self-interest, is a matter for debate. Certainly Reynolds, revealed by his occasional satirical writings as something of a wit, was, by all accounts, careful to keep this aspect of his character well hidden from prospective clients. A religious sceptic, an urbane man of the world with a shrewd grasp of human failings, he had little of Barry's reforming zeal in moral and aesthetic matters, and even his attitude to the revival of history painting was, in practice, equivocal. The man who wished that the name of Michelangelo might be the last word he spoke from the presidential chair of the Academy was temperamentally unsuited to the creation of epic art, and Mrs Thrale, in her verses for the Streatham portraits, wrote spitefully of

> His temper too frigid, his pencil too warm;
> A rage for sublimity ill understood . . .[56]

Reynolds was distressed by his initial lack of response to Raphael's frescoes in the Vatican, which only determination brought him to relish. But the episode is a reminder of the gulf which separated the indigenous naturalism and humour of English art from the idealism of the grand style which Reynolds and others tried, in the end ineffectively, to graft on to their native traditions. The use of Renaissance forms or of antique dress might dignify a portrait by association,[57] and rid it of the 'meanness' arising from the use of contemporary fashions (Cat. 201, 202); but the principles of the classical tradition, as distinct from Reynolds's sentimental or patriotic adaptations of it, had a diminishing appeal for the English public of the late eighteenth century.

Ruskin, writing in 1860, could see the century of Reynolds in sharp, if biased, historical perspective; he could see that artist's instinct for '"gentlemen and ladies", but neither heroes, nor saints, nor angels':[58]

> How wide the interval between this gently trivial humour, guided by the wave of a feather, or arrested by the enchantment of a smile,—and the habitual dwelling of the thoughts of the great Greeks and Florentines among the beings and the interests of the eternal world! . . . the age of miracles and prophets was long past . . . there is probably some strange weakness in the painter, or some fatal error in the age, when in thinking over the examples of their greatest work, for some type of culminating loveliness or veracity, we remember no expression either of religion or heroism, and instead of reverently naming a Madonna di San Sisto, can only whisper, modestly, 'Mrs Pelham feeding chickens'.[58]

NOTES

1. Roche 1933, esp. pp. 151–2, 231, 237, 262–3.
2. Walpole 1937–83, XXIII, pp. 210–12.
3. George 1959, I, pp. 147, 175.
4. *Sayer and Bennett's Catalogue of Prints for 1775* (repr. Holland Press 1970).
5. Goldsmith 1762, letter CIX.
6. W. Bates 1879, p. 83, quoted Hill 1965, p. 138.
7. *A second letter to her Grace the Duchess of Devonshire*, new edition 1777 (attributed to William Combe), p. 5. The thought was very commonly expressed in pamphlet literature.
8. *The justification: a poem. By the author of the Diaboliad*, 1777 (i.e. William Combe), Preface.
9. *Chalcographimania, or the portrait-collector and printseller's chronicle, with infatuations of every description; a humorous poem . . . By Satiricus Sculptor*, 1814 (attributed to W. H. Ireland and Thomas Coram), pp. 10, 145. Referred to by Godfrey (1978, p. 56 and note 31).
10. Walpole 1937–83, I, p. 67; II, p. 54; XLI, pp. 389f. The first catalogue of prints after Reynolds, published in *The Gentleman's Magazine*, 1784, mentioned the collectors of 'our modern Raphael'.
11. See note from the catalogue of sale of Johnson's effects, in the Bodleian Library, given by G. B. Hill in his edition of Boswell of 1887, IV, p. 441.
12. Northcote 1813–15, I, p. 148.
13. Walpole 1937–83, XV, p. 196.
14. Angelo 1904, II, p. 214.
15. Repr. in *Asylum for fugitive pieces* . . . new edn 1785, pp. 267–9. The writer specified 'the prints from pictures of a certain nobleman's mistresses in almost every shop window'.
16. Arts Council 1984, nos 40–3.
17. The catalogues listing paintings on glass are those of Walter Shropshire (1773) and Laurie and Whittle (1795); copies of both are in the British

Museum Department of Prints and Drawings. The Tarleton design is reproduced in C. Williams-Wood, *English transfer-printed pottery and porcelain*, 1981, p. 201, pl. 129. I am indebted to Terry Lockett for this reference.

18. *Sayer and Bennett's Catalogue* (see note 4), p. 79. Engraved by L. P. Boitard. For expensive fans painted by Poggi from Reynolds's designs, see *Diary and Letters of Mme D'Arblay* (Fanny Burney) with notes by Austin Dobson, 1904, I, p. 465.

19. R. Porter (1982, p. 86) classed him with the 'thousands of master-craftsmen and small manufacturers' who operated 'a client economy servicing the Great'.

20. Op. cit. in note 4, pp. 16–19.

21. Reynolds 1975, p. 60 (Discourse IV, delivered 1771).

22. *The Diaboliad, Part the Second*, 1778 (by William Combe). Dedication.

23. Pressly 1981, pp. 73–6, pl. IV and pp. 79–81, pl. 59.

24. 'Pasquin' 1786.

25. Northcote 1813–15, p. 38. Based on a passage in an obituary notice in the *General Evening Post*, 25 February 1792, quoted by Farington (Reynolds 1819, p. 135).

26. *Athenaeum*, no. 205, 1 October 1831, p. 633; quoted Godfrey 1978, pp. 75–6. On the libelling of public figures in the eighteenth century see Hobhouse 1934, p. 33.

27. Act IV scene 1.

28. From Burke's speech of 1 December 1783, on the East India Bill (Burke 1816, II, pp. 487–8).

29. *Brother Peter to Brother Tom* (i.e. Thomas Warton, the Poet-Laureate). Quoted from the 5th edn, 1789, pp. 37–8. There are many similar passages in Pindar's satires.

30. British Museum no. 5987.

31. Patten 1983, p. 332, claims that, with the exception of Gillray, 'In general, popular prints favored those out of power. Satire is a weapon of the dispossessed . . .'. But this generalization cannot be supported with reference to the 1780s and 1790s.

32. Butler 1981, p. 56.

33. This view originates with the engraver John Landseer, writing in the *Athenaeum*, no. 207, 15 October 1831, p. 667, in reply to a critical article (see note 26 above); but Landseer's contention that Gillray 'was a reluctant ally of the Tory faction, and that his heart was always on the side of whiggism and liberty' has little evidence to support it. Many of his satires of the 1780s were anti-Whig (Cat. 188, 192 in this exhibition), not just those of the 1790s for which he was paid by Canning. See Hill 1965, pp. 47–8 and Paulson 1983, pp. 183f.

34. Butler 1981, pp. 56–7, 68.

35. Burke's eulogy of Reynolds, quoted Northcote 1813–15, p. 372.

36. Angelo 1904, I, p. 299.

37. Ibid. p. 298.

38. Quoted from Mason in Reynolds 1798, III, pp. 34, 27.

39. Ibid. III, p. 134.

40. Richardson 1725, pp. 209, 211.

41. Barry 1798, p. 23.

42. Anon. 1786 (*More lyric odes*), p. 27.

43. *The Lousiad*, 1786, Canto the Second, 1787, p. 3.

44. Angelo 1904, I, p. 282.

45. *Secret Influence public Ruin. An address to the young premier on the principles of his politics . . . with a speech by Mr. Fox*, 1784, p. 30.

46. Hogarth 1955, Chapter 6, 'Of Quantity'.

47. In the caption to 'Wierd-Sisters . . .', British Museum no. 7937.

48. Farington 1819, p. 62, quoted British Museum 1978, p. 35.

49. Strange 1775, pp. 117–19. Compare *Touchstone; or the analysis of Peter Pindar*, 1795, p. 41.

50. Barry 1783, p. 21.

51. Anon 1790 (*Observations on the present state of the Royal Academy*), p. 12. The author may have been Northcote, since several passages reappear, slightly varied, in the *Memoirs* (see, in this case, p. 390). The over-indebtedness to the art of the past of Reynolds and other Academicians is satirized in Anon. 1781 (*The Ear-Wig*), Introduction. The Rev. Henry Bate, editor of the *Morning Post* and *Morning Herald*, often accused Reynolds of plagiarism: see W. T. Whitley, 'An eighteenth-century art chronicler: Sir Henry Bate Dudley' in *Walpole Society*, XIII, pp. 34, 55–6.

52. Reynolds 1975, p. 221 (Discourse XII, delivered 1784).

53. Walpole 1782, IV, Advertisement, pp. vi–vii, footnote.

54. Wind 1939: see especially p. 183. The ideas are developed by Paulson (1975).

55. Hazlitt 1830, pp. 301–2.

56. Hilles 1952, p. 10. The background, and a variant version of the verses, are given in Piozzi 1861, II, pp. 9f.

57. It is interesting, however, that Reynolds recognized that 'neither nature nor reason are the foundation of those beauties which we imagine we see' in the arts of classical antiquity; dressing a figure 'something with the general air of the antique' gratifies 'the more learned and scientifick prejudice', but he claims for it no absolute value. Reynolds 1975, pp. 139–40 (Discourse VII, delivered 1776).

58. 'Sir Joshua and Holbein', *The Cornhill Magazine*, I, March 1860, pp. 323–5, published anonymously.

Caricatures

I
High Art and Low Art in Eighteenth-century London

'ALEXANDER MACKENZIE' (Pseudonym)

174 The Hungry Mob of Scriblers and Etchers

Engraving and etching, 1762
10 × 16.6 cm
The Trustees of the British Museum

In contrast to the rise in the social prestige of painters in late eighteenth-century England, which Reynolds so greatly fostered, the mainly anonymous satirical draughtsmen were held in very low esteem, like the hired Grub Street pamphleteers and journalists with whom they were associated. Eighteenth-century artists, even those of the calibre of Gillray and Rowlandson, usually turned to political satire from necessity rather than conviction, and accepted commissions from either side indifferently, so that their crude attacks were assumed to be mercenary (see introductory essay p. 359 above). During the 1760s, the 'paper war' between the supporters of Wilkes and the unpopular first minister, Lord Bute, reached an exceptionally low point. The *Auditor* for 7 October 1762 complained that ministers were 'libelled in their persons by a million scandalous caricatures hung up for the gaping multitude'. However, in this print it is Bute who scatters coins disdainfully to a disreputable bunch of hacks, including several engravers. Among them—an ignominious slur—are Dr Johnson, shown holding the pension of £300 he had just received from the administration (see also Cat. 196), and possibly Hogarth, the gnome-like figure with an outsized graver on the left, who figures on account of his anti-Wilkes prints. The applicants also include satirists sponsored by the opposing faction such as Matthew Darly, holding his obscene 'transparency', 'Sawney discover'd' or 'The screen' (1760), one of many prints suggesting a liaison between Bute and the Princess of Wales, the King's mother.

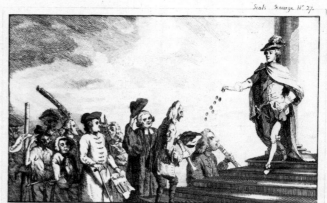

174

The biblical motto and the verse 'If their snarling you'd stop give the Hellhounds a Sop . . .' suggest that opponents were often bribed to desist or change sides. D.D.

LITERATURE Stephens 1883, IV, no. 3844; George 1959, I, p. 122.

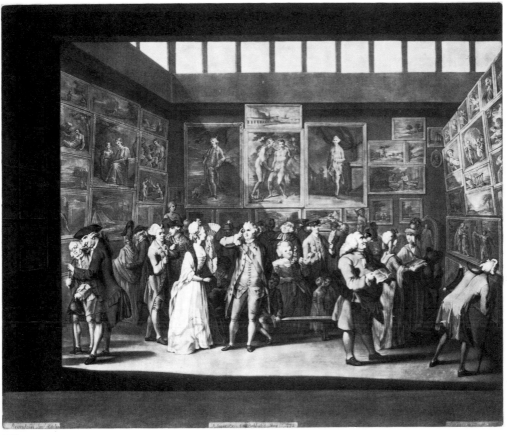

175

RICHARD EARLOM (after Charles Brandoin)

175 The exhibition of the Royal Academy of Painting, in the year 1771

Mezzotint. *London Printed for Rob^t. Sayer No. 53 in Fleet Street . . . 20 May 1772* [some were printed 15 May]
41.9 × 54.7 cm
The Royal Academy of Arts

This print, showing the Academy's exhibition in the modest premises of Lambe's auction rooms in Pall Mall, is as much concerned with the comedy of manners enacted below the paintings as with the artistic record, and displays a Rowlandson-like humorous scepticism in setting human imperfections against the idealization and high moral tone of academic art. Some of the pictures by Gainsborough and others are recognizable, but have been very freely rendered from Brandoin's sketch. Conspicuous in the centre of the back wall is Barry's Miltonic *The Temptation of Adam* (National Gallery of Ireland, Dublin), the classicizing nudities of which seemed a novelty to the English exhibition visitor of the 1770s. There is an ironic comment on Barry's theme in the sanctimonious attitude of the clergyman below, and in the contrast between the sexual innocence of the kiss-

ing children and the illicit flirtation of the fashionable couple to the left, whose poses echo those of Adam and Eve, with the lady raising her fan coquettishly (feigning modesty in front of the nudes?) and looking between its sticks at the fop with the eyeglass. Above them to the left is, appropriately, the coy symbolism of Reynolds's *Venus chiding Cupid for learning to cast Accompts* (Iveagh Bequest, Kenwood House). Another kind of comment on the relationship of art and life is implicit in the contrast between the slender elegance of the male portrait, with the imposing low viewpoint of Academic full-lengths, and the dumpy gaucherie of the 'real' citizen on the right. He consults his catalogue while looking complacently at the classical history painting, perhaps typifying the new middle-class public for art generated by the exhibitions of the late eighteenth century; he might have been more engaged by West's *Death of Wolfe* (National Gallery of Canada, Ottawa), which was the popular hit of 1771, but not visible in the print. The caricatured man on the left is even further removed from the ideal, as are the short fat lady and her cross-eyed escort, perhaps meant for Wilkes, in centre background. Sayer and Bennett's catalogue for 1775 listed this print and assured the customer of its authenticity, with 'a pleasing groupe of connoisseurs E.c. who were actually present, correctly drawn by Mr. Brandoin'.

Nicholas Penny notes that the uniformity of frames in this

print is remarkable. Reynolds had a standard simple, thin and battered moulding that he employed for exhibiting his fancy pictures, but for portraits the sitters could choose the frames (Fletcher 1901, pp. 163–4). D.D.

LITERATURE Chaloner Smith 1878–83, no. 44 (ii); Paston 1905, p. 69; Whitley 1928, I, pp. 283–4; George 1935, V, no. 5089; Tate Gallery 1983, p. 51.

ANON.

176 Spectators at a Print-Shop in St Paul's Church Yard

Mezzotint. *Printed for Carington Bowles, at his Map & Print Warehouse, No. 69 in St Pauls Church Yard, London* [25 June, 1774]
32.2 × 24.7 cm
David Alexander

A genre of prints depicting print shops developed in eighteenth-century England, reflecting the huge expansion in the print trade and the general development of retailing in London, where the newly paved and well-lit streets encouraged window-shopping. There are some scenes of the West End shops specializing in caricature (see Cat. 181), but this example is of interest in showing the more old-fashioned premises of Carington Bowles in St Paul's Churchyard, which sold both serious and satirical prints, as did Sayer and Bennett's in Fleet Street (see introductory essay, p. 355). Here, as in Dighton's more famous view of Bowles's shop of *c.* 1783, prints of clerical portraits including Hone's *Wesley* occupy the top rows of window panes, presumably as unexciting stock items, and below them, in piquant moral contrast, the comic genre and caricature mezzotints or 'postures' which Bowles issued in series. As in the views of art exhibitions (see Cat. 175 and 179), there is an implied comment on the relationship of art and reality: the behaviour of the spectators bears more resemblance to the scurrilous scenes which absorb them than to the piety of the men of God. A debtor is surprised by a sheriff's officer, and a fashionably dressed woman attracts the attention of a smirking and affected fop. The author of *A satirical view of London at the commencement of the 19th century* (1801) echoed the view of many in lamenting that 'The caricature and printshops, which are so gratifying to the fancy of the idle and licentious, must necessarily have a powerful influence on the morals and industry of the people . . . thither the prostitutes hasten, and with fascinating glances endeavour to allure the giddy and the vain . . .'. D.D.

LITERATURE Stephens 1877, III, part 2, no. 3758; New Haven 1980, no. 4.

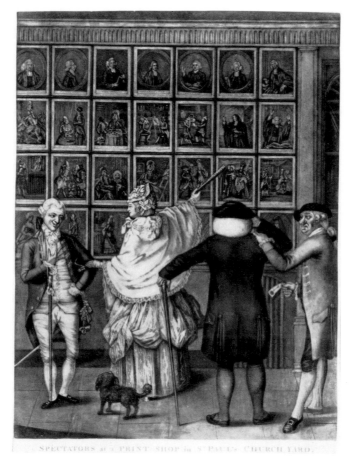

176

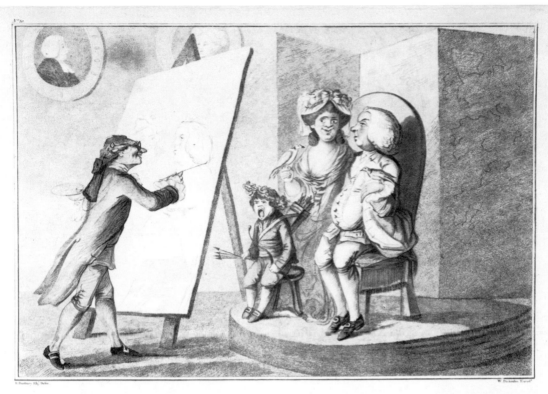

A FAMILY PIECE.

177

WILLIAM DICKINSON (after Henry Bunbury)

177 A family piece

Stipple, printed in sepia. *London, Publish'd October 15th 1781, by W. Dickinson, No. 158, New Bond Street*
24.7 × 36.3 cm
The Trustees of the British Museum

The family group are placed on a dais, as they would have been in Reynolds's studio, and although in ordinary dress, hold doves, while the child bears the emblems of Cupid. This is a comic allusion to the allegorical mode of contemporary portraiture typified by Reynolds's portraits of Lady Sarah Bunbury (Cat. 57, 58) and Lady Blake (fig. 15), sister-in-law and sister of Henry Bunbury, the amateur after whose drawing this is made. It has been suggested that the artist here is meant for Reynolds: this is unlikely, since he was a friend and admirer of Bunbury. Rather, it is a characteristic dig at the 'Cits', the rich City merchants who aped the fashions of the aristocracy, as is indicated by the coarse robustness of the wife and the clumsy pose of the husband, whose lumpy nose and receding chin are mitigated on the canvas by the obsequious painter. The print has been referred to Goldsmith's description of the Primroses's portrait in *The Vicar of Wakefield* (1766) an 'historical family piece' with a ludicrous assortment of incongruous symbolic fancy-dresses, painted by an itinerant limner 'for fifteen shillings a head'.

A more pertinent comparison might be with Samuel Foote's comedy *Taste* (1752), in which the uneducated but socially ambitious City alderman's wife, Lady Pentweazel, sits to a flattering charlatan. Turning her head this way and that to get the 'more betterer' side, she intends to 'call up a Look' in her eyes, which the painter pretends to despair of capturing. His admission that 'Where Nature has been severe, we soften; where she has been kind, we aggravate' epitomizes the practice of eighteenth-century portraitists, and is exactly opposite to that of the caricaturists. D.D.

LITERATURE George 1935, V, no. 5921; George 1967, p. 121; Riely 1975–6, p. 42; Sudbury 1983, p. 4.

THOMAS ROWLANDSON

178 The historian animating the mind of a young painter

Etching, 1784
18.8 × 27.2 cm
The Trustees of the British Museum

This ironically titled print, in which a desiccated pedant reads to a young artist below a bust of Homer, while the artist's pretty wife and baby play unregarded behind the easel,

echoes the Hogarthian theme of antithesis between everyday reality and the pretensions of 'high' art. Rowlandson's many variations on this idea can be seen as a subversive comment on Reynolds's *Discourses* to the Academy students, in which the artist is recommended to cultivate 'the conversation of learned . . . men' and to imbibe the grand traditions of literature and history, 'elevating' his art above common nature. For Rowlandson, nature and lived experience are the true inspiration of all art, and he contrasts the strained rhetorical gestures of the figures drawn by the artist with the easy spontaneity of the real mother and naked infant and of the artist himself. The portfolio perhaps suggests that he is following Reynolds's precept and example in imitating the works of the Old Masters. If so, there is a further irony in the fact, stressed by Paulson, that the pose of the mother and child echoes Reynolds's *Duchess of Marlborough and her daughter* (Cat. 59) in its turn based on Renaissance sources. But Rowlandson's figures are far more natural in their movements, and it is difficult to follow Paulson in his belief that Rowlandson meant to propitiate academic opinion by an acknowledgement that nature must be interpreted through art, although it is certainly true that the fluent command of figure drawing and composition of Rowlandson's generation of satirists owed much to the Academy's tutelage. However, it is noticeable that this aspiring history painter is working in a bare garret; a year after the completion of Barry's mural of the *Progress of Human Culture* in the Society of Arts, it was clear that the path pointed out, but not followed, by Reynolds promised future glory only at the price of present poverty. D.D.

LITERATURE Grego 1880, I, p. 150; Paston 1905, p. 71; George 1938, VI, no. 6724; George 1967, p. 121; Paulson 1972, pp. 23, 39; Baskett and Snelgrove 1977, no. 195; Paulson 1983, pp. 122–6.

PIETRO MARTINI (after Johann Heinrich Ramberg)

179 The Exhibition of the Royal Academy, 1787

Engraving and etching, hand-coloured. *Publish'd . . . July 1 1787 by A. C. De Poggi, No. 7 St. Georges Row, Hyde Park*
31.6 × 48.8 cm
The Royal Academy of Arts

The Academy's exhibitions, in the 1780s, were held in the grand new rooms of Chambers's Somerset House. A comparison with Cat. 175 highlights how much more impressive and fashionably successful they were in this setting. The Prince of Wales is shown being conducted round by Reynolds, who holds his ear trumpet and gestures grandly, while immediately above is his portrait of the Prince with a black (Duke of Norfolk). The Great Room of the Academy shown here (which measured about $53 \times 43\frac{1}{2}$ ft) is packed with paintings, fitted in like a jigsaw puzzle. The quotation in the subtitle of the Greek inscription which appeared over the doorway ('Let no stranger to the Muses enter') is perhaps ironic (compare Cat. 180) in view of this motley crowd's inattention to the pictures, and as with Cat. 175, there is an amusing awareness of the discrepancy between actuality and the elevated tone of the history paintings and portraits. The public of the 1780s was well aware of the crisis in the Royal Family caused by the Prince's scandalous affairs, his rumoured marriage with Mrs Fitzherbert (see Cat. 182) and his money problems, and many found Reynolds's portrait ludicrous in its baroque grandiloquence; the King pointedly ignored it.

The President's works now dominated the exhibition in

THE HISTORIAN ANIMATING the MIND OF A YOUNG PAINTER.

178

The EXHIBITION of the ROYAL ACADEMY. 1787.

179

their number and impressive range; also visible here are his portraits of Sir Henry Englefield (69; Private Collection) and Boswell (113—Cat. 136) Lady St Asaph and her son (100; Private Collection), the child portraits of Lord Burghersh (146; destroyed) and Master Yorke (167; Iveagh Bequest, Kenwood House) and 'A child's portrait in different views' ('Heads of Angels') (24; Tate Gallery, London). In *Observations on the present state of the Royal Academy ... by an old artist*, 1790, the author complains: 'In the annual Exhibitions people have, somehow or other, been habituated to reserve all their admiration for the pictures of *Reynolds*; and methods have been contrived to disgust many of those Artists who would have divided the public applause with him. ... Sir Joshua Reynolds very well knew, that a man of the largest human growth, must be surrounded with pigmies to appear a Colossus.' D.D.

LITERATURE Whitley 1928, II, p. 81; George 1938, VI, no. 7219; Hutchison 1968, pp. 66–7. (Ramburg's original drawing for the figures was lot 50 at Christie's, 9 July 1985.)

JAMES GILLRAY

180 Shakespeare—Sacrificed; or The Offering to Avarice

Etching and aquatint, hand-coloured. *Pubᵈ. June 20th 1789 by H. Humphrey No. 18 Old Bond Street*
46.6 × 36.9 cm
The Trustees of the British Museum

Gillray's devastating indictment of the Boydell Shakespeare Gallery, and especially of Reynolds's contributions, embodied his bitter hostility to the artistic establishment, which was shared by many artists and engravers (see

introductory essay, p 361 above) Gillray had personal reasons for the attack, having applied unsuccessfully to Boydell for employment in the scheme; but it is precisely the inventiveness and verve here demonstrated which would have been unacceptable in a reproductive engraver, and indeed, as Gillray realized, were rare among the history painters. With typical cynicism he mocks Boydell's pretensions to altruism, and imputes a crude commercialism. The Alderman consigns Shakespeare's plays to the flames, which are fanned by Folly and almost obscure the monument of Shakespeare behind. Avarice, a gnome with money bags, watches with glee from his perch on the 'List of Subscribers to the Sacrifice' and portfolios of 'Modern Masters'. The works of these modern masters are ruthlessly travestied above. With great wit Gillray parodies the histrionic gestures, the abrupt transitions in scale and drastic foreshortenings, and the *outré* fantasy which characterized the more melodramatic works in the gallery. The flying hair of Barry's *King Lear with the dead Cordelia* (Tate Gallery, London) is metamorphosed into a falling sack, and Gillray ridicules the effect observable in Barry's painting of wind irrationally blowing in both directions, in the smoke which now issues from the primitive chimney-like supports of Fuseli's nearby throne of Lear. But pride of place is given to Reynolds's dying Cardinal Beaufort (Cat. 148), particularly to the features which had excited most criticism—the exaggerated grin of agony and the inappropriate demon. The expression of Avarice parodies the theatrical grimaces of Reynolds's witches in *Macbeth* (Cat. 152), and indeed the whole composition of Gillray's satire and its incantatory theme recall that painting, together with spooky scenes of conjuration by Mortimer and West. Boydell is a sorcerer within a charmed circle inscribed in Greek: 'Let no stranger to the Muses enter', the words which appeared over the door of the Great Exhibition Room in Somerset House itself (see Cat. 179). Within this circle is a ragged boy with palette and brushes representing painting, who forbids entry to a boy

with engraving tools, symbolizing the exclusion of engravers from full membership of the Royal Academy; and a folio of 'Ancient Masters', representing the great art of the past which engraving perpetuated, also lies outside neglected.

In this complex and paradoxical satire, the huge profits of the print publisher are contrasted with the penury of the young history painter; but Gillray equally castigates the prejudice of the Academy in refusing to recognize the importance and artistic achievements of engravers, and the hollowness of the 'original' art on which Reynolds and the other Academy painters based their claims to superiority.

D.D.

LITERATURE McLean 1830, fol. 11; Wright and Evans 1851, no. 380; Wright [1873], pp. 110–12; Paston 1905, pp. 71–2, III; George 1938, VI, no. 7584; Hill 1965, p. 35; Roe 1971, pp. 460–70; Friedman 1976, pp. 76–8; Godfrey 1978, pp. 48, 74; New Haven 1980, no. 132.

RICHARD NEWTON

181 Holland's caricature exhibition

Pen and blue ink and watercolour, c. 1794
44.6 × 67.7 cm
The Trustees of the British Museum

This typically hilarious drawing by Newton (a self-portrait is traditionally identified in the youth on the right in riding

SHAKESPEARE · SACRIFICED; · or _ The Offering to AVARICE.

180

181

dress) depicts the room of his publisher, Holland, at a time when caricature exhibitions (entrance a shilling), together with the exhibitions of the Academy itself, provided one of the many popular resorts of London's fashionable society. Newton shows a number of his own prints (or larger drawings for them?) on the walls, mainly social satires; few of his royal and political caricatures appear to be included. Just as the comic exaggerations of form and ribaldry of the satirical prints of this time invert the idealism of academic art, so the composition of this drawing appears to parody the prints showing the Academy's exhibitions (see Cat. 175, 179), and even the poses of the figures can be closely paralleled in Brandoin's and Ramberg's scenes. As in the former, a young buck uses his quizzing-glass to ogle at a lady, but while gentlemen visitors to the Academy point out the beauties of the paintings to their female companions, the man on the left of the caricature exhibition grabs his wife's fan to hide the view of a risqué print, at which she nevertheless laughs heartily. George, without giving evidence, identifies the young women in the foreground as the Duchess of Devonshire and her sister. It is of interest that they are wearing tricolor ribbons and sashes, perhaps an indication of sympathy with the French Revolution. Holland had Whig sympathies and in 1793 had been sent to Newgate for a seditious publication. D.D.

LITERATURE George 1959, I, note p. 205; George 1967, p. 57.

II
Royal Follies

ANON.

182 The April Fool or the Follies of a Night

Etching, hand-coloured. *Published 1st April 1786 by S. W. Fores at the Caricature Warehouse, No. 3, Piccadilly*
24.4 × 37.2 cm
The Trustees of the British Museum

Rumours of the secret marriage of the Prince of Wales to Mrs Fitzherbert in December 1785 produced a spate of satire, notably a series of prints published by Fores, whose attacks on the Prince and his Whig friends indicate the move away from an invariable anti-ministerial line in satire. Most of these prints were light-hearted scurrilities contributed by amateurs. Their simple designs in coloured outline recall theatrical prints, a link confirmed by the titles, taken from contemporary plays, which become satirically allusive to the Prince's marriage. Henry Angelo recalled that one of the first, the *Marriage of Figaro* by Wicksteed, 'had so great a sale, that the publisher's premises were crowded with the

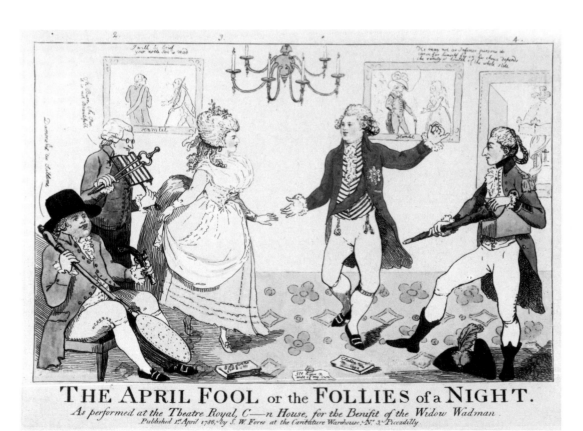

THE APRIL FOOL or the FOLLIES of a NIGHT.
As performed at the Theatre Royal, C—n House, for the Benifit of the Widow Wadman.
Published 1st April 1786, by S. W. Fores at the Caricature Warehouse, No. 3, Piccadilly.

182

servants of the *beau monde*' . . . and its successors 'were sought with scarcely less eagerness'. This is verified by Sophie von la Roche, who saw crowds looking at these caricatures, sold alongside portrait engravings of the Royal Family. The satires could not be more different from Reynolds's bombastic portraits of the Prince.

In this example, the Prince is indecorously dancing a reel with Mrs Fitzherbert, whose aquiline nose and bulging contours in the 'pouter pigeon' fashions of the day are unsympathetically exaggerated. The Prince's intimates, Weltje and George Hanger, improvise with lewdly suggestive instruments—pistol, warming pan (slang for 'a female bedfellow') and bludgeon—and Burke plays a gridiron with fire-tongs, the dialogue mischievously referring to his *Enquiry into . . . the Sublime and Beautiful*. His presence damagingly insinuates the connivance of the Whig leaders in the marriage, which in fact they deplored. The more serious aspect of the affair is also suggested by the crucifix visible beyond the bed (the Prince's marriage to a Catholic, if made legal, would have precluded his succession to the throne) and the quotation from *Hamlet*. 　　　　　　　　D.D.

LITERATURE Wright [1873], pp. 77–8 (as by Gillray); Paston 1905, pp. 114–15 (as by Gillray); George 1938, VI, no. 6937.

ANON. (James Gillray)

183 The Accommodating Spouse;—Tyr—nn—es delight!—Coming York over her;—or what you like

Etching, hand-coloured. *Pub^d. May 15th 1789 by J. Aitken, Castle Street Leicester Fields—London*
22.7 × 33.4 cm
The Trustees of the British Museum

The splendid formality of Reynolds's portrait of the Duke of York (Cat. 143), who was also Bishop of Osnabrück and the hope of the Royal Family as a military leader, is nearly contemporary with this alternative view of him, climbing into bed with Lady Tyrconnel, in whose blonde tresses, according to Wraxall (1884, v, p. 201) 'his Royal Highness was detained captive'. Both the scandal and the public's amusement were heightened by the willing connivance of her husband and father, Lord Delaval, 'notwithstanding that [they] . . . were both firmly attached to the Administration', unlike the Duke, who was closely identified with his

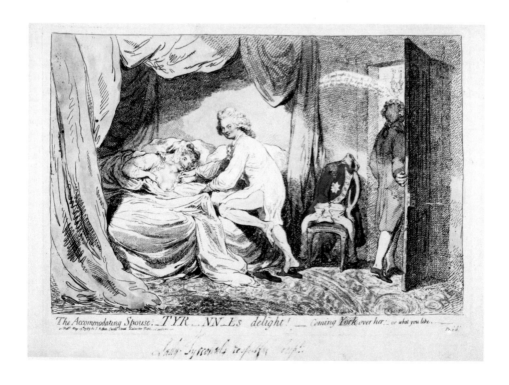

FASHIONABLE CONTRASTS;—or—The Duchess's little Shoe yeilding to the Magnitude of the Duke's Foot.

184

disaffected brother, the Prince of Wales. Gillray's inscriptions are smuttily suggestive ('Coming York[shire]' was to cheat, and a 'Jerry [Sneak]' was a henpecked husband). But the frivolity has as its background the Duke's serious unpopularity during the crisis of the King's insanity in 1788–9. Although George III's favourite son, he spoke in the House of Lords to press the Prince's claims to the regency, and on drunken evenings at the Whig club, Brooks's, is said to have openly ridiculed the King. His duel with Colonel Lennox, nephew of the Duke of Richmond, further exacerbated the bitterness between the Court party and the princes, which was public knowledge. D.D.

LITERATURE George 1938, VI, no. 7530.

ANON. (James Gillray)

184 Fashionable Contrasts;—or—The Duchess's little Shoe yeilding [sic] to the Magnitude of the Duke's Foot

Etching, hand-coloured. *Pub^d. Jan^y 24th 1792, by H. Humphrey N. 18 Old Bond Street*
24.7 × 34.5 cm
The National Portrait Gallery, London

The marriage of the Duke of York (Cat. 143) to Frederica Charlotte, Princess Royal of Prussia, was widely welcomed as the first sanctioned marriage of one of George III's off-spring. Miss Dee, one of the royal governesses, thought the diminutive Duchess looked 'squeezy and puny' on her first glittering appearance at Court, and the general opinion found her 'far from handsome'. But the press was ecstatic,

and a print reproducing her tiny diamond-covered shoe was, according to the *Public Advertiser*, 23 January 1792, bought by 'the major part of John Bull and his family'. Some of the satirists imagined Cinderella-like scenes of the ageing leaders of fashion trying to fit into shoes of the Duchess's size (sole 5½ in), while a print called *The Contrast*, published only a week before Gillray's, contrasted the 'Virtuous flame, or Nuptial Glory' of this marriage with the shame of the Duke of Clarence's ménage with the actress Mrs Jordan. It was probably this moralizing, as much as the popular adulation, which provoked Gillray's compulsive cynicism. He would not have forgotten the Duke of York's many affairs (see Cat. 183). Gillray's arresting *jeu d'esprit* surprisingly goes back to a well-known political print of 1762, *The Bed-Foot*, in which the projecting feet were those of Bute and the Princess of Wales. D.D.

LITERATURE Wright [1873], p. 137; George 1938, VI, no. 8058; Hill 1966, no. 58.

ANON. (Richard Newton)

185 Arming in the Defence of the French Princes or the Parting of Hector and Andromache

Etching, hand-coloured. *London Pub^d May 8 1792 by W. Holland No. 50 Oxford St.*
32.5 × 36.3 cm
The Trustees of the British Museum

The ceremonious character of most of the portraits of George III and Queen Charlotte, including those by Reynolds, could be compared with the hieratic stiffness of the cheap popular

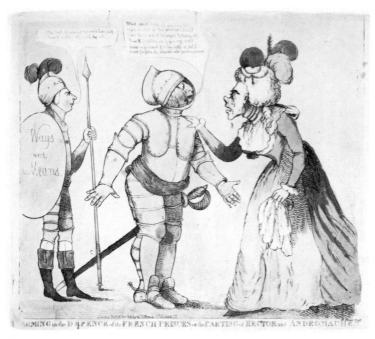

ARMING in the DEFENCE of the FRENCH PRINCES or the PARTING of HECTOR and ANDROMACHE?

185

prints of royalty sold ubiquitously in the eighteenth century. Very different was the brand of mockery purveyed by the more sophisticated London print shops, which drew on the equally familiar image of the King created by court gossips and satirical pamphleteers like 'Peter Pindar'. This banter represented him as parsimonious, homely and bucolic, 'the Windsor milkman', and recorded his inane remarks and eccentricities. According to Anthony Pasquin, such prints were hanging on the walls of the Prince's Brighton Pavilion. It is surprising that the ridicule was most marked in the early 1790s, when the plight of the French Royal Family and the political climate in England might have urged caution.

Some of the funniest and most uninhibited prints were produced by Richard Newton, then aged about fifteen, for Holland (see Cat. 181). In this burlesque scene the King has donned the armour of Henry VIII, and bids farewell to a cruelly caricatured Charlotte. He is supposedly incited by Pitt to combat the revolutionaries, probably a reference not only to the rumours of preparation for a war with France, but to Pitt's imminent proclamation suppressing 'tumultuous meetings and seditious writings', which many thought alarmist and reactionary. As is usual in the caricatures, the King's heavy features are shown in goggle-eyed profile; Newton seems to allude in a joking spirit to Lavater's widely-read *Essays on Physiognomy* in which the author (in vol. II of Hunter's translation, published in 1792) reproduces, and criticizes, Porta's comparison of man and ox, referring to the ancient belief in affinities of character corresponding to physical resemblances to animals. In this case, the bovine likeness would mark the King with 'gross brutality, rudeness, force, stupidity, inflexible obstinacy, with a total want of tenderness and sensibility'. D.D.

LITERATURE George 1938, VI, no. 8084

JAMES GILLRAY

186 A Voluptuary under the horrors of Digestion

Stipple, hand-coloured. *Pub^d July 2^d 1792, by H. Humphrey No. 18 Old Bond Street*
33.3 × 26.9 cm
Andrew Edmunds

While Reynolds, in his portraits of the Prince of Wales, sought to epitomize regality in the impressive manner of the sixteenth and seventeenth centuries, Gillray represents him as a monstrous glutton in the tradition of popular prints of Gargantua. The bulging stomach and thighs of the 'Prince of Whales', who at this time weighed about seventeen stone, here form undulations with which even the furnishings of the room and the joint on the table seem to sympathize, rendered more repulsive by the epicene elegance of the Prince's manner, which is confirmed by contemporary descriptions. Empty wine bottles lie under the chair, and the coat-of-arms gives a new meaning to the Prince's motto, 'I serve'. An overflowing chamber-pot anchors unpaid bills, and the view through the window of the unfinished colonnade of Carlton House also alludes to the Prince's disastrous extravagance. Other details charge him (unjustly) with gambling, and the Newmarket List refers to a racing scandal of 1791; but Gillray's most astounding defamation is the shelf with nostrums for venereal disease. The satire is made more deadly by his conscious delicacy of drawing and technique, which removes it from the company of the cruder caricatures of the time. For all its polished wit, however, there is an undertow of serious moral disgust which, in the 1790s, could take on a political complexion. The dangerous depravity of

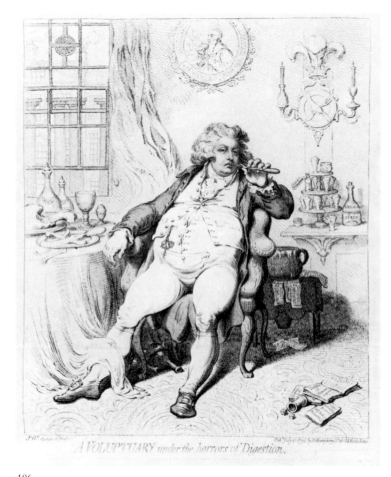

A VOLUPTUARY under the horrors of Digestion.

186

the Prince and his friends was continually deplored in the Press and in satires like Anthony Pasquin's *New Brighton Guide* of 1796; the radical Charles Pigott in *The Jockey Club* (1792) claimed that he was 'taking dust out of the eyes of the multitude . . . by exhibiting to public view, the corruption and filthy debauchery of those who are . . . wickedly attempting to establish an eternal and destructive authority over them'. D.D.

LITERATURE McLean 1830, fol. 191; Wright and Evans 1851, no. 85; Wright [1873], pp. 148–9; Paston 1905, pp. 117–18; George 1938, VI, no. 8112; George 1959, I, p. 216; Hill 1965, pp. 40, 118; Hill 1966, no. 56.

III
Heroes and Public Men

ANON.

187 Who's in Fault? (Nobody) a view off Ushant

Etching. *Pubᵈ Decʳ 1st. 1779 by Wm. Humphreys No. 227 Strand*
21.3 × 31.9 cm
The Trustees of the British Museum

A satire on the close friend and patron of Reynolds, Admiral Keppel, dating from soon after his acquittal at court-martial.

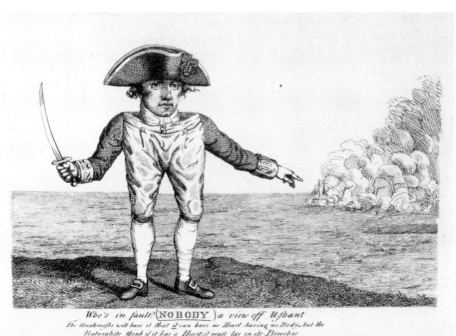

Who's in fault? (NOBODY) a view off Ushant
The Anatomists will have it that it can have no Heart having no Body, but the Naturalists think if it has a Heart, it must lay in its Breeches
Pubᵈ Decʳ 1ᵗ 1779 by Wᵐ Humphreys Nᵒ 227 Strand.

187

He had been charged with neglect of duty, for failing to re-engage the French navy in the indecisive action off Ushant (an island near Brest, commanding the entrance to the Channel) on 27 July 1778. In contrast to the nobility and steadfast-ness expressed in Reynolds's portraits of him at the same moment in his career (Cat. 60), the Keppel of the satire is represented by an old symbolic device as a literal 'No-body', a coward with 'a Heart . . . in its Breeches', while the point-ing gesture and shore setting seem to refer ironically to Reynolds's portrayals, especially that of 1754 (Cat. 19). The title refers to the fact that the exoneration of both Keppel and his accuser, Vice Admiral Palliser, resulted in a situation where no one could be held responsible for the reverse at Ushant, nor for the resulting national humiliation and danger. The whole train of events exemplified the close link between politics and military and naval appointments in the eighteenth century, and the muddle and disunity which resulted. Keppel was the hero of the Whig circle which included the Duke of Richmond, Fox and Burke, but at log-gerheads with the first Lord of the Admiralty, Sandwich, and the Court party. Allegations of half-heartedness in fight-ing the French laid him open to a more general charge of reluctance to secure a victory over the American colonists, who were openly supported by Keppel's political allies; the latter in turn made counter-accusations of ministerial incompetence. Thus Keppel's acquittal was not only a per-sonal vindication, but the occasion for a riotous display of hostility to Lord North's administration. The engravings

from Reynolds's potraits which 'were to be seen in every print shop', and the many satires on Keppel which appeared in opposition to them, can equally be understood as contribu-tions to the fierce political propaganda war of the time. D.D.

LITERATURE George 1935, V, no. 5570; George 1959, I, p. 161.

ANON. (James Gillray)

188 Rodney introducing De Grasse

Etching, hand-coloured. *Pub^d June 7^th 1782, by*
H. Humphrey New Bond Street
21.2 × 33 cm
The Trustees of the British Museum

Rodney, victorious over the French fleet led by de Grasse at the Battle of The Saints (April 1782), is shown presenting his captive to the King, while Fox and Keppel, who had just taken office after the fall of Lord North's ministry, reveal an unpatriotic annoyance. This reaction is explained not only by the equivocal attitude of the Whigs to the American war, but by the embarrassing fact that the new administration had just dispatched Pigot to replace Rodney. Fox is saying 'I have obligations to Pigot, for he has lost 17000 [pounds] at my Faro Bank', alluding to a damaging rumour that Pigot was appointed to enable him to pay his gambling debts. The huge

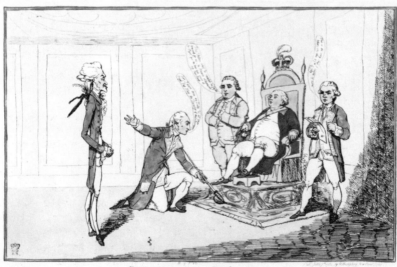

RODNEY introducing DE GRASSE.

188

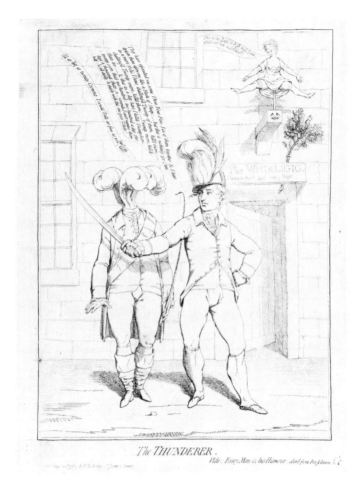

The THUNDERER.

Vide: Every Man in his Humour. alter'd from Ben Johnson i.C

189

popularity of Rodney led to a public outcry against this move, the grudging praise and relatively small rewards accorded to the national hero being contrasted with the position of the less-deserving Keppel as a newly-created Viscount and First Lord of the Admiralty. Keppel, as is clear from his speech here, had never thrown off the disgrace of his alleged failure at Ushant (see Cat. 187) and he frequently figures in the satires as 'Admiral Lee Shore', a mocking reference to his claim at his trial that it would have been unsafe to pursue the French 'with a fresh wind blowing fair for their port'. This reputation for prevarication must have conditioned the response to Reynolds's idealizing portraits, and in this connection it is interesting to read Wraxall's (admittedly biased) description of 'Little Keppel' in his *Memoirs*, which is to some extent authenticated by his appearance in the satires: 'There appeared neither dignity in his person nor intelligence in his countenance, the features of which were of the most ordinary cast, and his nose, which, in consequence of an accident . . . had been almost laid flat, gave him an equally vulgar and unpleasant air. His abilities were indeed of a very limited description. . . .' D.D.

LITERATURE McLean 1830, fol. 2; Wright and Evans 1851, no. 3; Wright [1873], p. 36; George 1935, v, no. 5997; George 1959, I, p. 166.

ANON. (attributed to James Gillray)

189 The Thunderer

Etching. *Pub^d Aug^t 20th 1782 by E^h D'Achery*
St. James's Street
31.5 × 22.8 cm
The Whitworth Art Gallery, University of Manchester

This satire on Tarleton is an obvious parody of Reynolds's portrait (Cat. 129), especially the flamboyant plumed helmet and tightly breeched muscular legs, but the immediate source, very closely followed, seems to have been a small engraved version of the Reynolds in *The Westminster Magazine* for 1 April 1782. The expression of the face has subtly changed from the alertness and ardour suggested by Reynolds to a cold arrogance. Tarleton is transposed from the American battlefield to a low London chop-house, above the door of which appears his lover, Mrs Robinson, impaled like an inn sign for 'The Whirligig' (the punishment of army prostitutes) with many sexual innuendos; a striking contrast to the dignified refinement expressed in portraits of her by Reynolds (Cat. 128) and others. Tarleton's companion is the Prince of Wales, Mrs Robinson's former lover, identifiable by the ostrich feathers which replace his head, and the dialogue is wittily adapted from Ben Jonson's *Every man in his humour*, one of the most popular comedies since Garrick's

revival of 1751 (Cat. 69). Jonson's character Bobadil is a worthless adventurer who brags about his fictitious exploits and privations in foreign wars, especially about his skills in swordplay. Equally pointed is the quotation identifying the Prince, who moved in the same gambling and racing set as Tarleton, as Jonson's vain 'country gull' Stephen, who foolishly imitates Bobadil's swaggering and oaths. The allusions insinuate, as did many of Tarleton's detractors, that his conduct as a commander in America depended more on rash individual feats than on wise consultation and strategy. There was mounting criticism of his disastrous defeat at Cowpens (1781) which in retrospect seemed a turning point in the war, and which Tarleton sought to justify in his egocentric *History of the Campaigns of 1780 and 1781, in the Southern Provinces of North America*, published in 1787. There is thus a typical polarity between the stirring heroics of the Reynolds portrait and the cynicism of the satire, which may more faithfully reflect contemporary estimation. Horace Walpole remarked: 'Tarleton boasts of having butchered more men and lain with more women than anybody else in the army,' to which Sheridan replied: 'Lain with! What a weak expression! He should have said ravished. Rapes are the relaxation of murderers!' D.D.

LITERATURE Wright and Evans 1851, no. 378; Wright [1873], p. 41 (both with erroneous identification); George 1935, v, no. 6116; Bass 1957, p. 201; Potterton 1976, p. 36.

JAMES SAYER[S]

190 Carlo Khan's triumphal Entry into Leadenhall Street

Etching. *Published 5th Dec. 1783 by Thomas Cornell Bruton Street*
29.7 × 22.4 cm
The Whitworth Art Gallery, University of Manchester

The spate of mock-heroic and libellous satire directed against the Fox-North Coalition of 1783 makes an interesting comparison with the statesmanlike dignity of Reynolds's portrait of Fox, commemorating this important episode in his political career (Cat. 135). The measure which brought down the Coalition was the East India Bill, which Fox, on the evidence of his correspondence with Reynolds, nevertheless saw as the main political and moral achievement of his ministry (see introductory essay pp. 358–9). The bill sought to reform the East India Company's finances and administration of its Indian subjects by a transfer of authority from the Company's directors and proprietors to a council of commissioners appointed by the Government; it was defeated by the intervention of the King, Fox's bitter enemy, in the House of Lords. It was widely believed that the ulterior motive of the Whigs in the bill was to augment and perpetuate the

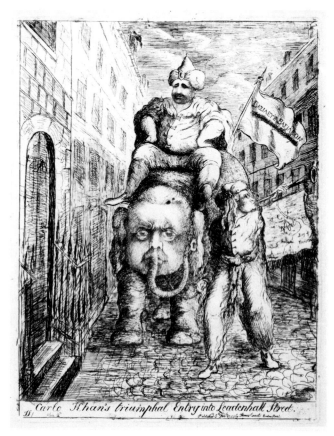

190

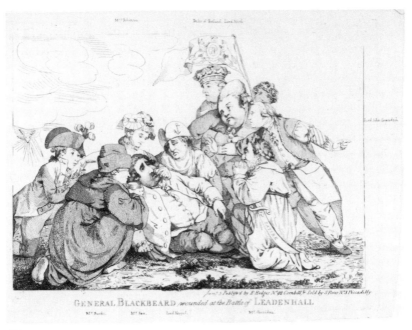

191

GENERAL BLACKBEARD *wounded at the Battle of* LEADENHALL.

power of their administration through the appointment of the India commissioners, and to reduce the influence of the King; indeed, the challenge to the royal prerogative became the key issue of this ministry, which Sayers has brilliantly brought out. With an aptness based not only on political roles but on physical appearances, Fox, the erstwhile 'Man of the People' (the words are crossed out on the banner), is transformed into the 'King of Kings', an Indian prince riding on the back of his fellow Secretary of State, Lord North, as a passive but worried-looking elephant, led by Burke, who had drafted the bill, as herald; above, a raven portends doom. They approach the East India Company's office in Leadenhall Street in a burlesque scene of triumph which recalls Coypel's then very familiar *Sancho Panza's Entry as Governor of Barataria*, one of the Don Quixote series engraved by Tardieu, and used to illustrate Thomas Shelton's translation of Cervantes in 1731, with prints by Van der Gucht. Sayers, although an amateur draughtsman with an unsure grasp of perspective, attracted attention through his striking graphic symbolism and personal caricatures. His group of anti-Fox satires, for which he was rewarded with a sinecure by Pitt, were among the most famous political satires of the eighteenth century, impressing the Prussian visitor, Archenholtz (whose *A Picture of England* appeared in translation in 1791) as prime examples of British freedom of opinion in this field. Fox complained that they 'had done him more mischief than the debates in Parliament or the works of the press'; Wraxall noted: 'Ridicule and satire joined their aid to expose the Coalition to laughter or contempt. . . . It is difficult to conceive the moral operation and wide diffusion of these caricatures through every part of the country.' D.D.

LITERATURE Twiss 1844, I, p. 162; Wraxall 1884, III, p. 254; George 1935, V, no. 6276; George 1959, I, p. 169; Cannon 1969, p. 118.

JOHN BOYNE

191 General Blackbeard wounded at the Battle of Leadenhall

Etching. *Jan.* 5 *Publish'd by E. Hedges No. 92, Cornhill & Sold by S. Fores No. 3 Piccadilly* [1784]
23.4 × 32.5 cm
The Trustees of the British Museum

Fox is shown after his dismissal from office by the King following the defeat of the East India Bill (Cat. 135, 190). He is succoured by his Whig colleagues who include Burke as a monk (in mocking reference to his supposed Catholic sympathies: compare Cat. 194), Admiral Keppel (see Cat. 187, 188), the obese Lord North and Sheridan with a laurel wreath and the sabre of 'Satire'. Mrs Robinson (see Cat. 128 and 189), Fox's admirer and one-time lover, administers a smelling-bottle, while another of her former lovers, the Prince of Wales, kisses her hand. The whole composition is clearly a parody of Benjamin West's *Death of Wolfe*, which had become enormously popular through Woollett's engraving.

The mock-heroic vein of this and other anti-Fox satires ridicules the Whig claims to patriotic reforming zeal and to the popular voice ('*Vox populi*' appears with the ironic Coalition symbols of the fox and badger on the banner). But the allusion to an emotive scene of death at the moment of victory also suggests that Fox still hoped that his opposition to Pitt in the Commons would soon restore him to power.

Fox's nicknames and appearance in the prints correspond with the descriptions of contemporaries such as Carl Philip Moritz, who saw him speaking in the House in 1782; . . .

'dark, small, thickset, generally ill-groomed and looks rather like a Jew, nevertheless ... his political sagacity is evident in his eyes ...'. D.D.

LITERATURE George 1938, VI, no. 6367.

ANON. (James Gillray)

192 The Political-Banditti assailing the Saviour of India

Etching and aquatint, hand-coloured. *Pubᵈ May 11th
1786, by Willᵐ Holland. No. 66 Drury Lane*
28.4 × 40.6 cm
The Trustees of the British Museum

This satire on the Whig Opposition's campaign to impeach Warren Hastings, the former Governor-General of India (see Cat. 66, 67), reveals the hallmarks of the mature Gillray in its vivid caricatures and imaginative energy, but also in its jaundiced and equivocal view of politics. Charges which included corruption, extortion, and criminal acts against the Indian people were then being drawn up, with a view to securing the assent of the House of Commons to Hastings's impeachment, and Gillray stresses the leading role of Burke, shown firing a blunderbuss at point blank range at Hastings's 'Shield of Honor'. The accusers are picturesquely

accoutred, very much as in the popular etchings of fanciful 'banditti' subjects by J. H. Mortimer, a mockery of the crusading spirit to which the Whigs laid claim. Burke's exaggerated emaciation, Quixotic armour and Jesuit's biretta make him an eccentric fanatic, while his bare feet suggest the poverty which was believed to have exacerbated his hostility to the East India Company. Fox (compare Cat. 190, 191) is a blustering actor, and the inscription on North's scabbard sarcastically compares his loss of America with the successes of Hastings in India. The latter, with his 'look commanding' also described by Wraxall, recalls the earlier portrayal by Reynolds. The characterization is, however, deeply ironic. The 'Saviour of India' is surrounded by bulging money bags, representing the ruthlessly acquired profits of the East India Company and his alleged personal fortune, as described in the mock-heroic *Hastiniad* of 1785. The 'Eastern Gems for the British Crown', echoed by the crown on the shield, suggest the royal protection Hastings was assumed to have bought. His self-defence in the Commons had generally failed to convince, and the *Morning Herald* of 11 May 1786, the day Gillray's print appeared, was indignant that 'the probable acquisition of wealth' was given as justification 'for taking up arms against my neighbours'. Hastings's disdainful unwillingness either to accept or to counter well-founded public criticism is ably conveyed by Gillray. D.D.

LITERATURE Wright and Evans 1851, no. 31; George 1938, VI, no. 6955; George 1959, I, p. 190; Hill 1965, p. 30.

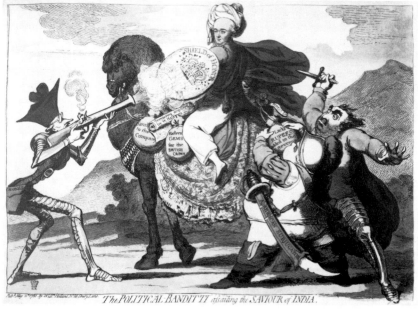

192

ANON. (James Gillray)

193 Blood on Thunder fording the Red Sea

Etching, hand-coloured. *Pub^d March 1st 1788 by S. W. Fores, No. 3 Piccadilly*
22.2 × 32.8 cm
The Trustees of the British Museum

What appears at first sight to be an outraged condemnation of Warren Hastings for cruelties against the Indians is likely to be as tongue-in-cheek as Gillray's earlier satire ostensibly taking the other side (Cat. 192). Hastings, secure with his misappropriated bags of '£4,000,000' rides on the back of his strongest champion, the supposedly venal Lord Chancellor Thurlow, and fastidiously draws up his feet to avoid contamination in the water stained by mutilated corpses. However, it is probable that the 'Red Sea' actually represents the tide of public hysteria and wild accusation in the Press generated by the emotive oratory of Burke and the other 'managers' of the impeachment, which had just opened in a packed Westminster Hall, with seat tickets changing hands at fifty guineas. While Burke claimed to act 'in the name of the Indian Millions, whom he has sacrificed to Injustice, . . . in the name . . . of Human Nature, which he has stabbed to the heart', he was clearly playing to the gallery in the description of atrocities, which, he wrote privately, 'will, if any thing, work upon the popular sense'. Another print of this time is called the trial 'The Raree show . . . A Tragi-Comi-Exhibition called the Nabob in Purgatory'. This tinge of cynicism is confirmed by the comical fierceness of Gillray's Thurlow (compare Cat. 127) whose 'sullen scowl' was celebrated in *The Rolliad* and, according to the satirists, once struck his horse dead with fright. D.D.

LITERATURE Wright and Evans 1851, no. 30; Wright [1873], p. 95; George 1938, VI, no. 7278; George 1959, I, p. 193.

ANON. (James Gillray)

194 Smelling out a Rat;—or—The Atheistical-Revolutionist disturbed in his Midnight 'Calculations'

Etching, hand-coloured. *Pub^d Dec^r 3d 1790 by H. Humphrey No. 18 Old Bond Street*
24.4 × 34.4 cm
The Trustees of the British Museum

The satirists' many characterizations of Burke as a political fanatic may be compared with the subdued suggestion of intellectual tension and vehemence in Reynolds's portrait (see Cat. 71) and with Fanny Burney's observation (1791) that

193

Smelling out a Rat,___ or The Atheistical Revolutionist disturbed in his Midnight Calculations.

194

in political discussions 'his irritability is so terrible . . . that it gives immediately to his face the expression of a man who is going to defend himself from murderers'. Burke's *Reflections on the Revolution in France* had been published in November 1790, and Gillray's extraordinarily ambiguous and two-edged satire appeared a month later. Burke is reduced to a monstrous caricature cipher of the long nose and spectacles by which he was already recognizable in the satirical prints (compare Cat. 192). In the fantastic apparitional manner of his own metaphors, he ferrets out the dissenter, Dr Richard Price, whose sermon praising the French Revolution, published by the Revolution Society, had occasioned Burke's *Reflections*. Burke believed that Price's intention was to incite a dangerous imitation of French political ideals in England. The imaginary tracts advocating 'Anarchy, Regicide, Atheism' which Price is here shown penning beneath a picture of the execution of Charles I, are probably Gillray's sceptical comment on this conspiracy theory.

Burke's reaction to the French Revolution was at first widely discredited as paranoiac exaggeration, or as propaganda for the administration and landed class prompted by self-interest. His dramatic defence of monarchy and religion are here humorously symbolized in the irradiated crown and cross he brandishes; the latter hints, too, at disguised Catholic sympathies. There is a further irony in the idea of 'Smelling out a Rat'. The dissenting group, former Pittites, seemed to Burke to have turned rebel, but Burke himself, the former opponent of royal dominance (see Cat. 190, 192), now 'rats' on his Whig colleagues in his invective against liberalism.

D.D.

LITERATURE McLean 1830, fol. 15; Wright and Evans 1851, no. 45; Wright [1873], p. 123; George 1938, VI, no. 7686; George 1959, I, p. 211; Hill 1965, p. 42; Hill 1966, no. 3; Paulson 1983, pp. 183, 203.

IV
The Muses: Literature and the Stage

MATTHEW DARLY

195 Title page illustration to 'The Theatres. A Poetical Dissection. By Sir Nicholas Nipclose', London 1772

Engraving and etching
11 × 13.5 cm
British Library

The popularity of Reynolds's *Garrick between Tragedy and Comedy* (Cat. 42) and Garrick's publicity consciousness, are attested by the fourteen different mezzotints of the painting which survive. Here the familiar image, celebrating Garrick's equal accomplishment as a tragic and comic actor, is turned against him in Darly's travesty. It appears on the title page of a satirical poem by a supporter of Foote, attacking Garrick (among other targets) for shabby treatment of actors, declining powers and avarice. 'Behold the Muses ROSCIUS sue in Vain/Taylors & Carpenters usurp their Reign.' Tragedy and Comedy, as equally respected dramatic forms, are now both on one side, and both try unsuccessfully to attract Garrick's attention, as he turns towards a Drury Lane tailor, scene-

and political prejudices were reflected in unsympathetic criticism of poets such as Milton and Gray; a severity that the satirist puts down to envy. The nickname 'Pomposo' comes from Charles Churchill's politically hostile satire, *The Ghost* of 1762, the year in which Johnson received his pension from Bute. Churchill described Johnson as 'a slave to Interest', vain, yet 'horrid, unwieldy, without form'. In the present print his ungainly bulk is ludicrously contrasted with Apollo's lithe grace. Reynolds, in his portraits of Johnson (Cat. 73, 80), had succeeded in revealing the varied qualities of his mind which dignified his heavy features; here, however, the face is a slightly caricatured version of Trotter's naturalistic etched portrait of 1782 (suppressed as too ugly for use as a frontispiece to the second volume of *The Beauties of Johnson*), which the satire follows in showing even Johnson's scrofula scars. His friends were conscious of his vulnerability to ridicule on the grounds of physical appearance. Frances Reynolds, the artist's sister, refused to describe him in print: 'it might probably excite some person to delineate it, and I might have the mortification of seeing it hung up at a print-shop as the greatest curiosity ever exhibited.' Nevertheless, when Johnson was told about this print at Reynolds's house,

he was unperturbed. 'I hope the day will never arrive when I shall neither be the object of calumny or ridicule, for then I shall be neglected and forgotten.' D.D.

LITERATURE Hill 1897, II, pp. 260–1, 419–20; George 1935, V, no. 6328; George 1967, pp. 128–9.

ANON. (James Gillray)

197 Melpomene

Etching and aquatint, printed in sepia. *Pub^d Dec^r 6th 1784 by J. Ridgeway No. 196 Piccadilly, London*
32.5 × 24.1 cm
The Trustees of the British Museum

In the wake of the immense success of Reynolds's *Mrs Siddons as the Tragic Muse* at the Academy exhibition in 1784 (see Cat. 134, 151) Gillray produced this cruel satire, which directly echoes it in the personification as Melpomene, imitating Reynolds as Reynolds had imitated Michelangelo.

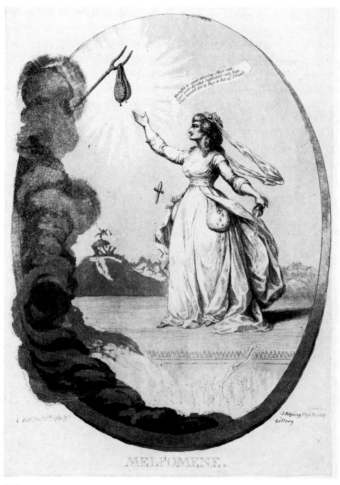

197

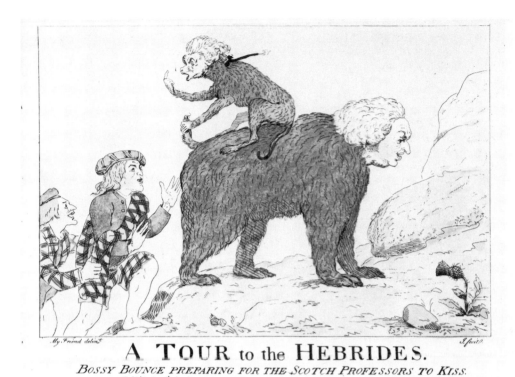

A TOUR to the HEBRIDES.

BOSSY BOUNCE PREPARING FOR THE SCOTCH PROFESSORS TO KISS.

Published 19.ᵗʰ April 1786. by S. W. Fores at the Caricature Warehouse Nᵒ 3 Piccadilly.

198

Gillray seems to make his own bid for 'high art' prestige in the qualities of technique and design, which are unusual for a satirical print of this date. While Reynolds embodied for posterity Mrs Siddons's triumphant reputation as an actress, Gillray, in an oval composition with rather the look of a memorial tablet, transmits the contemporary accusations of meanness and 'the most extreme hardness of heart'. Jealous rivals asserted that Mrs Siddons, despite her huge earnings, sometimes refused to appear in benefits for colleagues, or, if she did, required payment. A fellow performer, Charles Lee Lewes, described this malicious 'paper war' in his *Memoirs*. According to Mrs Siddons's biographer, Boaden, 'the theatrical world suggesting to the newspapers, a vast deal of the most positive assertion was poured out in the daily prints, which was canvassed in the morning at the tea-table But greatness is always in danger.' On 5 October 1784 she was hissed off the stage, and there were cat-calls on later occasions. Gillray's Mrs Siddons is shown in a pose as dramatic as that chosen by Reynolds, but aspiring only to the purse on the devil's pitchfork, her pockets full of coins and banknotes, while the cup and dagger of Tragedy are now discarded and the temple of Fame collapses in ruin. It is noticeable that while Reynolds contrived through expression and viewing angle to idealize Mrs Siddons's face, Gillray's profile confirms Walpole's verdict of 'neither nose nor chin according to the Greek standard, beyond which both advance a good deal'.　　　　　　　　　　　　　　D.D.

LITERATURE Wright [1873], p. 68; Paston 1905, p. 52; George 1938, VI, no. 6712; George 1967, p. 108.

ANON.

198　A Tour to the Hebrides. Bossy Bounce preparing for the Scotch Professors to Kiss

Etching, hand-coloured. *Published 19th April 1786, by S. W. Fores at the Caricature Warehouse, No. 3 Piccadilly*
15.6 × 22.8 cm
The Trustees of the British Museum

Boswell, as a monkey, rides on the back of Johnson, as a bear, whose tail he lifts for the kiss of two eager Scots, while even the thistle seems to do homage. This is one of many satires arising from the publication, late in 1785, of Boswell's *Journal of a tour to the Hebrides with Samuel Johnson LL.D.* The tour, which had taken place in 1773, had already been recorded in Johnson's own *A journey to the Western Isles of Scotland*, published in 1775; but whereas in the latter the travellers' experiences are abstracted in general reflections on Scottish society and history, Boswell's *Journal* presents a highly entertaining, and at times excessively candid, episodic narrative (see also Cat. 199). Boswell mustered as many as possible of the Scottish nobility and academics to dance attendance on 'the mighty sage' as deferential conversationalists, and Johnson's hosts, even in the remotest parts, were ingenuously expected to share Boswell's adulation. But, at the same time, many of the revelations of Johnson's arrogant condescension, rudeness and peevishness were felt by

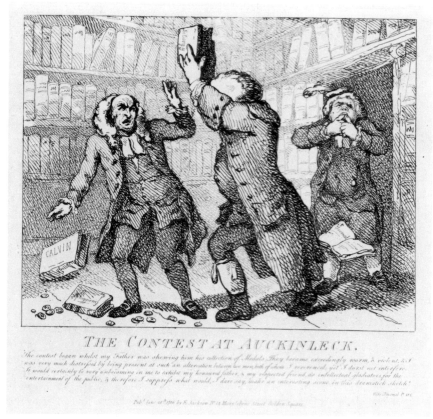

THE CONTEST AT AUCKINLECK.

The contest began whilst my Father was shewing him his collection of Medals. They became exceedingly warm, & violent, & I was very much distressed by being present at such an altercation between two men both of whom I reverenced, yet I durst not interfere. It would certainly be very unbecoming in me to exhibit my honoured father, & my respected friend, as intellectual gladiators for the entertainment of the public, & therefore I suppress what would, I dare say, make an interesting scene in this dramatick sketch.

Pub.d June 10.th 1786 by E. Jackson N.o 14 Marylebone Street Golden Square.

199

Boswell's readers (even as they relished them) to have tarnished his memory, and Walpole was amused by the irony of the inscription on the present print: 'My Friend delin[eavi]t'. An inscription on another caricature made Johnson's ghost complain:

> First, Boswell, with officious care,
> Show'd me as men would show a bear,
> And call'd himself my friend . . .

The simile of the bear also occurred to Lord Auchinleck and Mrs Boswell. Boswell later quoted, in the *Life* of Johnson, John Courtenay's tribute to the *Journal*:

> With Reynolds's pencil, vivid, bold and true,
> So fervent Boswell gives him to our view . . .

There is an interesting comparison to be made between the portrayal of Johnson in the *Journal* and Reynolds's portraits, which perhaps more successfully balance a consciousness of Johnson's frailties with an expression of his overpowering intellectual distinction. The objections to the personal details which Boswell, and his rival Mrs Thrale, supplied in their accounts of Johnson reflect the prevailing notions of decorum in public imagery, which affected the response both to the portraits of Reynolds and to the satirical prints. D.D.

LITERATURE Walpole 1937–83, XXV, pp. 640–1; George 1938, VI, no. 7029.

ANON. (Thomas Rowlandson after Samuel Collings)

199 'The Contest at Auchinleck': from the series 'Picturesque Beauties of Boswell . . . Designed and Etched by two Capital Artists', part II, no. 9, 1786

Etching. *Pub.d June 10th by E. Jackson No. 14 Marylebone Street Golden Square*
18.8 × 24.4 cm
Andrew Edmunds

This set of twenty plates from the drawings of Collings, a painter and caricaturist, is a hilarious visual commentary on Boswell's *Journal of a tour to the Hebrides* (see Cat. 198) with quotations from the book. It depicts the primitive landscape and living conditions of the Highlands which Johnson commented on so freely, and makes fun of the incidents revealing Boswell's vanity, naiveté and dread of offending Johnson, now that he had succeeded in enticing him 'to this remote part of the world . . . I compared myself to a dog who has got hold of a large piece of meat, and run away with it to a corner, where he may devour it in peace . . .' The incident

ridiculed here is typical of Johnson's extraordinary tactlessness and intellectual pugnacity. He promised Boswell to avoid argument with their host Lord Auchinleck, Boswell's father, 'as sanguine a Whig and Presbyterian, as Dr. Johnson was a Tory and Church of England man', but they soon 'came in collision . . . They became exceedingly warm, and violent, and I was very much distressed . . .'. For once, Boswell veiled the details which might have provided 'the entertainment of the publick' and is shown here clapping his hands over his mouth and dropping his *Journal*. D.D.

LITERATURE Grego 1880, I, pp. 197–8; Angelo 1904, I, p. 333; Paston 1905, pp. 70–1; George 1938, VI, no. 7049; Wolf 1945, pp. 192–3.

V

Manners and Morals

ANON.

200 'The Countess of L——a' and 'Scotius': illustration to the 'Histories of the Tête-à-tête annexed', nos 22, 23, in 'The Town and Country Magazine', vol. I, August 1769, facing p. 393

Engraving and etching
Each oval 7.2 × 5.7 cm
The Curators of the Bodleian Library

High society life in the eighteenth century was lived in the glare of publicity, much of it malicious. The notorious 'Tête-à-Tête' series, illustrated with portraits often derived from prints after Reynolds, or from engravings in books and magazines, reported the illicit amours of well-known people. It was often deplored as the lowest gutter journalism, but ran for over twenty years and obviously sold the magazine in which it appeared. Goldsmith's absurd Mrs Hardcastle in *She Stoops to Conquer* read it zealously in an effort to keep abreast of London standards of sophistication. However, the Rev. William Cole, recalling the occasion when his friend Horace Walpole had figured in it, condemned the lies it spread: 'Should such practises be allowed in any civilised country? It is carrying the liberty of the press to such an excess that it disquiets private families, and turns the head of the people.' Much of the information came from anonymous correspondents. In the first scene of *The School for Scandal* by Sheridan (1777) there is talk of a gossip who more than once has caused 'a Tête-à-Tête in the Town and Country Magazine—when the Parties perhaps have never seen each other's Faces before in the course of their lives'. Where it is possible to check the veracity of the articles, however, it is clear that they contained some facts, although padded out with rumours and often inaccurate, and they were made more readable by the candid appraisal of character, often allowing virtues as well as vices in their subjects. With some disingenuousness the *Magazine* suggested in August 1771 (p. 401) 'that suppressing this publication would be depriving posterity of a very curious piece of biography' which 'would furnish a lesson to future historians to adopt an impartial medium, which they seldom pursue, their characters being too frequently either gods or devils . . .'. Reynolds himself was featured in 1779 as the alleged lover of a Miss Jennings, and the present example describes the affair between the 'Contessa della Rena' (see Cat. 43) and the Earl of March, which had, in fact recently ended. D.D.

LITERATURE Stephens 1883, IV, no. 4358; Bleackley 1905, pp. 241–2.

200

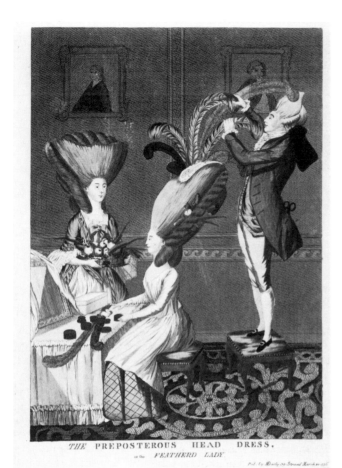

THE PREPOSTEROUS HEAD DRESS,
or the FEATHERD LADY.

201

201 The Preposterous Head Dress, or The Featherd [sic] Lady

Etching, hand-coloured. *Pub. by M. Darly, 39 Strand March 20, 1776*
31.3 × 22.2 cm
The Trustees of the British Museum

In one of many similar satires of the late 1770s, a lady puts on cosmetics, while her hairdresser arranges the ostrich plumes which crown her huge coiffure, decorated with side-curls and vegetables (see also Cat. 202). This may be compared with the unfavourable description of court dress in the Duchess of Devonshire's semi-autobiographical novel *The Sylph* (1779), Letter VIII: 'what with curls, flowers, ribbands, feathers, lace, jewels, fruit and ten thousand other things, my head was . . . three-quarters of a yard high, besides six enormous feathers . . .'. But the Duchess in fact led the fashion for high plumes, and it is interesting to note how Reynolds modified their effect in his portrait of 1776 (Cat. 102), reducing and curving them back to flow into the rhythm of the draperies. That this was not for aesthetic reasons alone is suggested by the many pamphlet satires on the Duchess, and

public criticisms of the fashion as meretricious and immoral; and it may even have had a political tinge, since Lady Louisa Stuart, commenting on the Queen's dislike of tall feathers, remembered that ladies connected with the Whig Opposition were 'glad to set her Majesty at defiance' and express their disaffection by wearing ostrich plumes. Sophie von la Roche, visiting England in 1786, did 'not find the general taste in pompous hair-dressing . . . at all pretty and graceful. Perhaps the fact that I had pictured English women like the originals of Reynolds's pictures, nobly and simply attired with Greek *coiffure*, accounts for this.' D.D.

LITERATURE Paston 1905, p. 22; George 1935, V, no. 5370.

202 Chloe's Cushion or The Cork Rump

Etching, hand-coloured. *Pub. Jan. 1. 1777 by M. Darly 39 Strand*
33.3 × 21.9 cm
The Trustees of the British Museum

This is one of a large group of caricatures of fashion, particularly of the vast pyramid-shaped coiffures (see also Cat. 201)

CHLOE'S CUSHION OR THE CORK RUMP.

202

A Peep into LADY W!!!!!'s Seraglio.

203

and 'cork rumps' or bustles of the time. Most were published by Matthew Darly in 1776–7, at which period many similar allusions occur in plays and verse by Anstey, Sheridan and Garrick. It is striking that they coincide with Reynolds's most classicizing phase in portraits of women (see, for example, Cat. 90, 91, 102, 103, 106), in which he sought to mitigate the passing extremes of fashion as much as the satirists exaggerated them. Reynolds believed that he 'who in . . . portrait-painting wishes to dignify his subject . . . will not paint her in the modern dress, the familiarity of which alone is sufficient to destroy all dignity' (Seventh Discourse, 1776; see p. 362 above). Many prospective customers may have disagreed: the satirist 'Peter Pindar' inveighed against the 'pretty Misses' visiting the Royal Academy exhibition who enthused over the realistically painted fashionable dress of inferior portraits, 'Whilst unobserv'd, the glory of our Nation/Close by them hung SIR JOSHUA's matchless pieces'. Reynolds's flowing draperies are quite different from the real formal dress of the time shown in this satire, with its tight corseting, looped-up gown 'à la Polonaise', elaborately decorated stomacher and flounced petticoat. Reynolds anticipated, and may actually have influenced, the softer, less structured styles of dress worn in the 1780s. D.D.

LITERATURE George 1935, V, no. 5429.

ANON. (attributed to James Gillray)

203 A Peep into Lady W!!!!!y's Seraglio

Etching. Pubᵈ April 29th 1782 by W. Humphrey No. 227 Strand
23.4 × 34.4 cm
The Trustees of the British Museum

The insouciance and provocative boldness which Reynolds conveyed in his portrait of Lady Worsley (Cat. 118) are evidence of his astute grasp of character; for soon after she had sat for him she became notorious through a much publicized case of 'criminal conversation', brought by her husband, Sir Richard Worsley, antiquarian, Member of Parliament, Governor of the Isle of Wight and Colonel in the Hampshire militia, against his colleague, Captain George Bissett, for damages of £20,000. The adultery was uncontested, but damages of only a shilling were awarded, on the ground that Worsley had encouraged Bissett's voyeurism, on one occasion lifting him on his shoulders to spy on Lady Worsley through the window of a bath house in Maidstone, which she frequented while the couple lived at Coxheath military camp. The incident provided the titillating scene shown in an anonymous print attributed to Gillray and published by Humphrey (George 1935, V, no. 6110). Evidently still cashing in on the public's eagerness for details of the Worsley scandal (see Cat. 118), Humphrey published this cutaway view of the insatiable Lady Worsley's bedroom, with a painting of the chaste Lucretia ironically hung over the door, and a long queue of lovers waiting on the stairs. This flight of fancy related to the lurid accounts of Lady Worsley's promiscuity, in the many pamphlets based on gossip and the legal evidence. The Memoirs of Sir Finical Whimsy and His Lady gave her at least eighteen lovers who 'have been the subject of tea table animadversions among the ton', while in Variety, or, which is the man? this 'great Lady of renown/The talk and scandal of a town' is made to boast of the 'strange motley crew' of lovers she has shamelessly taken to her bed, the list closely corresponding to the print. The most shocking aspect of the behaviour attributed to her was her total indifference to public opinion. At a time when the editor of a volume of divorce reports of 1779–81 remarked that 'conjugal infidelity is become so general that it is hardly considered as criminal, especially in the fashionable world', there was nevertheless still a distinction made between private conduct and the open flouting of convention, an issue which also arose in connection with the popularity of engravings from glamourizing portraits of courtesans by Reynolds and others. D.D.

LITERATURE George 1935, V, no. 6112.

ANON. (James Gillray)

204 St Cecilia

Etching, hand-coloured. *Pub^d April 24th 1782 by H. Humphrey New Bond Street*
16.9 × 13.4 cm
The Trustees of the British Museum

This satire on Lady Cecilia Johnston, a daughter of Lord Delawarr, is a direct burlesque of the portrait of Mrs Sheridan by Reynolds as 'A lady in the character of S. Cae-

204

cilia', which was familiar from Dickinson's engraving (Cat. 94). In imitating the exalted allegorical mode of the original, Gillray plays on the incongruity by which his fifty-five-year-old subject, mockingly referred to by her contemporaries as 'the divine' or 'St Cecilia', has been substituted for Reynolds's appropriately personified sitter, with squalling cats in place of the child angels. The sour and sharp-featured characterization recalls Horace Walpole's verdict on Lady Cecilia, that 'her narrow mind . . . never cultivated any seed but that of wormwood'; but the marked animosity of Gillray, or perhaps of an unknown sponsor, which prompted the frequent satires of her (compare Cat. 208) is unexplained.

D.D.

LITERATURE McLean 1830, fol. 20; Wright and Evans 1851, no. 392; Wright [1873], p. 35; Paston 1905, p. 27; George 1935, v, no. 6104.

ANON. (Thomas Rowlandson)

205 Wit's Last Stake, or The Cobling Voters and Abject Canvassers

Etching. [1784]
22.2 × 32.5
The Trustees of the British Museum

Georgiana, Duchess of Devonshire, celebrated by the portraitists as the darling of fashionable society (Cat. 102, 139), became, in 1784, the prime target of political satire, when she led the Whig grand ladies who canvassed for Fox during the Westminster election. The propaganda collected in the *History of the Westminster Election* (the second edition, 1785, in the British Museum Print Room, contains this and other prints) and Georgiana's agonized correspondence with her mother, make clear the extent to which a lady risked her reputation by such an involvement in public affairs. The supporters of Fox's opponent, Wray, slandered her, predictably, as a debauchee dispensing kisses to butchers; 'the print-shops exhibit in the most striking colours the depravity of the present day,' claimed one newspaper, '. . . When titled personages deign to become associates with the lowest publicans . . . the sarcasms and indecencies to which they expose themselves cannot be too plainly or too publicly held out.' But this ploy seems to have backfired, and Fox's ultimate narrow victory over Wray after forty days of polling, was recognized both as the effect of Georgiana's 'irresistible manners' (Wraxall) and as a vindication of her integrity. The opportunist Rowlandson, on the payroll of both sides, produced a series of naturalistic sketches which raised the vitality, if not the tone, of political satire. In this example, Georgiana, perched informally on Fox's knee in a slum street, pretending to have her shoe mended, passes large sums to the cobbler's wife, while a scavenger and a sweep are plied with drink; thus the many accusations of bribery, of collecting unqualified voters (only householders who paid poor rates were enfranchised) and of inciting drunken disorder are illustrated. But in Rowlandson's prints the obsessive contrast of plebeian coarseness with the Duchess's delicate beauty is more evident than either politics or malice. (See also Cat. 206.)

D.D.

LITERATURE Wright [1873], pp. 63–4 (as a joint work of Rowlandson and Gillray); Grego 1880, I, pp. 130–2; Paston 1905, p. 24; Walpole 1937–83, XXV, p. 495; George 1938, VI, no. 6548; George 1959, I, p. 185.

ANON. (Thomas Rowlandson)

206 Political Affection

Etching. *Pub^d April 22 1784 by Jn.^o Hanyer Strand*
22.3 × 32.7 cm
The Trustees of the British Museum

In this playful satire on the Duchess of Devonshire's canvassing for Fox during the Westminster election (see Cat. 205), her alleged improper attachment to him suggests an image

WIT'S LAST STAKE OR THE COBLING VOTERS and ABJECT CANVASSERS.

205

redolent of the 'Roman Charity' tradition, but also of Rowlandson's familiar erotic contrast of beauty and bestiality. Wittily adapting the old conventions of political satire, Fox is shown as an outsize fox, dressed as an infant and suckled by the Duchess, while the real nine-month-old Georgiana cries in vain, and the unnatural coupling of the cat (neglecting its kitten) and dog provides a symbolic counterpart. The satire is an interesting indication that the Duchess's Rousseau-inspired advocacy of breast-feeding was common knowledge, probably through prints like one called *The Duchess of Devonshire in the character of a mother*, and it provides a piquant comparison with Reynolds's slightly later portrait of the Duchess in her maternal rôle (see Cat. 139). On the left, Rowlandson shows Reynolds's portrait of the Duke of Devonshire (Althorp), probably alluding to the rumours of his annoyance at Georgiana's public exposure and vast expenditure in electioneering, from which, however, he would, as a peer, have been debarred. It also echoes a newspaper jibe: 'While her Grace is busied in canvassing the Constituents, her domestic husband is employed in the nursery, singing "Hey my kitten! my kitten!" and comfortably *rocking the Cradle!*'

<div align="right">D.D.</div>

LITERATURE Grego 1880, I, p. 132; George 1938, VI, no. 6546.

POLITICAL AFFECTION.

206

THOMAS ROWLANDSON (after Henry Wigstead)

207 Box Lobby Loungers

Etching, stipple and aquatint. *London Publish'd Jan^y 5th 1786 by J. R. Smith No. 83 Oxford Street*
38.8 × 56.3 cm
The Trustees of the British Museum

This foyer scene of the audience from the boxes at Covent Garden Theatre gives a vivid impression of the freedom with which different social classes and types mingled in late eighteenth-century London, and in particular the way in which the high-class courtesans, or 'impures of the *ton*', used the many places of public resort, especially theatres and masquerades, for assignation and display. Here Colonel George Hanger, crony of Tarleton and the Prince of Wales, chats with two courtesans dressed in the height of fashion; two others are eyed by rakes, and on the left older men pass money to a bawd, while the playbill titles, *Way of the World* and *Who's the Dupe*, provide an ironic comment. Mrs Robinson (see Cat. 128), when mistress of the Prince of Wales in 1780, appeared in her box at the theatre 'with all the grace and splendour of a Duchess', and later became the 'Priestess of Taste'. Yet the position of such women was equivocal; although they were painted by the leading artists, most memorably by Reynolds, there were often attempts to debar them from polite assemblies, and they suffered both satire and slander. The 'lovers of virtue' who wrote to newspapers objected to the endless publicity they were given in press gossip, and many writers deplored the popularity of engravings from their portraits on show in the print shops. D.D.

LITERATURE Grego 1880, I, pp. 180–2; George 1938, VI, no. 8254; George 1967, p. 107; Hayes 1972, p. 93.

207

ANON. (James Gillray)

208 La Belle Assemblêe [*sic*]

Etching, hand-coloured. *Pub.^d May 12th 1787, by H. Humphrey New Bond Street*
23.1 × 33.4 cm
The Trustees of the British Museum

Gillray's cruel satire on five middle-aged leaders of high society, fashionably dressed with feathers, puffed bosoms and '*derrières*', takes the form of a parody of allegorical portraits by Reynolds, in which beauties in semi-classical draperies are frequently shown as votaries of various divinities, with details very similar to Gillray's, such as the altar decorated with rams' heads. Here the grossly fat Mrs Hobart pours incense on the altar of Venus, and Lady Johnston (see Cat. 203) plays the lyre below a flower-strewn image of the Graces; their three witch-like companions (one of whom, Lady Mount-Edgcumbe, with the doves, had been painted by Reynolds in 1762), bear other emblems of love. Such

parody may in itself satirize the methods by which Reynolds, in turn, based his allegories on quotations from the Old Masters, producing a hybrid of antique allusion and modishness. Mrs Hobart's famed interest in amateur theatricals, in which she often acted and danced young parts, also suggests an echo of the play-acting implicit in Reynolds's portraits of this kind. But whereas portraits of women by Reynolds charac-

208

teristically commemorated youthful prime and marriage, Gillray's caricature typifies the satirists' cruel attitude to older women, an eighteenth-century equivalent of the old morality prints on vanity. D.D.

LITERATURE McLean 1830, fol. 7; Wright and Evans 1851, no. 374; Wright [1873], p. 86; Paston 1905, pp. 27–9; George 1938, VI, no. 7218; Hill 1965, p. 138; Hill 1966, no. 80; George 1967, pp. 62–4.

JAMES GILLRAY

209 The Fashionable Mamma, — or — The Convenience of Modern Dress

Etching with stipple, hand-coloured. *Pub^d Feb^y 15th 1796, by H. Humphrey, New Bond Street*
30.9 × 21.7 cm
The Trustees of the British Museum

According to McLean intended as a 'public admonition' to a specific Viscountess, this is Gillray's typically cynical comment on the revival of breast-feeding in the upper classes. The practice, although not unknown in the 1750s and 1760s, had been promoted in the 1770s and 1780s by the example of the Duchess of Devonshire (see Cat. 139, 206) and other passionate disciples of Rousseau. It is implied in many of Reynolds's portraits (see especially Cat. 52 and 88), which stress the bond of mother and child and the equally Rousseauist indulgence of the playfulness of young children. Gillray's

bored noblewoman, scantily dressed in the 'natural' style of 1790s fashion, inspired by the Enlightenment, is fancifully shown suckling her child through slit pockets, here conveniently raised to breast level. Her icy demeanour and serpentine figure are contrasted with the sweetness of the full-bosomed nursemaid; and 'Maternal Love' in the picture on the wall, a subject which often figured in prints like St Aubin's 'L'heureuse Mère', reflects the prevailing eighteenth-century myth that the children of the supposedly more tender and demonstrative peasant mother thrived better than their 'artificially' reared city counterparts. A further ironic touch is provided by the coach, in which the lady is about to depart for the daily round of dissipation: 'When mothers deign to nurse their own children,' Rousseau had written in *Emile* (1762), 'then will be a reform in morals; natural feeling will revive in every heart . . . The charms of home are the best antidote to vice. . . .' D.D.

LITERATURE McLean 1830, fol. 86; Wright and Evans 1851, no. 415; Wright [1873], p. 209; George 1942, VII, no. 8897; Hill 1965, p. 137.

The Fashionable Mamma, — or — The Convenience of Modern Dress Vide The Pocket Book &c.

209

Bibliography

ADAMS, C. K. and LEWIS, W. S. 'The Portraits of Horace Walpole', *Walpole Society*, XLII (1968–70), 1970, pp. 1–34.

ALEXANDER, D. 'The Dublin Group: Irish Mezzotint Engravers in London, 1750–1775', *Quarterly Bulletin of the Irish Georgian Society*, July–September 1973, pp. 73–93.

ALEXANDER, D. *Mezzotints after Sir Joshua Reynolds (1723–92), a Selection from the Cooper Abbs Collection on exhibition at the Treasurer's House, York*, York 1977.

ALEXANDER, D. See also New Haven 1980 and 1983.

ANGELO, H. *Reminiscences* (ed. H. L. Smith), 2 vols, 1904.

ANNAND, A. M. 'The Prince of Wales (later George IV) 1783', *Journal of the Society for Army Historical Research*, XLVIII, 1970, pp. 1–3.

ANON. *A Candid Review of the Exhibition*, London 1780.

ANON. *An Essay in Two Parts on the Necessity and Form of a Royal Academy*, London 1755.

ANON. *The Conduct of the Royal Academicians, while members of The Incorporated Society of Artists of Great Britain*, London 1771. [Possibly by Robert Strange.]

ANON. *Observations on the Discourses delivered at the Royal Academy*, London 1774.

ANON. *A poetical epistle to Sir Joshua Reynolds*, London 1777.

ANON. *The Ear-Wig; or An Old Woman's Remarks on the present Exhibition of Pictures at the Royal Academy . . . Dedicated to Sir Joshua Reynolds*, London 1781.

ANON. *More lyric odes to the Royal Academicians by a distant relation to the poet of Thebes*, London 1785 and 1786. [By an imitator of 'Pindar', 1785.]

ANON. *Observations on the present state of the Royal Academy by an old artist*, London 1790. [Possibly by James Northcote.]

ARCHIBALD, A. *Catalogue of Portraits in Oil* (National Maritime Museum), London 1961.

ARMSTRONG, W. *Sir Joshua Reynolds*, London 1900.

ARTS COUNCIL *Sir Joshua Reynolds* (by E. K. Waterhouse), 1949.

ARTS COUNCIL (Hayward Gallery) *The Georgian Playhouse: Actors, Artists, Audiences and Architecture 1730–1830s* (by I. Mackintosh), 1975.

ARTS COUNCIL *Samuel Johnson 1709–84* (by Kai Kin Yung), 1984.

ASPINALL, A. (ed.) *The Letters of King George IV 1812–1830*, 3 vols, Cambridge 1938.

BAETJER, K. *European Paintings in the Metropolitan Museum of Art . . . A Summary Catalogue*, 3 vols, New York 1980.

BAKER, C. H. Collins *A Catalogue of British Paintings in the Henry E. Huntington Library and Art Gallery, San Marino*, San Marino 1936.

BALKAN, K. S. 'Sir Joshua's Theory and Practice of Potraiture: a Re-evaluation' (Thesis presented to the University of California 1972), University Microfilms International 1979.

BARETTI, J. (i.e. Joseph for Giuseppe) *A Guide through the Royal Academy*, London 1781.

BARR, B. See York 1973.

BARRY, J. *An Account of a series of pictures in the Great Room of the Society of Arts*, London 1783.

BARRY, J. *A Letter to the Dilettanti Society*, London 1798.

BARRY, J. *Works* (ed. E. Fryer), 2 vols, London 1809.

BASKETT, J. and SNELGROVE, D. *The drawings of Thomas Rowlandson in the Paul Mellon Collection*, New Haven 1977.

BASS, R. D. *The green dragoon: The lives of Banastre Tarleton and Mary Robinson*, London 1957.

BATES, W. *George Cruikshank*, London 1879.

BEATTIE, J. *London Diary 1773* (ed. R. S. Walker), Aberdeen University Studies, 122, Aberdeen 1946.

BECKER, W. *Paris und die deutsche Malerei, 1750–1840*, Munich 1971.

BEECHEY, H. W. 'Memoir' attached to *The Literary Works of Sir Joshua Reynolds*, 2 vols, London 1835.

BERRIMAN, H. See Plymouth 1973.

BICKLEY, F. *The Diaries of Sylvester Douglas*, London 1928.

BIEBER, M. *The History of the Greek and Roman Theater*, Princeton and London 1961.

BIRMINGHAM *Exhibition of Works by Sir Joshua Reynolds* (by J. Woodward and M. Cormack), 1961.

BINYON, L. *Catalogue of Drawings by British artists and artists of foreign origin working in Great Britain, preserved in the Department of Prints and Drawings in the British Museum*, 4 vols, London 1898–1907.

LE BLANC, L'Abbé *Letters on the English and French Nations*, 2 vols, Dublin 1747.

BLEACKLEY, H. 'Tête-à-Tête portraits in The Town and Country Magazine', *Notes and Queries*, 10th series, IV, 23 September 1905, pp. 241–2.

BLEACKLEY, H. *Casanova in England*, London 1923.

BLEACKLEY, R. M. 'The Beautiful Misses Gunning', *Connoisseur*, XII, 1905, pp. 158ff., 227ff., XIII, 1906, pp. 198ff.

BLUNT, A. 'Blake's Pictorial Imagination', *Journal of the Warburg and Courtauld Institutes*, VI, 1943, pp. 190–212.

BLUNT, R. *Mrs. Montagu, 'Queen of the Blues'*, 2 vols, London 1925.

BOCK, H. 'Joshua Reynolds' George Clive und seine Familie mit einer indischen Dienerin', *Jahrbuch Preussischer Kulturbesitz*, XIV, 1977, pp. 163–73.

BORENIUS, T. *A Catalogue of the Pictures at Northwick Park*, London 1921.

BORENIUS, T. and HODGSON, J. V. *A Catalogue of the Pictures at Elton Hall*, London 1924.

BORENIUS, T. *A Catalogue of the Pictures and Drawings at Harewood House, etc. in the Collection of the Earl of Harewood*, Oxford 1936.

BORENIUS, T. *A Catalogue of the Pictures at Corsham Court*, London 1939.

BOSWELL, J. *Private Papers of James Boswell from Malahide Castle* (ed. G. Scott and F. A. Pottle), 18 vols, New York 1928–34 (plus Index volume 1937).

BOSWELL, J. *Life of Johnson* (ed. G. Birkbeck Hill and L. F. Powell), 6 vols, Oxford 1934–50.

BOSWELL, J. *The Correspondence of James Boswell with certain members of the Club* (ed. C. N. Fifer), London 1976.

BOULTON, W. B. *Sir Joshua Reynolds*, London 1905.

BOWRON, E. P. See Kenwood 1982.

BOYDELL, J. *A Catalogue of the Pictures in the Shakespeare Gallery, Pall Mall*, London 1790.

BREDIUS, I. *Rembrandt: The Complete Edition of the Paintings* (revised by H. Gerson), London 1969.

BRITISH MUSEUM *Gainsborough and Reynolds in the British Museum* (by T. Clifford, A. Griffiths and M. Royalton-Kisch), 1978.

BROWN, D. B. *The Earlier British Drawings*, vol. IV of *The Catalogue of the Collection of Drawings in the Ashmolean Museum*, Oxford 1982.

BRYANT, J. *Gemmarum antiquarum delectus . . . in dactyliothecis ducis Marlburiensis conservantur*, 2 vols, 1780–91.

BURKE, E. *The Speeches of the Rt. Hon. Edmund Burke*, London 1816.

BURKE, J. See also Hogarth.

BURKE, J. 'Romney's "Leigh Family" (1768): A link between the conversation piece and the Neo-Classical portrait group', *Annual Bulletin of the National Gallery of Victoria*, I, 1959, pp. 5–14.

BURKE, J. *English Art 1714–1800*, Oxford 1976.

BURNEY, F. (Mme d'Arblay) *The Diary and Letters of Madame d'Arblay* (ed. by her niece), 7 vols, London 1842–6.

BURNEY, F. (Mme d'Arblay) *The Journals and Letters of Fanny Burney* (ed. Joyce Hemlow), 12 vols, London 1972–82.

BUROLLET, T. *Musée Cognacq-Jay*, Paris 1980.

BUSCH, W. 'Hogarths und Reynolds' Porträts des Schauspielers Garrick', *Zeitschrift für Kunstgeschichte*, XLVII, 1984, pp. 82–99.

BUTLER, M. *Romantics, rebels and reactionaries*, London 1981.

BUTLIN, M. 'An eighteenth-century art scandal: Nathaniel Hone's "The Conjuror"', *Connoisseur*, CLXXIV, 1970, pp. 1–9.

BYRON, J. *Narrative . . . of the great distresses suffered by himself and his companions on the coasts of Patagonia*, London 1768.

CAMPBELL, J. *The Naval History of Great Britain*, 8 vols, London 1818.

CANNON, J. *The Fox-North Coalition*, London 1969.

CASANOVA, J. de S. *Memoirs* (trans. A. Machen), 6 vols, London 1894 (repr. New York 1958–60).

CAYLUS, Comte de *Mémoire sur la peinture à l'encaustique et sur la peinture à la cire*, Geneva 1755.

CHALONER SMITH, J. See Smith, J. Chaloner.

CHARTERIS, E. *William Augustus, Duke of Cumberland. His early life and times*, London 1913.

CHARTERIS, E. *William Augustus, Duke of Cumberland and the Seven Years War*, London [1925].

CHURCH, A. H. *The Chemistry of Paints and Paintings*, London 1890.

CLARK, A. M. 'Imperiali', *Burlington Magazine*, CVI, May 1964, pp. 226–33.

CLEVELAND (Museum of Art) *European Paintings of the 16th, 17th & 18th Centuries (The Cleveland Museum of Art Catalogue of Paintings Part 3)*, Cleveland 1982.

CLIFFORD, T. See also British Museum 1978.

CLOWES, W. L. *The Royal Navy*, 7 vols, 1897–1903.

COLLISON-MORLEY, L. *Giuseppe Baretti*, London 1909.

COPLEY, J. S. and PELHAM, H. 'Letters and Papers', *Collections of the Massachusetts Historical Society*, LXXI, 1914, *passim*.

CORMACK, M. 'The Ledgers of Sir Joshua Reynolds', *Walpole Society*, XLII (1968–70), pp. 105–69.

CORMACK, M. 'Star Quality', *Art News*, summer 1983, pp. 112–14.

CORMACK, M. See also Birmingham 1961.

COTTON, W. *Sir Joshua Reynolds and his works. Gleanings from his diary, unpublished manuscripts, and from other sources* (ed. J. Burnet), London 1856.

COTTON, W. *Some account of the ancient borough town of Plympton St. Maurice, or Plympton Earl; with Memoirs of the Reynolds family*, London 1859.

COTTON, W. *Sir Joshua Reynolds's Notes and Observations on pictures . . . extracts from his Italian Sketchbooks, also, the Rev. W. Mason's Observations of Sir Joshua's method of colouring . . .*, London 1859.

CROFT-MURRAY, E. and HULTON, P. *Catalogue of British Drawings: XVI and XVII Centuries*, 2 vols, London 1960.

CROFT-MURRAY, E. 'Decorative Paintings for Lord Burlington and the Royal Academy', *Apollo* 1969, pp. 11–21.

CRONIN, W. V. See Graves, A.

CROOK, J. M. 'Strawberry Hill Revisited I', *Country Life*, 7 June 1973, pp. 1598–1602.

CROOKSHANK, A. See Kenwood 1955.

CROSS, W. L. *The Life and Times of Laurence Sterne*, 3rd edn, New Haven 1929.

CROWN, P. 'Portraits and fancy pictures by Gainsborough and Reynolds: contrasting images of childhood', *British Journal for 18th-Century Studies*, VII, autumn 1984, pp. 159–67.

CUMBERLAND, R. *Memoirs*, London 1806.

CUMMINGS, F. See Detroit and Philadelphia 1968.

CUNNINGHAM, A. *The Life of Sir David Wilkie*, 3 vols, London 1843.

CUST, L. *History of the Society of Dilettanti* (ed. S. Colvin), London 1914.

DAVIES, M. *The British School* (National Gallery, London) 1946; 2nd revised edn, London 1959.

DETROIT and PHILADELPHIA *Romantic Art in Britain: Paintings and Drawings 1760–1860* (by F. Cummings and A. Staley), 1968.

DE VESME, A. and CALABI, A. *Francesco Bartolozzi: Catalogue des Estampes*, Milan 1928.

DEMONTS, L. *Catalogue des Peintures exposées dans les Galeries*, III, Paris 1922.

DODD, D. *Saltram* (National Trust Guidebook), 1981.

D'OENCH, E. See New Haven 1983.

DOERNER, M. *The Materials of the Artist*, New York 1949.

DOSSIE, R. *The Handmaid to the Arts*, 2 vols, London 1758.

DOUGLAS, S. *The Diaries of Sylvester Douglas, Lord Glenbervie* (ed. F. Bickley), 2 vols, London, Boston and New York 1928.

DUKELSKAYA, L. *The Hermitage: English Art Sixteenth to Nineteenth Century*, Leningrad 1979.

EASTLAKE, C. L. *Methods and Materials of Painting*, 2 vols, London 1847.

EDGEWORTH, M. *Letters from England 1813–1844*, Oxford 1971.

EDWARDS, E. *Anecdotes of Painters*, London 1808. [The facsimile edn of 1970 has a useful preface by R. W. Lightbown.]

ETTLINGER, L. D. 'Hans von Marées and the Academic Tradition', in *Correlations between German and non-German Art in the Nineteenth Century*, Yale University Art Gallery Bulletin, XXXIII, 1972, pp. 82ff.

FARINGTON, J. See Reynolds 1819.

FARINGTON, J. *Diaries*, 14 vols (I–VI edited by K. Garlick and A. Macintyre and subsequent vols by K. Cave), London and New Haven 1978–84.

FEILING, C. A. *Warren Hastings*, London 1954.

F[IELD], W. *An Historical and Descriptive Account of . . . Warwick and . . . Leamington Spa*, Warwick 1815.

FITZGERALD, B. (ed.) *Correspondence of Emily, Duchess of Leinster*, 3 vols, Dublin 1949–53.

FLETCHER, E. (ed.) *Conversations of James Northcote R.A. with James Ward on art and artists*, London 1901.

FORD, B. 'Sir Watkin Williams-Wynn, A Welsh Maecenas', *Apollo*, June 1974, pp. 446–61.

FOTHERGILL, B. *The Strawberry Hill Set*, London 1983.

FRANKAU, J. *John Raphael Smith, his life and works*, London 1902.

FRENCH, A. See Kenwood 1982.

FRIEDMAN, W. H. *Boydell's Shakespeare Gallery* (Thesis presented at Harvard University 1974), New York 1976.

GAMELIN, H. *George Romney and his art*, London 1894.

GARLICK, K. J. 'A Catalogue of the Pictures at Althorp', *Walpole Society*, XLIV (1974–76), 1976, *passim*.

GEORGE, M. D. *Catalogue of Political and Personal Satires in the British Museum*, 1771–83, London 1935; 1784–92, London 1938; 1793–1800, London 1942. [Vols V–VII of complete Catalogue were all subsequently reprinted in 1978.]

GEORGE, M. D. *English Political Caricature*, 2 vols, London 1959.

GEORGE, M. D. *Hogarth to Cruikshank: social change in graphic satire*, London 1967.

GERSON, H. *Ausbreitung und Nachwirkung der holländischen Malerei des 17. Jahrhunderts*, Haarlem 1942.

GETTENS, R. J. and STOUT, G. L. *Painting Materials: A Short Encyclopaedia*, New York 1966.

GIBBON, E. *The Autobiography . . . as originally edited by Lord Sheffield*, London 1901.

GODFREY, R. *Printmaking in Britain*, London 1978.

GODFREY, R. See New Haven 1980.

GOLDSMITH, O. *The Citizen of the World*, London 1762.

GOMBRICH, E. H. 'Reynolds's theory and practice of imitation', *Burlington Magazine*, LXXX, February 1942, pp. 40–5.

GOODISON, J. W. *Fitzwilliam Museum, Catalogue of Paintings*, vol. 3 (*British School*), Cambridge 1977.

GOODWIN, G. *James McArdell*, London 1903.

GOODWIN, G. *Thomas Watson, James Watson, Elizabeth Judkins*, London 1904.

GORE, R. St. J. *The Saltram Collection*, The National Trust 1967.

GORE, R. St. J. *The Faringdon Collection*, The National Trust 1982.

GOURLAY, A. S. and GRANT, J. E. 'The Melancholy Shepherdess in Prospect of Love and Death in Reynolds and Blake', *Bulletin of Research in the Humanities*, LXXXV, 1982, pp. 169–89.

GRANT, M. H. *A Chronological history of the Old English Landscape Painters*, 2nd edn, 8 vols, Leigh-on-Sea 1957–61.

GRAVES, A. and CRONIN, W. V. *History of the Works of Sir Joshua Reynolds*, 4 vols, London 1899–1901.

GRAVES, H. (and company) *Engravings from the Works of Sir Joshua Reynolds*, 3 vols, London 1865.

GRAY, T. *The Letters of Thomas Gray* (ed. D. Tovey), 3 vols, London 1904.

GREENAWAY, L. *Alterations in the Discourses of Sir Joshua Reynolds*, New York 1936.

GREGO, J. *Rowlandson the Caricaturist*, 2 vols, London 1880.

GREGO, J. See Wright 1873.

GRIFFITHS, A. See British Museum 1978.

GROSLEY, M. *A Tour to London* (trans. T. Nugent), 2 vols, London 1772.

GROSVENOR GALLERY *The Works of Sir Joshua Reynolds* (by F. G. Stephens), 1883.

GROVE, SIR G. *Dictionary of Music*, 5th edn, 10 vols, London 1954–61.

GUNNIS, R. *Dictionary of British Sculptors*, London 1953.

GWYNN, S. *Memorials of an eighteenth-century painter: James Northcote*, London 1898.

HAMILTON, E. *The English School*, 4 vols, London 1831.

HAMILTON, E. *Catalogue raisonné of the engraved works of Sir Joshua Reynolds*, London 1874.

HARCOURT-SMITH, C. *The Society of Dilettanti: its regalia and pictures*, London 1932.

HARLEY, R. D. *Artists' Pigments c. 1600–1835: A Study in English Documentary sources*, London 1970.

HARRIS, J. *Sir William Chambers*, London 1970.

HASKELL, F. and PENNY, N. *Taste and the Antique*, New Haven and London 1981.

[HASLEWOOD, J.] *The Secret History of the Green Rooms*, 2 vols, London 1790.

HAYDON, B. R. *The Diary of Benjamin Robert Haydon* (ed. W. B. Pope), 5 vols, Cambridge (Mass.) 1960–3.

HAYDON, B. R. 'Sir Joshua Reynolds' *The Civil Engineers and Architects Journal*, VIII, February 1845, pp. 40–1.

HAYES, J. *Rowlandson, watercolours and drawings*, London 1972.

HAYWARD, A. See Lobban.

HAYWARD, H. 'The Drawings of John Linnell in the Victoria and Albert Museum', *Furniture History*, V, 1969, pp. 1–118.

[HAZLITT, W.] *Sketches of the Principal Picture Galleries of England*, London 1824.

HAZLITT, W. *Conversations of James Northcote, Esq. R.A.*, London 1830.

HAZLITT, W. *Essays on the Fine Arts*, London 1873.

HERRMANN, L. 'The Drawings by Sir Joshua Reynolds in the Herschel Album', *Burlington Magazine*, CX, December 1968, pp. 650–8.

HIBBERT, C. *George IV Prince of Wales*, London 1972.

HICKEY, W. *Memoirs* (ed. A. Spencer), 4 vols, London 1913–25.

HILL, D. *Mr Gillray, The Caricaturist*, London 1965.

HILL, D. *Fashionable contrasts: caricatures by James Gillray*, London 1966.

HILL, D. *The Satirical Etchings of James Gillray*, London 1976.

HILL, G. B. (ed.) *Johnsonian miscellanies*, 2 vols, London 1897.

HILLES, F. W. (ed.) See Reynolds 1929.

HILLES, F. W. *The Literary Career of Sir Joshua Reynolds*, Cambridge 1936 (repr. 1967).

HILLES, F. W. *Portraits. Character Sketches of Oliver Goldsmith, Samuel Johnson, and David Garrick, together with other MSS of Reynolds recently discovered among the private papers of James Boswell*, New York, Toronto and London 1952.

HILLES, F. W. 'Horace Walpole and the Knight of the Brush', in *Horace Walpole: Writer, politician, and connoisseur* (ed. W. H. Smith), New Haven and London 1967, pp. 141–66.

HILLES, F. W. 'Sir Joshua at the Hôtel de Thiers', *Gazette des Beaux-Arts*, LXXIV, 1969, pp. 201–10.

HILLES, F. W. 'Sir Joshua and the Empress Catherine', in *Eighteenth-Century Studies in Honor of Donald F. Hyde* (ed. W. H. Bond), New York 1970.

HINE, J. 'Reynolds of Plympton', *Transactions of the Devonshire Association for the Advancement of Science, Literature and Art*, XIX, 1887.

HOBHOUSE, C. *Fox*, London 1934.

HOGARTH, W. *The Analysis of Beauty* (London 1753) (ed. J. Burke), Oxford 1955.

HOLTZ, W. 'Pictures for Parson Yorick', *Eighteenth Century Studies*, December 1967, pp. 169–84.

HOPE, A. 'Cesare Ripa's Iconology and the Neoclassical Movement', *Apollo*, 86, October 1967 (supplement), pp. 1–4.

HUDSON, D. *Sir Joshua Reynolds, a personal study*, London 1958.

HUTCHISON, S. C. *The History of the Royal Academy*, London 1968.

'I.N.' *A Critical Review of the pictures, sculptures, designs in architecture, drawings, prints etc. exhibited at the Great-Room in Spring Gardens*, [London] 1765.

? 'I.N.' *A Critical review of the pictures, sculptures, designs in architecture, drawings, prints etc. exhibited at the Great-Room in Spring Gardens*, [London] 1766. [This is not signed I.N. but is in the same style and with the same title and type as that pamphlet of 1765.]

ILCHESTER, Mary Countess of and Lord Stavordale *The Life and Letters of Lady Sarah Lennox*, 2 vols, London 1901.

ILCHESTER, The Earl of *Henry Fox, first Lord Holland*, 2 vols, London 1920.

ILCHESTER, The Earl of *The Home of the Hollands*, London 1937.

INGAMELLS, J. 'William Doughty: a little-known York painter', *Apollo*, July 1964, pp. 33–7.

INGAMELLS, J. *Wallace Collection: Catalogue of Pictures I: British, German, Italian and Spanish*, London 1985.

INGAMELLS, J. See also York 1973.

IRONS, E. E. *The Last Illness of Sir Joshua Reynolds*, Chicago n.d.

IRWIN, D. *English Neoclassical Art*, London 1966.

JACOB, J. See Kenwood 1975 and 1979.

JACQUES, D. *A Visit to Goodwood*, Chichester 1822.

JAFFÉ, M. 'The Picture of the Secretary of Titian', *Burlington Magazine*, 1966, pp. 114–26.

JAMESON, A. *Companion to the Most Celebrated Private Galleries of Art in London*, London 1844.

JARRETT, D. *England in the Age of Hogarth*, London 1974.

JEWITT, L. *A Catalogue of the Pictures . . . in the Cottonian Library, Plymouth*, Plymouth 1853.

JOANNIDES, P. 'Some English Themes in the Early Work of Gros', *Burlington Magazine*, CXVII, December 1975, pp. 774–85.

JOHNSON, E. M. *Francis Cotes*, London 1976.

JOPPIEN, R. 'Philippe Jacques de Loutherbourg's Pantomime "Omai, or a Trip round the World" and the Artists of Captain Cook's Voyages', *British Museum Yearbook*, 1979, pp. 81–136.

KEMP, M. *Dr William Hunter at the Royal Academy of Arts*, Glasgow 1975.

KENWOOD (Iveagh Bequest) *Exhibition of Paintings by Angelica Kauffmann* (by Anne Crookshank), 1955.

KENWOOD (Iveagh Bequest) *To Preserve and Enhance: Works of Art acquired for Kenwood, Marble Hill and Ranger's House, 1964–1974* (by J. Jacob), 1975.

KENWOOD (Iveagh Bequest) *Thomas Hudson* (by E. Miles and J. Simon), 1979.

KENWOOD (Iveagh Bequest) *Pompeo Batoni and his British Patrons* (by E. P. Bowron, Anne French and others), 1982.

KERR, S. P. *George Selwyn and the Wits*, London 1909.

KERSLAKE, J. '1965—A Vintage Year for the National Portrait Gallery', *Connoisseur*, CLXI, March 1966, pp. 159–63.

KERSLAKE, J. *Early Georgian Portraits* (National Portrait Gallery), 2 vols, London 1977.

KING, C. 'The Evolution of British Naval Uniform', *Connoisseur*, CIII, April 1939, pp. 191–7, 230.

KITSON, M. See Munich 1979.

KNIGHT, R. P. Anonymous review of 'The Works of James Barry', *Edinburgh Review*, vol. XVI, 1810, pp. 293–326.

KNIGHT, C. *Autobiography* (ed. J. W. Kaye), 2 vols, London 1861.

KNOWLES, J. *Life and Writings of Henry Fuseli*, 3 vols, London 1831.

LANSDOWN, H. V. *Recollections of the Late William Beckford of Fonthill, Wilts., and Lansdown, Bath*, Bath 1893.

LEE, R. *Names on Trees: Ariosto into Art*, Princeton 1977.

LESLIE, C. R. and TAYLOR, T. *The life and times of Sir Joshua Reynolds with notices of some of his Contemporaries*, 2 vols, London 1865.

LIPPINCOTT, L. *Selling art in Georgian London: the rise of Arthur Pond*, New Haven and London 1983.

LITTLE, D. M. and KAHRL, G. M. *The Letters of David Garrick*, 3 vols, Oxford 1963.

LOBBAN, J. H. and HAYWARD, A. (eds) *Dr. Johnson's Mrs Thrale*, Edinburgh and London 1910.

LUKE, H. 'Omai: England's First Polynesian Visitor', *The Geographical Magazine*, April 1950, pp. 497–500.

MACKINTOSH, I. See Arts Council 1975.

McLEAN, T. *The Geniune Works of James Gillray, engraved by himself*, 2 vols, from the original plates, London 1830.

MAGNUS, P. *Edmund Burke*, London 1931.

MAHON, D. *I Disegni del Guercino della collezione Mahon*, Bologna 1967.

MALONE, E. See Reynolds 1797.

MANDOWSKY, E. 'Reynolds's Conceptions of Truth', *Burlington Magazine*, December 1940, pp. 195–201.

MANNERS, J. H. *Journal of a Tour to the Northern Parts of Great Britain*, London 1813.

MANNERS, Lady V. and WILLIAMSON, G. C. *Angelica Kauffmann R.A.*, London 1924.

MANNINGS, D. 'Reynolds and the Restoration Portrait', *Connoisseur*, CLXXXIII, July 1973, pp. 186–93.

MANNINGS, D. 'The sources and development of Reynolds's Pre-Italian style', *Burlington Magazine*, CXVII, April 1975, pp. 212–22.

MANNINGS, D. 'A well-mannered portrait by Highmore', *Connoisseur*, CLXXXIX, June 1975, pp. 116–19.

MANNINGS, D. 'Two more pre-Italian portraits by Reynolds', *Burlington Magazine*, CXVIII, August 1976, pp. 590–3.

MANNINGS, D. 'Reynolds's portraits of the Stanley family', *Connoisseur*, CXCIV, February 1977, pp. 85–9.

MANNINGS, D. 'Notes on some eighteenth-century portrait prices in Britain', *British Journal for Eighteenth Century Studies*, VI, 1983, pp. 185–96.

MANNINGS, D. 'Reynolds, Garrick and the Choice of Hercules', *Eighteenth Century Studies*, spring 1984, pp. 259–83.

MANNINGS, D. 'Reynolds, Hogarth and Van Dyck', *Burlington Magazine*, CXXVI, November 1984, pp. 689–90.

MASON, W. *The Art of painting of Charles Alphonse du Fresnoy with annotations by Sir Joshua Reynolds*, York 1783. [Also included in Reynolds 1797 and 1798 which are generally referred to here.]

MASON, W. See Cotton 1859.

MAXON, J. *The Art Institute of Chicago*, revised edn, London 1977.

MERCIER, L.-S. *Parallèle de Paris et de Londres* (ed. C. Bruneteau and B. Cottret), Paris 1982.

MERRIFIELD, M. P. *Original Treatises . . . on the art of painting*, 2 vols, London 1849.

MILES, E. See Kenwood 1979.

MILLAR, O. *The later Georgian pictures in the collection of her Majesty the Queen*, 2 vols, London 1969.

MITCHELL, C. 'Three phases of Reynolds's method', *Burlington Magazine*, LXXX, February 1942, pp. 35–40.

MOORE, R. E. 'Reynolds and the Art of Characterization', *Studies in Criticism and Aesthetics 1660–1800* (ed. H. P. Anderson and J. S. Shea), Minneapolis, 1967, pp. 332–57.

MORGAN, H. C. 'A History of the Organisation and Growth of the Royal Academy Schools from the Beginning of the Academy to 1836, with special reference to Academic Teaching and Conditions of Study', PhD Thesis, Leeds 1964 [Copy on deposit in the library of the Royal Academy]

MORITZ, C. P. *Travels of Carl Philipp Moritz in England in 1782*, London 1795 (repr. with an introduction by P. E. Matheson, London 1924).

MUNBY, A. N. L. 'Letters of British Artists', Part I, *Connoisseur*, CXIX, September 1946, pp. 24–8, 64.

MUNBY, A. N. L. 'Nathaniel Hone's Conjuror', *Connoisseur*, CXX, December 1947, pp. 82–4.

MUNICH (Hans der Kunst) *Zwei Jahrhunderte Englische Malerei: Britische Kunst und Europa 1680 bis 1880* (relevant section by M. Kitson), 1979.

[MURRAY, P.] *The Iveagh Bequest, Kenwood: Catalogue of Paintings* (ed. Anthony Blunt), London n.d.

MURRAY, P. 'The Source of Reynolds's "Triumph of Truth"', *Aberdeen University Review*, 30, 3, 1944, pp. 227–9.

MURRAY, P. *Dulwich Picture Gallery: A Catalogue*, London 1980.

MUSSER, J. F. 'Sir Joshua Reynolds's Mrs Abington as "Miss Prue"', *The South Atlantic Quarterly*, spring 1984, pp. 176–92.

NAMIER, L. and BROOKE, J. *The House of Commons 1754–1790*, 3 vols, London 1964.

NASH, S. A. (ed.) *Albright-Knox Art Gallery: Painting and Sculpture from Antiquity to 1942*, Buffalo 1979.

NATIONAL PORTRAIT GALLERY *Sir Godfrey Kneller* (by J. D. Stewart), 1971.

NATIONAL PORTRAIT GALLERY *Johann Zoffany* (by M. Webster), 1976.

NEALE, J. P. *Views of the Seats of Noblemen and Gentlemen, in England, Wales, Scotland, and Ireland. . .*, 6 vols, London 1819–23.

NEVINSON, J. L. 'The Robes of the Order of the Bath', *Connoisseur*, CXXXIV, November 1954, pp. 153–9.

NEVINSON, J. L. 'Van Dyck Dress', *Connoisseur*, CLVII, November 1964, pp. 166–71.

NEW HAVEN (Yale Center for British Art) *Painters and engraving: The reproductive paint from Hogarth to Wilkie* (by D. Alexander and R. Godfrey), 1980.

NEW HAVEN (Yale Center for British Art) *Rembrandt in Eighteenth Century England* (by C. White, D. Alexander and E. D'Oench), 1983.

NICOLL, A. *The Garrick Stage*, London 1980.

NORTHCOTE, J. *Memoirs of Sir Joshua Reynolds*, 2 vols, London 1813–15.

NORTHCOTE, J. *The Life of Sir Joshua Reynolds*, 2 vols, London 1818. [The second edition 'revised and augmented' of Northcote 1813–15.]

NORTHCOTE, J. See also Hazlitt 1830, Gwynn 1898, Fletcher 1901.

O'CONNOR, C. 'The Parody of the School of Athens', *Bulletin of the Irish Georgian Society*, XXVI, 1983, pp. 4–22.

O'DONOGHUE, F. and HAKE, H. M. *Catalogue of engraved British portraits in the British Museum*, 6 vols, London 1908–25.

OLIVER, J. W. *William Beckford*, London 1932.

OMAN, C. *David Garrick*, London 1958.

PANOFSKY, E. *Hercules am Scheidewege*, Leipzig–Berlin 1930.

PANOFSKY, E. '*Et in Arcadia ego*: On the Conception of Transcience in Poussin and Watteau', in *Philosophy and History: Essays presented to Ernst Cassirer* (ed. R. Klibansky and H. J. Paton), Oxford 1936, pp. 223–54.

PAPENDIEK, Mrs *Court and private life in the time of Queen Charlotte: being the journals of Mrs Papendiek, assistant keeper of the wardrobe and reader to her Majesty* (ed. Mrs V. Delves Broughton), 2 vols, London 1887.

PARK LANE, 45 *Loan exhibition of the Works of Sir Joshua Reynolds* (by E. K. Waterhouse), 2 vols, 1937.

'PASQUIN' [John Williams] *The Royal Academicians*, London 1786.

'PASQUIN' [John Williams]: *An Authentic History of the professors of painting, sculpture & architecture, who have practiced in Ireland; involving original letters from Sir Joshua Reynolds, which prove him to have been illiterate. To which are added, Memoirs of the Royal Academicians . . .*, London 1796. [The two parts are separately paginated.]

PASTON, G. [pseudonym for Emily Morse Symonds] *Social caricature in the eighteenth century*, London 1905.

PATTEN, R. L. 'Conventions of Georgian caricature', *Art Journal*, winter 1983, pp. 331–8.

PAULSON, R. *Rowlandson, a new interpretation*, London 1972.

PAULSON, R. *Emblem and Expression*, London 1975.

PAULSON, R. *Representations of revolution*, London 1983.

PEARCE-EDGCUMBE, E. R. *The Parentage and Kinsfolk of Sir Joshua Reynolds*, London 1901. [Repr. from Graves and Cronin.]

PELZEL, T. O. 'Winckelmann, Mengs, and Casanova: A Reappraisal of a Famous Eighteenth-Century Forgery', *Art Bulletin*, LIV, September 1972, pp. 300–15.

PEMBROKE, SIDNEY, 16th Earl of *A Catalogue of the Paintings and Drawings in the Collection at Wilton House*, London 1968.

PHILIPS, C. *Sir Joshua Reynolds*, London 1894.
PILES, R. de *The Principles of Painting*, translated by a painter, London 1743.
'PINDAR, Peter' [John Wolcot] *Lyric Odes to the Royal Academicians for 1782*, London 1782.
'PINDAR, Peter' [John Wolcot] *Lyric Odes for the year 1785*, London 1785.
'PINDAR, Peter' [John Wolcot] *Farewell Odes . . . For the year 1786*, London 1786.
PIOZZI, H. L. (formerly Thrale) *Anecdotes of the late Samuel Johnson*, London 1786. [Repr. in Sherbo 1974, pp. 59ff.]
PIOZZI, H. L. (formerly Thrale) *Autobiography, letters and literary remains* (ed. with an introductory account of her life and writings, by A. Hayward), 2 vols, 2nd edn, London 1861.
PIOZZI, H. L. (formerly Thrale) *Thraliana: the diary of Mrs Hester Lynch Thrale (later Mrs Piozzi)* (ed. K. C. Balderston), 2 vols, Oxford 1951.
PIPER, D. 'The National Portrait Gallery: some recent acquisitions', *Connoisseur*, CXXXIII, April 1954, pp. 177–82.
PLYMOUTH *Sir Joshua Reynolds* (by H. Berriman), 1973.
POINTON, M. 'Portrait-painting as a business enterprise in London in the 1780s', *Art History*, June 1984, pp. 187–205.
PORTER, R. *English Society in the eighteenth century*, London 1982.
POTTERTON, H. *Reynolds and Gainsborough* (Themes and Painters in the National Gallery), London n.d. [1976].
POTTERTON, H. 'Reynolds's Portrait of Captain Robert Orme in the National Gallery', *Burlington Magazine*, CXVIII, 1976, p. 106.
PRESSLY, W. L. *The life and art of James Barry*, New Haven and London 1981.
PRESSLY, W. L. See Tate Gallery 1983.
PRIOR, Sir J. *Life of Edmond Malone*, London 1860.
PYE, J. *Patronage of British Art*, London 1845.

RADCLIFFE, S. M. (ed.) *Sir Joshua's nephew, being letters written 1769–1778, by a young man to his sisters*, London 1930.
READE A. L. 'Francis Barber, the Doctor's negro servant', *Johnsonian Gleanings*, II, 1912, passim.
REDGRAVE, S. See South Kensington 1867, 1868.
REDGRAVE, R. and S. *A Century of British Painters*, London 1981.
REID, H. 'One of the finest rooms in Europe', *New College Record*, 1983, pp. 13–14.
[REPTON, H.] *The Bee; or a companion to the Shakespeare Gallery* [1789].
REYNOLDS, J. *The Works of Sir Joshua Reynolds . . . to which is prefixed an account of the life and writings of the author by Edmond Malone*, 2 vols, London 1797; 2nd edn, 3 vols, London 1798 [the edn generally referred to here]; 5th edn, with an additional memoir by Joseph Farington, 3 vols, London 1819. [The memoir was also published separately.]
REYNOLDS, J. *The Letters* (ed. F. W. Hilles), Cambridge 1929.
REYNOLDS, J. *Discourses on Art* (ed. Robert R. Wark, New Haven and London 1975). [The first collected edn of 7 discourses was published in 1778. For a full bibliography see Hilles 1936.]
REYNOLDS, S. W. *Engravings from the Works of Sir Joshua Reynolds*, 3 (sometimes 4) vols, London n.d. (Between 1820 and 1830.)
RIBEIRO, A. 'Hussars in Masquerade', *Apollo*, CVI, February 1977, pp. 111–16.
RIBEIRO, A. 'Some evidence of the influence of the dress of the seventeenth century on costume in eighteenth-century female portraiture', *Burlington Magazine*, CXIX, December 1977, pp. 834–40.
RIBEIRO, A. 'The Exotic diversion. Dress worn at masquerades in 18th Century London', *Connoisseur*, CXCVII, January 1978, pp. 3–13.
RIBEIRO, A. 'Eighteenth-century jewellery in England', *Connoisseur*, CXCIX, October 1978, pp. 75–83.
RIBEIRO, A. 'Turquerie: Turkish dress and English fashion in the eighteenth century', *Connoisseur*, CCI, June 1979, pp. 16–23.
RIBEIRO, A. 'Furs in fashion', *Connoisseur*, CCII, December 1979, pp. 226–31.
RIBEIRO, A. *The Dress worn at Masquerades in England 1730–1790, and its relation to Fancy Dress in Portraiture*, New York 1984.
RICHARDSON, J. *Two Discourses*, London 1719.
RICHARDSON, J. *An Essay on the Theory of Painting* London 1725.
RIELY, J. C. 'Horace Walpole and the second Hogarth', *Eighteenth Century Studies*, IX, 1975–6, pp. 28–44.
RIELY, J. C. See also Sudbury (Gainsborough's House).

ROBERTS, W. *Memoirs of the Life and Correspondence of Mrs Hannah More*, 4 vols, 2nd edn, 1834.
ROBERTS, K. *Reynolds*, London 1966.
ROBINSON, J. R. *Old Q*, London 1895.
ROCHE, S. von La *Sophie in London 1786; being the diary of Sophie von La Roche* (trans. and ed. C. Williams), London 1933.
ROE, A. S. 'The demon behind the pillow: a note on Erasmus Darwin and Reynolds', *Burlington Magazine*, CXIII, August 1971, pp. 460–70.
ROGERS, S. *Recollections of the Table-Talk of Samuel Rogers* (ed. A. Dyce), London 1856.
ROLDIT, M. 'The Collection of Pictures of the Earl of Normanton at Somerley, Hampshire: I, Pictures by Sir Joshua Reynolds', *Burlington Magazine*, II, 1903, pp. 206–25.
ROSCOE, E. S. and CLERGUE, H. *George Selwyn, his letters and his life*, London 1899.
ROSENBLUM, R. 'Who painted David's *Ugolino*?', *Burlington Magazine*, CX, November 1968, pp. 621–6.
ROSENBLUM, R. *Transformations in late eighteenth-century art* (corrected edn), Princeton, 1970.
ROSENBLUM, R. 'The Dawn of British Romantic Painting, 1760–1780', in *The Varied Pattern: Studies in the 18th Century* (ed. Peter Hughes and David Williams), Toronto 1971, pp. 189–210.
ROUQUET, A. *The Present state of the arts in England*, London 1755. [The facsimile reprint of 1970 is prefixed with a valuable introduction by R. W. Lightbown.]
ROYALTON-KISCH, M. See British Museum 1978.
RUSSELL, C. E. *English Mezzotint portraits and their states: catalogue of corrections of and additions to Chaloner Smith's British Mezzotinto Portraits*, London 1926.

SAXL, F. and WITTKOWER, R. *British Art and the Mediterranean*, London 1948.
SCARISBRICK, D. 'Illustrious Virtuosity: the Marlborough Gems', *Country Life*, 4 September 1980, pp. 752–4.
'SHANHAGAN, Roger' [Robert Watson, Robert Smirke and William Porden]: *The Exhibition, or a second anticipation; being remarks on the principal works to be exhibited next month at the Royal Academy*, London 1779.
SHEPPARD, F. H. W. (ed.) *The Parish of St. James, Westminster, South of Piccadilly*, 2 vols (XXIX and XXX of *The Survey of London*), London 1960.
SHERBO, A. *Memoirs and Anecdotes of Dr Johnson*, London 1974.
SIDDONS, S. K. *Reminiscences* (ed. W. van Lennep), Cambridge 1942.
SIMON, J. See Kenwood 1979.
SLATKIN, R. S. 'A Note on a Boucher Drawing', *Burlington Magazine*, CXV, October 1973, p. 676.
SMART, A. *The Life and Art of Allan Ramsay*, London 1952.
SMITH, J. Chaloner *British Mezzotinto portraits; being a descriptive Catalogue . . .*, 4 parts (but 5 vols together with a separate portfolio of autotype plates), London 1878–83.
SMITH, J. T. *Vagabondia*, London 1817.
SMITH, J. T. *Nollekens and his Times*, 2 vols, London 1828.
SMITH, J. T. *A Book for a rainy day*, London 1845.
SOUTH KENSINGTON, *Special Exhibition of National Portraits* (with 'introductory-notices' by S. Redgrave), 1867.
SOUTH KENSINGTON, *Special Exhibition of National Portraits* (with 'introductory notices' by S. Redgrave), 1868.
SPENCE, J. *Polymetis*, London 1747.
SQUIRE, W. B. (with Helen Matilda, Countess of Radnor) *Catalogue of the pictures in the Collection of the Earl of Radnor*, 2 vols, London 1909.
STEEGMAN, J. *Sir Joshua Reynolds*, London 1933.
STEEGMAN, J. 'Portraits of Reynolds', *Burlington Magazine*, LXXX, February 1942, pp. 33–5.
STEPHENS, F. G. *English children as painted by Sir Joshua Reynolds: an essay on some of the characteristics of Reynolds as a designer, with special reference to his portraiture of children*, London 1867.
STEPHENS, F. G. *Catalogue of political and personal satires in the British Museum, 1751–60 and 1761–70* (vols III, part 2, and IV), London 1877 and 1883 (all repr. 1978).
STEPHENS, F. G. See also Grosvenor Gallery 1883.
STEWART, J. D. See National Portrait Gallery 1971.

STIRLING, G. 'Sir Joshua Reynolds at Richmond', *Country Life*, 25 October 1950, pp. 1426–31.

STONE, L. *The Family, Sex and Marriage in England 1500–1800*, London 1977.

STRANGE, R. *An Inquiry into the Establishment of the Royal Academy of Arts*, London 1775.

STRONG, S. A. *The Masterpieces in the Duke of Devonshire's Collection of Pictures*, London 1901.

STUART, Lady L. *Notes on George Selwyn and his Contemporaries by John Heneage Jesse* (ed. W. S. Lewis), New York 1928.

SUDBURY (Gainsborough's House) *Henry William Bunbury* (by J. C. Riely), 1983.

SUTTON, D. 'The Roman Caricatures of Reynolds', *Country Life Annual*, 1956, pp. 113–16.

TALLEY, M. K. and GROEN, K. 'Thomas Bardwell and his Practice of Painting', *Studies in Conservation*, XX, 1975, pp. 44–108.

TALLEY, M. K. 'Thomas Bardwell of Bungay, Artist and Author 1704–1767', *Walpole Society*, XLVI (1976–8), 1978, pp. 91–163.

TALLEY, M. K. *Portrait Painting in England: Studies in the Technical Literature before 1700*, London 1981.

TATE GALLERY *James Barry* (by W. L. Pressly), 1983.

TATLOCK, R. R. *A Record of the Collections in the Lady Lever Art Gallery . . .*, vol. I (*English Painting*), London 1928.

TAVISTOCK, A. M. the Marchioness of, and RUSSELL, E. M. S. *Biographical Catalogue of the Pictures at Woburn Abbey*, 2 vols in 4, London 1890.

THOMPSON, C. and BRIGSTOCKE, H. *National Gallery of Scotland: Shorter Catalogue*, Edinburgh 1970.

TINKER, C. B. *Painter and Poet*, Cambridge, Mass., 1938.

TOVEY, D. C. *The letters of Thomas Gray*, 3 vols, London 1900–12.

TOYNBEE, P. 'Horace Walpole's Journals of Visits to Country Seats, etc.', *Walpole Society*, XVI (1927–8), 1928, pp. 9–80.

TRAIN, K. 'The Byron Family', *The Byron Journal*, II, 1974, pp. 35–40.

TREVELYAN, G. O. *The Early History of Charles James Fox*, London 1880.

TURBERVILLE, A. S. (ed.) *Johnson's England*, 2 vols, Oxford 1952.

TWISS, H. *The Life of Lord Chancellor Eldon*, 2 vols, London 1844.

VAN DE GRAAF, J. H. *Het de Mayerne Manuscript also Bron voor de Schildertechniek van de Barok*, Mijdrecht 1958.

VERTUE, G. 'The Note-books', *The Walpole Society*, XVIII (1929–30), XX (1931–2), XXII (1933–4), XXIV (1935–6), XXVI (1937–8), XXIX (1940–2), XXX (1951–2).

WAAGEN, G. *Treasures of Art in Great Britain*, 3 vols, London 1854.

WAAGEN, G. *Galleries and Cabinets of Art in Great Britain*, London 1857 (supplement to Waagen 1854).

WAGNER, E. 'The pornographer in the courtroom' in *Sexuality in eighteenth-century Britain* (ed. P. G. Boucé), Manchester 1982.

WAKE, J. and PANTIN, W. A. 'Delapré Abbey, its history and architecture', *Northampton Record Society*, Northampton 1959.

WALCH, P. S. *Angelica Kauffmann* (Princeton Ph.D. thesis of 1968), University Microfilms International 1980.

WALKER, R. S. 'The Beattie Portrait', *Aberdeen University Review*, XXX, 1944, pp. 224–6.

WALPOLE, H. *Anecdotes of Painting in England*, 3rd edn, 5 vols, London 1782.

[WALPOLE, H.] *A Description of the Villa of Mr Horace Walpole*, Strawberry-Hill 1784.

WALPOLE, H. *Correspondence* (ed. W. S. Lewis and others), 47 vols, London and New Haven 1937–83.

WALPOLE, H. *Miscellany 1785–1795* (ed. L. E. Troide), New Haven 1978.

WARK, R. R. See Reynolds 1975.

WARK, R. R. *Sir Joshua Reynolds's portrait of Mrs Siddons as the Tragic Muse*, San Marino 1965 (repr. as Chapter IV in *Ten British Pictures, 1740–1840*, San Marino 1971).

WATERHOUSE, E. K. *Reynolds*, London 1941.

WATERHOUSE, E. K. 'Exhibition of Old Masters at Newcastle, York and Perth', *Burlington Magazine*, 93, 1951, p. 262.

WATERHOUSE, E. K. *Painting in Britain 1530–1790*, London 1953.

WATERHOUSE, E. K. *Three decades of British Art* (Jayne Lectures 1964), Philadelphia 1965.

WATERHOUSE, E. K. *The James A. De Rothschild Collection at Waddesdon Manor: Paintings*, Paris 1967.

WATERHOUSE, E. K. 'Reynolds's Sitter Book for 1755', *Walpole Society*, XLI (1966–8), 1968, pp. 112–16.

WATERHOUSE, E. K. 'Additions to the List of Pre-Italian portraits by Reynolds', ibid. pp. 165–7.

WATERHOUSE, E. K. 'A Child Baptist by Sir Joshua Reynolds', *Minneapolis Institute of Arts Bulletin*, 1968, pp. 51–3.

WATERHOUSE, E. K. *Reynolds*, London 1973.

WATERHOUSE, E. K. 'Pompeo Batoni's Portrait of John Woodyeare', *Minneapolis Institute of Art Bulletin*, LXIV (1978–80), pp. 54–61.

WATERHOUSE, E. K. *The Dictionary of British 18th Century Painters in oils and crayons*, Woodbridge 1981.

WATERHOUSE, E. K. See also Park Lane 1937, Arts Council 1949.

WATSON, F. J. B. 'Thomas Patch', *Walpole Society*, XXVIII (1739–40), 1940, pp. 16–50.

WEBSTER, M. See National Portrait Gallery 1976.

WEINSHEIMER, J. 'Mrs Siddons, The Tragic Muse, and the Problem of As', *Journal of Aesthetics and Art Criticism*, 36, spring 1978, pp. 317–28.

WHITE, C. 'Rubens and British Art 1630–1790', in *Sind Briten Hier?: Relations between British and Continental Art 1680–1880*, Munich 1981.

WHITE, C. See New Haven 1983.

WHITLEY, W. T. *Artists and their friends in England 1700–1799*, 2 vols, London 1928.

WHITMAN, A. *Valentine Green*, London 1902.

WHITMAN, A. *Samuel William Reynolds*, London 1903.

WILLIAMS, H. W. Jr 'Romney's Palette', *Technical Studies*, VI, 1937, pp. 19–23.

WILLIAMS, J. See Pasquin 1786 and 1796.

WILLIAMS, S. T. *Richard Cumberland: his Life and Dramatic Works*, New Haven 1917.

WIND, E. 'Humanitätsidee und heroisiertes porträt in der englischen kultur des 18. Jahrhunderts', *Vorträge der Bibliothek Warburg*, IX (1930–1), 1931, *passim*.

WIND, E. 'Charity', *Journal of the Warburg and Courtauld Institutes*, I, 1938, pp. 322–3.

WIND, E. 'The Revolution in History Painting' and 'Borrowed attitudes in Reynolds and Hogarth', *Journal of the Warburg and Courtauld Institutes*, II (1938–9), 1939, pp. 116–27, 182–5.

WIND, E. 'Giordano Bruno between Tragedy and Comedy', *Journal of the Warburg and Courtauld Institutes*, II, (1938–9), 1939, p. 262.

WIND, E. 'A lost article on David by Reynolds', *Journal of the Warburg and Courtauld Institutes*, VI, 1943, pp. 223–4.

WIND, E. 'A Source for Reynolds's Parody of the School of Athens', *Harvard Library Bulletin*, III, spring 1949, pp. 294–7.

WITTKOWER, R. See Saxl, F.

WOLF, E. C. J. *Rowlandson and his illustrations of eighteenth-century English Literature*, London 1945.

WOODFORDE, C. *The Stained Glass of New College, Oxford*, London 1951.

WOODWARD, J. See Birmingham 1961.

WRAXALL, N. W. *Historical and Posthumous Memoirs* (ed. H. B. Wheatley), 5 vols, London 1884.

WRIGHT, T. and EVANS, R. H. *Historical and descriptive account of the caricatures of James Gillray*, London 1851.

WRIGHT, T. (ed.) *The Works of James Gillray, the caricaturist*, London, 1873 (repr. 1970). [Substantially by Joseph Grego who is often cited as the author.]

YATES, F. A. 'Transformations of Dante's Ugolino', *Journal of the Warburg and Courtauld Institutes*, XV, 1951, pp. 99–100.

YORK (City Art Gallery and Minster Library) *A Candidate for Praise: William Mason 1725–97, Precentor of York* (by B. Barr and J. Ingamells), 1973.

YUNG, Kai Kin. See Arts Council 1984.

ZWIERLEIN-DIEHL, E. 'Der Divus-Augustus-Kameo in Köln', *Kölner Jahrbuch für Vor- und Frühgeschichte*, XVII, 1980, pp. 12–53.

List of Exhibitions

(Exhibitions, other than those in Reynolds's lifetime, cited in notes to essays and in Catalogue entries)

British Institution 1813, 1817, 1820, 1823, 1824, 1826, 1827, 1831, 1832, 1833, 1840, 1841, 1843, 1844, 1845, 1846, 1847, 1848, 1850, 1851, 1852, 1853, 1854, 1856, 1860, 1861, 1862, 1864, 1865, 1866 (The first of these was the first great loan exhibition ever dedicated to a deceased artist, 'Pictures by the late Sir Joshua Reynolds'. The catalogue included a preface by Richard Payne Knight. Two others among these exhibitions gave special emphasis to Reynolds: that of 1823, entitled 'Pictures by the late Sir Joshua Reynolds; with a selection from the Italian, Spanish, Flemish, and Dutch schools', and that of 1833 dedicated to Reynolds, West and Lawrence. The other exhibitions were either of portraits of famous people, or of Old Master paintings, sometimes from all schools, sometimes from the English schools alone.)

Suffolk Street 1830, 1833
R.B.A. (Royal Society of British Artists) 1834
Irish Institution, Dublin 1856
Manchester 1857 'Art Treasures Exhibition'
South Kensington 1862 'International Exhibition'
 1867 'Special Exhibition of National Portraits'
 1868 'Special Exhibition of National Portraits' (See Bibliography)
Leeds 1868
Royal Academy 1870, 1871, 1872, 1873, 1875, 1876, 1877, 1879, 1880, 1881, 1882, 1883, 1884, 1885, 1886, 1887, 1888, 1890, 1895, 1896 (These winter loan exhibitions of Old Masters continued those of the British Institution, to which the Academy had originally objected.)
Worcestershire Exhibition 1882
Edinburgh 1883
Grosvenor Gallery 1883 'The Works of Sir Joshua Reynolds' (See Bibliography) 1889 'A Century of British Art'
Guildhall 1890, 1892, 1899
New Gallery 1891 'Royal House of Guelph'
 1899 'Masters of the Flemish and British Schools'
Grafton Gallery 1894 'Fair Women'
 1895 'Fair Children'
École des Beaux-Arts, Paris 1897
Agnew's 1899
Birmingham 1900
45 Park Lane, London 1937 'Loan Exhibition of The Works of Sir Joshua Reynolds' (In aid of the Royal Northern Hospital) (See Bibliography)
Arts Council 1949 'Sir Joshua Reynolds' (See Bibliography)
 (Royal Academy) 1950 'Paintings and Silver from Woburn Abbey'
Plymouth 1951 'Sir Joshua Reynolds'
Royal Academy 1951 'The First Hundred Years of the Royal Academy 1769–1868'

Birmingham 1953 'Works of Art from Midland Houses'
Kenwood (Iveagh Bequest) 1955 'Exhibition of Paintings by Angelica Kauffmann' (See Bibliography)
Royal Academy 1956 'British Portraits'
Birmingham 1961 'Exhibition of Works by Sir Joshua Reynolds' (See Bibliography)
Detroit and Philadelphia 1968 'Romantic Art in Britain: Paintings and Drawings 1760–1860' (See Bibliography)
Royal Academy 1968 'Royal Academy of Arts Bicentenary Exhibition'
National Portrait Gallery 1971 'Sir Geoffrey Kneller' (See Bibliography)
Arts Council 1972 'The Age of Neo-Classicism'
Tate Gallery 1972 'The Age of Charles I' (See Bibliography)
Plymouth 1973 'Sir Joshua Reynolds' (See Bibliography)
York (City Art Gallery and Minster Library) 1973 'A Candidate for Praise: William Mason 1725–97, Precentor of York' (See Bibliography)
Arts Council (Hayward Gallery) 1975 'The Georgian Playhouse: Actors, Artists, Audiences and Architecture 1730–1830s' (See Bibliography)
Kenwood (Iveagh Bequest) 1975 'To Preserve and Enhance: Works acquired for Kenwood, Marble Hill and Ranger's House, 1964–1974' (See Bibliography)
 1977 'Nathaniel Dance' (See Bibliography)
National Portrait Gallery 1976 'Johan Zoffany' (See Bibliography)
British Museum 1978 'Gainsborough and Reynolds in the British Museum' (See Bibliography)
Kenwood (Iveagh Bequest) 1979 'Thomas Hudson' (See Bibliography)
Munich (Hans der Kunst) 1979 'Zwei Jahrhunderte Englische Malerei: Britische Kunst und Europa 1680 bis 1880' (See Bibliography)
New Haven (Yale Center for British Art) 1980 'Painters and engraving; the reproductive print from Hogarth to Wilkie' (See Bibliography)
Royal Academy 1980 'Lord Leverhulme, Founder of the Lady Lever Art Gallery and Port Sunlight on Merseyside: A Great Edwardian Collector and Builder'
Tate Gallery 1980 'Gainsborough' (See Bibliography)
Kenwood (Iveagh Bequest) 1982 'Pompeo Batoni and his British Patrons' (See Bibliography)
Royal Academy 1982 'Royal Opera House Retrospective'
New Haven (Yale Center for British Art) 1983 'Rembrandt in Eighteenth Century England' (See Bibliography)
Sudbury (Gainsborough's House) 1983 'Henry William Bunbury' (See Bibliography)
Tate Gallery 1983 'James Barry' (See Bibliography)
Arts Council 1984 'Samuel Johnson 1709–84 Bicentenary Exhibition' (See Bibliography)
Hôtel de la Monnaie (Paris) 1984 'Diderot et l'art de Boucher à David; les Salons: 1759–1781'
Wallraf-Richartz-Museum, Cologne 1984 'Englische Porträts des 18. und frühen 19. Jahrhunderts'

Index

Royal Academy Trust

The Trustees and Appeal Committee of the Royal Academy Trust wish to express their gratitude to the many companies and individuals who have already given their support to the appeal. Among many others they would like to extend their thanks to:

The Friends of the Royal Academy